Shooting War

SHOOTING WAR

Photography
and the American Experience
of Combat

SUSAN D. MOELLER

Basic Books, Inc., Publishers New York

Library of Congress Cataloging-in-Publication Data

Moeller, Susan D.
 Shooting war.

 Bibliographical Notes: p. 421.
 Includes index.
 1. Photography, Documentary. 2. War
photographers. I. Title.
TR820.5.M63 1989 778.9'9973 88-47898
ISBN 0-465-07777-3

*This book is
for my parents*

*and dedicated
to my brother Jeffrey.*

With all my love.

Contents

Contents

PART FOUR
The Korean War
June 25, 1950–July 27, 1953

PART FIVE
The Vietnam War
February 8, 1962–April 29, 1975

At the still point of the turning world. Neither flesh nor fleshless;
Neither from nor towards; at the still point, there the dance is,
But neither arrest nor movement. And do not call it fixity,
Where past and future are gathered. Neither movement from nor towards,
Neither ascent nor decline.
. . . both a new world
And the old made explicit, understood
In the completion of its partial ecstasy,
The resolution of its partial horror.
Yet the enchainment of past and future
Woven in the weakness of the changing body,
Protects mankind from heaven and damnation
Which flesh cannot endure.

—T. S. Eliot, "Burnt Norton," *Four Quartets*

Preface

He is come to open
The purple testament of bleeding war.
 —William Shakespeare, *King Richard II*

ON OCTOBER 7, 1986, 227 American correspondents were honored at an event just over the river from Washington, D.C.[1] The reporters and photographers were recognized for their consummate coverage of "wars or conflicts for the American people." The ceremony took place at Arlington National Cemetery; the occasion distinguished those journalists who had been killed on assignment.

The memorial stone commemorating the correspondents is carved into the shape of an open book. It reads: "One who finds a truth lights a torch." The ceremony, the monument, the epitaph are all evidence of the importance we Americans place on our access to the news. We believe that the public in a democracy has the right to know the affairs of the country. We believe that good journalism has a responsibility to present issues and events fairly and accurately. We believe that facts once published and publicized will help keep us free. We honor, we even fashion heroes out of, those correspondents who go through hell to bring us the stories of our time.

We read their war articles and we believe that we know the reality of combat. We look at their war photographs and we believe that we are standing next to them in battle. With their reportage we make our

decisions about how and whether to wage war. With the information gathered by others we redefine our view of war and our view of our own roles in wartime. During times of conflict, the media has helped us to investigate the actions of our country—and our own lives.

This book is both a history of how photography reported America's wars and a history of how this photography reflected and affected the changes in American politics, society, and culture. Since its invention, and certainly since it became advanced enough to stop the action of combat, photography—both still and motion-picture—has been the medium by which civilians have visualized war. It is photography that transports war into the safety and intimacy of our living rooms; it is photography that brings war home.

This book, however, focuses on still photography. While newsreels covered American conflicts during World Wars I and II, and television since the Korean War, still photographs have pictured U.S. soldiers fighting on foreign soil since the Spanish-American War. More than any other medium, still photography has documented the totality of war—both the combat itself and the impact of battle on society and culture. Still photography has contributed the most icons of war to our consciousness. The flag-raising on Iwo Jima entered our culture not through the "March of Time" but through still photography. The naked, napalmed girl running down that Vietnamese road was seen less on the television news than in the pages of magazines and newspapers. War photography, the best still photography, bares the essence of war for Americans. It identifies what Americans—at the time—are fighting for and what they are fighting against. The photograph of the flag-raising on Iwo Jima celebrated American patriotism and the common purpose of the people. The image of the napalmed child publicized American chauvinism and the malevolence of powerful elites. With still photography, then, a longitudinal examination of conflict is possible; such an inquiry can offer important insights into the changes in the perceptions of war over time. Such an investigation may perhaps reveal why photography's images have so defined the American consciousness of war.

For this examination I have set several parameters. First, most importantly and most comprehensively, I have confined my in-depth analysis of war photography to the five major American wars occurring roughly in this century—the Spanish-American War, World War I, World War II, the Korean War, and the Vietnam War. And within those conflicts, I have emphasized the years of official American involvement: for example, in my study of World War I, I have focused on the period 1917 to 1918 rather than on the war starting in 1914. I have also purposely ex-

Preface

cluded any lengthy discussion of the American Civil War. Although the Civil War was the first major conflict extensively covered by photographers, the pictures of it were seen by only a small fraction of the public. Technology did not yet permit photographs to be reproduced directly in the pages of the press; the halftone process was patented only in 1881.

Second, I have limited my discussion of war photography to *combat* photography: those photographs taken before, during, and after a "battle" that describe the American frontline soldiers' experience of war. "Battle" itself, of course, is one of those nicely amorphous terms—it was one thing in the trench warfare of the Western Front and something quite different in the guerrilla fighting in Southeast Asia. But for the purposes of this book, I have *not* investigated photo-essays of USO shows with Bob Hope, or Liberty Bond Drives, or congressional visits "in-country," or even one-day-in-the-life-of-the-motor-pool. I have also, for the purposes of this study, usually defined *battle* as "ground"—not "air" or "sea"—combat. My concentration has been on the infantry soldier's experience of war as interpreted by photographers—themselves not necessarily American—working for the American press.

Third, I have restricted my investigation to photography published in American mass-market periodicals during the conflicts in question. I have not been interested in all the war photographs ever taken. I have been interested in that photography which the American public saw at home while the wars were being fought overseas. Even in the Spanish-American War, and certainly in the later conflicts, thousands of photographs were taken that were not, for numerous reasons, published at the time. Many were shot by amateur photographers—even the Spanish-American War had three or four soldiers who brought their brand-new Kodaks to the front.[2] Others, taken by photojournalists assigned to the wars, never saw the light of day because they were rejected by the photographers' editors, or censored by the military, or considered inadequate or inappropriate by the photographers themselves. It was the photographs that actually were published at the time of the conflict itself that affected the attitudes toward the ongoing war. Therefore, for each war I have primarily looked at those half dozen or so picture magazines and newspaper sections that have had a broad, especially national audience. Although there was some change over time in the publications I used as resources—some magazines folded, such as *Scribner's*, or changed their format to preclude photography or current events, such as *Cosmopolitan*—many survived through several wars and therefore offer particularly useful studies in comparison among the wars.

* * *

Despite the inherent grimness of the subject, war photojournalism is an often incorrigibly optimistic, even idealistic profession. In writing this book, I have been impressed again and again by the aesthetic values and by the physical and moral strength of the men and women photojournalists with whom I have come into contact. I admire their courage, their vision, their modesty, and their faith. Witness to the worst that men can do to one another, war photojournalists often persist in believing the best about humanity. Combat photographers are like Anne Frank, persuaded against the odds that everybody is really good at heart. They are not naive, just hopeful. They believe in the perfectability of man; they believe that if you can only show people the truth then they will act to improve themselves and the world. God knows, however, photographers (especially today) recognize that their "truth" may not be total, and that action resulting from their attempts at documentation may not be immediate. But fundamentally they are convinced that there is something about knowledge that is liberating, that can send a shaft of light into even the deepest, darkest dungeon. "One who finds a truth lights a torch."

Acknowledgments

THE MOST IMPORTANT RESOURCES for any work are seldom listed in the footnotes and bibliography. The institutions and people who make a labor of scholarship possible are those whose engagement with the work is so great that they cannot be credited in perfunctory citations. Funding agencies give an author priceless time in which to think. Formal and informal advisers go far beyond their prescribed role of providing direction. Strangers graciously share their experiences so that others may learn. Friends who have no investment in the subject care enough to ask good questions and offer pertinent suggestions. Family and loved ones unqualifiedly support the author through the years of late nights and cranky days; their trusting concern is the best help of all.

This book first started out as a Ph.D. dissertation with the History of American Civilization department at Harvard. With that in mind, I would like to thank several professors for their direction and advice during my graduate years: Bernard Bailyn, Robert Coles, David Herbert Donald, Barbara Norfleet, Simon Schama, Allen Steinberg, and John Stilgoe. And I would also like to thank Stephan Thernstrom, the chair of my program, for his support of my unorthodox subject; Alan Brinkley for his unfailingly on-target criticisms of my assumptions about history—and for the grace and modesty with which he made them; and Daniel Aaron for his continual willingness to discuss the major and minor problems and questions that arose as my research and writing progressed. His "Renaissance" knowledge guided me through many crises, yet he always allowed me to believe that it was a learning experience that we both were sharing. Finally, I would like to thank the American

Acknowledgments

Association of University Women for a fellowship for my final year of graduate school that enabled me to pour all my energies into the writing of my thesis.

As the work made its transition into a book, I accrued more debts. I would like to thank all those whom I interviewed or with whom I corresponded. Eddie Adams, Malcolm Browne, Russell and Vicky Burrows, David Douglas Duncan, Philip Jones Griffiths, Ralph Morse, Carl Mydans, Joe Rosenthal, and George Silk—to list just the major contributors—opened up their lives so that I could better understand how the experience of combat is reflected in the photographs of it. Their kindness and generosity overwhelmed me, who had no claim on their time or interests. I would like to say about my study of war photographers what Joe Rosenthal said of his photography of soldiers: "I hope I have done them justice, for they have done the world justice."

I would like to thank those who over the past several years aided me by asking the right questions at the right moment or by reading the various drafts and making recommendations. Professors Bob Herbert and John Morton Blum at Yale independently suggested that I focus my study of photojournalism on war photography. Professor Larry Levine at Berkeley helped me understand the pertinence of my questions to broader historical fields. Professors Arno Mayer and Dick Challener at Princeton helped me make connections between my study of photography and my interest in foreign affairs. Curator Frances Fralin of the Corcoran Museum in Washington, D.C., gave me the benefit of her expert eye when she let me watch her put together the best exhibition of war photography that has ever been done. Curator and friend Will Stapp of the National Portrait Gallery in Washington, D.C., was quite simply indispensable. And the students in my American Studies course at Princeton kept me excited and enthusiastic about my subject even as I was bogged down in the last year of writing and revisions. Needless to say, with such extraordinary counsel, any mistakes or errors in judgment present in this book are the result of my own pigheadedness.

Other friends also helped, by compassionately editing my all-too-rhetorical prose, by feeding me and putting a roof over my head when I couldn't be troubled, and by believing that I was capable of accomplishing what I had set out to do. Elaine Abelson, Deirdre Ball, Mimi Baron, Tom Blanton, Jay Handy, Jim Hershberg, Jim Higgins, Debby Kalb, Eric Lindblom, Marilyn Mellowes, Jimmy Miller and Annette Furst, Mark Parthemer, Bill Pease, Paul Stidolph, and David Watt cared about me and my work. And to Steve Ansolabehere, Brian Cooper and Margueritte Murphy, Richard Martin Davis, Shanti Fry and Jeff Zins-

Acknowledgments

meyer, Michele Gammer and Andy Salter, "HR" Bob Hauptman, Ken Hoffman and Michele Ward, Edgar James and Kathy Kinsella, Andy Moravcsik, John Zucker, and Pooka I cannot say enough. I only hope by now they realize that this could not have been done without them.

Finally, I would like to thank my family: my mother and my father, my brother Scott and his wife, Julie, and their two children, Christine and Andrew, who weren't even born yet when this got started. Their love has made it possible and worthwhile.

Shooting War

INTRODUCTION

Interpreting War

Behind the camera there must be a man's eye, and a soul.
—Carl Mydans

WAR IS ABOUT COMBAT. The moviegoer and daily newspaper reader may be forgiven for thinking combat is *all* that war is about. It is not, of course. Sometimes the fighting is irrelevant; what happens behind the scenes in the diplomatic "peace" talks in the world's capitals may be much more to the point. And even in the arena of the war itself, the men on the front lines are always greatly outnumbered by their "support troops." But combat, no matter how peripheral, how Pyrrhic, how purposeless, is the heart of war. It is what young boys glamorize, old men remember, poets celebrate, governments rally around, women cry about, and soldiers die in. It is also what photographers take pictures of.

Since the advent of photography, war, for the home front, has been more than romantic dreams and glorious slogans. Battle has become something in which everyone participates—if only in absentia. The camera has brought the exotic and dangerous near; it satisfies a lust for seeing the action, with the bonus that the viewer at home is never in any danger. Like the voyeurs of the past century who drove their carriages out to a hillside to watch the battle below, the armchair audience gazes at, but does not participate in, war. Whereas the infantry actually lives through the mud, blood, and guts, for civilians combat is a vicarious experience composed of certain moments observed secondhand in the pages of the press.

Photography is a way for armchair participants of past, present, and future conflicts to store away memories in lieu of being there. War photography observes for those who are not in battle what they are missing, and reminds those who were what it was like. Photographs of the land-

scape record the devastation wreaked by the shovels, barbed wire, leaden bullets, and tromping feet imported to the scene. Photographs of the dead recall that the scenery includes more than a blasted earth and sky. And photographs of the living mirror this sight of hell; the "thousand-yard stare" in the soldiers' eyes reflects what—in the words of Edgar Allan Poe—often seemed to be the single "choice of death with its direst physical agonies, or death with its most hideous moral horrors."[1]

Photography makes war accessible. Photographs not only describe the actual landscape of battle, they capture the mood of the times. The story that war photographs tell is not the only story that can be told. It is not a completely true story. But the photohistory of combat is key to understanding the American perception of war. Images of war are defined by the moral position of the individual photographer, the institutional structure of the media, the official censorship of the military, the propaganda needs of the government, and the technological advances of both the photographer's equipment and the armed forces' weaponry. To look at the photographs and to chart their transformation, therefore, is to investigate the nature of "progress" in American politics, culture, and society—and also to follow the changing attitudes (the hopes and fears) and the changing perceptions (positive or negative) about war. The study of combat photography goes beyond debates about waging war; it enables us to investigate our civilization and our psyches with new vision. This study helps to confirm the reflection that rather than simply making culture, we also seem to be made by it.

The Context of War

To analyze the photography of war and to assess how that photography reflected and affected the American experience of war, it is necessary to investigate the conflicts themselves and to chart their changes over time. Each war in the past hundred years has had a different feel, a definite texture, a distinct "persona" in the minds of the American public that, to a great extent, was created by the photography of battle. War photography captures the gallant postures, the patriotic gestures, the resolute stances, and the disillusioned features. Through its repetition of images, it has helped to foster certain physical and emotional stereotypes about each war.

In place of the more equivocal reality, photography has created a unique history of each conflict. Pictures of the stricken *Maine* sunk in the harbor at Havana prompted the Spanish-American War's clamor for "Duty" and "Destiny." Photographs of the fetid filth of the trenches of World War I represented to Americans the degeneracy of the Old World. One vivid image of six soldiers raising a flag over Mount Suribachi on Iwo Jima distilled the essence of the Pacific islands crusade of World War II. Photographs of the tired faces and dull eyes of the men on the front lines caught the interminableness of the peace talks in Korea. And the picture of a naked little girl running down a road after having been drenched with American napalm condensed into a single image the years of struggle for the "hearts and minds" of Southeast Asia. The photographs from these wars witnessed the journey from the birth of an empire to the demise of its dominance, and traced the glory of a successful imperial adventure to the tragedy of its failures.

Parallel to this political shift has been a concomitant shift in the rhetoric, technology, and ethics of the wars. These latter variations have strongly influenced how (or whether) photographs could be taken and how those photographs could be presented to the public, thereby affecting the public's ultimate perception of each war as shaped by the press. Whereas war was once heralded as a glorious and manly pursuit, by World War II it was portrayed as being a distinctly unpleasant but necessary task, and by Korea the country appeared to be just going through the motions. The rhetorical, ostensible, and official purpose for going to fight changed over time. The Spanish-American War for "Manifest Destiny" turned into World War I's "War to End All Wars." And the "liberating army" of World War II became the "Big Green Machine" trampling over the peasantry in Vietnam. With each succeeding war, the U.S.'s view of its role in the world and its perception of its enemies and allies altered.

Changes in the face of battle also affected coverage of the wars. The landscape over which the conflicts were waged varied between pastoral landscapes and rank jungles, and the fighting fluctuated between trench warfare and guerrilla fighting. The type of photography feasible under conditions of a battle fought on a fighting line against conventional forces necessarily differed from that type of photography possible in combat waged by single men fighting a largely unseen enemy. Similarly, the technology of war has helped to modify the landscape and transform the experience of the soldiers within it. A modern war fought by highly mobile armies with helicopters could not help but be repre-

sented differently from a turn-of-the-century conflict fought by relatively static troops with balloon lookouts.

Finally, the changing rules and morality of combat, both for the U.S. government at war and for the individual troops at arms, have swayed the coverage of a particular conflict. The question "Are we fighting a just war?" has always been a crucial interpretive point as far as American attitudes toward war are concerned. Attempts to cast the war effort in a positive moral light have characterized the policymakers and the military strategists' depiction of every American engagement. But that portrayal has become increasingly strained; the official opinion that the United States fights only "just" wars has been increasingly at odds with the photographic portrait of battle. If combat was once an endeavor that brought out the best and the worst in men, Americans came to believe that it brings out only the worst.

This lessening of support has affected the images of war that the press has taken and disseminated. The less popular backing a war receives, the more critical the press can be without alienating its audience (unless official censorship forestalls criticism). The relationship is one of "reciprocal circularity": the more critical the press is, the less support a war receives; the less support a war receives, the more critical the press can become. Of course, the converse can also be true: a popular war can earn generally positive recognition from the press. During the Spanish-American War, for instance, the press played up the heroism of the troops while soft-pedaling the gross mismanagement of the conflict. In contrast, during the Korean War, the press vociferously disapproved of the official conduct of the war, although they did continue to champion the fortitude of the soldiers.

Beginning with the first published halftones of a major conflict—during the Spanish-American War—photography helped to affect a subtle shift in the perception of war. Over time, a greater explicitness in the photography of combat prompted a greater sensitivity to American casualties, a greater reluctance to engage in certain kinds of exceptionally bloody warfare, and, ultimately, a greater reliance on military technology. Visual portrayals of death and destruction began to outweigh the rhetorical arguments in favor of the wars. Although other elements were also significant, there is at least an indirect causal link between the increasingly graphic portrayal of dead Americans and, for example, the growing hesitancy of the government and the military to engage in the dramatic frontal assaults, casualties be damned, that were so much a part of the Civil War (Lee at Gettysburg, Grant in the Wilderness), or even the Spanish-American War and, to a degree, World

War I. The contrast can be seen explicitly in the Second World War: the shift from the calculated slaughter of Gallipoli when the censorship was enveloping, to the long-delayed D-Day invasion of Normany, launched under conditions designed not only to capture territory but to minimize casualties, when the coverage was enveloping. By midway through World War II, officials were unwilling to brave—more than was necessary—the public's reaction to photographs of slaughtered soldiers.

America's increased sensitivity to its own casualties, however, did not cause a concomitant sensitivity to enemy casualties. Until Vietnam, photographs that exposed disfiguring forms of warfare turned against the enemy, such as flame-throwers and napalm, caused little concerted outcry. Indeed, it could be argued that the American penchant for bloodthirsty images is sated by the extraordinarily explicit photographs of the dead enemy that have appeared in print—especially those of non-Caucasians: Chinese, Japanese, Koreans, and Vietnamese.

It is a truism that Americans' opinion of war over the past century has changed from a romantic to a tragic to an abhorrent vision. But it is no less true for being a cliché. What helps to give the cliché currency is that the photography of war underlines the changes expressed in the truism. Photography is an attractive shorthand way to learn about war; many more people know about the island fighting during World War II because of Joe Rosenthal's photograph from Iwo Jima than because of any books or articles they have read on the subject. That visual knowledge gained from photography cannot but have an effect on American attitudes toward war. Photography is the way in which most of us have experienced war. To study war and to omit an investigation of war photography is to refuse to factor into the military and political equation of war the cultural expression of war that the majority of Americans have shared.

The Photographers of War

War photographers, as well as the wars themselves, underwent a transformation during the past century. Just as no reality of war has held across the twentieth century, no single photographic mind has remained across time. As the wars changed, the photojournalists who reported them changed; journalists responded to the varying restrictions of censorship, to the increasing possibilities of their camera equipment,

and to the shifting demands of the wars that they covered. The changing nature of the photographers' role naturally helped to prescribe the photography of combat that was taken and published.

Censorship and technology were key elements in the parameters set for the photography of war. Limited by official regulations, photographers were told where they could travel, which units they could cover, what kind of photographs they could take, and how they could get their pictures home. Bound by the size of their cameras, the length of their lenses, and the speed of their film, photographers could take only certain types of images. Within these constraints, photographers were sensitive to the prevailing attitudes about war in the field and at home; their images reflected both the logistical prohibitions and the emotional atmosphere surrounding a particular campaign.

Photographers who took pictures during the slack censorship of the Spanish-American War, for example, found their coverage of the battles to be more restricted by their bulky cameras, slow film, and their own inhibitions than by any externally imposed regulations. By World War I, camera equipment had improved; what was more limiting was the blanket prohibition of any images of American dead. During World War II, photographers had the luxury of 35mm Leica or Contax cameras, fast film for low-light situations, and even the option of color. Censorship, although it initially mirrored the regulations of the previous war, was liberalized in 1943. In the Korean War, the equipment only improved; several photographers shifted to the hardy Japanese Nikon 35mm cameras. After an initial flurry over problems resulting from no censorship, regulations similar to those of World War II were established. A difference in the "look" of the Korean War compared to that of the Second World War resulted not from slight variances in censorship policies or photographic technology but from the different attitudes that prevailed toward each war: World War II was a heroic and costly battle for world survival; Korea was an ambivalent and costly fight for a controversial "defensive perimeter." And finally, during the Vietnam War, photographers enjoyed both the technological advantages of fast color, motor drives, and satellite communications and the freedom from official censorship. As a result, the images from the Vietnam conflict exhibited an unprecedented technical virtuosity and an unprecedented candor, which, in turn, reinforced the Vietnam correspondents' adversarial coverage of the war.

Other factors also delineated the potentiality of war photography. In addition to the limitations imposed by censorship regulations, photographic technology, and the prevailing attitudes of the home front,

problems inherent in war itself handicapped photographers in their coverage of battle. Still cameras could never capture the sounds and smells of war. Night fighting, particularly common during World War II, Korea, and Vietnam, could not be adequately represented on film; all that could be satisfactorily recorded were the fireworks of the artillery. And the extreme hazard of lifting one's camera to shoot a picture in the middle of a firefight prevented photographers from capturing sharp daytime action. "You see only those photographs that a correspondent was able to take," said Carl Mydans, a photojournalist who has been at Time-Life for over fifty years. "You don't see all the things that were happening all around him when he couldn't raise his head."[2]

Despite their inability to duplicate the realities of combat, photographers made a unique contribution to the public's understanding of war. As the twentieth century grew older, that contribution became increasingly appreciated: the public's high estimation of the value of "objective" reportage spilled over to a reevaluation of photography's documentary potential. War photography has never been objective. However, because a photographer's interpretation of events relies on a mechanical instrument, photographs have been considered to be more accurate than their verbal counterparts. Over the course of the twentieth century, words have become suspect; especially since World War I, Americans have been aware that their opinions have been manipulated by the government, the military, and the press. In an imperfect world, photography has been viewed as the closest one can come to an unimpeachable witness to war.

One reason for the belief in the validity of the photographic "document" is that photographers have to be on the spot to get their pictures, whereas reporters can sit back behind the lines and write their columns without ever having heard a shot fired. During the Spanish-American War, at the "charge" of the Rough Riders up Kettle Hill, photographer Jimmy Hare joined the notoriously foolhardy Stephen Crane and Richard Harding Davis at the top of the ridge. They were the only correspondents on the front line. Observing Hare, one American soldier exploded, "You must be a congenital damn fool to be up here. I wouldn't be unless I had to!" Hare responded, "Neither would I, but you can't get *real* pictures unless you take some risk!"[3] Forty years later, Robert Capa, the most famous war photographer of them all, argued the identical premise: "If your pictures are no good, you aren't close enough."[4] Photographers and cameramen sang a doggerel during the Korean War bemoaning the inequality of their situation with that of the reporters'. *Newsweek* recorded the lyrics:

Bless all the writers and columnists, too.
With their front-line exclusives from back at Taegu.
And the photogs with cameras wet.
All dusty and dirty with sweat,
Are there when it happens,
Get Hell for no captions,
No raises or bonuses yet.

(In rebuttal, a writer commented, "We consider this a lot of blah, and point to . . . those tremendous telephoto [long-distance] lenses.")[5]

Although photographers complain of their lot, their loud laments often mask a real devotion to their work, as is evident in their attitudes during the wars of the past hundred years. Throughout the past century, the attractions of war photojournalism have remained substantially the same. Only the relative importance of those reasons to journalists have changed. First, photographers go into combat to shoot dramatic, life-and-death images and thereby create a historically important oeuvre. War is extremely photogenic; everywhere one looks is a potentially prizewinning picture. Although the conception of what makes a good picture changed over time, photographers throughout the last century traveled to war to make their name in journalism. The top photojournalists during each war gravitated to the battlefields, and younger photographers established their reputations in the heat of combat and competition.

What has consistently attracted the vast number of photographers to war is the incredibly rich, raw material of war itself. War is the cutting edge of history. "My major motivation," said photographer Mydans,

is to record what is happening in my time. I began with a view as a historian when I made pictures for the Farm Security Administration. This is America. This is what is happening to my land. . . . I was moved also to tell the story so that one seeing it might be moved to do something about it. And that was true in covering war, the dead and injured, the terrible lives of refugees. That is what is happening. That is history. That is my job. No matter what to cover it.[6]

Winston Churchill, after his stint as a correspondent in the Boer War, was frequently quoted as saying that a war correspondent's duty is to go as far as he can as fast as he can. But speed and distance alone do not make a great war photojournalist. To be good, photographers of any era have needed some kind of perspective on the raw history that passes in

front of them. "In the photography of war," said Philip Caputo in his novel about a war photographer, *DelCorso's Gallery*, "it wasn't courage that counted, though courage was needed; it wasn't closeness, though you had to be close to arrest the truth; and it wasn't the lens, the angle, or technique. The critical difference was made by purpose in the photographer's mind, the purpose above all."[7] The best photographers—the James Hares, the Robert Capas, the Carl Mydans, the Catherine Leroys—have not created images willy-nilly; they have interpreted life through the lenses of their cameras. "I like to think that photography is an intellectual pursuit as well as a visual one," said photographer Joel Meyerowitz in a recent interview. "More and more I've come to trust that the interior workings of my mind and my responses are phrased in my photographs."[8] And Capa stated, "In a war you must hate somebody or love somebody, you must have a position or you cannot stand what goes on."[9]

So, second, photographers go to war to make a statement. During the Spanish-American War, photojournalists such as Richard Harding Davis used their reportage to support the Cuban struggle for independence. During World War II, photographers such as George Silk took pictures to support the "good" war effort, while at the same time hoping that their images would help prevent future conflicts: "That was my crusade, you see. I was going to save the world by my photographs."[10] And during the Vietnam War, photographers such as Philip Jones Griffiths shot their photographs with the purpose of criticizing the American "imperialist" involvement.

Many photographers, especially those since World War II, have tried to use their photography to condemn war. Those who try to effect change are often haunted by what Joseph Conrad called, in *Heart of Darkness*, "The horror! The horror!"[11] These photographers have focused on images that expose the dichotomy of a "civilized" nation—the United States—using brutality—war—to achieve its ends. What the World War II photographer W. Eugene Smith said about his own work held true for many of his latter-day colleagues:

I wanted to use my photographs to make an indictment against war. . . . I hoped that I could do it so well that it might influence people in the future and deter other wars. [It was a little naive] but I still believe it. There are some things which you must attempt to do, even though you know you're going to fail. Sometimes, enough can be done in small ways.[12]

All photographers, not only idealistic ones, make moral decisions when they choose to go to war, when they choose what pictures to shoot and not to shoot, and when they choose how to compose their images—what to crop and whether the picture should be light or dark, sharp or grainy, stop action or blurred. (The editor also makes moral decisions in selecting which photographs to print, and the audience, in determining which magazines to buy.) How are the decisions made? Even when a photographer has an articulated position, the choices are not self-evident or easy. "Slowly," admitted Capa in 1938 during the Chinese-Japanese War, "I am feeling more and more like a hyena. Even if you know the value of your work, it gets on your nerves. Everybody suspects that you are a spy or that you want to make money at the expense of other people's skins."[13]

The coverage of war, like war itself, is not a civilized business. The incentives of a war photographer can be high and noble, but they can also be selfish, egotistical, immature, and greedy. Photographers can go to war to indict the horrors and to bring the news back home. But they can also go to become famous, to make money, or to indulge a fascination with death and destruction. Either way—and there are few photographers from any war who do not have all these motives in some combination—war photographers are obsessed with war, with observing and recording the events of battle.

And so, finally, photographers go to war and keep going back into combat because they are addicted to the frisson of danger. After the excitement of battle, other assignments pale in comparison. Nothing seems as vital, nothing seems as important. Because combat photographers, by job definition, take pictures from the front lines (as well as from behind them), the profession has always appealed to those who are challenged by danger. During the Spanish-American War, photographers, caught up in the war fever of the period, rushed to Cuba to discover the romance of battle. By World War II, the desire for capturing the glory of war had faded, but the photographers continued to be interested in "testing" themselves in combat. War remained the greatest challenge of the day.

As part of their job, war photographers, and, it must be added, a solid number of reporters, choose to share the frontline soldiers' proximity to death, danger, frustration, uncertainty, and noise. There is a difference, however, between soldiers' and journalists' experiences of war. Soldiers are in combat to kill. Correspondents are in combat to get the news. Journalists are voyeurs, but voyeurs who partake only of the life-

style, not the restrictions, of their subjects. Journalists do not have to be in combat.

This crucial distinction has, typically, created strains. Most correspondents respect the character and role of soldiers. But senior military officers often resent correspondents' ability to walk blithely through the armed services' regulations, and GIs at times resent that same freedom. "They weren't judging me," said Vietnam War reporter Michael Herr of the soldiers, "they weren't reproaching me, they didn't even mind me, not in any personal way. They only hated me, hated me the way you'd hate any hopeless fool who would put himself through this thing when he had choices, any fool who had no more need of his life than to play with it in this way." Yet even these men held a grudging respect for the journalists. "Even they," said Herr, "would cut back at the last and make their one concession to what there was in us that we ourselves loved most: 'I got to give it to you, you guys got balls.' "[14]

War photography is life on the edge, and the problem with it—as with any risk-filled occupation, such as drug smuggling, mountain climbing, or commodities trading—is that it can become an addiction. Don McCullin, a photographer during the Vietnam War, said of himself in 1967, "I used to be a war-a-year man, but now it is not enough. I need two a year now. When it gets to be three or four, then I will get worried."[15] Robert Capa did not miss a conflict between the Spanish Civil War in which he began his career and the war in Indochina in which he was killed. Although there have always been a handful of photographers, like the World War II journalists Gene Smith and George Rodger, who refused to photograph any more wars, there have been many more since the beginning of the profession of war correspondence who have reveled in it.[16]

A dilemma for such war photographers who lose sight of the horror and inhumanity of their environment is that they also lose their ability to distinguish sanity from insanity, kindness from brutality. Without an outraged perspective, without the belief that the world is mad, war seems normal. Many war correspondents feel they need to be rotated back home from their assignments because they, as well as the soldiers, can become disoriented.[17]

Left out in combat too long, a soldier or a photographer loses the sense of a line of demarcation between war and ordinary life; sooner or later, a photographer, like an infantryman, either rebels or breaks down. Because photographers (and reporters) are the intermediaries between the soldiers and the public back home, they have to retain a foot in both

worlds, to comprehend both the soldier's life and mentality and the public's. If they lose their ability to understand either world, they no longer can perform the role of go-between. If they become strung out, if they lose (or never had) a sense of reality, their value as interpreters and communicators is diminished. The primary obligation of a war correspondent is to stay alive, alert—and human. Those who are interested only in going the farthest the fastest and the longest are not likely to come back.

The Photographs of War

The published photographs of war have always been a distillation of battle marketed for home consumption. Photographers and their editors, ever since halftone pictures first appeared in the pages of the press, have directed what the public sees of war—and how it sees. Photographers and editors created and, over the course of the past century, helped to change the parameters of communication. Painter and photographer Robert Rauschenberg noted, "It's only through the arts that people can speak to each other. That's why we're more dangerous than soldiers." Soldiers are the event. Photographers make the event. Photographers choose the subjects to take and compose each shot by cropping out details that detract from their vision of what they want to show. Editors select those prints that will be seen by the public and frame them on a page. And the public rarely recognizes that reality is manipulated through the lens of a camera and through the layout of a publication. Censored and uncensored, photographers and their publications have controlled how the American public regards battle.

Where and how the photographs of war appear has always affected their impact. During the Spanish-American War, coarsely screened halftones joined engraved images in the pages of the turn-of-the-century periodicals. Most pictures appeared in stories of combat as individual illustrations, although some of the more "popular" publications, such as *Collier's*, began grouping images together on a page. Photographs were laid out in a rectangular grid and identified by captions. This technique was continued during World War I, except that the now-ubiquitous photographs were more loosely gathered together in double-page spreads; some pictures overlapped others, some were in oval frames, and some remained rectangular. Specialized supplements, such

as the *Mid-Week Pictorial* begun by *The New York Times*, capitalized on the new process of rotogravure to publish their visual portrait of the war. Twenty years later, the periodicals during World War II, notably the photomagazines such as *Life* and *Look*, adapted these spreads to exploit the storytelling potential of the war photographs. Whereas the pictures of the Spanish-American War were subservient to the text they illustrated and the images of World War I often had no verbal context except their short captions, during World War II and thereafter, photographs themselves became articles. Frequently introduced by a short opening paragraph of copy, the new photoessays told a story in a militantly visual fashion. (Photographs also appeared in other outlets. During both the Spanish-American War and World War I, for instance, photographic stereoviewing cards of the battlefields were sold by the thousands.)

Although the publications in which the images of war have appeared have changed over time, certain verities of photography have remained true. Graphic layouts have varied, the politics of editorial decisions has shifted, and the aesthetic mechanisms of the images themselves have altered during each war of the past century. The clarity of images, the perspective of the camera, the distance of the photographer from the subject, and even the choice of subject have changed. But what has remained the same is that war as represented by still photography does not really exist. The camera "both document[s] events and [is] the instrument of assigning meaning to them."[18] Photographs, all war photographs, do not re-create life on the battlefield; they interpret it.

Since their first application, photographs of war have captured a visual essence but not the total experience of war. The camera takes a picture out of context, a moment out of time. And it often does not take just any moment; it takes, instead, a *"decisive* moment."[19] A fleeting second—such as the instant of the shooting of the Vietcong prisoner by South Vietnamese General Loan—is arrested and analyzed. In photography, reality becomes hyperreality.

In its approximation of life, photography enshrines a slice of time that the normal flow of the world immediately innundates. Photography merely masquerades as human sight; its information is visual, but its manner of collecting and imparting that information is radically different from the totality of a human being's sight. A person's vision is made up of flickering glances that are supplemented by hearing, touch, taste, smell, and, perhaps most important, memory. A person's eye never rests. It darts from object to object like the silver ball in a pinball game, returning more frequently to certain objects—another person's eyes, a

15

brightly colored item. The viewer comprehends the whole by connecting the dots. Added to this staccato, stuttering perception is the information collected by all the other senses. The nose smells a foul odor, the tongue tastes the grit in the air, the skin feels the humidity, the ears hear the clammer. And the brain supplies memories and connections for all this information.

Conversely, a photograph provides only visual information, and even that image is an isolation of an instant that could never have been isolated by the human eye. Yet the inability of a photograph to impart anything other than visual information is partly compensated for by the viewers' insertion of their own sensual experience in the void left by the image's inarticulateness, and the narrowness and precision of the camera's vision is partially relieved by the viewers' observations of different images of an event taken by a spectrum of photographers. Nevertheless, photography still adds up to less than life. David Hockney, an artist and a photographer, derided photography precisely for this reason. "It takes time," he observed,

> to look at anything if you really want to see it. But there is no time in photographs. That's why you can't look at them for very long. . . . They sort of stare you down. . . . You have been putting things together with memory in time. . . . The world really looks that way. . . . In most familiar photographs, everything looks static. And everyone looks stuffed. We've come to think that the world looks like a photograph. That's how mad it's got.[20]

The camera furnishes one with pictures of things, events, and people, but it has never been able to reproduce exactly the same mood, strain, or distortion with which they were seen. Photographs can furnish hints but not whole pictures of things as they were at the time. They have a circumscribed angle of vision, a perspective that is limited to the optics of the camera and to the skill, imagination, and beliefs of the camera's operator. A still photograph's impressions are static in space and time, whereas those of the human consciousness are dynamic and in a constant state of flux.

World War II photographer Robert Doisneau isolated one of the complexities of the medium: photographs draw their life from their viewers; they have no animation of their own. Photographers, Doisneau said,

> must always remember that a picture is also made up of the person who looks at it. This is very, very important. Maybe this is the rea-

son behind these photos that haunt me and that haunt many other people as well. It is about that walk that one takes with the picture when experiencing it. . . . One must let the viewer extricate himself, free himself for the journey. [The photographer] offer[s] the seed, and then the viewer grows it inside himself.[21]

To be persuasive and influential, a photograph must seize the attention of its audience; it must cause its viewers to think. In such a picture, the subject and the composition awaken a reaction within the viewers that vivifies both the viewers and the photograph. Suddenly a semblance of life is created; a chain of thoughts and sensations reanimates a moment in time that in actual fact can never recur. A kind of two-dimensional primitive theater is born. Image mimics—and thereby creates—a new reality. "There are pictures," Doisneau suggested,

that may not only possess an astonishing graphic presence, due to some uncommon element or strange composition, but that may also radiate a unique atmosphere of their own, one that stays with you and that leaves an important imprint in your mind. . . . But how are they made? There isn't any law to describe them. . . . [It] does not happen just by saying that there is an encounter with the setting, a meeting with the people. There is light too. . . . I can't remember who said that "to describe is to kill, to suggest is to give life." This, I think, is the key.[22]

Several "suggestive" mechanisms allow such photographs to influence their viewers. The effective war photographs of the past century, for example, play on certain conventional images of battle. War photography improvises on stereotypes of death and wounding, on scenes of combat, and on portraits of soldiers. These improvisations metamorphose over time. During World War I, for instance, photographs of the wounded recalled religious paintings of the Renaissance; by World War II, pictures of the dead resembled an Alfred Hitchcock thriller. During World War I, images of battle were retouched fantasies of combat; by the Vietnam War, battle was portrayed as a horrendous nightmare. During the Spanish-American War, troops were pictured from a reverential distance; by the Korean War, men were seen in aggressive close-ups.

To have an effect, photographs have to shock their audience. But the same type of image will not continue to have an impact over time; an image is shocking only as long as it retains enough newness to be radical. Therefore, photographers have felt continually pressured to shoot

ever more graphic images—to up the ante so the prurience of the civilians at home stays continually piqued. Over the course of the wars in the twentieth century, photographers have taken increasingly explicit pictures to support the growing habit of the public; photographs of wounded, dying, and dead Americans have been the images of greatest concern. During the Spanish-American War, it was scandalous to take and publish a picture of a dead Rough Rider so swaddled in blankets that all one could see were his hobnailed boots. During World War I, photographers were not allowed to horrify their audience; censorship prevented publications from printing pictures of even explicitly wounded Americans. It was only after the war that the really grim images of battle came out—and they were so much worse than anything that had been seen during the war that they sent isolationist shock waves throughout the country. During World War II, after the strict censorship was liberalized, pictures of dead Americans were seen in significant numbers. Although the faces and other identifying features were carefully concealed, the Second World War photographs clearly described the cause of death. Mothers and fathers across the country and soldiers around the world wrote to the publications both condemning and praising the new candor. In the Korean War, the example had been set: photographs of dead American soldiers consistently appeared in print. But, in keeping with the decline in popularity of the conflict, the dead were not wrapped in the same mantle of patriotism as they had been during the previous war—and for Americans caught up in the "Red Scare," that loss of heroic posturing was shocking. By the Vietnam War, the lack of official censorship encouraged photojournalists to view the loss of heroism as a challenge to official policy. In the 1960s, the media's blunt and graphic depictions of dead GIs and Vietnamese allowed the military's strategy to be questioned by the Armed Forces' own victims.

But these progressive challenges to American attitudes about war were not incited by every photograph that was published. Most of the images of battle that are taken during a war are never acknowledged or even observed; they are aesthetically and conceptually boring. They are part of the scenery: muddy squares in the pages of newspapers and magazines. But out of this morass, the public seizes on those few "uncommon" images mentioned by Doisneau; the public sifts out the ordinary or banal images and remembers the extraordinary or the picturesque. These images become personal icons, involuntarily remembered when a particular war is mentioned. Collected together in one's brain,

they become, in Susan Sontag's words, "an anthology of images"; entire wars are miniaturized and summed up in one or several photographs.[23]

Usually the images that are recalled are those that live in infamy; they are memorable and persuasive because they are the most compelling, the most horrifying. Three such pictures from the Vietnam War, for instance, are the photographs of the burning Buddhist monk, the executed North Vietnamese, and the napalmed child. Viewers recall these photographs, rather than the hundreds and thousands of others that also appeared in the media, because of the imminence of death to each of the three victims.[24] The pictures are effective compositions, but the horror of the specific form of death overtaking each of the subjects—a principled suicide, a perfunctory execution, an indiscriminate bombing—is what causes these photographs to stand out. With photographs, people discover that human beings, not just faceless "casualties," are dying. The transformation of mass calamity into individual people and incidents arrests the viewer. Through photography, war becomes personal and comprehensible—more than just grand patriotic schemes and unintelligible statistics.

The best war photography is an epiphany of life and death. The famous photograph of the Spanish Civil War, Robert Capa's "Moment of Death for a Loyalist Soldier," pictures a soldier stopped in mid-stride. A bullet has caught him. His arms are thrown back. His rifle is flung from his hand. The photograph arrests the viewer as the bullet arrested the soldier. The image is striking because it captures the moment of death. Few of the most famous war photographs of the past century have not included people in direct conflict with death, although some—like the picture of the mushroom cloud 30,000 feet over Nagasaki—inspire such an awareness of death that the absence of people is a minor point.

Many war images portray the actual dead or dying. But even those that do not, those that show gripping moments of fighting or the taut faces of soldiers, gain their bite because of the viewer's recognition of the impermanence of life in the midst of war. The subject of any photograph might very well have been dead a week, a day, or five minutes after the photograph was taken. A photograph fools the viewer into believing in the reality of life when empirically the person pictured no longer exists. Photographs profess their own reality. They all lie. Photography reinforces people's belief in their own and others' immortality in the face of every evidence to the contrary. "Our own death," said Freud, "is indeed unimaginable, and whenever we make the attempt

to imagine it we can perceive that we really survive as spectators."[25] The inherent realism or literalness of a photograph—the incontrovertable "thereness" of an image—works a powerful deception. The slice of time captured by a photograph will never return, despite the photograph's eternal insistence on it.

A second reason for the effectiveness of the photographic icons of war is their successful employment of recognizable, but often subliminal, motifs, metaphors, and myths. Photographers, editors, and art directors rely on the images, objects, and relationships found in American and Western culture to communicate their message to the public. War photography, for instance, often trades on the classic vision of the pietà. Michelangelo's Mary cradling the dead Jesus becomes the photograph of a soldier clutching his dead comrade. By evoking the Christian tradition, the photograph acquires a certain resonance; in both the sculptural and photographic images, the hope, the promise, the flower of manhood is destroyed and the world, knowing, grieves. In both, the faith in the resurrection, in the ultimate triumph because of that sacrifice, sustains the world in its darkest hours.[26]

From Frederic Remington to Tomi Ungerer, *The Rough Riders* to *Dispatches*, "Stars and Stripes Forever" to "The Draft-Dodgers Rag," American culture has helped frame the way people view war. "We live by symbols," Supreme Court Justice Felix Frankfurter wrote to President Franklin Roosevelt in the months before Pearl Harbor, "and we can't too often recall them."[27] Photography capitalizes on that heritage. Photography "signifies" because of the ready-made historical "grammar" of iconographic connotations that are learned from the graphic arts, literature, and music. Photography gains depth of meaning by usurping the images imbedded in American popular culture. It can shock or sound a call to action precisely because its most evocative photographs are those that trade on the "classic" images of battle or the traditional myths of American society. Political economist Robert Reich spoke of "the same stories we tell and retell one another about our lives together in America; some are based in fact, some in fiction, but most lie in between.... These parables," he said, "are rooted in the central experiences of American history: the flight from an older culture, the rejection of central authority and aristocratic privileges, the lure of the unspoiled frontier, the struggles for social equality."[28] The best photographs, the icons of war, illustrate these American parables. The World War II photograph of Iwo Jima, for example, draws its power from the symbols of the American community: the barn raisings, quilting bees, the all for one and one for all. The photograph is memorable not

only because of its taut graphic composition but because it is, in the words of historian Paul Fussell, "so successful an emblem of the common will triumphant."[29]

Photographs of battle both reflect and influence the current interpretation of American culture. The American icon of the rugged individual gone to war has been revised over time by the combat photographs of the twentieth-century soldier. Where once, at the turn of the century, soldiers were photographed à la Teddy Roosevelt—as volunteer heroes gallantly courting a patriotic death—sixty years later, the pictures of men in combat showed disillusioned and disheartened draftees who were counting the minutes until their time in-country was up. The myth of America as that white city upon a hill also underwent a similar revision. In 1898, the Spanish-American War was viewed by most as a glorious mission to free Cuba from the degenerate colonialism of Spain. In 1968, the Vietnam War was seen by many as an imperialist attempt to export American capitalism. The increasing candor of the published photographs of war induced Americans to question the righteousness of their cause.

Perhaps the metaphor that twentieth-century war photography has most neatly embraced is that of the American frontier. There have been, of course, two principal frontier theses. The first was Frederick Jackson Turner's "classic conception of [the frontier] as a vast emptiness awaiting peaceful occupation by agrarian pioneers ... where democracy and individualism could thrive."[30] The second, more recent, thesis views the frontier not as a place of peaceful settlement and gradual civilization of the West, but as an arena for race war. The frontier, in short, was a frontier of violence.[31]

War, and its portrayal in photographs, bears little resemblance to that first bucolic vision of the West. The landscape of war is not the gorgeous landscape photographed and mythologized by Timothy O'Sullivan, William Henry Jackson, and others in their expeditions of Western exploration in the 1860s, 1870s, and 1880s. Although the first American war photographs taken after the closing of the frontier—the Spanish-American War images—romanticized the role of the soldier as much as the Western exploration photographers romanticized the pioneer and the cowboy, the gentle, gradual taming of the frontier celebrated in the Jeffersonian agrarian thesis little resembled the brutal imposition of man on nature and man on man that was evident in war photography from its beginnings.

A much stronger parallel can be discovered in the comparison of the second, revised thesis with war photography. The experience of the

West and the experience of war share, by this parallel, a calculated conquering of the land and the men on it. On the frontier, the line was drawn between the "civilized" whites and the red "savages." In America's foreign wars, the fight has also been identified as between the forces of good—the "Yanks"—and the forces of evil—the Spanish "Butchers," the German "Hun" or "Krauts," the "Japs," and the "Gooks."[32] The common denominator of the frontier violence and the foreign wars has been the characterization of the enemy as an inferior race or ethnic group and, at times, the degeneration of these race wars into little wars of extermination. At times, the association of war and the frontier has even been explicit; Americans in Vietnam, for instance, referred to Vietcong-controlled territory as "Indian country." Ironically, both on the frontier and in war, Americans have had to "destroy" a people to "civilize" or "save" them.[33] The photography of war has captured that paradox and kept pace in publicizing the changing emotions and attitudes about each succeeding enemy and war.

The express connection of photography to the frontier is the synergistic relation of the events depicted in the images of war to the themes embedded in American political culture. Although Frederick Jackson Turner's frontier thesis has been widely discredited, his definition of the frontier—"the meeting place between savagery and civilization"— seamlessly fits into the more contemporary account of the thesis. It is also an apt definition for war: "between savagery and civilization." War is the meeting place between the base passions of greed and aggression and the exalted emotions of patriotism and comradeship.

Over the past hundred years, photography has influenced Americans' impression of that "meeting place." Photography has helped to shift Americans' belief that war is a glorious calling to the belief that war is a necessary job to the belief that war is a murderous pursuit. Photography has depicted, with increasing candor, the horror of war. Informed by this portrayal, Americans have begun to find the search for glory and the urge of patriotism that formerly led them into war to be frivolous rationales for engagements characterized also by death and destruction of the most obscene order. As a result, the nature of twentieth-century warfare has altered. As the century's battles have worn on, generals have chosen, for example, to depend on technology as a way of husbanding their human resources. "The bomb," especially, was one technological invention initially employed to save the lives of American soldiers—although, paradoxically, the descendants of those atomic weapons are the greatest threat to survival today.

At the end of World War II, General of the Army George C. Marshall

wrote in his war report to the nation that the "harnessing of atomic power should give Americans confidence in their destiny."[34] Marshall was wrong. Americans are not confident. There are very few who would not trade the enormous destructive capability of nuclear weapons for the conventional armaments of early World War II. We are no longer alone in harnessing nuclear destruction. Today, we Americans can also be obliterated in one fell swoop.

War photography has brought images of our destruction home. War photography has allowed us to see the consequence of our actions. War photography has pictured for us the atomic wastelands of battle. With photography we know what we have done; with photography we know what to expect. War photography illustrates Frederick Jackson Turner's awful rendezvous; war photography records America's last frontier.

The Early Years

And let me speak, to the yet unknowing world,
How these things came about: so shall you hear
Of carnal, bloody, and unnatural acts;
Of accidental judgments, casual slaughters;
Of deaths put on by cunning and forc'd cause;
And, in this upshot, purposes mistook
Fall'n on the inventors' heads: all this can I
Truly deliver.

—William Shakespeare, *Hamlet*

"When you are covering anything in journalism," believed *Life* photographer Ralph Morse, "you are the eyes of the world."[35] And when those eyes blink, the world blinks. Photography, whether still or motion-picture, visualizes and verifies events for the world's audience. It always has. To certify the relationship between pictorial journalism and politics, all one has to do is investigate the contemporary case of South Africa. "When the networks were in full force there," the *Boston Globe* reported, "pictures of South African police murdering the black citizenry mobilized this country's consciousness much as the pictures in the early '60s doomed the survival of segregation in the South. But the South African government censored those photos, the networks lost interest and the public agenda went elsewhere. It was a case of the net-

works living by the picture and dying by the picture. Nothing to show, nothing to report."[36]

One could also look back to the early years of war photography to corroborate the longevity of that association between images and politics. "Reportage," wrote Will Stapp, photographic historian and curator of photography at the Smithsonian, "was understood to be one of the most significant potentials—and goals—of photography at the very beginning of its history." But the restrictions of the early technology initially inhibited the "systematic recording and reporting with the camera of ongoing or current events until late in the century." At the time of the American Civil War, only twenty years after the invention of Daguerre's photographic process in 1839, photographers could not "photograph activity, they could not photograph quickly nor take many pictures at any one time, and they could not photograph spontaneously."[37]

As a result, photographs of war prior to the late 1880s (when the photographic equipment itself, the communication systems, and the reproduction technology all had advanced to a sufficient point where photographs could be easily taken and disseminated) were necessarily photographs of preambles or aftermaths—usually either staged portraits of men before battle or reproductions of the static carnage and destruction on the field after the fighting was over. Early daguerreotypes of the Mexican War during the Polk administration fall into this category, as do the more famous wet-plate–processed images from the Crimean War and the American Civil War.

Yet the photographic coverage of war, especially of the U.S. Civil War, can still be considered direct inspiration for the more comprehensive photojournalism that was to follow. Subjects that were to continue to be focal points in later engagements—the soldiers, the military camps, the battlefields, and the dead—first received careful notice in these early conflicts. Photographers, such as the Civil War chronicler Mathew Brady, "envisioned a great popular demand for war photographs." The project of covering the conflagration "appealed to Brady's innate sense of historical mission"[38]—a motivation that remained a spur for photographers shooting later wars. Although actual combat or scenes of action could not be captured until faster film and smaller cameras evolved, the coverage of the Civil War was the first systematic attempt to document a conflict in its entirety.

Concurrent with the interest of capturing the war in photography grew the desire to circulate those images. Gallery shows, carte de visite prints available from catalogs, and special edition books all brought the minutia of the Civil War to the rapt attention of the public. The Brady

studio pictures of Antietam, for example, taken by Alexander Gardner, "literally stunned the American people" because of the photographs' relentless portrayal of the dead. As the first of that war's images "to confront the horrible reality of war and its human cost," the Antietam pictures received greater contemporary attention than any others subsequently taken during the conflict: they were exhibited and simultaneously offered for sale at Brady's gallery, they were reproduced as wood engravings in *Harper's Weekly*, and articles about them appeared in the *New York Times* and *The Atlantic Monthly*. The *New York Times* wrote in its review of the gallery exhibit: "Mr. Brady has done something to bring home to us the terrible reality and ernestness[sic] of war. If he has not brought bodies and laid them in our door-yards and along streets, he has done something very like it." For the first time, although not for the last, photographs of war challenged "the public's long nurtured belief that death on the battlefield was glorious and heroic."[39]

The Antietam photographs, especially, received much popular attention because they were taken and distributed as stereo cards. Stereo cards remained a favorite novelty well into the twentieth century; mounted on a rectangle of cardboard and looked at with a binocular-like viewer were two nearly identical photographic prints that seen together produced an illusion of a three-dimensional image. Since 1850, the public had collected these cards, and by the 1860s such national figures as Oliver Wendell Holmes promoted them for their educational value. Companies emerged to exploit the medium; pictures of cataclysmic events, views of technological achievements, and scenes of natural beauty could be purchased in sets. Stereo cards of war, especially, were perennial favorites; Keystone View Company, for instance, "sold more cards from its series on the sinking of the USS *Maine* in Havana Harbor than any other title in its extensive catalog."[40]

But despite the popularity of the Antietam photographs, the Civil War images reached far fewer of the public than did the images even from the next American engagement, the Spanish-American War. Few of the public saw the Civil War's gallery shows or could afford the limited-edition books. Relatively few bought stereo cards. And the rare photographic images that did make it into the pages of the press were translated into engravings and thereby lost much of the detail and veracity for which the original prints were remarkable. By 1898, however, technology allowed photographs to be liberally and literally reproduced in the mass-market, national press. As a result, the Spanish-American War's audience became privy to war in the comfort of their homes. The invention of the halftone ushered in the first "living-room war."

PART ONE

The Spanish-American War
in Cuba
April 25–August 12, 1898

1

The Context:

"A Grand Popular

Movement"

"IT SEEMS ALMOST MADNESS," admitted war correspondent H. Irving Hancock, "that sets thousands of men slaying each other. It seems almost unnatural, and yet I am pagan enough to feel . . . that war is really an exhilarating business; that it requires and develops the best qualities of American manhood."[1] Thirty-three years after Appomattox, it was time for a war. America needed an infusion of hearty blood, high spirits, and vigor. "I wish to Heaven," Theodore Roosevelt wrote in 1897, "we were more jingo about Cuba and Hawaii! The trouble with our nation is that we incline to fall into mere animal sloth and ease, and then to venture too little instead of too much." Elsewhere he remarked, "There seems to be a gradual failure of vitality in the qualities . . . that make men fight well and write well."[2] The cure, of course, the way to regain the vigor and vitality, the fighting edge responsible for the glory of the American past, was by—what else?—going to war.

War would recapture the glory that was America's heritage; war was America's "Duty" and "Destiny." This exalted belief about Duty and Destiny served the military strategists well: Duty caused the soldiers to follow where the officers led them, and Destiny allowed them to think it was inevitable that they would win. Duty meant that America had a moral obligation to fulfill. Destiny meant that America would fulfill it. "Duty," said President William McKinley, "determines destiny."[3]

29

The Spanish-American War remains the most popular war of the past hundred years; in 1898, the campaign for Santiago was known as "The People's War and the Soldier's Campaign." Its ostensible cause was the growing impatience of the United States with Spanish colonial rule in Cuba and the consequent sympathy felt for the Cuban guerrillas. But, as historian Richard Hofstadter observed, the "primary significance of this war in the psychic economy of the 1890's was that it served as an outlet for expressing aggressive impulses while presenting itself, quite truthfully, as an idealistic and humanitarian crusade."[4]

The press rallied the American public to the side of the Cuban insurgency. Whereas during the First World War the press became an adjunct of the government's propaganda effort, during the Spanish-American War, the press was independently jingoistic. The journalists wanted war because they revered—and traded on—the vision of America as the gallant defender of freedom. Correspondents, such as the celebrated Richard Harding Davis, journeyed to Cuba in the period before the U.S. involvement and wrote strongly worded articles extolling the Cuban cause. Many saw parallels between the Cuban insurrection and the American Revolution; in one of the most famous of the early stories, Davis drew an implicit connection between the execution of a Cuban patriot and the death of Nathan Hale.

As a result, the Americans' early sympathies lay with the Cubans. Indeed, well before the American troops left the port of Tampa, the war in Cuba had splashed front-page headlines across the U.S. papers. The war raged for three years before the official American troops entered, but American correspondents, soldiers of fortune, and gallants of all stripes had long traveled south on personal missions to aid the Cuban rebels. The correspondents supported the Cubans' battle because it was represented to them as a righteous war. In fact, the Cubans—and their American supporters—orchestrated their actions to encourage the American public's belief in the rightness of their cause. The contemplated assassination of the captain-general of the Spanish forces, Valeriano Weyler y Nicolau (better known as "Butcher" Weyler to the American public), for example, was explicitly forbidden by the Cuban leader, Maximo Gomez. "Why did we allow Weyler to live?" repeated Gomez to correspondent James Creelman. "Because he was more useful to us alive than dead. . . . A dozen patriots offered to kill the Captain-general and die with him. . . . But we would not stain our cause with murder. . . . If we had assassinated Weyler, we would have lost the sympathy of the American people and destroyed our only chance for liberty and independence. There is nothing equal to patience in a fight against

oppression."[5] The Cubans wanted, needed, American intervention. They staked out the moral high ground in the battle for public opinion.

Allegations of serious misconduct by the Spanish troops framed the public rhetoric in the months and years before the U.S. engagement. Actual and alleged atrocities by the Spanish received prominent attention, especially in the Hearst and Pulitzer papers. And, in addition to print articles accusing the Spaniards of atrocities, periodicals across the country utilized the new photographic halftone to verify their accusations. Magazines and newspapers published pictures "made on the spot" by the technology of the camera, which could not "lie." One such photograph appeared in Leslie's Illustrated Weekly in December of 1896 showing "the bodies of six Cuban pacificos lying on their backs, with their arms and legs bound and their bodies showing mutilation by machetes, and their faces pounded and hacked out of resemblance to anything human."[6]

Accusations of atrocities continued once the United States entered the fray. The rumors were fanned by what appeared to be the frequent desecration of the American dead and wounded. Writing for The World, Stephen Crane reported on June 12, 1898, that two marines killed in the first land battle at Guantanamo's harbor were "horribly mutilated." Two days later, however, he corrected himself, saying that the medical officer believed that the "dreadful" wounds were due to bullets fired at close range. "There was positively and distinctly no barbarity whatever," Crane wrote.[7] On other occasions, the cause of the mutilation of corpses turned out to be animal scavengers; as Theodore Roosevelt noted, "One of our own men and most of the Spanish dead had been found by the vultures before we got to them; and their bodies were mangled, the eyes and wounds being torn."[8]

Rumors of Spanish atrocities had initially inflamed the passions of the American press and people. But once the United States immersed itself in the war the press and public became horrified as well by the "knowledge" that their Cuban allies—perhaps as often as the Spanish—were fighting with the reprehensible tactics of a guerrilla war. To the Americans for whom the war had little real immediacy, such conduct by their "allies" was inconceivable. In the years before the official American participation in the conflict, the press had spoken of the Cubans and their guerrilla tactics in positive terms, asserting that such strategies were appropriate to an "underdog" people who were beseiged by a cruel colonial power. However, upon the U.S. entry into the fighting, the Americans expected that those tactics would change and that the war would then be conducted along more moral, more "manly"

lines. "When war came," noted Crane, "the regular United States regiments heaved a sigh of relief, and said: 'Well, the (Red) Indians have been bush-whacking us all our lives, and we've been bush-whacking Indians; now, thank heaven, we've got an enemy that will come out and fight.' But the Spaniards were no greater fools than the Red Indians or the Cuban insurgents."[9]

Few Americans understood the pressures of a guerrilla war; other incidents of guerrilla fighting in American history—the Indian wars in the West and the mountain fighting during the Civil War—had consistently been viewed as aberrant, their lessons dismissed. Americans failed to internalize the facts of guerrilla war: that there are no rules and that there are no noncombatants; and that everyone—with no exceptions—falls within the purview of combat. At the turn of the century, Americans still believed that war was a rule-governed activity and that there were moral limits, even in the midst of hell. (It was not until World War II and, more generally, until the Vietnam War sixty years later that Americans began to face up to the imperatives of guerrilla combat.)

As a result of the "exigencies" of guerrilla warfare, friction arose between the Americans and their Cuban allies, and the battle was played out in the pages of the press. Americans had little comprehension of how to fight a guerrilla war and no intentions of learning. The Cubans, conversely, had no understanding of conventional warfare and no resources to attempt it. To the Cubans, the Americans' haste was incomprehensibly wasteful. To the Americans, the Cubans' delays were downright lazy. To the Cubans, a "fighting line" would have been suicidal. To the Americans, guerrilla tactics were cowardly and, what was worse, un-American. Stephen Crane showed some grasp of the problem. "There is no specious intercourse between the Cubans and the Americans," he wrote. "Each hold largely to their own people and go their own ways. The American does not regard his ally as a good man for the fighting line, and the Cuban is aware that his knowledge of the country makes his woodcraft superior to that of the American."[10] (Ironically, one of the few Americans who showed some appreciation of the guerrilla fighting was Theodore Roosevelt. To him, "a curious feature of the changed conditions of modern warfare" was the greater need for that valued and positive commodity: "individual initiative."[11])

Whereas the American public, cued by the reportage of the press, had initially believed that Cuba was destined for the heritage of the Declaration of Independence and the American Revolution, attitudes began to shift after the American army reached Santiago. Once the U.S.

troops experienced the actual strains of side-by-side combat, the Cubans were perceived to be not noble martyrs but incompetent, even ungrateful allies. The Cubans—at least as often as their colonial oppressors—were portrayed in the periodicals at home as stupid, cruel, lazy, and selfish. "To put it shortly," explained correspondent Crane, "both officers and privates have the most lively contempt for the Cubans. They despise them. They came down here expecting to fight side by side with an ally, but this ally has done little but stay in the rear and eat army rations, manifesting an indifference to the cause of Cuban liberty which could not be exceeded by someone who had never heard of it."[12] Richard Harding Davis, who had come a long way from depicting Cubans as reincarnated Nathan Hales, felt simply that they were "worthless in every way."[13]

Dissatisfaction with the Cuban allies was undisguised even in the military. Major-General Nelson A. Miles, the commander of the army, reported to the War Department:

> There has been a great deal of discussion among officers of this expedition concerning the Cuban soldiers and the aid they have rendered. They seem to have very little organization or discipline, and they do not, of course, fight in the battle line with our troops. Yet in every skirmish or fight where they are present they seem to have a fair proportion of killed and wounded. They were of undoubted assistance in our first landing, and in scouting our front and flanks. It is not safe, however, to rely upon their fully performing any specific duty, according to our expectation and understanding, unless they are under the constant supervision and direction of one of our own officers, as our methods and views are so different, and misunderstanding or failure so easy.[14]

By mid-July, relations were so strained that, as one correspondent reported, the Cubans were "not only . . . not . . . allowed to participate in the negotiations or the ceremonies of the surrender, but . . . they were not even . . . permitted to visit their homes in the city [of Santiago] to the capture of which they had substantially contributed."[15]

Although by the end of the war Americans thought that the Cubans were hardly deserving of support, they had not lost faith in their own abilities or in the rightness of their fight. They had fought a "good fight"; "their" war, if nobody else's, remained "bully." American jingoism, American imperialism, and American chauvinism grew, prospered,

and flourished, only to cast a shadow that would darken the country over half a century later during the American war in Vietnam.

On the evening of February 15, 1898, at 9:40 P.M., the battleship USS *Maine* blew up in the Havana harbor, killing 260 of its crew. The cause of the explosion was never determined—although investigators swarmed over the twisted hulk posthaste—but the American press was all too ready to blame the Spanish colonial government in Cuba for the sinking of the ship. "Remember the Maine" became the slogan of the hour, and despite earnest diplomatic efforts by the Spanish and by the American ambassador in Madrid to prevent a war, policymakers in New York and Washington were jingoistic.

On April 11, President McKinley sent his war message to Capitol Hill. "In the name of humanity," the president wrote, "in the name of civilization, in behalf of endangered American interests which give us the right and the duty to speak and to act, the war in Cuba must stop."[16] Congress debated the message for days, first passing a resolution recognizing Cuba's independence and then, on April 25, voting for war.

The public, coached by partisan statements in the press, reveled in war fever. Thousands of young men from the Brahmin clubs of Ivy League universities; from the cities, towns, and countryside of the Old South; and from the cowboy ranches of the closed frontier hastened to join up. The volunteer regiments had to turn candidates away; they refused 25 percent before inductions and an equal number thereafter. The Fifth Army Corps, commanded by Major-General William Shafter, after swallowing the entire regular army of the United States, turned down 75 percent of its over 100,000 new applicants. Even after this seemingly heavy-handed selection process, the regulars and volunteers still admitted 100,000 more soldiers than were needed or could be outfitted.[17]

By August 1898, the Regular Army totaled 56,365 and the Volunteer Army, 207,244.[18] Reflecting their greater number, the volunteer hometown boys were, in the view of many Americans, the essential and preeminent unit of the war. The public heaped so much attention on the volunteer regiments—especially the Rough Riders—that volunteer officer Theodore Roosevelt went out of his way in later years to comment, "The newspaper press failed to do full justice to the white regulars, in my opinion, from the simple reason that everybody knew that they would fight, whereas there had been a good deal of question as to how the Rough Riders, who were volunteer troops, and the Tenth Cavalry, who were colored [regulars], would behave; so there was a

tendency to exalt our deeds at the expense of those of the First Regulars."[19] As journalist Crane bitterly noted, in an article sent home from the war:

> The public doesn't seem to care very much for the regular soldier. ... Just plain Private Nolan, blast him—he is of no consequence. He will get his name in the paper—oh, yes, when he is "killed." Or when he is "wounded." Or when he is "missing." In fact, the disposition to leave out entirely all lists of killed and wounded regulars is quite a rational one since nobody cares to read them, anyhow, and their omission would allow room for oil paintings of various really important persons.[20]

For all the soldiers, regulars and volunteers alike, training for the Cuban conflict was rudimentary, at best. Because of poor planning, overeager recruits, and the lack of appropriate uniforms and arms, little more than the basic manual of arms was taught before the troops traveled down to Tampa, Florida, the port of embarkation. In Tampa, affairs were even more chaotic; there were not even enough ships to transport all the troops to Cuba. Thousands of would-be heroes were left behind. Only three of the volunteer regiments—the Seventy-first New York, the Second Massachusetts, and the First Volunteer Cavalry (better known as the Rough Riders)—actually made the sailing to Santiago. Competition for places on board the departing ships became so keen, wrote Theodore Roosevelt, that

> I ran at full speed to our train; and leaving a strong guard with the baggage, I double-quicked the rest of the regiment up to the boat, just in time to board her as she came into the quay, and then to hold her against the Second Regulars and the Seventy-first, who had arrived a little too late, being a shade less ready than we were in the matter of individual initiative. There was a good deal of expostulation, but we had possession.[21]

It was typical of the mood of the Spanish-American War that when some officers and privates were informed there was no room for them on the transports they "burst into tears."[22] To miss what appeared to be the one chance for glory in a lifetime, to miss the experience analogous to their fathers' and grandfathers' in the Civil War, loomed far, far worse than the possibility of a *glorious* death.

The potential for "gallantry," after all, was what made the war so

appealing both to the volunteers and to the public back home. The soldiers of the Spanish-American War appeared in uncommon numbers as those "perennial phenomen[a]" of war. "These soldiers," asserted military historian J. Glenn Gray, "cherish the conviction that they are mysteriously impervious to spattering bullets and exploding shells. . . . Death is an impersonal force that can rob other men of their motion and their powers, but for them it has no body or substance at all. . . . If such soldiers command men . . . they have the capacity to inspire their troops to deeds of recklessness and self-sacrifice."[23] Colonel Leonard Wood, the ranking officer of the Rough Riders, for example, made no effort to hide from the Spaniards during the first battle at Guasimas. He "wandered slowly about on horseback among his men," reported Edward Marshall, a correspondent wounded in the fight, "with the bullets continuously shrieking their devilish song in his ears, and playing their infernal tattoo on the ground near him. He left the battle-field without a scratch. It was wonderful."[24] Theodore Roosevelt, too, and countless others exposed themselves in such a foolhardy manner that they either must have believed they were immortal or discounted their own personal significance in contrast to the grand scheme for which the war was fought. It was a war peopled with amateurs committed to demonstrating their personal courage in the glorious defense of a moral cause.

The storming of the San Juan hills—the climactic event of the war in Cuba—was just such a reckless strategy. The attack was born of desperation. It was not a prearranged military plan, but instead what has been happily described as "a grand popular movement"—a moment of irresistible, valiant action.[25] The troops could not retreat because the single-file trail behind them was wedged with men for two miles. They could not remain where they were because they were being shot to pieces. They had only the single option—go forward and take the heights by assault. "It was as desperate as the situation itself," wrote correspondent Davis:

> To charge earthworks held by men with modern rifles, and using modern artillery, until after the earthworks have been shaken by artillery, and to attack them in advance and not in the flanks, are both impossible military propositions. But this campaign had not been conducted according to military rules, and a series of military blunders emanating from one source had brought seven thousand American soldiers into a chute of death, from which there was no escape except by taking the enemy who held it by the throat, and driving him out, and beating him down.[26]

THE CONTEXT: "A GRAND POPULAR MOVEMENT"

The charge up San Juan Hill and its outpost, Kettle Hill, has remained in memory as one of the most heroic deeds in American military history. As Davis described, "Roosevelt, mounted high on horseback, and charging the rifle-pits at a gallop and quite alone, made you feel that you would like to cheer."[27] It was a moment of conspicuous gallantry in a war renowned for bravery. Still, the image that was left in the public's mind was not quite true to the reality. "I have seen many illustrations and pictures," wrote Davis,

[of the] charge on the San Juan hills, but none of them seem to show it just as I remember it. In the picture papers the men are running up hill swiftly and gallantly, in regular formation, rank after rank, with flags flying, their eyes aflame, and their hair streaming, their bayonets fixed, in long, brilliant lines, an invincible, overpowering weight of numbers. Instead of which I think the thing which impressed one the most, when our men started from cover, was that they were so few. It seemed as if someone had made an awful and terrible mistake.

They had no glittering bayonets, they were not massed in regular array. There were a few men in advance, bunched together, and creeping up a steep, sunny hill, the tops of which roared and flashed with flame. . . . Behind these first few, spreading out like a fan, were single lines of men . . . moving slowly, carefully, with strenuous effort. It was much more wonderful than any swinging charge could have been. They walked to greet death at every step, many of them, as they advanced, sinking suddenly, or pitching forward and disappearing in the high grass, but the others waded on, stubbornly. . . . When it had reached the half-way point, and we saw they would succeed, the sight gave us such a thrill as can never stir us again.[28]

A short time before his death, after his terms as president, Theodore Roosevelt looked back on his life and concluded, "San Juan was the great day of my life."[29] Stephen Crane declared at the time, "It was the best moment of anybody's life."[30] The foreign attachés present on the spot criticized, "It is very gallant, but very foolish."[31] And Joseph Chamberlin, a correspondent who witnessed the fighting, admitted, "On a battle-field it is as good to be a fool as to be brave."[32]

Major Matthew F. Steele, who took part in the battle, and later became a military historian, criticized the charge up Kettle Hill as "but one incident of an engagement badly mismanaged but gallantly carried

out."[33] Journalist Davis was more scathing in his summary of the military tactics and planning of the Santiago campaign. "The truth," he said,

> is that it was not on account of [Commanding General] Shafter, but in spite of Shafter, that the hills were taken. . . . His self-complacency was so great that in spite of blunder after blunder, folly upon folly, and mistake upon mistake, he still believed himself infallible. . . . His troops, without the aid they should have received from him of proper reconnaissance and sufficient artillery, devotedly sacrificed themselves and took the hills above Santiago with their bare hands.[34]

The press excoriated the military bureaucracy for its criminal ineptitude—although at first journalists tempered their criticisms for fear that they would be perceived as attacking the validity of the war itself. In late May 1898, Davis wrote his brother from Tampa about the abysmal state of supplies:

> The volunteers are like the Cuban army in appearance. . . . Half of the men have no uniforms nor shoes. . . . I have written nothing for the paper, because, if I started to tell the truth at all, it would do no good, and it would open up a hell of an outcry from all the families of the boys who have volunteered. . . . It is the sacrifice of the innocents. The incompetence and unreadiness of the French in 1870 was no worse than our own is now. It is a terrible and pathetic spectacle, and the readiness of the volunteers to be sacrificed is all the more pathetic.[35]

Indeed, the entire land campaign in Cuba was so mismanaged—the critical lack of matériel, the abysmal care of the wounded and fever patients, the supply of rancid food, and the stumbling military strategy—that a well-publicized commission was appointed by President McKinley to investigate the conduct of the war.

Even if the campaign had been "well" conducted according to the lights of the American military establishment of the time, the soldiers' training, the combat strategy, and the recommended arms would probably still have been inappropriate to the war that was being fought in Cuba. The Spanish-Cuban War was predominately a guerrilla battle; the American soldiers were unequipped to fight the war they entered. Put bluntly, the American troops in 1898 (like most of their counter-

parts in 1968) were trained to fight with conventional tactics in the classic battle patterns dear to the memory of those high-ranking officers who dated from the Civil War. The Americans were fortunate that the Spanish enemy was so weak (and that the American navy warships were not). And they were fortunate that when the soldiers did engage the Spanish troops, the fighting progressed along conventional lines. But rarely were the American soldiers opposed by massed forces. Most often, the Spanish enemy remained invisible to the Americans. The Spaniards avoided direct confrontations. The landing of the American troops at Daiquiri, for example, was uncontested; all the high points that had been occupied by the Spanish troops were vacated without a fight. The only Americans killed were two who died by drowning.

"The method of warfare with which our soldiers were here opposed," wrote J. C. Hemment, a photographer for the Hearst-owned *Journal*, "was quite novel and very destructive. The Spanish soldiers—and the Cubans, too—practise the same means of deception. They cover themselves with large palm leaves or other dense foliage.... By stealthy crouching [they] come into close quarters with the enemy before detection."[36] Alternatively, Spanish sharpshooters, hidden in the trees, harassed the Americans. One observer commented that "the quickest movement from point to point, or a temporary rise to snap one's camera, was inevitably rewarded with a special visitation of bullets."[37] Even Spaniards in their trenches were notoriously difficult to discover. From as close as fifty yards, the Spanish line was invisible because dirt from the excavations was carefully carted away rather than piled in front of the trench.

In armaments, however, the American regulars and the Spanish troops were well matched. Both were issued roughly comparable arms; the Spanish carried the Mauser and the Remington, the Americans the Krag-Jörgensen and the Lee-Metford. All had an outside range of 2,000 yards and burned smokeless powder. The two American volunteer infantry regiments, though, carried different arms because the U.S. War Department did not have sufficient .30 caliber arms on hand and could not manufacture them quickly enough. Volunteers fought with Springfield rifles that had a range of only 1,000 yards and burned black powder that defined their positions as clearly as if they had set up road signs. After each explosion of the black powder, a curtain of white smoke hung over the Americans' guns for fully a minute before the volunteers could see the opposing trenches—a full minute for the Spanish to mark their position. This, and the discrepancy in range, rendered the two volunteer units worse than useless in battle; early in the conflict, both

units were ordered to cease fighting. (The American artillery was also issued the black powder and similarly found itself in an inevitably suicidal position whenever it formed within range of the Spanish guns.) Major-General J. C. Breckinridge acknowledged at the end of the fighting: "It has certainly been clearly demonstrated in this war that smokeless powder and rapid fire are absolute necessities for both small arms and field guns."[38]

The rapid fire from rifles, machine guns, and artillery, all protected by barbed wire and operating from the cover of entrenchments, earthworks, or blockhouses, made it difficult and sanguinary for any offensive to be brought to close quarters. According to military historian Field-Marshal Viscount Montgomery of Alamein, "the spade had now become an essential article of military equipment; the only defence against machine-guns and artillery fire was to dig in."[39] Both sides in the trenches fired high, often in volleys, and at long range, causing damage not by individual accuracy but by sheer volume. As Crane noted, "two or three thousand Spaniards armed with Mausers and each man having from five hundred to a thousand cartridges at hand, are bound to hit at most everything when the enemy begins to cross open ground in their front."[40] One example of the severity of the fire at El Caney was given by a British military attaché, Captain Arthur Lee. Lee wrote, "Seven men of the Seventh Regiment broke through a hedge into the field beyond and instantly a volley killed three of them and wounded the remaining four."[41] The colonel of that regiment was killed in the fight by three bullets: one through his chest, one in his knee, and one at his heel—another graphic example of the fire-swept zone of the Mauser.[42]

Although the Spaniards' individual Mausers could shoot thirty or more shots per minute, the Spanish machine guns could shoot ten times that amount. One twenty-year-old who had joined the Rough Riders and who was wounded in the fighting before Siboney wrote about the combat with amazement. The Spanish "had several machine guns," he said, "which were quickly put into action, and then the men began to drop. You have never been under the fire of a gun shooting 300 times a minute; this is one of the first battles in civilized warfare in which it has been used. When the bullets strike the ground they all appear to do so at once, and as if they were strung out in a row."[43]

The American machine guns were used in the most advanced trenches to hold down the enemy's fire and to prevent them from using their artillery. Primitive machine gun nests were created by Lieutenant John Parker, the commander of the Gatling Gun Detachment, by re-

moving the wheels from the guns and putting them in the trenches with a sandbag parapet in front as cover. Prophetically, Parker wrote that the machine gun would be a "weapon to be reckoned with in some form in all future wars."[44]

In addition to the side arms, rifles, and machine guns on both sides was the artillery, generally referred to as "dynamite guns" (actually a compressed-air or pneumatic cannon), that threw shells filled with high explosives. According to John Black Atkins, an English correspondent, "The dynamite gun was not fired very often, because it used to become jammed, but everybody loved it as a great big expensive toy. . . . When the gun was fired there was very little noise—only the sound of a rocket; but when the shell exploded there was a tremendous detonation. . . . In one case, a Spanish gun and a tree were seen to be hurled bodily into the air."[45]

The noises of battle created a cacophony that was music to one side's ears and terror to the other's. Theodore Roosevelt told of the moment the Gatling Gun Detachment entered the action during the San Juan hills fighting. "Suddenly," he wrote, "above the cracking of the carbines, rose a peculiar drumming sound, and some of the men cried: 'The Spanish machine-guns!' Listening, I . . . jumped to my feet, smiting my hand on my thigh, and shouting aloud with exultation: 'It's the Gatlings, men, our Gatlings!' . . . Our men cheered lustily. . . . It was the only sound which I ever heard my men cheer in battle."[46]

Other writers spoke of the noise made by a bullet. Crane emphatically stated that the "modern bullet does not whistle," adding that the Mauser bullet either sounded as if "one string of a most delicate musical instrument had been touched by the wind into a long faint note" or as if "overhead some one had swiftly swung a long, thin-lashed whip."[47] Correspondent Casper Whitney commented that the nearest bullets sounded "like never-ending strings of fire-crackers completely encircling you, while 500 or 600 yards away it seemed as if the crackers had all been tumbled into barrels."[48] And from his perspective as a wounded correspondent, Edward Marshall believed that "the noise of the Mauser bullet is not impressive enough to be really terrifying until you have seen what is does when it strikes. It is a nasty, malicious little noise, like the soul of a very petty and mean person turned into sound."[49]

The clamor of battle both masked the horror of war, by drowning out the sounds of the wounded, and added to the horror, by sapping the resolve of many of the well. "On the firing line," said correspondent Hancock, "one sees men killed, or sees them wounded, or hears, per-

haps, their anguished groans. Still he does not realize the horror of it all. The incessant pop-pop-popping of infantry fire is all around him, and this martial racket tends to shut out or supersede the notes of human agony."[50] But the individual sounds themselves, such as the omnipresent whine that signaled the bullets' presence, could be enervating. "You would see a soldier walking along the trail quite boldly for a little way," observed journalist Davis,

> and then a bullet would come too close to his head or too many of them would whistle by at the same moment, and his nerves would refuse to support the strain any longer, and he would jump for the bushes and would sit there breathing heavily until he mustered up sufficient will-power to carry him farther on. It was hardest for the wounded who had just fallen during the charge up the hill. They had paid their dues, and felt that they deserved a respite; but the bullets pursued them cruelly.[51]

Davis's observation was a rare sentiment to appear in print. Few of the magazine articles of the correspondents, the reminiscences of the officers, or the letters of the men contradicted the belief that the soldiers—all the soldiers—were anything but always gallant, brave, and stoic. "No one seemed frightened," remembered Marshall. "These men who had scarcely been able to realize the existence of real war with a real Spanish army a few moments before, waded into it when it came with an excited delight which amounted to ecstasy."[52] "The men and officers," wrote Captain John J. O'Connell of his battalion's first engagement, "acted with great coolness, considering that most of them were under fire for the first time."[53]

Much of this fabled coolness could be attributed to the fact that relatively few men died in combat. However, the novelty of seeing a comrade get shot in battle shocked those who were left all the more. John Winter, Jr., a young Rough Rider, told the story of the march toward Santiago on July 1:

> Then came the most unique experience of my life, and one I shall never forget; both lines opened fire, and Mauser bullets began to whistle around our heads. . . . [We] were ordered to march "by the right flank, double time". . . . There was a man named Irvine in our troop with whom I had been thrown a good deal. We had become as close friends as an acquaintanceship of several weeks could make us, and we had been fighting together a good deal. In execut-

ing the order just mentioned he was a little in front of me and to one side, both of us running . . . as I looked . . . in front of me the breath left my body for the moment as the whole top of his head flew up in the air, his skull blown to atoms by an explosive bullet. He fell heavily with a thud, and I ran on past his body, but I knew at last the meaning of the phrase, "The art of war."[54]

Winter knew "at last" that there was no "art" to the "art of war." Death, when it comes, even in a small and glorious war, is not pretty. Death in war is not like death in the theater. One photographer noted that when shot, the men fell "like logs. There was none of the stage dropping, by first jumping five or ten feet into the air—no Rialto business."[55] But ultimately there were too few casualties to teach the country about the perils of force. The myth of battle as ennobling survived the two brief months of the war in Cuba to find new life in the rhetoric of World War I twenty years later.

What did not outlive the Santiago campaign, however, was the belief that an army could exist without adequate preparation for combat and without adequate care for the wounded. The latter omission was evident at all stages of the conflict. There were few medical corpsmen to see to the wounded or dead during combat, there was pitifully little transportation with which to conduct the injured to aid stations or hospitals behind the lines, and, more generally, the medical supplies, facilities, nurses, and commissioned surgeons were inadequate to tend to the number of wounded or ill once they were at the aid stations, hospitals, or on the hospital ships going home.[56]

The wounded, for the most part, were on their own; they were left behind in the frenzy of the fighting. They had to trust to the strength of their own constitutions and to the friendship of their comrades. "Those who are still with the firing line," said correspondent Hancock, "are going forward, a few yards at a time, and so, gradually the injured men are left further to the rear. . . . Those who are able to walk, or even to hobble, often those who are able only to crawl, make their way to the rear. . . ."[57] The dead also were left behind in the advance of battle. They lay at the roadside, in the chapparal, on the crest of a ridge, or in the outer trenches of the enemy's captured lines of defense. When night came they were buried with haste. Any left for long in the open, day or night, were ravaged by vultures and by the large, numerous land crabs. According to Hancock, "in a few minutes they will pick a human being's bones clean." Even the wounded were not safe from their rav-

ages. "Had a wounded man fallen by the roadside, unconscious . . . he would unquestionably have been devoured."[58]

Only three ambulances had been transported to Cuba. The wounded were forced to make their way back to help as best they could, some in springless mule wagons, some carried on stretchers as far as thirty miles to the field hospitals. Most walked. Crane described the Goya-esque scene:

> The wounded were stringing back from the front, hundreds of them. Some walked unaided, an arm or a shoulder having been dressed at a field station. . . . Others hobbled or clung to a friend's shoulders. Their slit trousers exposed red bandages. A few were shot horribly in the face and were led, bleeding and blind, by their mates. And then there were the slow pacing stretcher-bearers with the dying or the insensible, the badly wounded, still figures with blood often drying brick color on their hot bandages. Prostrate at the roadside were many others who had made their way thus far and were waiting for strength.[59]

The trauma for the wounded on their trail back to the field hospitals involved more than the length and agony of the journey itself. Spanish sharpshooters followed the procession. Their presence was so ubiquitous that the road from El Caney and San Juan back to the field hospitals in Siboney became known as "Sharpshooters' Lane." Irving Hancock noted:

> One or two isolated cases of firing upon our wounded would not furnish an indictment against the enemy. But this is the systematically attempted murder of non-combatants who, by all the rules of war, are entitled to safety and consideration. A man wounded on the firing line throws down his gun and goes to the rear. He is no longer a soldier, an enemy. Wounded and without arms, he should be sure of humane treatment and succor. . . . He cannot be knowingly fired on—so runs the law of civilized warfare. It is a law founded on chivalry and humanity, a law maliciously defied by our Spanish enemy at Santiago. . . . Spanish honor? What a hollow mocking phrase![60]

It was one more appalling indictment to be charged against the practice of guerrilla war. Crane wrote: "Red Cross men, wounded men, sick men, correspondents and attachés were all one to the guerilla. . . . You

can't mistake an ambulance driver when he is driving his ambulance. You can't mistake a wounded man when he is lying down and being bandaged. And when you see a field hospital you don't mistake it for a squadron of cavalry or a brigade of infantry."[61] "This is not a war" exclaimed Davis, "it is a state of lawless butchery, and the rights of correspondents, of soldiers and of non-combatants are not recognized."[62]

Surprisingly, despite the "state of lawless butchery," despite the thirty miles, and despite "Sharpshooters' Lane," an injured soldier's chances for recovery were high—as long as he didn't catch yellow fever. As Theodore Roosevelt noted, "If a man was shot through the heart, spine, or brain he was, of course, killed instantly; but very few of the wounded died—even under the appalling conditions which prevailed."[63] One reason for the high recovery rate was the relatively "humane" effect of the small-caliber Mauser bullets. "Whipping through the body at so great a velocity, it cauterises and in a sense acts as an antiseptic to the wounds. . . . Many men who have had bullets through them have never gone into hospital."[64] The application of first-aid dressings (often in the field), the employment of relatively novel aseptic and antiseptic treatment, and the institution of triage also resulted in a high incidence of recovery. In addition, major operations were rare (few men could have survived one—even if the time and the personnel had existed—on rations of mildewed hardtack and rancid pork). Only 98 major surgical operations were recorded as being performed between May and December 1898; 34 arm and leg amputations, 18 for hernia, and 15 for appendicitis.[65]

Casualties during the war in Cuba were so few that the official report to the secretary of war listed the names of both the killed and wounded officers. From June 22 to July 17, 23 officers and 237 enlisted men were killed and 99 officers and 1,332 enlisted men were wounded. Unfortunately, significantly more men died from disease. In Cuba alone, 427 died of malarial fever and another 87 died on the voyage home. A total of 2,485—counting deaths from fever in the United States, the Caribbean, and the Philippines—died from disease.[66] The war took its toll, yet, as Richard Harding Davis noted, in "the great battles of the Civil War . . . the men killed and wounded in a day outnumber all those who fought on both sides at San Juan."[67]

The Spanish-American War was short, small, and successful; it was really more of a skirmish than a war. In their summer of involvement, the American soldiers never had to confront the imperatives of guerrilla warfare: they never had to choose whether to fire on the wounded;

they never had to investigate their own atrocities committed in the heat and passion of a colonial war. The Americans landed in Cuba on June 25; the Spanish surrendered on July 16. At the formal end of the war, on Friday, August 12, 1898, the Americans were left with a handful of heroes, a collection of island colonies, and a firm belief in their own superiority. It was, when all was said and done, as splendid a little war as the United States was ever likely to see.

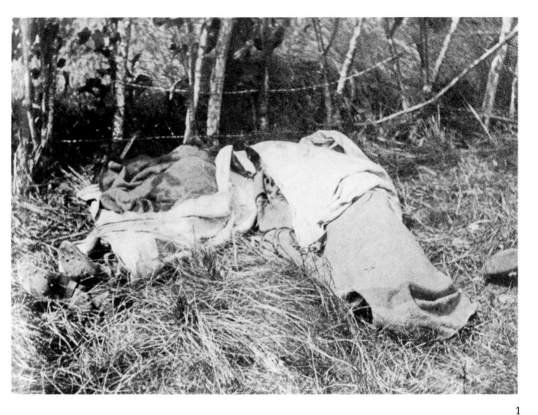

1
Burr McIntosh
"Rough Riders as they fell in the
bloody engagement of June 24th—
Hamilton Fish to the left—
They died for humanity's sake."
Leslie's Weekly, July 28, 1898

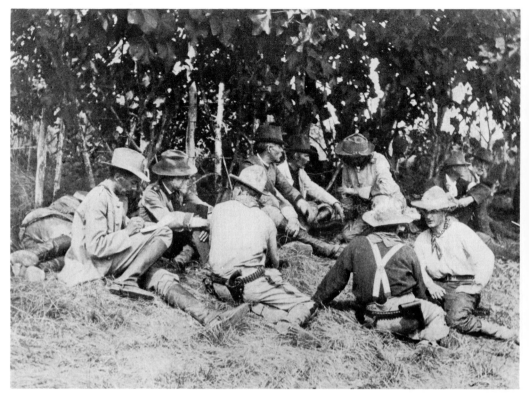

2
Burr McIntosh
"The council of war before
Roosevelt's Rough Riders made their
irresistible onslaught on the Spaniards."
Leslie's Weekly, July 28, 1898

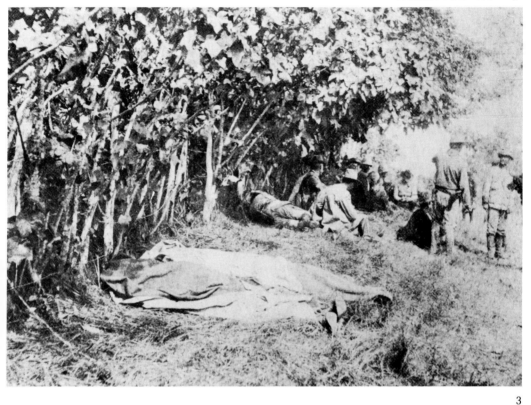

3
Burr McIntosh
Officers and correspondents conferring;
dead soldiers in foreground.
1898

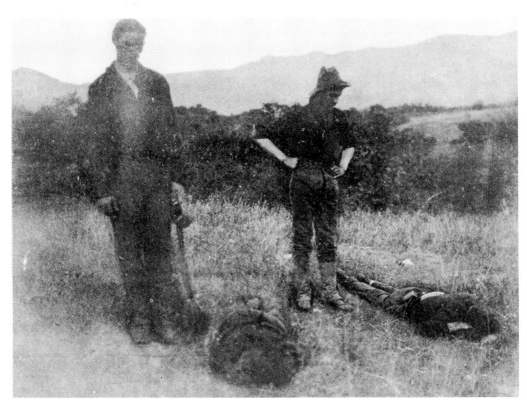

4
James Burton
"Killed on the field of battle."
Harper's Weekly, July 30, 1898

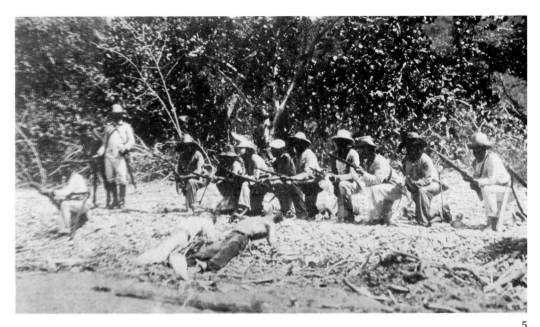

5

J. C. Hemment
"Cubans watching to capture or kill
the Spanish marines as they escaped
from their sinking war-ships—
Two dead Spaniards in the foreground."

Leslie's Weekly, August 4, 1898

6

Unknown naval officer
"Charred Remains of a Spanish Gunner."

Collier's Weekly, August 6, 1898

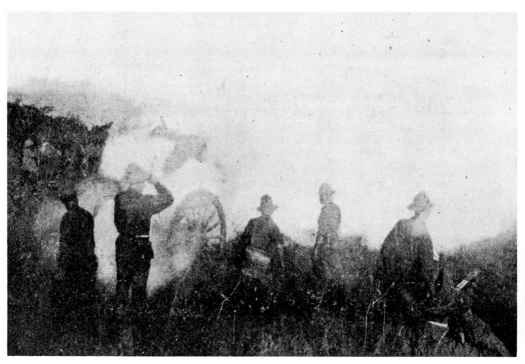

7
William Dinwiddie
"Captain Capron's battery in action
before El Caney, July 1.
The second shot carried away
the flag on the block-house."
Harper's Weekly, August 6, 1898

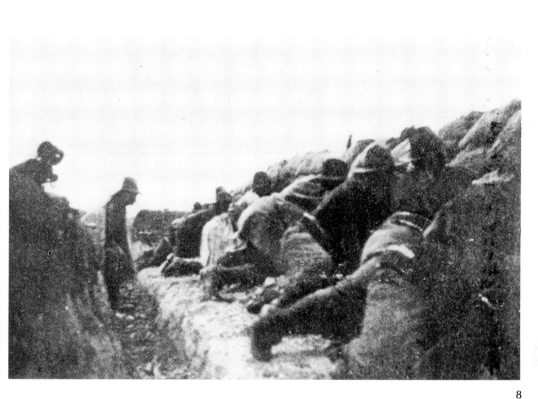

8
James Burton
"9th Infantry firing in the rain,
from intrenchments,
at Fort San Juan, July 9."

Harper's Weekly, August 6, 1898

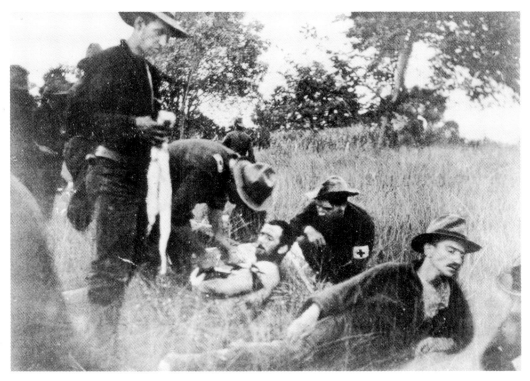

9
James Burton
"Surgeon attending to the wounded
in the field hospital."

Harper's Weekly, July 30, 1898

2

The Photographers:
The New Profession

Who, What, Where, When

AT THE OUTBREAK of the Spanish-American War, only a handful of reporters, artists, and photographers had any experience covering battle. Some had been in Greece in 1897 or in Cuba before the direct U.S. involvement, but most of the correspondents who were sent down to cover the war were neophytes. Untried and untested under fire, they, like the rest of America, were eager to experience the fighting.

Seeking to hire the most prominent correspondent available, fifty to a hundred newspapers cabled Rudyard Kipling in England: "Want you to report the war. Will you?" Three of four were able to add to their cable: "How much?—you can have it, however much."[1] But Kipling did not bite. In his stead, newspapers turned elsewhere. Two of the best correspondents, according to Richard Harding Davis (who was one of the few who did have war experience), "served their respective papers, previous to the war, as drama critics, and their only knowledge of war had been gathered from performances of 'Secret Service' and 'Shenandoah.' "[2] Others literally came in off the street to volunteer their services. After the explosion of the *Maine*, Jimmy Hare, who had been photographing features for the *Illustrated American*, walked into the offices of *Collier's Weekly* with a proposal to take pictures both of the wreckage and of Cuban life. He embarked for Havana a few days later.

All told, between 300 and 500 correspondents wended their way

south. The War Department allowed 7 accredited journalists per periodical in the war zone. "Consequently," remarked Davis, "we as a class are a pest to the officers and to each other." "The fault," he believed, "lies with the army people at Washington, who give credentials to any one who asks." Distinctions were made, however, in the treatment of the journalists. "I ought perhaps to say," admitted Davis, "that the position of the real correspondents is absolutely the very best. . . . Generals fight to have us on their staffs and all that sort of thing, so I really cannot complain, except about the fact that our real news is crowded out by the faker in the rear."[3] This was the crowded beginning of the phenomenon of the roving American war correspondent. As Ralph Paine, a young reporter during the war, recalled, "this was one of the happy phases of the trade we followed, that you met your newspaper comrades again in Havana or San Francisco, in London or Shanghai, and were not in the least surprised."[4]

Of the hundreds who traveled to cover the Spanish-American War, few were photographers. Newspapers and magazines would send a dozen or more reporters to cover all aspects of the war—Hearst sent twenty-five—but others sent no photographers and only a few sent one or more. Frequently, the publications hired only artists and illustrators—artists Frederic Remington and George Luks were two examples. But a small number of photographers did cover the battles, and it is to their credit that the Spanish-American War is now regarded as being the first war in which photojournalism had a significant presence in the media. Prominent among the photographers sent to cover the fighting in Cuba were Jimmy Hare and his assistant, George Parsons, for Collier's; Hare's son George; J. C. Hemment and his several assistants for the New York Journal; Burr McIntosh for Leslie's Illustrated Weekly; James Burton for Harper's Weekly; Dwight Elmendorf for Scribner's; and the first known American woman war photographer, Frances Benjamin Johnston. Most of these photographers also served as reporters in some capacity, and many of the reporters, including Davis, Stephen Bonsal, James Creelman, and William Dinwiddie, also took photographs regularly to supplement their reportage.

Although photographers were few, their unique contribution to the reportage was appreciated. "The photographs of scenes in the Santiago campaign," stated Munsey's Magazine a few months after the war,

> form a remarkably interesting historical document, such as could scarcely have been secured in any previous war. They were taken at the cost of no little labor, hardship, and peril. . . . A photograph,

of course, pictures its subject with a vivid fidelity that no drawing can equal, and in looking over the accompanying illustrations the reader sees before him our fighting men and the scenes amid which they fought just as they actually were during those eventful July days when our army and our navy did such splendid work at Santiago de Cuba.[5]

The correspondents in the Spanish-American War played extraordinary roles. Many clearly pictured themselves as actors on a real-life stage; they strutted and posed, championed the downtrodden, and risked their necks as if they were heroes in a melodrama. Never, before or since, have correspondents been quite so conspicuous and ubiquitous. Not content to remain noncombatants in their duties as journalists, they took a major part in the military operations. To get the story meant to participate in it. Journalists scouted the enemy, directed gunfire, and led charges. The first American wounded in Cuba during the war was a correspondent, James F. J. Archibald. Other correspondents acted as gunrunners and secret agents. Most carried a revolver as a matter of course. Few failed to insert themselves as players in the war.

The journalists were allowed unusual freedom in their activities. They could go almost anywhere and do almost anything. Foreign observers were surprised; the German Emperor said he was "greatly amused at the idea of a fleet of warships going to battle accompanied by a fleet of newspaper dispatch boats."[6] The American press dogged the military at every turn. Major-General William Shafter, commander of the army's expedition to Cuba, was clearly hostile to the correspondents, yet he permitted them extraordinary access to the land operations. In his story of the war, which appeared the following year in The Century Illustrated Monthly Magazine (motivated, no doubt, by the torrents of criticism directed against his command of the troops), Shafter grudgingly accepted the existence of war correspondents. "It is my opinion," he wrote,

> that newspaper men should not be allowed to accompany an army, but they all came with credentials from the Secretary of War, and I gave them passage. I recognize that, with a people like ours, it may be better to risk the injury their news even under censorship may do than cause the dissatisfaction their exclusion would give rise to at home.[7]

At the outset of the war, magazines and newspapers freely published reports of the movements of the navy and army. The press itself admit-

ted, "We gave the Spaniards no use for spies, for our yellow journals became themselves the spies of Spain."[8] Stricter enforcement of the censorship came once the troops rendezvoused in Tampa. Suddenly, the journalists had Signal Corps censors peering over their shoulders. Certain information could not be passed. "The United States authorities," commanded chief censor Lieutenant-Colonel George Squier on May 19,

> declare that all messages containing information of prospective naval movements and current military operations are inimical to the United States, and are consequently forbidden. Senders of press or other messages are requested not to include such matter. If any such is found it will be stricken out by the censor.[9]

Journalists found, as well, that if they were too incautious about stating the actual status of affairs, intimating that the army was in no condition to enter upon a campaign, their War Department credentials were revoked—their criticisms, although accurate, gave "aid and comfort to the enemy." To the formerly untrammeled journalists, such an imposition of censorship was onerous. Photographs were similarly restricted. The New York *Evening Journal* reported that same week in May that a bill was pending in the House which would levy a $25,000 fine or 10 years' imprisonment on anyone who published a photograph that gave information on the strength of American fortifications.[10]

But censorship was not the only impediment to getting the war reports printed in the American press. Communication from Santiago to Key West was a major obstacle. American correspondents were forced to resort to fast dispatch boats that plied the waters between the coast of Cuba and various points in Florida and the Caribbean. Because the Havana cable had been cut, most of the reportage went out over cable from various scattered stations—in Key West, Kingston, Cape Haitien, St. Thomas, and Port-au-Prince—to the head offices of the press in the United States. Time was of the essence for newspapers eager to score a "beat" on their rivals; races developed among competing reporters to get to the nearest cable station. Cable rates to the New York offices ranged from five cents to almost ten dollars per word, depending on the distance the message had to travel and whether the message was sent press rate, commercial rate, or urgent rate. Correspondents at the Key West terminal filed as many as 5,000 words a day. At that volume, some journalists became rich; Davis got ten cents a word from *Scribner's* for

"everything I send them, if it is only a thousand words," and a $400-a-week salary from the *Times* "and all my expenses."[11] Adding up the costs of the dispatch boats' rental, the coal needed for steam, the wages of as many as a dozen crew members per boat, the correspondents' salaries, and the cable costs, not to mention the everyday needs in running the newspaper and the extras, the price for covering the war ran as high as $1,000 a day. William Randolph Hearst's expenditures were estimated at $3,000 a day and half a million dollars for the whole war.

Photographers, unfortunately, were unable to use the cable facilities, although the New York *Herald* was secretly working on arrangements to send images by telegraph. The *Herald* even sent a telegram to its correspondent Stephen Bonsal to that effect: "We are making arrangements to have pictures sent by telegraph," the telegram said. "It will be the sensation of the century, the scoop of the war. We trust you will help us all you can." Bonsal was amused. "Was there ever such tommy rot," he laughed, "to send pictures by telegraph!"[12] Only in World War II did it become technically feasible to send war photographs back to the United States over cable and radio channels. In the Spanish-American War, photographs and film were either sent by dispatch boats to Florida and then by rail up the coast or given to shipping traffic in the region bound for East Coast cities. (J. C. Hemment, for example, sailed to Port Antonio, where he then sent his first batch of war photographs home on a steamer of the Boston Fruit Company.[13])

Magazines and newspapers during the Spanish-American War (unlike during the succeeding conflicts of the twentieth century) had little opportunity to publish photographs taken by photographers other than those with whom they had a contractual agreement. There was no reservoir of official military photographs. In 1898, there was as yet no Signal Corps Photographic Section—that would be established in 1917 to oversee the military photography of events. The need for a photographic military record of events was understood, however. Toward that end, army photographers were trained for duty at the Signal Corps Noncommissioned Officers School at Fort Riley, Kansas. "The use of photography," noted the chief signal officer in his 1898–99 report to the War Department, "having become an indispensable correlative of military service, especially in war, the signal companies in the commands of Cuba, Porto Rico, and the Philippines have been fully furnished with cameras and complete photographic supplies."[14]

At least one Signal Corps officer, Lieutenant-Colonel Samuel Reber, had photographs of the Cuban battlefields reproduced in the army's report on the war. Two years earlier, Reber had authored the army man-

ual of photography. In the manual's introduction, he suggested the value of photography to the army's operations. "The compactness of modern apparatus and the rapidity of the recent photograph processes," he wrote,

> render the reproduction of terrene [sic] and enemies' works or positions the labor of a few hours, while formerly it necessitated days and weeks to achieve the same object. A military photograph possesses value from the fact that it contains an accurate and graphic description of the object desired, and can be made in much less space of time than by any of the processes of manual reproduction.[15]

Reber also detailed the type of camera equipment that military photographers would find useful. "For hasty work in the field," he said,

> the photographer needs but little in the shape of impediments. A hand camera, preferably 5 × 7 inches with Russian leather bellows, double plate holders, or a roll holder, a rapid rectilineal lens, pneumatic shutter, folding tripod, and rubber focusing cloth, in which the camera may be inclosed for protection against the weather, will prove a compact and light kit for any field work. The cut films now manufactured possess a great advantage over glass, owing to their lightness, portability, and absence from liability to breakage.[16]

The civilian photographers covering the war, however, did not necessarily take the army's advice on what equipment to bring. The best photographers—or at least the best subsidized photographers—took along several large-format cameras. For many, good photographs were still synonymous with larger cameras and glass-plate negatives. Underwritten by his employer William Randolph Hearst, J. C. Hemment carried three cameras and a variety of lenses of different focal lengths. His largest camera was 12 × 20 inches and had a long-focus lens that he used for photographing the sea battles. His second largest camera was 11 × 14 inches; also used for photographing from on board ship, it was less bulky but took clear pictures at only half the distance of the 12 × 20. His smallest camera was his "good and trusty" 6 × 10, to be used for "field operations." Hemment had anticipated using the latter camera most frequently and so equipped himself with four gross of 6 × 10 glass plates. He was so well stocked that on board the yacht that served as

his floating darkroom he had "sufficient photographic material to start an ordinary photograph supply shop."[17]

Others, such as Jimmy Hare, less well funded or unwilling or unable to lug around the bulky equipment, relied on small hand cameras that used the recently invented cut film. (Several of the soldiers even carried "Kodaks," the amateur camera invented ten years earlier that held a hundred negatives on a roll. Once all one hundred shots were exposed, the entire camera had to be sent back to Rochester for developing and reloading at a cost of ten dollars.) But photographers who used the hand-held cameras proved to be the most prescient. At the end of his book *Cannon and Camera*, Hemment admitted to the greater manageability of the smaller-format cameras:

> I would say that the future photographing of war scenes will be done with cameras quite different from those I used in this campaign. . . . All through this war I carried glass plates in large quantities, and in travelling from place to place I found them a very heavy burden. They could not be stowed away in small places or with the convenience of films, therefore I should advise that films be used wherever a long journey is expected. . . . I would advise the use of a rapid-working lens . . . with a large, plain field, good depth of focus, and plenty of brilliancy. A lens that is not exactly a land-scape lens, but one between the two, a lens more on the portrait style . . . [as] we know that portraits and figures are the most impor-tant parts in photographing such a subject as I have here before me.[18]

In sum, he concluded, "A camera not larger than five by seven is the most convenient to use."[19] For similar reasons, most photojournalists found themselves carrying a minimum of personal equipment. Artist, photographer, and writer Frederic Remington recalled that the corre-spondents carried "three days of crackers, coffee, and pork in our hav-ersacks, our canteens, rubber ponchos, cameras, and six-shooter—or practically what a soldier has."[20]

Cameras were only half the equation of war photography. Getting usable images was the other half. Most photographers had to provide for some kind of improvised darkroom. Once again, Hemment had the most luxurious arrangement. He and his assistants had outfitted the "spacious second-cabin dining room" of the Hearst-hired yacht and "fixed it up to answer the purpose of a dark room. We had darkened all the windows with red muslin, put up an electric fan, and fitted up tables

and baths and made other arrangements for developing, until we had a place which would do credit to many studios in New York."[21] Other photographers had to set up their darkrooms in less commodious quarters; they made do without electric fans and hung their red muslin in tents on shore. On land, a journalism ghetto developed; three buildings and various tents in Sibony were dubbed "Newspaper Row." The strip became the principal gathering place for reporters, artists, and photographers back from the front. Officers and foreign attachés dropped in as well, mail was delivered, and dispatches and film were sent out. As correspondent Irving Hancock noted, "Newspaper Row became an exchange—a sort of forum. Everyone who wanted to hear or tell something came our way."[22]

Accommodations offshore, however, were more luxurious. On the Hearst yacht, Hemment even had the advantage over the other photographers in the printing of the negatives once developed. "Printing in this climate and on a boat," he chortled,

> is delightful work. One does not have to choose the glaring sun of the tropics to print by, as one can take the shady side of the deck and print in beautifully diffused light. This enabled us to get off fine, clear prints. The paper and the plates which I took along acted very nicely with careful manipulation, and I can say that I did not have one case of "frilling" either with plates or paper in the whole expedition . . . [since] we had a large supply of ice and other facilities on board.[23]

Photographers went through all sorts of contortions to get their pictures and to protect their cameras and film—many times sacrificing their own skin and comfort to save their materials from injury or rain. Tents and rubber blankets were often just large enough to shelter the equipment. And unanticipated threats to the successful completion of their assignments were inherent in the coverage of foreign war. On one occasion, Jimmy Hare's horse bolted, throwing Hare and his camera into a river. In an attempt to salvage the soaked photographs, Hare waited until dark and then unwound the film and wiped the negatives dry. The following day, he sent the film with instructions to *Collier's*. Unfortunately, on the trip north, the film's edges stuck together with the moisture and when it finally arrived in Philadelphia it appeared to be ruined. But an ingenious staff member suggested cutting the ends of the roll instead of unwinding it and thus many of the pictures were saved.[24] Burr McIntosh also lost numerous pictures. His film was de-

stroyed at customs. McIntosh had sent the film to New York, and when it arrived at quarantine, the disinfecting law went into effect and the box enclosing the film was steamed. Only nineteen of his eighty-four negatives were printable.[25]

To be successful, the war photographers had to be athletic and courageous as well as resourceful. In an article profiling J. C. Hemment, the *Journal* commented, "Not only is his technical manipulation of the camera the most skillful and artistic, but his personal prowess and enterprise in getting at the most hazardous subjects is remarkable. He is a notable exemplification of the fact that the successful illustrator nowadays must have something of the athlete, the sportsman, the soldier, and the sailor in his composition."[26]

While these qualities were advantageous for all correspondents, they were particularly crucial for photographers. Reporters could always fudge their stories a bit if they were not right on the spot, but photographers had to be where the pictures were—and getting the pictures often meant fording streams, bushwhacking through brush, climbing trees, and hiking up hills at double time carrying heavy camera equipment.

Perhaps Burr McIntosh of *Leslie's* went to the greatest lengths to take a photograph. As Richard Harding Davis told the story:

> When the troops arrived at Daiquiri, a general order was issued forbidding any of the correspondents to accompany the soldiers when they made their first landing. The men on the press-boats of course promptly disobeyed this order; but the correspondents on the transports were forced to obey it, or run the risk of losing their credentials. Mr. MacIntosh [sic] was the one exception. [Davis, himself, was forced to stay on board ship.] He was most desirous of obtaining a photograph, taken on the shores of Cuba, which would show the American soldiers making their first hostile landing on that shore. To this end he gave his camera into the hands of a sergeant in one of the shore-boats, and hid his clothes under the cross seats of another. When these boats started, MacIntosh dived from the stern of the transport, and after swimming a quarter of a mile [McIntosh remembered it as three-quarters of a mile] through a heavy surf, reached the coast of Cuba in time to recover his camera and perpetuate the first landing of our Army of Invasion.[27]

The incident seems gratuitously foolhardy because McIntosh realized at the time that since the other correspondents on the press boats would be landing—several of them with cameras—there was no way

for him to score a "beat" on the other correspondents and get the first or only shot of the troops landing on shore. In retrospect, the act appears to have been dangerous as well. There was a strong undertow offshore, which, together with his poor health from his passage on board ship, weakened McIntosh and led to his being one of the first to come down with yellow fever. McIntosh survived the disease but was forced to leave Cuba early. His photographing days were cut short.

McIntosh's stunt was extreme yet typical for a correspondent during the Spanish-American War. As was the case with the volunteer soldiers, the war did not force the journalists to act "professionally"—to husband their resources so they would live to photograph another day. The war did not last long enough nor was the fighting severe enough. On the contrary, the correspondents cavalierly took extraordinary chances—only partly to get their stories. Taking chances was one thing. It was expected. Certain pictures and stories could not be gotten without being in front, without putting oneself on the line. But during the Spanish-American War, there was a gratuitous bravery that smacked of posturing and affectation. Photographers and journalists feared that if they did not flagrantly risk their lives, the reason for being in battle would have escaped them—the exhilaration of war would have passed them by.

Although no journalist was killed during the Spanish-American War (although one was killed reporting the war before the United States entered the conflict), at least four correspondents were wounded in action. The New York *Journal's* reporter, James Creelman, was wounded in the fighting at El Caney. Not satisfied with having led the charge up the hill that took the fort, Creelman decided that he needed the Spanish colors. "Suddenly," he wrote, "I thought of the flag. It was the thing that I had come to get. I wanted it for the *Journal*. The *Journal* had provoked the war, and it was only fair that the *Journal* should have the first flag captured in the greatest land battle of the war." Finding the flag on the ground outside the fort and still attached to its shattered staff, Creelman picked it up. He "waved it viciously at the village and a volley from the main breastworks was the only reply." Minutes later, another "bullet from the village came through a loop-hole, smashing my left shoulder and tearing a gap in my back. . . . I was very weak and in great pain," he remembered, "but I shall never forget the cheer that went up when the soldiers saw my body emerge from the breach, and the next thing I knew the Spanish flag I had taken was thrown over me."[28]

For the reporters and photographers of the Cuban conflict, merely reporting the facts was not enough: *how* they got their stories and photo-

graphs was at least as important as *what* those stories said and those photographs depicted. For most journalists, only the most swashbuckling postures would do. After all, the journalists had to live up to a gallant image of themselves and to the glorious image of war.

Image and Reality

The American people of 1898 had a better opportunity to view the events in Cuba than they had had for any previous war. The mere fact that photographs could now be reproduced in the pages of the press was a quantative leap forward in the accuracy of reporting the visual events of war. But the American audience was still a long way from seeing unvarnished truth; the photographs that were taken and that appeared in the newspapers and periodicals were circumscribed by the specific conditions of the warfare in Cuba and the limitations of the film itself.

The light and weather in the tropics frequently prevented the photographers from taking images. The light could be too bright at noon out in the field yet too dark under cover of the jungle. Morning mists were impossible to shoot through. And the constant danger of being shot prevented photographers from finding perspectives on the men in action. Although the telephoto lens had been invented in Germany in 1891, it was not yet in commercial use. Without a long lens, most of the photographs of battle were taken either from a distance or from a position of safety and, therefore, most images lacked the immediacy that would be captured in future conflicts. "Although, I was . . . on the first firing-line," said photographer James Burton, "and many men were wounded and killed all about me, as you will see by my photographs . . . I found it impossible to make any actual 'battle scenes,' for many reasons—the distance at which the fighting is conducted, the area which is covered, but chiefly the long grass and thickly wooded country."[29]

It was also difficult to capture the traditional drama associated with battle scenes. In previous wars, the infantry on the battlefield had used black powder that belched the dramatic clouds of smoke that silhouetted and obscured the clash of arms. Illustrations had depicted these conflicts as theatrical studies in chiaroscuro. But in the Spanish-American War, only the American volunteer regiments were issued the black powder, and even they, within several days of the start of the fighting, were ordered to stop fighting to prevent the telltale smoke from rising

up and giving away the men's positions. (The artillery that had also been issued the black powder continued to use it, however, and photographs were taken of the clouds of smoke billowing around the cannons.)

J. C. Hemment mourned the passing drama while looking to the future. "The pictures made nowadays," he noted,

> do not convey to the reader the same romantic spectacle that one is accustomed to seek and find in past war pictures, for the use of smokeless powder has taken away the effect of clouds of dense smoke. . . . I imagine that if a shutter can be made fast enough to take the bullets as they whiz through the air, then war scenes may again become very vivid, picturesque, and romantic. . . . This is, of course, but a dream, as we know it will never happen, but we know there must be something that will give that vividness and reality which the absence of smoke now deprives.[30]

Photography was only just beginning to bring the war home; it could not yet capture the totality of combat. Without long lenses, the distances were too great to get views of the Spaniards in their trenches, and the foliage and topography were such that it was difficult to get the Americans in theirs. At times, the weather was so poor for the light range of the film that entire battles could not be photographed. And the guesswork involved in gauging distance and exposure—especially under stress—caused many failures. But, despite the problems, it was the first war in which the United States fought that photographs were taken showing action during battle. Burr McIntosh described his photograph of the first artillery shot on San Juan: "Captain Grimes gave the order to the gunner of gun No. 1. As the latter prepared to fire, I picked up my machine and gauged it for fifty feet and, just as he pulled the string, I squeezed the bulb. The picture is not at all a clear one, because of the concussion caused by the shot, which seemed to shake the very ground upon which we stood."[31]

War photography was beginning to be able to show action—but action paced at a walk rather than a speeding bullet. "The shrieking of shells and shrapnel over my head," recalled Hemment, "had a fascination for me akin to the eye of the hypnotist on his subject, for I could not prevent my head turning upward when they hissed by, and I could not restrain the idea from arising in me that I ought to photograph them as they flew."[32]

Practically, however, photography could not stop artillery shells. It

could, however, depict static blood and gore. Hemment mentioned taking photographs during an operation in which a man's leg was amputated,[33] and McIntosh told of photographing the recently wounded (although he seems to have been singularly unlucky in how many of his pictures developed). "After proceeding for half a mile," McIntosh recalled,

> two men were noticed ahead of us, assisting a man who had received a very severe wound in his ankle; he had paused and was bending over to adjust the bandage, when we heard the sharp whir-r-r of a bullet. With a low moan he fell forward. We rushed up to find his whole left jaw had been shattered. I took a picture of the group as he lay there, but it did not develop. . . . Another two hundred yards or thereabouts were traversed, when suddenly there came the most piercing shriek I ever heard in my life. Looking back some twenty-five feet . . . we saw a young man bending over and feeling his knee; as he did so, the blood spurted out at both sides. . . . I "snapped" a picture of him, which was also unsuccessful.[34]

Despite the opportunity for portraying the blood and gore, many photographers exercised self-restraint both in choosing what subjects to photograph and in deciding how to photograph them. With minimal official outside censorship restricting them, the photographers made many decisions on ethical grounds. Most refrained from photographing the dead. Hemment, in his documentation of the wreck of the *Maine*, consciously refrained from photographing the body of one of the officers. As he explained it:

> While the divers were busy one afternoon . . . one of them reported that the body of an officer was in the forward torpedo room. It was recovered a little later. The features were all but unrecognisable; but it was identified as being that of Lieutenant Jenkins. I . . . was so much affected that I had not the heart to photograph it, for . . . he was a dear friend of mine, a gallant officer, and popular with his shipmates.[35]

McIntosh, when faced with a similar experience of viewing the dead Rough Rider Hamilton Fish, Jr., chose not to uncover the body for a shot. He did, however, take a photograph of the corpse and another laid out next to it, but both were so completely shrouded that they looked

like two piles of blankets. "It was some time before I was able to locate the body I was in search of. I finally found it. . . . My first impulse was to steal a picture of the face while no one was looking; but I didn't, and am glad of it."[36]

Many of the photographers believed there was an appropriate attitude toward the dead that had to be upheld. The dead were heroes and deserved respect. Photographs could be taken of the horribly wounded as testaments to their bravery or as examples of the brutality of the enemy (although no such graphic images were published). But the dead were dead and what was important was not what they looked like in death but that they were the noble dead, fallen in a noble cause. Nobility was not to be uncovered for all and sundry to gawk at, but neither was it to be forgotten. McIntosh, after taking the photograph of "Ham" Fish and the other corpse, was shocked to hear

> someone laughing. Looking to the right about fifteen feet I saw a group, apparently discussing the events of the day. I took a photograph of it, and then another to show the distance from the two bodies. The photographs were taken with a heart filled with resentful bitterness. It was all "war," and time has shown me that one should be able to drink to "the next one who dies," but I felt a resentment toward certain of those men, who were joking with that boy's body lying within a few feet of them.[37]

Photographers and newspaper correspondents of any stripe have a mission to report on war: to capture the experience and to bring it home for scrutiny. They have countless options in how to portray that experience, many of which are valid. But journalists cannot avoid making a choice. And their decision affects how they and, therefore, the reading or viewing public interpret events. Objectivity is a myth. "To go through a war," said photographer Hemment,

> and depict the scenes with which one momentarily comes in contact is to do something for which I can hardly find a fitting comparison. The life there depicted is full of trials and tortures, experiences which would almost rend a man's heart asunder. . . . No man can go on a field of battle and witness such things without becoming callous. I do not mean to say that a man loses all his sympathy, but he temporarily parts with his nicer feelings in the terrible realities that he passes through.[38]

Many of the "terrible realities" of the Spanish-American War never made it to film. Some were not pictured because the technology of the camera was too crude to allow such shots to be taken. Others were not photographed because the photographers, for various reasons, chose not to record them. Still others were not taken either because there were no photographers present to take them or because the "reality" was not visual but aural or emotional. No photographs exist of the capture of Kettle Hill. No photographs were published of identifiable American dead on the field of battle. No photographs arrested the moment of a soldier's death.

The photographic images of the Spanish-American War document the war, but it is a different war from the "splendid little" one of myth or the poorly planned one of reality. Few photographs appear to document the excitement or gallantry of the troops, although many pictures exist of the men striking tough poses for the camera. There are also few images that picture the incredible shortfalls of the war. But unlike the photography during the Civil War, a handful of pictures of action were taken, and a wide spectrum of activities were documented in the pages of the press. The photography of the Spanish-American War was a hint of what was to come. The intrusion of war into the living rooms of America had begun.

And Why

Correspondent Edward Marshall was wounded in the first battle of the Cuban campaign. A Spanish Mauser bullet shot away part of his backbone. Although told by the attending surgeon at the first-aid station that he "only had a few minutes to live," Marshall survived half-paralyzed and with one leg amputated. In an article written in September 1898 for *The Cosmopolitan* entitled "How It Feels to Be Shot," Marshall concluded his essay about the shock and pain of being wounded with the following sentence: "As a newspaper man I should say that the principal disadvantage in helping to report a war resides in the fact that it will make other newspaper work seem rather dull."[39]

Photographers and reporters during the Spanish-American War were caught up in the same enthusiasms as the American public. "God bless you," said Richard Harding Davis, "this is a 'merry war.' "[40] Journalists wanted to go to battle. They wanted to prove their courage, their gal-

lantry. Davis told of being on the Rough Riders' front lines with photographer Jimmy Hare and writer Stephen Crane. Crane walked to the crest and standing there, silhouetted, instantly attracted opposing fire. Although ordered to lie down by the commanding officer, Crane pretended not to hear, appearing "as cool as though he were looking down from a box at a theatre." Calling his bluff, Davis yelled, "You're not impressing any one by doing that, Crane." Crane instantly dropped down and crawled over to where Hare and Davis were crouched. Davis turned to him and explained, "I knew that would fetch you." Crane grinned and said, "Oh, was that it?"[41]

Members of the press wanted their chance for glory. War was exciting in a way no other story was. It was life and death, do or die. It was bigger than a major train wreck, more important than the political machinations of the Free Silver faction. In war there was an opportunity to witness and to report on history, on the rise and fall of governments and nations. And this war, the Spanish-American War, had the appeal not only of being convenient to home but of being a war for a good cause, a war for the triumph of the democratic forces of the Western Hemisphere over the degenerate colonialism of Europe.

Chauvinism and a certain joy in the trappings of patriotism suffused the soldiers and the correspondents. At the taking of El Caney, Irving Hancock observed, "All around me men look as if they wanted to break out singing the 'Star Spangled Banner,' or 'My Country, 'Tis of Thee.' Undoubtedly they would do it, were they not afraid of being laughed at for showing so much emotion over the whipping of so insignificant an enemy."[42] Troops still bore the colors into battle. Stephen Bonsal quoted one soldier as saying: "The sight of the flag has a powerful grip on a man's heart, and of course, when the colonel said it was old-fashioned to carry flags up to the front, and wanted to leave them behind on board the ship, we allowed that we were old-fashioned volunteers, and would stick to the flag, as we had sworn to do."[43] The journalists were not immune to such emotions; James Creelman was wounded in his rash attempt to capture the Spanish colors atop the blockhouse at El Caney. The flag remained a mystical motif. "With the last light of the closing day," Bonsal wrote of the soldiers who captured the San Juan Heights,

they saw, or thought they saw, imaged upon the retina of the dead man's open, staring eyes the reflection of the flag which only a few moments after he had fallen was hoisted over the fort. I did not see this wonderful thing myself, but many did, and I can well believe how the wounded man, with all the intensity of his dying gaze, had

watched the flag as it rose over the fort for which he had striven so mightily, and how that vision had become impressed there where it would remain until death and decay came to displace it.[44]

The conviction that the war was being fought for a noble cause only spurred the journalists in their efforts to "get" the news. "They are taking chances," noted Davis, "that no war correspondents ever took in any war in any part of the world."[45] Once there, once involved, the serious journalists labored hard to bring their stories and pictures back. The risks, although taken both to prove the correspondent's courage and to get a better story, were forgotten once the assignment was under way. "A man gets to work," wrote J. C. Hemment, "and if he is in earnest I really think he forgets everything around him and is wrapped up in the results which he has taken such chances to gain." Despite the danger, the demands were no less than for a job anywhere: "It is one's duty to depict that which seems to be the best." When pictures needed to be taken, one was able to—one had to—mask out the paralyzing fear of death: "I found that while I was exposed to the dangers of the bullets and the breaking of shells around me my work kept me preoccupied; that I really forgot in a great many instances that I was on the field of battle."[46]

The gallant poses struck and the glory won framed the solid accomplishments of the reporters and photojournalists; the photography of the war established the reputations of several periodicals, *Collier's* among them. The photograph gained validity and power in the public's eyes as a truthful record of events; J. C. Hemment, for instance, was hired by the federal government to take photographs of the wreckage of the *Maine* for the congressional investigation. After the efforts of the photographers during the Spanish-American War, illustrators were only employed when an event could not be captured with a camera. Photographs became the first choice of editors who sought to give their news stories credibility. Said one commentator: "The hand camera . . . is more effective and satisfactory than the sketching pad, and has consequently superseded it."[47]

The Spanish-American War was the first American war to be documented by halftone photographs appearing in the press. Still, the pictures of the conflict rarely capture the passion and enthusiasm of the journalists who took them. The technology of the camera was crude, but, more important, the operators of the cameras were too naive to translate effectively their personal zeal onto film. Because photographs of war had not previously appeared in the media, few journalists had

any idea of how to communicate the sights and sounds of battle. It was a first-time experience for most of them; the novelty of war still dominated their thoughts. "How strange it is to sit quietly, pencil in hand, and watch such a scene," James Creelman wrote of the fighting at El Caney, "to set down the sounds and colors as a matter of business—to be in the midst of the movement, but not a part of it!—but no stranger, surely, than to be moving on, rifle in hand, destined to kill some man against whom you have no personal grievance, some fellow-mortal with a home and kindred like your own."[48]

3

The Photographs:

A Validation of Expectations

The Publications

MORE THAN in any other war since 1898, reporters and photographers during the Cuban conflict made the news rather than just reported it. They wanted so much to be in the center of events that it was impossible for them to remain outside as mere observers. The quintessential war reporter and photographer, Richard Harding Davis, correspondent for the New York *Herald*, wrote home to his family telling about his participation in "the hottest, nastiest fight I ever imagined." Joining Theodore Roosevelt and the Rough Riders, Davis "got excited and took a carbine and charged the sugar house, which was what is called the key to the position. If the men had been regulars," Davis argued, "I would have sat in the rear . . . but I knew every other one of them, had played football . . . so I thought as an American I ought to help. . . . After it was all over Roosevelt made me a long speech before some of the men, and offered me a captaincy in the regiment any time I wanted it." The offer was particularly sweet because in the earlier days of the war, Davis had received the appointment of a captaincy and had declined it on advice from friends that his services were more valuable as a correspondent. At least for a time, Davis regretted his decision: "We shall not have another war and I can always be a war correspondent in other countries but never again have a chance to serve in my own."[1]

The New York *Journal's* writer and photographer, James Creelman, was wounded in Cuba after his own immersion in the fighting. He had

suggested a bayonet charge to capture the fort at El Caney and had offered to lead the way. "This was hardly the business of a correspondent," he admitted, "but whatever of patriotism or excitement was stirring others in that place of carnage had got into my blood too."[2]

Creelman later responded to the allegation that the members of the press had overstepped the bounds of responsible journalism. "One of the accusations against 'yellow journalism,' " he wrote in 1901,

> is that it steps outside of the legitimate business of gathering news and commenting upon it—that it acts. It is argued that a newspaper which creates events and thus creates news, cannot, in human nature, be a fair witness. There is a grain of truth in this criticism; but it must not be forgotten that the very nature of journalism enables it to act in the very heart of events at critical moments and with knowledge not possessed by the general public; that what is everybody's business and the business of nobody in particular, is the journalist's business.[3]

Journalists took their business seriously—none more so than Sylvester Scovel, "Special Commissioner" of the New York *World*. Scovel, who had been at once an artist and reporter for the *World* and a spy for Washington, placed himself center stage during the Spanish surrender ceremony in Santiago, Cuba. Although all correspondents had been warned to remain in the background during the proceedings, Scovel situated himself upon the roof of the palace, beside the flagpole, and waited to hoist the Stars and Stripes above the captured city. Scovel was ordered down. He paid no attention. He was dragged off his perch. He became indignant. The affront to the *World* was unpardonable. He swung at General Shafter, the major-general commanding the American army in Cuba. Shafter believed that the action "deserved death." Instead, Scovel was arrested and deported.[4] Scovel had believed that because he and his paper had helped start the war and helped fight the war, he and his paper should help end the war.

Journalists did not hesitate to admit their complicity in inciting the conflict. Many believed that the press appropriately jumped in where others feared to tread. "It may be that a desire to sell their newspapers influenced some of the 'yellow editors,' " wrote Creelman,

> but that was not the chief motive; for if ever any human agency was thrilled by the consciousness of its moral responsibility, it was "yellow journalism" in the never-to-be-forgotten months before

the outbreak of hostilities, when the masterful Spanish minister at Washington seemed to have the influence of every government in the world behind him in his effort to hide the truth and strangle the voice of humanity.[5]

The Spanish-American War might well have been Hearst's and Pulitzer's crusade, but it was the "people's war." Propaganda campaigns can only succeed if the time is ripe. Hearst himself in later years doubted whether journalism "led public opinion or merely reflected it."[6] With a stronger president in the White House, with less war fever in Congress, without the national belief in "Manifest Destiny," and without the country's earnest commitment to humanitarian causes, the war might never have happened. But none of that was the case. The press unquestionably exacerbated the aggressive spirit of the era, but its opinions could not have held sway if the people were not attracted to the issues. "The newspapers in your country seem to be more powerful than the government," observed the prime minister of Spain to journalist Creelman. "Not more powerful, your Excellency," Creelman responded, "but more in touch with the real sovereignty of the nation, the people. The government is elected only once in four years, while the newspapers have to appeal to their constituents every day in the year."[7]

The war, the press believed, was for a good cause, but even if it was not, it was good business. War sells papers. Several months before the sinking of the *Maine*, E. L. Godkin, the caustic editor of the *Nation*, addressed the issue. He was blunt. "Newspapers," he said,

> are made to sell; and for this purpose there is nothing better than war. War brings daily sensation and excitement. On this almost any kind of newspaper may live and make money. . . . It follows from this, it cannot but follow, that it is only human for a newspaper proprietor to desire war. . . . [The press] would stir up a war with any country, but if it sees preparations made to fight, it does not fail to encourage the combatants.[8]

Godkin was right about the interest of the press in initiating the war, but wrong about the profitability of it for the magazines and newspapers. Although almost all the periodicals that covered the war gained tremendously in circulation—for example, the New York *Journal's* circulation almost doubled to 1.5 million copies per day, and *McClure's* gained 100,000 readers a month—most publications lost money in the process. Newspaper editor Arthur Brisbane reported in September

1898: "Every newspaper of the first class has run far behind since the outbreak of the war."[9] There were three reasons for this loss: advertising declined sharply, competition for extras and editions was expensive, and the cost of covering the war was immense.

During the war, the *Journal* put out as many as forty editions in one day. Another day it ran 200,000 copies short of the advance order. Circulation and market share were more important goals than short-term profits. The demand was there. And the magazines and papers were eager to supply the news. "From March, 1895, until April, 1898," wrote one historian of the period, "there were fewer than a score of days in which Cuba did not appear in the day's news."[10] Many periodicals published special "Cuban Numbers." On May 28, 1898, *Collier's* filled its entire magazine with articles on Cuba, and ten out of its twenty-four pages were illustrated—many with photographs by Jimmy Hare. Muckraker Lincoln Steffens was not the only commentator who saw "the new journalism [as] the result of a strictly commercial exploitation of a market," although, as he graciously noted, "it is pretty generally recognized now that a newspaper has to print the news."[11]

But not even the most ardent supporters of the new "yellow" periodicals argued that the journals always printed the facts. The cutthroat competition between the newspapers and magazines did not foster an environment conducive to truthful or responsible reporting. The press made up skirmishes and battles out of whole cloth and embroidered minor engagements into major victories. They showed a reckless disregard for national security by writing about classified naval maneuvers. Documents and photographs were given captions that misidentified or distorted their content. "Nothing you read in the papers," wrote Richard Harding Davis in a letter home to his family, "is correct."[12]

Inaccurate reporting was often perpetuated from one publication to another. Although the top newspapers and magazines around the country sent their best correspondents to cover the Cuban conflict, lesser publications relied on the reports of the Associated Press or on the syndicated services of the various New York papers. Many periodicals subscribed to both—the New York syndicates differed from the Associated Press in that they supplied their client-publications with photographs and illustrations in addition to their news. This pooling of information and images helped to create a uniformity of news, opinions, and look in the national press.

Visually, the journalism of the late 1890s was distinguished by its lavish use of photographs and illustrations and by its large-type scare heads, printed either in black or red. The layout of the magazines and

newspapers was "opened up." Photographs and drawings, headlines that broke the column, bolder rules, and "white space" all helped alleviate the monotony of the formerly "gray" pages. For the first time in the pages of the press, through clever and innovative design, a reader's eyes could be directed to a particular story or image; stress could be given to an issue that the journalist, editor, or publisher wanted emphasized. The frequent use of photographs and the cleaner, starker graphics created a revolution in layout still felt today.

Yellow journalism brought more pictures than ever before into the press at just the time when technical achievements were making the direct reproduction of photographs possible. The adaptation of halftone engravings to the large rotary presses a year before the war eliminated the time-consuming hand-engraving processes. Photographs could get into the pages of the paper faster and with less loss of resolution than had been possible before photoengraving.

To take advantage of the new possibilities, *Collier's Weekly* reserved a special section of its paper during the war, "printed on a special newspaper press at the last moment," to supply its readers with the "VERY LATEST Pictorial News from the Front."[13] Other magazine supplements and newspapers' Sunday feature sections carried early examples of "photo-essays." The older established "quality" magazines, such as *Harper's* and *Scribner's*, and the new national periodicals catering to the middle ground of public taste, such as *Munsey's* and *McClure's*, liberally scattered photographs in their pages. The wide use of photographs in the yellow press affected even those periodicals that did not subscribe to the sensationalism of the large-circulation publications.

Although the two major New York papers, Pulitzer's *World* and Hearst's *Journal*, had used striking headlines and halftone photographs for months, the widespread practice and the general change in design and layout in the pages of the press started with the sinking of the *Maine*. Headlines became so excessive that only one or two words could fit in the "banner" or "streamer" head. One editor, writing immediately after the war, commented that the first outward sign in the press of the coming of war,

was a gradual increase in the size of type. The more conservative newspapers began to look as though they recognized important news at sight and the other newspapers grew to be more and more like aggravated circus posters. . . . The largest size which won distinct favor made it impossible to use more than five letters in the width of a newspaper page. Soon a new genius was in demand—

the man who could think of short words with energy and fire in them suitable for the construction of headlines. The fact that there were only three letters in "war" was the greatest blessing. Had we had the French "guerre" or even the German "Krieg" to deal with, we should have been lost.[14]

"The beauty of the scare head," admitted one publisher to Steffens, "is that it scares. And, besides, it catches the eye on a news-stand or over the shoulder of the man who bought the paper."[15]

From the beginning, the yellow journals tended to erase the line between news and editorial. The attitude of each periodical infused every element within it. This partisanship seemed forgivable in the minds of its proponents; after all, the causes the yellow journals championed were of grave social concern. "How little they know of 'yellow journalism' who denounce it!" cried correspondent Creelman. "How swift they are to condemn its shrieking headlines, its exaggerated pictures, its coarse buffoonery, its intrusions upon private life, and its occasional inaccuracies! But how slow they are to see the steadfast guardianship of public interests which it maintains!"[16]

Considered by some to be sensationalists who preyed on misfortune and death, the photographers and reporters of the Spanish-American War were the active hands at the end of the long arm of yellow journalism. Photographer Burr McIntosh said, "There are many necessary evils in this world. Among others are newspaper men."[17] But editors and journalists were only the most visible vultures hovering over the edge of the Spanish-American War. People were dying to hear about people dying. The prurient interest in death and destruction, this "lust of the eye," was not new—only the means for gratifying it had changed.

War was big news, and the new journalistic photography was just a more explicit way of being there, of fascinating the public, of standing nose to the glass and looking in. "Modern man," wrote William James in 1910, "inherits all the innate pugnacity and all the love of glory of his ancestors. To show war's irrationality and horror has no effect upon him. The horrors make the fascination."[18]

The Aesthetics

Sergeant Hamilton Fish, Jr., "joined the Rough Riders to win an enviable name," wrote *Leslie's Weekly* photographer Burr McIntosh.[19] In Theodore Roosevelt's opinion, Fish was "one of the best non-

commissioned officers we had . . . he took naturally to a soldier's life."[20] But young Fish never had a chance to prove himself under fire. He was one of seven killed in the Rough Riders' first skirmish at Las Guasimas. "Poor old 'Ham' Fish died as would have been expected," said McIntosh, "in the extreme front, looking for danger, courting a fight with the odds against him."[21]

Fish had acted as point (forward infantry) man during the Rough Riders' fighting at Las Guasimas; he was shot and killed instantly by the Spanish advance guard. Three others were wounded in the same burst. Some time later, journalist Richard Harding Davis, who had been following the fighting, "found Fish and pulled him under cover—he was quite dead."[22] McIntosh, who had also been behind the front that morning, hurried forward when an officer informed him that Fish had been killed. After finding the shrouded corpse along the roadside next to the body of another victim, Private Stevens, McIntosh was tempted to take a picture of the sergeant's dead face. He refrained, although he did look for a moment. "I removed the blanket from his face for a few brief seconds," he said. "There was no sign of pain, only the faint suggestion of the old smile of victory, which I had so often seen."[23]

Sergeant Hamilton Fish, Jr., became a hero during the Spanish-American War. His was one of the few names during the brief Cuban excursion that was mentioned by everyone everywhere. His unit was famous, his family was well known, he was killed. When Ham Fish died, photographs of him appeared in publications across the country. Such images helped to create the hero. For the public to take a soldier to heart, he has to be recognizable from the crowd. Each war has its unknown soldiers, but the real "heroes" of combat, those who are memorialized or who come home to parades, are the men who are widely recognized: Hamilton Fish, Jr., Theodore Roosevelt, Eddie Rickenbacker, and Douglas MacArthur. Through photography, the faces of American heroes become ubiquitous.

The studio photographs of Fish that were distributed after his death showed him staring out of the page with a youthful, direct, almost defiant glare. His gaze of aggressive confidence seemed to mirror the aggressive confidence of the country at large. Fish's death, Burr McIntosh felt, "seemed more cruel" than the death of other men. "Many times, in the enthusiasm of youth," McIntosh believed, "his strength and power . . . had gotten the better of his judgment, but he was always the essence of gentleness to the weak."[24] Such a summation, the public believed, was an apt assessment of the United States as well. The physiognomy of the man reflected the physiognomy of the nation.

During later wars, heroes were certified by pictures of their every move. Combat scenes and candid poses were recorded by the camera to be disseminated in the press. But during the Spanish-American War, there were few possibilities for such photographs. Without small cameras, telephoto lenses, and fast film, major actions during a "hero's" career—such as a photograph of Theodore Roosevelt leading the charge up the San Juan hills—could not be documented. What was taken and printed in abundance, however, were static portraits of celebrities.

It is not surprising that the majority of the photographic images relating to the Spanish-American War that appeared in the magazines and journals of the time were these "head shots." Images of battle were rare and took time to transport home. In the place of more "active" photographs, then, "head shots" of officers and gentlemen gone to fight the war illustrated the periodicals; these portraits were the wartime equivalent of the pictures of the barons of industry that had formerly graced the pages of the press. Many of the studio portraits appeared in commemoration of the deaths of American soldiers. Weekly columns of likenesses of those killed were published as a visual record of the deaths during that time.

These likenesses of the dead that appeared in the press were never postmortem combat pictures. McIntosh, for example, did not take his picture of Hamilton Fish's face in death. Instead, he snapped three other pictures. He took his first photograph of the swaddled bodies of Sergeant Fish and Private Stevens (figure 1). His second photograph was of a group of officers and correspondents—including Lieutenant-Colonel Theodore Roosevelt, General Joseph Wheeler, Colonel Leonard Wood, and the sleeping correspondent Davis—sitting and laughing only fifteen feet away (figure 2). His third picture was of the two groups—the corpses and the relaxing men—in juxtaposition (figure 3). McIntosh's first two photographs received considerable attention. Each was published by Leslie's Weekly in its July 28, 1898, issue and then later in 1899 in McIntosh's book about his Cuban experiences. The photograph of Fish and Stevens was perhaps the most famous photograph of the war and, together with the numerous pictures of the wreckage of the Maine, became one of the most enduring images of the Spanish-American War.

Leslie's did not reproduce the third photograph. Yet, of the three photographs, it is the strongest depiction of war. It is more than a static, euphemistic picture of death; it is more than a casual photograph of a military conference. The third image, because it juxtaposes the stolid finality of death with the normality of life, best approaches the conflict inherent in war. Death in the midst of life. Death as such a constant

that, as photographer James Burton observed, "even the sight of dead and wounded failed to move me."[25]

Leslie's caption underneath the photograph of the bodies of Fish and Stevens read: "Rough Riders as they fell in the bloody engagement of June 24th—Hamilton Fish to the left—They died for humanity's sake."[26] The caption underneath the picture of the officers and correspondents said: "The council of war before Roosevelt's Rough Riders made their irresistible onslaught on the Spaniards."[27] What could they have said of the third image if they had chosen to print it? Here are the leaders of the American forces relaxing after battle while ignoring their fallen brethren in the foreground?

The first two photographs fell neatly within the established conventions of photography. The straight-on, straightforward documentation of an object, as in the first image of the two corpses, was the preeminent tradition in photography since its invention in 1839. Because of the long exposures needed by early photographic chemistry, subjects were immobilized to prevent a blurring of the image. Finesse was not possible; frontal portraiture was the rule. The aesthetics of necessity became the style of the genre. Documentary photography—as in the documentation of the two bodies—settled into a consistent look that has continued to the present day. It became the tradition that the "truthful" portrayal of a person or a situation should be head on. Such a perspective, especially after other more descriptive camera angles became technologically possible, seemed the least manipulative and the most dispassionate. And, ironically, precisely because of its perceived objectivity, a documentary photograph carried power, especially when its subject matter was controversial. The presumably straightforward pose argued that the subject was "speaking" for itself. No "tricks" were needed—when the subject was strong enough—for the photograph to grab the attention of its audience.

The photograph of Sergeant Fish and Private Stevens is taken from such a documentary stance. Seen without a caption, the photograph is shorn of its particularized, personalized, politicized meaning; there is no way for the audience to realize who the victims are. But the picture has just enough human incident in it for it to retain power as an image. First, on the extreme right-hand side is a lone military cap; in a period and in an environment when all men wore hats, the fact that the hat is not perched on a head only emphasizes the death of its supposed owner. Second, although both bodies are obscured by layers of blankets, the man on the left is only covered to the ankles. His large hobnailed boots protrude from underneath the covering. His feet, sticking out from the

blankets at a slight angle, call attention to the humanity hidden within the mounds of covers.

McIntosh's photograph of the conference of officers and correspondents tapped into a more recent genre of photography: the snapshot-type picture of Americans at leisure. Beginning in 1888 with the introduction of George Eastman's Kodak camera, all photographers had to do was press a button. Freed from the alchemy of the more professional equipment, the American middle class took pictures by the thousands. The Kodak was marketed to tourists, sports lovers, and families. These new photographers took pictures of everyday life, of casual groups in ordinary settings. The multitude of snapshots that resulted convinced the public and the professional photographers that pictures did not have to be either formal or momentous. This relaxed attitude fit the new self-confident temperament of the turn of the century.

The photograph of the conference was a new look for military photography but a look that was conversant with the photography of the times. Formerly, most group pictures of military officers were posed shots, the most senior officers sitting in front, the junior officers standing behind. Even for a photograph taken in the midst of war, the men would have attempted to sit and stand up straight, their uniforms would have at least been buttoned if not full dress. But McIntosh's photograph captured the exigencies of the Spanish-American War. It was a short war in which military protocol gave way to politics, in which an officer of the volunteers garnered more attention than the commander of the army, in which casual intercourse between different ranks of officers and between the military and civilians was an expected and natural occurrence.

McIntosh's third photograph juxtaposing the corpses with the group of men did not fit into any established photographic conventions. At the time that he took the picture, McIntosh felt "bitterness" and a "resentment toward certain of those men, who were joking with that boy's body lying within a few feet of them—a resentment which I never expect to be able to overcome."[28] McIntosh's bitterness about what he perceived to be the cynicism and callousness of the American military toward its own casualties, as communicated in his third photograph, was unacceptable for publication during the war. It would be at least until World War II before such photographs criticizing the American military establishment would make it into the pages of the press during wartime—and even then only rarely.

Ironically, the two subject-components of that photograph, when separated out into the first two of McIntosh's images, accurately reflected

the mood of the day. The picture of the "shrouded" Hamilton Fish displayed a natural reverence toward death, toward those who had "fallen" in defense of American ideals. Popular thinking believed death in war to be a noble, yet poignant sacrifice. The photograph of Fish underlined both dimensions of that sacrifice; the fact that those sentiments were made manifest by a photographic print only served to reinforce the validity of the public's romantic view of the "supreme sacrifice." The second of McIntosh's images spoke to another dearly held conception of war: that the battlefield is the place for male communion; in war, men fulfill their maleness both as individuals and as a gender group. McIntosh's photograph of men at their ease while in the wake of combat once again seemed to verify that popular belief for another generation—ensuring that twenty years later, with the American entry into World War I, men would still volunteer to fight, believing that it would give them entrée into the sanctum sanctorum, that it would make them "men."

This genre of photography, as reflected in McIntosh's second image, continues to be a popular aesthetic, both in still photography and on film. Throughout the twentieth century, photographers have taken pictures of war that emphasize the camaraderie of combat, that reflect a view that war is "not just a job, but an adventure." ("It's not just a job, it's an adventure" was, of course, the post-Vietnam recruiting slogan used by the American navy from 1976 until 1986. In 1986, the slogan was revamped to "Live the adventure," a change reflecting the greater revisionism—and chest pounding—of the waning Reagan administration.[29])

McIntosh's first two photographs appeared in a four-page spread of his pictures in Leslie's Weekly on July 28, 1898. The photograph of the group of men appeared on the first page, a right-hand page of the spread. It was the top photograph of the two, positioned in the spot of greater impact. The photograph of Fish's corpse was placed in the middle of the center two pages—the most important pages—in the most important position. Although the Fish photograph is one of the smallest of the seven pictures in the layout, it is the image that initially seizes the viewers' attention. The sharpness of the photograph and its position in the spread partly account for the attraction. But the primary reason the picture stands out and holds the viewers' attention is because it is not immediately decipherable. It is the one static image among the seven photographs. All the other pictures capture trivial moments of movement and gesture; they surround the photograph of the corpses with a blurred frieze. The Fish image is arresting because it takes a moment to compre-

hend what it is. The stillness of the image stops the viewers long enough for them to decipher what they see. It depicts arrested action—action stopped dead.

One of the few other images of the American dead to be published during the war appeared in *Harper's Weekly* on July 30, 1898—the same week the Fish photograph appeared in *Leslie's*. Captioned "Killed on the field of battle," the photograph was taken by James Burton after the battle of El Caney on July 1 (figure 4).[30] As reproduced in the magazine, the image appears more painterly than photographic; it is a wartime example of the Pictorialist movement in photography. Pictorialism, soon to become known in 1902 as Photo-Secession, was a late nineteenth- and early twentieth-century artistic movement in photography more concerned with creating beauty than with reproducing fact. Pictorialists such as F. Holland Day, Clarence H. White, and Gertrude Käsebier imbued their landscapes and portraits with a sense of "elegiac melancholy." They challenged the dull documentary images of much of photography, they substituted realism for the "art of nuance, mystery and evocation."[31] The Pictorialists looked to painting to find their inspiration.

The composition of Burton's war photograph borrows from the earlier "peasant" paintings of Jean-François Millet; it emphasizes the same monolithic figures in positions of restrained action, encompassed by a similar pastoral landscape. Unlike most other photographs from the war, the picture does not appear to have been taken from a standing viewpoint. Whereas McIntosh shot his photograph of Hamilton Fish from eye level looking down, Burton took his photograph of two corpses from a low level—only slightly above the height of the bodies—looking up.

As with Millet's paintings, this upward-tilted perspective emphasizes the figures standing in Burton's landscape; what the figures are doing—in this case, looking at two dead bodies—is of secondary importance, although still meaningful. The act of observation and the bodies being observed give political and social significance to the image. But the emphasis on the two live men, rather than on the two dead ones, drains the photograph of much of its confrontational impact.

Burton's photograph is curiously obscure. McIntosh's photograph is boringly distinct. The somber tones in Burton's photograph—relieved only by a slice of sky, two forearms akimbo, and the shine of bullets in a bandolier on one of the corpses—add mood but not impact to the image. His figures stand against four bands of flat gray; unlike most other images taken during the American engagement, the background of the

photograph is not immediately identifiable as Cuba. No palm trees, scrubby brush, or thigh-high grasses obscure the action. The blades of grass in the foreground and middle distance add texture, rather than depth or specific detail to the image. If the photograph had been taken in the same merciless light as the McIntosh picture, the shock of its subject matter would have been greater. But the photograph as art would have suffered (the McIntosh picture is hardly "artistic"). Burton's photograph as published is aesthetically beautiful—too pretty to be a powerful statement about combat. McIntosh's photograph, which has none of the aesthetic grace of Burton's image, makes a more trenchant comment on war.

Although both these photographs depict American dead, neither photograph gives an especially vivid testimony of those deaths. Little can be seen of the four bodies in the two pictures. The impact of the photographs, therefore, relies on the emotions that the viewer brings to the images—rather than any graphic punch inherent in them. The bodies are American boys killed fighting for justice in a foreign land; that is the ostensible emotional hook of the two images.

Photographs of the enemy dead employed no similar hook. Bodies could be shown in explicit poses without fear that American mothers would recognize their sons. Published photographs of enemy corpses conjured up the death of the enemy troops desired by the public at home; such photographs could be an outlet for hatred against the enemies of the United States. Photographs of the dead enemy are always more grim than any published images of American soldiers killed in combat; the photographs of the Spanish during the Spanish-American War were no exception.

In the August 4, 1898, issue of Leslie's Weekly, a large half-page photograph appeared that pictured the Spanish dead (figure 5). Taken by J. C. Hemment after the destruction of the Spanish fleet off Santiago, the photograph was captioned, "Cubans watching to capture or kill the Spanish marines as they escaped from their sinking war-ships—Two dead Spaniards in the foreground."[32] The picture, shot by Hemment while he was apparently standing in the water or sitting in a boat and looking back toward the rocky beach, is a contrived portrait of a line of kneeling Cubans, guns at the ready. Watched over by a dapper officer with one hand on his sheathed sword, the Cubans stare fixedly out to sea. The two dead Spaniards lie in the middle of the line of Cubans— slightly left in the photograph, spread-eagle at the water's edge. Their heads are turned away from the camera; the viewer sees them in quarter profile.

Taken as a whole, the photograph is not especially gripping. The conventional pose held by its subjects robs the image of the veracity that would have been implied had the photograph been a candid moment seized by the eye of the camera. An audience learns less about war by looking at a posed picture than by looking at a candid shot; in a posed photograph, viewers are not privy to the mysteries of war, they are witness only to the realized imagination of the photographer.

The stiltedness of the image, however, is typical of posed photographs of people taken before and during the Spanish-American War. What gives this picture force, therefore, is not the staged ferocity of the Cubans, but the inclusion of the two dead bodies. Their stripped, bloated torsos and the surprising intimacy of their ears and the napes of their necks call attention to the intentional positioning of their bodies. Clearly, they did not wash ashore to rest in that position; in some fashion, their death was violated by a conscious manipulation of their corpses. They lie as trophies to the power of the Cuban soldiers.

The photograph plays on the notion of the hunter and the hunted—except that the two dead Spaniards are not a brace of pheasants or a pair of deer casually displayed to show the hunters' prowess. The calculated pose of the photograph of the Cubans may not tell its audience anything about the actual fighting of the war, but it did say a lot about the attitude of the participants in that war and of the public who permitted such an image to appear in the press. It is doubtful that a comparable image would have appeared during the Spanish-American War that substituted Americans for the Cubans. In 1898, the rules of the game for Americans still prohibited conduct that was ungentlemanly. (By 1918, that was to change. The magnitude of the world war coupled with the "knowledge" of "Boche" atrocities operated to justify such behavior.) In 1898, it was witty to picture the "barbarous" Cubans in a pose reminiscent of one taken by the society swells at their hunting lodges, but it would not have been the thing to have Americans making such crude allusions.

A second image of the Spanish dead appeared the same week in *Collier's Weekly* (figure 6). Entitled "Charred Remains of a Spanish Gunner," it was taken by an unnamed naval officer. *Collier's* correspondent W. Stanley Church explained the circumstances of the picture. "The Spanish flagship 'Maria Theresa' and the 'Almirante Oquendo,'" he reported, "were still in smoke and parts of them in flames when they were boarded by a party of naval officers and a press correspondent from Sampson's fleet. . . . By the breech of a gun in the starboard battery was

ing scenes of action. For the most part, the photographs of combat were simply photographs taken under fire. There were no classic illustrations of men charging toward enemy trenches or men falling after being hit. The entire oeuvre of action photographs published during the war consists of a handful of blurred images of artillery firing and one or two more images of men crouching in trenches or along streambeds. And there is little internal evidence to identify even these pictures as being taken "under fire"; the knowledge that a photograph was an image of battle is derived from the information related in the photograph's caption.

To compensate for the shortfalls of the photographs, editors and photographers directed the opinions of their readers by subtitling the images with suggestive comments. If one could not tell by looking at a picture that it was taken under fire, the captions said it: "The Bullets were cutting the Branches from the Trees in a steady Shower." If one could not tell by looking at a picture that the dead died in a glorious cause, the captions said it: "They died for humanity's sake." The rhetoric of "the splendid little war" found a better outlet in the captions than in the images of battle. The photographs of the war were less successful than their captions in the propagandizing of the conflict.

One of the few occasions of action to be widely captured in print was that of Captain Capron's artillery firing on the Spanish during the battle for El Caney. Early in August 1898, several magazines published nearly identical photographs taken by various observers. Collier's, Scribner's, and Harper's all printed similar images shot from the same angle—from behind and to the right of the guns—and from a roughly similar distance. William Dinwiddie's image in Harper's Weekly (figure 7), however, was the most evocative of the group. Dinwiddie's composition best captured the moment when the smoke from the guns roiled around the soldiers. The men's gestures, rather than appearing to be random movements little connected with the action of the battery, as in the other images, are identifiably martial; several men are peering through binoculars, others are firing the guns.

Dinwiddie's photograph recalls that romantic view of combat associated with the American Civil War; it could have been either an illustration for Stephen Crane's Red Badge of Courage (written only a few years before the Dinwiddie picture was taken) or an outtake from D. W. Griffith's battle scenes of the Civil War in Birth of a Nation (filmed a few years afterward). Men stand knee high in a meadow; swirling billows of smoke obscure the great wheels of the cannon. The photograph

found the charred body of a Spanish gunner, who, being wounded, was unable to escape with his more fortunate comrades who took to the boats."[33]

The photograph parallels the McIntosh picture of the body of Fish in its straightforward documentation of death. But whereas the photograph of Fish was reticent about the cause and effect of death, the picture of the Spanish gunner is unambiguous about the form of death it represents. The caption "charred" is a euphemism. The Spanish gunner was so burnt as to be crumbling into charcoal. His hands and feet were consumed by the fire; one leg is no more than scattered coals. The facts are stated baldly; the innate grotesqueness of the crackling corpse is all the greater for the unsophisticated presentation.

Unlike the image of the two corpses posed by the Cuban troops in Hemment's photograph, the image in *Collier's* does not picture the body of the Spaniard in relationship to living soldiers. Indeed, a placement of troops in a position of victory over the body would have been objectionable; to have explicitly associated even Cuban individuals with the horrific death of the Spaniard would have subverted the ostensible cause of the war: that the Americans and Cubans were fighting evil, not creating it.

Pictures such as the "charred gunner" rarely appeared in the pages of the press. Even those photographers from the yellow journals took few graphic images of the dead enemy, and no one shot explicit photographs of Americans killed in action. The sensationalist impulses of the press were satiated by the rare images of the Spanish dead and by the suggestive photographs of the detritus of battle, such as those prewar images of the wreckage of the *Maine*. Despite the often-cited bloodthirsty attitudes of the American press and public, the existence of so few pictures of death and destruction in magazines and newspapers— even of the enemy—argues that the Americans of the time were— relative to later generations—restrained in their desire to see blood and gore. Their chauvinism notwithstanding, the press—especially the photographers—conspired to help Americans retain the notion of war as an ideal, not as the botched, vainglorious affair that could have been shown.

During the Spanish-American War, pictures of action were as unusual as photographs of death. However, although photographers consciously chose not to take pictures of death, photographers had no choice about whether to take pictures of battle. Their cameras, their film, or the circumstances of the conflict prevented them from captur-

served to reinforce Americans' attitudes about the drama inherent in— the larger-than-life quality of—war.

Two of the few other "action" photographs to appear during the war—of men crouched in trenches—appeared on the same page of *Harper's Weekly* as the Dinwiddie photograph of Captain Capron's battery. James Burton took one of the images. Laid out at the top of the page, next to the battery picture, the photograph was captioned "9th Infantry firing in the rain, from intrenchments, at Fort San Juan, July 9" (figure 8). Dinwiddie shot the second image, entitled "6th Infantry in the creek-bed of San Juan, July 1, Where the Bullets were cutting the Branches from the Trees in a steady Shower," which ran at the bottom of the page.[34] The two photographs had much in common; both captured an attitude of fearful expectancy. The transfixed gazes of the soldiers on some point beyond the frames of the photographs communicated the intensity of the moments. Both featured a wedge of sky, a horizon line in the middle of the picture, a diagonal composition, and a lot of backs and sides of men huddled against the bullets. The primary difference between the two was the crisper exposure of Dinwiddie's image.

The distinctness of Dinwiddie's picture emphasized the specificity of the image both to the time—the Spanish-American War—and to the place—Cuba, behind the lines. Conversely, Burton's photograph holds a greater universality. The softer focus, the blurrier figures, and the fewer men give the image a certain timelessness. Although the crushed hats of the soldiers could identify the photograph as dating from the Spanish-American War, the hats and other identifying features do not dominate the image as they do in Dinwiddie's picture. In the Burton photograph, one sees the same shapes and silhouettes that one could see, for example, in World War I photographs of men waiting to go "over the top." This is what "war" was like; this was the emotion that all the novels of combat, all the short stories of battle, and all the reminiscences of the old soldiers referred to. Burton's photograph caught that time-out-of-mind moment so the audience back home could see it as well as hear it. War, the Burton picture averred, was just like it was supposed to be.

Interestingly, pictures depicting aid being given to the wounded also communicated a sense of the action and urgency of war. Of all the published images of the war, one photograph of the wounded by Burton, published in *Harper's Weekly*, best realized and communicated the demands of combat. The photograph appeared in the same issue and on the same page as Burton's image of the two dead soldiers mentioned

above. This other Burton photograph, laid out to the right of the picture of the dead, was entitled "Surgeon attending to the wounded in the field hospital" (figure 9).[35]

The image is a square one, filled with fragmentary action. In the middle of the photograph, in the middle of a field, a doctor, assisted by another medical officer, adjusts a bandage or tourniquet on the arm of a wounded man. Surrounding the trio are a number of other soldiers, some likely wounded: the man lying prone in the foreground, others aiding the victims, the man standing on the left with a bandage trailing from his hands.

The picture is unusual in the oeuvre of Spanish-American War photography for its success in arresting action. Most of the photographs to come out of the war were "still lifes." Pictures were posed, and gestures were frozen. But Burton's photograph of the wounded soldier stops an instant in an ongoing chain of events. The subjects are oblivious to the camera. Clearly, the situation was not posed or even improved upon.

The image is particularly striking because it is the nearest any photographer came to taking a close-up of action during the war. The photograph is a unique record of the Spanish-American War. To take the picture, Burton must have been within the circle of men he photographed. Portions of a face and a shoulder frame the image on the right and left margins. The immediacy that is communicated through the closeness of the camera was rarely duplicated even during World War I; it was only in the Spanish Civil War and World War II that close-ups of groups and individuals before and after battle became common.

Yet close-ups are integral to an audience's comprehension of the realities of combat. Shots of distant battlefields, in which men are the size of ants, can give viewers a sense of the broad panorama, but such images do not tell of the spectacle of war; they do not communicate the individual's experience of battle. Few photographs of the Spanish-American War gave the public back home the opportunity to learn the intimate details of war. The photographs showed few individual soldiers, fewer deaths, and little action—the reality of a war in which there actually *were* few soldiers, few deaths, and little action. Yet the photographers and reporters, even given the limitations of the camera technology, the constraints of the terrain, and their self-censorship, could have made a more imaginative attempt to capture the full range of emotions and experience of the conflict on film. The reportage from the front served to reinforce, rather than challenge, the attitudes of the public. Even though those journalists who traveled to Cuba realized that the war had not always been what they had expected or what they could have

wished, these correspondents (and perhaps their editors and publishers even more so) failed or refused to communicate the discrepancies. The famous, brash "yellow" journalists of the war settled, in the end, for giving the public only what it expected—and what the journalists themselves in the months before the war had led the public to expect. As a consequence, the United States entered World War I with all its naïveté intact.

PART TWO

World War I
in Western Europe
April 6, 1917–
November 11, 1918

4

The Context:

"An Affair of the Mind"

WORLD WAR I began as a grand pastime and ended as a grand massacre. The bright young men who volunteered at the beginning of the war in 1914 saw it all as a lark and thought they'd be home by Christmas. "Come and die," wrote the poet Rupert Brooke to a friend. "It'll be great fun."[1] Less than four years later, Wilfred Owen opened a poem with the lines, "What passing-bells for these who die as cattle?"[2] World War I was a conflict on a scale previously unimaginable, a war that over half a century, a Holocaust, and two atomic bombs later, still sets a standard for slaughter.

The history of World War I, though, is not just about numbers, their magnitude notwithstanding. It is a story of disillusionment. The casualties were greater than just the mountains of dead and the hospital wards of the wounded. "Injuries were wrought to the structure of human society which a century will not efface," wrote Winston Churchill. These injuries, believed George Kennan, "were in the souls of the men who took part in that war—the survivors. And what can one say of the six million who never came back?"[3] For Americans, World War I was a war that began with high hopes, high dreams, and high resolve—all keyed to the sticking point by an efficient and effective propaganda machine—that ended in a sorry slide into bitterness, isolation, and a lost generation.

"Sacred" words, words significant for the United States—like "democracy" and "A War to End All Wars"—motivated the public to the sacrifice. Whereas during the Spanish-American War, war fever came

from the pages of the press and the public itself, during World War I the enthusiasm for the conflict was rallied by the federal government. Under the direction of George Creel and the Committee on Public Information (CPI), the war became a crusade. For the United States, in lieu of any imminent peril or overwhelming crisis, the Great War, as historian David Kennedy has said, "was peculiarly an affair of the mind."[4]

Surprisingly, considering the claims made during the American involvement in the war, there was little early recognition in the United States that either the origins of the conflict or the issues at stake affected American interests. When newspapers of the time discussed "the war," they meant the fighting in Mexico. As late as 1916, President Woodrow Wilson said that with the objects and causes of the European war, "we are not concerned. The obscure foundations from which its stupendous flood has burst forth we are not interested to search for or explore."[5] Even after the United States declared war—but before the Americans were committed and dying in any number at the front—the conflict did not seem immediate enough to engage the emotions of the public, although it did engage their sense of morality. A "friend and contributor" to *Collier's Weekly*, who had "a positive gift for discovering the average man's mind," made the observation: "No hate in the country. Everywhere I go I am astonished by the absence of hatred. A great people going to war willingly without murmur and also without hatred. I am wondering if the absence of hatred may not be due to something more positive than mere lack of realization. I am wondering if it may not, perhaps, be due to an instinctive but all-underlying sense of the absolute justice of our position?"[6] As Kennan wrote, the United States "would not have been happy unless they had been able to clothe their military effort in the language of idealism and to persuade themselves that anything so important as Americans fighting on foreign soil had to end with a basic alteration of the terms of life among nations and a settlement of this business for once and for all."[7]

Americans trooped off to war, more boyish than bellicose, more Boy Scouts than warriors. Much of the jingoism of twenty years before had been supplanted by the traditional American belief in its native superiority, which had led the United States to isolate itself from the Old World infection of war. Americans had to be convinced that it was in their interests to become involved. To rouse the homefront, therefore, marched Creel—a prominent muckraker who had been on previous, more local, crusades—and his CPI. Behind him in the parade of patriotism were such diverse homegrown institutions as the YMCA, the Knights of Columbus, and Theodore Roosevelt. The Knights of Colum-

bus brought a little bit of home to "our boys" on the front lines in the shape of chocolate and cigarettes. The YMCA kept their morals high with uplifting trench-side entertainment and facilities. And Theodore Roosevelt, still enamored of war, sixty years old, ailing, and soon to die, wanted to lead a group of volunteers "over there" to fight the foe. "The issues at stake," he wrote as hyperbolically as ever, "are elemental. The free peoples of the world have banded together against tyrannous militarism and government by caste. It is not too much to say that the outcome will largely determine, for daring and liberty-loving souls, whether or not life is worth living."[8] Edith Wharton, in her novel *The Marne*, published in 1918, concurred. "There had never been anything worth while in the world," she asserted, "that had not had to be died for, and it was as clear as day that a world which no one would die for could never be a world worth being alive in."[9]

For Roosevelt and others, and according to the wartime propaganda, the European war was the opportunity to show the Old World the moral superiority and the not-coincidental military superiority of the New. As Floyd Gibbons, correspondent for the *Chicago Tribune*, wrote in his book, *And They Thought We Wouldn't Fight*, "And surely it had been America's God-given opportunity to play the big part she did play."[10] God and the dogs of war were on America's side.

To reinforce the belief in America's mission to lead the Allies in conquering the foe, CPI-generated propaganda—on posters, in the newspapers, in the classrooms, and on Capitol Hill—pictured the Germans as infidels who were laying waste to Europe while raping her inhabitants. The Boche were on the march, and suddenly Germany and everything German became persona non grata. Sauerkraut became Liberty Cabbage, churches dropped the singing of hymns with Germanic melodies, symphony orchestras refused to play Bach and Beethoven, schools stopped offering the German language, and hoodlums stoned stores owned by German immigrants. Rumored German atrocities were confirmed by hearsay and swallowed by a gullible public who wanted to believe that they were fighting an evil nation. The war of words was not simply an idealistic one. As always on the homefront, there was an appeal to racism. It was "us against them." Americans were the "Yankees" and the Germans were the "Hun."

Above all, Americans saw the war as an adventure; it was difficult for them to identify with the level of devastation wreaked on the European populations and landscape. Scotland, for instance, had sent one million men out of its total population of five million. By 1917, many Europeans were sick of war and grand gestures, but the Americans had just begun

to display their might. Calls to glory did not seem inappropriate. Gibbons told of General John Pershing, the American commander of the American Expeditionary Forces (AEF) speaking to the troops on the day before their departure for the front. Pershing, Gibbons said, "spoke of the traditions which every American soldier should remember in the coming trials. He referred to the opportunity then present for us, whose fathers established liberty in the New World, now to assist the Old World in throwing off its yoke of tyranny."[11] A bit more down to earth, but still demonstrating the same sense of moral sacrifice, were the words of Arthur Guy Empey, writing in his book 'Over the Top' by "An American Soldier Who Went." "War," he stated clearly, "is not a pink tea but in a worthwhile cause like ours, mud, rats, cooties [lice], shells, wounds, or death itself, are far outweighed by the deep sense of satisfaction felt by the man who does his bit."[12]

However, once in Europe and on the line, American soldiers and officers spoke in less highfalutin terms. Heywood Broun, correspondent for the New York Tribune, reported on a frontline survey conducted by the YMCA on the subject "Why I joined the army." "Only a few of the answers came from the heart," Broun thought.

Most of the rest were of two types. One sort was swanking and swaggering, in which the writer unconsciously melodramatized himself, and the other was cynical, in which the writer betrayed the fact that he was afraid of being melodramatic. Thus there was one man who answered, "To fight for my country, the good old United States, the land of the free and the starry flag that I love so well." "Because I was crazy," wrote another and it is probable that neither reason really represented the exact feeling of the man in question.

Some were distinctly utilitarian such as that of the soldier who wrote "To improve my mind by visiting the famous churches and art galleries of the old world." There was also a simplicity and directness in "to put Malden on the map." But the two which seemed to be the truest of all were, "Because they said I wasn't game and I am too" and "Because she'll be sorry when she sees my name in the list of the fellows that got killed."[13]

Throughout the American involvement, there was a broad belief in the rightness of the cause, that the United States was fighting a just and necessary battle. But at the front, mention of glorious themes seemed inappropriate. Even those American soldiers who spoke about such

ideas as "justice" did so in a personal, not in an abstract way. Gibbons told of a conversation he had with one "ideal, young American soldier" whom he questioned about his life. "I found," Gibbons noted,

> that he and his father had worked in the copper mines in Michigan. They were both strong advocates of union labour and had participated vigorously in the bloody Michigan strikes.
> "Father and I fought that strike clear through," he said, "Our union demands were just. Here in this war I am fighting just the same way as we fought against the mine operators in Michigan. I figure it out that Germany represents low pay, long hours and miserable working conditions for the world. I think the Kaiser is the world's greatest scab. I am over here to help get him."[14]

"Patriotism," said Robert Graves, the English author. "There was no patriotism in the trenches. It was too remote a sentiment, and rejected as fit only for civilians. A new arrival who talked patriotism would soon be told to cut it out."[15]

It finally became true for the Americans as a George Orwell character had said it had for the Europeans, "If the war didn't happen to kill you, it was bound to start you thinking."[16] Once the Americans who had been in the trenches started thinking, their disillusionment with abstractions began. It all boiled out in the books written after the war. "Were they all shams, too, these gigantic phrases that floated like gaudy kites high above mankind?" asked John Dos Passos.[17] "It's words you're fighting for . . ." noticed Dalton Trumbo.

> You're being noble and after you're killed the thing you traded your life for won't do you any good and chances are it won't do anybody else any good either. . . . Surely there are ideals worth fighting for even dying for. . . . But what do the dead say? Did anybody ever come back from the dead any single one of the millions who got killed did any one of them ever come back and say by god I'm glad I'm dead because death is always better than dishonor? Did they say I'm glad I died to make the world safe for democracy?[18]

"I was always embarrassed by the words sacred, glorious, and sacrifice and the expression in vain," admitted Frederic Henry in Ernest Hemingway's *A Farewell to Arms*.

> I had seen nothing sacred, and the things that were glorious had no glory and the sacrifices were like the stockyards at Chicago if noth-

ing was done with the meat except to bury it. . . . Abstract words such as glory, honor, courage, or hallow were obscene beside the concrete names of villages, the numbers of roads, the names of rivers, the numbers of regiments and the dates.[19]

During the war, Americans at home got caught up in the emotions and propaganda of the conflict. In its Thanksgiving issue for 1917, *Collier's Weekly* rejoiced that war had finally come. "The air we breathe is clearer for the decision of last spring," it said. "It is a fine thing to think about and give thanks for that the heart and brain of the manhood of America were finally able to force the issue on the reluctant politicians at Washington and command, at their peril, no longer to hold back our armies and fleets from their share in the great struggle."[20] But a long year of war caused Americans to begin to question their premises. To forestall negative answers, the CPI, at the close of the fighting, ran public-service advertisements aimed at the mothers of America. "He Will Come Back a Better Man!" they shouted. "When that boy of yours comes marching home a Victorious Crusader he will be a very different person from the lad you bravely sent away with a kiss, a tear and a smile. He will be strong in body, quick and sure in action, alert and keen in mind, firm and resolute in character, calm and even-tempered."[21] When the boys did come marching home, many *were* strong in body and mind. Some more were not. But in both groups were men who had fought in Europe and could tell those who had remained in the United States that the war was not like what they had read and seen in the papers.

After the war, when the censorship was lifted and the diplomatic outcome was known, the civilians also realized that behind the rhetoric were the true costs of the war. Patriotic words had distorted truth into propaganda. During the conflict, Americans had not been privy to the facts: numbers had been suppressed, dates deleted, places razed, and bodies buried or atomized. The documents and photographs of the events, places, and people that could have refuted the dishonest war of words were censored. As correspondent Wythe Williams of the *New York Times* wrote, "There is an ostrich policy that if facts are hidden they cease to exist."[22] The official and voluntary censorships coordinated by the CPI had accomplished their jobs.

But after the lifting of censorship at the end of the war, with their new knowledge gained, Americans vowed never again to be duped into fighting someone else's—anyone else's—war. The "crusade" for de-

mocracy and for "The War to End All Wars" appeared to Americans to have been just a tale, full of sound and fury, signifying nothing.

On April 2, 1917, President Wilson read to the Congress, assembled in extraordinary session, his request for a declaration of war against Germany. "The world must be made safe for democracy," he asserted. "To such a task we can dedicate our lives and our fortunes, everything that we are and everything that we have."[23] Four days later, the House—after some opposition—joined the Senate in passing the resolution declaring war.

When war was declared, there were only 200,000 men in the army. Two-thirds of these were Regulars and one-third were National Guardsmen who had been called to federal service along the Mexican border. By the end of the war, this force had been increased 20 times, and 4 million men had served. More than half a million came into the service from the Regular Army, 400,000 entered through the National Guard, and over 3 million came in through the selective service or National Army enlistments. What is remarkable about these figures is the willingness with which the American public accepted the universal draft, especially in contrast to the turbulent response to the draft during the Civil War. Even the official statistical summary of the war, prepared by the General Staff of the War Department, commented on the fact. "It is a noteworthy evidence of the enthusiastic support given by the country to the war program," it reported, "that, despite previous hostility to the principle of universal liability for military service, a few months after the selective service law was passed, the standing of the drafted soldier was fully as honorable in the estimation of his companions and of the country in general as was that of the man who enlisted voluntarily."[24]

The United States hustled its first troops over to France as early as June 1917 to raise the morale of the Allied armies and people. Organized from existing Regular Army units, these first soldiers formed the famous 1st Infantry Division—The Big Red One. Major, soon to be General and Commander-in-Chief, John "Black Jack" Pershing beat them over to France. After assessing the situation in Europe, he cabled the War Department for the mobilization of an American force to number at least 1 million in France by spring 1918 and for longer-range plans for 3 million men in Europe by 1919.[25] Nine days later, on July 20, 1917, the first draft was drawn to select 687,000 men from the nearly 10 million who had registered.

The American soldier who went to France received an average of six

months of training in the United States, two months of training over-seas, and another month in a quiet sector of the line before going into battle. But there were many men, especially in the last months of the war, whose training was speeded up to put them into the line against the Germans in the Argonne Forest and the valley of the Meuse. Despite the pressure of time, Pershing was adamant both that the AEF (Ameri-can Expeditionary Force) fight as a unified force, rather than be assimi-lated into already existing Allied units, and, equally important, that the AEF learn the tactics and spirit of the offensive. "The long period of trench warfare had so impressed itself upon the French and British," wrote Pershing in his final report on the conduct of the AEF, "that they had almost entirely dispensed with training for open warfare. It was to avoid this result in our Army and to encourage the offensive spirit that the following was published in October, 1917: . . . All instruction must contemplate the assumption of a vigorous offensive. This purpose will be emphasized in every phase of training until it becomes a settled habit of thought."[26]

The hope of the AEF—and the Allies—was that once the fresh blood and determination of the American soldiers was felt on the Western Front, the stalemate would end. "The United States Army," said one observer in 1918, "will fight in its own fashion, utilizing the past experi-ence of others with an untired vision and a strong vitality. Gradually there will come a new evolution of tactics and theory on the American front."[27] And, to a remarkable degree, the United States *was* involved in "open warfare" offensives, although the German drives in the spring of 1918 were more responsible for the war of movement than was the new American involvement. For the first time since the opening months of 1914, the geography of the line of trenches substantially changed.

In training, however, the brash Americans were willing to profit from the bitter lessons learned by the other troops in the mud and slime of the trenches. Although committed to offensive fire and movement, the war, as it existed on the Americans' declaration of war, was mired in the trenches. Therefore, it behooved the officer corps to prepare their troops for what lay ahead. Instructors in training at Camp Custer in Battle Creek, Michigan, read to their raw recruits for a half an hour a day from such best-sellers as 'Over the Top' and Kitchener's Mob. Little interested in the inspirational message of the books, the camp com-mander "thought the American testimonies about the trenches made the war seem like such a nightmare that the recruits would be 'guarded against panic' when they landed in France and discovered the real war was not quite so bad."[28]

The Context: "An Affair of the Mind"

In the months before the first American operations, in the mud and the marsh of the Moselle and the Meuse, the U.S. troops did bog down alongside the English and French in the position warfare that had existed since 1914. Then, during the last half of 1917 and much of the spring of 1918, came the war of "semi-movement." Recounting the days before the battle of Cantigny in late May 1918, correspondent Gibbons wrote,

> Our positions were located in a country almost as new to war as were the field of Flanders in the fall of '14. . . .
>
> On every hand were evidence of the reborn war of semi-movement. One day I would see a battery of light guns swing into position by a roadside, see an observing officer mount by ladder to a tree top and direct the firing of numberless rounds into the rumbling east. By the next morning, they would have changed position, rumbled off to other parts, leaving beside the road only the marks of their cannon wheels and mounds of empty shell cases.
>
> Between our infantry lines and those of the German, there was yet to grow the complete web of woven wire entanglements that marred the landscapes on the long established fronts. . . . Fat sandbags were just taking the places of potted geraniums on the sills of first floor windows. War's toll was being exacted daily, but the country had yet to pay the full price.[29]

During World War I, the bucolic European countryside, which had started out as a pastoral landscape, passed through the indignity of No Man's Land and then on to the "seventh circle of Hell"—where, according to Dante, "are punished the VIOLENT AGAINST THEIR NEIGHBORS, great war-makers . . . all who shed the blood of their fellowmen. As they wallowed in blood during their lives, so they are immersed in the boiling blood forever."[30] "I have suffered seventh hell," wrote Wilfred Owen in a letter home.

> I have not been at the front. I have been in front of it. I held an advanced post, that is, a "dug-out" in the middle of No Man's Land. We had a march of 3 miles over shelled road, then nearly 3 along a flooded trench. After that we came to where the trenches had been blown flat out and had to go over the top. It was of course dark, too dark, and the ground was not mud, not sloppy mud, but an octopus of sucking clay, 3, 4, 5 feet deep, relieved only by craters full of water.[31]

This "sucking" war tapped into men's most primitive reflexes. Survival demanded not only that men live like animals in the dirt and slime of the earth but that they demonstrate animal cunning. As Erich Maria Remarque observed:

> By the animal instinct that is awakened in us, we are led and protected. . . . A man is walking along without thought or heed;—suddenly he throws himself down on the ground and a storm of fragments flies harmlessly over him;—yet he cannot remember either to have heard the shell coming or to have thought of flinging himself down. . . . It is this other, this second sight in us, that has thrown us to the ground and saved us, without our knowing how.[32]

The soldiers quickly learned to differentiate between the sounds of the different kinds of shells and artillery and to tell if one had their "address written on it." The knowledge was common to all and, as Gibbons noted, "Time after time the collective judgment . . . and consequent prostration of the entire party was proven well timed by the arrival of a shell uncomfortably close."[33]

Single, directed shells could "crash," "slam," "whine," or "whimper." But a barrage was like an entire blacksmith's shop sailing over head. Correspondent Gibbons tried to describe the totality of sound. "You know the old covered wooden bridges that are still to be found in the country?" he asked. "Have you ever heard a team of horses and a farm wagon thumping and rumbling over such a bridge on the trot? Multiply the horse team a thousand times. Lash the animals from the trot to the wild gallop. Imagine the sound of their stampede through the echoing wooded structure and you approach in volume and effect the rumble and roar of the steel as it rained down."[34] Even the soldiers who manned the artillery itself never got used to the earsplitting noise. They lessened the shock by clapping their hands over their ears and balancing on their toes each time they pulled a big gun's lanyard.

In his work, *The Structure of Morale*, J. T. MacCurdy maintained that it took an average of 1,400 shells to kill a man during the First World War.[35] If accurate—and, by all accounts, his estimate is not far off the mark—the explanation for the great number of shells needed to inflict mortal injury is that many of the artillery barrages were aimed at the German wire or directed at the troops in dugouts, where only the high explosive shells had any chance of inflicting serious damage. Although this may seem inefficient—and it certainly was, to a great degree—the cutting of the barbed wire was the artillery's highest priority.[36] If the barbed wire did not get cut—and the barbed-wire belts could be

as wide as forty feet—any infantry advance would be arrested in the machine-gun-scoured wasteland of No Man's Land.

Anachronously, in this war of "walls of steel," of barrages of artillery, the Americans retained their faith in the rifle. Its use was appropriate to their insistence on an offensive war of movement. The rifle could be carried by a single infantryman more easily than any other repeat-action arm. "Even in these days of changed German methods, there are many times when the rifle can do the best work."[37] And when the rifle proved insufficient for the job, the machine gun, that "concentrated essence of infantry ... put into the hands of one man the fire-power formerly wielded by forty."[38] Americans believed, correctly, that the use of the machine gun on a large scale during World War I, as the secretary of war reported in 1916, "profoundly modified the art of war."[39] It had, the historian John Keegan observed, "not so much *disciplined* the act of killing ... as *mechanized* or *industrialized* it."[40]

Another sign of war's increasing "mechanization" was the blanket use of artillery. The artillery used in World War I could be divided into two classes: the 75-millimeter gun in one class and all other sizes in the other. The 75s, which made up half the American field artillery, threw projectiles weighing between 12 and 16 pounds and had an effective range of over 5.5 miles. Other guns used in numbers were the various sizes of trench mortars, infantry field guns, and howitzers.[41]

Other, more extreme applications of technology profoundly altered the face of battle. New inventions—the tank, the airplane, and poison gas—not only contributed to the increased mechanization of war, but added to the greater horror inherent in the quantative and qualitative experience of twentieth-century war. Of the three new technologies, the tank racked up the most ambivalent record. The number of tanks available to the AEF was never great, and even when they were available, the untrustworthy, hulking behemoths often sank in the mud, turned turtle going over trenches or shell craters, and broke down or ran out of fuel short of their objective. But when they were on the march, they struck terror into the hearts of their enemies and were a thing of beauty to their own side. By late in the war, the tanks waddled to victory by helping to break the trench deadlock on the Western Front. Correspondent Gibbons described the tanks in action in the surprise attack on July 18, 1918, during the Aisne-Marne offensive. "The preliminary barrage moved forward," he recalled,

crashing the forest down about it. Behind it went the tanks ambling awkwardly but irresistibly over all obstructions. . . . Our assaulting

waves moved forward, never hesitating, never faltering. Ahead of them were the tanks giving special attention to enemy machine gun nests that manifested stubbornness. We did not have to charge those death-dealing nests that morning as we did in the Bois de Belleau. The tanks were there to take care of them. One of these would move toward a nest, flirt around it several minutes and then politely sit on it. It would never be heard from thereafter.[42]

Gibbons's slightly jocular treatment of the tank attack obscured perhaps the most notable effect these tanks had in the war: their ability to demoralize the enemy into panic and flight. Major-General J. F. C. Fuller, who planned the first successful tank attack at Cambrai in November 1917 when he was an English staff officer, thought the tank's "predominant value [was] its morale effect. It showed clearly that terror and not destruction was the true aim of armed forces."[43]

Together with the tanks, airplanes were primarily responsible for the broadening, for the larger geographic commitment, of the war. World War I was the first war in which the atmosphere itself became an arena of combat. Only a few years earlier, airplanes had been a gossamer dream. But by the time the United States entered the war, they played a critical, fourfold role: planes scouted for artillery direction, observed the terrain for map-making purposes, bombarded distant enemy targets, and combated other aircraft. Although the United States lagged lamentably behind its Allies in its supply of aircraft to the war effort, the American flyers were second to none in their achievements in the air. In the battles of Chateau-Thierry, St.-Mihiel, and the Meuse-Argonne, the American fighters shot down 755 enemy planes while losing only 357 of their own.[44]

Poison gas was the third significant weapon introduced during World War I. First used by the Germans against French Algerian troops near Ypres on April 22, 1915, the gas caused the French troops to flee their trenches. But the Germans naturally hesitated about entering the French positions too soon after the release of the cloud of chlorine and so lost their advantage when the Canadians on the French flank closed the gap. By the time the Germans were prepared to use the gas on a large scale later that summer, the Allies were equipped with antigas equipment and were training to use poison gas themselves.

Death and wounding by gas were particularly horrid. Wrote one correspondent about that first April attack: "Hundreds, after a dreadful fight for air, became unconscious and died where they lay—a death of

hideous torture with the frothing bubbles gurgling in their throats and the foul liquid welling up in their lungs. With blackened faces and twisted limbs, one by one they drowned—only that which drowned them came from inside and not from out."[45] Gas was especially insidious because it was a silent killer. Originally introduced in clouds from cylinders planted in No Man's Land when the wind was blowing into the opposing trenches, the favorite method for delivering the poison became gas-filled artillery shells. As Gibbons noted, "They just crack open quietly so you don't know it until you've sniffed yourself dead."[46] Gas wounded an incredible number of soldiers; in 1918, between 20 and 30 percent of American casualties were due to gas.[47]

Although there were loud outcries against the Germans by the Allies, the usage of poison gas was soon adopted by all the participants in the war. The troops, naturally enough, disliked it most and blamed its use on the Germans. "It's damnable," said one British soldier. "It's not soldiering to use stuff like that even though the Germans did start it."[48] Once the censorship on the subject had been lifted and the war correspondents were able to talk to survivors of the attacks in the hospitals, the story achieved sensational prominence and helped convince the neutral nations of Germany's barbarism. The resulting political gain to the Allies soon outweighed Germany's initial military advantage.

But military violations of the "code" of war occurred on both sides. Aside from the use of gas, there were, of course, the accidental-on-purpose bombings of civilian targets and the shooting of prisoners. True atrocities, however—personal violations of civilians or soldiers by rape, mutilation, or torture—it was agreed, were rare. Few, if any, of the spectacular rumors were ever found to be true—that the Germans had crucified a Canadian soldier, that they boiled their dead to get grease, or that they chopped off the hands of Belgian children. The only firsthand account of large-scale atrocities heard by Robert Graves, for example, was actually committed by an Allied battalion of French Turcos, who overtook a column of "dead-weary Germans." An old woman who witnessed the event told Graves about the slaughter that ensued, ending, "Et enfin, ces animaux leur ont arrachés les oreilles et les ont mis à la poche."[49] As Frederick Palmer said, "War itself is an atrocity."[50]

During the war, with the exception of sensationalist atrocity reporting, few of the American magazines or newspapers gave a blood-and-guts version of the front. Americans were privy to rumors of horrors, but the realities of combat were denied them. And after the entrance of the United States in the war, the cheery, just-the-facts-Ma'am tone of the news stories depicting the experiences of the "Yanks" was due

both to the blanketing censorship imposed on correspondents and photographers and to the changed nature of the conflict after the American entry: much of the obvious, senseless slaughter was in the past. The combination of censorship and the actual changes in the war itself enabled Americans to retain their idealism; the belief that the soldiers were dying heroically in a just cause sustained the country for more than a year.

Fortunately, for the Americans, the war did not last long enough—nor was the censorship lifted to allow for second thoughts. After the war was over and won, recriminations were just hindsight. During the war, of course, the American troops knew—even if their families at home did not—that more often than not they were climbing out of their trenches and shell holes and running to their deaths. Even the American soldiers led the tense, slogging, despairing, pathetic, quotidian lives of the front lines. But such was the "corps d'esprit" that the men charged anyway. Such was reported in a captured German intelligence report: "The Second American Division may be classed as a very good division, perhaps even as assault troops. The various attacks of both regiments on Belleau Wood were carried out with dash and recklessness. The moral effect of our firearms did not materially check the advances of the enemy. The nerves of the Americans are still unshaken."[51] And, as Gibbons observed of the same battle, "I was with the Marines at the opening of the battle. I never saw men charge to their death with finer spirit."[52] Gibbons told the story of that charge.

> A small platoon line of Marines lay on their faces and bellies under the trees at the edge of a wheat field. The bullets nipped the tops of the young wheat and ripped the bark from the trunks of the trees three feet from the ground on which the Marines lay. . . .
>
> As the minute for the advance arrived, [an old gunnery sergeant] arose from the trees first and jumped out onto the exposed edge of that field that ran with lead, across which he and his men were to charge. Then he turned to give the charge order to the men of his platoon—his mates—the men he loved. He said:
>
> "COME ON, YOU SONS-O'-BITCHES! DO YOU WANT TO LIVE FOREVER?"[53]

American soldiers, like their counterparts during the Spanish-American War, believed in their own immortality. "We are a people given to discounting futures; and the average American soldier, to put

it bluntly, discounted being killed in action," stated the prominent American correspondent Frederick Palmer.[54]

Some men, particularly in their first days at the front, wanted to be schoolbook heroes. But more were trapped in the lemming mentality. They had lost control over their own lives. "Going under fire," said Palmer, "was in answer to duty or the desire to be nearer the realities. Every man was subjective at intervals. The less time he had to think of anything but his work, the more objective he was. One man might be killed when he left the parapet the first time he was under fire; another might go through showers of missiles again and again, and never receive a scratch."[55]

To lessen the risk of death across the board, soldiers on both sides in certain quiet sectors developed what amounted to mutual nonaggression pacts. According to writer Tony Ashworth, breakfast truces, Christmas truces, truces to recover the wounded, as well as agreed general reductions in the level of hostilities were not uncommon.[56] Gibbons told of being in such a sector. "I can't understand the dropping of that shell over here to-night," Gibbons quoted one colonel as saying. "When we relieved the French, there had been a long-standing agreement against such discourtesy. It's hard to believe the Boche would make a scrap of paper out of that agreement. They must have had a new gunner on the piece. We sent back two shells into their regimental headquarters. They have been quiet since."[57]

Of course, there were always soldiers who were trigger-happy, gung-ho, or just plain patriotic. Many soldiers at the front, reported journalist Gibbons, "had undergone their baptism in German fire and had found the experience not distasteful."[58] And Heywood Broun noted early in the American effort that one officer was "still getting a tingle out of the war that had nothing to do with the cold wind that was coming over No Man's Land."[59] Some viewed the war as a kind of all-American sport; they played the game with a vengeance. "It was fine to see our men go at the Huns," said one American soldier who had been severely wounded by shrapnel. "All of us, who thought baseball was the great American game, have changed our minds. There is only one game to keep the American flag flying—that is, kill the Huns. I got several before they got me."[60] And an American officer was quoted as saying, "This is a mean and nasty kind of war, but it's the only war we've got, and I hope it's the last we'll ever have. The right way to fight it is to be just as mean and nasty, and just as much on the job, as the mean and nasty Boche."[61]

Finally, there were the soldiers who were on the line hanging by a thread; they were numb automatons who behaved as mechanically as the machines they operated. For them, there was no excitement left in terror, no horror left in death. Many had even lost their sense of curiosity. "When you had seen the front once," said the journalist Palmer, "you had seen it all, in one sense; in another, little."[62]

Once settled in at the front, though, many men outgrew both their fear of and appetite for battle. First-time soldiers feared being cowards. A favorite theme of war stories in feature publications was the conquering of fear in a man's first battle. Invariably, in the stories at least, the man would triumph over his cowardice and prove himself a hero and a man among men. Veteran soldiers, however, were appropriately more concerned about other fears—of specific wounds, of death, of capture, and of torture; they had already proved to themselves and others that they were not cowards. During the Spanish-American War, the men had wanted to go into battle; the conflict was not expected to—and did not—last long enough for the soldiers to change their minds. During World War I, however, the men began to worry about surviving intact until the end of the war. The veterans had it figured out. "The best way of lasting the war out was to get wounded," said one. "The best time to get wounded was at night and in the open because a wound in a vital spot was less likely. Fire was more or less unaimed at night and the whole body was exposed. It was also convenient to be wounded when there was no rush on the dressing-station services and when the back areas were not being heavily shelled. It was most convenient to be wounded, therefore, on a night patrol in a quiet sector."[63]

Among the possible injuries, the best was a "million-dollar wound," a wound that would not incapacitate a soldier for civilian existence but that would buy him a ticket out of the army, say, getting his trigger finger shot off. Then there were the wounds that one did not talk about—being blinded, getting part of one's face shot away, and, worst of all, being hit in the genitals. And there was everything in between. Sucking chest wounds, abdominal wounds that would lead to peritonitis, traumatic amputations, and concussions. The obscenity of the war was never clearer than when looking at the wounded. "We see men living with their skulls blown open" remembered Remarque in his novel, "we see soldiers run with their two feet cut off, they stagger on their splintered stumps into the next shell-hole; a lance-corporal crawls a mile and half on his hands dragging his smashed knee after him; another goes to the dressing-station and over his clasped hands bulge his intestines; we see men without mouths, without jaws, without faces;

we find one man who has held the artery of his arm in his teeth for two hours in order not to bleed to death."[64] Photographs exist to document such injuries—although such graphic images were only published *after* the war. There was no need to exaggerate the truth. All this happened, and more.

Once wounded, a soldier walked, if possible, or was carried by stretcher back to a relief station close to the front lines. There a medic sorted the casualties and sent all but the lightly wounded in an ambulance back to a clearing station miles in the rear. At the clearing station, the process of triage sorted the wounded into three groups. Those who could stand an additional journey were sent on to a local or base hospital. And those remaining were divided into one group considered worth subjecting to major surgery and another group considered impossible to save. The greater the press of wounded, the larger the group left to die. Without antibiotics, much of the surgery was, perforce, radical, but with the new application of field dressings, blood transfusions, and debridement and with the elaborate evacuation system for casualties, many men were saved who would have been lost during the Spanish-American War.

Still, the soldiers called the Western Front the "Sausage Machine": it swallowed live men and churned out corpses. The dead littered the ground. They were collected by details and buried, then, like as not, chewed up again in shell blasts. Some bodies could not be rescued. They swelled and stank on the wire, "until," as Graves recorded, "the wall of the stomach collapsed, either naturally or punctured by a bullet; a disgusting smell would float across. The colour of the dead faces changed from white to yellow-grey, to red, to purple, to green, to black, to slimy."[65] The smell was almost as disturbing as the sight; some men, when forced to share quarters with a ripe corpse, donned gas masks in defense.

It was a curious transformation—the transforming of boys and men into cold corpses and bits of flesh after having passed through days and months of uncertainty, of fear and pain. And once it was all over, when the dead were bodies? One presumed a grand scheme, an overarching significance to it all. And there were several. There was the theme of the "Crusade." The theme of "Democracy." The theme of "The War to End All Wars." What there was not was any theme that survived the war. The soldiers in World War I thought that, like their fathers in the Spanish-American War, they could march off and fight a war and that their victory would validate their cause and their effort. But there were too many bodies for too few reasons.

Words that were supposed to mean something turned out not to. After the war, when the dust had settled, men tried to fight the "glorious" words of the war with "bitter" words of their own. Charges were made. Books were written. In the literature that came out of the war, the same theme recurred over and over. Although I died, he died, you died, it did not make a difference. The individual did not matter; the cause had been a mirage. From a journalist's book that appeared in 1915: "Their night and day of fighting—their defeat of an attack, their suffering under shell, bullet, and bomb, their nine killed and their thirty-six wounded—were all ignored and passed by. The despatch for that day said simply: 'On the Western Front there is nothing to report. All remains quiet.' "[66] From an autobiography that was published in 1917: "Out of the twenty that were in the raiding party, seventeen were killed. The officer died of wounds in crawling back to our trench and I was severely wounded. . . . In the official communique our trench raid was described as follows: 'All quiet on the Western front.' "[67] And from Remarque's 1929 work: "He fell in October, 1918, on a day that was so quiet and still on the whole front, that the army report confined itself to the single sentence: All quiet on the Western Front."[68] It seemed such a colossal waste. "War kills," stated philosopher Michael Walzer, "that is all it does; even its economic causes are not reflected in its outcomes; and the soldiers who die are, in the contemporary phrase, wasted."[69]

Because of World World I, the dead rested in No Man's Land, and the living were left in The Waste Land. In the literature after the war, some men wondered, as did John Dos Passos in his novel *Three Soldiers*, "Was civilization nothing but a vast edifice of sham, and the war, instead of its crumbling . . . its fullest and most ultimate expression?"[70] What was the fate or the purpose of the American cause if that were the case? Together with Wilfred Owen, Americans refused to believe "The old Lie; Dulce et decorum est/Pro patria mori."[71] "The cannon fodder," said Frederick Palmer, "has learned something from the World War. . . . It knows there is no glory in going into the teeth of the thresher."[72]

During the last week of October 1917, American troops moved up at night to share the frontline trenches with the French. On the night of October 27, an American patrol in No Man's Land met its first Germans. One American was wounded and later died. One week later, German infantry invaded the American trenches, killing three and capturing twelve. On November 4, the first three American soldiers were buried in France. "It was a very touching ceremony," Palmer wrote. "Our blood had been shed. Ten million able-bodied Americans were now committed as they had not been before to their task."[73]

THE CONTEXT: "AN AFFAIR OF THE MIND"

One year after its first appearance in the line, the United States Army held 101 miles of front, or 23 percent of the Allied battle line. Two out of every 3 American soldiers who reached France took part in battle—1,390,000 out of 2,084,000. Twenty-nine out of 42 divisons fought.[74] The total number of American deaths caused by the war was 81,141: 35,555 killed in action; 15,130 dead of wounds received in battle; 5,669 dead of other injuries; and 24,786 dead of disease.[75]

The war ended at 11:00 A.M. on November 11, 1918. The shooting stopped. All, finally, was quiet on the Western Front. But the noise at home had just begun.

5

The Photographers:
The Command Performance

Who, What, Where, When

"IS THE CAMERA a more deadly weapon than the machine gun?" asked one photographic commentator in 1918. "A bullet may kill a man, perhaps two," he concluded, and "a round from a machine-gun [can] bring down an enemy 'plane. But the influences of the [photograph] are wider, more deadly."[1] A photograph could be the guide to a swarming attack over No Man's Land. It could direct artillery to destroy enemy emplacements. It could distinguish friend from foe. But most important, a photograph could sway emotions, could manipulate, persuade, and convince—all without any obvious machinations, just because of the presumption and assumption that it was telling the truth.

Before the Gallipoli operations began in the Dardanelles, General Ian Hamilton pleaded with Lord Kitchener and the British War Office to allow two of the most prominent American journalists to accompany the expedition: Jimmy Hare, the famous photographer from the Spanish-American and the Russo-Japanese wars, and Frederick Palmer, an equally well-known print correspondent. Hamilton wrote in his diary, "I begged hard for Hare and Frederick Palmer, the Americans, knowing that they would help us with the Yanks just as much as aeroplanes would help us with the Turks, but I was turned down on the plea that the London Press would be jealous."[2] And Hare himself noted that "photographs seem to be the one thing that the War Office is really afraid of."[3] Actually Hare was wrong. Photographs were only what the

War Office was *most* afraid of; the War Office was afraid of war reports of *all* kinds.

The British were not alone in fearing the entrance of correspondents into the war. Both sides in the fighting and all parties—Austria, Germany, England, France, Italy, and eventually the United States—imposed restrictions that at best hampered and at worst disallowed news gathering and communication at the fronts, behind the lines, and back home. Military officials regarded the press merely as a repository of information for the enemy; the French General Staff, for example, still blamed the press's publication of information about military movements, plans of the generals, and the condition and morale of the troops for their defeat in the Franco-Prussian War of 1870. (Historians now are more likely to blame France's overconfidence, inferior artillery, internal politics, and general ineptitude.[4]) Journalists walked a narrow line. To go out and dig up a story was courting a suspension of the writer's or photographer's privileges, at best. To stay away from the front and gather the story by piecing it together from the official communiqués was, for a writer, to relinquish any activist, investigative role and, for a photographer, impossible. "There can be no broader chasm," admitted Frederick Palmer, a journalist and later the army's chief press officer, "than that between an army headquarters and a city editor's room. One thinks in terms of 'tell nothing as the only safe way' and the other in terms of 'tell everything that is interesting'; one writes 'secret and confidential' across the page and the other writes head-lines."[5] In World War I, the military held sway. The old-style, swashbuckling days à la Richard Harding Davis were over.

It was only through experience in this new twentieth-century war that the countries involved came to any understanding of the role of the press. According to William Shepherd, the correspondent for the United Press Association, the war years could be divided into three distinct periods of journalistic activity and military control. "The first stage," he wrote in 1917, "may be known as the 'free-lance days'. . . . The second stage is called by European war correspondents the 'dark ages'. . . . The third stage, the one we have entered only recently, is the stage of the new twentieth-century war correspondent."[6]

"The harum-scarumness of those early free-lance days is almost unbelievable, as one looks back on it now," Shepherd wrote.

> Never, in the modern world, did news count for so much in the lives of so many millions of people as it did during those first months of the Great War. . . . Those were the good old days in the

Great War, those days when war correspondents, unbidden, un-
welcome, deluged Belgium and the northern part of France. . . . In
those happy-go-lucky early days of the war the armies had not
learned how to control us. The great machinery of that cyclonic
blast of war that hit the civilized world of 1914 left newspaper cor-
respondents entirely out of its operations. It ignored them, and
therefore it had no way of dealing with them. We puzzled the gen-
erals. The rules said, "No newspaper correspondents allowed." But
there were always American newspaper correspondents around
somewhere.[7]

Those early days of the war were characterized by a freedom that was
not to be repeated for the duration of the conflict. It was not so much
that the correspondents could go anywhere, see anything, and report
back to their newspapers or magazines whatever they wanted, but that
the rules to limit the journalists were not always known, evenly ap-
plied, or without loopholes.

But the freedom of that period had its negative side for the reputation
of the media. "The public," noted Shepherd sadly,

> was often misled in that period. In the mass of war news, no small
> amount of fake [sic] and lies was fed to it by unscrupulous adven-
> turers who were not trained correspondents and who had no repu-
> tation for veracity to sustain. . . . Their fakery, in the main, was
> not injurious, but there have been instances where their work has
> produced serious results—especially in their reports of German
> atrocities in Belgium.

Shepherd went on to say, "I couldn't find atrocities. . . . I offered sums
of money for photographs of children whose hands had been cut off or
who had been wounded or injured in other ways. *I never found a first-
hand Belgian atrocity story: and when I ran down the second-hand sto-
ries they all petered out.*"[8]

The stories of atrocities during those early months of the war, how-
ever, were not always discouraged by the various Allied governments.
Ironically, many of the officials had an easier time allowing the passage
of news that they knew or suspected to be false than they did in passing
news they knew to be true. Palmer, as the accredited correspondent to
the British Expeditionary Forces for the three U.S. news services—the
Associated Press (AP), the United Press (UP), and the International

News Service (INS)—and the only journalist to be so accredited—raged about his experiences with such stories. "There was the report," he said, "that German soldiers had crucified a Canadian soldier. It appeared unreasonable to me, uncircumstantiated. I asked the staff if there were any proof. I was told there was none; it was not true. But 'it had an excellent effect on Canadian recruiting'—this tale, authenticated by propaganda, in its stark, cold, deliberate savagery."[9]

By June 1915, the suspense was over. That happy-go-lucky time when any day might bring the decisive action that would end the war and any journalist might cover it was over. The war had settled down to its grinding monotony. And for the journalists, this meant, as Palmer said, that "there was not the freedom of the old days, but there can never be again." These were the "dark ages," the period when "the important items were those we left out; and these made us public liars!"[10] Palmer was fortunate, however, in at least *learning* the news; most journalists were not allowed anywhere near the front, and many Americans went home to the United States in frustration. Noted Shepherd: "In London there were at least thirty war writers practically prisoners. . . . The War Office would not recognize them; they had been informed that any individual attempts on their part to get to the front by stealth or sneaking would be severely punished." Shepherd, who was one of the "brave spirits" who risked getting to the front lines, struck out for Italy on the theory that the Italians might not have yet heard of "the newest wrinkle in War Office procedure." Upon arriving in Udine, Italy, by hook and by crook, he was taken into custody and informed at headquarters: "Well, you may remain in Udine if you wish to; but if you do we'll be forced to shoot you." He departed from Udine two hours later, only "because a train didn't leave sooner."[11]

The gloom of these "dark ages" was finally dispelled, Shepherd remarked dramatically, because of "a light that dawned in Germany." Germany—convinced of the propaganda value of the press by the favorable publicity following the news story of Hindenburg's first defeat of the Russians at Mazurian Lake—began to allow war correspondents to take conducted trips to the various fronts. When the German news stories began trickling out of Germany, the Allies were forced to counteract them with stories of their own. The "privileges" to the correspondents that resulted moved the journalists into the third era of their existence, the "era of the twentieth-century war correspondent."[12]

"The twentieth-century journalist," said Shepherd cynically, though honestly, "is a patented war correspondent."

You find him on both sides. He had [sic] been tested in a hundred ways as to his dependability and his sympathies. He is tabulated on the military records. His headquarters are always in some European capital, and he makes it a point to keep in daily touch with the War Office. He visits these offices regularly, like a police reporter or a city-hall reporter doing his daily rounds. Once in a while he is told that he may pack up his field kit and take a trip to the front. . . . He writes only about what he has actually seen or what comes to him from official sources, and his stories are strictly censored.[13]

Photographers labored under the same—if not worse—constraints as the print journalists. In 1915, Jimmy Hare wrote that, "to so much as make a snapshot without official permission in writing means arrest." By 1916, Hare, with other members of the press, was escorted to the front on a number of occasions but was allowed to take only those notes and photographs of the trench warfare that met with British approval. The British passed certain photographs of tired "Tommies" and a devastated countryside; the resulting stories reflected what the British wished the United States to see, rather than what the photojournalists actually saw. As Hare, the photographer, said bitterly several months later, "All I can do in this war is to write and let that be censored."[14]

The American media, even at the beginning of the conflict, sent more correspondents and photographers to Europe than any other nation's press. In 1914, the American press had fifty to seventy-five staff and stringer representatives; by the end of the war, it numbered several hundred in the various capitals and on the Western Front. As neutrals, the Americans were based in both the Allied and the German-Austrian capitals until the entry of their country into the war. When the United States became a belligerent in April 1917, the focus of the American correspondents naturally shifted to the American role in the conflict. Many correspondents and photographers, including Hare, were called home to follow the training of the troops over the spring, summer, and fall. Back in the United States, Hare, for one, covered such breaking news stories for *Leslie's Weekly* as "War at the Golden Gate," "The Red Cross Nurse," and "Hard Work for the National Guard."[15]

Then, beginning in July 1917, a press base of the American Expeditionary Force (AEF) was established in Paris, and, because the headquarters of the AEF was in Chaumont, France, another press base was created thirty miles from there at Neufchâteau, attached to G-2, the Army Intelligence Section. The total number of journalists accredited to the AEF until the summer of 1918—which meant all the American,

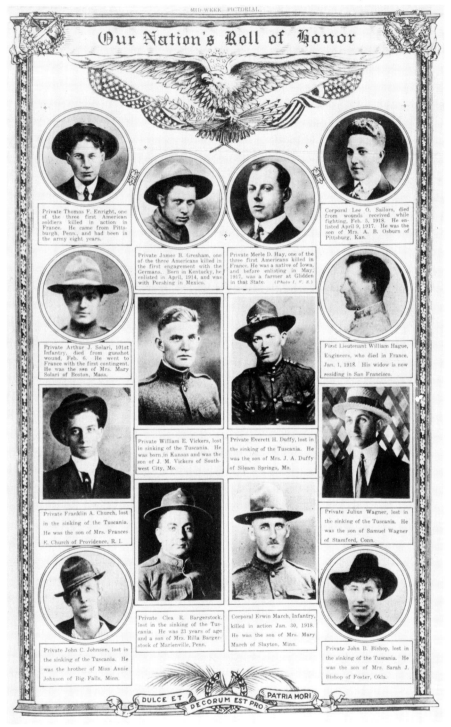

10
Unknown
"Our Nation's Roll of Honor. Dulce Et Decorum Est Pro Patria Mori."
Mid-Week Pictorial, March 14, 1918

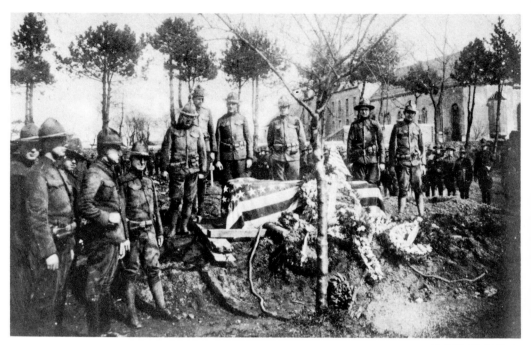

11

AP/Wide World Photos

Kadel & Herbert
"The burial of an American officer
who died from wounds received in action."
Mid-Week Pictorial, May 16, 1918

12

Underwood & Underwood
"American ambulance men in the front line trenches
rendering first aid to a soldier
who had been in a gas attack."
Mid-Week Pictorial, March 14, 1918

Bettmann Archives

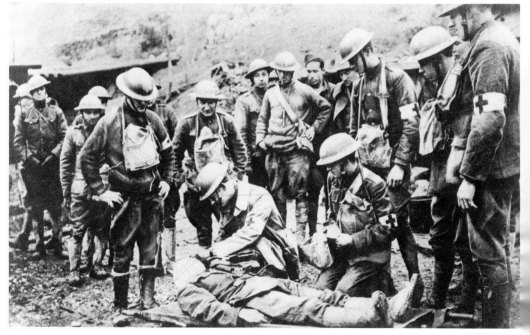

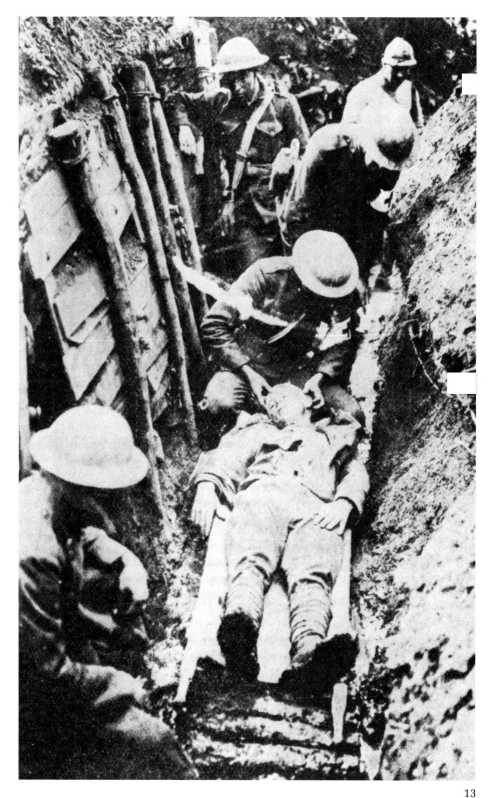

13
Unknown
"If he saw his chum picked off by a sniper,
he might understand it's a life-and-death matter."
Collier's Weekly, July 27, 1918

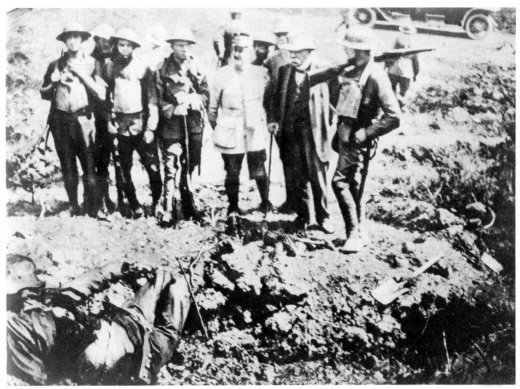

14

Bettmann Archives

Underwood & Underwood
"Premier Clemenceau and General Mordacq
with American soldiers
on the battlefield of Chateau-Thiery [sic].
In the foreground lies a dead German."
Mid-Week Pictorial, August 29, 1918

15
James H. Hare
"After an action members of the sanitary corps
sprinkled disinfectants over all bodies."
Leslie's Weekly, August 24, 1918

*Photography Collection, The Harry Ransom Humanities
Research Center, University of Texas at Austin*

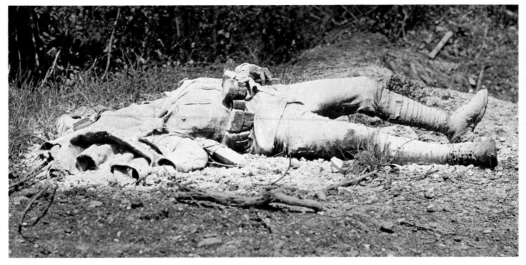

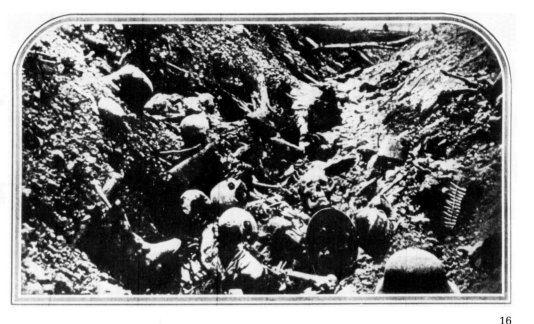

16

Lucian S. Kirtland

"War's Skulls *and* Crossbones: Death evens all scores, and for the individual Germans, nobles and peasants alike, whose bones lie moldering in this abandoned trench in France which they gave their lives to defend, few can feel aught but pity. But, in a broader sense, they and their blood brought to the earth its four bitterest years since the dawn of light, and before peace and happiness return to East and West, hundreds of thousands of other men marching under the eagles of Germany and Austria must rot amid the pickelhauben, iron hats, and other panoplies of war which their Kaiser loves above the love of man and constantly puts before his God."

Leslie's Weekly, May 25, 1918

17

Underwood & Underwood

"United States troops on the Lorraine Sector ready for a gas attack."

Mid-Week Pictorial, March 14, 1918

Bettmann Archives

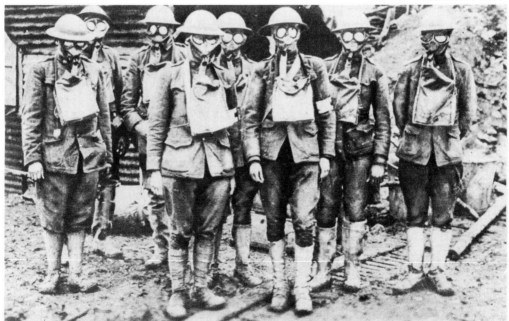

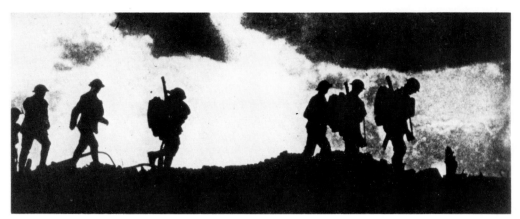

Bettmann Archives

18
Underwood & Underwood
"Moonlight silhouette. Men going over conquered ground
to their trenches for the night."
Saturday Evening Post, October 9, 1918

19
Edmond Ratisbonne
"While the Big Guns Clear the Way."
Leslie's Weekly, July 20, 1918

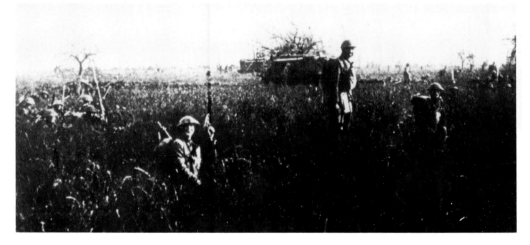

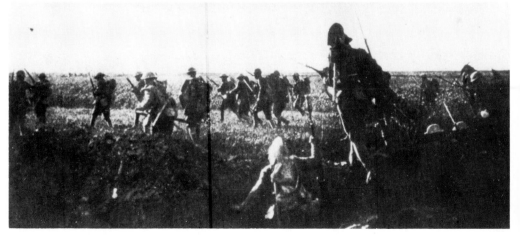

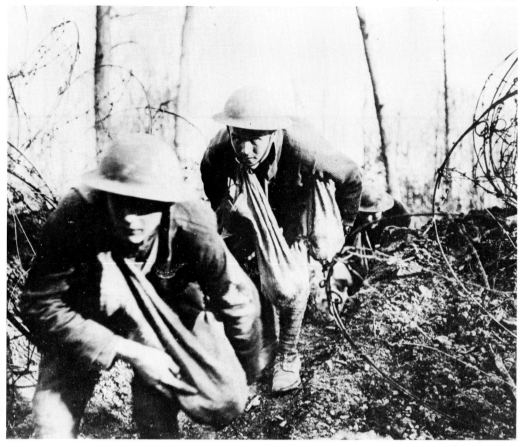

20
CPI
"American soldiers carrying sacks of hand grenades
as they creep forward in
the direction of No Man's Land."
Mid-Week Pictorial, May 30, 1918

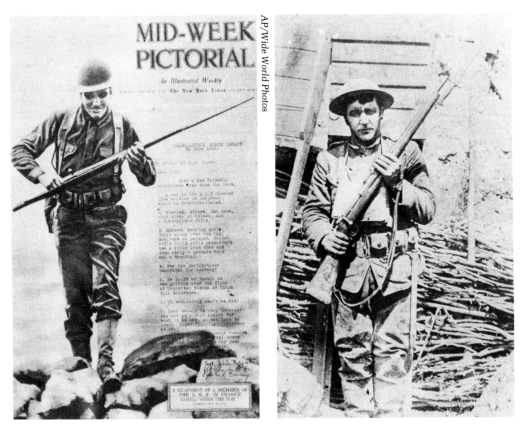

21

Gilliams Photo Service (*left*)
"A Mid-Week Pictorial cover which evoked a letter of criticism from
'A Bunch of Doughboys,' now in France. Their letter is interesting
because it indicates that there is a great difference between
training operations at home and real fighting on the front."

Central News (*right*)
"This official photograph is more like the real thing.
The American soldier seen here had a hand-to-hand fight
with a German at Chateau-Thierry. Having already
used his ammunition, he killed his adversary
with the butt of the rifle which he is holding.
His name is Private Victor Vandermerck."

Mid-Week Pictorial, August 8, 1918

Allied, and neutral journalists who were interested in reporting on operations in the American sector in France—was held to about fifty. Twenty-one of them were American print correspondents, and the remaining twenty-nine were American photographers and artists and the Allied press. In addition, at any given time, there were also a sizable number of "visiting" correspondents.[16] This policy was changed in June 1918, under pressure from hometown papers that were interested in following their "boys" to the front. Pershing split the number of accredited journalists into a "CENTRAL BODY COMPOSED OF NOT MORE THAN 25 ACCREDITED CORRESPONDENTS" and "ONE ACCREDITED CORRESPONDENT WITH EACH DIVISION." The central body had the run of the territory; the correspondents were furnished with automobiles and cable facilities. The correspondents stationed with the forty-two divisions were "MAIL SPECIALS ONLY," permitted no transportation, conducting officer, cable facilities, or travel outside the zone of the particular division.[17]

Initially, the only authorized photography of the AEF was that taken by the Army Signal Corps. Those not authorized to take photographs in the zone of the AEF or those who were found taking photographs of forbidden subjects were severely disciplined. (Although in 1917 and 1918 no one suffered the threat of capital punishment in existence during the earlier years of the war.) But it soon became clear that many American correspondents were taking photographs clandestinely to illustrate their articles—not to mention the French official photographers who were taking photographs in the American zone and making their photographs available to different film services in Paris for use in the United States. General Pershing, bowing to the inevitable, cabled Washington on the day after Christmas, 1917, to allow "OFFICIAL PHOTOGRAPHERS OF THE ALLIED ARMIES TO TAKE PHOTOGRAPHS IN OUR ARMY AREAS" and "ACCREDITED AND VISITING CORRESPONDENTS ... TO TAKE PHOTOGRAPHS, SUBJECT TO OUR CENSORSHIP, TO ILLUSTRATE THEIR ARTICLES."[18] With this authorization—for the duration of the war—there were ten to twenty correspondents who "had in their possession a camera and the right to use it."[19]

Six months later, Pershing again capitulated to the unavoidable. On June 19, 1918, he cabled Washington to announce that the General Staff was now authorized to "EMPLOY CIVILIAN PHOTOGRAPHERS IF CIRCUMSTANCE WARRANT FOR PHOTOGRAPHIC OPERATIONS," noting that the "FIELD TO BE COVERED IN PRESENT WAR IS SO HUGE THAT THIS RECOURSE MUST BE ADOPTED period THERE

IS NO DANGER OF DUPLICATION BUT ON CONTRARY IS NEED FOR MUCH WIDER RECORDING OF EVENTS FOR HISTORICAL AND NEWS PURPOSES ALIKE THAN CAN REASONABLY BE EXPECTED OF SIGNAL CORPS." Pershing described the conditions of employment:

UNDER THIS ARRANGEMENT PHOTOGRAPHERS SHOULD BE ACCREDITED AND BEFORE LEAVING UNITED STATES SHOULD GIVE BONDS SIMILAR TO BONDS NOW FILED BY ACCREDITED CORRESPONDENTS period THEY WILL AGREE TO PAY ALL EXPENSES TO SUBMIT ALL WORK TO CENSORSHIP TO ATTEND TO THEIR OWN DEVELOPING AND TITLING UNDER ANY ARRANGEMENT THEY WISH SUBJECT TO APPROVAL HERE BUT WILL BE ALLOWED TO DEVELOP IN SIGNAL CORPS LABORATORY IF THEY WISH period THEY WILL SEND FILM TO UNITED STATES FOR DISTRIBUTION THROUGH THEIR OWN COMPANIES WHICH ARE WELL EQUIPPED FOR HANDLING DISTRIBUTION OF NEWS PICTURES period THEY WILL FURNISH SIGNAL CORPS LABORATORY IN PARIS WITH DUPLICATE NEGATIVE FOR MAKING HISTORICAL RECORD AND ALSO RELEASE TO COMMITTEE PUBLIC INFORMATION IN PARIS FOR USE AS COMMITTEE WISHES AFTER SPECIFIED RELEASE DATE AND ONLY IN EUROPE period THIS WILL IN NO WAY INTERFERE WITH WORK OF SIGNAL CORPS BUT WILL PROVIDE AMERICAN PUBLIC WITH BETTER OPPORTUNITY TO SEE IN PICTURE FORM AMEXFORCE ACTIVITIES JUST AS ACCREDITED CORRESPONDENTS NOW FURNISH THEM WITH WRITTEN NEWS OF THESE ACTIVITIES period[20]

Accredited photographers labored under the same military regulations as the correspondents. Both were provided with passes and identity cards similar to those of the AEF officers. They were authorized to travel within the zone of the American Army, but, unlike the journalists in the other Allied jurisdictions, did not have to travel with a military escort. Because they held the status of officers, both the accredited photographers and correspondents wore the uniform of an officer "without any insignia of rank or arm of service," but with a "U.S." on the collar and Sam Browne belt. Photographers wore a blue armband with a white "P" on it; correspondents, a green brassard with a red letter "C." Visiting journalists did not wear the uniform, although they

were given a coded armband for the duration of their pass. Their travel was also more restricted; generally, a conducting officer accompanied them on their tour; if not, they were furnished with a specific pass.[21]

Under these new regulations, the major publications could legally permit their correspondents to take photographs to accompany their articles. Several periodicals also sent over photographers or had their photographer-correspondents register for the new photographic permits. Photographic services were also now eligible to sponsor a "PHO-TOGRAPHIC PARTY OF ONE MOVIE OPERATOR ONE STILL OPER-ATOR AND ONE HELPER."[22] Companies such as Underwood & Underwood, Keystone View Company, International Film Service, Universal Film Company, Brown Brothers, Paul Thompson, Kadel & Herbert, Harris & Ewing, Western Newspaper Union, News Enterprise Association, and others sent newly documented representatives.

Until the middle of 1918, relations with the press photographers were maintained through the Paris office of the Committee on Public Information (CPI), and all the military photography was handled by the chief photographic censor, Captain Joe T. Marshall, Cavalry. However, in May 1918, a photography subdivision within G-2 Press Section was established. The new subdivision took charge of all photographic responsibilities—the taking of official photographs, the censoring of all photographs, and the titling and captioning of official photographs. In October 1918, an editing section was added to revise and correct inaccurate captions.[23]

All pictures taken in the American zone, whether by the newspaper photographers and correspondents, the Red Cross, YMCA, and Knights of Columbus representatives, or the Army Signal Corps, were sent to the Signal Corps laboratory for developing, printing, and censoring. Photographs taken by the journalists and authorized visitors were copied for the army files, and a print and the negative were usually returned to the photographer within four days.

Once the system was in place, the civilian correspondents and photographers sent home hundreds of pictures a week and the military sent fifty or so more. For example, in the three-month period of May–July 1918, a total of 1,650 photographs that were taken for publication by correspondents were passed by the censor. To list a few of the correspondents: Walter Ball, of the *Providence Journal*, had 96 passed; Herbert Corey, of the Associated Newspapers, 97; Fred Ferguson, of the UP, 92; W. J. Kirtland (either Helen Johns Kirtland or L. S. Kirtland) of *Leslie's Weekly*, 130; Arthur Ruhl of *Collier's Weekly*, 57; George Seldes, of the Marshall Syndicate, 146; Frank Sibley, of the *Boston Globe*, 119;

Frank Taylor, of the UP, 185; Joseph Timmons, of the *Los Angeles Examiner*, 233; and Junius Wood, of the *Chicago Daily News*, 176. Other well-known photographers, such as J. C. Hemment, the Hearst photographer in the Spanish-American War, and Lewis Hine, the social documentary photographer, took pictures for the service organizations; Hine was issued a permit in October 1918 as a Red Cross official photographer, and Hemment was issued a permit for the Knights of Columbus.[24]

The general policy of press censorship was controlled by Palmer, now a major in the army. Since 1914, Palmer, as representative of the three major American press services—AP, UP, and INS—had been the foremost U.S. correspondent in Europe. Although solicited to be the chief correspondent for the *New York Herald* at the unprecedented salary of $750 per week, Palmer turned the offer down when General Pershing pressed him to accept a commission to be the major in charge of the Press Section of G-2 (Intelligence). Patriotism spurred him to accept the lower salary of $175 a week.

Once in office, Palmer subjected photography to the same regulations and censorship as print journalism. The self-evident principle of the censorship was to prevent the enemy from obtaining any useful information about the American forces. Chief among the taboo photographs were those that showed movements of troops, which meant that any insignia that could be recognized as belonging to an identifiable outfit and any identifiable locale, especially military emplacements, would prevent a photograph from being passed. For similar reasons, photographs that portrayed specific war matériel, especially technical or tactical inventions, were stopped.

The other major category of forbidden photographs were those that had a potentially deleterious effect on the AEF soldiers, the public at home, or the U.S.'s relationship with the Allied governments. An example of the kind of picture that was assumed to affect the morale of the American soldier was a photograph "that showed soldiers improperly equipped or 'out of uniform', or that represented them in unseemly attitudes or improper environment,"[25] such as a naked soldier in bed in a whorehouse. In addition, photographs were considered to have a depressing effect on the public at home if they pictured "the mangled remains of a fallen airplane . . . the wreck of a war vessel . . . a trench of American dead . . . an operating room in a military hospital . . . the picking up of Americans killed in action," or any other subject that would "cause unnecessary and unwarranted anxiety to the families of men at the front. The average mother," it was assumed, "sees her own boy subjected to the dangers portrayed . . . and she visualizes her own son in

each corpse she sees pictured. . . . The American public does not want horrible pictures, as the editors know from experience, nor was it wise policy to publish them. As a result, official pictures of American dead, mutilations and accidents were usually withheld from publication, although the demand for such pictures was negligible."[26] Surprisingly few photographs that were submitted were ever held by the censor. But that is not to say that the censorship was generous. Rather, by the time the American censorship was in place, the war photographers were well versed in what would and what would not pass and, therefore, took and submitted few controversial photographs. Wythe Williams, the Paris journalist for the *New York Times*, observed "a feeling among our correspondents of 'What's the use anyway?' If we have a story about the American expeditionary force that is any good, it is a safe bet that it will not be allowed to pass, so why write it?"[27]

The official photography of the war was largely the work of the Army Signal Corps, although the Navy and the Marine Corps also appointed military photographers. The Signal Corps Photographic Section was created in July 1917, and, at the beginning, was charged with all photography for the army. By January 1918, however, the fledging Air Service claimed the field of aerial photography, and the Corps of Engineers acquired the "technical photography connected with engineering construction, surveying and map reproduction."[28] On January 1, 1918, two American photography schools were established to train the needed corps of photographers: one at Columbia University for land photography and the other in Rochester, New York, for aerial photography. On April 1, the first students entered the Rochester school for five weeks of training, and on July 1, the first classes at Columbia began their six-week course. Although 2,500 students went through the aerial training course and another 4,000 were at the land photography school, few completed their photography course and their one-month army training in time to be sent overseas before the Armistice. By necessity, therefore, the army had to draw on the reserves of men who already had experience in photography. Articles and advertisements calling for photographers emphasized the "urgent need of *expert* news photographers [emphasis added]." "Owing to the shortness of time," stressed one article in a photographic journal in March 1918, "it is requested that only men fully qualified apply for this service."[29] By the end of the war, there were 92 officers and 498 enlisted men in the Signal Corps Photographic Section, 54 officers and 418 of the men in France.[30] The vast majority of the men were employed in the Signal Corps laboratories in Washington, D.C., and Paris. The shortage of men in the field continued until November 1918.

115

The first four detachments of land photographers joined the AEF during late summer and early fall 1917. Each detachment consisted of one or two officers and five or six enlisted men. Some of the officers, at least, had extensive experience. First Lieutenant Ira Gillette, one of the two officers attached to the third group, was a still and stereoscopic photographer, formerly with Underwood & Underwood and the International Film Service. And one of the two officers sent in the fourth detachment in late October was to become one of the twentieth century's most famous photographers: Captain Edward Steichen, who later moved over to the Air Service when it was detached from the Signal Corps.[31]

The Signal Corps assigned its photographic units to each army division and corps; additional units were stationed with other military divisions and service organizations, such as the Services of Supply and the Red Cross. By Armistice, there were thirty-eight divisional units in France and one in Siberia, slightly under the number needed to cover all the assigned territory. The units theoretically consisted of "an officer and three enlisted men . . . containing one motion picture camera man, one still photographer and two helpers, both of whom naturally are photographers," but were often understaffed, numbering only two or three men. Originally, the units stayed with their own divisions, but that system was changed to allow the commanding officer "to detach units from divisions in repose and order them to the front with [the] division going into action, thereby assuring a better prospect of covering the combat area than under the old method." Another three units were floating—able to move where the action was from their base in Paris,[32] although the lack of transportation was so severe that several major engagements were not documented because the photographic units could not get to the front.

The official photography could be roughly divided into three classes—military, historical, and educational. Military photography was used to gain information about "the forces, dispositions, and conditions in and behind the enemy lines."[33] Photographic observers most frequently made their observations from the air, although they occasionally crept into No Man's Land or climbed trees or other tall landmarks to take topographical photographs of the opposing side.

Aerial photography, especially, developed into an important military science. During 1914, the greatest height at which serviceable photography was considered possible was about 3,000 feet. But in response to the more accurate and intense fire from antiaircraft guns, the altitude of the observation photography was increased during 1915 to 6,000 feet; in 1916, to 15,000 feet; and by early 1918, to 20,000 feet.[34] In the air,

every moment counted. While still in the plane, after the photographs were taken, the photographer-observer transferred the exposed plates to a daylight developing tank, then fixed and rinsed them. Back on the ground, a waiting messenger sped the wet negatives to the finisher in a darkroom who developed the prints and passed them on for delivery to the commanding officer. Alternatively, the exposed film or plates could be dropped by parachute to the ground and then processed. Using either system, an officer who was organizing an attack and waiting on photographs to direct it could receive a print within fifteen minutes after the exposure was made.[35] By August 1917, much of the process was automated. Using the newly invented De Ram Camera, the photographer was freed from having either to manipulate the film or plates or to set the exposures. This allowed him to man a machine gun, when necessary to check pursuit planes, giving the observation planes an independence they had not previously had. By the middle of 1918, the system "might properly be considered mass production"; in one case, 56,000 prints were produced and distributed in four days.[36]

Historical photography consisted of making a scholarly record in still and moving pictures of the various army operations. As stated in the Signal Corps Annual Report of 1919:

Film records show our first efforts at preparation . . . the beginnings and progress of the American Expeditionary Forces from Hoboken to Coblenz, with its ramifications into [sic] Italy, England, Luxembourg, France, Belgium, Holland, Germany, Austria-Hungary, and Siberia. . . . There are pictures of troops going over the top at dawn, pictures taken at night by the flare of star shells, pictures made in clouds of asphyxiating gas, under shell fire, in sunshine and pouring rain, from airplanes, balloons, shell holes, mine craters, dugouts, and tanks; pictures of the billeting towns, marshes, training areas, hospitals, and first-aid stations. The auxiliary organizations at home and abroad, and the ceremonies of army life, sad and gay, are reproduced as a permanent record. There are thousands of portraits of the men who fought the war from commanding generals to privates.[37]

These photographs and films were deposited at the Army War College in Washington, D.C.

Educational photographs and films were taken both to educate the raw recruits in their training programs and to serve as propaganda ma-

terial for the American and worldwide public. To ensure the effective distribution of its "educational" propaganda, the Signal Corps, through the CPI, contracted to distribute its photographs through the Photographic Association. The Photographic Association, which included such members as Underwood & Underwood, Kadel & Herbert, and Harris & Ewing, syndicated its photographs nationally and internationally, placing them in daily newspapers, weekly and monthly magazines, technical publications, and other media.[38] Signal Corps pictures were either given away or sold for the nominal fee of ten cents each, which only covered expenses.[39]

Although the majority of the photographs published in newspapers and magazines in the United States were credited to the photographers and correspondents of the press, the Army Signal Corps took five times the number of pictures taken by all the accredited correspondents put together.[40] Many of the Signal Corps photographs were taken for military or historical purposes, but, even so, consistently throughout 1918, the Signal Corps was sending twice as many photographs back to the United States for distribution as were any one of the correspondents and several times the number sent by the Allied official photographic services.[41] By the end of the war, 35,000 still photographs, complete with titles and descriptions, had been deposited in the files of the AEF.[42]

The army was concerned. Why was the press not using its photographs? In a letter to General Pershing, the chief signal officer, Brigadier General E. Russel, urged that "the army should take steps to insure the publication of pictures, taken by its only authorized agency, the Signal Corps, especially as these pictures are carefully selected for their military propaganda value."[43] "We are going to considerable trouble to get these enlarged and captioned pictures rushed through at the earliest possible moment and cannot understand why the papers do not use them," admitted Captain William Moore of the Historical Branch, General Staff, in Paris—the supervisor of the production of pictures for historical, news, and propaganda purposes. "I should think that the papers would eat them up, but in the Washington Star Sunday, editions of June 2nd and June 9th, each edition carried only two official A.E.F. pictures." The lack of interest by the media seemed particularly puzzling because "Lieut. Cushing, who does the editing and selection, is eminently qualified for this work, having been news editor and managing editor of Collier's Magazine."[44] A month and a half later, in his August report to the chief of the Intelligence Section, Moore had decided that "the reason very plainly lies in some fault of distribution and . . . this fault my own editorial experience tells me is the element of time." Moore, therefore,

made the suggestion to the director of CPI in France that the photographs be distributed from New York rather than from Washington because "New York is the chief news distributing center for America."[45]

Washington had other, more compelling, explanations. Major Kendall Banning, of the War Department, Office of the Chief of Staff, War College Division—the conduit for the photographs after they reached the United States—and Gardner Wood, the director of the CPI's Division of Pictures, together concurred that the Signal Corps photographs were "lacking in dramatic value and in news interest." Wood believed that the official U.S. photographs were "not being used by the press because the pictures do not compare favorably with the French and British official pictures." Banning was less diplomatic. The official U.S. pictures, he stated, "appear to be scrappy and inconsequential. They create the impression that the camera men were sent out with no definite purpose in mind and took occasional snapshots that seemed to take their fancy ... generally speaking, our pictures have not the human interest that they should have and from the point of view of the military men, our foreign pictures have very trifling value as military records." Banning concluded: "Of course, the press is not using as many of our pictures as we would like, nor as many as they doubtless will use when the quality of our pictures warrants."[46]

There were undoubtedly other reasons for the failure of the press to use the official U.S. photographs. The fact that many of the prominent publications had a representative taking photographs on the spot in France often obviated the need for the publications to illustrate their articles with official pictures. Helping to create this near-exclusory affiliation between the correspondents and their periodicals or the picture services and the press, was an understanding by the civilian photographers of the distinct editorial policy of each magazine or newspaper for which they were working. The Signal Corps could not hope to compete. Officialdom had its own priorities that did not necessarily parallel or intersect with those of the press; naturally, the photojournalists in France who were being paid by the publications had the interests of their employers closest to heart.

The military photographers also labored under the handicap of poor or inadequate equipment. On their arrival from the United States, new Signal Corps units were often left to cool their heels at the Signal Corps laboratories in Paris until sufficient photographic equipment could be found—either by ransacking the continent for spare cameras and lenses or by spreading the existing equipment around more thinly. Some units were forced to make do with any castoff that was available. "Captain

Miller," remembered one frontline photographer, "had as one camera a French Gaumont, 35mm job, plain junk, all it did was buckle film."[47] By mid-1918, the photographic markets of Europe were thoroughly depleted and trade journals in the United States ran ads requesting the donation of camera lenses to the cause. "Are You One of Those Reluctant Ones?" demanded one headline. "It Is Your Patriotic Duty to Offer Your Lenses to Your Government."[48]

The standard still camera issued to the field units was the revolutionary single-lens reflex Graflex. Introduced at the turn of the century, it made possible fast exposures, control over focus, and a large image size. Depending on the available light, it could either be hand held or affixed to a tripod. Usually the units carried a 4 × 5-inch Graflex and a 4 × 5-inch Speed Graphic and a 6½ × 8½-inch Cycle Graphic with two lenses. A 5–6-inch f4.5 lens was issued for the Speed Graphic, an 8-inch f4.5 for the Graflex, and both a long-focus 12-inch f5.6 or above lens and a telephoto lens, six power, that could be mounted on either 4 × 5-inch camera that was issued. The still photographers also carried several filters, two tripods, plate magazines, and many rolls of 3-A film.[49]

Photographers from the press were not so heavily laden with photographic materials. Albert Dawson, of the picture service Brown and Dawson, spoke of the necessity of packing light. "The war-photographer's life is exactly like that of the soldier," he reported. Forced to carry his material on his back—unless it was possible to enlist a soldier-helper—Dawson

> soon learned to cut down to the bare essentials. One suit of heavy waterproof material with lots of pockets, marching-shoes and leather leggins, woollen-shirt, soft-felt hat, overcoat and gloves completed my clothing-outfit. Bright colors must be avoided, gray and brown I found to be the most practical. My photographic outfit was equally simple. A 3¼ × 5½ roll-film camera made most of my photographs, and this I carried on my back in a large case, which held the camera and a stock of films.[50]

Systematic combat camera coverage of the Americans in battle began with the first American offensive in France, at Cantigny on May 28, 1918. Although a small engagement, it was decisive. First, it showed the mettle of the American soldier—green but determined. Second, as two prominent military historians wrote:

> It was the excellent performance of the 1st Division at Cantigny and the 2d and 3d Divisions at the Marne which contributed most

to the quick Allied recovery from the shock of these three German offensives [in 1918]. Although Allied losses had outnumbered those of the Germans (800,000 to 600,000), the Allies could look forward to the early arrival on the battlefield of more such American divisions, while the Germans could ill afford their losses.[51]

The press and the Signal Corps photographers were there to document the battle. Private Edward R. Trabold of the 1st Division, Second Field Battalion, is credited with taking the first official combat photographs of American troops in action during World War I.[52]

Trabold recalled the events in a series of letters to the Signal Corps Photography Division over thirty years later.

As I recall, Captain Paul D. Miller arrived at our Photo Unit about the 23rd of May. We were then stationed in the village of Bonvilliers which was eight kilometers from the front. He contacted me, and asked me to take him up to the front next day. I was only a private so I agreed. Also, I meant to take him to a spot on the front which was always hot, I wanted to see if he was a good officer, if he had guts. This is all it takes to get a picture. Miller pointed out just what I was doing. I then found out he had served in the Boer War. . . . I had already taken pictures of all the terrain, which had been requested, so the Captain did not have to take any pictures of 'No Man's Land.' From my pictures, a mock battle field had been planned. They made their attack on it, and it worked out, so they made the actual attack.

On the morning of this attack at about 2 A.M. I was awakened. . . . Captain Miller told me he was giving me the honor of making the actual stills of this battle, as he would not himself take any camera but would go with me and aid me in the job, telling me some things he wanted shot. Sgt. J. C. Zimmerman of my unit drove us within two Kilometers of Brayers, which is short distance from Cantigny. from [sic—other typographical mistakes follow] there we were on our own, We first stopped and shot pictures at and old Chateau where our Signal Corps had set up telephone boards etc, I shot these making time shots, in poor artifical light, next we shot the French and Americans who were using 75mm and heaver French guns, next we went to front line where at Jump off spot we shot view of artillery in action. . . . Next we shot scenes of 1st, Wave, Next Second Wave and 3rd, Wave then we ourself's went back of 3rd, Wave.

... the day was very bright and it was all shot over a field that was flat and level with not a thing to obstruct your view. I was hit twice going over, also we both got caught in shell hole and was pinned there by artillery fire for some time that kept creeping inon us, directed by german sausage ballons who could see us easy[53]

Despite the obvious hazards for photographers on the front line, there were surprisingly few casualties. None of the civilian photographers were reported killed in the course of World War I, although a number of correspondents were wounded, including the gallant Floyd Gibbons who was shot in the head. Gibbons recovered and went back into battle sporting a dashing black eyepatch. The military photographers were similarly lucky. The postwar *Report of the Chief Signal Officer* lists just seven Signal Corps photographers who were wounded in action and only one who was killed. One of the wounded, Corporal Daniel Sheehan, was captured by the Germans after a gas attack. Before his interrogation, Sheehan was asked by a Prussian officer, "What have you there?" Thinking rapidly, he answered, "Just a camera. See?" and pulled out the plate magazine from the camera, exposing the negatives and thereby preventing the Germans from developing them.

The single photographer fatality, First Lieutenant Edwin Ralph Estep, died from shellfire only four days before the end of war. A member of the Signal Corps, Estep also had photographed for *Leslie's Weekly*, covering a range of subjects from the Western Front and the Balkans to U.S. training camps, munitions factories, and shipyards. A professional to the death, he was killed on duty with an infantry patrol, 42nd Division, near Sedan, on November 7, 1918. The *Report of the Chief Signal Officer* records that "the photos taken from his camera showed the last acts of his life."[54]

But despite those who fatally exposed themselves on the front lines for the sake of a few negatives, despite the improved camera technology, despite all the machinations of the journalists, the photography of the First World War never lived up to its potential. It couldn't. It was not independent; the government and the military did not want to chance that the press—either visually or in writing—would make substantial criticisms of the war effort. As Wythe Williams of the *New York Times* wrote, "the present American censorship stands only for a muzzled American press. Criticism is forbidden."[55]

Not only did the photography from 1914 to the end of the war not uncover the true nature of the conflict—the extravagant waste of men—it did not even capture the manicured image of what the war

propaganda proclaimed was happening. Photographers at the front were rarely allowed even to proselytize for the cause. The censors were so fearful that the photographs would show the real mess that they were unwilling to allow *any* war to emerge in pictures.

Image and Reality

All the equipment, all the training, all the organization was to one end: getting the pictures. And to the people back home, "the pictures" meant pictures of combat. It was not as easy or as doable or as glamorous as it looked. First, the men—not to mention the weather and the war— would not cooperate. Veteran war photographer Jimmy Hare related his experience in a shell hole during an Italian counteroffensive on June 23, 1918. "Like nearly all other persons the Italian is not adverse to posing for his picture even when the shells are falling," Hare said. "Under hot fire it was difficult to keep them from assuming a pose, so the only way I could get a natural picture was to spring it on them suddenly as a shell exploded. But I was handicapped, as at that particular time I was a bit shaky and unsteady, almost uncertain about the need for that particular picture."[56]

Second, it was difficult to focus under fire. Photographer Albert Dawson described the paralyzing fear at the front that inhibited his taking photographs:

> The enemy's shells which come screaming overhead plunge down with dull explosions all around. They come usually in sixes, with an interval of ten or fifteen seconds between each shell, and until the last one has struck and exploded I never know whether the next one will get me or not. Then a lull may follow, of an hour or so, and I crawl out of my burrow and continue my photographing where it was suddenly interrupted. Or the shelling may continue all day, and I lie there scared and trembling, like a frightened rabbit, and I dare not stick my head out of my hole for fear a piece of shell will carry it away. . . . There is no such thing as making pictures from a place of safety.[57]

The frontline trenches, however full of meaningful incident, were not a comfortable vantage point for gaining a picture of the conflict. It

was rare to witness something and be able to catch the event on film. You could not even take a picture of what you were experiencing and have it approximate your own reality. This new war was peculiarly unphotogenic. "The war," wrote one historian, "made exciting reading but generally dull viewing. What action there was took place on a featureless landscape, from which trees and buildings had long since disappeared; all that remained was mud, shell holes and barbed wire. The battles began with an artillery barrage, and the troops moved forward under cover of poor light or a smoke screen."[58] And it was no help that in the month of October 1917, for example, photography "was greatly hindered by the weather, there being but four days during the entire month entirely free from rain, and the constant ground haze and fog made the taking of large movements where distance was a factor almost an impossibility."[59] Brigadier General Russel told Washington: "In raids and advances, every advantage is taken of poor light conditions and although the photographers have taken many chances, and several have been wounded by exposing themselves to fire, little success has been attained in action pictures. When conditions are good for fighting they are, of necessity, poor for photography, and vice versa."[60]

Sweeping battle scenes were out of the question. "In the first place," said one photographer in 1919, "if you take a wide range of a battle going on all you get is a lot of shells bursting. There's no way of showing hundreds of men making a charge, because they don't go forward in close formation. You're lucky if you can get half a dozen figures in the range of your camera."[61] The problems were exacerbated by the fact that the still photographs were inert images, unaccompanied by noise, temperature, or smell. Battle, if one could get close to it, was characterized, on the other hand, by shrieking bullets, screaming artillery, icy mud, scalding coffee, rotting flesh, and putrid ooze. World War I may have been hell, but on film, it looked only slightly disreputable.

The Historical Division in Paris complained. "At the end of one week's continuous fighting [at Chateau-Thierry], in which the American troops were brilliantly engaged, only 24 still photographs had been received at the photographic laboratory from the various units on the fighting front," noted Captain Moore in disbelief. "Even these pictures were very poor and did not indicate in any way that they were taken in a combat zone." What was this going to look like back home? Moore continued:

I attended the censoring of the photographs at the Vincennes laboratory yesterday, July 22nd. Although for a week the U.S. had been

engaged in an historical battle the pictures which we viewed were those taken of parades on the 4th of July and on the 14th [Bastille Day]. These will be sent to the U.S. in the mail leaving July 24th and, with the best of luck, will arrive there at the early part of August, and probably be shown to the American Public around the first of September.[62]

Where was the war?

The war never showed up. With few exceptions—and those often turned out to be faked or staged pictures—the photographs that were allowed to pass the censor were mundane and uninspired. The image of battle in the Great War was more violent, tumultuous, and disturbing than the published pictures actually showed. Both the public who imagined the war from the home front and the soldiers who witnessed it from the front lines believed that the photographs of the European conflict lacked a certain authenticity; somehow, the pictures did not show it as it really was. Lieutenant-Colonel Kendall Banning wrote soon after the war about a man who had come to the Army War College to borrow some "action photographs, the real inside uncensored stuff," for an exhibition:

The officer in charge took him to the metal cabinets where nearly half a million prints of one kind or another were filed ... including photographs made in the "zone of advance" under actual battle conditions. He glanced casually over the photographs. ... "No, I don't mean that sort of thing," he explained with a gesture indicating disappointment in what he saw, "I want snappy pictures of men charging the enemy and being killed in hand to hand fighting, with bombs going off and all that sort of thing—the kind of pictures you don't show the public ordinarily—I want the real thing."

As a matter of fact, he had been looking at photographs of the "real thing" and did not know it. He did not recognize, in a simple little picture of a few soldiers walking along quietly, at intervals of a few yards, an actual modern "charge" of Yankee infantry against the enemy trenches. He did not know that the indistinct little print of a half dozen doughboys lying in an open field, really showed them pulling forward in the dim light of early dawn, in the face of a rifle fire so intense that one could almost hear the ping of the bullets as they cut through the grass—or that the photographer was killed by a shell only a few hours after this picture was snapped. ... No, the visitor did not want the "real thing," after all. It looked

too tame. He wanted the kind of battle picture that he was accustomed to seeing in the motion picture play ... [or] as painted by artists in Philadelphia or New York. They had real punch; they showed men being bayonetted and gassed, and airplanes swooping down with machine guns shooting and flags waving, and shells exploding, and tanks charging, and prisoners being captured 'n everything—all in one picture![63]

The lasting image of World War I existed in the mind, not in the photographs. Although it was true that the "real thing" was not like the war portrayed in the movies, neither was it much like the photographs taken of it. Censorship and the limits of camera technology circumscribed the types of images possible. Those photographs that were possible to make and get past the censors rarely transcended their documentary purpose with either graphic appeal or poignancy of subject. The photographs of the World War I describe a different reality than the one history remembers.

What seems so disappointing about the World War I photographs is the near-total absence of either a sense of the horror or the thrill of the danger. The photographs are remarkably static—more so than the camera technology insisted. They portray neither a sense of emotion nor one of movement. No photographs were published during the war of individual faces showing the glazed eyes of the shell-shocked or the naive look of the recruits. With the exception of studio portraits, few pictures of individuals were published at all. There were many dull, pedestrian images of groups, interesting now for their quaint sepia-toned evocation of times gone by. But periodicals did not publish pictures of U.S. troops vaulting desperately over trenches or American bodies lying soddenly in heaps. The scenes existed, but they either were not photographed or, if they were, the negatives were not printed. Censorship of the civilian press and general incompetence and snafus by the military photographers robbed the world of images that could do a certain justice to the war.

And Why

"To get to the front is the correspondent's chief object in life," wrote William Shepherd. "To see things is the main effort of all correspondents in Europe." But seeing war, he said, "gave only a meager under-

standing of it. Our ears, our eyes, and, to a certain extent, our noses, helped us to sense what was going on, but it was too gigantic to be taken in by the senses alone."[64] Seeing a battle, being physically present, did not always help a correspondent to understand what was going on. The Great War was literally too large to comprehend—save within the imagination.

"I stood on a hill at Scherpenberg, Belgium, a few miles south of Ypres, during the second battle of Ypres, in April of 1915," Shepherd mused, "and saw forty miles of battle. The rattle of rifle-fire, the pounding of machine-guns, and the thunder of thousands of artillery pieces filled the air with sound-waves that beat against my very insides. It was a battle; that was all I knew of it. How it was going, who was winning, what strategy was being used, and what tactics, I did not know." But back in command headquarters, "men bending over maps in a room that was lined with busy telephones were watching the battle and knew exactly what was happening."[65] It couldn't be done. You couldn't stand in the thick of the fighting and understand the whole battle.

Yet there was no other way to picture the war—and no better way to experience it for oneself. One had to try to sift out the moments of meaning and the scenes of significance and somehow communicate them to those back home. Unfortunately, the means of communication were often inadequate. It was, and is, impossible to duplicate a first-person experience. Isolated moments and scenes captured on film cannot replicate the totality of war. The whole is not the sum of the parts.

But the correspondents and photographers had to try and convey their experience. At the very least, it was their job. A scene Shepherd witnessed brought the difficulty of the journalists into focus. "Passing along a country road in Galacia, near Przemysl," he remembered,

> I saw a score of Austrian soldiers lying on the ground in a farm-yard. . . . A military priest moved about in the mud of the orchard, and when he found men who were strong enough to rise to their knees he bent toward them, as they did so, received their confession, and granted them extreme unction. There were no doctors for these men. . . . I took photographs of the priest and of the men who were doomed to die; I took a photograph of the boys digging the big grave in the field across the way. I was beholding things at first hand, and my only excuse for using my camera on such a scene is that I wanted my reader also to see the horror of war as I had seen it there in the orchard.
>
> And yet all the words that I could write of this small thing which

I had seen, and all the photographs I might take, fell short of telling adequately the full horror. . . . Again I had come up against the hard fact that the Great War is too big to be seen.[66]

Always there was the horror. "War" and "horror" are at times synonymous, yet there is more to a man's experience of war than just the experience of death and destruction. Primarily there is the experience of coping with the immediacy of death and the uncertainty of survival. One does not want to die and one does not want to be a coward. When a battle is over and one has survived, there is a thrill of victory. One has conquered—for a time, at least—both death and one's fear of it.

The correspondents, like the soldiers they covered, were not immune to this feeling. They could not help but react to this frisson of danger, this testing of mental and physical limits. The thrill was intoxicating. The journalists never felt so alive as when they were cheating death. Photographer Jimmy Hare, together with seasoned correspondents Richard Harding Davis, William Shepherd, John Bass, and war artist John McCutcheon, could admit, after coming back from the front, to having been "jubilant over the fact that they had been under fire." And Davis could add, "with a contented smile . . . 'Well, I've been a war correspondent long enough to have the right to say I like it. There's a thrill about it that's pleasant.' "[67]

Like Ernest Hemingway's bull fighters, the correspondents of World War I were fighting a "man's" sport. In war, there was not only the timeless horror. There was the universal confrontation with it. The journalists' job—their bread-and-butter work—was to face down death. Soldiers, for the most part, were drafted into the line. War correspondents sought out the horror. As reporters and photographers, they wanted to inform the public of the news of the conflict. Their profession was a "calling." But as men who were heirs to the age of "manly pursuits," they wanted to be in the front lines of whatever adventure was most worthy, significant, and provocative. To have missed the Spanish-American War would have been to have missed one's chance for personal glory. To have missed World War I would have been to have missed one's chance for personal service to a higher cause.

Yet, unlike their counterparts during the Spanish-American War, the journalists of World War I were not prowar. Fundamentally, war was not like it had been in 1898. The First World War lasted years, not

months. It killed thousands and millions, not hundreds and thousands. In World War I, the American photographers and reporters backed the U.S. war effort and despite the frustrations could even thrill to the challenge of covering it. But the challenges of censorship proved too great to be overcome. At the end of World War I, both the glorying in war and the naive enthusiasm for the coverage of it were irrevocably in the past.

6

The Photographs:

A Suppression of Evidence

The Publications

"I CONCUR MOST HEARTILY," wrote Major Frank Page of the Signal Corps to his superior officer, "in the view that it is the editors and publishers of the magazines, rather than the writers, who should be brought into close touch with prevailing conditions over here and thereby be brought to a realization of the necessity of a proper presentation of the situation. When this is accomplished," Page believed, "it naturally follows that the editors will force the individual writers to furnish the kind [of] material desired and the magazines will then be closed to the publication of articles which are not in accord with the actual facts."[1]

With that in mind, Major Page drafted a command cablegram to be sent to the publishers of thirteen magazines, including *Scribner's*, *Collier's*, and the *Saturday Evening Post*: "You are invited to visit the Headquarters and Army of the American Expeditionary Forces for the purpose [of] rendering such aid as may lie within your power. A prompt acceptance of this invitation should be regarded as a patriotic response to your country's call to duty. PERSHING."[2]

The American military and government during World War I so constrained the press during the conflict that coverage of the war could not be conducted as it had been during the Spanish-American War. During the American engagement in 1917 and 1918, publishers, editors, writers, and photographers had to conform to the spirit as well as the letter of censorship. Official Washington only tolerated editorializing or criti-

cism—whether in opinion pieces, news stories, or visuals—if the views of the press matched its own. For the publishers and editors at home, deviation from the spirit of censorship meant public outcry and official censure. For the journalists abroad, deviation from the letter of censorship resulted in their credentials being revoked. To continue to function as purveyors of information, publications were committed to "toeing the line" in the collection and dissemination of the news.

The censorship in Europe was mandatory and inclusive; the censorship in the United States was "voluntary." A publication could voluntarily choose not to agree to the established provisions, but it then would be shut out from obtaining and releasing the news and images that it needed to print for its continued existence. The Committee on Public Information, for example, furnished those editors and publishers "who have patriotically placed themselves under censorship of their own enforcement" with official photographs and statements of information. Any misuse of the pictures and statements, however, resulted in those publications being "deprived in the future of the privilege of obtaining statements issued."[3] Expressed doubts became tantamount to treason (enforced by Post Office bans, the Espionage and Trading-with-the-Enemy acts of 1917, and the Sedition Act of 1918). The government and the military "volunteered" the press for their wartime propaganda campaign.

The military's and government's constraints reinforced a new tendency within the press to emphasize "objective" reporting and photography—"objective" being defined as an emphasis on the "facts," but only those facts that supported the American position; errors of omission that tended to enhance the Allied cause were not only condoned but encouraged. This new, more "objective" style in evidence during World War I derived from three inclinations: the dependence of the press on the official bulletins and photographs of the military, a greater reliance of publications across the country on news and picture agencies and wire services, and a repudiation of some of the more egregious excesses of yellow journalism.

Because of the comprehensive orchestration of press activities on the European front by the American Expeditionary Forces, correspondents were forced to take the direction of the military in choosing which events to cover. Many operations were closed to the civilian press and, therefore, journalists had to rely upon the official communiqués and photographs supplied to them. Even in the arenas that were open to them, few scoops were possible; the best a journalist could do was

to score a beat on the competition—and even then, the story or photographs had to clear the censors and agree with the official version.

Few of the journalists during World War I were able to conduct their work as their colleagues had done during the Spanish-American War. "Judging them as war correspondents," considered Captain Arthur Martzell of Intelligence, AEF, "I would say that all but a very few were rather reporters of the war than war correspondents such as those men who have made themselves famous in previous wars."[4] Increasingly, the kind of personalized, flamboyant articles and photo-essays made popular by correspondents such as Richard Harding Davis during the Spanish-American War gave way to the more perfunctory, "objective" reportage supplied by the employees of the news agencies and wire services and by the military officers of the AEF. The writers and photographers of the First World War who filed the "objective" stories rarely pretended to be war correspondents in the tradition of Davis—a man who was equally at home with a pencil or camera, a man who had a keen understanding of, and carte-blanche entrée into, military, political, and social affairs. World War I journalists were too constrained by the severe censorship and accreditation process and by the sheer magnitude of the European war to be the masters of all situations, as their peers of twenty years before had been.

"Subjective" reporting of the news was avoided, as far as possible, by the news agencies and wire services. The Associated Press, in particular, had always been noted for its dry, colorless treatment of its subjects, while the more recent United Press aimed for a livelier style, although its president Roy W. Howard still demanded "honest-to-God objective reporting," or, at least, as one journalist wrote, "an intellectually honest attempt at objective reporting."[5] Acknowledging that not all their client publications adhered to the same political views, most agencies and services traditionally had confined themselves to the "who-what-where-when-and-why" of events, rather than offend some of their subscribers by including political commentary. The client periodicals, in turn, had attempted to achieve a consistent style within their publications and so aimed for objectivity in their local reports. Editorials and obviously slanted articles often were either relegated to their own page or more clearly identified as partisan.

Hearst's International News Service was the one organization of the three services that was neither mechanical nor apolitical in its approach to the news. Because of its anti-British and, thereby by default, pro-German position at least during the early years of the war, the International News Service was denied facilities for normal operations in

the Allied countries until the United States entered the conflict. After the entry of the United States, the Hearst agency and papers, along with most of the other previously pro-German publications, came out in support of the American involvement. However, the International News Service continued to be stylistically more "sensational" than its AP and UP counterparts, partly because of its affiliation with the Hearst empire and partly because it was the underdog of the three and therefore desirous of the attention that sensationalism attracted.

For Americans during the World War I era, "objective" reporting meant being direct and concise while being supportive of the Allies. Most American newspapers and periodicals, especially on the East Coast, strongly championed the Allied cause throughout the four years of the war, yet many were considered to be "objective" publications. The *New York Times* and its *Mid-Week Pictorial* magazine, for example, were outspoken in their sponsorship of the Allies, yet the *Times* publications won the first Pulitzer Prize for their "disinterested" (and "meritorious") service.

The *New York Times* offered the most exhaustive pictorial coverage of the war, not in the body of its daily paper, but in its new Sunday rotogravure section and in its *Mid-Week Pictorial* magazine that appeared on Wednesdays. The *Times* established the *Mid-Week Pictorial* in 1914 specifically to provide an even wider distribution of its photographic war reporting than was possible in its Sunday supplement. That same year, the *Times* began its monthly *Current History* magazine to present supplemental war information, including maps, important documents, and a day-by-day chronology of events. (The *New York Times* was the only newspaper in the world to run the entire text of the Treaty of Versailles.) Neither of these two new publications, however, had any direct representation in Europe; they received their photographs, articles, and documents through the newspaper's London bureau.

Americans' demand for war news at the outbreak of fighting in Europe, and especially after the entrance of the United States into the conflict, so overwhelmed the press that publications such as the *Mid-Week Pictorial* sprang up solely to cover the war; other periodicals and papers, such as *Collier's* and the *New York Times*, often ceded half a dozen or more pages per issue to stories and illustrations of the war.

During World War I, *Collier's* and *Leslie's* magazines continued their comprehensive photographic coverage of war, and the revamped *Saturday Evening Post* contributed both photo-essays and pages of illustrated war articles to the public's knowledge. Several once-prominent publications that had actively published articles on the Spanish-American

War had faded—especially those muckraking magazines such as *Mc-Clure's* and *Munsey's*—and they contributed little to the coverage of the European war. Scores of daily newspapers and hundreds of weeklies—*Harper's Weekly* the most prominent among them—either died or were swallowed up in consolidations during the years of the war. The inflationary cost advances of salaries, cable charges, paper, ink, linotype metal, machinery, transportation, and postal rates conspired to wreck numerous publications. Advertising rates, although they reached new levels by the end of the war, declined during the business recession of 1914, inhibiting growth. Many periodicals were forced to increase their subscription rates or arbitrarily reduce their circulation figures.

The *New York Times*, unlike many in the periodical press, felt a strong commitment to publishing the expensive "hard" war news in addition to the more "cost-effective" features. If reports or photographs warranted extra space, the paper omitted as much as sixty to seventy columns of advertising in a day—at a great loss in revenue. In addition, the *New York Times* correspondents were authorized to send dispatches at double-urgent rates; cable costs ran to $780,000 a year. The news agencies also made large investments and were especially committed to comprehensive coverage of the hard-news military and political events. The total AP expenditure for its war coverage from 1914 to 1917, for example, was estimated at $2,685,125.[6]

Many publishers threw up their hands at the costs and constraints of delivering hard news and concentrated their war coverage on feature stories. Several news associations, such as Associated Newspapers, Universal Service, and the Newspaper Enterprise Association, catered primarily to the personal side of the war represented in features. These "human-interest" articles and picture essays rarely pretended—as they had in the past—to be either political or military documents. The photographic essays in particular laid little claim to be military reports; often, photographs were not allowed to pass censorship if their captions mentioned where or when—or even of whom—the image was taken. Photographic services, therefore, such as Underwood & Underwood, Keystone View Company, International Film Service, Universal Film Company, Brown Brothers, Paul Thompson, Kadel & Herbert, and Harris & Ewing, served more of a propaganda than a news function. The photographs in the periodicals and the stereopticon slides viewed by the public existed to establish and confirm a certain prescribed look for the war; they rarely identified a particular event within which particular soldiers acted.

During the Spanish-American War, the headlines and captions for

the photographic spreads clearly noted the facts surrounding the images. "General's Lawton's Attack with the Right Wing—The Battle of El Caney, July 1," said one. "Before Santiago—Photographs Taken Under Fire," commented another. Photographers were credited for their work: James Burton took the first set of photographs, William Dinwiddie the second. Headlines and captions accompanying photographs of American troops during the First World War, however, rarely identified the precise battle or location pictured in the images. Typically, photo-essays or articles that included photographs were titled and captioned generically: "Our Heroes at the Front" or "Men Going Over Conquered Ground to Their Trenches for the Night." Dates and places were never mentioned unless the images appeared months after the event. Individual photographers, unless employed by the magazine publishing their photographs, were never credited. Some publications credited the picture agencies—Underwood & Underwood, for example, which had taken the photographs—but many images carried only the line "photograph passed by the Committee on Public Information."

The publications of World War I lost the screaming headlines and captions of the Spanish-American War but retained the best graphic legacies of yellow journalism. The worst excesses of yellow journalism remained only in the realm of the new tabloids. For most publications, scare heads became more restrained in style and substance. The greater simplicity of broken columns and white space helped to clarify and prioritize the articles and images presented. Typefaces became easier to read and photographs became crisper. Beginning in 1914, several newspapers and periodicals took advantage of the invention of rotogravure, a high-quality photographic reproduction process adapting intaglio engraving to rotary press work; no halftone screen is used, the images have more modulation of tone. Rotogravures appeared only in special supplements, all printed with colored inks of a blue, sepia, or greenish cast. The *New York Times* pioneered their use in this country in its Sunday supplement and *Mid-Week Pictorial*—a decision that helped establish the *Times* as the best news organization in the country.

World War I was a pivotal moment in the twentieth-century history of American war photojournalism. The previous war, the Spanish-American War, witnessed the emergence of yellow journalism, and with it, the entry of photographs as halftone illustrations into the pages of the press. The succeeding war, the Second World War, saw the triumph of photographs as ends in themselves: in World War II, journalistic photographs both told a story and illustrated it. During World War I, the potential storytelling ability of photography was realized, but be-

cause of that realization, a strict censorship was levied on the publication of photographs.

Military censors, government officials, and some publishers recognized that photographs could be dangerous tools of information; photographs could add to, subtract from, and contradict the account of the war the powers-that-be wanted the public to have. The officials acted to protect themselves from the perceived danger, causing photographers, such as Jimmy Hare, to "fight . . . the officials as much as photograph . . . the enemy."[7] The effected settlement placed thousands of photographs into the pages of the wartime periodicals, but the photographs that passed the censor's muster rarely illuminated more than the preestablished parameters of the war.

The Aesthetics

"One of the most insistent demands on the part of the press," wrote former Major Kendall Banning of the War Department, Office of the Chief of Staff, "was for official photographs of the so-called 'horrors of war'—snapshots of the dead and dying and wounded for example." But the Committee on Public Information refused to release any images of the death and destruction of American troops. As Banning explained:

> It is doubtful . . . if the public wanted such scenes. . . . Such pictures caused needless anxiety to those whose friends and relatives were at the front, and tended to foster the anti-war spirit that was always so persistently cultivated by the enemy. Accordingly the general policy was adopted of withholding such views from the public— although as a matter of fact only a bare handful of such pictures reached this country.[8]

Unlike during the Spanish-American War, no photographs of dead Americans were published in the press during World War I. Neither shrouded nor shadowed corpses were allowed to be shown. Only a few pictures of wounded Americans were allowed to pass; those that were passed portrayed composed men already receiving medical treatment—no contorted bodies of those racked by pain were printed. Even images of the destruction of American property—wrecked aircraft, blown-up trenches, derailed trains, or shelled buildings—were prohib-

ited. Any photographs of downed airplanes and devastated battle lines depicted those of the enemy.

The theory for such a blanket prohibition was that "those kind" of images would "tend to have a depressing effect upon the public." The censors and the CPI believed that "because the public is so susceptible to the message of a picture," there was a "need of care in selecting those which might undermine that *morale*."[9] Americans at home, and not incidently the soldiers waiting to go overseas and the troops already abroad, had to be protected from the realities of war. War, as witnessed in the photography of the AEF, was something that happened only to the other side.

In the press, studio portraits of those who were killed and photographs of battleside graveyards were the closest that death ever came to the American soldiers. The *New York Times Mid-Week Pictorial* regularly ran a page or pages of formal portraits of men killed in the war. The decorative border of the pages remained the same. At the top, written on a ribbon floating over a bald eagle that clutched an olive branch and a sheaf of arrows, the headline always read: "Our Nation's Roll of Honor." And at the bottom, on a ribbon draped in front of a laurel wreath and crossed palm fronds, the epitaph always said: "Dulce Et Decorum Est Pro Patria Mori" (figure 10). The men pictured were often privates, although a smattering of all ranks received mention. Rarely were the photographs of black soldiers, as in the image and caption of "Corporal Aaron Cook, Jr., died from gas asphyxiation, Jan. 7, 1918. He was one of the first of America's negro soldiers to lose his life in France."[10] And on several occasions a photograph pictured a woman, for example: "Nurse Helen Fairchild, who died while tending wounded men in France, Jan. 18, 1918."[11]

Many photographs were of soldiers posed in uniform, others were of men dressed in civilian clothes—with straw boaters and high-neck collars or soft-brimmed hats and flannel shirts. Most of the men gazed directly into the camera lens; a few turned a three-quarter or full profile. With the exception of the several who cocked their heads, there was little gesture or individuality recorded in the photographs other than the personal choice of dress. The photographs were arranged in a symmetrical pattern on the pages; some pictures were framed by rectangular mats, others by circular ones. The caption for each man identified his home town: Big Falls, Minnesota; Marienville, Pennsylvania; Foster, Oklahoma. The impression given was of the depredation of small-town America.

The framed pages of stolid portraits were a patriotic—if unimagina-

tive—commemoration of the dead. "Dulce Et Decorum Est Pro Patria Mori." Men were being killed, the pages of dead faces admitted, but they were dying in a deserving cause. They had, the *Mid-Week Pictorial* argued, "given their lives for their country." Portraits of men dead in the Spanish-American War, in contrast, had been printed without any sentimental, ornamented framework. But that war had been near to uniformly popular; there had been no need to remind the reading public that the men were gallant and the cause was noble. The public already believed that was the case. During the First World War, however, the public needed to be reassured.

One task for photography, then, during the nineteen months of the U.S. engagement in World War I, was to affirm and proclaim the worthiness of the American deaths. Several photographs that did so during the war pictured the pageantry of battlefield funeral ceremonies. "Pershing's Army in France Now Engaged in Warfare in Grim Earnest, as Shown by the Daily Report of Casualties Sustained," proclaimed one headline over the image of two burial scenes. The photographs featured wreaths of flowers and flag-covered coffins.

The caption of the bottom photograph was direct enough: "The burial of an American officer who died from wounds received in action" (figure 11). The image, however, credited to Kadel & Herbert, was quietly humorous, despite its subject matter.[12] A coffin draped with the Stars and Stripes and layered with funereal ornaments took center stage to two flanking rows of American troops. Perched above all stood a line of topiary—slender trunks with lollipop tops mimicking the solemn stances of the uniformed soldiers. With the exception of the trees, little is aesthetically interesting about the burial photograph; the pose is stagey and reveals nothing about how, when, or where the "officer" died. What was made clear, however, was *why* the soldier died: he died, so all the patriotic trappings declared, in the crusade for "democracy." Such photographs of pomp and circumstance served, like their Dulce et Decorum counterparts, to direct American attitudes of war toward the belief that it was "sweet" to die for one's country and that this was a war worth the sacrifice.

The aesthetics of the frontline photographic imagery, such as the Kadel & Herbert burial picture, drew little from the current trends in American photography inspired by the European avant-garde arts exhibited at the Armory Show of 1913. The Kadel & Herbert photograph, together with much of photography of World War I, reflected more the stylized set photography of the nineteenth century that emphasized—what seems now to modern eyes—incongruous backdrops and awk-

ward props. Contemporary art photography of 1918, such as that created by Alvin Langdon Coburn, Paul Strand, and Alfred Stieglitz, emphasized unconventional vantage points, complex spatial geometry, and syncopated rhythms denoting time and motion. Few images from the war wrestled with any of these new "cubist" concepts.

In contrast to the art photography, the war photographs seemed less "created" and more "directed." Government censors and the CPI tried to apply the traditional themes in American history to the notion of fighting the war. It would not have been appropriate to attempt to subvert those themes, as the contemporary photographic artists were trying to do. In their campaign to channel American attitudes into support for the war, the government and the military looked to the past to find reassuring images, rather than to the future for challenging ones.

The Cubist proclivity toward tackling innovative themes and abstracting hackneyed ones rarely surfaced in the photographs from World War I. Even pictures of the wounded that appeared disturbing and provocative during the Spanish-American War seemed generally derivative and peculiarly posed in their few First World War incarnations. *Mid-Week Pictorial* ran a photograph from the picture service Underwood & Underwood the week of March 14, 1918. Captioned "American ambulance men in the front line trenches rendering first aid to a soldier who has been in a gas attack," the photograph depicts a soldier on a stretcher having his head swaddled in white bandages by two kneeling medics (figure 12).[13] Behind the three figures in the immediate foreground crowd a battery of studiously casual attendants and troops. If the caption did not state that the action was occurring in the frontline trenches, one would assume from the demeanor of the men that they were having their picture taken for an illustration in a lifesaving manual. Despite the supposedly horrific situation, the men do not appear concerned or anxious about the victim. At best, they seem curious about the bandage-wrapping procedure.

The Underwood & Underwood photograph fails to communicate the victimizing of the troops by the technology and machinery of war. The focus of the image, the bandaged face of the gassed soldier, does not incite any appropriate emotions of anger, shock, or compassion. Instead, the bandages evoke a visual parallel with supernatural tales of Egyptian mummies and the latter-day "Invisible Man"—a sensation heightened by the fact that the bandage in the photographic print has been retouched to show more clearly the overlapping folds of the white material and possibly to obscure any identifying facial features left exposed. The image as a whole, while intellectually curious in a similar manner

as the burial photograph with the odd topiary, also falls short of delivering any trenchant message about the perils of this new warfare. From these two photographs, the public at home could have learned that Americans were being wounded in gas attacks and that some were dying in battle, but they already knew that. The pictures published during World War I did not make evident the quantitative leap forward in the horrors of war because of the new technology and tactics of a world war. Americans were being protected from the facts, and their attitudes toward the conflict followed accordingly.

A second photograph of the wounded, credited only to the CPI, was more successful in imaginatively—and presumably more realistically—portraying the flotsam of combat. It is the only photograph of the American wounded that was published in the major picture periodicals during the war to do so. Perhaps because so few such images were released, this second photograph appeared both in the July 27, 1918, issue of *Collier's Weekly* and in the August 10, 1918, issue of *Leslie's Weekly*. The picture in *Collier's* illustrated an article entitled "Under Fire with the Yanks" by their correspondent William Slavens McNutt (figure 13). The same picture in *Leslie's* was one of four on a page of photographs headlined "Our Heroes at the Front." *Collier's* caption read: "If he saw his chum picked off by a sniper, he might understand it's a life-and-death matter." *Leslie's* said: "A wounded United States infantryman received first aid in the front-line trenches. Many of our sorely wounded men have heroically begged to be allowed to remain at the front and many nurses and surgeons bear testimony to the ardent desire of those in hospital to get back into the fighting."[14] Both captions portrayed the troops as heroes for their disregard of being wounded; *Leslie's*, however, implicitly chided Americans at home for any possible lack of commitment by mentioning that the men overseas—even the wounded—were eager to commit their lives to the battle.

The photographs in both *Leslie's* and *Collier's* were sized and cropped similarly. The vertical framing of the action is strongly reinforced by the sides and floor of the trench, which trisect the image, and by the dominant figure of the wounded soldier lying on a pale stretcher in the lower center of the picture. The diagonal directional gazes of the five other men in the trench focus attention on the wounded man's face situated almost precisely in the middle of the photograph. The gesture of the medic adjusting the man's bandaged head appears believable, if stylized. The image is evocative of a religious setting. The crossed uprights and boards supporting the mud walls are reminiscent of Christian

iconography; the Christlike wounded soldier rests as if laid out for a saintly burial.

The omniscient viewpoint of the camera, positioned well above the scene, accentuates the mood. Whereas the knee-level camera angle of the photograph of the "invisible man" helped to trivialize it, the unusual perspective of the picture of the stretcher case in the trenches added to its power. The artistic effectiveness of the image, however, does not undercut the strength of the photograph in relating the specific problems of the wounded in World War I. What the aesthetic quality of the picture does is to seize the viewer's eyes long enough for the viewer to assimilate the details of the photograph. For once, an audience sitting at home could learn something more than clichés about the conduct of this war.

More common than pictures of American wounded—yet still not numerous—were photographs of the enemy wounded and dead. Few constraints hampered the photographers and publishers in taking and reproducing pictures of the opposing side. The military and the CPI wanted to foster hatred in the minds of Americans; military officers instructed their men during drill: "More pep! . . . And hate! A lot more hate!"[15] Killing the enemy soldiers seemed easier and more justifiable if they were hated. Photographs of the German and Austrian dead helped to reinforce the impression that the enemy was killable, defeatable.

Many of the pictures of the enemy dead in World War I resembled those of the Spanish dead during the Spanish-American War. In the August 29, 1918, issue of Mid-Week Pictorial, a half-page photograph imitated the earlier picture of two Spanish marines washed up on shore and guarded by a group of armed Cubans (see figure 5). The First World War photograph, credited to Underwood & Underwood, was captioned: "Premier Clemenceau and General Mordacq with American soldiers on the battlefield of Chateau-Thiery[sic]. In the foreground lies a dead German" (figure 14).[16] The 1918 photograph, although clearly a publicity shot taken during Clemenceau and Mordacq's tour of the battlefield, is more casual and less contrived than its 1898 predecessor. The central group of American soldiers looks relaxed even though posed; a few of the men are attending to the two officials, several are staring at the corpse in the foreground, one or two are gazing into the middle distance, and others in the extreme background are walking off toward an automobile partly cropped out of the frame.

The raison d'être for the framing of the photograph, the German

corpse, is also less "arranged" than the spread-eagled bodies of the Spanish men in the previous war's image. The German clearly lies where he had fallen. His grotesquely twisted, swollen body has not been manipulated into a position of greater servility, although the corpse could hardly rest in a pose of greater indignity; either the force of his killing or the bloating of his body had opened the buttons of his pants, his shirt is wrenched open, and his arms and legs are in unnatural positions. His head is thrown back, and his face is hidden by the fortuitous placement of a German helmet. The helmet, the man's undergarments, and other small details appear to be the handiwork of the retoucher's obscuring brush. A fingerprint, either from the retoucher or from the makeup person for the rotogravure, adorns the print immediately above the corpse's head.

(Other photographs of the German dead were not so circumspect in their depiction of faces. A photograph of a dead German that appeared in the June 15, 1918, issue of *Leslie's Weekly* deliberately exhibited the face of the corpse. The photograph, framed similarly to the image of Clemenceau and entourage, was captioned: "War is too intimately horrible for realization when the dead are viewed at close range, one by one. The eyes of the Allied soul must look over the dead to the battle-line where the living soldiers still are fighting the biggest battle in an as yet unsaved world.... Above are dead Huns in an abandoned trench."[17])

The Clemenceau photograph is too "busy" with extraneous details—the clods of earth and a shovel—and too indistinct—the corpse, although in the immediate foreground of the picture, is barely recognizable as a body among the surrounding debris—for the image to be compelling for any one of its parts. The strength of the photograph rests on the intriguing nonchalance of the official group in viewing the corpse and the battleground. But because of the muddiness of the image, the clever juxtaposition of the premier of France and a German corpse might have been overlooked if it was not for the accompanying caption.

The Clemenceau photograph, for all its weakness as an aesthetic image, ably demonstrates the salient differences and similarities between the photographs of World War I and those of the Spanish-American War. During the world war, photographs were taken that were closer to, if not yet "close-ups" of, the featured subject. Pictures still lacked an immediacy, a trenchancy. At best the war was figuratively and literally at arm's length. But the effect of those few feet closer—coupled with the real differences in the technology and tactics of the war—made war less glorious and men less gallant. Whereas during the

Spanish-American War no picture would have been published showing American soldiers standing over their dead enemies, such was not the case during World War I. The enemy was not as obviously a "trophy" as had been the case when the Cubans exhibited the corpses of their Spanish foe, but still a critical point had been made: Americans were killers. Perhaps that is an obvious statement to make about troops in combat, but never before had civilians at home seen both the American soldiers and their dead enemy in the same picture. The decision to make that act visible was a crucial moment in the history of published war photography—comparable only to the moment during World War II when it was decided that pictures of uncovered (although still unidentifiable) American dead could be published. From World War I on, the photography of war became increasingly graphic—and increasingly realistic.

The same week that the Clemenceau picture appeared in *Mid-Week Pictorial* (August 24, 1918), two images of Austrian dead, photographed by Jimmy Hare on the Italian front, appeared in *Leslie's Weekly*. Similar to another image of the enemy dead during the Spanish-American War—the charred Spanish gunner (see figure 6)—the photographs of the Austrians were reductive portraits of single bodies. The captions for each of Hare's photographs described both. "When action ended in June on the Piave River the roads were dotted with bodies," read the left-hand picture. "After an action members of the sanitary corps sprinkled disinfectants over all bodies," read the right-hand one (figure 15).[18]

The right-hand image was eerie in its simplicity. The body had been dusted with a fine white powder; it lay in stark relief against a somber leafy background and a dark pebbly foreground. Death spoke for itself. As had been the case with the photograph of the charred Spanish gunner, the image of the dead Austrian was succinct; the vignette did not need captioning or the inclusion of other elements in opposition to the corpse. It was a stronger portrait of war than the photograph of Clemenceau and entourage, even though—or perhaps because—it attempted to do less. The Clemenceau image was a propagandistic effort to show the triumph of the Allies over the "Hun." It was reasonably successful. The intention of the picture of the Austrian dead, however, was not so obvious or grandiose. Although the captioned Hare photograph demonstrated the victory of the Allied forces over the Austrians, the image alone spoke primarily to the generic horror of war. The unintentional visual isolation of the Austrian corpse because of the sprinkling of disinfectant over the body served as a metaphor for the separation that death creates between the living and the dead. Whereas the

Clemenceau portrait addressed itself specifically to the role of the French and the Americans during the war, the Hare picture spoke to that universal state in war: death.

The most graphic photograph to appear in a major publication during the American engagement in World War I was a picture taken by Lucian Kirtland, a *Leslie's* staff correspondent, while visiting the Lorraine front. One of two photographs in a page spread in *Leslie's* on May 25, 1918, headlined "War's Skulls and Crossbones," the photograph literally pictured a morbid assortment of German skulls and bones (figure 16). "Death evens all scores," noted the caption,

> and for the individual Germans, nobles and peasants alike, whose bones lie moldering in this abandoned trench in France which they gave their lives to defend, few can feel aught but pity. But, in a broader sense, they and their blood brought to the earth its four bitterest years since the dawn of light, and before peace and happiness return to East and West, hundreds of thousands of other men marching under the eagles of Germany and Austria must rot amid the pickelhauben [pickaxes], iron hats, and other panoplies of war which their Kaiser loves above the love of man and constantly puts before his God.[19]

With this photograph, the ante, even of the Spanish-American War portraits of the enemy dead, was raised. No picture during the war of 1898 had a leering skull as its centerpiece. (The photograph is reminiscent of one of the first—and most famous—war photographs, Roger Fenton's picture of a gully littered with expended shot outside Sevastopol, during the Crimean War. Whereas Fenton's image, entitled "The Valley of the Shadow of Death," makes its subtle point by using cannon balls as a synecdoche for the war, in the World War I instance the point is bludgeoned into the viewer—the rounded skulls are the synecdoche. The extravagant prose of the caption adds to the blatancy of the image.)

Although Kirtland's skull photograph and Hare's two pictures of the Austrian dead were laid out on left-hand pages (the less important and second-seen of a double-page spread), the strength of their imagery riveted the eye. The Hare photographs of the dusted corpses were the smallest by half of the eight pictures on the two pages, yet the simplicity of the two images in comparison to the other pictures attracted attention. By contrast, Kirtland's photograph was one of the two largest of four on its opposing pages. The skull image, of course, was naturally arresting. But the juxtaposition of it with the lower image on the page,

of two grinning American soldiers pointing to the top of a skull, that, according to the caption, some "Boche humorist" threw over "instead of a hand grenade," makes the entire layout particularly chilling. Such casual disregard for life by Americans—even of the enemy—would never have been advertised during the Spanish-American conflict. The numbing length of the world war (both for the soldiers at the front and the reading public at home) and the sheer number of the dead (although not the *American* dead) made such attitudes thinkable.

Not surprisingly, the frontline documentation of the enemy dead was more explicit than the battlefield depiction of American soldiers in combat. By the time the enemy was dead, most of the danger had passed; photographers could work with certain impunity. They could move in for relative close-ups; they could take the time to worry about the composition of their pictures. In the midst of battle, however, photographers rarely had those luxuries. "Point and shoot" was the best many photographers could manage; the problem was that doing so made the composition weak, the focus blurry, and the subject matter problematical. The inability of most photographers to get "on top" of the fighting doomed most pictures to be uninspiring images of distant action.

It *was* feasible, only twenty years after J. C. Hemment thought it such a ludicrous possibility, for the camera lens to stop bombs—if not bullets—in midflight. Despite the potential, however, most World War I images of battle look static to modern eyes. And some photographs that claimed to be depictions of action continued in the Spanish-American War tradition to be merely stilted poses assumed for the benefit of the camera. For an Underwood & Underwood photograph entitled "United States troops on the Lorraine Sector ready for a gas attack," for example, one would expect to see soldiers with gas masks on, crouched and expectant, guns at the ready. Not so. The photograph, as published in *Mid-Week Pictorial* the week of March 14, 1918, pictures eight men at ease standing for the camera as if at a high school reunion (figure 17).[20]

Such contrived images form a large portion of that collection of photographs the public recalls of the First World War. History stereotypes the conflicts of the past—often with good reason. Recollections of the Great War are incomplete without memories of the "classic" sepia-toned photographs (the color both of many contemporary rotogravure supplements and of now-faded photographic prints) of young men posing awkwardly in ill-fitting tunics, spiral puttees, and funny bowl-shaped helmets—incomplete because so many of the "war" images were only pictures of men standing around, seemingly far from battle. (Perhaps

underlying World War I's reputation as a war that accomplished so lit-tle, both militarily and politically, was the fact that by far the majority of the images from the "front" that were seen by the public at home were pictures of men doing nothing.)

Visual recollections of the Great War, however, also encompass im-ages of sodden men in mud-filled trenches and, later—after the Ameri-cans' entry—silhouetted soldiers running against backdrops of barbed wire and louring skies. Perhaps the prototypical photograph of that lat-ter type of image appeared in the October 19, 1918, issue of the *Saturday Evening Post*. The picture was the first illustration in an article entitled "There!"—a reference to the popular song refrain "Over there, over there, send the word, send the word to beware, That the Yanks are coming . . ." The photograph, credited to Underwood & Underwood, gave evidence that the Yanks had arrived over "there." The caption read: "Moonlight silhouette. Men going over conquered ground to their trenches for the night" (figure 18).[21]

The photograph is one of the most successful of the war. Not only is it successful in encapsulating the mood of the times, but it is one of the few images to be published during the war that could be considered compelling solely on aesthetic grounds. The image opposes the omi-nous, brooding earth and sky against the deliberation and determina-tion of the six major figures walking through the landscape. The low camera angle lends a power to the two groups of three soldiers, suggest-ing a triumph of the men over their environment. The photograph is both kinetic and sculptural.

The photograph is everything the armchair participant of the war be-lieved that battle was and should be: dangerous but romantic. The blocks of light and dark effectively play off one another and form a sug-gestive framework for the gestures of the six silhouetted soldiers. The distinctive outlines of the men striding along the ridge of ground com-municate preparedness, fearlessness, and resolve. Few other photo-graphs from World War I capture such an atmosphere. Technological factors and fears for their own safety prevented photographers from tak-ing many such shots, but the real reason for the dearth of photographs that were at once artistic, evocative, and true is that rarely did the war live up to the expectations of the dime novel– and Hollywood-educated soldier and citizen.

Yet that Hollywood education did inform some of the photographic and editorial decisions made during the war. A series of five images, French official photographs by Edmond Ratisbonne exclusive to *Leslie's Weekly*, appeared in the July 20, 1918, issue of that periodical. The pho-

tographs were taken of the American troops' first victory in the battle of Cantigny on May 28, 1918. One page into the article entitled "First Pictures of Our First Victory," the five photographs were laid out in a double-page spread—two half-page photographs verso, three narrow horizontal photographs recto (figure 19). Unlike most photo-essays of the time, which featured a jumble of numerous pictures of various shapes and different subjects, the Cantigny images were all of the same subject and all similarly composed; the narrower photographs on the right-hand page were smaller only by virtue of the cropping of their sky and land. Taken individually, the Ratisbonne pictures were not especially strong images; they worked best synergistically, arranged as freeze-frames from a film. The layout was a tacit recognition of the power of cumulative imagery, of moving-picture images.

The captions started under the top left-hand photograph. "American soldiers accompanying French tanks waiting behind the lines for the artillery to demoralize the enemy...." the narrative began. "Over the top they go.... Over the rough, shell-torn ground, with the shrapnel bursting overhead and showering them with iron death, the lines advanced in perfect order.... The infantry went forward on the flanks while the tanks held the center of the line until the village was reached.... The men carried their bayonets high and many officers were smoking as they crossed to the final effort."[22]

Photographer Edward R. Trabold was also on the scene. Trabold, whose photography at Cantigny was credited as the first comprehensive combat coverage ever taken by a Signal Corps cameraman, described the operation in an article entitled "Counterattacking with a Camera." "When we got to the front," he recalled,

> our boys were already on the way across, and I hastily snapped pictures. The light was against me, as the sun shone almost directly into my lens, so I had to make cross shots. Shells were bursting all around, and I secured several fine shots at them [sic]. In twenty-five minutes the boys reached Cantigny. The loss up to then was slight. Everyone was on his toes, and all were doing the part allotted to them in fine style. It made one's blood thrill to see our boys go along. Afraid? Not them. Why they rolled "bull" cigarettes going through the shell-fire.[23]

(Trabold's photographs were not released until well after the war, but his comments paralleled the French photographer's experience.)

Ratisbonne's pictures shared characteristics as well with the afore-

mentioned Underwood & Underwood image in the *Saturday Evening Post* of six soldiers "going over conquered ground." Both the Underwood & Underwood and the Ratisbonne photographs featured simple shapes and silhouetted soldiers on the march, yet in contrast to the Underwood & Underwood photograph, which stood alone, the Ratisbonne storyboard of images was more narrative. In both, however, the American audience was treated to the same view of war that they had received from William Dinwiddie's photograph of Colonel Capron's battery during the Spanish-American War (see figure 7) and that they had seen in illustrations of the Civil War: the simple view that war is both grand and fought on a grand scale. It would take until World War II (or at least until the Spanish Civil War) before civilians on the home front became privy to the nasty bits of war that were the norm of combat.

One of the few action close-ups to be published during World War I appeared both in *Collier's Weekly* and the *Mid-Week Pictorial*. The photograph was first printed in *Mid-Week Pictorial*'s issue of May 30, 1918, captioned "American soldiers carrying sacks of hand grenades as they creep forward in the direction of No Man's Land," and then in *Collier's* on July 27, 1918, captioned "Starting across No Man's Land— life in one hand and grenades in the other" (figure 20).[24] Both magazines credited the picture only to the CPI. The photograph is a heavily retouched depiction of three soldiers walking toward the camera, crouched, with a cloth sling bag of grenades diagonally across their shoulders. The figure in the foreground is out of focus, the middle man is gazing into the lens, and the third man is barely evident—only his head and shoulders are visible.

The photograph is especially unusual because the photographer was with the men in the barbed wire (if one accepts the truthfulness of the captions), out in front of the action, looking back—instead of secure in the trenches, behind the action, peering forward. In concept, the image is a precursor of the photography of the Second World War, when photographers *had* to be out among the men because so little of the fighting was conducted by waves or sorties from entrenched positions. In effect, the image dates clearly from World War I; aside from the uniforms that identify it from that time, no picture later in the century was so egregiously retouched. Although the World War II censors frequently wielded a brush, their retouching of photographs was restricted to obscuring military secrets (division badges and the like) or to hiding identifying facial features of those Americans who were wounded or dead. World War I retouchers used their brushes lavishly to "enhance" the details in a photograph, the result being that many of their photographs

look fake (and often were); the soldiers look embalmed and the land-scapes look like sets.

A particularly painful example of the "retouched" look made the cover of *Mid-Week Pictorial* on May 2, 1918. The striking cover was a full-length picture of an American doughboy "Going," as the caption claimed, "Over the Top" (figure 21).[25] The cover was strikingly bad. The "Member of the AEF" looked like an airbrushed mannequin. Any relationship between the final cover art and the original photograph was coincidental. To add further insult, three months later, in its August 8, 1918, issue, *Mid-Week Pictorial* was shamed into running what it titled "A Word of Criticism from 'A Bunch of Doughboys.'" Not only was the cover picture one of the worst photographs of the war, it was not what the magazine had said it was—a doughboy going over the top. "Friendly" American soldiers in France had sent back to the magazine a copy of the cover with their corrections and criticisms marked on it.

"Just a few friendly criticisms from some who know," their note read.

1. A man in the A.E.F. dressed like soldier in snapshot would be court-martialed.
2. Missing: Blouse, gas mask, chin strap on helmet, and a Springfield rifle.
3. Excess: Beaming smile while going over the top, boulders on parapet, French rifle (only rifle grenadiers use a rifle like that and then carry a grenade belt and a tromblon.)
4. Was the photographer decorated for bravery?
5. He looks as though he was gliding over the floor at Manhattan Casino or Union Hill Schuetzen.
6. It absolutely can't be did [sic].
7. Your weekly is very interesting and is always looked for when it is due. Do not take to heart these friendly criticisms, as they are our recreation.

Mid-Week Pictorial noted, "Their letter is interesting because it indicates that there is a great difference between training operations at home and real fighting on the front," a backhanded admission of a—at best—misleading caption on its initial cover.[26]

To atone, the periodical printed next to a reproduction of its old cover a photograph passed by the CPI from Central News. Underneath the new photograph—unretouched—it said: "This official photograph is more like the real thing. The American soldier seen here had a hand-to-hand fight with a German at Chateau-Thierry. Having already used

his ammunition, he killed his adversary with the butt of the rifle which he is holding. His name is Private Victor Vandermerck" (figure 21).[27]

Partly responsible for the publishing and miscaptioning of the *Mid-Week Pictorial* cover of May 2, 1918, was the fact that the United States of 1917 and 1918 was infatuated with the concept of "going over the top." The slogan was catchy. It implied drama. It promised action. In the First World War, "going over the top" became both the figurative and literal goal of Americans at home and abroad—even after the war left the trenches. Because of the phrase's appeal, editors labeled as many different images as they could with it, regardless of the aptness. Only occasionally did an image appear to merit it.

The overeager, overzealous miscaptioning of photographs neatly segued into the outright faking of images. One commentator writing in the 1920s lamented the wartime propensity for lies. "To the uninitiated," he said,

> there is something substantially reliable in a picture obviously taken from a photograph. Nothing would seem to be more authentic than a snapshot. It does not occur to anyone to question a photograph, and faked pictures therefore have special value, as they get a much better start than any mere statement, which may be criticized or denied. Only a long time after, if ever, can their falsity be detected. The faking of photographs must have amounted almost to an industry during the war.[28]

Occasionally faked photographs were recognized and exposed. In its issue of January 26, 1918, *Collier's* ran a double-page spread of six photographs—three real and three fake—under the headline "Real War Pictures—And the Other Kind." The three images on the left-hand page—the real ones—were stunningly boring. They had nothing to commend them. They were poorly focused, poorly composed landscape shots with no obvious human beings of any size, shape, or variety in them. The three on the right—the fakes—unfortunately were only marginally more interesting in that at least some recognizable human activity could be perceived. Although neither group of photographs contained the most thrilling examples of either real or fake war photography, *Collier's* point was made. Real war is not especially photogenic, and those few moments that may be are not conducive to a photographer's health.

In the caption to two of the real images, *Collier's* wrote:

> Nine out of ten real war photographs are as unexciting as the two reproduced above—both of which were taken from cover because

the photographer would have been instantly shot if he had exposed himself. To the uninitiated eye the photographs on the opposite page—all three of them fakes—are more like war. It is only when you look closely at the picture of the Zeppelin that you realize how the photographer cut a photograph of a Zeppelin in two, joined the parts at an angle, and painted in the smoke.

On the right-hand page, the caption continued:

Thirty or forty obliging Russian prisoners and a dozen rifles strewn on the ground supplied the material of this German photograph labeled "Russian Army Surrenders." The picture on the right, being French, is more ingenious. It pretends to be a snapshot taken from an airplane at a height of 10,000 feet and shows a German aviator with hands up in signal of surrender. It was made by superimposing two photographs, working in the necessary detail with a brush, and rephotographing—cameraflage.[29]

The intention of the Collier's article was to alert its readers to the existence of photographs created or doctored especially to serve propagandistic functions. Collier's practiced responsible journalism in calling attention to the manipulation of photographs presumed to be truthful. For the historian, however, what the photo-essay succeeded in doing was to demonstrate graphically the abject failure of 90 percent of the World War I photographs to capture either the reality of war as the soldiers lived it or the vision of war as the civilians invented it. All the high-flown or misleading captions did not change the fact that the war in the published pictures was not the war as fought in Europe.

The technology of the camera, the lack of access to the front, the censorship of the images, and the failure of imagination were all at fault. Most important, however, the censors and editors of World War I conspired to water down the potential photographic portrait of the war. Censors, editors, and some photographers intentionally misled readers with spurious captions and robbed many images of their gritty impact by the heavy-handed use of the retoucher's brush. Still, the photographs of the war were, on the whole, a more comprehensive record of the range of wartime action than those taken and published during the Spanish-American War. (With the sole exception being that photographs of the American dead were printed during the earlier conflict and not during the world war.) And, on rare occasions, the World War

I photographers were more successful than their earlier colleagues in capturing both the action and the mood of the times, as a few of the photographs described in this chapter demonstrate. Yet those photographs that best represent the real conflict were denied any exposure until after the war. And it is those *unpublished* photographs that best recall the horrors of the first "great war."

PART THREE

World War II

December 7, 1941–

August 10, 1945

7

The Context:

"An Urgent Obligation"

THE SECOND WORLD WAR was the biggest ever. Although there have been two major American conflicts since 1945, the "postwar world" still refers to the post–World War II world. World War II remains the monolith on the horizon. Whereas the more limited wars that succeeded it—in Korea, Vietnam, Cuba, Lebanon, and Grenada—continue to proliferate and the world staggers on, conventional wisdom holds that life as we know it could not survive another world war.

Yet, recalled one former machine gunner, Ted Allenby, "it was a war that had to be fought. It's probably the last one."[1] Even after the war and the propaganda blitz ended, it still seemed that civilization itself had been in the balance, that it had been a war against palpable evil. In the Second World War, combat was no longer a glorious, gallant calling, but an urgent obligation to be met with grim resolve and a stolid belief in America's virtue. Unlike during the previous world conflict, during World War II there was little talk of glory, but much talk of necessity.

At the start of the war and continuing until the finish, Americans believed in the ultimate righteousness of the Republic. The troops marched into battle with fewer illusions but "Christian soldiers" still. The myth of America as being the bastion of good was once again reconfirmed. Comparatively speaking, the United States *had* been the land of the free, the shining city on a hill, the last best hope. The myth of American virtue *was* based on some essential truths. And, although it was acknowledged that the actions of the United States had not been all sweetness and light, in this total war, the means, it was believed,

155

never exceeded the ends. Even the dropping of the two atomic bombs could be compared to the loosening of the "fateful lightning"—fateful but necessary. If the American government was not perfect, if it fire-bombed Dresden or interned the Japanese-Americans, these actions appeared to be "misdemeanors" compared to the extermination of millions under Nazi Germany's Final Solution or millions under Imperial Japan's Co-Prosperity Sphere, or, for that matter, millions under Stalin's wartime and postwar policies. In this war, if not in World War I, after the "monsters" had been caged and the "horrors" totted up, the enemies' atrocities were found to be not rumor, but fact. If Americans lost their innocence in World War I, in World War II they gained sophistication.

The Americans' beliefs were not as simple and straightforward as they had been twenty years earlier. The First World War had convinced the country that man was not fundamentally good. By 1941, the world was visibly more complicated and the public was chary of "The War to End All Wars" slogans. As the military commentator S. L. A. Marshall perceived, "the Second World War produced 'about the mutest army we ever sent to war,' an army unwilling to waste its breath on exhortations, noisy encouragements, yelling for the fun of it, or even much conversation."[2] Men did not tramp off to the cadence of "Over There." Perhaps it was the nature of the war, perhaps it was the simple fact that the Great Depression had knocked the music out of men, but Americans in the Second World War never had a song like "Over There." There were songs—like the pilfered "Lili Marlene"—but they were not war songs. Still, just once, novelist and correspondent John Steinbeck thought he might have found the song for World War II. The American troops were crossing the Atlantic in early summer 1943. One pitch-dark night, the soldiers were sprawled on deck. "They sit quietly," he reported for the New York newspapers.

> A great bass voice sings softly a bar of the hymn "When the Saints Go Marching In." A voice says, "Sing it, brother!" The bass takes it again and a few other voices join him. By the time the hymn has reached the fourth bar an organ of voices is behind it. The voices take on a beat, feeling one another out. The chords begin to form. There is nothing visible. The booming voices come out of the darkness. . . . The song becomes huge with authority. This is a war song. This could be the war song. Not the sentimental wash about lights coming on again or bluebirds. The black deck rolls with sound. One chorus ends and another starts, "When the Saints Go

Marching In." Four times and on the fifth the voices fade away to a little hum and the deck is silent again. The ship rolls and metal protests against metal.[3]

In World War II, Americans were still the saints marching to overcome evil with good.

Americans fought the Second World War, they said—as was true of all the other wars in which the United States has battled—for a moral cause, as well as for economic and political reasons. Americans sought symbols that would "assist the imagination in converting daily drabness into a sense of vicarious participation in danger." As in World War I, "Europe had been occupied, Russia and China invaded, Britain bombed; only the United States among the great powers was 'fighting this war on imagination alone.' "[4] Perhaps the American soldier in combat has an even tougher job than the combat soldiers of his allies," observed cartoonist Bill Mauldin. "Most of his allies have lost their homes or had friends and relatives killed by the enemy. The threat to their countries and lives has been direct, immediate, and inescapable. The American has lost nothing to the Germans, so his war is being fought for more far-fetched reasons."[5]

Freedom was the watchword chosen for the home front. For World War I, the word had been "democracy." And the phrase "Freedom and Democracy" still rang out in the early days of World War II, when the United States was assisting England and France. But after the German attack on Russia, the association of the U.S.S.R. with the Allies made the word "democracy" sound hollow. (After the war, the word "freedom" echoed unpleasantly as well.)

Franklin Delano Roosevelt, the past master of the catch phrase, himself a symbol of America, stood before Congress in the opening hours of 1941 and unveiled the new moral cause. "In the future days," he intoned,

which we seek to make secure, we look forward to a world founded upon four essential human freedoms:

The first is freedom of speech and expression—everywhere in the world.

The second is freedom of every person to worship God in his own way—everywhere in the world.

The third is freedom from want . . . everywhere in the world.

The fourth is freedom from fear . . . anywhere in the world.

That is no vision of a distant millennium. It is a definite basis for a kind of world attainable in our own time and generation.[6]

"Freedom" was at once more ambiguous, more imperative, and more tangible than was "democracy." The military could equate freedom with power, as did General of the Army George C. Marshall. "We are determined," he said to the West Point graduating class in 1942, "that before the sun sets on this terrible struggle our flag will be recognized throughout the world as a symbol of freedom on the one hand and of overwhelming power on the other."[7] And the soldiers and the public could equate freedom with the values of family, a home, and a living wage. "Ours is not a naïve Army," believed John Steinbeck.

Common people have learned a great deal in the last twenty-five years, and the old magical words do not fool them any more. They do not believe the golden future made of words. They would like freedom from want. That means the little farm in Connecticut is safe from foreclosure. That means the job left when the soldier joined the Army is there waiting, and not only waiting but it will continue while the children grow up. That means there will be schools, and either savings to take care of illness in the family or medicine available without savings.[8]

The soldiers that photographer Margaret Bourke-White spoke to in Italy agreed. " 'Believe me,' " said one top sergeant,

"here's one soldier who intends to see there will be no breadline this time."
Pops sized it up, "We often wonder if this just won't end up like the last war, a big grab by everyone."
"It isn't so much cash that the men want," the top sergeant concluded . . . "It's a job—a good job—with enough pay so we can buy a home, an automobile, and raise a family. Is that too much to ask?"[9]

John Hersey, reporting from Guadalcanal, received the simplest response. "Today, here in this valley," he asked,

what are you fighting for? . . . Their faces became pale. Their eyes wandered. They looked like men bothered by a memory. They did not answer for what seemed a very long time.

Then one of them spoke, but not to me. He spoke to the others, and for a second I thought he was changing the subject or making fun of me, but of course he was not. He was answering my question very specifically.

He whispered: "Jesus, what I'd give for a piece of blueberry pie."[10]

During the Second World War, the mythic freedoms of World War I received a precise, explicit interpretation. Roosevelt spoke of four "freedoms," but he defined them with hard and tangible terms. Freedom of speech and religion, freedom from want and fear. Freedom was no longer an ethereal concept but was symbolized by the church on the corner and money in the bank. The soldiers fought for particular symbols. They fought for home, for their vision of home, for concrete symbols of home: for a good job and a hunk of blueberry pie. All of America was "rallying around the flag"—more than just an expression. The American flag was, as Marshall believed, the ultimate symbol of America's freedom and power. Not coincidentally, the icon of World War II was a photograph of the American flag being raised in combat over enemy territory. Symbols of the flag, home, and pie helped to focus the reasons for fighting. They were an aide-mémoire for those at home and in battle who were asked for personal sacrifice. Why was one fighting? Oh yes, one was fighting so that once again one could come home from church on a Sunday afternoon, sit down at the kitchen table, be surrounded by friends and family, and sink one's teeth into the purple lushness of a flaky blueberry pie.

Soldiers fought both for the positive symbols of home and against the negative symbols chosen to represent the enemy. Based on certain realities, fed by racism and fostered by propaganda, a vicious image of the enemy was created. The "Japs," the "Krauts," the "Eye-ties" were pictured as hairy apes, inhuman butchers, or drooling degenerates. It was short work to establish a climate of hate necessary to sustain warfare and to make it possible for American boys to kill in cold blood. The Japanese, especially, were vilified in the government's propaganda and in the media and entertainment industry's outlets.[11] The national media largely ignored the fact that Germany had attacked neighboring countries without provocation and had engaged in systematic genocide, and instead consistently portrayed Japan as the more treacherous and barbaric enemy. Of course, after the bombing of Pearl Harbor, the reasons for the Americans to hate the Japanese were more nearly the kind that motivated the European allies against Germany. And added to this

effect of Pearl Harbor was the preexisting American racism toward the Japanese as a people. "In Europe," noted the much-loved, much-imitated columnist Ernie Pyle, "we felt that our enemies, horrible and deadly as they were, were still people. But out here [in the Pacific] I soon gathered that the Japanese were looked upon as something subhuman and repulsive; the way some people felt about cockroaches or mice." Even the normally sympathetic Pyle was not immune to the hatred. "Shortly after I arrived I saw a group of Japanese prisoners in a wire-fenced courtyard, and they were wrestling and laughing and talking just like normal human beings. And yet they gave me the creeps, and I wanted a mental bath after looking at them."[12]

M. Brewster Smith, in the famous set of surveys taken during World War II by the Research Branch of the United States Army, found that "veteran enlisted men and officers in the Pacific were more vindictive toward the Japanese than their counterparts in Europe." Thirty-five percent of the Pacific-based officers and 42 percent of the Pacific enlisted men, when questioned, wanted to "wipe out the whole Japanese nation" after the war. But only 13 percent of the officers based in Europe and 22 percent of the enlisted men in Europe wanted to "wipe out" Germany.[13]

Although the Nazis were painted as loathsome, some attempt was made, even during the war, to separate the Nazis from the German people—much to the disgust of many soldiers in Europe. ("It makes the dogfaces sick to read articles by people who say, 'It isn't the Germans, it's the Nazis,' " said Mauldin. "Our army has seen few actual Nazis, except when they threw in special SS divisions. We have seen the Germans—the youth and the men and the husbands and the fathers of Germany, and we know them for a ruthless, cold, cruel, and powerful enemy."[14]) No similar attempt was made on behalf of the Japanese people. Time, for instance, instructed its readers in how to tell the difference between the Japanese and the Chinese. "The Chinese expression is likely to be more placid, kindly, open; the Japanese more positive, dogmatic, arrogant. . . . The Japanese are hesitant, nervous in conversation, laugh loudly at the wrong time. Japanese walk stiffly erect . . . Chinese more relaxed . . . sometimes shuffle."[15] And its sister publication Life published a similar article. Its photo-illustrations, one of a smiling Chinese man and the other of a scowling Tojo, were scored like anatomical charts, pointing out, for example, the "heavy beard" of Tojo and the "scant beard" of the pleasant Chinese.[16]

For the American troops, moral ideals, words, and both positive and negative symbols helped initially to justify the war and their presence

in it, but once the United States was engaged in combat, the men on the lines fought to stay alive, to avenge their buddies' deaths, to support their own company, and to ensure the continued existence of the United States.[17] "All the phrases," wrote Peter Bowman in his blank verse novel *Beach Red*, "all the mouthings, all the ideas in the world are patently ridiculous when the only thing that counts is keeping alive from one day to the next."[18] For the soldiers, the war became self-perpetuating after the first casualties. "I read someplace," Mauldin remarked, "that the American boy is not capable of hate. Maybe we don't share the deep, traditional hatred of the French or the Poles or the Yugoslavs toward the krauts, but you can't have friends killed without hating the men who did it."[19]

Over time, a shift in the attitude of the country and its fighting men occurred. The soldiers and the civilians needed less convincing. The war and its propaganda had done the trick. "Apparently it takes a country like America about two years to become wholly at war," wrote Ernie Pyle in 1943,

> and if I am at all correct we have about changed our character and become a war nation. . . .
>
> The men over here have changed too. . . . The home-going desire was once so dominant that I believe our soldiers over here would have voted—if the question had been put—to go home immediately, even if it meant peace on terms of something less than unconditional surrender by the enemy.
>
> That isn't true now. Sure, they all still want to go home. So do I. But there is something deeper than that, which didn't exist six months ago. I can't quite put it into words—it isn't any theatrical proclamation that the enemy must be destroyed in the name of freedom; it's just a vague but growing individual acceptance of the bitter fact that we must win the war or else. . . .[20]

Even earlier, in August 1942, Shirley Star, in the Army surveys, found that 91 percent of the white enlisted men polled believed that "we have to fight now if we are to survive."[21] The men fought for their own individual survival and, they believed, for the survival of the United States itself.

The U.S. Naval Institute's 1943 manual entitled *Hand-to-Hand Combat* informed the soldier-to-be what he was going to be up against. "The daily story of the war emphasizes again and again the fact that we are facing an enemy which is careless of life because they are so steeped in

a fanatical nationalism. The common rules of war mean nothing to a desperate enemy." With that in mind, the navy instructed its cadets that "the code of sportsmanship is suspended 'for the duration.' " The teaching perverted the Golden Rule: "You do to the enemy exactly what he would like to do to you—only, you do it first!"[22] The implication was clear. "Fair play," and "gentlemanly conduct" mean nothing to the Japanese or German soldier. Kill him in any way possible before he kills you. "You don't fight a kraut by Marquis of Queensberry rules," reported Mauldin. "You shoot him in the back, you blow him apart with mines, you kill or maim him the quickest and most effective way you can with the least danger to yourself. He does the same to you. He tricks you and cheats you, and if you don't beat him at his own game you don't live to appreciate your own nobleness."[23] Don't feel too badly about it, the soldiers were counseled, because the enemy cares little about his own life. He is a diabolical machine programmed by his State to subvert all that is civilized. "The dogface," said Mauldin, "is quite human about things, and he hates and doesn't understand a man who can, under orders, put every human emotion aside, as the Germans can and do."[24]

Kill or be killed. Appalling things were done in the name of survival. But even more horrifying was the fact that the appalling things done to survive seemed to condone anything. Who could draw the line between torching an enemy to death and adjusting the flamethrower so it took the target just a little longer to die? Is burning someone alive humane, and slow burning them not? "What kind of war do civilians suppose we fought, anyway?" asked Edgar Jones, *The Atlantic Monthly* correspondent, in an article that appeared shortly after the war. "We shot prisoners in cold blood, wiped out hospitals, strafed lifeboats, killed or mistreated enemy civilians, finished off the enemy wounded, tossed the dying into a hole with the dead, and in the Pacific boiled the flesh off enemy skulls to make table ornaments for sweethearts, or carved their bones into letter openers."[25]

During combat, or even during the war's more quiet moments, it often would have been meaningless to ask a soldier to distinguish between a legitimate act of war and an atrocity. The society itself that caused the soldier to be in combat seemed to commit heinous offenses. How could a soldier be responsible for those actions he took to survive or for those actions he committed because the strain of survival pushed him into forgetting his own and another's humanity? Often (and in other wars) the war itself was an atrocity that inevitably spawned lesser crimes. What is the morality of the individual soldier's deeds if he is acting to survive and if the State—in all its power—is committing "de-

fensible" atrocities of an incalculable greater magnitude, such as dropping two atomic bombs? What is the morality of the State's actions if its cause is just—defensive war—but its means are not—killing civilians? And are the same means always similarly judged: are any tactics of a government in a fight for its life justifiable, but the same tactics from a winning State unconscionable?

What are the criteria that separate a just war from an unjust one and necessary force from unnecessary? George Kennan, one of America's most thoughtful foreign policy analysts, addressed himself to these issues. There was a failure during the Second World War, he thought,

> to appreciate the limitations of war in general—any war—as a vehicle for the achievement of the objectives of the democratic state. ... It is essential to recognize that the maiming and killing of men and the destruction of human shelters and other installations, however necessary it may be for other reasons, cannot in itself make a positive contribution to any democratic purpose. It can be the regrettable alternative to similar destruction in our own country or the killing of our own people. It can conceivably protect values which it is necessary to protect and which can be protected in no other way.... But the actual prospering [of the democratic purpose] occurs only when something happens ... that makes [a man] aware that, whenever the dignity of another man is offended, his own dignity, as a man among men, is thereby reduced.... Force, like peace, is not an abstraction; it cannot be understood or dealt with as a concept outside of the given framework of purpose and method.[26]

The American soldier in World War II was trained to believe that the all-important goal in the war was to win, to effect the complete defeat of America's enemies at almost any cost. Whatever would contribute to a quick victory would typically diminish overall casualties—especially his own. Therefore, it appeared to many to be self-evident that any force that hurried victory represented the highest morality. The United States cloaked its decision to resort to the bombing of civilian targets and to the use of the atomic bombs with the same logic: "It will shorten the war." The American State clothed its actions in rhetoric that from an individual standpoint appeared justifiable, but viewed from the perspective of a government, seemed less defensible. In reality, such actions as the bombing of civilians by a powerful government no longer

fighting for survival are considerably different from the parallel actions of an individual faced with his own death.[27]

But the powers-that-be argued that bombing the enemy's home front was necessary and justified because such bombing would hasten the enemy's capitulation and, therefore, lessen the war's total cost. Such attacks had been made before—and were still being made. Zeppelins bombed London during the First World War, the Fascists bombed Loyalist cities during the Spanish Civil War, and both the Axis and Allies bombed their opposing countries during the Second World War. Rarely, however, did such attacks achieve their ends. On the contrary, civilian bombings often heightened the enemy's morale at home without appreciably damaging the war effort. Even today, debate continues as to whether the Allied bombing of civilian targets in Germany accomplished its objectives. Probably it did—but at a late date and with a high cost in bomber casualties.

During World War II, American government officials explained their decisions with classic moral defenses. "The world will note," President Harry S Truman averred in his speech after the dropping of the bomb,

> that the first atomic bomb was dropped on Hiroshima, a military base. That was because we wished in this first attack to avoid, in so far as possible, the killing of civilians. But that attack is only a warning of things to come. If Japan does not surrender, bombs will have to be dropped on war industries and, unfortunately thousands of civilian lives will be lost. . . .
>
> I realize the tragic significance of the atomic bombs. . . .
>
> We have used it against those who attacked us without warning at Pearl Harbor, against those who have starved and beaten and executed American prisoners of war, against those who have abandoned all pretense of obeying international laws of warfare. We have used it in order to shorten the agony of war, in order to save the lives of thousands and thousands of young Americans.[28]

In his speech, Truman reasoned, in effect, that if the Japanese broke the rules of international warfare, the United States could not be held accountable for its own retaliatory actions. The Japanese started it, therefore, no matter how the balance of war shifted, the Americans had total license. For the American decision makers, the greater morality in the war was not what saved the most lives, but what saved the most *American* lives. If the cause was just—and most Americans believed

that it was—then, Truman and others believed, the means were just, or at least not unjust.[29]

The rhetoric of World War II, the self-conscious "democratic" language that defined Americans' attitudes toward the war, was undercut by elements of racism (both toward the enemy and toward American minority groups), intolerance, and chauvinism that permeated that same rhetoric. Americans' belief in the cause of World War II legitimated the methods of their fight. Questions were not asked, contradictions were not noted. The conflicts inherent in trying to wage a war for democratic ends remained largely undetected during the fighting—ensuring that when those conflicts eventually surfaced (as they were to do in Korea and even more violently in Vietnam) American policymakers would be uneducated and unprepared to address and resolve the dichotomies. Then, ironically, the turmoil that resulted, twenty-five years after World War II, would attempt to destroy that very heritage World War II was fought to save: the democracy of the United States.

At exactly 2:31 P.M. on Sunday afternoon, December 7, 1941, CBS radio, reading off the United Press ticker, announced the Japanese attack on Pearl Harbor. Nine minutes earlier, Presidential Secretary Stephen Early had telephoned the news to the three major wire services: the Associated Press, the United Press, and the International News Service. The teletype bulletins came every few minutes late into the night, but much was unsubstantiated rumor. Little information could get out of the Pacific; the Navy Department had immediately censored all news dispatches, and radio and cable communications from Hawaii and farther east were partially blocked. However, INS claimed a first on-the-scene account with a phoned-in report from Honolulu at 2:33 P.M. And at 2:58 P.M., UP carried the first eyewitness news of the bombing of Pearl Harbor Naval Base and Hickam Field.[30]

A few hours later, CBS correspondent William Shirer came on the air. "We didn't want war with Japan," he stated, "but now it's been forced on us. . . . Thus ends for this country twenty-three years and one month, the space and time which separate us from November 11th, 1918, when peace came over the battlefields of France."[31] Even if little hard news could be verified in those opening hours, one thing was certain: the War to End All Wars had not done so. The peace was over, and the United States was once again at war.

The next day, the president addressed the combined Houses of Congress and the national radio audience. Introduced by House Speaker

Sam Rayburn, Franklin Roosevelt asked for a declaration of war. "Yesterday," he proclaimed, "December 7, 1941—a day which will live in infamy—the United States of America was suddenly and deliberately attacked by naval and air forces of the Empire of Japan. . . . I ask that the Congress declare that since the unprovoked and dastardly attack by Japan on Sunday, December 7, a state of war has existed between the United States and the Japanese Empire."[32] Minutes after the president's speech, the Senate voted to adopt the resolution, 82 to 0. The House adopted the resolution 388 to 1. On the air, "The Star-Spangled Banner" played.

The following evening, Roosevelt again spoke to the country, this time in a "Fireside Chat." "So far, the news has been all bad," he said.

> It will not only be a long war, it will be a hard war. . . . I was about to add that ahead there lies sacrifice for all of us. But it is not correct to use that word. The United States does not consider it a sacrifice to do all one can, to give one's best to our nation, when the nation is fighting for its existence and its future. . . . Rather it is a privilege. . . .
>
> The true goal we seek is far above and beyond the ugly field of battle. When we resort to force, as now we must, we are determined that this force shall be directed toward ultimate good as well as against immediate evil. . . .[33]

Two days later, on Thursday, December 11, Congress declared war on Germany and Italy. The recruiting offices were already swamped.

Four months before Pearl Harbor, the Selective Training and Service Act—on the recommendation of Roosevelt—had been extended, a move that had avoided the "disintegration" of the existing army and with it, the pool of experienced soldiers. With the declaration of war, the country was able to call on the reserves of men physically fit for active war service, estimated at between 15 and 16 million. Men aged 18–37 were inducted, but preference was given to those of 18, 19, and 20 years. Older men, the armed forces believed, not only had family responsibilities, but, more important to the services, often had valuable, irreplaceable skills on the home front and were physically less able to stand the stress of modern warfare. Out of the total pool of available men, the air forces were given "the highest priority for the best qualified both physically and by educational and technical ability." The requirements of the navy, Marine Corps, and merchant shipping were also given "a high order of priority." But the army took the bulk of the

men. By the end of 1943, two years after Pearl Harbor, the army numbered over 6 million men; the army air forces, over 1.5 million; and the navy, marines, and Coast Guard, close to 3 million.[34]

The men who were called up for the army passed through twenty-nine large reception centers around the United States, where they were classified, uniformed, and routed to twenty-one replacement training centers. At the replacement centers, each entering soldier received thirteen weeks of basic training and then was assigned to a tactical unit in a division for further training. The training of an entire division took a year; men called up in December 1942 reached the front lines as a fighting unit in December 1943. (A much shorter period, however, was needed to train an individual line soldier. As a replacement for a casualty, an individual soldier could be quickly fit into the divisional structure with the guidance of the more experienced veterans.) Air force, navy, or Marine Corps recruits followed a similar timetable. Each airman, sailor, or marine was first taught military discipline in basic training camps, then learned the fundamentals of a specialty while still in the United States, and eventually was sent to the various theaters of war for final preparation for fighting.

As late as 1939, when the war broke out in Europe, the American military had envisioned a World War I single-front war necessitating one General Headquarters. But almost immediately in 1941 the Army recognized the impossibility of commanding the obviously global conflict from the perspective of a single base of operations. Instead, theaters of combat were created, modified, and set aside as the conflict progressed. Acronyms sprung up to identify them all: NATO, MTO, ETO, SWPA, SOPAC, POA, CBI, and IBT.[35] The grand scale of the world war made multiple bases of operations essential, but the conflicting demands of the global war, as well as the inevitable dependence on amphibious assaults, also made harmonious operations between the sea, land, and air forces imperative as never before. General Marshall, among others, recognized that the various services and supply agencies must be "integrated into a command organization."[36]

By September 2, 1945—V-J day (when the Japanese surrendered)— the United States possessed a military power unmatched in the world's history. Yet four years earlier, the American forces were barely able to hold on under the attack of the Axis. "I saw," recalled Winston Churchill, "the creation of this mighty force—this mighty Army—victorious in every theater against the enemy in so short a time and from such a very small parent stock."[37] Success had depended on several factors. First, the United States tapped a great reservoir of home-front industry.

The productivity of the agricultural, industrial, and technological sectors was sufficient to supply not only the Americans but the Allies as well. Technological and scientific innovations were exploited to the fullest, giving the Allied forces an often-needed edge in tactics and combat. Second, the United States created an efficient command structure, capable not only of sound tactical decisions but of competent logistical support. Third, and perhaps most important in this two-ocean war, the United States exhibited unparalleled strategic mobility. The Americans both effectively circulated troops and supplies among the numerous theaters and employed mobile forces—such as strategic bombers, aircraft carriers, and parachute and glider troops.

Such mobility was essential to win the war. And it was unavoidable when carrying on two ultimately successful—yet critically different— wars on opposite sides of the earth. In Italy, and in France and the Low Countries after the D-Day invasion, the main force of the American combat troops was fighting up to the final weeks before Germany's surrender. Many divisions were in the line for months on end with little relief. Casualties were frequently heavy, owing, in part to the effective and extensive use of artillery by the Germans. Long periods of heavy losses occurred, for example at Anzio, Normandy, and the Bulge. However, the troops were fighting in Western countries among people who shared a similar cultural heritage. Periods of relaxation were, therefore, reasonably satisfactory rest stops. And even the obstacles posed by the weather—the rainy season's mud and the winter's cold and snow— were familiar problems to the displaced Americans.

In the Pacific, the strategy of island hopping meant that the troops experienced short periods of intense fighting, relieved by longer intervals away from combat. For the first two or three years of the war, the battle casualties were relatively light. The heavy casualties sustained on Saipan, Iwo Jima, and Okinawa were not typical of the earlier years; the Japanese made extensive use of heavy weapons and artillery only late in the war. Therefore, although the Japanese resistance was observed to be more savage than the European theater—Fight to the Death—the actual incidence of battle casualities in an average division was considerably less than in the war against Germany. However, in other respects, the Pacific troops suffered more. Compared to the forces in Europe, the troops spent a long time overseas and, because the campaigns were fought on islands, opportunities for rest and rehabilitation (commonly called R & R) were poor. "Infiltration" warfare, rather than a well-defined front, undermined the soldiers' morale and efficiency

in combat. And malaria and other tropical diseases were a serious menace.[38]

Most soldiers—in Europe or in the Pacific—met with one or more of four types of combat situations. The first type was the classic battle formation, with clearly demarcated front and rear zones. In this situation—not uncommon in the European theater—an advancing army fought along an organized but flexible front. In the forward zone, the attacking army would be engaged in close fighting—if not exactly hand-to-hand combat—using such weapons as the rifle, pistol, machine gun, bazooka, grenade, and mortar. Often artillery support was not possible, since the opposing forces were so intermingled that any artillery fire was likely to threaten both sides. Because the advance was rapid in the face of the enemy's disorganization, casualties were frequently light, which led to high morale and a strong sense of achievement.

The second pattern of battle—encountered most frequently in the Pacific—was that of infiltration warfare. In this often jungle fighting no traditional front or rear existed; combat units were forced to guard their entire perimeter against the likelihood of snipers or infiltration attacks at night. Actual fighting was done either by small groups or individuals. The confusion, isolation, and incessant danger led to enormous strains on morale.

The third situation encountered in combat was the assault on fortified positions. Attempted successfully only with careful planning and specific armaments, such attacks were launched both in the European and Pacific theaters, as at Monte Cassino and Mount Suribachi. Even with the use of heavy artillery, armor-piercing shells, flame throwers, and air support, the success of the operation was usually dependent on the determination of the attacking force to persist in the face of overwhelming casualties.

The fourth and most dreaded combat situation was the assault on defended beaches. Also practiced both in Europe and the Pacific—as at Salerno or Tarawa—the initial attack and formation of a beachhead faced the probability of severe casualties. Usually plagued by problems of interservice coordination, the amphibious assault could also be troubled by inclement weather and seasickness of the troops. Sustaining high morale, particularly in the Pacific, when many troops had participated in several amphibious operations was difficult.[39]

Not all the American fighting operations were sweeping movements forward. Defending a position, as on the Anzio beachhead; retreating under concerted attack, as at the Ardennes bulge; and holding a stable

line, as in the end of the Italian campaign; were all possibilities of combat. Defense and retreat provoked their own specific psychological stresses. And holding actions often caused long periods of enforced idleness and boredom. The "never-ending monotony of days and weeks and months and years of bad weather and wet clothes and no mail . . . ," observed Bill Mauldin, "sends as many men into the psychopathic wards as does battle fatigue."[40]

The fronts, however disparate, shared a common denominator: the individual soldier. With all the hoopla about modern machinery—about aircraft carriers and radio transmitters, B-17 bombers and sonar, LSTs (landing ship, tanks)[41] and radar—it was still the combat troops that had to exploit these technical advantages to win the war. "It seemed to many," wrote Robert Sherrod from the hotly contested Pacific outpost of Tarawa, "that machines alone would win the war for us, perhaps with the loss of only a few pilots, and close combat would not be necessary. . . . Certainly, air supremacy was necessary. But airpower could not win the war alone. Despite airplanes and the best machines we could produce, the road to Tokyo would be lined with the graves of many a foot soldier."[42] "The facts were cruel, but inescapable," he believed. "Probably no amount of shelling and bombing could obviate the necessity of sending in foot soldiers to finish the job. The corollary was this: there is no easy way to win the war; there is no panacea which will prevent men from getting killed."[43] All that could be done was to learn from the mistakes made and then try to anticipate the next go-round. "Success in modern war," said General Douglas MacArthur, "requires something more than courage and a willingness to die: it requires careful preparation."[44]

To the individual soldier, the military's tactics were imposed from above, rather than a natural outgrowth of any close-in fighting. The grand strategies acted as logistical plans *before* a battle and as a way to decode the discrete events for history *after* a battle, but *during* a battle, any pattern seemed to be more one of random action than of calculated design. Within this whole, the individual soldier was left to wonder about his role in the scheme of war; he may not have doubted the government's motive for war, but he may have failed to understand how he as a very small piece fit into the overall strategy. Despite his cumulative importance, the significance of the single individual paled beside the huge scale of the war. He was dwarfed by the larger campaign and he was dwarfed even by the equipment and matériel that attempted to ensure his continued existence.

Personal equipment alone metamorphosed the foot soldier. At the

beginning of the war, the men looked like World War I extras; they were still outfitted with the flat helmets, canvas leggings, and Springfield rifles of 1918. Soon, however, the exigencies of the new combat caused their uniforms to be modernized and individualized. The men in the South Pacific wore their green cotton fatigues loose, with either their sleeves rolled up or their shirts off and their backs burned to a dark red or black. In Italy, the men dressed in woolen olive drab, buckled leather boots, and unadorned helmets without the camouflage covers sported in the Pacific. In wintertime France and in Germany, the infantry donned long overcoats and scarves and wore woolen caps under their helmets. An army boot modeled after the L. L. Bean hunting shoe, with rubber bottoms and leather uppers, helped combat trench foot. Front-line troops everywhere slung a belt around their waists, on which dangled compasses, wire cutters, first-aid kits, knives, and other paraphernalia. Packs typically weighed sixty pounds but could weigh twice as much, depending on whether the soldier carried broken-down weapons, communication supplies, or souvenirs.

The basic U.S. infantry weapon was the Garand M1 semiautomatic rifle; officers and squad leaders carried Colt .45s—unless they had captured one of the eminently superior German Luger or Walther pistols. The personal weapons were viewed with ritualistic reverence. Audie Murphy wrote of his service pistol: "Automatically I pick it up, remove the clip, and check the mechanism. It works with buttered smoothness. I weigh the weapon in my hand and admire the cold, blue glint of its steel. It is more beautiful than a flower; more faithful than most friends."[45]

The weaponry that was brought to bear on the enemy ranged from the handgun to the atom bomb. Normally in an offensive—especially in an attack on a beachhead—bombers, rocket guns, and navy cannon would initially be employed to "soften up" the opposition, then the infantry-borne bazookas, mortars, and light-assault guns would be used to gain a toehold in the enemy camp. Although such matériel did not replace the individual soldiers, World War II warfare was impossible without it. "Modern war," noticed John Steinbeck, "is very like an automobile assembly line. If one bolt in the whole machine is out of place or not available, the line must stop and wait for it. Improvisation is not very possible."[46] And at an earlier date he had written, "The wrecked equipment comes in in streams from the battlefields. Modern war is very hard on its tools. While in this war fewer men are killed, more equipment than ever is wrecked, for it seems almost to be weapon against weapon rather than man against man."[47]

Despite the official contention that the American army was well armed and well equipped, it was no secret that the German weapons were superior in several particulars. The German tanks were more heavily armored than the American version, although the U.S. tanks had greater mobility and were less prone to breakdowns. The German antitank bazooka was more penetrating than its U.S. counterpart, and, most important, the German 88mm gun outclassed any piece of American artillery. Originally, the Germans designed the 88mm as an antiaircraft gun, and only later literally stumbled over its antitank capabilities. The 88mm also functioned as an air-bursting fragmentation—antipersonnel—weapon. In all three categories, it was unmatched by anything in the American arsenal. "Their 88mm is the terror of every dogface," agreed Mauldin. "It can do everything but throw shells around corners, and sometimes we think it has even done that."[48]

In sum, however, the Allies enjoyed a "quantitative and qualitative" advantage over Germany and Japan. Although some equipment failed in its purpose—the sci-fi Handy-Talkies, the "smokeless" powder, and the anachronistic World War I Browning machine gun—there were, as well, certain stunning American and Allied inventions. Overshadowing all other technological advances was the development of the atomic bomb. And the long-range B-29 bomber, the Norden bombsight on the B-17s, radio control of massed artillery, proximity fuses, the jeep, the 2½-ton truck, and the various amphibious landing craft all contributed heavily to the U.S. victories in battle.

But in a war in which the trend was toward the development of intricate weapons requiring highly specialized skills, ground warfare still required the maximum of physical and emotional endurance and a minimum of mechanical or technical skills. Technology had only expanded the "killing zone";[49] it did not replace the need for men in combat.

Fighting between men remained the preeminent image of the war, and combat duty still defined the social and psychological status of all the men in the forces—although only a small proportion of all those who served saw combat. Because it continued to be perceived as the be-all and end-all of war, combat still lured men like an opiate—at least until they had had a whiff. "Usually before we have learned what danger really is," noted the early nineteenth-century war theoretician Carl von Clausewitz,

we form an idea of it which is more attractive than repulsive. In the intoxication of enthusiasm to fall upon the enemy at the charge,

who cares then about bullets and men falling? To hurl ourselves, with eyes a few moments shut, into the chill face of death, uncertain whether we or others shall escape him, and all this close on the golden goal of victory, close to the refreshing fruit for which ambition thirsts—can this be difficult?[50]

After the men had been in combat, however, most lost their eagerness for action, although the experience had already acted like a drug on their system. "You try to remember what [war] was like," observed Steinbeck, "and you can't quite manage it. . . . A woman is said to feel the same way when she tries to remember what childbirth was like. . . . Perhaps all experience which is beyond bearing is that way. The system provides the shield and then removes the memory, so that a woman can have another child and a man can go into combat again."[51]

Men wanted to be in battle. Or at least they wanted to say and believe they had been. This desire led to some disagreement about how many men had actually been in the front lines. Although World War II combat was also conducted in the air and on the sea, more men saw fighting on the ground than in any other arena. All frontline troops, such as rifle and heavy weapons companies, tank and tank destroyers companies, and medical aides, were automatically granted combat credit. However, in this war of long-range artillery and aerial bombing, those in rear areas felt they had some claim to the exclusive club. In the end, it depended on whom one talked to.

The ultimate test of combat—of any kind of combat—was that it was twenty-four hours a day, seven days a week. "Minutes," noticed correspondent Drew Middleton, "lapse into hours and hours into days and days into nights."[52] For the first time, Americans were trapped in the same relentless fighting, year after year, that the Europeans had faced during World War I. During the Second World War, the American soldiers were rarely pulled out of line unless they were casualties. In comparison to the brief engagement of the Americans in World War I, during World War II men could be in combat for years. Strain, alone, killed them. At the very least, it gave them that thousand-yard stare. "Look at an infantryman's eyes," said cartoonist Mauldin,

and you can tell how much war he has seen. Look at his actions in a bar and listen to his talk and you can also tell how much he has seen. If he is cocky and troublesome, and talks about how many battles he's fought and how much blood he has spilled . . . then he has not had it. If he is looking very weary and resigned to the fact

that he is probably going to die before it is over, and if he has a deep, almost hopeless desire to go home and forget it all; if he looks with dull, uncomprehending eyes at the fresh-faced kid who is talking about the joys of battle and killing Germans, then he comes from the same infantry as Joe and Willie [his cartoon characters].[53]

It was not so much that the raw troops that came over were cocksure as that they were scared that they would run, would not be able to kill, or would be killed themselves. "Every man builds in his mind what it will be like," Steinbeck wrote,

> but it is never what he thought it would be. . . .
> These are green troops. They have been trained to a fine point, hardened and instructed, and they lack only one thing to make them soldiers, enemy fire, and they will never be soldiers until they have it. No one, least of all themselves, knows what they will do when the terrible thing happens. No man there knows whether he can take it, knows whether he will run away or stick, or lose his nerve and go to pieces, or will be a good soldier. There is no way of knowing and probably that one thing bothers you more than anything else.[54]

If, as Steinbeck believed, enemy fire was the deciding factor in the creation of a combat soldier in World War II, all the men who saw action in the front lines were soldiers. If firing one's own weapon, however, was the critical issue, than relatively few, even of the forward troops, were christened. Military historian S. L. A. Marshall, in his classic work *Men Against Fire*, made the dramatic discovery that only 15 percent of the men in American rifle companies in action in the central Pacific and European theaters actually fired their weapons in battle. Those most likely to do so were in small groups working together, particularly when the enemy was within a "ten-yard interval."[55] Despite the incontestable danger, despite the logic that argued that they would be more likely to survive if they helped to defend their position, most soldiers watched the battle around them rather than join in the fighting themselves. They, like the civilians at home, tended to see the war as a movie. "It didn't seem like men getting killed, more like a picture, like a moving picture," one soldier lying on a beachhead told Steinbeck, "and then all of a sudden it came on me that this wasn't a moving picture."[56] At some point reality clicked in. No longer could a man count on the traditional Hollywood plot of the good guys winning and the

heroes surviving to come home in the final reel. But even after this realization, some men could not or would not comprehend that *they* were the ones that had to fight, that *they* were the ones that had to kill. Despite the blood-and-glory image of many of the battles in World War II, one must assume from Marshall's figures that there was very little Audie-Murphy-come-hell-or-high-water fighting. The slow-tawkin' ("My mama said there'd be days like this"), fast-actin' ("This company specializes in killing"), real-life Murphy was an anomaly in battle.[57]

Most veterans expected to be scared, knowing their anxiety would be understood and accepted as long as they continued to make a firm effort to control it. Even an occasional paralyzing experience was not uncommon. Sixty-five percent of a survey of wounded combat veterans from the European theater admitted having had "at least one experience in combat in which they were unable to perform adequately because of intense fear." When asked to identify their symptoms of fear, over 50 percent and as many as 84 percent of one combat division (2,095 men) in the South Pacific mentioned such mild problems as a "violent pounding of the heart," "shaking or trembling all over," or breaking out in a "cold sweat." But over a quarter of the men reported "vomiting," 21 percent admitted to "losing control of bowels," and 10 percent responded "urinating in pants."[58] The gung-ho man of steel was largely a myth. "I read a very nice piece in a magazine about us," Steinbeck reported one tail gunner observing to his buddies. "This piece says we've got nerves of steel. We never get scared. All we want in the world is just to fly all the time and get a crack at Jerry. I never heard anything so brave as us. I read it three or four times to try and convince myself that I ain't scared."[59]

Most men were afraid, and many, as a result of cumulative factors, became psychiatric casualties. It was another myth that soldiers toughened and became braver in the course of the war. For a while, it was true, they learned survival skills and became more competent fighters. But the downward slope started within months to a year; what the men gained in technique, they lost in nervous exhaustion. In the American army as a whole, evacuations for psychiatric reasons totalled 23 percent. The incidence of psychiatric casualties fluctuated, depending on the adequacy of the men drafted, the intensity of battle, the time spent in combat, and the general state of morale. At one point in early 1943, psychiatric casualties were being discharged from the service faster than new recruits were being drafted. Psychiatric casualties in the U.S. 2nd Armored Division, during forty-five days of sustained operations in Italy in 1944, were 54 percent of the total casualties. However, the high-

est overall rate of American psychiatric casualties was sustained by the U.S. 1st Army in Europe, averaging 101 per 1,000 troops per year. (But this level was not even close to the highest suffered by the Allies: in the ill-starred Arakan offensive of 1942, the 14th Indian Division "reached such a low ebb that the command psychiatrist described the entire division as 'a psychiatric casualty'."[60])

Such a high level of psychiatric breakdowns among the American troops was due largely to the U.S. system of combat replacement. Divisions were kept in line indefinitely, and replacements were sent as the need arose. The problem had not arisen to such an extent during World War I because the troops were in the front lines for barely a year. Although the men of both wars served for the duration, the duration was considerably shorter for the Americans in World War I than in the Second World War. The World War II troops had good reason to crack; they knew they would be likely to stay at the front for years—until they were either wounded or killed. Said General Omar Bradley:

> The rifleman trudges into battle knowing that the odds are stacked against his survival. He fights without promise of either reward or relief. Behind every river, there's another hill—and behind that hill, another river. After weeks or months in the line only a wound can offer him the comfort of safety, shelter and a bed. Those who are left to fight, fight on, evading death, but knowing that with each day of evasion they have exhausted one more chance of survival. Sooner or later, unless victory comes, this chase must end on the litter or in the grave.[61]

Despite the fact that, at times, psychiatric casualties incapacitated an outfit, the majority of combat officers adopted a "tolerant attitude" toward men who developed extreme fear reactions in combat. In answer to the explicit question "In your opinion what should be done with men who crack up in action, that is, men who get shell-shocked, blow their tops, go haywire?" 67–77 percent of a cross section of company grade officers in both the European and Pacific theaters responded that they "should be treated as sick men." At most, 6 percent and as few as 1 percent said they "should be treated as cowards and punished."[62] There was, however, one notorious incident that came under the latter category—the infamous case of General George Patton slapping a hospitalized soldier in Italy for "malingering." Although the story was personally censored by General Dwight D. Eisenhower because it would have been "bad for morale at home," the story was so newsworthy that when

it was leaked several months later, it was still front-page news. Patton himself remained unrepentent to the end, noting in his war memoirs, "I am convinced that my action in this case was entirely correct, and that, had other officers had the courage to do likewise, the shameful use of 'battle fatigue' as an excuse for cowardice would have been infinitely reduced."[63]

As was true for the psychiatric casualties, men were more likely to be wounded the longer they stayed at the front. "A doomlike quality hangs over the beachhead," wrote Audie Murphy. "Already we old men feel like fugitives from the law of averages."[64] Despite the constant self-denial, most men felt fatalistic about their chances. They were waiting to be wounded or killed; it was only a matter of time. The men had seen too much to believe in their own survival. In the words of one witness:

> I saw mutilated bodies that were still alive stumbling along with nothing but instinct to keep them on their feet and searching for aid. I saw drunks whose drunkenness was the nervous disintegration that doctors call shellshock. . . . I heard the wounded in the tent hospital—when the shock and the morphine had worn away—screaming in the night and cursed their cries for keeping me awake. . . .
>
> I walked through acres of red jelly, splintered bone, strewn entrails and Japanese skins that had been emptied of their contents. I slept with dead Japs beside me and ate heartily within a few feet of formless messes which shortly before had been living men presumably containing men's memories, loves, dreams, schemes and holiness. . . .
>
> My only feeling about them was to hope that if I were killed it would be by a rifle; I didn't want anyone to find me looking like the ones who were killed by grenades. I never felt bad about a dead American until one of my friends had his brains shot out.
>
> The wounded were a little different. The wounded still had life in them and life, oddly enough, still seemed worth helping.
>
> But the dead were nothing. . . . There were too many.[65]

Soldiers grew accustomed to the sights of battle, but the veneer of detachment could be torn away by the sight of a badly wounded man. Raleigh Trevelyan witnessed a scene so dreadful that he could not put it into words even in the privacy of his own diary. "Yesterday evening there was something on a stretcher that was the worst sight I have ever

seen at this bridgehead . . . *and it was still alive.*"[66] As had been the case during previous wars, the men feared the "living death" of disfiguring wounds to their face or genitals and feared lingering injuries that would inexorably lead to a painful death, such as stomach wounds. The discovery of sulfa drugs and penicillin; the institution of vaccinations against typhus, bubonic plague, cholera, and yellow fever; and the use of plasma transfusions, mobile X-ray units, and evacuations by air all helped to improve the treatment of casualties, but the fear of being horribly mutilated continued to dog the men in battle.

The logical and incremental progress of the wounded through the medical and surgical system reflected the more rapid evacuation process and the improved skills of the World War II medical and surgical teams. The reality was that often within half an hour of being wounded a soldier would be given first aid and plasma by a medic in the field, and would be tagged to be moved back to the battalion aid station. From the aid station, he would either be sent forward to the front if his wound was light or, after an injection of morphine, transported further back to the division clearing station and field hospital. At the clearing station, triage would separate the casualties for surgery and care. After approximately a week of treatment, the soldier would be returned to his battalion or passed along farther to the rear. If his injuries could be healed sufficiently to enable him to go back into action, he would be transferred to an evacuation hospital and, from there, either sent directly to the front lines or to a convalescent hospital to regain his strength before going back into combat. If his case was more serious, he would be moved to a general hospital within the theater of operations and then finally home to the United States to be invalided out of the service or treated in a Veterans Administration hospital, such as Walter Reed in Washington, D.C.[67]

In addition to a full complement of male doctors, many of the forward hospitals operated with a large staff of female nurses. It was not just practical—to free men for other jobs—it was a morale boost. As one doctor commented to war photographer Margaret Bourke-White, "It's amazing how much good even a hot drink does when they are carried in here wondering if they are going to die. . . . Then he sees a woman and knows that war can't be so bad if there are women nurses there. A little of that 'Eve' stuff does a lot of good for those boys when they are brought in from the front."[68]

The average operation under the tents in the forward hospitals took about a third of the time it might have in a civilian hospital in the United States: meatball surgery. But speed was not carelessness; it was

a necessity. There were too many who were too badly wounded. John Steinbeck described an emergency surgery situation:

> All night long the operations went on. Probing for bullets, hands and arms and legs cut off and put aside. Eyes removed. The anesthetists worked delicately against pain, dripping unconsciousness onto the masks. It went on through the night, the procession of the maimed to the hospital. The doctors worked carefully, speedily. Quick judgments—this one can't live—keep consciousness away. This one has a chance if both legs are sliced off. Judgments and quick work."[69]

The battle surgery and medical care in World War II reduced the rate of death from wounds to less than one half the rate of World War I. This high rate of survival permitted more than 58 percent of the wounded to return to service. The medical care also reduced the incidence of nonbattle deaths. During the Spanish-American War in Cuba and the Philippines and in World War I, 1.6 percent and 1.3 percent of the soldiers, respectively, died from disease; in World War II, however, only 0.6 percent died of illness.[70] Even the treatment of shellshock patients had improved. Whereas fewer than 10 percent of the psychiatric cases returned to duty in the early part of the war, 40–60 percent of the cases returned to combat and another 20–30 percent returned to limited service by the end of the war.[71]

But these figures cannot hide the fact that the victory in Europe was earned with 772,626 army battle casualties, of which 160,045 were deaths. The price of winning in the Pacific was 170,596 army battle casualties, including 41,322 dead. Army casualties in all theaters, from Pearl Harbor to the surrender on the *Missouri*, totaled 943,222: 201,367 killed; 570,783 wounded; 114,205 prisoners; 56,867 missing. The totals for the navy, Marine Corps, and Coast Guard were 56,206 dead, 80,259 wounded, and 8,967 missing.[72]

The end of World War II came first with Germany and second with Japan. It was only fitting. The United States had always looked toward Europe first. The United States had always wanted to defeat Germany first. It did. Germany formally surrendered—"unconditionally"—on May 7, 1945. Japan surrendered four months later, on September 1, 1945. The American participation in the war had opened and closed with Japan—the more hated but less feared of the two major opponents.

"This is a victory of liberty over tyranny," proclaimed Truman to the world.

> It was the spirit of liberty which gave us our armed strength and which made our men invincible in battle. We now know that that spirit of liberty, the freedom of the individual and the personal dignity of man are the strongest and toughest and most enduring forces in all the world.
> And so, on V-J Day, we take renewed faith and pride in our own way of life.[73]

So ended the Second World War. The United States had reason to be proud of its victories. But America's pride in its "own way of life" was already turning to self-righteousness. And the celebration of the freedom of the individual and of the State was becoming an insistence on adherence to the American way. A chill in the air announced the incipient Cold War.

8

The Photographers:

A Model Partnership

Who, What, Where, When

WHEN THE UNITED STATES entered the Second World War in December 1941, the five-year-old *Life* magazine had the country clamoring for photographs. *Life* and its fellow photomagazines had whetted the public's appetite for pictures and raised expectations about both the quality of images and the speed with which they appeared in print. But, unlike the previous world conflict, World War II was not a conveniently concentrated war that could be covered adequately by a handful of staff. Action was not limited to a Western Front that a corps of official photographers could handle with a minimum of logistics. As a war on five continents, seven seas, and a dozen different fronts, it posed entirely new problems of personnel, expense, transportation, and communication. Yet, for the first time in any war, single photographs could be transmitted across oceans by radio and across continents by wire. Long-range airplanes could rapidly deliver rolls of film and thousands of prints. The challenge that remained when the war began, therefore, was to organize the picture-taking so that all the fronts would be covered and all the publications would have access to the images.

As in the First World War, U.S. military photographers were assigned to divisions and took all the needed official or technical pictures. But civilian photographers were also permitted to take combat pictures. Immediately after Pearl Harbor, the War and Navy departments (soon to be joined by the army) set down strict guidelines under which pictures

could be made. Government policy emphasized that all combat pictures—official or civilian—had to be equally available to all as a matter of public policy. Therefore, all civilian coverage had to operate on a basis of pooled staff. The absolute number of correspondents allowed into any theater was limited, so it was not cost effective for agencies to duplicate assignments. Photojournalists were spread around to as many fronts as permitted, and their photographs were pooled.

The original participants in the pool were the three chief American picture-gathering agencies—the Associated Press (AP), Acme Newspictures, and International News Photos—and *Life* magazine. The Still Photographic War Pool, agreed to by the four in January 1942, provided that photographers be supplied from each organization and that pictures be available to all. The first pool photographer left on assignment on January 14. Through the three agencies and the various services they supplied, all the daily and weekly newspapers across the United States had access to the photographs. Although there were no exclusives, later amendments to the original contract stipulated that *Life*, as a weekly magazine laboring under different deadlines, could request that pictures from its representatives be held for simultaneous release in the magazine. This arrangement applied only to "nonspot" feature material, however, and the pool had the right to appraise the work of the *Life* photographers before the magazine made its own selection.

A year after its inauguration, there were twenty-eight pool photographers in the various theaters. Full-time photographers who had already been on foreign assignment constituted its nucleus. The number of photographers in each theater from the member agencies was subject to mutual agreement and when new assignments came open, photographers were supplied from each organization by rotation. Each member of the pool paid the salary and expenses of its own representative. The army or navy picked up the bill for transportation and usually billeted and fed the photographers when they were at the front. The four pool members spent approximately $400,000 a year for their war pictures.[1]

Although *Life* was only one of the outlets for war photography, it was the most prestigious. It put more photographers in the field—21—than the other pool members. *Life* photographers spent a total of 13,000 days on assignment outside the United States, half in combat zones; 1 photographer, George Rodger, traveled 75,000 miles in 1½ years to cover stories. Five *Life* photographers were wounded in action, 2 were torpedoed, 1 was imprisoned, and a dozen contracted malaria. But *Life* was not alone in paying a high price to cover the war. All told, 37 print and photographic correspondents were killed in the course of the war, 112

were wounded, and 50 were interned in prisoner-of-war camps. The casualty rate for correspondents was four times greater than it was for the military. As one marine sergeant said, "I may get it some time, but I'll be damned if I'll go out and reach for it like those newspaper reporters and photographers."[2]

There were three classifications of photographers in combat zones: the official accredited civilian photographers, the official military photographers, and the unofficial civilian photographers. All were issued photographic identification cards that stated where they were eligible to travel. Both types of official photographers—military and civilian—could photograph "classified" subjects; unofficial photographers were limited to "unclassified" subjects, that is, subjects that were generally well behind the front lines.[3] Accredited war correspondents officially had "the status of officers, [were] subject to military law, [were] forbidden to wear civilian clothing in the theater of war, and [were] provided military accommodations. . . . [They had] the assimilated rank of Captain, Army, or in the case of correspondents afloat, Lieutenant, Navy."[4] Their uniforms were well defined. Accredited male photographers were to wear the dress of an officer "less all insignia of grade, arm or service." Women photographers were to wear the same uniforms, "except that female correspondents will wear either skirts or (when in the field) slacks, if desired, and berets."[5] Early in the war, correspondents were to wear arm brassards, as they had in the First World War. But it soon became obvious that the enemy used the brightly colored brassards as a target for fire, so the brassards were abandoned in favor of more discrete cloth insignia.

That was the official policy on rank and dress. The reality was different. According to the rule books, journalists were supposed to be treated as officers. But their rank was only "assimilated," which meant that it only took effect when and if they were ever captured by the enemy. It was not an especially useful system. However, certain correspondents were able to turn their designated status to some effect. When by ukase Vice-Admiral R. K. Turner declared the journalists stationed with the navy to hold the rank of lieutenant commander for the purpose of billeting and eating—to make up for generally shoddy naval provisions—the correspondents took to calling each other "Commander" when within earshot of impressionable civilians or sailors.

The strictures on uniforms were also less precise in practice. Most journalists had no assignment to individual units and, therefore, had to draw work uniforms by "devious methods or not at all." They rarely presented a picture-perfect appearance. As one *Saturday Evening Post*

correspondent wrote, "Dressed in a variety of Army, Marine and Navy uniforms—or combinations of the three—[the newsmen] are balding, graying, overstomached in some cases, overbearded most of the time." They "seldom have laundry facilities . . . [and] their luggage makes movies of the Okies look like migrations of the privileged classes."[6]

Even though all correspondents labored under identical military regulations no matter which theater they worked in, they were not all equal. Journalists on assignment in the Pacific always felt that they were second-class citizens; one indication of their status was that their pay was generally lower than that of the journalists in Europe. The amount of attention that the correspondents received from their home offices also varied according to where they were stationed. A Pacific correspondent groused:

Home offices beat tom-toms about men who make a landing or two in Italy or France, and forget to mention those who make a landing every month in the Pacific, and have been doing it for years. Newsmen hitch-hike their way back to their temporary quarters on some unspeakable island after days on the front line, and find mail complaining that there isn't enough front-line coverage. . . . Their copy moves from the scenes of battle to their newspapers by such slow means that most of it arrives long after headquarters communiqués have taken the edge off the stories they have to tell, and much of it never sees the light of day in newspapers.[7]

But in all theaters, the correspondents suffered with "three main problems," as John Gunther, assigned to the Mediterranean, discovered: "first, transport; second, communications; third, censorship."[8] Transportation was critical; without transport to the lines, the journalists could not write or photograph their stories. Early in the war, once correspondents were on site in a theater, they had to fend for themselves and hitchhike on army vehicles or planes or even buy their own cars, if possible, to get to the fighting. But by 1943, the Armed Forces Public Relations Offices had more organized transportation available; the offices arranged regular courier services to and from the front or beachhead and doled out a few jeeps to be shared among the journalists. Frequently, a reporter and photographer—not necessarily from the same news organization—would pair up in a jeep to cover a story. Although there were few possible "beats" or "exclusives" that could be scored, most photographers and reporters wanted to protect their own turf—and byline. By traveling together as a reporter-photographer

team, each would have company and a second pair of eyes and ears to pick up stories, without worrying that another journalist of the same breed was homing in on the same subject.

Although transportation was a challenge everywhere, in the Pacific—predictably—there were greater problems in getting from here to there. Most of the difficulties experienced by the press were intrinsic to covering island-to-island combat. "The Pacific was a naval command and the Atlantic was an Army command," explained *Life* photographer Ralph Morse.

> You were still the same war correspondent, but you were dealing with two different beasts on operation. In the Navy command, unless you were on an island and staying with the Command or Marines you were going places on ships, you weren't transporting across land. . . . After the Marines took the island of Guadalcanal we set up a press camp. Before then your base was on the ship you came in on.
>
> When the Army took over they kept a press camp. When you went into a landing in Europe, the press camp moved with the command. You were with the 3rd Army or the 1st Army. You had a base. It was a different method of covering [combat].[9]

It was not just different, the Pacific correspondents grumbled, it was unfair. "In the Central Pacific," wrote a Pacific correspondent, journalists "go green with envy at stories from Europe or other fronts about correspondents having jeeps assigned to each one or two men. In the Pacific, they have had jeeps assigned once or twice—usually one jeep for about twenty-five men, all [of whom are going in] different directions."[10]

Communication—both getting the photographs back home and receiving reports from the office—was a greater hurdle in the Pacific as well. "You had more problems shipping with the Navy than the Army," believed photographer Morse, "because you've got to get the film back to somewhere. . . . With the Army you're on land and there's planes going back to London. . . . You go into a place like Guadalcanal—headquarters to send film was the Presidio in California. How are you going to get film out of there?"

Morse told how he tried to ship his film back to *Life* from the D-Day invasion on Guadalcanal:

> I went in on the heavy cruiser *Vincennes* and then switched to a Marine landing ship off Pago-Pago. I . . . knew that the *Vincennes*

185

was a five-year-old ship and she was going back for a five-year-old overhaul. So the night of the landing . . . I thumbed my way back on a landing craft to the *Vincennes* and gave the packet of films to the chaplain on board. I said, "Father, would you do me a favor and when you get to San Francisco take this to Presidio for me? If you're leaving within 48 hours and going straight back for overhaul this is a good way to get film out of here." Course, that night it got in a sea battle and got sunk. The film's on the bottom of the sea. . . . But it was a good idea.[11]

There were problems in getting film back even in the European theater. But in the Atlantic war, the task was complicated more by military red tape than by problems of distance. *Life* photographer George Silk, a New Zealand national, told of his difficulty in getting his story of a troop landing to press even when he hand carried it to the United States.

I went into Southern France with the Airborne on a glider and got hurt, . . . cracked three ribs. So I got out of there and took the film . . . back to New York trying to catch the Saturday deadline. But because the weather was bad they flew us to Washington and the FBI grabbed me because I was all taped up. They just ripped all that tape off and x-rayed it and x-rayed me. They were quite sure I was a spy. And it finished up with me not getting to New York until late Sunday. And they wouldn't call New York or wouldn't call the Washington office or wouldn't do anything to get the films out. And so by then it was too late to use the story.[12]

The alternative method of getting one's film back to the United States was to use radio photo facilities. The Signal Corps and Office of War Information (OWI) transmitters sent photographs over the radio channels from European outlets—London; Caserta, Italy; and Bern—to New York—and from Far Eastern locations—Chungking, Brisbane, and Manila—to Los Angeles. At times, however, it could be almost as difficult to get film developed, printed, and to the radio transmitters as it was to send it directly to Washington to be printed there. In late 1942, in North Africa, for example, the nearest clear facilities to England were 1,500 miles away in Cairo. All the closer terminals went through occupied France. And the Cairo transmitter was often bogged down in a torrent of army messages and, consequently, had little available time to send the correspondents' material.[13]

An additional problem was that the quality of the radio photographs was never as good as that of pictures that were developed in the United States. Unavoidably, the transmitted photographs came through with a haze of horizontal stripes because their tonalities of grey had been sent line by line over the airwaves. But, although their quality was poor, the speed was unbeatable. It took seven minutes to transmit a photograph from London to Washington, the scanning rate being one inch per minute. On D-Day in Normandy, the first print showing a landing arrived at the Pentagon at 5:22 that afternoon. Forty-seven others came during the day.[14] A total of 25,000 stills were sent by radio facsimile to Washington from all theaters of operations during the war years.

Even color images could be sent. The first full-color photograph for publication was transmitted on August 3, 1945, and showed the Big Three—Harry S Truman, Clement Attlee, and Joseph Stalin—at the Potsdam Conference. To make the transmission, a set of three black-and-white prints was made to correspond to the three basic colors—red, yellow, and blue—and each was sent separately. The time required for transmission from Berlin to Washington was twenty-one minutes, three times the normal transmission time.

Because of the distance from the fronts to the United States, photographers rarely saw their own work; they took pictures in a creative vacuum. "You don't see your pictures, ever," said Morse. "Either you come back [to New York] or they're published and you see them in an old copy of a magazine or newspaper."[15] Joe Rosenthal, the AP photographer who snapped the immortal Iwo Jima photograph, did not even know which of his photographs had created all the fuss in the United States. "I took one picture when the staff was halfway up," he said, "another when it was all the way up, and then I got a lot of Marines to stand around cheering to make my last one. When they wired from Guam that my flag picture was very good, I thought they meant the last one. All my stuff from Iwo was shipped out in negative, and I never had any idea how the picture looked till I got back to Guam and saw how it developed."[16]

It was a challenge for the photographers and reporters to overcome the distance from the front to their offices in New York in time to make their deadlines. They had to get the pictures back while they were still hot. *Life* photographer George Rodger catalogued his troubles. "Difficulties in the field," he said,

> were numerous enough; lack of advance information when news was going to break; relying on one's own judgment as to what was

going to develop into the best story; arranging for supplies of film; being able to take only light equipment when travelling from place to place by air; both military and political censorships, and the usual technical difficulties when operating in tropical countries— protecting films from the heat and processing under adverse conditions. But none of these compared with the obstacles in getting the finished stories back to the magazine. I was told at the *Life* offices that time and again my pictures arrived so long after the event they illustrated that they were practically useless. By that time the eyes of the world were already focussed on some other major event and the pictures could only be used retrospectively instead of being splashed through a leading news story. Something would have to be done to speed up delivery . . . but that was entirely in the hands of the Army Public Relations Units.[17]

It was the duty of the public relations officer (PRO) and staff in each theater to assure full press coverage of all combat operations. This simple-sounding job was a nightmare of logistics. The ordeal began well before a photographer shot his or her first picture. The PROs controlled press boats, seaplanes, extensive radio and teletype facilities, and even parachute equipment for dropping press reports to censors. They decided which news agencies or papers would cover an operation with which units and arbitrated among those who wanted to go in with the assault troops or those who wanted to follow the activities of the fleet or air wings. Their chief difficulty was not in getting the photographs back to the United States but in getting the journalists' film or copy from the front to the first PRO station. Once a roll of exposed film and accompanying captions had been delivered, the film advanced with all deliberate speed to the headquarters of the theater for developing and censoring by the section staffs. General MacArthur's censors, for example, scrutinized the pictures of pool photographers in Australia. General Eisenhower's staff looked over the pictures in North Africa. Admiral Chester Nimitz's office in Pearl Harbor inspected pictures from the Pacific outside the army area. From these individual sections, the photographs traveled on to Washington, where they were censored again by the War or Navy Departments. Only after the photographs had made it through the Washington bottleneck were the pictures released to the various publications.

Sometimes from the European theater film would go straight from the frontline photographer to Washington via army pouch. *Life* photogra-

pher Margaret Bourke-White explained that review process. "The films," she said,

> were developed in Washington, either by the Signal Corps or by *Life* technicians under Army supervision. Only those pictures which passed censorship were sent on to *Life*. Since my mission was partly for the Army Service Forces [as was true for all accredited photographers], those of my pictures which could not be published could still be used by the War Department. Certain technical subjects had to pass British as well as American censors. At the review desk, in the Pentagon Building, the picture censors went over every photograph very fairly and carefully, and often helped us to save a picture for publication where only part of the photograph revealed restricted subjects. In this case they would indicate what portions of the picture must be retouched before publication. Caption material was censored twice. First my rough notes were reviewed: these served only as a basis for *Life*'s writers, who would draw upon them for captions as the layouts were compiled. Then the completed layout was censored once more in Washington, so that text and pictures could be reviewed as a whole before publication.[18]

To facilitate the clearance of pictures and stories through the bureaucracy, *Life* both strengthened its Washington office and placed a man in London. *Life*, the recognized leader among the mass-market magazines, at times received special treatment from the censor. "Since *Life* first appeared," noted its general manager during the war, Andrew Heiskell, "the War and Navy departments have recognized it as a powerful instrument for public education and have gone out of their way to provide the editors with raw material such as no U.S. magazine has ever had at its disposal."[19]

Yet even for *Life*, the censorship process was heavy-handed. And at times it could become intolerable. "I can give you one example of the censorship business," Ralph Morse recalled.

> I was in Honolulu and was told there was going to be a task force leaving. What correspondents wanted to go? . . . I said I was going to go. . . . And when we were at sea about two days they announced over the loudspeaker that we were going to meet the carrier *Hornet* and we're going to bomb Tokyo with Army-based planes on board

the carrier. This was the [Doolittle] "Shangri-La" mission. We didn't know this. I can't tell this to New York. I think I was the only civilian photographer there. Most likely was. All the pictures of Doolittle taking off the carrier were all mine. But when [my film] got to Washington, President Roosevelt held it for thirteen months. I didn't know if it came out. I didn't know if I screwed up. I had no way of knowing. Thirteen months later [it was] finally released.[20]

The Tweedledum and Tweedledee of the censorship process were Byron Price, the director of the Office of Censorship, and Elmer Davis, the director of the OWI. In a joint interview given to the *New York Times* in 1942, Mr. Price said: "We tell them what they cannot print." Mr. Davis said: "We give them stuff we hope they will print." The official government stance was based on Franklin Roosevelt's famous "propaganda of truth" phrase. As the *Times* summarized Davis and Price's *1984* language, "The press can check for its own facts and versions when it chooses so long as it does not infringe requirements of censorship."[21] In reality, of course, the war did not always match the official "truth," but rarely was the press permitted to expose the complete truth. That would have "infringed" the censorship.

There were clear official "errors"—to put the matter as charitably as possible. One *Harper's Magazine* author wrote in 1946 about the government's playing fast and loose with the facts. "Nineteen Japanese heavy cruisers were claimed sunk before the battle of Leyte Gulf, chiefly by the bombers of the MacArthur command. The Japs had eighteen at the beginning of the war, and had built none since; yet they showed up for the big fight with fourteen. But no correspondent was permitted to call attention to these mathematical discrepancies, as long as any censor had anything to say about his copy." Some discrepancies came out during the war, but as the author noted, "the information reached the public through writers who were not war correspondents and who therefore were not subject to having their copy examined before it was printed."[22]

In addition to the outright falsehoods, there were white lies. "It is in the things not mentioned," observed John Steinbeck, "that the untruth lies." The correspondents and photographers were accomplices in deceit—together with the rest of America. What was not reported, Steinbeck wrote,

was partly a matter of orders, partly traditional, and largely because there was a huge and gassy thing called the War Effort....

To a large extent judgment about this was in the hands of the correspondent himself, but if he forgot himself and broke any of the rules, there were the Censors, the Military Command, the Newspapers, and finally, most strong of all in discipline, there were the war-minded civilians, the Noncombatant Commandos of the Stork Club, of *Time* Magazine and *The New Yorker*, to jerk a correspondent into line or suggest that he be removed from the area as a danger to the War Effort. . . .

Yes, we wrote only a part of the war, but at the time we believed, fervently believed, that it was the best thing to do. And perhaps that is why, when the war was over, novels and stories by ex-soldiers, like *The Naked and the Dead*, proved so shocking to a public which had been carefully protected from contact with the crazy hysterical mess.[23]

Correspondents in World War II were on the "Team." As General Eisenhower wrote, "Correspondents have a job in war as essential as the military personnel. . . . Fundamentally, public opinion wins wars."[24] The job was not so irksome. After all, it was "The Good War." It was a war that needed to be fought. So to support the war effort seemed not compulsory but essential, not dishonorable but American.

But even if the civilian press had written nothing at all, if they had taken no photographs, there would still have been some news of the war. A range of organizations and miscellaneous others took photographs in forward areas, including the American Red Cross, the American Field Service, individual photographers on assignment for the War Department or by War Department approval, the Psychological Warfare Branch, the Surgeon-General's Office, and the military press such as *Stars and Stripes*. The army, the navy, the marines, and the Coast Guard all assigned military combat correspondents and photographers to their operations. Daily official communiqués and a package of photographs were issued from the several theaters and made available to the media; for an important event, such as a D-Day, the first announcement to the public always had to come from the commander in charge of the theater. The general opinion prevailed, however, that it would have been un-American to have had only official military reporters covering the war. The presence of responsible civilian journalists assured the continuation of a relatively free wartime press.

Although the photographs from the civilian representatives dominated the media, the various military organizations took some extraordinary images. The navy combat photography group, especially, had a

deservedly excellent reputation for its coverage of the war afloat. The classic photographs from Pearl Harbor of the USS *Shaw* blowing up at anchor, for example, were official navy ones. The primary reason for the consistent high quality of the navy pictures was that Edward Steichen—the former chief of the army's photographic section in World War I and subsequently the director of photography for the Museum of Modern Art—headed the naval aviation's photographic unit. Steichen, who was signed up by the navy after much lobbying, was allowed to handpick his group of photographers. The images that came out of this unit were frequently technical masterpieces—a tribute to their leader's emphasis on the craft of photography. But the best of the navy photography is notable not for its artistry but for its depiction of the "essence" of war. Steichen counseled his group to "photograph every thing that happens, and you may find that you have made some historic photographs. But above all, concentrate on the men. The ships and planes will become obsolete, but the men will always be there."[25] This was curious advice to give a military photographic unit; military photography is generally concerned with documenting the matériel of war, not its eternal verities. But Steichen's group, together with a few other military photographers—such as Marine Corps photographer David Douglas Duncan—and some of the civilian photographers, successfully depicted the traumas of war, not just of World War II.

More of the military photography, however, was taken for official rather than for emotional or propaganda reasons. If the still pictures sent back to the United States helped to win the war at home, photographs taken for military purposes helped to win the war on the battlefields. In 1938, the German General Werner von Fritsch had said, "The country with the best photographic reconnaissance will win the next war." During the Second World War between 80 and 90 percent of all the Allied information about the enemy came from aerial photography. "It's the greatest detective story of the war," said one officer. The American armed services in World War II could not take a step and could not fire a shot without photographs and the maps created from them. H. H. Arnold, the commanding general of the army air forces, averred, "A camera mounted on a P-38 often has proved to be of more value than a P-38 with guns."[26]

In a little over two years of war following Pearl Harbor, U.S. airmen photographed 8 million square miles of the earth. To do so, reconnaissance pilots flew at an altitude of up to 30,000 feet. With the newly invented trimetrogon camera—actually three cameras set at oblique angles to each other—pilots could map an area 30 miles by 9 miles in

one shot. Using a continuous-strip camera, pilots could fly at an extremely low altitude—300 feet—and take 1 continuous picture that would map out an entire sector of an invasion beach. With huge flashlight bombs of nearly a billion candlepower, it was possible to photograph enemy activities at night. The aerial photographs that resulted from these inventions were so detailed that a skilled interpreter could identify new types of aircraft on the ground and name enemy ships from a photograph with a scale of 1 to 10,000. Observers could accurately read bomb damage from pictures taken 6 miles up. So fast were the photo planes that in one case, a pilot followed a bomber squadron to its target, photographed the results of the foray, flew back and had the prints on the commander's desks before the bombers returned home.

Although the coverage of the army air forces and the navy operations was highly touted, the majority of the military photographers who covered combat were in the Signal Corps. Only slightly better organized than it had been in 1917, the Signal Corps in the months leading up to Pearl Harbor was frantically training its units. Signal Corps training centers were expanded; in late 1941, the Signal Corps moved into the old Paramount Studios on Long Island. The training of military photographers at civilian organizations was also begun. *Life* magazine, AP, International News Service, Acme, the *New York Daily News*, the *Daily Mirror*, the *New York Times*, the *World-Telegram*, the *Journal-American*, and *PM* pitched in. At these institutions, the corpsman accompanied a professional photographer on his rounds, took photographs on the assignment, and compared his photographs with those made by the journalist. Through their exposure to the media, the students gained both an experience with composition and technique and, it was hoped, an ability to judge newsworthy photographs—a talent sorely lacking in the Signal Corps during the First World War.

The Signal Corps companies that were created each consisted of seventy-five men. Twenty were still photographers, thirty were motion picture cameramen, twenty were darkroom technicians, two were film recorders, and three were maintenance men. Some of the photography units were assigned to combat areas, others to communication zones. Those photographers stationed in forward areas received two sorts of orders: a general assignment to cover an operation, such as an assault on an island or a town, and a specific assignment, such as to record the effect of enemy tank-destroyer fire on friendly tanks. The photographs these units produced were put to many uses: tactical, for immediate use in the theaters; strategic, for use in planning; training, for the instruction of troops; morale, for the support of troops and civilians at home;

public relations, for the media in the United States and abroad; intelligence, for reconnaissance; technical, for the improvement of equipment; historical, for future study; legal, for war criminal trials.

Immediately after Pearl Harbor, the first two Signal Corps photographic companies went on assignment. Beginning in January 1942, others followed. A year later, special photographic units were stationed in the southwest Pacific, Iceland, Ireland, China, Hawaii, Panama, Puerto Rico, Trinidad, Newfoundland, New Caledonia, and North Africa. Although these units accompanied the troops from the beginning of the U.S. operations abroad, they did not have a major presence until later in the war. When the American soldiers first landed in Algeria, a sergeant and a private were the only combat photographers with the operation. In Tunisia, 12 photographers covered a 148-mile front, 5 of whom were held in reserve behind the lines for emergency coverage of events. By Normandy, 100 combat photographers covered the D-Day invasion, and during the 7½ weeks following the assault, they sent 8,746 stills to the War Department. By April 1, 1945, there were 200 photographers on the European front—exclusive of others elsewhere in the European theater—who had taken 55,000 stills. All told, the combat photographers supplied half a million still pictures to the various agencies.[27]

The key camera used to take these thousands of still photographs was the Speed Graphic. It produced 4×5-inch negatives and folded into its own carrying case, complete with leather handle. Images were viewed through an optical finder, a wire sports-finder, or on a sheet of ground glass. The camera accommodated interchangeable lenses and offered a choice of two shutters—a between-the-lens shutter and a focal plane shutter built into the body of the camera. It could be hand held, and it froze action at what was an incredible $\frac{1}{1000}$ of a second. By World War II, the camera could be loaded with a film pack, by which film was changed rapidly by pulling a paper tab.

Both the civilian press and the Signal Corps relied on the Speed Graphic camera, although photographers in the tropics expressed dissatisfaction with it because the fabric shutter curtain and the leather bellows were subject to attack by fungus. This was particularly distressful for the military photographers because "ordinarily, a broken camera puts a photographer out of action until it can be sent to a rear area for repair and returned, which is usually the duration of an operation." The Graphic's weight and bulk were criticized during amphibious operations, as was the fact that it had to be carried in an open position to be ready for action and so was susceptible to damage. Many military

photographers voted with their feet and "used their own cameras in place of the Speed Graphic whenever it was possible." The civilian photographers—especially those who worked for *Life*, such as George Rodger and Eliot Elisofon—swore by the new 35mm camera, of which Contax and Leica were the most popular. In addition to the rugged 35mms, many photographers carried a 2¼ × 2¼-inch Rolleiflex.

Often photographers lightened their load when out in the field. To do so, they opted for the 35mm cameras and removed the range finder and synchronized flash gun that equipped many of the still cameras. Working outdoors in the daytime with fast film, they were able to operate by stopping down to f:8 or smaller, setting their cameras for infinity and estimating the exposure. This was necessary under battle conditions, when there was no time to use range finders or exposure meters. Some of the weight saved by using the smaller cameras was applied to carrying telephoto lenses, which were considered "absolutely necessary to secure worthwhile pictures of the battlefield under present warfare conditions." Cameras were also made combat ready by painting over their chromium-plated parts with dull black lacquer so the silvery metal would not reflect the light and draw snipers. The film generally used was the black-and-white 35mm Panchromatic, with Kodachrome employed for the small amount of color work that was done. Kodak film was preferred over Agfa because the Eastman emulsion was harder and, therefore, more resistant to heat and humidity—less likely to stick to contiguous surfaces or to grow fungus.[28]

In spite of the then-recent advances in the photographic equipment, camera crews stationed in the various theaters during the war struggled against the combined forces of nature to deliver their results. In the North African desert, film had to be buried six feet under the sand to keep it cool. When the water supply failed in Tunisia, prints were rushed to the nearby seashore and washed in the ocean. Other inspired darkroom assistants used melted snow, swamp water, or roadside mud puddles for rinses. In the tropics, temperatures in the light-sealed darkrooms could climb to 130 degrees, causing the emulsion to melt off the film. In humid areas, prints could take three or four days to dry. Giant cockroaches in one sector voraciously ate their way through the darkroom supplies. Tropical fungus grew on camera lenses and secreted acids that etched the glass. In the Pacific, film was sent home in cans that were packed with rice or tea leaves to act as a dehumidifier. "One pound of rice or tea leaves," photographers were informed, "will dry about 200 feet of motion picture film or the equivalent still film."[29]

A slightly more disreputable way to cope with the problem of mois-

ture was to use rubber condoms to protect a roll of negatives. Legend has it that the practice initiated with a cartoon of Bill Mauldin's showing Willie and Joe using condoms over the barrels of their rifles to keep water from getting inside and rusting the innards. Robert Capa, the story went, then had the brainstorm to use condoms to keep his film dry. The practice became so widespread that PROs ordered condoms by the gross and passed them out to the Signal Corps and civilian photographers. At least one photographer, Bill Bryant from INS, charged his agency for them on his expense account with a line item "One gross condoms," with the price in pounds, piastres, or pesetas correctly translated into American currency.[30]

The professional supplies and personal equipment that the photographers took to war varied remarkably. Some traveled with less than most people would take on an overnight trip, while others needed porters to carry all their paraphernalia. Dickey Chapelle packed only a change of fatigues and socks, soap, a towel, and a can of C-rations. Not including twenty pounds of camera equipment, it all fit into a U.S. combat knapsack and weighed fifteen pounds. Bert Brandt of Acme Newspictures, preparing for the Normandy invasion, stuffed forty-five pounds of equipment, including his cameras and their supplies, into his pack and his pockets. He also carried a canteen of water, a pocket knife, a first-aid kit, one carton of cigarettes, two Zippo lighters, a gas cape with the army's manual on how to use it, and a Hershey bar.[31]

Margaret Bourke-White went to the other extreme. Her clothes and personal effects alone weighed fifty-five pounds. Always the lady, she carried "on all trips" a pigskin case of cosmetics, which included face cream that she applied so religiously that an infantry major with whom she shared a dugout on the lines one night called her "Crisco-puss." She carried vitamins, a spare shirt, trousers, heavy field clothes, Bond Street jodhpur boots, a hand-tailored battle jacket, "skirts for those occasions when even a war photographer has to wear a skirt," green silk pajamas, and a diaphanous evening gown designed for her by Adrian of Hollywood. Even the two uniforms she brought—summer and winter—had flair. Because she was the first woman correspondent accredited to the army, a new uniform had to be designed. Bourke-White happily served as a consultant on the materials and tailoring and as a model for the fit. The Army War College laid it out and Abercrombie & Fitch stitched it up.

Bourke-White also carried an extravagant amount of camera equipment. To cover Italy, she carried 250 pounds of supplies: "One Speed Graphic, two Rolleiflexes, three Linhofs, a Graflex fitted for telephoto

... various filters, film packs, flash guns ... thirty-odd lenses, their infinite repair parts and accessories, along with a sufficient quantity of film and peanut flash bulbs to last half a year"—not to mention a typewriter and a bedroll. But, as she said, "This was an improvement over the 450 pounds I had carried to the wars the year before, and a great reduction from the 800 pounds with which I had flown across China into Russia at the outbreak of the war with Germany. To compress my equipment and supplies into 250 pounds I had figured down to the last ounce." Needless to say, she never budged without her assigned photographic assistant, Corporal Jess Padgitt. (Even when Bourke-White had to evacuate a ship after it had been torpedoed off the west coast of Africa, she carried two cameras, five lenses, and a hefty film supply. But she got results. She took pictures of the victims in the lifeboats and of the rescue operation, and the resulting story made a suitable splash.) Brandt, on the other hand, carried a Speed Graphic and a Rolleiflex with a flash gun, thirty rolls of film, twenty film packs, and one hundred flash bulbs. And Chapelle carried her Speed Graphic and a leather shoulder case with her extra film weighing, she moaned, "at least twenty pounds."[32]

Perhaps the most extensive photographic coverage of combat—both in terms of people and matériel—was for D-Day in Normandy. In addition to 100 military photographers with their units, close to 400 civilian correspondents from the Allied countries covered the invasion line, 237 of whom were Americans. Of that number, 214 were writers and 23 were photographers. (There were 91 British journalists, 64 writers, and 27 photographers.) About half the press covered the assault from General Eisenhower's headquarters and the rest went in with the ground troops, the naval forces, or the airmen.[33] The operation was so zealously planned that each civilian correspondent was asked to write his or her own obituary—just in case. As the PRO in charge recalled, "Some of them took [the request] in high good humor to cover their real feelings, others straight, and some were shaken." Brandt, the Acme photographer, who survived the D-Day landings to beat everyone back to London with his photographs, even gave "laying-out" instructions. "Part my lips in a smile," he said. Then, in an afterthought he added, "if they ever find me."[34]

Black humor carried the day. *Life*'s Robert Capa was one of several photographers scheduled to go in with the first waves.

Just before 6 o'clock we were lowered in our LCVP [landing craft, vehicles, and personnel] and we started for the beach. It was rough

and some of the boys were politely puking into paper bags. I always said this was a civilized invasion.

We heard something popping around our boat but nobody paid any attention. We got out of the boat and started wading and then I saw men falling and had to push past their bodies. I said to myself, "This is not so good." I . . . hid behind some tanks that were firing on the beach.

After 20 minutes I suddenly realized that the tanks were a certain amount of cover from small-arms fire but that they were what the Germans were shooting shells at, so I made for the beach. I fell down next to a guy who looked at me and said, "This is harder than sweating out an inside straight." And another guy said, "I see my old mother sitting on the porch waving my insurance policy."

It was very unpleasant there and having nothing else to do I started shooting pictures.[35]

Capa photographed the first and second waves, which crawled ashore at H-hour, plus minutes on "Easy Red," Omaha Beach. The fighting was so bad that General Omar Bradley on the headquarters ship considered withdrawing the troops and attacking elsewhere. Capa kept repeating a little sentence from his Spanish Civil War days, " 'Es una cosa muy seria. Es una cosa muy seria" (this is very serious business).[36]

On the beach, between barbed wire and the sea, Capa frantically continued to shoot frame after frame. He finished a roll and reached in his bag for a new one, but his wet shaking hands ruined it before he could get it inserted. "I paused for a moment," he recalled, "and then I had it bad. . . . An LCI [landing craft, infantry] braved the fire. . . . I did not think and I didn't decide it. I just stood up and ran for the boat."[37]

But he had gotten the photographs he came for. "From the air," Capa noted, " 'Easy Red' must have looked like an open tin of sardines. Shooting from the sardine's angle, the foreground of my pictures was filled with wet boots and green faces. Above the boots and faces, my picture frames were filled with shrapnel smoke; burnt tanks and sinking barges formed my background." The photographs were all the more arresting for their "sardine's angle." And they were all the more striking for almost being destroyed.

Capa had handed the films off to an army PRO, but in the confusion, the films did not reach *Life*'s London office until 9 P.M. the following evening. To make the magazine's deadline in New York, the photographs had to be on a plane the next morning. The darkroom crew mobilized. The negatives came out of the developer, and the office went

wild. They were fabulous. Minutes later all but a few were destroyed. In the rush, the negatives had been hung up to dry in the heated drying cabinet without the fan being turned on. The emulsion cooked and ran off the film. Depending on whose story one hears, either 11 out of 72 were salvageable[38] or, as Capa claimed in his autobiography, 8 out of 106.[39] No matter. It was a tragedy. But, ironically, the photographs may have gained aesthetic power in the process. The heat made the surviving images blurred and grainy—exactly the view that the world had of the gritty battle for France. They were considered the best of the invasion.[40]

They were not the first, however. "Invasion No. 1, No. 2, and No. 3" had been taken by the other civilian photographer to go in on Omaha Beach, Bert Brandt of Acme. Brandt personally took his film back to London and had arrived there early on D-Day plus one. The negatives were hurriedly processed, but the censors refused to pass any of them. One photograph, for example, showed a French farmhouse near the beach with a huge shell hole through it from the naval bombardment. The censors held it on the grounds that it showed the American destruction of French property. After much argument, three were approved and sent to New York on the army telephoto transmitter. "It was a happy day for me," Brandt said.[41] Capa was less pleased. He wrote in a bit of a huff and rather snidely, "I learned that the only other war correspondent photographer assigned to the 'Omaha' beach had returned two hours earlier and had never left his boat, never touched the beach. He was now on his way back to London with his terrific scoop."[42]

Other *Life* photographers sent their stories on the invasion back from a hospital ship (Ralph Morse), an LST (David Scherman), and a Marauder plane (Frank Scherschel). Radio, however, had the biggest initial scoop of the media. U.S. newspapers got their first eyewitness copy from radio reporters; most of the print correspondents' reports dribbled in to the United States from twenty-eight hours to four days late. The first copy came to Dover after twelve hours—by carrier pigeon. Initially laughed at by D-Day planners, carrier pigeons had looked hopelessly antiquated alongside the electronic equipment that could send an estimated hundred million words daily. Nevertheless, the descendants of World War I's Bon Ami came through again.

Despite the hassles of transportation, communications, and censorship; the omnipresent possibility of death; and the lesser irritants of heavy equipment, homesickness, and insects, the consensus was that it was worth it. The chore of bringing the war home in pictures was worth everything. Emotionally and financially. The American public, which

only five years before had never heard of the word "photojournalism," by the time of World War II handsomely recompensed any publication that carried the new reportage. During the war, *Life* magazine had a circulation of over six million, and *Look*, its closest competitor, of over two million, yet *Life* had only been founded in 1936 and *Look*, in 1937.

But, as photographer George Silk remembered, it was a reciprocal arrangement; *Life* and the rest of the new photojournalism press needed the war. "The war had made *Life* magazine into the magazine it was," Silk said.

> It felt its way along until the war came in '39—and, of course, had the Spanish war in the meantime. [But during World War II] the magazine filled itself each week. Nobody had to do anything. When the war ended, how do you keep circulation of six and a half million going when you've got no war to report? . . . The magazine after the war was really awful because it had no direction. And indeed it probably didn't until the Korean War came along, and the Vietnam War came along. Those things were just made for *Life* magazine.[43]

Image and Reality

During World War II, the frontline photographers *deserved* the cognomen "combat" photographers—not because they toted a gun (at least in theory, they were noncombatants), but because they were in the thick of the fighting. In one of the last Pacific landings, the comparatively green troops followed the combat photographers because the photographers were the veterans. The journalists told the soldiers to move away and to spread out. That was a better tactic and also a better picture. But the troops stuck close. "It didn't do our films any good," said one, "but it sure was flattering."[44]

Being there, up front, did not ensure that the photographers could capture the realities of war. Pictures could be inadequate to the task. The subjects of war would not cooperate. Battles raged in the night, but photographers could not take pictures then. Combat was loud and stinking, but pictures could not capture the sound or smell of the front. The photographers had all this wonderful newfangled equipment. But

the images they shot often lacked the immediacy of battle. "Photographically," said George Rodger,

> there was a disappointing sameness to it all. Though the machine-gunners kept plugging away in the face of heavy fire—kept firing until their hands were blistered and sweat and sand inflamed their eyes—though shells fell round us and bullets pinged viciously, it was impossible to record it pictorially. All that would show in the pictures would be the crews taking up their positions or firing their machine-guns—pictures which might be taken to better advantage on any practice range.[45]

Photographers were alternatively exhilarated and frustrated in their attempts to capture their interpretation of a scene. "In all the take-off pictures I had seen," wrote Captain Edward Steichen,

> the planes looked as though they were glued to the deck. They gave no impression of the terrific onrush as the planes started their run for the take-off. Nor did they suggest the noise, which is tremendous. . . .
> There was nothing I could do in the photographs to reproduce the sounds, but I was going to try to give a sense of the motion of the rushing plane. Instead of making a fast exposure to stop the motion and get a sharp picture of the plane taking off, I made a series of exposures around a tenth of a second. . . . Even the pilot is blurred.[46]

Most other problems of combat photography did not have such happy solutions. In many battle situations, it would have been certain death to have stopped and stood still long enough to focus or make a well-composed picture. George Rodger told of his stymie in the Burmese jungle. "Hoping to get pictures of the fighting," he wrote,

> we kept working forward, running for a few yards and then clapping down in the damp jungle mould for a few moments to regain our breath. But, though the battle raged all around me and shots were fired from as close as ten yards, I couldn't catch a glimpse of the enemy. Neither Tozer [Alec Tozer, a British photographer] nor I got a single picture.
> "To hell with this," said Tozer as he slumped down beside me at

the foot of a tall tree. We ducked our heads automatically as a bullet clopped into the solid wood above us.

"And anyway," he went on, "it's obvious in this damned thicket, if we do see any Japs, they'll be within five yards of us, and it would take a better man than I to stand up and take their photographs." I agreed wholeheartedly.[47]

The irreverent Capa said, after throwing himself flat on the ground to avoid the shells whistling overhead, "from my angle this war [is] like an aging actress: more and more dangerous, and less and less photogenic."[48]

The traditional difficulty of capturing the experience of war on film was only exacerbated during World War II. Photographers still could not orchestrate the show. They could try to figure out where the stories were going to be, they could calculate the risks of a certain shot, but sometimes they were luckier than at other times. They could be there and snap the photograph at the precise moment when the war all came together in one beautifully composed shot—as in Rosenthal's Iwo Jima picture—or they could wait all day in the thick of the fighting and nothing remotely photogenic would come along. "The worst," said *Life* photographer Eliot Elisofon, "is to get caught in a bombardment. Then you spend your time in a foxhole with a fine opportunity to get closeups of the crumbling earth next to your face, and nothing else."[49]

Of course, the fundamental question was how to bring the war home: how to tell the world what the mud, blood, and fighting were like. And everyone discovered the same thing. You could not. You had to live it. "I guess you have to go through it to understand its horror," said Bill Mauldin. "You can't understand it by reading magazines or newspapers or by looking at pictures or by going to newsreels."[50] "Why don't somebody write it right?" wrote Audie Murphy. "Why don't somebody put it so everybody can see men cringing in the snow like miserable, frightened and frozen rats, wondering whether the krauts or the cold will get them first." And then he answered, despite his own book-length attempt, "Nobody can. You've got to live it."[51]

The consensus was that the people at home and the soldiers before they went into combat all thought of war in a certain way. They had read books, they had seen pictures, and they had imagined a lot. The war turned out to be different. "The men can see the roofless houses, the burned-out houses," wrote John Steinbeck of the American troops' first view of war. "They have seen pictures of this and have read about

it, but that was pictures and reading. It wasn't real. This is different. It isn't like the pictures at all."[52]

The real front could not be found in a magazine or on a movie screen. "It didn't look at all the way I had imagined the front would look," wrote Margaret Bourke-White of one landscape. "We drove into a little birch grove that a Sunday-school class would pick for its yearly outing. During our whole course along the front lines we traveled from one little cluster of trees to another, each grove looking more suited to picnic baskets than cartridge cases."[53]

Occasionally, of course, the front did live up to expectations. "The place looked like the end of the world," Bourke-White said of another front. "Here were the ghosts of blasted trees, great trunks split and smashed as though a giant hand had picked them up in bundles and dropped them broken back to earth. As far as the eye could reach was wasteland, pitted with shell holes, channeled with trenches, littered with the remains of war."[54] But on the earlier trip the front had not looked like that at all.

Dickey Chapelle barely even recognized the front when she was deposited on it. She told a story about photographing on Iwo Jima:

> Finally the lieutenant pulled the truck to one side and cut the motor. "End of the line," he breathed. "This is it right now. . . ."
>
> I was never more disappointed in my life.
>
> I knew no editor on earth would accept a picture of a truck and a man on a track in the sand as showing a front line. And that was all I could see.
>
> But, wait a minute. If I climbed up on top of one of the sand ridges, I'd overlook half the island. . . . At last gasping for breath, I reached the top of the ridge. . . .
>
> I realized I'd forgotten to ask the lieutenant the most important question of all. In which direction lay the front lines? I thought [of an easy] solution. I'd take four sets of pictures, each in a different direction. One set and probably two was bound to show the front properly. . . .
>
> It was hot now and the wind carried a shout over me. But it didn't sound as loud as my own breathing or the noises of bugs. . . . I realized I was really frightened now. . . .
>
> By the time I finished the last set of pictures, I could hardly steady my hands on the camera. I knew what it meant when people said

they felt their skin crawl. I was heart-in-throat glad to leave the ridge.

The lieutenant . . . fixed me with a steely glare. . . . "*That*—was the goddamndest thing I ever saw anybody do in my life! Do you realize—all the artillery and half the snipers on *both* sides of this fucking war had ten full minutes to make up their minds about you?"

Chapelle flew back to Guam that evening, slightly chastened, and told the story to her tentmate who asked, "You mean, the island was so quiet all the way across that you could do a thing like that?"

"I don't know, but I did."

"There hasn't been a lull like that since the fighting started. It's news that it happened. Think hard now. Tell me every sound you heard on the top of that ridge."

"A tank fired once. A man shouted. I breathed real hard and there were wasps and I could hear the shutter of my camera click."

"There were what?" . . .

"Wasps. . . ."

She said gently . . . "I guess somebody will have to tell you . . . There is no insect life on Iwo Jima. It's a dead volcano."

My voice squeaked, "You mean, those weren't—" . . .

"They were not wasps," she said with finality.[55]

The question remained that if one was to attempt to bring the war home, to try to depict life on the front lines, what did one photograph? And especially, did one take pictures of the dead? Casualties were always a touchy subject. What does one show and tell the mothers? What does one tell the soldiers who are preparing for their own battles? Verbally the issue could be finessed. One could release information that initially gave only generalities—"casualties were light, moderate, heavy during the engagement"—while stressing the more positive aspects—"which succeeded in holding the position, pushing the enemy back, gaining the objective." Photographs—it was trite to say—were black and white on the subject. Either they depicted the dead or they did not.

At the beginning of World War II, the policy of picturing the dead was identical to that of the previous world war. One could publish photographs of the enemy or even the Allied dead. But not of American boys. Even photographs of destruction to "things" American were looked at

askance and released with caution. It was a year after Pearl Harbor until the United States had been shown some pictures of the calamity—pictures of roiling smoke, belching fire, and twisted ships. But the navy never (to this day) showed the most terrifying pictures—of the burned and contorted human wreckage.[56]

Then in mid-1943, President Roosevelt, the military, and the War Department reversed the time-honored practice. American soldiers *could* be shown bleeding, dying, and dead in the picture press. The War Department and OWI decided that the time had come for Americans to see the reality behind the carved names on sun-dappled monuments in hometowns across the country. But, as Newsweek wrote, "The pictures were unbelievably stark. . . . Photo editors gulped. Never had the War Department or the Office of War Information been so cooperatively frank." Much of the media across the country were uncomfortably ambivalent. The *Seattle Post-Intelligencer* said, "[We want] no sugar coating of the war [nor] stomach-turning pictures." On the one hand, gore sold papers; but on the other hand, no paper wanted its readers to lose their breakfast over the front page. "I personally try to select pictures that will go down well when I have my coffee in the morning," commented Thomas Dickson, acting photo editor of the *New York Daily News.*[57]

Some newspapers welcomed the decision with open arms. "We are anxious to get more of these pictures," said the *San Francisco News.* Others seemed blasé. The New York tabloid *PM* admitted, "We've printed more gruesome pictures." And the *Boston Traveler* argued that they had seen no new unusual or grim war images. "But," they promised, "when such pictures are available, we'll use them."[58] In the grand scheme of things, *PM* and the *Boston Traveler* were right. The pictures that were released were hardly the depths of hell. Yes, they were a little more explicit and, yes, they did show the dead. But the censors made certain that the dead or grieviously injured could not be identified. No faces were shown. Faces were cropped out, blackened in, or obscured by shadows. Names on uniforms and division patches were retouched out. No one could say after looking at one of these photographs, "That's my boy."

They were pretty restrained, given what *could* have been pictured. The photographs did not show the same devastation that the men at the front saw. There were no dismembered carcasses, there were no faces with hunks missing, and no eyeballs with flies crawling on them. The soldiers could not understand what all the fuss was about. When asked, they were in favor of letting the home front know the truth. "It seems

to me," one airman said to Steinbeck, "that the folks at home are fight-
ing one war and we're fighting another one. They've got theirs nearly
won and we've just got started on ours. I wish they'd get in the same
war we're in. I wish they'd print the casualties and tell them what it's
like."[59]

In September 1943, the authorities released three of the first photo-
graphs under the new ruling. One was a field-hospital scene that cen-
tered on the freshly amputated stub of the leg of a soldier that had been
shot away. Another showed the mangled, bullet-ridden bodies of Amer-
ican paratroopers in Sicily. But the most famous photograph—the one
that is remembered not only for being one of the first published pictures
to show dead Americans but for being a beautifully composed, artisti-
cally gripping image—is the one taken by *Life* magazine's George Strock
on Buna Beach in New Guinea (figure 22). The photograph pictures
three U.S. soldiers sprawled in the sand of the beach, washed by the
surf and overtaken by the tide. Two are laying face down. The third is
on his back, but his head is hidden by the height of his chest. *Life* ran
the photograph full page, full bleed, in its September 20, 1943, issue. An
editorial ran opposite defending its publication. "Here lie three Ameri-
cans," it began.

> What shall we say of them? Shall we say that this is a noble sight?
> Shall we say that this is a fine thing, that they should give their
> lives for their country?
> Or shall we say that this is too horrible to look at?
> Why print this picture, anyway, of three American boys dead
> upon an alien shore? Is it to hurt people? To be morbid?
> Those are not the reasons.
> The reason is that words are never enough.[60]

Seven months previously *Life* had run the story of the fight on Buna
Beach, of which this was a picture. The editorial continued:

> Last winter, in the issue of Feb. 22, we told about Bill, the Wis-
> consin boy; how he struggled through the dark and nervous jungle
> of New Guinea, stalking Japs like a cat; how he came at last to the
> blue sea at the rim of the jungle, and ran out onto the white beach,
> blazing mad; how the Japs got him there, suddenly, when the job
> was almost finished, so that he fell down on the sand, with his legs
> drawn up; and how the tide came in. . . .
> And we said then that we thought we ought to be permitted to

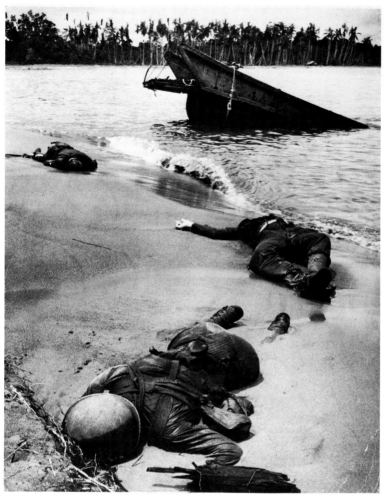

22
George Strock
"Here lie three
Americans. . . ."
Life, September 20, 1943

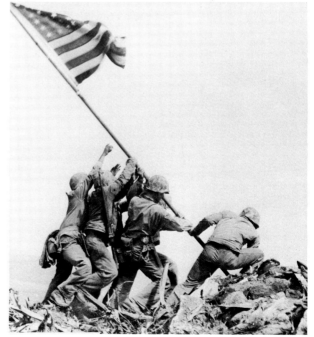

23
Joe Rosenthal
"Marines raise flag atop Mt. Suribachi.
This is the dramatic picture made by
AP Photographer Rosenthal.
It was second flag raised on peak,
which was still under fire."
Life, March 26, 1945

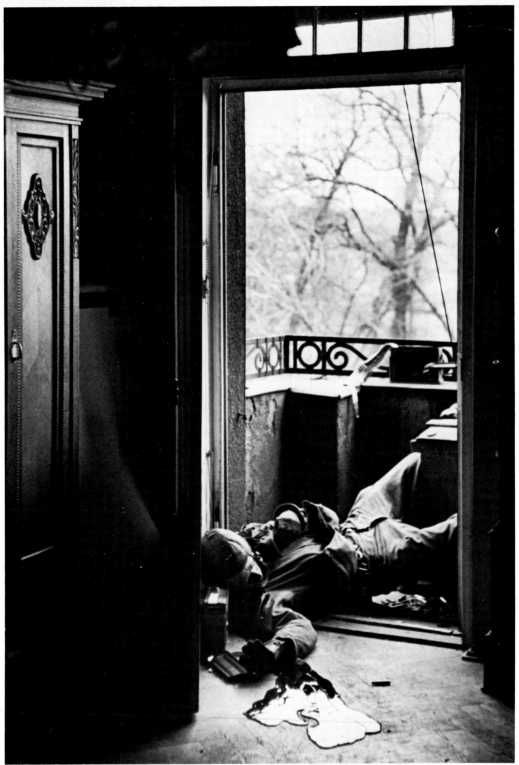

Magnum © Robert Capa

24
Robert Capa
"Blood starts flowing from soldier's forehead forming pool on floor.
He died instantaneously."
Life, May 14, 1945

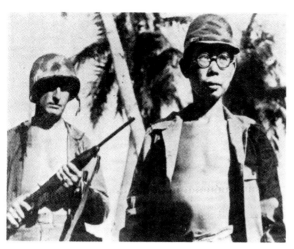

25
U.S. Navy
"Jap captive: For the first time
they quit in large numbers."
Newsweek, July 2, 1945

26
Ralph Morse
"A Japanese soldier's skull is propped up
on a burned-out Jap tank by U.S. troops.
Fire destroyed the rest of the corpse."
Life, February 1, 1943

LIFE MAGAZINE © *1943 Time Inc.*

National Archives

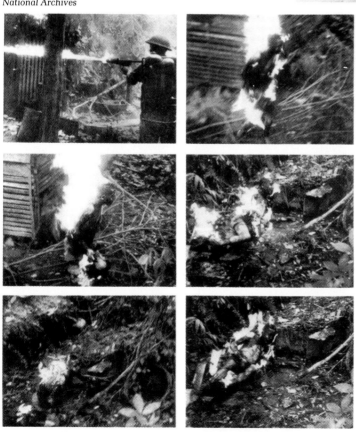

27
U.S. Signal Corps
"A Jap Burns."
Life, August 13, 1945

John Florea
"After execution, spies lurch and sag forward from the posts.
The cement wall is pocked with bullet holes.
The prisoners refused the ministrations of a U.S. chaplain.
They kept up their nerve by singing patriotic German songs.
After they were officially pronounced dead,
the spies were cut down by MPs, carried away and buried."

Life, June 11, 1945

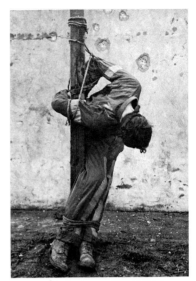

29

U.S. Signal Corps
"In ruined Norman town a Frenchman (in cap)
exhibits body of German he killed.
German had forced him to work for equivalent
of two dollars a week."
Life, July 3, 1944

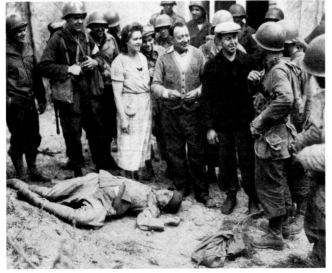

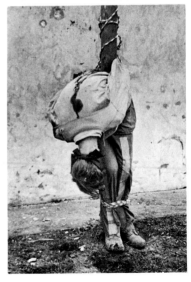

National Archives LIFE MAGAZINE © 1945 Time Inc.

30
U.S. Navy
"Pearl Harbor: A gigantic fireball
blossoms hideously
behind wrecked planes
at the naval air station."
Newsweek, December 14, 1942

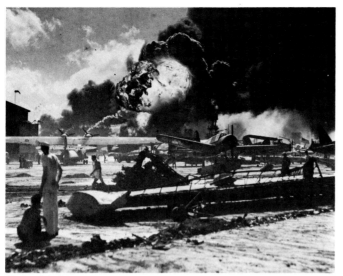

National Archives

31
W. Eugene Smith
"The scene of demolition Iwo Jima symbolizes is the saga of battle that in years
to come will take on the epic quality of Roncevaux, Agincourt and Gettysburg.
Blown up into this column of smoke is a blockhouse and some stubborn Japs
who would not leave their hiding place, although invited by the Marines
to surrender quickly."

LIFE MAGAZINE © 1945 Time Inc.

Life, April 9, 1945

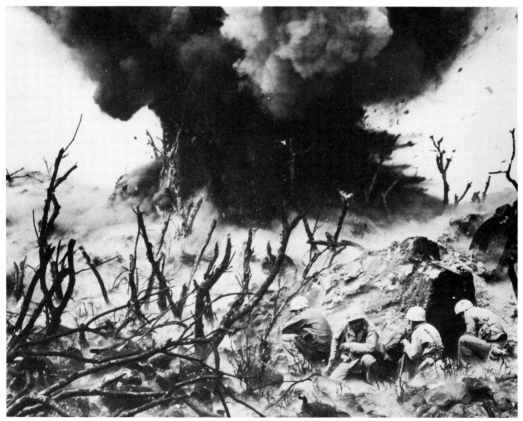

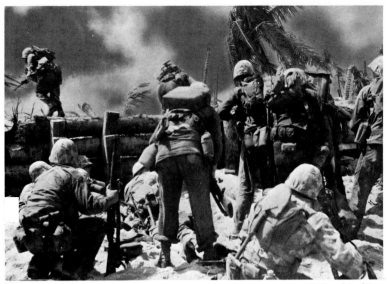

32

U.S. Marine Corps

"Over the top of a coconut-log retaining wall goes a U.S. marine while his comrades, crouching low or firing, prepare to follow him. This picture, taken from water's edge, shows entire 20 feet of beach in which marines had to operate before they came to wall which surrounds all Betio."

Life, December 13, 1943

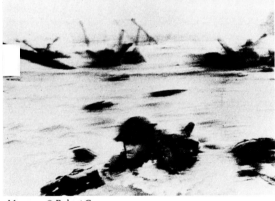

33

Robert Capa

"Crawling through the water, U.S. soldier edges toward the beach. Immense excitement of movement made Photographer Capa move his camera and blur picture. The Germans were still pouring machine-gun and shellfire down on the beach, apparently from concrete pillboxes."

Life, June 19, 1944

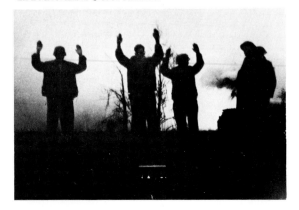

34

George Silk

"Glow of burning houses and haystacks lights battlefield as prisoners . . . head for the rear."

Life, December 18, 1944

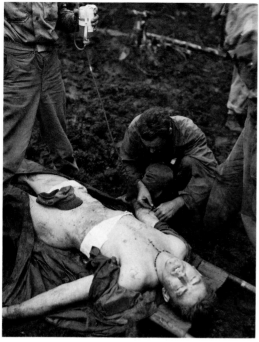

National Archives

35
U.S. Marine Corps
"Crucified to a stretcher by
Japanese bullets during
the invasion of New Britain,
this Marine is given blood plasma.
Have you donated any blood lately?"

Look, February 20, 1945

36
U.S. Signal Corps
"Drama in Blood: A tense
American soldier pours plasma
into a wounded companion
in Sicily."

Newsweek, September 13, 1943

National Archives

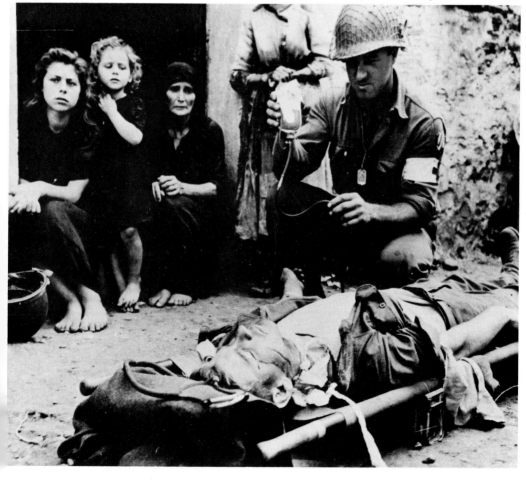

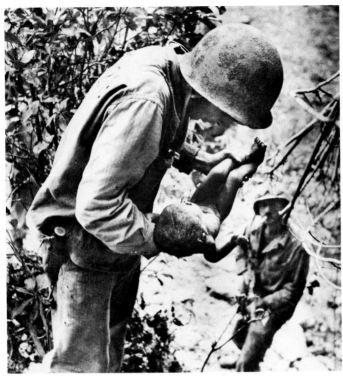

37
W. Eugene Smith
"Only living person among
hundreds of corpses in one cave
was this fly-covered baby
who almost smothered
before soldiers found him,
rushed him to hospital."
Life, August 28, 1944

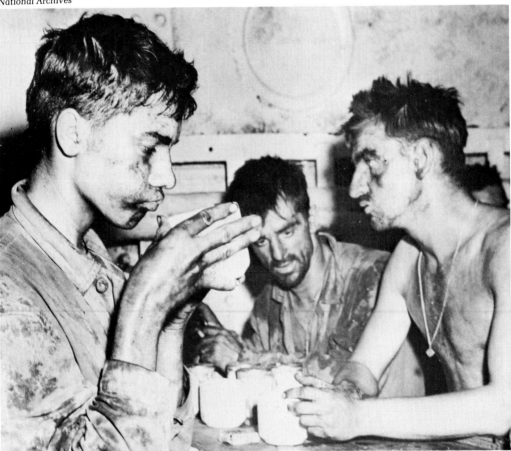

LIFE MAGAZINE © 1944 Time Inc.
National Archives

38
U.S. Coast Guard
"The conquerors of Eniwetok—
after two days and two nights
of fighting."
Life, March 20, 1944

show a picture of Bill—not just the words, but the real thing. We said that if Bill had the guts to take it, then we ought to have the guts to look at it.

Well, this is the picture.[61]

The letters to the editor came in torrents. One came from a lieutenant who had fought at Guadalcanal and another came from a private in army camp in Mississippi. Most supported the editorial and the publication of the photograph. "Your Picture of the Week," wrote one, "is a terrible thing, but I'm glad that there is one American magazine which had the courage to print it." " 'Three dead Americans on the beach at Buna' is the greatest picture that has come out of the war," said another. Rather than depress Americans, the photograph seemed to inspire them. They did not see only the loss; they saw instead, as directed, the death of men fighting for "freedom." And, to them, the fact that men had died for it made freedom only that more precious, that more essential, that more urgent. "I served in Guadalcanal," wrote the lieutenant, "and the real and only heroes of this war are the fine American lads who have made the supreme sacrifice for freedom and their homes." The final lines of the editorial reinforced this. "All we can do," it said, "is give meaning to their death. And this is to say that when freedom falls, as it has here on the beach at Buna, it is our task to cause it to rise again." The sentiment touched a chord. "This editorial," wrote the private, "is the first thing I have read that gives real meaning to our struggle."[62]

The precedent had been set. By D-Day on Normandy, three-quarters of a year later, pictures of mutilated and dead Americans were appearing in the nation's press with some regularity. Such photographs had a measurable impact on the everyday American. After the Buna Beach photograph was published, one man wrote to say that after he had put up the picture on his office's bulletin board, the number of employees who participated in payroll deductions for war bonds rose from 55 to 100 percent. And after a photograph of a row of shrouded Americans laid out for burial on the Normandy beach appeared in Life one woman wrote, "I have never seen a more heart-searing picture. . . . Pictures like this do more to wake us up than bombs dropped on our cities."[63] Photographer George Rodger told of being stopped often in the course of his week by people who had seen his photographs and who wanted to discuss his view of the war.[64]

The photographs and the photographers—and through them the American public—bore witness to the monstrous in war. The photo-

graphs still, perhaps, did not add up to the reality of war at the front, but, after 1943 and the decision that the blood and guts of Americans could be splashed across the home-town press, the image of war mirrored more truthfully the reality of it.

And Why

For the journalists, the front was not only a place, it was a state of mind. "Driving forward," wrote Margaret Bourke-White, "every quarter of a mile has a kind of increased significance. No one has to tell you that the enemy is near. If you were lifted out of lower Broadway and suddenly placed there, you would feel the presence of the enemy through the pores of your skin."[65] Visiting the front, going to war, was a religious ritual. It inspired awe, as well as fear and trembling.

But the fear was not always oppressive or debilitating. The conquering of fear for a correspondent could be invigorating. "I will have to admit," wrote Ernie Pyle, "there was an exhilaration in [war]; an inner excitement that built up into a buoyant tenseness seldom achieved in peacetime." For some journalists—Pyle and Robert Capa were prime examples—war became an addiction, a drug that their minds and bodies craved. They couldn't let go. "The outstanding thing about life at the front . . ." said Pyle, "was the feeling of vitality, of being in the heart of everything, of being a part of it—no mere onlooker, but a member of the team. I got into the race, and I resented dropping out even long enough to do what I was there to do—which was write. I would rather have just kept going all day, every day."[66] "If you didn't get killed," concluded photographer George Silk, "[World War II] was really a very enjoyable time for a hell of a lot of people including me."[67]

They loved the urgency of meaning their lives were given. They loved the edge that being on the edge gave to their work. They got high on the war and were sickened by their addiction. It was the classic love-hate story. Capa would curse a quiet day without battle because it meant no pictures and then curse himself again for being a vulture hungry for photographic carnage. Correspondents struck machismo poses—even the women—with one eye on their image and another on their story. Ernest Hemingway was their hero. (Capa called on Hemingway in the emergency room of a London hospital. And, as Capa proudly related, the hospital staff, after hearing him call Hemingway "Papa,"

took to calling him "Mr. Capa Hemingway."[68]) But because they *were* scared, they *were* horrified, they had to act tough, for as W. Eugene Smith said, "It's what you think of yourself that keeps you going."[69]

Writers—even "Papa" Hemingway—could always cheat. It was a frequent occurrence during the drive across Europe to see print correspondents sprinting to just inside the city-limits sign when a town was under attack so they would qualify for the prized dateline: "In Cherbourg" or "In Cologne." But photographers had to be on top of the action to get their pictures. "If your pictures are no good," said Capa, "you aren't close enough." Some thought that they could afford to get that close because their cameras offered them a strange immunity. The camera was a shield; as long as they peered through the lens, they were on the outside looking in—they could not get hurt.

But, of course, if they were close enough to shoot a picture, they were close enough to get shot. Some did. As was often said, a dead photojournalist cannot send any stories, but a photographer who stayed behind in the officer's mess couldn't either. "The trouble with taking photographs when the air is full of lead," reminisced Gene Smith after being wounded on Okinawa, "is that you have to stand up when anyone with any sense is lying down and trying to disappear right into the earth. I got to my feet. . . . The next thing I remember was a spiral ringing in my ears and I knew . . . I had been hit." For a wounded photographer, the process of getting medical help was surreal. After being hit, Smith observed the activity around him, but for the first time he was not photographing the procession of the wounded from the field to the hospital bed; he was the one being photographed. "How many times I have photographed a corpsman standing over the same kind of smashed body," he reflected.[70]

Bourke-White, a woman and, therefore, presumably more sensitive to the horrors of war, was often asked how she could photograph the ghastly scenes that defined her job. "Sometimes I have to work with a veil over my mind," she replied. At another time, she said that when she was photographing Buchenwald, "I kept telling myself that I would believe the indescribably horrible sight in the courtyard before me only when I had a chance to look at my own photographs. Using the camera was almost a relief; it interposed a slight barrier between myself and the white horror in front of me."[71]

The barrier the camera interposed was so complete that Bourke-White felt no emotion while she was operating the camera. It was only afterwards that she felt the impact. "It is a peculiar thing about pictures of this sort," she wrote, speaking of some graphic photographs she had

taken in Russia. "[I] consider focus and light values and the technique of photography, in as impersonal a way as though I were making an abstract camera composition. This blind lasts as long as it is needed—while I am actually operating the camera. Days later, when I developed the negatives, I was surprised to find that I could not bring myself to look at the films. I had to have someone else handle and sort them for me."[72] The confrontation with horror was essential to a war photographer's work. But to deal with the horror day after day as a matter of fact, to seek it out as a necessity of the job, photographers had to block themselves off from its corrosive effects. They could seal themselves off from the emotion, as Bourke-White did, or they could rationalize it—claim the photography was for a greater purpose—as others did.

Edward Steichen thought his photographs could make a difference. "I had gradually come to believe," he said, "that, if a real image of war could be photographed and presented to the world, it might make a contribution toward ending the specter of war."[73] Smith had the same faith. "Each time I press the shutter release," he said, "it was a shouted condemnation hurled with the hope that the pictures might survive through the years, with the hope that they might echo through the minds of men in the future—causing them caution and remembrance and realization." "I would," he said at another point, "that my photographs might be, not the coverage of a news event, but an indictment of war."[74] Steichen, Smith, and others used their photography for a moral purpose or, in Carl Mydans's words, "behind [the camera] there must be a man's eye, and a soul."[75] To these photographers their images were truthful pictures of news events, but they were also symbols in the fight against war, in the endeavor to explain man to man. "Everyone's got to have a crusade, or they haven't lived," said Silk. "I was going to save the world by my photographs."[76]

During World War II, most photographers were "engaged"; they may have used their cameras to shield themselves from the extremes they were picturing, but they fervently believed in America and in the American cause. Many of the photographers of the war came out of the 1930s tradition of documentary photography. Mydans, who had worked with Roy Stryker at the Farm Security Administration, believed that the experience "deeply affected my life. . . . I'm a documentary photographer no matter what I do. The instinct to document something runs so deep in me that whatever I do it comes out."[77] Documenting the soldiers in war was an expansion of these photographers' prewar project of documenting the people of the United States. It was a continuing attempt to reaffirm and repossess the democratic ideals of the country.

The Photographers: A Model Partnership

During the succeeding wars, in Korea and Vietnam, the photography of combat came to be an exposure of America's and Americans' limitations; during World War II, the photography of Americans at war was still an affirmation of what was possible.

Initially, when the war began, photographers focused on the group—the American team—that by fighting together was going to whip the Krauts and the Japs. And although that sense of common purpose and common action was never lost—the ultimate World War II photograph was a celebration of that united effort: the raising of the flag at Mt. Suribachi on Iwo Jima—there was a shift to examining the trials and successes of the individual. Journalists Ernie Pyle, Bill Mauldin, Richard Tregaskis, Bob Capa, and Gene Smith wrote about and photographed the men with whom they came into contact, showing their simple dreams within the context of an overwhelming war. Each man they encountered was an individual with unique hopes and fears, yet each also stood for the whole of America. In the microcosm could be found the macrocosm. Each was individually recognizable but, taken together, the men were so alike as to be anonymous. The common democratic cause was still served and it was all the better served for their being individuals.

Steichen, Smith, Silk, and Mydans were not primarily photographers of war, they were photographers of people. To make the vast dehumanizing panorama of war comprehensive, they focused on the individual caught in the maelstrom. How have war's "big bloody tracks" obliterated the little man? They studied people—soldiers and civilians—under the extreme stress of battle. They photographed the individual who was lost in a world not of his own making and one which he could not change. They photographed not war itself, because it was impossible to photograph anything as amorphous and intangible as "war," but war as it was blown back and reflected in the faces of the men. They photographed the emotion that war evoked in the hearts and minds of the victims and the observers. The camera completed the images.

The reason for the emphasis on the individual was simply that the mind could not take in the whole. The terror and the noise of the bombs, the horror, and the number of casualties were so overwhelming that one had to fasten onto something small and ordinary and comprehensible. The individual soldier and his struggle for survival became the symbol of the war. To describe it all one started with numbers and bombs and fire and smoke and ended up with a simple story of one soldier on the very last day of the war against Germany. Capa took a picture of him (figure 24). "The last man shooting the last gun," he said,

was not much different from the first. . . . But the boy had a clean, open, very young face, and his gun was still killing fascists. I stepped out onto the balcony and, standing about two yards away, focused my camera on his face. I clicked my shutter, my first picture in weeks—and the last one of the boy alive.

Silently, the tense body of the gunner relaxed, and he slumped and fell back into the apartment. His face was not changed except for a tiny hole between his eyes. The puddle of blood grew beside his fallen head, and his pulse had long stopped beating. . . . I had the picture of the last man to die.[78]

9

The Photographs:

An Inspiration to Sacrifice

The Publications

"FUNDAMENTALLY, public opinion wins wars," wrote General Eisenhower in a memorandum distributed in the worrisome days before D-Day. In a draft version of his statement, the general had continued: "In his Farewell Address, George Washington said: 'It is essential that Public Opinion be enlightened.' What was true then, is doubly true now in this day of global war."[1] Americans in both the government and the military realized from their experiences during the Spanish-American and First World wars that the waging of military and industrial war could not prosper without a concomitant waging of war at the psychological level. That battle, they recognized, was most effectively waged in the pages of the press.

Officials had long noted that the distinctive contribution of the press during wartime was less the dissemination of news and more the manipulation of public opinion. The government and the military, then, believed it behooved them to feed the press such information as would create the opinions and attitudes they desired. To that end, during World War I and, to an even greater extent during World War II, government and military officials "managed" the distribution of the news. The press had few options but to submit to their direction. Total war demanded a patriotic sacrifice of truth—even at the price of a loss of journalistic integrity. Both willingly and grudgingly, the publishers, editors, reporters, photographers, and broadcasters concurred that the "man-

agement" of news was merited, although some did express their distaste for a policy that forced them to render service for the perceived "common cause." Publisher Henry Luce of *Time* and *Life* complained in 1944 that the meaning of freedom of the press was no longer self-evident. Luce thought that "big government" controlled the news—not so much by its censorship as by its flooding of the news channels with handouts, communiqués, and military photographs.[2]

The World War I pseudo-objective style of reporting that argued that one could be factually honest while remaining partisan had been discredited in the years following that conflict. By World War II, there was an even greater interest in disseminating the facts of war, and the official military bulletins and the laconic prose of the wire services still served to reinforce that interest. Captions appended to the picture agencies' photographs also tended to emphasize the factual details of the images.[3] But the imperative commitment to total war and the new belief that objectivity had never been a journalistic possibility—even if it were a desirable one—made the members of the press considerably more pragmatic than they had been during World War I. As early as 1922, Luce had written in his prospectus for his newsmagazine *Time*: "The editors recognize that complete neutrality on public questions and important news is probably as undesirable as it is impossible, and are therefore ready to acknowledge certain prejudices which may in varying measure predetermine their opinions of the news."[4]

By World War II, the members of the press had lost their naïveté. They were conscious—as they had not been previously—of the repercussions of abandoning their objectivity in favor of all-out support of the war effort. They recalled from World War I that being partisan meant telling only a partial story, but most were careful not to fall into the trap of intentionally faking the news to bolster the American side. They faced with relative equanimity the interesting dilemma of wanting to protect their credibility as reporters, photographers, editors, and publishers, while slanting the news in such a way as to aid the Allied side.

Editorials, news stories, and photo-essays unabashedly championed the American cause. Luce was particularly vocal in expressing his support for the war effort throughout the pages of his publications but differed from his colleagues in the press by criticizing the government's handling of it. Ten days after Pearl Harbor, Luce wrote President Roosevelt, "And in the days to come—far beyond strict compliance with whatever rules may be laid down for us by the necessities of war—we

can think of no greater happiness than to be of service to any branch of our government and to its armed forces. For the dearest wish of all of us is to tell the story of absolute victory under your leadership." *Life*, as longtime reporter and editor Loudon Wainwright believed, became "a sort of national house organ." But together with its cheers of support for the American cause, Wainwright recalled, "*Life* exposed embarassing shortcomings in war production, quarreled with military tactics and grand strategy and in 1944 came out strongly for the Republican Thomas Dewey."[5]

Luce had submitted with ill grace to the Democratic administration's management of the press; in retaliation, he used the pages of his periodicals as a forum to air his disagreements with governmental policies. Luce was a Republican and Presbyterian idealist; he believed in progress, in capitalism, and in the American Way of Life. With the missionary zeal learned from his father, he set out to educate America by his lights. In an era dominated by New Deal Democrats (including most journalists), Luce was hostile toward Roosevelt. He grew to hate FDR so much that when FDR died in 1945, Luce put Truman's face on the cover of *Life* rather than Roosevelt's. And inside, the caption for the photograph of FDR read, "People will remember Roosevelt for his smile"—not for his New Deal nor for his winning of the war, but for his "smile." The final lines of *Life*'s editorial said: "It will be different history without him. Now it is for us to make it better."[6]

Luce, the premier magazine publisher of the era, also differed from the majority of his colleagues in the press by virtue of his paramount interest in Asia. During a war in which most of the eyes of the United States were focused on Europe—Pearl Harbor notwithstanding—Luce had his firmly trained on China and the Far East. In an article published in February 1942, Luce wrote his prescription for "America's War and America's Peace." "I select," he said,

three relatively simple concepts as keys to the whole.

First, the *instrument of victory* is American production.

Second, the *condition of victory*, which is most important because least understood, is a complete, unswerving partnership between America and China.

Third, the *imperative of victory* is American leadership. The war must be mostly America's war, mostly American-managed, mostly American-fought and mostly American-won.[7]

That "most important" partnership should not be with Great Britain or any one of America's other European Allies, Luce believed, but with China.

Luce's obsession with Chiang Kai-shek's China colored Time-Life's publications through the Vietnam War. During World War II, his interest led his periodicals to run stories on the Pacific war in prime space. He sent top correspondents to the Asian war when the wire services and other newspapers and magazines were reserving their best people for the European theater. He religiously championed the at-times questionable Philippines and Pacific campaign of General Douglas MacArthur.

But Luce could only work within the constraints of what the military and his own correspondents gave him. All members of the press complained heatedly about the censorship of the news, but few, other than Luce, found the American leadership as embodied in Franklin Roosevelt so onerous. The rest of the influential press—the wire services, the photo agencies, and the periodical press with representatives abroad— kicked less against the Democratic administration's management of the news. But, then, few other news organizations had the political power or journalistic genius of a Luce behind them. Luce's mastery of events was so great that it was said: "Things happen twice in America. Once when they happened and then a week later in *Life*."[8] Not coincidentally, of all the places to work to cover the war, *Life* was the place to be. The brilliant photographer W. Eugene Smith, famous or infamous for resigning from *Life* not once but twice, conceded, *"Life* was really the only outfit to work for if you covered a war. They had the greatest freedom, the greatest power, and the best expense accounts!"[9]

At bottom, the controversy in the press was over the collection and dissemination of the news. The news was perceived by all, and rightly, as being as vital a matériel of war as dollars, bombs, and soldiers. During World War II, members of the American press had greater access to battles than they had during the earlier worldwide conflict. They knew more facts than they had known in 1917 and 1918, but, if anything, the Second World War was more "total"—and the need for propaganda greater. As a result, the news itself—at best an elusive commodity— was subjected to a comprehensive prodding and pummeling to shape it into a manageable substance. Under guidance from the military and civil officials—and with the conformity of the press—written facts were omitted, glossed over, and recast into the image of what the officials wanted.

It was both easier and more difficult to control the photography of

war than it was to manipulate the verbal reportage. It was easy for officials who controlled the censorship and accreditation of the war-photography pools to prohibit any images that depicted subjects which the military and civil officials believed to be harmful to the war effort. Yet because photographs are nonverbal documents, it was more difficult to control the reception of those photographs that were published. Captions, of course, could help to direct the opinions of viewers, but, ultimately, war photographs made an impact on the strength of their imagery.

The control over the reception of war photography was especially difficult in those new periodicals that emphasized photographic essays over the more traditional text-heavy articles. In newspapers and publications like *Time* and *Newsweek*, in which photographs were generally limited to single illustrative images, a photograph was subsumed by the mass of copy surrounding it. In the newer photomagazines, however, photo-essays took precedence over verbal articles. Captions and copy became mere appendages to the photographic stories—important, yet second seen. The experience gained by flipping through the pages of *Life* or *Look* was visual, not verbal, and any opportunities for the manipulation of a viewer's photographic experience were themselves visual controls.

When censors blue-penciled articles, therefore, they retouched photographs. However, the airbrushing of pictures had come a long way since the heavy-handed days of the earlier wars when photographs were so retouched that they looked like paintings. In World War II, retouching was less aesthetically offensive. Some few images had street signs and uniform name tags indetectably brushed out, and a few other pictures had indistinctly hazed-out features of the dead, but most often the photographs that were passed were not retouched but censored. A flat gray bar or a flat gray field covered any objectionable portions of the image—a more honest approach to censorship because it was obvious even to the casual glance that the image had been tampered with.

The censoring of the actual images and their accompanying captions was the extent of the official control of photography. Much discretion was left to the editors and publishers of the periodicals in which the photographs appeared. Editors could enhance the impact of a picture by running it on a cover or by playing it large on the right-hand side of a double-page spread. They could subtly shift a photograph's meaning by surrounding it with other images or texts of corroborating or conflicting subjects. And they could ignore a picture altogether. But compared to the wholesale rewriting of the verbal reportage, the photo-

graphs remained relatively untouched. Carl Mydans noted: "I think that *Life* magazine, without any question, was a reflection of the editors. But the editors didn't affect what the photographers said about their pictures: the caption. And I'm not aware that they ever cropped my photographs to make a point. They used my pictures as I took them. And they sometimes shortened but they never changed the meanings of my captions." But Mydans did admit that not everyone at *Life*, and certainly not all the photographers covering the war for the picture services, were so fortunate: "I'm not one who thinks they were editorially treated poorly. There are many who do think so, however."[10]

"Most picture stories at *Life*," remembered Loudon Wainwright, "were discovered or somehow dreamed up by non-photographers. And once the photographer had made his or her absolutely crucial (and often deeply personal) contribution to the job, the editors took over. Generally speaking, photographers did not select the pictures that were used in the stories (they usually played little or no part even in deciding which pictures the editors would see), and they had little or no say about the emphasis pictures were given or the space their stories got in the magazine. Likewise, photographers were not consulted about the writing or the headlines in the stories, even those stories that had originated with them."[11] Even at *Life*, photographers took a back seat to editors; their pictures received respect and acclamation, but they lost control over their own work.

Not all the magazines that used illustrations treated photographs alike. *Life* was the only one with a commitment to telling the news pictorially. *Look*, the other prominent, specifically photographic magazine, often laid out its photographs in a similar format to *Life*, yet its photo-essays consistently covered features rather than breaking news. Since World War I, the major picture periodical *Leslie's Weekly* had died, and the other long-established magazines such as *Collier's* and the *Saturday Evening Post* were less responsive to hard news stories than they had been during the previous conflict. Their new emphasis was on short fiction and longer serials; their nonfiction pieces were scheduled months in advance. *Life's* chief competitors, then, in the pictorial reproduction of breaking news were more often the news magazines *Time* and *Newsweek*, which always scattered photographs throughout their publications and which frequently used several images as illustrations for a single article.

Time and *Newsweek* followed the traditional approach to magazine photojournalism. Previously, even picture magazines had illustrated their articles with discrete, individual images that were largely un-

related to one another. The new photomagazines created in the mid-thirties, such as *Life* and *Look*, however, laid out their photographs in a sequence; they relied on photographs—rather than on text—to tell a story. Pictures were run large and simply. Photo layouts were clean and modern looking with an effective use of complimentary typography and white space. No longer were figures silhouetted out of photographs or blocks of type routinely dropped on top of them. Picture stories and picture sequences developed themes with the resulting product often being greater than the individual parts. And in *Life*, at least, photographs had to be "newsworthy" as well as graphically strong. Photomagazines initiated a new respect for the photograph.

The new periodicals were successful because their photographs were. *Life*, especially, the first of the American photo-essay magazines, was more than just popular; it was a triumph beyond anyone's wildest speculation. Its astonishing celebrity from the moment it hit the stands in November 1936 "turned Time-Life into an empire and [founder Henry] Luce into an emperor."[12] In the days before television, *Life* was the kind of journalistic *succès fou* that television was eventually to become. Luce had discovered the American craving for photographs. He then simultaneously proceeded to exacerbate that need and to supply the fix.

Life covered war and war covered *Life*. As Luce said: "*Life* magazine didn't start out to be a war magazine, but that's what it became."[13] In its very first issue, *Life* ran Robert Capa's photographs of the Spanish Civil War. Later issues carried articles about the Chinese-Japanese conflict. And when war was declared on December 7, 1941, *Life*'s publisher, Roy E. Larsen, wrote to its subscribers: "With the beginning of the Second World War, LIFE has undertaken a new and grave responsibility—the responsibility of recording for the American people what may well prove to be the most crucial era in the history of the world—and the responsibility of helping America see with its own eyes what it means for the world to be at war."[14]

Life's journalism, the new photojournalism, thrived on the visual richness of war. Luce, Larsen, and the editors of *Life* took the time and space to describe small incidents of the war in depth—the didactics of *Life*'s layout and sequential photographs meant that it could make a small topic seem important and a large topic appear accessible. Luce's exploitation of the photographic cover story, for instance, drew his audience into new issues, conferred importance on those issues, and ensured the audience's engagement with them.

With increased respect for the photographs came a rise in status for

the photographer. *Life* began publication with five photographers—Margaret Bourke-White, Alfred Eisenstaedt, Thomas D. McAvoy, Peter Stackpole, and Carl Mydans, who, together with later staff photographers such as Robert Capa, became stars in their own right. *Life* was *the* showcase for the photojournalists' talent. *Life* attracted the best.

The most direct American forerunner of *Life* and the rest of new thirties' picture magazines had been the *New York Times's Mid-Week Pictorial*, which first appeared in 1914 as a "pictorial war extra." Throughout the twenties, *Mid-Week Pictorial* continued its publication as a rotogravure weekly with thirty-two pages of regular news pictures. Sold in 1936 to Monte Bourjaily, it was converted into a larger magazine with a more attractive picture format that featured the new photo-essays, as well as the single images emphasized previously. The revamped publication appeared on the stands in October 1936, one month before *Life*'s maiden issue. Although its circulation jumped from 30,000 during the period of the *New York Times*' ownership to a new high of 117,000, it did not approach the 1 million mark of *Life*. Concluding that he had misjudged the market, Bourjaily suspended *Mid-Week Pictorial*'s publication shortly after the appearance of *Life*, again to restyle it. It never resurfaced.

Look, first a monthly then a biweekly, appeared on the newstands two months after *Life*. No slavish imitator of *Life*, *Look* had evolved from the rotogravure section of the Des Moines *Register and Tribune*. Acting on the results of a survey conducted by George Gallup, the Cowles family who owned the paper began printing series of photographs in their rotogravure section rather than the single images run previously. The response was so favorable that Gardner Cowles, Jr., began planning a separate magazine, *Look*. Cowles and Luce even traded ideas about the publication of a photographic magazine because they never regarded their two periodicals as competitors. Each man had staked out different turf. In *Look*, Cowles aimed for a mass-market audience through an emphasis on features, while in *Life*, Luce attempted to appeal to a more cultured audience that was interested in hard news and the arts and sciences. Ironically, although the mass-market–aimed *Look* "consistently sold up to the limit of its press capacity," *Life* garnered a much larger circulation.[15]

The concurrent success of the two magazines spawned numerous imitators with equally monosyllabic names: *Click*, *Pic*, *Foto*, *Picture*, *Now and Then*, *Focus*, and *Photo History*. Varying in format, emphasis, and quality, some achieved substantial success but none, other than *Life* and *Look*, survived much beyond the Second World War. "As it finally

emerged," wrote journalism historian Theodore Peterson, "the picture magazine was the result of at least five influences. The illustrated week-lies at home, the illustrated magazines from abroad, the movies, the tabloid newspapers, and advertising photography all combined to pro-duce the picture magazine. They were helped by technological ad-vances in printing and photography."[16]

Before the mid-1930s, it was impossible to publish high-quality pho-tographs on the expensive coated stock needed for clarity under weekly or biweekly deadlines at a cost that was not prohibitive. Normal inks used in high-quality reproductions were loaded with linseed oil and dried by a slow process of oxidation. Any speedup forced the presses to switch over to cheap paper and resulted in smeared images. However, in the mid-thirties, a printing company in Chicago, the Donnelley Com-pany, which coincidently printed Luce's *Time* magazine, was tinkering with a new press that had a built-in heating system, which enabled the ink to dry as the paper was being printed. At the same time, a new ink with a petroleum base, called Flash-dry ink, was found to be appropri-ate for high-quality reproductions. The only sticking point was a paper that was fine enough for the type of reproductions desired yet cheap enough for a mass-circulation magazine. A new machine-coated paper had just been invented but not yet put into production. Luce heard about the new possibilities and pressured the printing company to run some trial sheets of *Life* through a jury-rigged operation. The results were all that could be desired. Fearful that someone would beat his new photomagazine to the stands, Luce gave the go-ahead, even when it appeared that the company would initially lose money by having to use expensive coated stock until the machine-process paper was on the market.

The new glossy magazines of World War II had almost more in com-mon with their counterparts from the Spanish-American War than with those periodicals published during World War I. Whereas the quality and size of the photographs reproduced in World War II photo-magazines were reasonably similar to those from the First World War, the information appended to those images was much more specific than it had been during the extreme censorship of that war. Once again, as had been the case during the Spanish-American conflict, photographs carried credit lines acknowledging individual photographers or their organizations, rather than just saying "Passed by the Committee on Public Information." Captions also were precise, often dating, locating, and identifying the subject in the image. World War II photographs that said only "Our Heroes at the Front" (a typical caption in 1917–18) were

more likely to be found opposite the editorial page than accompanying a news article. Moreover, photographs published during World War II were less overtly propagandistic than those of World War I. Of course, this was not to say that they were not propaganda; they were just a more insidious form of it. As *Life* admitted in a self-advertisement run in November 1942: "LIFE serves as a force in creating a sound, practical Psychological Front in the common, united effort to win this war and world-wide freedom." The advertisement was headlined, "There are two ways to learn about war." "People who live where the war breathes hotly in their faces have an intimate knowledge of what war means. . . . We Americans . . . must get our inspiration to work and sacrifice through facts we read and hear."[17]

Life believed that Americans at home should not be shielded from the horror of war. To that end, the propaganda of World War II was radically different from that of the First World War. In 1917 and 1918, Americans were protected from seeing the worst of war. They saw few bodies and few scenes of raw action. The intent of the censorship was to encourage the belief that the war was not so bad, that the United States would inevitably triumph. The war was short, and few real sacrifices had to be made. World War II, however, called for a major commitment of resources, more than could be skimmed off the top. Hence, the propaganda needs changed. Americans needed to learn that an all-out effort was demanded; one way of doing so was to show them how lucky they were compared to the Polish, the French, or the British. "LIFE," the self-advertisement had continued,

> has shown how Greeks starve to death, how Russians are hanged by the invading Nazis, how Poles and Frenchmen have been deported to work in Germany's slave-labor gangs. LIFE has illustrated and described the suffering of American soldiers on Bataan, the miseries of women and children in Belgium, Norway, Holland, and the Balkans. And never has LIFE glossed over the horrors that stalk in the wake of the Axis aggression, but has shown war as it really is . . . stark, brutal, and devastating.[18]

For the first time, in a concerted premeditated fashion, Americans at home witnessed the constants of war—they looked upon violent death, torture, and wounding. All the news and photomagazines joined in exhibiting those horrors formerly seen only on the battlefields. *Life* wrote: "In the regular course of its fact-reporting of the world, LIFE shows its readers in vivid picture-story form what this war *looks* like, *feels* like, and *does to people*."[19]

The Aesthetics

Long before America's engagement in World War II, *Life* magazine was publishing pictures of the opening salvos. In early 1938, *Life* introduced a photo-essay by Robert Capa on the Spanish Civil War with these words:

> Once again LIFE prints grim pictures of War, well knowing that once again they will dismay and outrage thousands and thousands of readers. But today's two great continuing news events are two wars—one in China, one in Spain. . . .
>
> Obviously LIFE cannot ignore nor suppress these two great news events in pictures. As events, they have an authority far more potent than any editors' policy or readers' squeamishness. But LIFE could conceivably choose to show pictures of these events that make them look attractive. They are not, however, attractive events. . . .
>
> Americans' noble and sensible dislike of war is largely based on ignorance of what modern war really is. . . . The love of peace has no meaning or no stamina unless it is based on a knowledge of war's terrors. . . . Dead men have indeed died in vain if live men refuse to look at them.[20]

Over four years later, in September 1942, *Life* ran a series of grim photographs from the Western Desert. Readers wrote in to complain. "I would like to enter my protest," said one woman from Washington, D.C., "against such depressing realism which only the most morbid among us can find interesting." "I have just purchased the Aug. 31 LIFE," another woman wrote, "and will destroy it, having seen the pictures which are disgusting in their graphic portrayal of the horrible side of the life our soldiers are forced to lead." In response, *Life* reiterated its statement from the 1938 issue: " 'Dead men have indeed died in vain if live men refuse to look at them.' LIFE still maintains that position."[21]

Life's attitude foreshadowed official government policy. In spring 1943, James Byrnes, chief of the Office of War Mobilization, "disturbed at public criticism of rationing and wage and manpower controls, suggested to the President that more photographs showing the ordeals of the men on the fighting fronts might harden home morale." Roosevelt

223

passed the message to the War Department, which decided to appoint the aggressive head of the Signal Corps photographic unit in Long Island, Colonel Melvin Gillette, as the new chief of the Army Pictorial Service. At Gillette's urging, the war theaters were instructed to facilitate frontline shots by Signal Corps and civilian photographers. The navy was also convinced to cooperate. Slowly, beginning in September 1943, a trickle of photographs showing wounded and dead American soldiers and sailors was released to the press.[22]

Americans at home began to agree with the rationale. Instead of complaining about the stark pictures in a photo-essay, most letters to the editor now supported the new candor. In reaction to Life's article "It's a Tough War," one reader said, "The pictures are grim. But it's a lot easier to look at a picture than at the real thing, as the boys over there are doing." And a soldier wrote to say, "The pictures clearly portray the bitterness and grimness of the battle to be fought before we reach Berlin and Tokyo. It also brings home the realization of their responsibility in doing all they can to support the boys with bonds and work on the home front."[23] Such letters seemed to substantiate the opinion of OWI that the publishing of graphic pictures would improve morale. By the fall after the decision, much of the press was still cautious about printing the "stomach-turning" pictures on the grounds of "taste and decency," but OWI was more commited than ever to the policy: "The people will be shown that Americans also get killed—that this is not an armchair war."[24] Almost a year after Life had written an editorial berating the government for its creation of a phantom "happy" war, where "you don't let out any more bad news than you can help—and you can count on the headlines to play up the good news," the happy war in America was collapsing.[25]

In the opening weeks of World War II, before the calculated official destruction of the "happy" war, press stories on the American war dead printed studio portraits of the men, rather than candid photographs taken from action. Studio photographs, it was thought, were less disturbing to Americans at home; such portraits admitted the tragedy of young men's deaths, yet they did not allow the specific horror of men dying in war to be communicated. Respect was paid, but American attitudes were not challenged. The pages showing the World War II dead were similar to those formal pages of American dead published during World War I and the Spanish-American War; they pictured banal images that carried captions with the names of hometowns and next of kin. Two weeks after Pearl Harbor, on December 22, 1941, Life ran two pages of those killed during the Japanese surprise bombardment. Most of the men were in uniform, and most of them were smiling. Life laid

out the portraits in ruled rows on a black background; its only acknowl-
edgment of Americans' loss of naïveté during the twenty years between
the two world wars was reflected by the fact that the maudlin "Dulce
Et Decorum Est Pro Patria Mori" headline of World War I was replaced
by *Life*'s straightforward banner, "Killed in Action: These Men Fell
First at Hawaii."

Soon, however, isolated photographs of flag-shrouded coffins substi-
tuted for the remote-from-war studio portraits. In its February 23, 1943,
issue, *Newsweek* printed a Wide World photograph of a burial at sea.
The image pictured men standing at attention, an honor guard with
rifles raised in salute, and a chaplain with Bible in hand. Six sailors
tilted a flag-covered bier; the white body sack slid out from underneath
the Star and Stripes into the water. The caption stated, "Killed in action.
Casualties were few in the far Pacific action."[26] The war, it was already
evident, would be a long and difficult one, even if "casualties were
few." Photographers, censors, and editors spared nothing in their at-
tempts to rally the country behind the war effort. The American flag
was an especially powerful symbol to use in that attempt.

The American flag had been a symbol of challenge during the
Spanish-American War and a badge of honor in the First World War.
During the Second World War, the flag was employed as a reminder of
home and, more specifically, as a reminder of the need to defend the
American way of life. During World War II, there was not the gratuitous
gallantry of the Spanish-American War, there was not the naive enthu-
siasm of World War I, but there was, still, an unabashed patriotism ap-
parent in the ubiquitous display of the colors. The American flag was
never far from the pages of the press. *Life* magazine alone, aside from a
flag-draped coffin featured on the cover of its Fourth of July issue in
1943, ran two other covers during the course of the war that exhibited
the Stars and Stripes waving in the breeze; one was in black and white
two weeks after the declaration of war, and the second was in color for
the July 4 issue of 1945. And the most famous photograph of the war—
of *any* war—centered on the raising of the American flag on the Pacific
island battleground of Iwo Jima. "I still think of it as our flag," recalled
the photographer, Joe Rosenthal, forty years later. "That was just the
way I thought about it. I still don't have any other words" (figure 23).[27]

The patriotism evident during World War II shielded Americans from
the horrors of war even when those horrors were published for all to
see. By contrast, Americans' loss of patriotism during Vietnam made
that later war's photographs that pictured dead and mangled Ameri-
cans much more difficult to take. In the Southeast Asian war, there was
no stimulant of patriotism that could raise the morale at home precisely

because the evidence of the war was grim. In Vietnam, the sentiment became "cut our losses." Conversely, in World War II, the attitude was "the cause is worth the sacrifice." In its July 5, 1943, flag-covered coffin issue of *Life*, the magazine set aside twenty-three pages to list the army and navy servicemen who were killed in action or died of wounds in the first eighteen months of the war. On the list were 12,987 names, together with the addresses of their next of kin. At the end of the list was an editorial, "The American Purpose." "This is the list," *Life* wrote.

> Those are the boys who have gone over the Big Hill.
>
> Those are the names in the telegrams flashed over the long, sagging wires—"Regret to inform you . . . your son . . . killed in action. . . ."
>
> The people who get these telegrams ask a question: and this question is one that everybody in America must answer, and this question is WHY?
>
> What is it that called them over the Big Hill? What is that purpose? . . .
>
> It matters a great deal what *we* say the purpose is, it makes all the difference in the world: indeed, it is for us to decide whether he died for the fulfillment of a purpose, like the boys of the American Revolution, or whether he died for the fulfillment of practically nothing, like the boys of World War I. The dead boys will become what we make them. . . .
>
> And this purpose for which our nation was founded, and in which our nation has persisted, is TO MAKE MEN FREE. . . .
>
> This is the answer to the question that is raised by the people who get these telegrams from the Adjutant General.[28]

"The dead boys will become what we make them." *Life* never wrote truer words. The American dead of World War II, like those of the Spanish-American War (no images of American dead were published during World War I), never lost their dignity in those photographs that were published during the conflict. Throughout World War II, the dead still died for a worthy cause in which all Americans believed. Although pictures of dead Americans during the Vietnam War often called into question the morality of the war and its participants, photographs published during World War II never did. The difference was that the photographs from Vietnam had a reference point that implicitly opposed the actions of war to the actions of peace. Often, a dichotomy was set up within an image itself that was unacceptable to civilians at home:

dead bodies festered while soldiers stood oblivious. Occasionally the reference point was to be found in the common values held by the viewing public; all found something horrific in the naked agony of a young man holding his buddy killed just moments before. But during World War II, no similar juxtapositions were established. The presumption of patriotism sweetened the bile even of any potentially antipathetic images of dead Americans. American soldiers remained heroes in death.

There was, however, considerable change over time in the aesthetics of those images of death, even though there were only two years in World War II during which such pictures were allowed to be published. Whereas at first the pictures of casualties were little more explicit than the head-and-shoulder studio images that had previously represented the dead—and certainly no more explicit than the famous blanket-shrouded photograph of Sergeant Hamilton Fish in the Spanish-American War (see figure 1)—by the end of the conflict, pictures of the dead portrayed more of the "unvarnished facts" of death. The vividness of death was made more explicit, but the context of those deaths remained fundamentally positive.

This change in aesthetics denoted a basic change in the official policy formulated to influence the attitudes of Americans at home. In those two years, the United States began to win the war. Initially, the government wanted to depict American bodies fallen in combat to help "harden" the resolve of the public at home. But as the war's victories became American and Allied rather than Axis ones, the coverage could afford to communicate the imperatives of war while still protecting the identity and the dignity of the "fallen heroes." "There's always a difference," remembered *Life* photographer Carl Mydans, "in photographing war when we're winning and when we're not winning."[29] The military and the press became less cautious about the public's sensibilities; the photographs of the dead became more candid.

The first combat photograph of a dead American in the pages of *Life* appeared on August 2, 1943, in an article entitled "First Pictures of Sicily Invasion." The image, taken by *Life*'s Bob Landry, pictured a windswept beach and a soldier, back to the breeze, gun in hands, standing to one side of a stretcher. Lumps under a blanket were all that told of a dead soldier. The caption read: "On the beach near Gela an American stands guard over a fallen comrade."[30] Not quite two years later, the last combat photographs of a dead American killed in the European theater, taken by Capa, appeared in the article "End of War," May 14, 1945. Part of a series of images shot in Leipzig, the photographs pictured a machine gunner killed by a German sniper. In succeeding images, the

227

American manned the gun, then fell; the puddle of blood from his head grew larger and larger. "Blood starts flowing from soldier's forehead forming pool on floor," said the caption to the last, strongest image. "He died instantaneously" (see figure 24).[31]

Landry's photograph of the soldier guarding his fallen comrade recalled those photographs taken of dead Americans during the Spanish-American War (see figures 1 and 4). In Landry's photograph, as in the earlier images, the shock of the subject matter was blunted by the picture's uninspired composition and its decorous depiction of death. Capa's photograph of the fallen machine gunner, by contrast, was perturbing. The photograph recollected the strong chiaroscuro imagery of an Alfred Hitchcock film: light strakes through an open door, the dead man sprawls on a balcony framed by curls of iron grillwork, blood forms a shiny black mirror on the gritty parquet floor. The photograph would not have been inappropriate on the cover of a thriller; it is unambiguous in its representation of death, yet mysterious and obscure about the details. Capa's final photograph alone tells the story detailed by the other images in the series.

The Second World War photographs of the enemy dead were not as protective of the dignity of man. In fact, most pictures of the enemy, alive or dead, intentionally called the humanity of the foe into question. The Japanese, in particular, were viciously stereotyped in the pages of the press. Seconded by the government, the press exacerbated Americans' racist attitudes. Articles and photographs built up the case that all "Japs" were alike; they exploited the ethnocentricity of Americans who "could not tell them apart." An article in Life appeared two weeks after Pearl Harbor instructing the United States on "How to Tell Japs from the Chinese." With photographs of Japanese and Chinese marked for telltale physiognomic features, the copy pointed out psychological distinctions as well. "An often sounder clue" than facial appearance, one caption mentioned, "is facial expression, shaped by cultural, not anthropological, factors. Chinese wear rational calm of tolerant realists. Japs, like General Tojo, show humorless intensity of ruthless mystics."[32]

To illustrate articles on the enemy, editors chose photographs that emphasized and reinforced this stereotyped image. Toward the end of the war, for example, a navy photograph that accompanied a Newsweek article entitled "At Last Some Japs Are Giving Up but Bloody War Still Lies Ahead" could not have pictured a more stereotypical Japanese soldier than if the photographer had put out a call to Central Casting (figure 25). The photograph looked like an outtake from the movie The Sands

of Iwo Jima. Out-of-focus palm trees wave in the background and a firm-jawed U.S. soldier with an open shirt, helmet askew, and rifle at the ready stands behind his "Jap captive." The Japanese, in the extreme foreground of the image, gazes myopically out of the frame. His round black glasses, buck teeth, and weak chin—the only elements of the photograph in sharp focus—all underscored the notion that the Japanese are an inferior race.[33]

In a more overt campaign to discredit and dehumanize the enemy, articles and photographs appeared in the press to document Japanese atrocities. Pictures of the Bataan death march and a captured snapshot of a Japanese officer in the act of beheading an Australian flyer received universal attention. Other pictures, when they surfaced, were widely printed. Two pictures illustrated a March 1942 story in *Newsweek* entitled "Hong Kong Blood Bath." One showed a Japanese soldier straddling the beheaded body of a Chinese man; in one hand the Japanese held a sword, in the other he grasped the severed head. The second image pictured a half dozen Japanese in a ravine bayonetting bound but live human beings. Scores of other soldiers looked on. The captions reminded, "Acts in China such as beheadings . . . and bayonet drill with live targets forewarned of Japanese cruelty."[34]

With such cruelty as their defense, Americans felt appallingly few compunctions about treating the Japanese similarly—and publishing the evidence of that treatment. Even the remarkably sympathetic Carl Mydans found himself caught up in the emotions of the times. "I am still aware," he said, "of how vindictive I was when we liberated my prison camp in the middle of the night. [He and his wife had been imprisoned in a Japanese camp upon the fall of the Philippines and had been traded two years later.] The Japanese refused to open the gates, and we went through on tanks—I was on the back of one. It was a highlight in my life—it's not a proud highlight. But I'm telling you that, because one must understand that one cannot be involved in a war and stand apart from it. Photographers and war correspondents are not apart from the conflict they're in, they're part of the conflict."[35]

A more extreme example of that attitude came out in the controversy surrounding one of the "classic" images of the war—the photograph taken by *Life*'s Ralph Morse of a Japanese skull speared on top of a wrecked Japanese tank (figure 26). The photograph appeared in *Life* on February 1, 1943, in a story on "Guadalcanal: Grassy Knoll Battle." Two captions neatly finessed the question of how the skull happened to be where it was. One explanation, dropped on top of the full-page, full-bleed, right-hand photograph, said: "A Japanese soldier's skull is

propped up on a burned-out Jap tank by U.S. troops. Fire destroyed the rest of the corpse." The second caption, on the facing left-hand page, stated: "On one Guadalcanal beach U.S. troops knocked out a Jap tank. After it had stopped burning, the Americans advanced to investigate it. What dropped out is shown at the right."[36]

Forty-three years later Morse defended his picture. "The photographs that became a classic," Morse recalled,

> pretty much happened in front of you. I don't think you made them classic. If you call pressing the button, ok. Like the picture of the skull on the tank. I had nothing to do with it. Sure as hell I didn't pick it up and stick it there. It was there. Now, whether some GIs went by earlier in their walk through the jungle or whether it was the Japanese who put it there, no one knows. No one's ever owned up to it. What I'm trying to say is, you don't plan. It was there.
>
> We were walking through the woods, and we came to this little clearing where the tank had been stopped and obviously this guy had climbed out or his head had been blown off—I don't know what happened. It was there, and then we kept going. At that moment it was no classic. At that moment it was a picture you take because you're there to do it. If you don't shoot it you're a dope.[37]

Three issues later, *Life* ran two indignant letters to the editors. "Words fail to express fully my feelings after seeing the picture of the dead Jap in your Feb. 1 issue," wrote in one man from Ohio. "Of all the pictures that have appeared in your heretofore fine magazine this is the most uncivilized, repulsive, morbid, barbarous, sickening, foul, nauseous, horrid, obnoxious, abominable, odious, offensive, shocking, disgusting, malicious, revolting, savage and vulgar." A second reader, from Philadelphia, concurred, believing it to be "the most terrible picture I have ever seen. Are we cannibals or headhunters to display the foe's skull on a spear? The cruelty of war is no excuse for sadism. You better leave that kind of stuff to Hitler and Tojo." *Life* editors responded to the two letters by supporting the photograph's publication. "War is unpleasant, cruel and inhuman," they averred. "And it is more dangerous to forget this than to be shocked by reminders."[38]

Two weeks after the readers' letters appeared, three more letters were published on the subject—two from servicemen. The first letter, from a man in Indiana, commented, "I say that the sickening carnage at Pearl Harbor on the morning of Dec. 7, 1941 made pictures that were infinitely worse. The burned Jap in LIFE is small retribution for such

scenes. If Messrs. Rosner and Jacoby [the former letter writers] had been there, they might appreciate the grim humor of the men who put that skull on the tank." The second letter, from a corporal, also responded to the earlier writers. "In regard to [the query] in your Feb. 22 letters column: 'Are we cannibals or headhunters to display the foe's skull on a spear?' I'd like to answer that question. I am in the Army and as far as the Axis is concerned, I am both for the duration." The third letter, from a lieutenant in a bomber squadron, also disagreed with the February 22 sentiments. "If Readers Rosner and Jacoby had seen the dead American and Australian soldiers that I and my squadron saw in New Guinea after their 'capture' by the Japs, they would realize that dead Japs make good pictures regardless of how they died."[39]

Images of skulls of Japanese and of burned Japanese surfaced frequently over the course of the war. One notorious photograph that ran in *Life* as a "Picture of the Week" showed an attractive American woman writing a thank-you note to her navy lieutenant boyfriend. His present to her, which perched on the side of her desk, was a Japanese skull. Another image in *Life*, taken by George Strock, pictured a Japanese soldier emerging from a foxhole. A flamethrower had melted his face and shoulders.

One of the most egregious examples of wartime cruelty to appear in print ran in the last issue of *Life* before the Japanese surrender, August 13, 1945. (Issues were always postdated.) The page-long photoseries, concisely titled "A Jap Burns," depicted six frames of an Allied soldier torching a Japanese soldier to death (figure 27). The effect was of slow-motion photography; the extended caption acted as subtitles to the event. 1. "Australian soldier on Borneo uses flamethrower on Jap hiding place." 2. "Moment later Jap who wouldn't quit ducks out enveloped in flames." 3. "With liquid fire eating at his skin Jap skitters through underbrush." 4. "Blind and still burning he makes agonized reach for support, falls." 5. "He tries to crawl, falls again. Flames have already consumed clothing." 6. "After one last effort, the Jap slumps in his own grisly funeral pyre." In each frame, viewers witnessed the excruciating death of a man. They saw the grimace on his face and his hand reaching to hold his belly, to protect his genitals.[40]

Such photographs—the Japanese skull on the tank, the torching of the soldier—when published, appeared to some Americans as representing not an act of war but a hitherto unthinkable atrocity. Propaganda and rampant hatred toward the Japanese, however, made such images acceptable. But no similar images appeared of the German enemy. In the midst of the war against Hitler, the American government

still protected that enemy that shared the skin color and cultural heritage of the mass of Americans. No photographs of *caucasian* bodies *mutilated* by the Allies were ever printed. Photographs exist and were published of German corpses, and historically the publishing of photographs of charred "white" enemy corpses can be traced back to the picture of the Spanish gunner during the Spanish-American War (see figure 6). But in those cases, the deaths were the result of the "normal" actions of war—the bodies that were exhibited in the published photographs were not "mutilated" by Allied hands. Even the World War I image of the trenchful of German skulls and bones (see figure 16) was part of the "natural" course of war. In that scene, the men died and turned to skeletons where they lay; the bones were clean, no leathered skin hung in strips from a skull speared on top of a tank.

The World War II photographs of the German enemy most analogous to the series of the burning Japanese were pictures documenting the execution by firing squad of three captured German spies (figure 28). However, the photographs were only released by the War Department and appeared in *Life* a month after the surrender of the German forces, although the executions had occurred the previous December after the Nazi breakthrough at Bastogne. In a series of nine images taken by *Life* photographer Johnny Florea, the process of the executions was traced from the prisoners walking out to their blindfolding and death at the stake. The close-up images, though horrible, pictured a traditional and universally applied form of death; compared to the flamethrower's modern twist of killing by burning a person alive, death by a volley of bullets to the heart is quick and relatively painless. The Germans also appeared to deserve their fate; whereas the burning Japanese was a regular soldier in combat, the Germans were killed only after being captured as spies in American uniform and tried by military court. A final difference between the two photographed incidents was that the series on the Japanese was passed before the end of the conflict in the Pacific; the pictures of the Germans were held until after the European war had ended.[41] The restraint of Americans toward the German enemy contrasted sharply with the vindictiveness of Americans toward all Japanese—enemy or American resident.

The published photographs of Germans killed by Americans were only moderately explicit—especially in comparison to the published images of the dead Japanese—but grotesque images of atrocities perpetrated by the Germans appeared in the American press. Perhaps the most graphic to appear, before those taken during the liberation of the concentration camps, were photographs from the Polish Ministry of In-

formation showing naked, dead Russian soldiers and Polish and Jewish civilians heaped in carts and tumbled into mass graves. These photographs and the ones printed three years later when the Allied troops began entering areas of former German occupation were numbing in their scope. The German pictures were the equal of any published images of Japanese atrocities; indeed, of the photographs that were published in the United States, the horrors perpetrated by the Germans appeared more brutal than those of the Japanese. If pictures were published from both camps showing attacks on American and Allied soldiers, only pictures explicitly depicting the *Germans'* systematic murder of children by starvation or torturing of women by slicing off their breasts were published in major magazines. (Although, again, many of these latter pictures were published only after the European conflict had ended.) *Look* wrote in its article "Lest We Forget," "The pictures on the next four pages are enough to open anybody's eyes—permanently. They are shocking, sickening, and as unforgettable as nightmares. But they are not nightmares. They are actual German atrocities."[42]

Despite this knowledge and publicity, the Japanese were still treated more harshly in the pages of the press than were the Germans. Racism is the only viable explanation for such treatment. No articles appeared teaching how to tell the Germans from the Dutch. No photographs were published of Germans slowly frying to death. In fact, most images of dead Germans followed the identical conventions as those of the American dead: a refusal to show identifiable faces or extreme forms of death. The most explicit photograph of a dead German—because the man's face is clearly identifiable—may well have been a Signal Corps picture of a dead German surrounded by Allied soldiers and French townspeople (figure 29). The photograph was printed both in *Life* and in *Look* during the summer of 1944. *Life* captioned it: "In ruined Norman town a Frenchman (in cap) exhibits body of German he killed. German had forced him to work for equivalent of two dollars a week." *Look* said: "How Hitler's manpower crisis grows: here he lost two men—the dead soldier and the slave laborer (dark jacket) who shot him. The ex-slave is now an Allied fighter."[43]

In the photograph, the dead German soldier lies at the feet of a laughing crowd; he is not obviously wounded, but his ungainly posture signals his death. None of the sixteen soldiers and four townspeople standing over him spare him a second glance; their self-confident gestures and facial expressions tell a story of triumph. The casualness of the grouping lends power to the subject; the incongruity of a corpse beside a crowd clearly enjoying itself would have been a striking novelty to an

American audience unused to the rigors and absurdities of battle on the home front. The photograph is enlightening about the intrusion of war into the daily lives of civilians, yet the picture displays a fairly benign portrait of the enemy. The intent of the photograph is not to garner more hatred for the German foe but to educate its audience about a familiar occurrence in war: the confrontation between the living and the dead.

Photographs of similar confrontations between Americans and dead Japanese were also published during the war, although the images of the dead Japanese differed from those of the dead Germans in that the former pictures were more explicit; the Japanese were invariably photographed bloody and battered. Two pictures, taken a year apart, of General MacArthur looking down at a dead Japanese soldier received attention, an earlier one in *Newsweek*, the later one (shot by Mydans) in *Life*.[44] All three images—the two of MacArthur and the one of the Normandy townspeople—are reminiscent of the World War I photograph of Premier Clemenceau standing over a dead German (see figure 14) and of the Spanish-American War picture of Cuban troops on a beach crouched behind two Spanish corpses (see figure 5). In contrast to the Normandy image, however, the Spanish-American War picture, the World War I photograph, and the World War II images of General MacArthur fail to make incisive comments about "life and death"; they lose credibility as artifacts of war because of their clearly posed compositions. The Normandy image from World War II is the most effective. Both the unconsciousness of the French crowd to the presence of a camera and the perceived fact that the same scene would have occurred even if representatives of the press had not been present make the Normandy photograph a more trenchant picture of war than the other images. It best showed all-American boys caught up in the backwash of war.

The very first photographs of Americans experiencing war appeared in January 1942, released by the navy at Pearl Harbor. In the opening years of the conflict, before the American engagement, the United States had been privy to the contortions of the Europeans and Asians at war, but the threat of combat had been distant. The war only interrupted others' lives. To most in the United States, World War II was someone else's front-page news. But after December 7, the "Day of Infamy," the imperatives of battle touched Americans, too—although it took several months for Americans to see what had really happened. Those first few photographs of Pearl Harbor were distant, across-the-island shots of towers of billowing smoke; it was not until February that the navy provided the first real close-ups of the destruction of the fleet.

Finally, a year after Pearl Harbor, explicit shots of the widespread damage to the Hawaiian-based ships and airplanes appeared in the press.

Some of the photographs released in the several months after Pearl Harbor portrayed the quiescent wreck of the USS *Arizona*, sunk up to its turrets, resting in the bottom mud of the harbor. The images recalled those earlier famous pictures of the Spanish-American warship the *Maine*, demolished in the harbor of Havana; both pairs of photographs showed the massive boats reduced to twisted hulks. But the most dramatic photographs from Pearl Harbor were not the days-after, postmortem pictures but those that showed the Pacific harbor and airfields during the moments of destruction. Fireballs blaze up from the exploded magazines of the USS *Shaw* and *Arizona*, airplanes lie in smoking splinters, and partly clad men watch in horror-struck awe.

A year after the event, both *Newsweek* and *Life* in their issues of December 14, 1942, ran the same official navy photograph of the devastation of the naval airfield at Ford Island: it was one of the few released images of that Pearl Harbor morning to include people. Men in undershirts and boxer shorts race across the field; another man, bare chested, stands next to one crouched—both unconsciously arrested by the black clouds and brilliant fireball covering half the sky (figure 30). *Life* gave a long and depressingly informative caption: "Navy planes on the ramps at Ford Island were hit as gas and oil tanks flamed up behind them. Of the 202 Navy planes of varied types on Ford Island, 150 were destroyed or disabled there by enemy action and of the remaining 52, 38 took off to fight the Japs while 14 were blocked by debris or could not be serviced in time to be of much use during the battle." *Newsweek* was more emotional: "Pearl Harbor: A gigantic fireball blossoms hideously behind wrecked planes at the naval air station."[45]

Fireballs and black smoke came to symbolize the war—especially the war in the Pacific. The world was blowing up: Americans were being blown up, Americans were blowing others up. The malevolent billows of explosives pictured in photographs throughout the war recalled to those at home the evil spewing of satanic volcanoes; "Hell," as some termed it, "was in session." The most effective *Life* cover of the war carried a photograph by W. Eugene Smith of the battle on Iwo Jima (figure 31). An immense, almost three-dimensional black cloud dominated two-thirds of the photograph; at the bottom of the image, four marines ducked behind the burned-out remains of a banyan jungle as they blasted the Japanese out of an underground gun post.[46]

The Smith image was a "classic" war shot. The telescoped, up-close perspective of the camera argued that such an image could never have

been taken in an earlier war, yet the emotional feel of the image was not at odds with the emotional feel of previous conflicts. It was a moment of intense excitement, of patriotism triumphant. The improved technology of the camera and the new power of armaments made the photograph possible, but the sentiments that the picture captured were timeless. The navy image of the Ford air base, although also identifiably from World War II, isolated gestures that would have been conceivable during the Spanish Civil War, World War I, or even the American Civil War. The sensations of men caught in war by surprise are roughly universal, as are the attitudes of men at war as they wait to see the evidence of their destructive actions. The importance of such shots is not that such moments existed or were now possible to retain on film, but that photographers and editors during World War II wanted to evoke emotions about this war that could be connected to traditional attitudes about combat. World War II was a battle of grim necessity; because it was such a necessity, there was a need to draw upon every conceivable resource that would help win the war. And the American interest in reliving those classic moments of wars gone by was one such resource.

But two World War II pictures of billowing smoke had no antecedents and no connections to past wars. On August 20, 1945, in Life's issue announcing the war's end, appeared two hitherto unimaginable photographs: one of the atomic bomb over Hiroshima and one of the atomic bomb over Nagasaki. The photograph of the first mushroom cloud was headlined, "Hiroshima: Atom Bomb No. 1 Obliterated It." The caption elaborated:

> In the moment of its incomparable blast, air became flame, walls turned to dust. "My God," breathed the crew of the B-29 at what they saw. . . . White smoke leaped on a mushroom stem to 20,000 feet where it spilled into a huge, billowy cloud. . . . Then an odd thing happened. The top of this cloud structure broke off the stem and rose several thousand feet. As it did so, another cloud formed on the stem exactly as the first had done. On the ground, from a distance, a Jap saw the explosion. . . . "A lightninglike flash cover the sky," he said. "All around I found dead and wounded . . . bloated . . . burned with a huge blister. . . . All green vegetation . . . perished."

Life titled the second photograph "Nagasaki: Atom Bomb No. 2 Disemboweled It." The caption continued:

This bomb was described as an "improved" type, easier to construct and productive of a greater blast. . . . Unlike the Hiroshima bomb, it dug a huge crater, destroying a square mile—30% of the city.

When the bomb went off, a flyer . . . saw a big mushroom of smoke and dust billow darkly up to 20,000 feet . . . and then the same detached floating head observed at Hiroshima. . . .

With grim satisfaction, [physicists] declared that the "improved" second atomic bomb had already made the first one obsolete.[47]

With surprising candor, Life's editorial in the issue recognized the questions that were to come. "It is bootless to argue," Life believed, "at what stage of modern warfare, or by whom, the old Hague rules of war were violated. The point is that Americans, no less than Germans, have emerged from the tunnel with radically different practices and standards of permissible behavior toward others. . . . We are in a strange new land."[48]

The photographs of that strange new landscape had no referents. In the days before space exploration, images from miles above the earth were uncomfortably otherworldly. The atomic cloud pictures included no hints of the ground-level destruction they had wreaked, yet the enormity of their existence portended ill. A child could do the calculations. If a puff of smoke rising a story high from the ground could kill and maim a squad or platoon of soldiers, a mushroom cloud almost four miles high was apocalyptic. The photographs were awful.

Less cataclysmic in expression, yet still novel in appearance, were the strange new photographs of ground combat in the Pacific. Whereas the World War II photographs of combat in the European theater shared a certain attitude and cast of light with those images taken during the First World War, the photographs from the Pacific theater pictured a different war to American eyes. Photographs from the Northern European campaigns—from France, Germany, and the Low Countries—often had a gray, gritty look to them, partly because of the foggy, snowy landscapes and partly because of the conditions of battle that forced photographers to take their pictures in the morning mists or evening dusk. Even pictures from the sunnier climes of Italy and the Western Desert seemed dusty and "colorless" in contrast to the humid jungle and beach images from the Pacific. A comparison of two photo-essays in Life, one of the marines' fight for Tarawa in late 1943 and the other of the D-Day invasion of Normandy in mid-1944, clearly reveals the differences.

The first article, "The Fight for Tarawa," which appeared in *Life* on December 13, 1943, was illustrated primarily with photographs taken by Marine Corps combat photographers (figure 32). The images, especially on the opening double-page spread, were "action-packed" slices of battle. At the end of World War I, the American people complained that the images they had seen of combat were too "tame." As one observer commented, they wanted to see "men being bayonetted and gassed, and airplanes swooping down with machine guns shooting and flags waving, and shells exploding, and tanks charging, and prisoners being captured 'n everything—all in one picture!"[49] In the photographs of the invasion of Tarawa, that is what the public got. Men crowded the frames of the pictures. Some aimed their rifles, others lobbed grenades; some clambered over walls, others hid behind them to catch their breath. Bombs burst in the distance, making it unclear whether their explosions or a gale-force wind was responsible for the whipping fronds of the palm trees. Sandbags and knapsacks, guns and ammunition crates littered the terrain. Captions to the pictures underscored the chaos of battle: "Over the top of a coconut-log retaining wall goes a U.S. marine while his comrades, crouching low or firing, prepare to follow him. This picture, taken from water's edge, shows entire 20 feet of beach in which marines had to operate before they came to wall which surrounds all Betio." "Marines swarm over blockhouse," said a second caption, "while still exposed to Jap fire from other positions. Only way such a blockhouse could be destroyed was for Americans to fight their way on top of it, shoot down at its occupants. Battered coconut palms lie around, while an oil dump explodes over hill."[50]

Although the photographs were taken in black and white, the range of tonality of the images because of the harsh tropical sun gave a clarity to the subjects that few pictures from the European theater captured. Shadows were black, the sand was white, and faces and uniforms were distinct shades of gray. The Pacific island photographs from such locations as Tarawa brought home a war that was different from any other war that Americans had ever seen. Aesthetically, the images did not look anything like combat photographs taken during any previous American engagements; indeed, they foreshadowed the pictures taken during Korea and the first years of Vietnam. The photographs of troops wading ashore or advancing through the jungle were precursors of the sixties' images of sodden soldiers stumbling through the swamps and undergrowth of Southeast Asia. The mood these Pacific island photographs evoked, the war they reflected, also bore slim resemblance to what was reflected in images from previous wars. The photographs

from the Pacific theater remained cognizant of the "masculine" thrill of war; yet that war, these photographs proclaimed, had changed into a "most dangerous game." The photographs from the European theater still reflected the traditional opinion that armies "battle" armies; even shots of individual soldiers in combat gave an impression of "us against them." In the Pacific, however, a new war emerged; men "tracked down" other men: "it's either me or you."

The photographs from the European theater bore fewer similarities to those taken twenty years later during Vietnam—with the exception of a few experimental color images taken by Life photographer George Silk in Italy that captured the same shock of bright color in the midst of a sordid war present in the early Vietnam photographs.[51] World War II's European pictures were muddy; black shaded off to gray without the crispness of the images from the Pacific and Southeast Asia. The European photographs were the descendants of the images of the First World War, when the quintessential combat pictures consisted of shadowy figures marching through a smoky landscape.

The photographs taken by Robert Capa for the Life article on the D-Day invasion, "Beachheads of Normandy," were such World War I scions (figure 33). Like the Tarawa photo-essay, the Normandy article opened with a half-page of copy and then continued with a strong double-page spread of four photographs. Also like the Pacific campaign's photo-essay, each of the Normandy pictures incorporated a number of soldiers in relative close-up within each image—and in that respect, these photographs differed from the World War I combat pictures that were invariably taken from a distance with a short lens, precluding the possibility of any close-ups of the action. Yet although the D-Day images were active and filled with incident, the details of that action were impossible to distinguish; the photographs were only two toned: black and medium gray. There was no subtle or precise shading of tones allowing viewers to recognize any minutiae of action; even the line between the sky, horizon, and sea was impossible to detect. The D-Day images were unintentionally smudgy—but they were all the more successful in their evocation of the romance of warfare for being so.[52]

Other photographs of the war in northern Europe shared the grayness of these images. Perhaps the photo-essay from the European theater that best covered all phases of a battle was an article and photographs by George Silk entitled "Attack in Holland" (figure 34). The essay, which appeared in Life on December 18, 1944, followed British troops in their crossing of a canal in the Netherlands. The attack began at 4 P.M., already dusk on the western front. The seven pages of pictures

were taken in the rain, fog, dusk, and night. Half-seen figures tramped through a veiled landscape. Trees and tanks, boats and water became one in the amorphous images. High-powered searchlights and burning haystacks were the only illumination during the evening and night; prisoners with hands held high and stretcher carriers with wounded were silhouetted in the glow.

Both the Capa and Silk images communicated the drama of war rather than documented the simple facts of it. Some of that attitude was unintentional; given the problems with which the two photographers wrestled—poor light, extreme danger, and faulty darkroom procedures—their photographs were as clear and explicit as they could make them. But much of the style of the images was purposeful. Both Capa and Silk were non-Americans: Capa was Hungarian, Silk was a New Zealander. Their style of photography was often more obviously romantic (although not naive) than that of their American counterparts who had been weaned on the documentary tradition of the Farm Security Administration. Silk, in an interview forty years after the war, discussed his photographic approach to war, in contrast to that of his *Life* colleague Mydans. "Carl Mydans," recalled Silk,

> was motivated by the spirit of the documentary much more than I was. I was motivated by it, but I also had an incurable streak of romanticism in me, because of the way I was brought up and what I did in New Zealand. My ambition in life was to go to the North Pole. I was living on dreams of [Ernest] Shackleton. Those Victorians who dominated the British scene were my heroes. Here I was being a war photographer and to a great extent being still motivated by those sort of things British. The do or die things. . . . I tended to want to photograph the scene, the big romantic scene—the big bang. . . . Mydans wasn't brought up with that. Those legends didn't have the appeal to him that they did to me. And actually having been in the Farm Security program—Carl's ten years older than me, not quite I guess—Carl practiced a purer reporting and a purer style of documentation than I did.[53]

Mydans, together with other American-born photographers, such as Margaret Bourke-White, were greatly influenced in their war photography by the documentary work done in the 1930s under Roy Stryker. Scenes depicted frontally rather than through consciously innovative perspectives, and events taken with "natural"—diffused—light, were hallmarks of the Depression-era work. The photographers of the FSA

and those who were influenced by their work continued to draw on the documentary style in their photography of war. Mydans, who photographed primarily in the Pacific theater during World War II, continued to be known for his compassionate yet realistic representation of events. Mydans, Bourke-White, and many of the photojournalists in the picture agencies and the military units practiced a photography that was not unaware of the propagandistic needs of the war effort, yet was less *overtly* manipulative of the subjects than had been the photography of World War I. Photographs were more candid than they had been during the previous conflict, but the care exercised in choosing which images to take and which images to publish still resulted in a "selective objectivity."

Photographers such as Capa and Silk drew on the new candid photography of news events popularized in the pages of *Fortune* by Dr. Erich Solomon, but Capa, Silk, and others like them were less concerned with the appearance of objectivity than were their FSA-influenced colleagues. Capa and Silk considered a honest representation of events to be paramount to their photographic reportage, but they did not believe that objectivity was a desirable or obtainable option. "There's no such thing as being unbiased," argued Silk. "You'd have to be a neuter to be unbiased, and if you were unbiased then nothing would be worth reading that you'd wrote or took."[54] World War II would be the last war in which the majority of combat images in the press argued for a romantic element in war. Capa and Silk were surely not the only photographers to emphasize the heroic values in the war; Joe Rosenthal, Hank Walker, and many, if not most of the service photographers, saw a tough poetry in World War II. These photographers, especially, shaped American attitudes toward the war. They helped confirm that the Allies were "fighting the good fight"—that the Second World War was "The Good War."

Magazine editors and the OWI joined with photographers in harnessing combat photographs for the war effort. "To harden home-front morale," *Newsweek* editors wrote, "the military services have adopted a new policy of letting civilians see photographically what warfare does to men who fight." The magazines published pictures of the dead and wounded that manipulated their audience both because of their subject matter and their aesthetic composition. An image that appeared in the February 20, 1945, issue of *Look*, credited to the U.S. Marine Corps, played upon the emotions of its viewers by its depiction of a naked, wounded marine (figure 35). The injured soldier glowed pale white against the other dark figures and the ground. He rested exposed on a

wet poncho on top of a stretcher. His head was tilted back, his eyes were closed, his chest was wrapped in bandages, and his genitals were covered by a soft hat. He lay diagonally across the square image: his head in the lower right, his thighs by the upper left. His left arm reached to the lower left, his right arm was being tended to by a crouching medic. The image is reminiscent of Renaissance paintings of the descent from the cross and the laying out of Jesus' body. The wounded marine's vulnerability, the wound in his chest, and the cross around his neck make the allusion concrete. The caption of the image reinforces the sentiment: "Crucified to a stretcher by Japanese bullets during the invasion of New Britain, this Marine is given blood plasma. Have you donated any blood lately?"[55] This coupling of war imagery with religious iconography was practiced during World War I as well; in both wars, the power of certain photographs—of the wounded especially—was enhanced by the unapologetic borrowing of Christian symbolism.

But much more clearly than was the case during World War I, World War II photographs of casualties showed them suffering under the real traumas of a real war. During the First World War, pictures of the wounded rarely looked believable; the men had been cleaned up; there was no blood, there was no agony. But during the Second World War, as Look magazine wrote, "As the pictures on these pages show, casualties are not statistics; they are men, known and loved. Their torn bodies have been ripped by German and Japanese steel—to date over 600,000 of them. The war is not something in the newspapers; it is the boy from Kankakee, Milwaukee, Houston—bleeding in the mud."[56] During World War II, pictures of the wounded were not posed portraits more suitable for a lifesaving textbook than for a weekly newsmagazine. During World War II, the intention of the photographs of the wounded was not to insulate Americans from the tragedies of war, but to inspire them to greater sacrifice. A photograph in Newsweek from September 13, 1943, for example—even though its subject was similar to the stolid picture of the gassed soldier in the First World War (see figure 12)—was a gripping image of the effects of the violence of war (figure 36). Looking at it, a reader was forced to empathize, forced to care.[57]

The photograph showed a medic holding a plasma bottle over a wounded man on a stretcher. The medic's concern is evident; the wounded soldier is clearly in pain. Yet the intensity of the image comes from the expressions of nonchalance, interest, worry, and solicitude of the civilian observers. Of the three women in the doorway, the oldest, alone, grieves; she, one assumes, has also known hurt and loss. The younger woman on the left looks not at the casualty but at the photogra-

pher; young enough not to be overwhelmed by death, presumably calloused by her proximity to the war, she is interested more in the uncommon spectacle of a photographer than in the photojournalist's wounded subject. The little girl in the middle peers curiously at the face of the man on the stretcher; she is yet uncomprehending of the phenomenon of pain. A fourth woman standing and a man in the distance watch with an air of anxiety. The varied emotions of the three generations of women dressed in black and overlooking the tableau of medic and casualty presented for American viewers a new window on the reality of war. Americans had seen a multitude of images of combat, yet the presence of civilians in this photograph placed the scene within the context of peace and home and family. War, this image affirmed, affects more than just the soldier-participants.

Civilians appeared in many more photographs of World War II than they had during World War I. But the purpose of their inclusion was rarely to document the horrors of battle for those civilians standing in the way, as was to be the case with photographs of Vietnam. As with World War I, most pictures during World War II that included nonsoldiers did so to underscore the humanity of the American GIs. Perhaps the most famous picture of the war to show American soldiers in juxtaposition with civilians was a photograph taken on Saipan by W. Eugene Smith (figure 37). The image pictured a soldier, with his back and side to the camera, carrying an infant. A second soldier, cigarette hanging out of his mouth, rifle at the ready, stood in the background looking at the child. The caption in Life read: "Only living person among hundreds of corpses in one cave was this fly-covered baby who almost smothered before soldiers found him, rushed him to hospital."[58]

The first soldier carrying the infant grasped him by his ankles; his right hand supported the baby's back and head. The gesture was that of a doctor just having slapped a baby's bottom following birth; the implication was that the American GI was giving the child another chance to live. To encourage this belief, Life chose not to report the notes of photographer Smith that further explained: "A baby was found with its head under a rock. Its head was lopsided and its eyes were masses of pus. Unfortunately, it was alive. We hoped that it would die."[59] That comment was more cynical than the published caption about the possibility of life existing in the midst of war. Smith's statement added nothing to further the conception of the American soldier as the savior of humanity. It was ignored.

Although many of the photographs of World War II tried to imply that the GIs were the saviors of—or martyrs for—humanity, many more

pictures, for the first time in an American war, were content to portray the soldier as the boy next door, the father up the road, or, more simply, the common man. What emerged from the photography of the war was a self-conscious democratic aesthetic. For the first time in the coverage of the United States at war, the camera closed in on an individual soldier's face; it recorded the fear, exhaustion, triumph, or indifference in his eyes. Cover stories featuring a head shot of an average infantryman or inside photo-essays of anonymous GIs just eating or stopping by the side of the road emphasized the fact that most of the soldiers in the American forces were not larger than life; they were not supermen who could perform feats of extraordinary endurance without showing the strains of battle. Straightforward, black-bordered photographs of privates taken by Silk on the western front, for example, were a new twist on the FSA documentary portraits of the 1930s. The captions, too, could be artless: "After a week in the line, PFC Alfred Wektor of Holyoke Mass. smiles tiredly"; "PFC John Wauthier, carrying a heavy automatic rifle, is too tired to smile"; "Wincing with fatigue, PFC George Sprouse of Spartanburg, S.C. sits in the snow"; "PFC James Varvard of Brooklyn stoops under load of ammunition, equipment."[60]

Such pictures were the photographic equivalent of the columns of correspondent Ernie Pyle. Photographers and journalists took the same approach. "I liked to work with the platoon," recalled photographer Silk. "Go up, get to know the guys. . . . I knew them all wherever I went."[61] It became one of the new looks of the war, sympathetic portraits of the men even when they were not being heroes. The U.S. Coast Guard took a photograph of the soldiers who fought at Eniwetok Island: three boys not even old enough to be men, mugs of coffee in their hands (figure 38). They stare off into space. Shiny with sweat and begrimed with dirt, they look so exhausted that their faces are distorted with fatigue. The caption in Newsweek acknowledged: "The conquerors of Eniwetok—after two days and two nights of fighting."[62]

Precisely because such photographs of the everyday GI appeared in the press, it became an accepted premise that the war was being fought and won not by the gallant elites of the Spanish-American War nor by the naive doughboys of World War I but by the resolute GIs who knew the odds that they faced yet advanced despite them. The ultimate symbol of common man triumphant was AP photographer Joe Rosenthal's image of six marines raising the flag atop Mt. Suribachi, Iwo Jima (see figure 23). Originally rumored to have been posed because the composition made so ideal a symbol, the photograph was actually a candid image. "It wouldn't have been any disgrace at all," Rosenthal admitted to

the New Yorker less than two months after taking it, "to figure out a compositon like that. But it just so happened I didn't. Good luck was with me, that's all—the wind rippling the flag right, the men in fine positions, and the day clear enough to bring everything into sharp focus."[63]

In a recent interview, Rosenthal told the story behind the photograph he had taken. His was an image of the second flag-raising on top of Mt. Suribachi that morning—the first flag-raising had been documented an hour and a half earlier by Marine Corps photographer Louis Lowery. On D-Day plus four, Rosenthal remembered, "I and a couple of Marine Corps cameramen started up Mt. Suribachi."

I guess we were about a third of the way up when coming down from the hill were several other Marines. One of them, Lou Lowery, who had gone up with the first patrol and taken pictures of the first flag-raising, said, "Aw, you guys are too late." We laughed and said, "Well, we'll see what's up there anyway." And he said, "Oh, it's a good view, you ought to go up and see." So we passed them and went up.

It wasn't easy going up. It was a hard climb. The ground was sandy and shifting. There were brambles and the hill was pocked with caves. Every once in a while someone would yell, "Fire in the hole!" and throw a grenade or dynamite into a cave opening.

As I came up to the top section of the hill, just over the brow, I could see this long pole with a small flag on it. A very small flag on it. Two and a half by five feet. It was waving in the breeze.

I stopped and looked at it—I guess I needed a rest anyway. But as I got closer—I guess I was fifty feet away from it—I saw there were several Marines that were kneeling on the ground and doing something to an iron pipe. One had a folded flag under his arm and some rope to tie it with. And I said, "What's doing fellows?" And one said, "Aw, we're going to take down that flag and put this one up. A bigger flag so it can be seen by all the Marines down on the island."

As I backed off to estimate quickly how tall the iron pole was and guess how much I'd get in, the hill started to slope downwards because I was in the inner part of the volcano's crater. So I pushed together a couple of old sandbags from the knocked-out Japanese emplacement there and got myself a two and a half foot platform—because I'm already built too close to the ground—to get me above

the brambles in front of me that were going to cut off the foreground and the men's legs.

I stood up on that and said, "This is better than nothing." Just at that moment the Marine with the movie camera [one of the men Rosenthal had walked up with] crossed in front of me and went to my right. He turned and said, "I'm not in your way, am I, Joe?" And I turned to him and said, "No, Bill. That's fine." As I turned to him and he turned to me, I saw movement out of the corner of my eye. I said, "Hey, there it goes, Bill!" And I swung my camera, steadied, and shot.

That was *the* picture. I then took a second picture when three of the guys stayed to hold the pole up while the other three went to get the guy ropes to hold it all in place. But even when I shot it I knew it was a static picture. So I wanted to take a third one. By this time there were fifty or sixty Marines around doing various things. So I said, "Come on fellows, I want to get a crowd picture." This was my backstop photograph, in case I didn't get the first one. I'm trying to think, "What picture can I get? I was late for the first flag-raising. I want to get at least *one* picture of an American flag on top of this hill."

When I encouraged them, some of them muttered, "We're not Hollywood Marines. We're busy." But about 18 or 20 of them came around, stood, and I took their picture. Now that group picture was the last film on my pack. Just for insurance I had a second pack—it didn't take but two seconds to put it in. I repeated the crowd picture on number one of the next pack. And those were the only four that I took of the flag-raising—except that with my Rolleiflex I took some personal pictures. I was up there all of about 25 minutes.

It was two days later, as I recall, I was back on the command ship, when there was a message for me from New York. "Congratulations on fine flag-raising picture." At that time, I was not sure which one it was—not that I thought that one was better than another—but I had not seen the developed film.

But a week later, when I got back to Guam, I saw a copy of the picture and said—forgive me—"Gee, that *is* a good picture."[64]

The raising of the flag on Iwo Jima was *the* photograph of the war. Its image of men striving together, of the Stars and Stripes waving over a newly conquered territory, was a latter-day modification of the urge for Manifest Destiny. As the marines on Mt. Suribachi demonstrated, the United States was still raising its flag around the world.

THE PHOTOGRAPHS: AN INSPIRATION TO SACRIFICE

Government officials, editors, and publishers compelled the photographs of war to celebrate America. Willy-nilly, the pictures from World War II reinforced the rhetoric of the war: as published they were positive about the stated role of the United States in the war, they were supportive of the demand for a strong commitment of men and matériel. Some pictures, of course, such as Rosenthal's from Iwo Jima, appeared inherently to favor the American cause. But even pictures that treated subjects that were construed as critical or nonpartisan in later wars were enlisted by the government censors and the magazine publishers to fight for the war effort. They were packaged with captions and text and other images in such a way that their hostility or neutrality was obscured. Even those images that pictured American soldiers bleeding, tortured, and dead were published so as to jar the public at home into a realization that its ideals had to be fought for, that heavy sacrifices had to be made to ensure the continuation of the American way of life.

The lifting of the censorship in 1943 to allow the depiction of serious American casualties gave the public at home its most accurate view of the effects of war. Still, Americans saw few pictures of the extensive destruction of U.S. property, and they were never witness to the kind of explicit images of death of the American soldiers that were printed of the Japanese enemy. A balance was sought. The War Department, the Office of War Mobilization, and the Office on War Information wanted to show Americans enough graphic pictures of combat that they would understand—and respond accordingly to—what the government believed were the imperatives of the war. Yet, the officials did not want to show the public so many or such vivid photographs that the collective enthusiasm for the war effort would collapse under the impression that the war effort was not worth Americans suffering such horrors.

The uneasy balance survived the war. But it did not survive this century's wars. Perhaps an analogous equilibrium between the disclosure of and support for war was not discovered during the succeeding conflicts in Korea and Vietnam. Perhaps World War II had used up Americans' tolerance for battle. Perhaps Americans came out of the Second World War proud, but too tired and scared to make the financial, logistical, emotional, and moral commitment that they had called together in the four years between December 7, 1941, and August 10, 1945. Or perhaps World War II really was, in some defensible way, a "good" war. And the others were not.

PART FOUR

The Korean War
June 25, 1950–July 27, 1953

10

The Context:

"The Concept of Restraint"

OFFICIALLY, THE KOREAN WAR was not an American "war" but a United Nations "police action." Unofficially, everyone at home and abroad regarded the conflict as an American, rather than a UN, fight. The imprimatur of the UN Security Council and the military contributions of the UN allies gave protective coloration to an engagement largely controlled and directed by American authorities.

It was not, on many levels, a satisfactory war. The fighting in the beginning weeks was desperate; the troops retreated until it appeared that another miracle at Dunkirk would be necessary. The triumph of Inchon turned into a disaster when the UN troops tried to drive to the Yalu. As the eminent military strategist Bernard Brodie wrote, "The ensuing fighting was not, as some have made out, the worst disaster that has ever overtaken American arms. Pearl Harbor still has that distinction. But it was bitter in the extreme."[1] And then, half a year later, Harry Truman dismissed UN Commanding General Douglas MacArthur amid fireworks that rocked the nation. All this, perhaps, could have been forgiven or forgotten if the United States had won the truce at Panmunjom. But after an investment of three years and 33,000 American dead, the Korean conflict ended with a *status quo ante bellum*—the sole difference being the much heavier American commitment.[2] "What had to happen was happening," wrote *Life*. "In the second week of the Korean War, which the United Nations still called a police action, Americans felt no less pride in the stand their country had taken, but every

stand has its price, and righteousness sometimes the highest price of all."[3]

When the war erupted in Korea, the United States plunged into it without even a week's warning. "In every previous war," wrote General Matthew Ridgway, the successor to MacArthur as commander-in-chief of the UN forces,

> there had been time to gird our loins, recruit our spirits, and deliberate over where and how best to apply our force. . . . Korea, however, burst into flame without apparent warning. . . . The outbreak of hostilities found us at peace and awoke us to full-scale war. It took young family men, hardly settled down after dreary months of warfare, and transported them at airplane speed straight to the fighting front.[4]

The United States went to war so quickly and so unequivocally because both the government and military were confident that they were facing an imperative threat to the integrity of the West (and not coincidentally, to the viability of the Truman administration). The Truman White House felt it could ill afford the loss of Korea after suffering the loss of Eastern Europe and China. The Korean War was not really a war for Korea as much as a battle against the Soviet Union and what the Americans believed were the Russians' surrogate forces. Once again, the United States marched off to fight against the principle of aggression—in this instance, in the guise of communism—as well as against a particular foe. Once again, Americans were convinced, in *Life*'s words, that their cause was "righteous."

In 1950, Americans believed what the years of McCarthy hysteria seemed to affirm, that they were confronting an enemy dedicated to the destruction of the United States. If the "Communist Menace" was not contained and eradicated, so the theory went, it would infect, subvert, and overcome the American body politic. (The Klaus Fuchs and Rosenberg spy cases both erupted in the early months of 1950.) "In June," Truman said, "the forces of Communist imperialism broke out into open warfare in Korea. . . . Then in November, the Communists threw their Chinese armies into the battle against the free nations. By this act they have shown that they are now willing to push the world to the brink of a general war to get what they want."[5] The United States is, Truman believed, in "grave danger." "The future of civilization," he said, "depends on what we do."[6]

The stakes were high yet puzzling. How was the United States to react

to what it believed was a proxy battle of the Soviet Union? To defend American democracy it appeared essential to wage war on the opposite side of the globe. But the threat to the United States was less immediate than it had been in World War I or II. No American naval base had been attacked and no ship that carried American nationals had been sunk. How were the Americans to solve the limited military *and* political problem of the encroachment of communism on the relatively minor state of Korea?[7] With the experiences of World Wars I and II in recent memory, the concept of restraint—of achieving limited political ends through limited military means—had to be painfully learned. Unfortunately, the sheer size and potential power of the United States were not at issue; what was, was the depth of commitment the opposing sides could bring to bear on the conflict. And as Vietnam was later to confirm, the total sacrifice that a lesser power (especially one with outside assistance) was willing to make could be more than a match for the limited commitment of a greater nation. The Korean War was, after all, the United States's first limited war of the nuclear age.

The military and the politicians were not the only ones to have a different wartime experience with this new type of conflict. The country was not mobilized as had been necessary during World War II. There was a draft, but much of the nation—its people, its industry, its culture—remained untouched. Often the war was not even page-one news; as cartoonist and writer Bill Mauldin commented, "If an account of [an] action gets printed at all in [a combat man's] home town paper, it appears on page 17 under a Lux ad."[8] James Michener, in one of the few novels of the war still read thirty years later, *The Bridges at Toko-ri*, agreed. In the Sisyphean tale published in 1953, his protagonist stated bitterly that the war "would be easier to take if people back home were helping. But in Denver nobody even knew there was a war except my wife. Nobody supports this war."[9] Michener's quotation was hyperbolic. But it was true that the Korean War did not permeate as deeply through the general society and culture as had the previous two American engagements.

The Korean War inspired no romantic heroes—except for General MacArthur—no catchy songs, and no books of dashing valor. It produced no clever slogans. It was not a war to end all wars or a war for the four freedoms. The most that was ever said to rally the public was that it was a war against communism. However, in the early fifties, the word *communism* was enough to assure the president of sizable support for his decision to intervene. And for the first four months of the war, at least, public support for American intervention was extremely high.

In the opening weeks, over three-quarters of the Americans who were polled approved of Truman's "decision to send United States military aid to South Korea," despite the fact that 43 percent in the same Gallup poll felt this action would "lead to another world war." Support for the war remained high over the late summer months, throughout both the retreat to Pusan and the landings at Inchon. But, after the well-publicized Chinese "hordes" entered the battle from across the Yalu River in November, support for the war plunged 25 percentage points. No longer could the Americans at home believe that the boys would be back by Christmas. The enemy appeared more formidable; Americans were no longer opposing some minor, third-rate power.[10]

Surprisingly, however, after the November drop in percentage points, support at home, as measured by the various pollsters, stayed relatively constant for the remaining two and a half years of war. The boys were not coming back any time soon (which kept the approval rating down), but fighting against the communists was still as imperative (which kept the rating up). Despite the mounting casualties, the recall of General MacArthur, the fitful peace talks, and the 1952 presidential election, many chose to support the Korean War because it was "ours."[11] Many were dissatisfied with the war's conduct, unhappy about the sluggish pace of the peace talks, or appalled at the mounting casualties, but, in the early fifties, it was "us" against "them." As a character in Michener's novel commented, "Like the book says, you fight to save your civilization."[12]

Americans' fear of amoral and irreligious communism neatly intersected with traces of their World War II racism against Asians. Americans believed that communists of any nationality or background were somehow inhuman—programmed to do the bidding of their Kremlin masters. Americans simply added this characteristic to the negative attributes they already associated with the "Red Hordes"[13] opposing them in Korea. The American troops were confidently advised by the Department of the Army's *Korea Handbook* that the North Koreans "have the Oriental disregard for human life and consider cruel and inhuman treatment of their enemies justifiable."[14] Even journalist Marguerite Higgins remarked, "They frequently seemed to care very little for life."[15] The death of thousands of Asians, it was assumed, could not be compared to the death of an equal number of Westerners.

As a sign that the American soldiers had taken this admonition to heart, one British observer remarked that the Americans "never spoke of the enemy as though they were people, but as one might speak of apes. If they remarked a dead Korean body of whatever sex, uniformed

or ununiformed, it was simply 'dead Gook' or 'good Gook' "—a term that in Korean means "person" or "people."[16] And although one reporter believed that "no Korean could object to being called a Gook,"[17] the word "gook" quickly became derogatory, an onomatopoeic racial slur commonly used by all.

The Korean War raised certain logistical and ethical difficulties for the American soldiers that were more commonly associated with the later war in Vietnam. To the Americans, the enemy, quite simply, looked just like the civilians. Not to mention that the enemy often masqueraded as civilians and the civilians often gave refuge to the enemy. "Villagers," wrote correspondent Reginald Thompson, "poked their heads cautiously from their dark doorways, or peered anxiously round the angles of their walls, while others stood inscrutable at the roadsides. It was the opinion of the P.I.O. [Public Information Officer] and our driver that all these were enemy or potential enemy, having left their uniforms and rifles hidden on our approach."[18] In the Pacific during World War II, Americans had fought a war with no defined fronts, but the Korean War was the first war the Americans fought in which they could not easily differentiate between friend and foe. The Korean War was a civil—and at times a guerrilla—war between two indistinguishable populations. The uncertainty and lack of trust that resulted rationalized the Americans' extension of the World War II policy of denying support to the enemy through the destruction of civilian targets. This military strategy caused the death of "civilian men, women and children, indiscriminately and in great numbers, and [the destruction of] all that they have."[19] Although the Korean War was more frequently a battle between identifiable conventional forces, the North Koreans' tactical blurring of enemy and civilian was used to great effect—and was to be used to an even greater advantage by the North Vietnamese during the Vietnam War.

The Korean conflict was, as Mauldin wrote, "a slow, grinding, lonely, bitched-up war."[20] In the opening weeks of battle, the soldiers despaired. Marguerite Higgins, a war correspondent for the New York Herald Tribune, observed the troops: "It was routine to hear comments like, 'Just give me a jeep and I know which direction I'll go in. This mamma's boy ain't cut out to be no hero,' or, 'Someone really gave old Harry [Truman] the wrong dope on this war. He can find someone else to pin his medals on.' "[21] A character in Michener's novel admitted, "Militarily this war is a tragedy."[22]

At home, the public didn't know how bad it was. "Lieutenant Edward James," reported Higgins, "twenty-five years old, who had crawled

down a river bed to safety after having held 'at any cost,' approached me in a fury. As his lips trembled with exhaustion and anger, he said, 'Are you correspondents telling the people back home the truth? Are you telling them that out of one platoon of twenty men, we have three left? Are you telling them that we have nothing to fight with, and this is an utterly useless war?' "[23]

Correspondents who did tell the sordid story of those first few weeks received a harsh reprimand. The Korean credentials of both an Associated Press and a United Press reporter were revoked for giving "aid and comfort to the enemy." The AP reporter, Tom Lambert, had quoted a frontline GI as saying: "You don't fight two tank-equipped divisions with .30-caliber carbines. I never saw such a useless damned war in all my life."[24]

The soldiers' assessment of the military failures of the war was compounded by the fact that they did not know what they were fighting for. "We must realize," said Captain Stephen Patrick, in an army interview conducted after the war,

> that unlike World War II there were no clear goals in the Korean fighting. To the average soldier, myself included, there were no doubts as to the purpose of the action stated in broad, general terms. I am absolutely sure that the morale of the men was seriously impaired, however, because of the apparent lack of specific goals; in World War II we had those goals clearly delineated. It is almost axiomatic that the individual soldier must have specifics to which he can relate himself and his actions.[25]

If the soldiers did not have any sense of why they were fighting, it wasn't because the military hadn't tried to tell them. "Considerable attention," said one official report, "was given to the orientation of these replacements on the situation in Korea and on why they had been called upon to fight. They even participated in two hours of lectures and discussions during the train ride from Yokohama to Sasebo on their way to Korea."[26] Bulletins were printed explicitly stating "Why we are in Korea!" There were four reasons: "I. WE HAVE NO CHOICE We must fight here—or closer to home. II. OUR COUNTRY HAS DECIDED We are here by decision of properly constituted authorities. III. WE FIGHT FOR OUR TYPE OF LIVING Communism plans to destroy US and the Free World. IV. WE FIGHT IN KOREA TO PREVENT THE SPREAD OF WAR We fight to keep war from OUR shores."[27]

Despite its stridency, the message did not get through. Lieutenant-

Colonel James Klein, the executive officer of the Information Division, spoke of the success—or lack thereof—of the Allies' propaganda. "When I went to the frontline," he said, "I interviewed the men in the bunkers and I heard our own troops say that this was a war for the Asians and we shouldn't be in it. Thus perhaps the Chinese propaganda was more effective than we thought and we hadn't done the job as well as we thought we had. Most of the men didn't know why they were in Korea. If they were told, they didn't remember, and perhaps they weren't told in the right manner."[28]

The men were not interested in what they called "lollypop measures," which were supposed to enhance their morale and their willingness to fight. All that mattered to them were their buddies in line next to them. "The basic, most important factor," believed Captain Patrick,

> in considering morale is esprit de corps—unit spirit. It wasn't unusual to see a unit go two or three days without chow or sleep and still emerge from the ordeal in a cheerful state of mind—a state of mind brought about almost solely by the esprit which those men possessed and the pride they felt in their accomplishments . . . the men knew what their job was and felt confident in themselves, in the men with whom they were working, and utmost, in the quality of their unit as a team.[29]

As before, as always, the combat soldier didn't fight for fine words or high ideals. He fought because he didn't want to let his buddy down or because his buddy had been killed or because he himself wanted to survive until morning. *Life* photographer David Douglas Duncan accompanied the marines on their unendurable retreat to Changjin Reservoir. In bitter subzero winds, the marines marched. Duncan took pictures, one at a time, warming the camera up inside his clothes between each shot. He took a photograph of one marine shortly after dawn. As Duncan described in his book *This Is War!*: "A Marine kept prodding with his spoon, trying to break loose a single, frost-coated bean from the others in his can. He could neither move it nor long continue holding the spoon between his gloved but almost rigid fingers. He found one, and slowly raised it to his mouth. He stood unmoving, waiting for it to thaw." Duncan asked the marine, "If I were God and could give you anything you wanted, what would you ask for?"[30] "[The marine] continued to stand motionless, with empty eyes. Then his lips began to open slightly, and close, as though the effort of a word was too great. He tried again, and failed. He stood just looking into his glove holding the

can. He tried once more . . . as he tried his eyes went up into the graying sky, and he said, 'Give me Tomorrow.' "[31]

On June 25, 1950, John J. Muccio, the American ambassador in Seoul, Korea, sent the first official notice to the United States that North Korean forces had launched an all-out offensive. The ambassador's report on the Sunday dawn attack was received at the U.S. Department of State on Saturday, June 24, at 9:26 P.M. However, the ambassador's message was not the first word of the invasion to reach this country. Muccio was scooped. At least half an hour before the embassy's cable went out, Jack James, the UP correspondent in Seoul, had sent the story out on the wire—at 9:50 A.M. Korean time. (Korea was thirteen hours ahead of Washington, D.C.) Ambassador Muccio, who was not even awakened by his staff until about the time James sent his story, was informed of the UP report when he arose.[32]

The Americans jumped quickly into the kind of war they had said repeatedly they would never fight.[33] It had long been a military truism that the United States should not become involved in any Asian ground wars. And Korea was outside Secretary of State Dean Acheson's recently delineated "defense perimeter." Yet President Truman (much to the surprise of General MacArthur stationed in Tokyo) committed the United States to air and sea intervention even before the UN Security Council called for any such action. The North Koreans attacked on June 25, 1950. Two days later, on June 27, United States air and naval forces gave cover to the besieged soldiers of the Republic of Korea. And on July 5, American ground troops—Task Force Smith—entered combat.

General J. Lawton Collins noted on that Sunday morning when he first heard of the North Korean strike, "I thought how fortunate it was for us that the Soviets had picked for this venture the one area in the world where the United States military forces of all arms were well positioned."[34] However, the army, navy, and air force troops in the Far East, although available, were hardly combat ready. The four infantry divisions in the Eighth Army stationed in Japan on occupation duty were ruinously understrength. Because of the rapid demobilization and military budget cuts after World War II, the four divisions were even below their authorized makeshift strength of 12,500—which, in itself, was under the wartime number of 18,900. Every division was short rifles, all its antitank guns, missing one firing battery out of three in divisional artillery, and lacking all regimental tank companies. There were no corps headquarters, and no corps units such as medium and heavy artillery, engineer, and communications. In addition, with the expira-

tion of the Selective Service Act after World War II, the army had been forced to rely on short enlistment terms and lowered physical and mental standards to fill its manpower needs. At the outset of the Korean War, 43 percent of the enlisted men in the Far East Command were rated as Class IV or V, the lowest ratings on the Army General Classification Tests.[35] And, because of their occupation duties and the limitations of the military facilities in Japan, even those soldiers classified as infantry had little combat training.

The navy and air force were shortchanged, too. The navy was below strength in combat ships, amphibious craft, and minesweepers. The air force was missing all its jet fighters and many of its combat and troop-carrying planes and was suffering from a severe lack of trained photographic reconnaissance personnel. General Ridgway summed up the situation:

If any war that our country ever engaged in could have been called a forgotten war, this was it. If ever we were unprepared for a war, we were on this occasion. The primary purpose of an army—to be ready to fight effectively at all times—seemed to have been forgotten. Our armed forces had been economized almost into ineffectiveness and then had been asked to meet modern armor with obsolescent weapons and had been sent into subarctic temperatures in clothing fit for fall maneuvers at home.[36]

The Republic of Korea (ROK) troops were hardly a top-flight fighting force either. The caliber and resolve of the South Korean Army was frequently at issue; after the initial North Korean capture of Seoul on June 27, for example, the ROK Army of 100,000 dissolved to fewer than 20,000. In those early days, the ROK troops simply appropriated American jeeps and trucks and headed south along the same roads on which their Americans allies were marching north—leading the American soldiers to believe that they were carrying the burden of the war that should have been on South Korean shoulders.

Although the Korean War was essentially an American and Korean effort, by the time the war ended, twenty-four of the UN member nations had offered military assistance to the United States and South Korea. Sixteen of that number furnished ground-force components; the British Commonwealth and Turkey sent more than a battalion of infantry into combat, and others furnished staging areas, matériel, or medical, air, and naval units.[37] All the countries involved suffered casualties proportionate to those suffered by the American troops.

Few of the other nations had any personal interest in the conflict other than their commitment to the United Nations or their interest in retaining good relations with the United States. Remarked General Mark Clark (who succeeded General Ridgway as UN commander-in-chief in 1952): "Many of the nations that sent troops to fight and die in Korea were not immediately threatened by the North Koreans, the Chinese Communists or, in some instances, by communism itself."[38] Despite the thinness of the veneer, the UN commitment gave a welcome façade of respectability to the American intervention in Korea— especially when one considers how the United States would be pilloried in world opinion in the 1960s for its involvement in Vietnam. For the first, and probably the last time (although minor forces continue to be raised under UN auspices, to patrol—not fight—along truce lines), the blue and white flag of the United Nations was carried into battle.

With the start of the war, General MacArthur, the American Far East commander and soon-to-be UN commander-in-chief, asked for increasing commitments of men and arms. Initially, he asked for two full-strength divisions. On July 7, he urgently requested four divisions, an armored group, and an airborne team, adding, "It is a minimum, without which success will be extremely doubtful."[39] Two days later, he doubled that demand. "The situation," MacArthur said, "has developed into a major operation."[40] But there was nowhere to find the trained manpower needed except to call up into the General Reserve those recently discharged veterans of World War II who had barely settled down to their new lives—any men drafted would take a year to be combat ready. Men were stripped from units in Hawaii and Okinawa and from duty in the current General Reserve to meet the shortages in the Far East caused by casualties and understrength divisions. Without a declaration of war or a national emergency, it was difficult to call up the necessary manpower.[41] But after Congress almost unanimously extended the Selective Service Act, 7,350 replacements were airlifted to Korea by the end of July, and 25,000 members of the Enlisted Reserve Corps were recalled. President Truman asked for a draft of over half a million men aged 19–25.[42]

Training the ROK troops also became an early priority; in fall 1950, the Americans instituted whirlwind ten-day soldier schools for the South Koreans. Correspondent Higgins reported: "The Koreans were allowed to fire nine rounds of ammunition and were given instruction on carbines, mortars, and machine guns. But ten days is an awfully short time. Major Dan Doyle, one of the instructors, said to me, 'We teach them how to dig foxholes and how to take care of their guns. But

I'm afraid they have to get most of their practice in battle.' "[43] With this rushed training, it was inevitable that the combat quality of some of the South Korean units remained low.

Assessed in total, the allied ground forces in Korea differed in three main ways from their counterparts in the Second World War. First, the troops were more heterogeneous; they were younger and less educated—especially after the first year, when the recalled World War II veterans were rotated home. In the only sociological survey conducted during the Korean War, it was found that well over the majority of the men were twenty-one years old or younger. Few had attended college, and less than a third had graduated from high school. Second, the men were individually rotated home on the basis of the risk they confronted. Soldiers received points for service in Korea, but only for their time served. The system could neither be accelerated with "Good Conduct" medals nor decelerated by punishments. Thirty-six points sent a man home. Infantry divisions received four a month, everyone else received two. No longer were the men kept indefinitely in line either until they became casualties or the war ended. Third, almost a quarter of each infantry platoon were ROK soldiers. Each Korean soldier was paired with an American sponsor, but the ROK soldier's role was restricted; he was not required to go on patrols, he was never assigned as an assistant on the automatic rifle, and he did not "pull KP" when his company was in reserve.

Aside from these three distinctions, there were many similarities in American combat operations during the two wars. The basic organization of the infantry units was identical to World War II, with only minor changes made in weaponry. Tactical formations were identical. And the conditions of infantry life—"harsh, primitive and close to the ground"—remained the same.[44]

Another constant between the two wars was the military leadership. The Korean War erupted only five years after the Second World War. The generals who had won their spurs during the World War II campaigns were the commanding officers in Korea. And, of those leaders, no one had a higher profile than the man who waded through the surf to return to the Philippines, General Douglas MacArthur. At times, MacArthur garnered more publicity than the war he was directing. Until he was dismissed as commander-in-chief of the UN forces by President Truman, Korea was *his* war. He was removed for wanting it too vocally his way. He was an arrogant military genius—with all the attendant advantages and disadvantages. He caused contention in

every camp. One correspondent wrote about the press's assessment of MacArthur:

> Though there may have been one or two newspaper men who thought highly of MacArthur's ability, there were none, I think, who liked him. His assumption of a kind of divinity had alienated him, apart from his attempts to control the news by feeding it exclusively through the four agency channels of the entourage he carried round with him. Above all, he had tried to expel a total of seventeen journalists for their criticisms, and this had closed the ranks against him with all shades of opinion.[45]

By better than six to one, in a Roper and Harris survey conducted by the *Saturday Review of Literature*, correspondents in Washington, at the UN, and in the Far East, believed that President Truman was right to recall MacArthur in April 1951. When polled shortly after the event, correspondents commented on the public's support for MacArthur, saying that they believed the public would come to realize that Truman was right. "Truman can rely," said one journalist, "as Grover Cleveland did, on 'the sober second thought of the people.' " And indeed, popularity for the general peaked in May and fell thereafter.[46]

MacArthur's leadership and his conduct of the war were as controversial to the troops as they were to the politicians or the Fourth Estate. MacArthur had to take the opprobrium for the disastrous drive to the Yalu, as well as the kudos for the landing at Inchon. General Ridgway, commander of the Eighth Army in Korea and later MacArthur's successor as UN commander-in-chief, was the general whom the men on the front lines credited with turning around the morale of the American army. One reporter noted that "Ridgway has been visiting the front mostly on bad days when we were going backwards, instead of just on good days when there were 'good' headlines to make, as had been MacArthur's obvious policy." Another wrote, "Morale of American troops reached the nadir in January. We had there a defeated, demoralized Army, which was running south and had no aim but to get out. Ridgway in January and February revitalized it, turned it around. By the time MacArthur was recalled he was no longer a factor in morale." A third concluded, "The performance and morale of the American soldier in Korea can be dated like the calendar of the Christian world BR (before Ridgway) and in the years of Ridgway. The soldier once willing to run away is now becoming a professional soldier, more so than the one in World War II."[47]

THE CONTEXT: "THE CONCEPT OF RESTRAINT"

In Korea, the soldiers needed to be professionals. They confronted an indefensible border at the 38th parallel, barriers of sawtoothed mountains stretching north to south, and trails and passes too narrow to walk two abreast. The men encountered temperatures that dropped to 30 degrees below zero with chilling winds or climbed to 90 degrees above, with choking humidity. They floundered through deep snows, sucking mud, torrential rains, and obliterating dust.

Compounding the problem of climate and geography was the insistence of the American officers on sticking to the roads—such as they were—and the reluctance of the military command to move without all their high-technology paraphernalia. Despite their immense advantage in the air and on the sea and (after those first weeks) with their advantage in tanks, the Americans were unable to dominate the fighting.[48] The highways belonged to the Americans—during the day at least—but the hills that overlooked the roads belonged to the enemy. The enemy, traveling light and on foot over a more familiar terrain, could harass and interdict the long columns of American troops and vehicles wherever they pleased. One American colonel noted unhappily, "Without air or artillery they're making us look a little silly in this Godawful country."[49]

The North Koreans and the Chinese had vast quantities of easily maneuverable manpower—that was their main advantage. Early in the war, when the American divisions were significantly understrength and underarmed, the enemy, with its Russian tanks, rolled over the American positions, attacking the American troops as often from the rear and flanks as head-on. The Americans were faced with what they called the "circular front."[50] Marine Colonel "Chesty" Puller won fame for his pep talk to the troops: "The enemy is in front of us, behind us, to the left of us, and to the right of us. They won't escape *this* time." Even after the entry of the Chinese into the war and during the years of stalemate, the basic pattern rarely changed. The North Koreans and Chinese would take the high ground, setting up positions or attacking by night with a massive number of men. Avoiding frontal assault, they depended on infiltration and enveloping movements for their offensives. The main tactical change, over time, was that during the long period of negotiations, no major ground offensive was initiated by either side. The conflict degenerated into a series of patrol engagements, artillery duels, or hill battles—hardly less bloody than before. General Clark observed that the "frozen front" cost the UN Command "half as many dead, wounded and missing going nowhere as the defense of the Pusan

perimeter, the Inchon landing, the 1950 advance to the Yalu and the grim winter retreat from North Korea combined."[51]

The American command had to relearn painfully the rudiments of fire and movement on foot. Ironically, the Americans were too dependent on the supporting tanks, artillery, and aircraft that had been designed to save their lives. And compared to their Korean and Chinese enemy, they were too dependent on other "luxuries."[52] The American troops lacked the independence of the Asian soldiers; their demands on supply and communications were a heavy drain on the allied war effort. The Americans had nine men back for one man forward, whereas the Chinese and North Koreans had one man back for one man forward.

The Americans were further weakened by problems of matériel. After World War II, only limited amounts of military equipment had been retained as a "mobilization reserve," much of which could not be released for Korea because of the threat of another conflict breaking out elsewhere. And within the mobilization reserve earmarked for the Far East was an unbalanced inventory of armaments and supplies; the army had been authorized to retain only that equipment which would not be useful in the civilian economy. Furthermore, much of this unbalanced inventory was unserviceable because of the lack of maintenance or simply because it was "war weary"; it had been used in the Pacific campaigns, hauled from island to island, and then "rolled up" into Japan. Finally, in the five years between World War II and the Korean War, only token quantities of equipment had been procured owing to budgetary limitations.

By the outbreak of the war, little attempt had been made to produce any light-weight, more powerful, better-designed weapons because it was too expensive to retool the defense plants and to shelve the old equipment.[53] Small arms; light, medium, and heavy artillery; tanks; and the full complement of ammunition remained identical to that used in World War II—or even in the First World War—although there were some exceptions. One major exception was the helicopters, introduced as a means of transportation, reconnaissance, evacuation, and rescue work. Although these new "choppers" increased the mobility of the war, they were extremely limited in comparison to the larger helicopters available ten years later in Vietnam; the Korean-era helicopters could accommodate only one person other than the pilot or two wounded strapped in litters to the skids.

Another invention employed as a significant force during the Korean War, yet also associated more with the later Vietnam conflict, was na-

palm. (Actually, the discovery of the incendiary thickener napalm oc-curred during the Second World War. During World War II about 14,000 tons of napalm bombs were dropped, primarily on Pacific Islands, com-pared to 32,557 tons of napalm dropped on Korea alone during the Ko-rean War—and 400,000 tons dropped in the later Southeast Asian con-flict.[54]) An American correspondent, E. J. Kahn, interviewed a U.S. air force pilot who "had no compunctions about using it against human beings. . . . The first couple of times I went on a napalm strike," the pilot said,

> I had kind of an empty feeling. I thought afterward, Well, maybe I shouldn't have done it. Maybe those people I set afire were inno-cent civilians. But you get conditioned, especially after you've hit what looks like a civilian and the A-frame [backpack] on his back lights up like a Roman candle—a sure enough sign that he's been carrying ammunition. Normally speaking, I have no qualms about my job. Besides, we don't generally use napalm on people we can see. We use it on hill positions, or buildings. And one thing about napalm is that when you've hit a village and have seen it go up in flames, you know that you've accomplished something. Nothing makes a pilot feel worse than to work over an area and not see that he's accomplished anything.[55]

Most of the pilots did not get a chance to see their handiwork. How-ever, one reporter for the BBC did. At a field hospital brought to his attention by medical officers, René Cutforth met one civilian.

> In front of us a curious figure was standing, a little crouched, legs straggled, arms held out from his sides. He had no eyes, and his whole body, nearly all of which was visible through tatters of burnt rags, was covered with a hard black crust speckled with yellow pus. . . . He had to stand because he was no longer covered with a skin, but with a crust like crackling which broke easily. "That's na-palm," said the doctor, "and I'm not going to argue about the rights and wrongs of using it. Not my job. But somebody's got to start look-ing after these chaps, that's the twenty-fifth this week at this hospi-tal alone, and in the battalions the doctors have even more. . . ." I thought of the hundreds of villages reduced to ashes which I, per-sonally, had seen and realised the sort of casualty list which must be mounting up along the Korean front.[56]

A last major invention introduced during the Korean War was the 3.5-inch rocket launcher or "bazooka." Experimental work on the weapon had begun in 1945, and by 1950, the new bazooka had been authorized for use, although it had never been issued because the ammunition had not been completely tested. But the need was so great for an effective antitank weapon that when a desperate call came in on July 3, 1950, an instruction team took the rocket launchers off the production line in the United States and airlifted them to Korea. On July 20, members of the 24th Infantry division destroyed seven tanks with the new weapons. It was none too soon.

The speed with which supplies made it to the lines was as critical as the weapons themselves. Fortunately, priority handling was capable of moving imperative equipment from factories in the United States or warehouses in Japan to the troops on the front lines in a matter of days, despite the problems of the on- and off-loading of matériel onto ships and airplanes and the transporting of the stock over poor roads and railways. Army and air force personnel had learned and honed these vital skills during the Berlin airlift.[57]

It was good they had the practice. The UN forces, because of their various retreats, needed a heavy resupply of equipment. In the first ten months of the war, the U.S. ground forces lost 7,236 M1 rifles, 7,357 carbines, 1,184 light machine guns, 244 heavy machine guns, 176 105-mm howitzers, 1,545 jeeps, and 844 2½-ton trucks. The ROK troops— which, for the most part, were supplied by the United States—lost 68,215 M1 rifles, 37,560 carbines, 1,619 light machine guns, 1,363 heavy machine guns, 201 105-mm howitzers, 1,751 jeeps, and 1,263 2½-ton trucks.[58] Even without the massive loss of equipment, it was a costly operation. One marine in the artillery told Bill Mauldin that the service was becoming price conscious. He had been ordered to remind the artillery observers how expensive it was to fire one shell. "So," Mauldin wrote, "he calls a 105 a Chevrolet, a 155 a Buick and an eight inch shell a Cadillac."[59]

To save money and to win the war, the United States military and government exhaustively discussed the possibility of using "Chemical Warfare, Biological Warfare and Radiological Warfare" (CW-BW-RW) in a knockout blow. Moral considerations were denied. "There should be no moral implications expressed concerning these possible weapons," stated the secret "Public Information Policy: CW-BW-RW." "Use of the terms 'weapon of mass destruction' and 'unconventional weapons' shall be avoided." Any consideration of using the weapons other than defensively was denied. "No unauthorized public policy state-

ment on possible offensive use of CW-BW-RW by the United States in event of war will be made by any Department of Defense personnel."[60]

But, after all, the government and military officials decided not to employ these armaments. Korea was a "limited war," fought within self-imposed limitations, because the Americans feared that if they used all the methods and weapons available to them, they risked provoking World War III. The United States applied the principle of sanctuary to the war. "The arguments against bombing" China beyond the Yalu, stated the *Saturday Review of Literature*, "are based on the military point that we now do not have all the air power we need to provide effective cover within Korea. In addition, it is logical to expect that our own sanctuary in Japan would be subject to air attack. But the main argument against the bombing of Manchuria was a political one: it might provoke Russia into a Third World War, and that is not worth the risk."[61] Americans also held back on dropping the atom bomb.[62]

Both the military and civilian officials realized that restraint was a difficult concept for the American people who were losing husbands, sons, and brothers to the war. While big-city, liberal newspapers such as the *New York Times*, the *St. Louis Post-Dispatch*, and the *San Francisco Chronicle* agreed with the wisdom of not using the atom bomb, more conservative papers perceived no reason to hold back. The *Denver Post*, noted *Time*, "saw no moral issue in the use of the bomb." "Mr. Truman," the paper had said, "had indicated that the atomic bomb will not be dropped until such time as this country is in grave danger. . . . That day is today."[63] Truman disagreed with the *Denver Post's* pronouncement of Armageddon, but the principle of bombing a country "back to the Stone-Age" was to continue to hold appeal for a vocal, conservative element of the country up through the Vietnam War.

In place of these potential "weapons of mass destruction," the allied infantry forces relied on the more conventional army artillery and bombing support of the air force and navy to save them from being backed into the sea at Pusan. The airplanes of the air force, marines, and navy destroyed strategic targets and flew close air support to the ground troops. The navy ships blockaded the Korean peninsula and permitted amphibious landings. But, as General Ridgway observed, "it was the performance of the infantry that determined the success or failure of the United Nations effort, which in turn determined the course of United States and United Nations policy." The ground troops suffered proportionally to their involvement. Ninety-seven percent of the U.S. battle casualties were army and marine ground troops.[64]

Especially in that first summer and winter of fighting, casualties dev-

astated the army and marine units.[65] In the opening ground engagement on July 5, 1950, the army troops in "Task Force Smith" fought back enemy Russian-built tanks for seven hours although hit from the front, flanks, and rear. Forced to abandon all equipment, their dead and many wounded, the remnants escaped through the lines. One hundred and fifty officers and men were lost: killed, wounded, and missing.[66] Other equally fatal events ravaged the marines. In early December, when the marines were ordered to fight their way back from Yudamni to Hagaru, one company was isolated for five days on a hilltop. When two regiments finally fought through to Fox Company, they had only seventy-five men left—every one of them wounded.[67] The men made wise-cracks about the war's status as a "police action." "Damned," said one, "if these cops here don't use some big guns." "I wonder," said another, "when they're going to give me my police badge."[68]

Some soldiers saw so much action, reported one correspondent, that they "could only recall the highlights of it."[69] Stress set in. As had been observed in World War II, after prolonged exposure to combat, the infantryman "wore out, either developing an acute incapacitating neurosis or else becoming hypersensitive to shell fire, so overly cautious and jittery that he was ineffective and demoralizing to the newer men." The problem of battle fatigue was not simply a reaction to a prolonged fear of being killed; often the precipitating factor in frontline breakdowns was anxiety or guilt over killing another human being.[70] The incidence of battle fatigue varied over the years that the troops were in Korea. During the first six months, when the fighting was the fiercest, the rate was 99 per 1,000. It dropped to 59 per 1,000 during the next year; to 21, in 1952; and to 14, by the last six months of the war. Psychiatric conditions represented over 9 percent of the admissions for disease among the division troops.[71]

During the Korean hostilities, the services applied many of the lessons learned in World War II. Soldiers were treated as far forward as possible; many were not admitted to rear hospitals for psychiatric treatment—which tended only to reinforce the feelings of fear and guilt—but were given support and guidance by their officers in the field. Other simple aids were instituted: warm food, occasional rest periods, and a stated maximum period of time in combat.[72] Rest and rehabilitation (R & R)[73] and rotation were perhaps the greatest aids to morale. Rare five-day furloughs to Japan helped to break the strain of battle. And the "Big R," or rotation to the United States, was the ultimate goal. When a man's rotation time drew near, the pressure to "make it" was intense. Some soldiers slacked off if they could; sympathetic commanders as-

signed the shorttimers to less hazardous duty. In April 1951, the first men (about 1 percent of the total troop strength) were rotated home. Eventually, so many men were on different rotation schedules that in one unit there was a turnover of 900 men in a year's time, and in another, 400 different soldiers were in the same company in a period of three months.[74]

Such a tremendous turnover could not but hurt the camaraderie of the men in the frontline units. Many ranking officers argued that combat effectiveness was appreciably decreased. Military historian S. L. A. Marshall had conclusively demonstrated in his army surveys during World War II that more soldiers fired their weapons when they were in small groups working together.[75] Therefore, to break up those small groups—those "buddy" relationships—by rotation was to fiddle with a critical factor.

Marshall had demonstrated that only about 15 percent—or at best 25 percent—of the men in combat ever fired their weapons, even when threatened with their positions being overrun and their own imminent death.[76] Similar findings were made in Korea; in the hard-pressed companies of Task Force Smith, fewer than half the men fired their weapons. "The squad and platoon leaders," reported the official history, "did most of the firing. Many of the riflemen appeared stunned and unwilling to believe that enemy soldiers were firing at them." Others could not fire because their rifles were broken, dirty, or incorrectly assembled.[77]

Men were wounded and died in Korea of the same causes as during World War II. But proportionately more battle casualties died during the Second World War. In World War II, 24.5 percent of the total army casualties were killed in action, compared to 19.7 percent during the Korean War. In World War II, 75.5 percent of the total casualties were wounded in action, 3.4 percent of whom died of their wounds. In the Korean War, 80.3 percent were wounded in action, of whom 2.1 percent died of their wounds. The lower mortality rate of those who were wounded in Korea was due partly to the success of the new helicopter in rapidly evacuating seriously wounded soldiers.[78] During the first year of the war, for example, the 3d Rescue Squadron evacuated 2,000 "downed and wounded" UN personnel from forward areas to field hospitals.[79]

Treatment for soldiers who were wounded in action followed a pattern similar to that of World War II. There was a comparable network of aid, clearing, and collecting stations near the front lines; surgical, evacuation, and field hospitals farther back; and medical treatment fa-

cilities outside the theater of operations. During the initial six months of the campaign, however, hospital support was critically low. Four mobile army surgical hospitals (MASHs), in addition to three "evac" hospitals, four field hospitals, one station hospital, and three hospital ships, handled the tens of thousands of casualties.

From the beginning of the war, casualty figures were an issue to the press and the public. How many were there and how many were there compared to the enemy casualties? The numbers were in question. In an attempt to keep the figures secret, Army General Headquarters, Far East Command, issued a confidential order. "CUMULATIVE CASUALTY FIGURES," the cable read, "CONSIDERED HERE AS SECRET AND SHOULD NOT RPT NOT BE RELEASED IN FUTURE UNLESS PROPOSED BY THIS HQ AND APPROVED BY DA."[80] But there was no keeping them secret. The numbers were news. During the presidential campaign of 1951, the New York *World Telegram and Sun* began printing the weekly American casualty figures under scare-sized headlines.

Other members of the press and even the military counseled skepticism for those willing to believe the released casualty figures. Robert Miller, a UP correspondent writing in the *Neiman Reports*, advised his audience, "I urge you to be particularly suspicious of casualty estimates from Korea, both those suffered by us and inflicted by us." Miller quoted Eighth Army commander General James Van Fleet who said that if he had believed the casualty estimates made by his corps commanders, "there wouldn't be a live Chinese or North Korean opposing us."[81] The air force was particularly notorious for its inaccurate operations report. As one reporter wrote, from "not having known enemy strength previously to within one or two hundred thousand, [intelligence officers] now knew the exact totals down to the last man. They invited such questions as: 'Can you tell us how many of the Chinese communist forces were A.W.O.L. last Tuesday?' "[82]

When the numbers were compiled at the close of the fighting, it was found that all services of the United States suffered 33,237 men killed in action; 103,376, wounded; 5,131, captured; and 410, missing, for a total of 142,154 casualties.[83] Within these figures are hidden the statistics for American atrocity victims, most of whom were killed by North Koreans in the first year of the war. As of mid-1953, there were 10,233 reported American war crimes victims, of which 6,113 were listed as "probable." Of this total, 511 bodies were recovered and 216 survivors returned to the UN forces exclusive of the prisoners of war who were exchanged.[84] Information on the war crimes was amassed from many sources: "from eye witnesses, from UN escapees, from enemy prisoners

of war, from intelligence sources of many kinds and from evidence uncovered on the ground by advancing UN forces."[85] The victims had been shot, bayonetted, burned alive, starved, and tortured to death; their hands were taped, wired, or tied behind them, often with their own bootlaces. Many were mutilated both before and after death.

After the first year of the war, with the stabilizing of the line of battle, negotiations for a truce began on July 8, 1951. The peace talks sputtered on and off for the next two years, stalemating on the issue of a voluntary or forced repatriation of war prisoners. On July 27, 1953, the truce was finally signed, witnessed by fifty-seven UN-accredited reporters, twenty photographers, and five radio and television journalists. The document was a purely military one. No political leaders signed it; it was not a peace treaty. The war officially had no beginning; officially it could have no end.

"Our people in America," wrote General Clark, "have demonstrated time and again they have the courage to perform any service required for the security of our country. The magnificent infantryman fighting the frustrating, unhappy war in Korea demonstrated that. His kinfolk and parents behind him demonstrated it, too. I wrote a letter to the parents of every lad killed in Korea.... In my letter of condolence I always used the statement that the soldier 'died manfully.' "[86]

The first parents to receive such a letter lived in Skin Fork, West Virginia. They were Private Kenneth Shadrick's mother and father. "Kenneth's father," reported *Life* magazine, "was sad but resigned. 'He was fighting against some kind of government,' " Mr. Shadrick said of his son.[87]

When the soldiers of Task Force Smith brought in that first body, Private Kenneth Shadrick, correspondent Marguerite Higgins was at the medic's hut. The men carefully laid Shadrick down on the bare boards of a table. His face was uncovered. Higgins looked at him. "I noticed," she said,

> that his face still bore an expression of slight surprise. It was an expression I was to see often among the soldier dead. The prospect of death had probably seemed as unreal to Private Shadrick as the entire war still seemed to me. He was very young indeed—his fair hair and frail build made him look far less than his nineteen years.
>
> "What a place to die," said the medic.[88]

Surprise, shock, and resignation. These were the emotions expressed by the soldiers, the reporters, and the corpsmen in that early engage-

ment of the war. Surprise that youth so immortal could be killed, shock that Americans were dying in a war they were not winning and that had begun such a short time before, and resignation at the place chosen for a stand against communism.

Surprise. In war, and Korea was no exception, men always fought, always died, always were surprised. They never truly understood why they were fighting. They heard the words the officers from the propaganda office told them, but the words were not a sufficient justification for the war. Fight the communists in Korea or fight them closer to home. That was the argument. They were adequate for the men in the training camps, but once a soldier was out in the field deciding whether to take a life or trying to protect his own, such phrases became useless incantations. All wars are the same. Young men die and they never expect to. And words are never enough to make those deaths right.

Shock. The public was both bewildered and shocked. Previous experience and the new Cold War had taught Americans to believe that communism was a monolithic evil and, therefore, that the United States must eradicate it wherever it threatened. But the Americans had chosen to fight with limited means a battle they said had to be won— which would have been fine except the troops were not clearly winning the war. Americans had believed in the omnipotent might and power of the United States. Ultimately, there was a failure of imagination and courage in identifying and choosing other options that would preserve the freedoms of the United States. "I was gripped with a sense of unreality," mused correspondent Higgins, "that followed me through most of the war. Reality, I guess, is just what we are accustomed to."[89]

Resignation. Secretary of State Dean Acheson's "defense perimeter" notwithstanding, the Truman administration and the Joint Chiefs of Staff argued that Korea was the spot to make America's stand against the forces of communism. MacArthur agreed. The stand, all believed, had to be made. It might as well be Korea. The fight had come. The country was resigned.

Americans *did* take the Korean "Conflict," as General Clark had said, "manfully." But Korea would be the last war in which American men would die, uncomplainingly, "for some government."

11

The Photographers:

A Maturing Responsibility

Who, What, Where, When

AT LEAST SINCE THE Spanish-American War and the advent of the halftone photographic process, war has been depicted both in words and in pictures. Words give details that photographs cannot. Photographs illustrate situations that words cannot. They complement each other. And perhaps they best complement each other when the words and pictures spring from the same observer. Critics heaped extravagant praise on Korean War photographers Carl Mydans and David Douglas Duncan, both of whom wrote articles and books detailing their war experiences in addition to taking photographs for *Life* magazine. One article on Duncan described him as "a rare one who, like his colleague, Carl Mydans, can handle a typewriter as deftly as a camera. . . . What his photographs can't communicate his written dispatches can. . . . [His] perceptive mind functions through lens images as well as word symbols."[1] It was no coincidence that Mydans and Duncan became two of the most famous journalists in Korea. Among the hundreds of other journalists, few other photographers—even those of award-winning caliber—received the same level of public recognition.

Photographers, according to most of their reporter-colleagues, were still second-class citizens. Writers who wrote up the events of battle after the fact believed themselves to be conscientious commentators, yet those same reporters believed photographers who had to capture the war at the moment of action to be callous paparazzi. These writers

believed that if photographers did not write, they could not think. "Photographers," wrote one more liberal journalist in a story on the truce talks, "are apt to be looked down on by those who deal solely in words, and the cameramen in Korea must have got a big bang out of the fact that five of their caste were chosen by the Army as the first civilian correspondents to enter Kaesong ... and were permitted not only to take pictures but to write a collective story for the theoretically more literate correspondents."[2]

Many writer-journalists believed in an elitist hierarchical structure for the press. As the British reporter Reginald Thompson remarked:

> There were three distinct types of correspondent: the writers and serious observers [of which he clearly believed himself to be one]; the communications experts and stunt angle seekers; the photographers. The communications experts often have cropped heads, and in language and behavior are very like G.I.s in the marines. Few of them can write at all and are able to convey simple thoughts in crude fashion. But they could bash their way through with these messages when others might fail, and the rewrite men would do the rest. As for the photographers, in the main they have become a race apart, flinging themselves in the paths of people and things, flashing their bulbs anywhere and everywhere, and even demanding the repetition of acts of violence if discontented in any way with their first "shot". . . . Not all communication men and photographers were of this rugged order, but in the main they were. In the same way some of the serious writers and observers were not unskilled at getting on communications in numerous subtle ways, and even might take good photographs when opportunity offered.[3]

Covering the Korean War was quite different from covering World War II. A tacit hierarchy was in place because competition was keen; the lack of pooling meant that each journalist was trying to score a beat on the opposition. Of course, some correspondents were supportive of each other, but such camaraderie was only likely to flourish among journalists who were not in direct competition with each other, such as between a photographer and a reporter or between a wire service correspondent and a weekly magazine feature writer.

On June 25, 1950, the day of the surprise North Korean attack, 77 reporters and photographers were accredited to the Far East Command. Two months later, 330 were. A total of 19 countries had press representatives with the UN forces by August: the United States had 163, Great

Britain had 44, France had 14, the Australians had 9, and other countries had fewer than 5 each. The U.S.S.R. and China also sent correspondents: China sent 17 and Russia sent 2.[4] The field was crowded; the UN perimeter in Korea was only 120 miles long. By comparison, at the height of the fighting during World War II, only 185 correspondents had been accredited to the Allied forces in Europe.[5]

Not all the accredited journalists operated at the front. Many worked in Tokyo and some at the press billets news center, Eighth Army Headquarters, in Korea. According to reporter Marguerite Higgins, "there were never to my knowledge more than sixty-odd correspondents actually at the front at any one time, and the average was closer to twenty."[6] Some of the newspapers, magazines, networks, and wire services had as many as a dozen journalists and photographers relaying stories and film back, from the front lines to the Korean press headquarters to Tokyo. Others managed with a single representative. All were subsidized by the army, air force, navy, and marines. The press was flown thousands of miles without charge and was sold combat uniforms at cost (when they were available). And words and photographs were transmitted free over the military's communication systems from all sectors of Korea to Tokyo (although not from Tokyo to the United States). The service was estimated at $100,000 per month.[7]

The armed forces's public information officers shepherded the correspondents through the military's bureaucracy. In Tokyo, the PIOs facilitated (usually) the journalists' travel orders, courier airplane reservations, post exchange cards, and authorization to purchase clothing suitable for the field. After the journalists cleared Japan, they flew to Korea on courier airplanes; those heading for the front lines often received credentials to attach themselves to a division headquarters.

Once the correspondents were in Korea, the PIOs theoretically were to furnish them with the current military information they needed to follow and report on the fighting. PIOs, as often as twice daily, gave briefings on the status of the battlefront. And the PIOs issued daily communiqués—written reports supplemented by official photographs and personal quotations from the troops. There were three levels of such reports. First, there were generally the separate "Korean releases" (one each for the army, navy, and air force) that covered a twenty-four hour span of combat operations. Second, there were "official communiqués" from such sources as Headquarters United Nations Command, Headquarters Eighth Army, and Headquarters X Corps. Third, there were "immediate releases" on specific newsworthy events prepared by PIOs in all the various branches of the service.

The Korean release, the most critical official report for the combat correspondents, "set the stage upon which all the theater's activity is played." According to one air force PIO, such a release was "the commander's diary of his operational day. It is the dry statistics of battle. It is the sober, stately summary of activities for the archives. It is free from excess verbiage—factual, pertinent, informative."[8] It was also, according to many of the correspondents, littered with falsehoods. "To add to the difficulties of reporting the war with accuracy," correspondent Thompson observed,

> the United States Air Force reports became even more disquieting. From the outset these grandiose statements had been regrettably unreliable and grossly inaccurate. They now became a joke, ridiculed on all sides. . . . Many reports had proved on examination more than 90 per cent wrong. . . . Until overcome by ridicule in early February 1951, pilots gave figures of enemy killed down to digits, and presently General MacArthur's intelligence advisers followed suit. . . . The Air Force also reported material damage in the same way, so that it would have been no great surprise for any one of us to read that a pilot attacking a farmyard had wounded five geese, killed a hen, seriously damaging three ploughs (ancient pattern) and one hoe totally destroyed.[9]

The air force was also known to play fast and loose with the photographs it released. Robert Miller, a United Press correspondent, charged the air force with misrepresenting the facts. "An aerial photograph," Miller said, "on exhibit at the Fifth Air Force Headquarters in Tokyo showed a destroyed Korean bridge, cut cleanly in half by 'pin point bombing.' The bridge looked familiar, and upon a closer study, I found it to be the highway bridge north of Taejon which had been blown up by Army Engineers during out retreat south. That photo was distributed and used by all the major picture syndicates as an official Air Force photo."[10] The photograph had not been doctored, but the caption had.

Only five years after World War II, the partnership between the military and the press was dissolving. Many in the military regarded the press as a necessary evil at best. One senior officer, reported correspondent Miller, put it bluntly: "He said that if he had his way there would be two communiques issued about the Korean war; one would announce the beginning and the other our victory."[11] The press returned the military's hostility. Instead of supporting the military in its varied "propaganda" efforts—as they had been willing to do in the previous

war—in Korea the press was more likely to take a dubious view of such "chicanery" and to publicize the apparent discrepancies.

Caught in the middle were the PIOs, who, in addition to their role as purveyors of military information and disinformation, helped furnish the press with transportation to and around the front. "It must never be forgotten," said one relations officer, "that these are the few who speak to and for the millions who read or hear them. . . . the correspondents must have access to troops so that they may observe scenes of action. This implies transportation—jeeps, planes, ships or whatever the situation requires."[12] Jeeps especially allowed the war correspondents to work in luxury. Food and heavy equipment could be carried in them, and they could serve as beds at night. Ideally, a ratio of one jeep to every one and a half correspondents was allotted. With jeeps, the journalists traveled at their own discretion; they decided when to head to the lines and when to rush back to the communications facilities. Unfortunately, as Higgins noted, "We had, as a press corps, almost no co-operation in obtaining two essentials to our trades as war correspondents: transportation and communications." In the early days of the war, Higgins was the envy of many for having access to a jeep that a colleague of hers had rescued from the fall of Seoul. "For many months we had the only available vehicle," she admitted. "The rest of the press usually hitchhiked."[13]

Jeeps and other methods of transportation, if not forthcoming, could occasionally be scrounged. The same could not be said of the means of communications. Hal Boyle, a veteran correspondent with the Associated Press since World War II, said of Korea, "Never since, and including, the Civil War have correspondents had so few of the facilities vital to their trade."[14] All the news and photographs from Korea were fed to the United States through the agencies' or publications' bureaus in Japan. But during the early phase of the conflict, journalists had to rely on one cable to transmit their stories from the battlefields to Tokyo. Reporters hitchhiked fifty miles to call their stories in and then frequently found that their dispatches were bumped because the military claimed priority over the line. In addition, the press was originally limited in the hours it could use the phone. Whether or not the line was free of military traffic, the journalists could only send stories between 12 and 4 A.M. or between 2 and 4 P.M.[15] At times, the only way to get a story out was to hand carry it to Japan. During the first six months, some correspondents flew to Japan most nights and returned the following morning. "Getting the story," wrote Higgins, "has been about one fifth

of the problem; the principle energies of the reporters had to be devoted to finding some means of transmission."[16]

In those first weeks of heavy fighting and long retreats, the photographers suffered similar difficulties. Acme, AP, and International News Photo had to send their images to San Francisco via the Army Signal Corps radio, at commercial rates. They too had to give way for the military traffic; the only trans-Pacific commercial transmitter was the RCA Seoul station, which was in enemy hands until Inchon.[17]

By the early fall of 1950, however, communications had been vastly improved. Some telephone and teletype lines were extended to division headquarters, and commercial channels, similar to those in use in Europe during the Second World War, were installed. On a good day, wire service copy and photographs could reach Tokyo within one to six hours after filing, instead of within a day or days—or never. And those photographers who had weekly deadlines, like Duncan and Mydans of *Life*, were able to get their exposed rolls of film and captions cleared by Friday of each week and on Pan American or Northwest Airlines to New York.

Life was especially fortunate in its coverage of the war. With at least two photojournalists (such as Duncan and Mydans) in Korea at any given time—eleven photographers in all rotated through Korea for *Life*—*Life* never missed a beat. "Carl Mydans and I worked together beautifully," remembered Duncan. "He covered one phase, I another and we always got our films through on time. We were really very lucky as a result of which there never has been a war story run continuously for so long in *Life* without a break and without losing a major angle. Because of the time difference between Tokyo and New York our Friday shipments arrived in New York on Saturday morning and appeared in the following week's issue of *Life*."[18]

In the opening weeks of the war, the accredited correspondents[19] had relatively little military bureaucracy through which to maneuver— surprisingly, a situation that was not always to their liking. The army instituted the wearing of uniforms by correspondents, for example, only after Peter Kalischer of UP was captured by the enemy. Kalischer's fate alerted the journalists that it was in their interest to wear uniforms and carry army identification cards in the theater of operation. After being petitioned by the various news agencies, the service authorized the wearing of winter wool and summer cotton fatigues with a khaki and blue "War Correspondent" insignia. Correspondents stationed in Japan continued to dress in civilian clothes.[20]

The institution of censorship also caused much controversy—not be-

cause the press wanted *less* censorship but because many wanted *more*. General Douglas MacArthur was adamant in his decision to avoid formal censorship by the use of a voluntary press code. "A true democratic free press," argued MacArthur, "will accept this challenge."[21] The American free press was less than ecstatic. Marshall Andrews, of the *Washington Post*, wrote, "It is my own belief that the correspondents in the field would welcome so much censorship as would keep them clear of error."[22] And the Overseas Press Club transmitted the following resolution to MacArthur:

> The Overseas Press Club in principle now as always opposes any restriction of freedom of the press; however, it recognizes the dangers of general unclarified restrictions on news reports in current emergencies. It especially deplores the condition which now exists in the Far East whereby correspondents are required to censor their own dispatches under the broadest and vaguest guidance. It therefore urges full security control of news material by the armed forces in any active combat theatre.[23]

The voluntary press code consisted of the "ordinary Field Security catalogue," which requested nondisclosure of "Names and positions of Units. . . . Figures of friendly casualties. . . . Strength of reinforcements . . . or any such information as may be of aid and comfort to the enemy."[24] It was this last article that caused uncertainty. Would a photo-essay on the plight of refugees in South Korea give moral ammunition to the enemy? Three hundred correspondents had three hundred different answers. What made the situation particularly troublesome was that the correspondents were censured as much for reporting events that undermined military prestige as for reporting events that undermined military security.

The principle of "voluntary censorship" sounded wonderful, but, in practice, the military officials refused to disclose any confidential information for fear of it being leaked to the public by scoop-hungry journalists. To get a story, the correspondents were forced to rely on guesswork and their personal connections. Finally, after six months of chaos, MacArthur, under specific direction from the Joint Chiefs of Staff, grudgingly imposed censorship. "It is indeed a screwy world . . ." he grumbled, "when a soldier fighting to preserve freedom of the press finds himself opposed by the press itself."[25] With an official censorship in place in December 1950, similar to that imposed during World War II, journalists were freed from having to police their own stories. But it

was a Pyrrhic victory; when it finally was imposed the censorship was little more judicious and balanced than it had been previously. There even was a brief period of "double censorship" (stories and photographs were first censored in Korea and then again at General Headquarters in Tokyo); after complaints, censorship became largely a function of the theater of operations.

After the imposition of censorship, when laboratory facilities were available, photographs and accompanying captions were censored in Korea prior to their shipment or radio transmission. When facilities were not available, negatives were sent as expeditiously as possible to the Department of Defense in Washington, D.C. Once there, the negatives were printed and censored, and copies were delivered to the agency employing the photographer. Three prints of all photographs made by the war correspondents were delivered to the Office of Public Information for its archives.

Censorship of still photographs followed the identical guidelines for print reportage. "Control," declared the regulations, "should be exercised over the release of photographs rather than the taking of them. Photographers are expected, however, to refrain from taking pictures that violate security or hamper the Armed Forces or their allies in the discharge of military duties."[26] When approved, photographs were stamped "Passed for Publication as Censored" and initialed on the reverse. Required major deletions within images were indicated with a red grease pencil; minor deletions to prints were made by the censor "gently scratching out the nonreleasable information with the point of a razor blade or other cutting instrument. In the case of larger deletions the emulsion containing the nonreleasable information should be cut out and then separated from the back of the print." "Not to Be Released" photographs were returned to the photographer's agency to be filed with the negative as evidence of their censorship ruling.[27]

U.S. photographers and reporters in Korea, weaned on World War II combat coverage, were yet on the American "team." Their coverage of the war was sympathetic; few seriously contested the parameters of censorship. The journalists believed the war was basically a just one; they wanted to see the UN forces triumph against the communists. But the times were definitely changing. In Korea, correspondents acquired a dislike for certain military authorities—especially MacArthur—a distrust of much official information that was being fed them, and an ambivalence about the role of the United States in the war. Such sentiments anticipated the journalism of the Vietnam War. Korea was clearly the midway point between the "partner" relationship of the

press and the military in World War II and the "adversary" relationship of the two during the Vietnam War.

However, the more than 700 servicemen from the Army Signal Corps, the navy, the air force, and the marines who photographed the war for the military remained partners with the officers and soldiers in Korea. The pictures they took "not only inform the public, but they also constitute a valuable fund of intelligence to help military commanders. That is why photographers are now considered integral parts of the division."[28] The distinct photo companies of World War II were superceded by the new practice of placing photographers and technicians in the table of organization of the combat units themselves. An army infantry division, for example, included one photo officer, six still photographers, five laboratory technicians, one camera repairman, one motion picture photographer, and one projector repairman, who doubled as a film-library clerk.

Many of the official photographs taken by the military photographers were of noncombat subjects: visiting dignitaries, captured weaponry, and rear-action facilities. But, of course, the primary assignment of the military photographers was to take photographs of combat situations for tactical, intelligence, and archival purposes. The air force's photo reconnaissance, especially, was a critical step in both tactical planning and intelligence assessment. Air force photographs were used by Intelligence in the preparation of a "North Korean Target Album" of industrial targets designated by the Joint Chiefs of Staff. And for ordinary operations, 5,000 photo negatives were needed per day for defensive action alone; an additional 1,000 were needed when the UN forces were on the offensive. Requests for photographs from the air force could be turned around in 24 to 48 hours.[29]

Many ground-combat photographs were intended for the press; the military photographers had a higher rate of success in getting their images published in the media then had been the case during World War II. In an early memorandum commending the combat photographers on their work, the Department of the Army mentioned that "570 still pictures were released to the American press through 23 August 1950. An extremely high ratio of usage has been noted. This record of usage indicates that our combat photographers are doing an outstanding job in obtaining the type of pictorial coverage desired by American news media for public consumption."[30]

Those photographs taken for potential release to the media were given priority handling. In the Signal Corps, for instance, the pictures of combat were rushed back to the division command post for process-

ing at a portable photo laboratory. Once they were developed, the Eighth Army Headquarters screened the prints, picked the best ones, and flew them to General Headquarters in Tokyo. There the photographs received a further screening, and the very best were released to the news services to be radiophotoed to the United States. Photographs on breaking news stories were transmitted directly from Korea to San Francisco for immediate release to the news agencies there.

The other armed services had slightly different procedures for developing and releasing the images taken by their cameramen. The air force sent its film to Tokyo for developing and release, and the Marine Corps sent its unprocessed film directly to Washington, D.C. The navy photographers developed their films on board ship and flew their released photographs to Tokyo; their unreleased pictures remained on board until a port was reached and then were delivered to the Navy Photo Center in Anacostia, Maryland.[31]

Each branch of the armed forces trained its photographers at its own facilities; military combat photographers received their training at the Signal Corps Photo Center at Fort Monmouth, New Jersey; the Photo Branch of the Navy and the Photo Section of the Marine Corps at Pensacola, Florida; or the Air Force Photo School at Lowry Field, Denver, Colorado. The Signal Corps course for still photographers, for example, lasted twelve weeks and included a short section on motion pictures; the course for motion-picture cameramen was eleven weeks with no still photography orientation. Lesson number one began with a typical army understatement: "Combat photography is the same type of photography as that done under normal conditions, except that there is a change of environment . . . live ammunition can kill you."[32]

The aim of these schools was to produce men who could spend "90 percent of their time *thinking* the picture and 10 percent *taking* the picture."[33] Efficient combat operatives were desired: "Photographers will be trained to fully use their technical skill to capture peak action or expression, to take advantage of natural lighting, to avoid wastage of negative through duplication or 'overshooting', and to obtain optimum coverage of their assignment."[34] Military photographers learned their trade on various cameras: the Speed Graphic, Leica, Kodak 35, Bolsey B, 8 × 10 copy camera, 8 × 10 view camera, 35mm identification camera, the Rolleiflex, Contax, Polaroid Land camera, K-20 aerial camera, and the Bell and Howell 35mm Eyemo movie camera. But in combat, the primary camera used was the Speed Graphic; 35mm cameras were employed only in exceptional circumstances.

Most of the military photographers preferred the 35mm Leica or

Bolsey camera to the heavy press Speed Graphic, but the military continued to requisition the larger format 4 × 5 camera because "of the abuse which negatives receive in a combat zone. On top of that, films constantly are being yanked out of the files to make extra prints. Thirty-five–mm strips are difficult to caption, hard to file, require kid-glove processing, and don't stand up as well as 4 × 5 film. Once in a while we have to make super-sharp negatives for tremendous blow-ups; then 4 × 5 will give a hell of a lot sharper image."[35]

The civilian photographers were not so constrained. They overwhelmingly carried the 35mm cameras. The 35mms were lighter, had more depth of field, and held more film. Margaret Bourke-White switched to the 35mm after being caught in a riot in Tokyo while en route to the war. She was photographing from the top of a station wagon with her usual complement of cameras. After the first rock "whizzed" past her ear, the view camera on a tripod became untenable. She shot through her film in her Rolleiflexes in minutes and never had time to reload them. Two other reflex cameras "were almost impossible to adjust, with my eyes streaming from repeated bursts of tear gas." Finally, her only options were two Japanese-made Nikons that "focused easily and gave me a total of seventy-two shots." The "miniature cameras" were of even greater importance in Korea, Bourke-White believed, "where I dealt with human situations which could be recorded in no other way."[36]

David Douglas Duncan as a Marine Corps photographer in World War II had used the twin-lens Rolleiflexes. But in Korea, Duncan also switched to the smaller 35mm cameras. In combat, he carried two 3C Leicas that were equipped, however, not with the matched Leitz lenses but with Nikkor lenses made for the Nikon cameras. He carried a 50mm f/1.5, a 85mm f/2, and a 135mm f/3.5 lens.[37]

Military photographers rarely had the luxury of being able to change their lenses. They shot almost exclusively with ones of short focal length—35 or 50mm lenses on the 35mm camera and the slightly wide 127mm Kodak Ektar on the Speed Graphic. In its defense, the army argued that the long lenses used by the press gave a false impression of action and terrain.

Photographs made from far away with either a normal or a telephoto lens tend to have flat perspective because the distances between objects are made to appear less than they really are. Our guys are close enough to the enemy without needing optical aid to make it appear that they are on top of them. Such faked photo-

graphs might be dramatic from a news or propaganda point of view, but they would be of little use to field commanders. Any soldier could tell that they were phony.[38]

The army did admit to some need for long lenses—to take candid pictures of the troops without obviously having to invade their privacy. "Sometimes guys who are beat up and feel like hell," said Lee Larew, the chief instructor of the Signal Corps' motion-picture section, "don't like having their pictures taken. They don't want their folks to see them that way. But that's your job. That stuff is history. You slap a long lens on your camera and stand off at a distance so that you're not too obvious. That way you get the picture without hurting feelings." But Larew believed that to use long lenses for other purposes was at least misleading and certainly cowardly. "When you're photographing combat you have to be in combat—you can't play it safe from a hilltop behind the lines with a big telephoto lens."[39]

Even the toughest-sounding military combat photographers, who in actuality were no braver or more daring than their civilian counterparts, wanted to keep their heads down when shooting on the front lines. One of the most important techniques emphasized in the military instruction schools was guess focusing. In combat, there was no time to focus with coupled range finders. "Holding the camera up long enough to take a picture," it was taught, "often is an act of heroism; fiddling with the focus can be downright foolish."[40] Photographers were taught equations for the hyperfocal system; when applied, everything from half the hyperfocal distance to infinity was in focus.

For the military as well as the civilian photographers, the goal was to make photography instinctive. "To be a good combat photographer," said Sergeant Peter Ruplenas, a photographer with the 7th "Crushed Beer Can" Division,

you've got to be a screwball. Sometimes the guys on the line crack wise that it must be safe because the photographer is here, but after they see what we have to do they think we're nuts. You just can't get combat pictures in the rear. When you're up front you have to shoot fast, you can't risk missing anything. . . . You're afraid that you're going to be hit; you're afraid that you're not in focus, that your exposure is way off, that the pictures won't be any good. But the main problem is getting back without a hole in your head.[41]

Duncan, the ex-marine, had solid advice on how to survive while taking good photographs. "Get some understanding of military tactics," he said. "so you'll know what to do to protect yourself. It's like boxing; your chances of getting hit are less if you know defensive tactics. . . . Know your equipment so that you can use it automatically. Use [the] lightest possible camera and shoot from eye level."[42] Ultimately, he had, he said "no war-photography philosophy . . . except keep it down—and move in close."[43]

Duncan traveled to the front with the minimum of camera and personal equipment necessary. He always covered the marines; he knew them, they knew him, and he cared most about them. But to follow them, he was usually limited to what he could bring on his back; he couldn't count on having a jeep available to transport his gear. So all he carried was a marine backpack, two cameras and lenses, a pistol belt with a Weston Master meter clipped to it, enough film in his pockets to last about two weeks, two rubber liferaft waterbags for use as waterproof camera bags, a poncho blanket, a spoon, a toothbrush, a bar of soap, mosquito lotion, a wrist compass, two canteens, and a steel helmet.[44]

Many correspondents also carried some sort of weapon. On assignment to cover the guerrilla fighting in the war, Margaret Bourke-White carried a .45 or a carbine. Although she hadn't known how to use either, her photographer's eye stood her in good stead. Out of thirty-five practice rounds with the .45, she hit thirty-three bull's eyes. With the carbine, shooting from the prone, squatting, kneeling, and leaning-over-the-jeep positions, she shot twenty-five out of twenty-five bull's eyes.[45] Reporter Fred Sparks, of the Chicago *Daily News*, also decided to carry "an instrument of defense." "I was lying there in my foxhole one day after a battle in which the regimental command post itself had been overrun," he recalled. "I started thinking to myself, 'Suppose a Gook suddenly jumps into this foxhole. What do I do then? Say to him, "Chicago *Daily News*"!' "[46] And after being trapped in a furious firefight with the 27th "Wolfhound" Infantry Regiment, correspondent Marguerite Higgins carried a carbine. Higgins, who was not a photographer, "was a lousy shot, but," she said, "I know I duck when bullets start flying my way, even if they are considerably off course. I reasoned that the enemy had the same reaction and that my bullets, however wild, might at least scare him into keeping his head down or might throw his aim off."[47]

Higgins discussed the new kind of war in Korea and the correspondents' new method of covering it, which had led so many to the decision

to carry a gun even though they were officially noncombatants. "The enemy had no qualms about shooting unarmed civilians," she said.

> And the fighting line was so fluid that no place near the front lines was safe from sudden enemy attack. In those days the main difference between a newsman and a soldier in Korea was that the soldier in combat had to get out of his hole and go after the enemy, whereas the correspondent had the privilege of keeping his head down. It was commonplace for correspondents to be at company and platoon level, and many of us frequently went out on patrol. We felt it was the only honest way of covering the war. The large number of correspondents killed or captured in Korea is testimony of the dangers to which scores willingly subjected themselves.[48]

The Korean War was almost as rough on journalists as it was on soldiers. The shifting nature of the war trapped correspondents behind enemy lines. Roads over which the press had to travel were land mined; units that the journalists were trying to find had "bugged out"; and infiltrators who snuck up to attack at point-blank range were ubiquitous. Clothing was inadequate for subzero temperatures; food took an hour that no one could spare to thaw; and rats, lice, and fleas were epidemic.

Not only were members of the press exposed to the same dangers as the troops, but the more intrepid of them took daring risks to bring back exclusive stories. Perhaps the best print coverage of the war appeared in the *New York Herald Tribune*, which had two reporters on assignment in Korea—each competing with the other for top billing on the *Tribune's* front page. Pulitzer Prize–winner Homer Bigart wrote in one early dispatch: "This correspondent was one of the three reporters who saw the action and . . . the only newsman to get out alive." Bigart made it, but his colleague Ray Richards of the International News Service was shot through the head and Corporal Ernie Peeler of *Stars and Stripes* was hit in the chest as they all ran for a jeep when the battalion they were covering was cut off. And Higgins, the second *Tribune* reporter, not to be outdone, mentioned in a story she sent home several weeks after Bigart's: "A reinforced American patrol, accompanied by this correspondent, this afternoon barreled eight miles deep through enemy territory. . . . Snipers picked at the road, but the jeep flew faster than the bullets which knicked just in back of our right rear tire."[49]

Frank "Pappy" Noel, an AP photographer captured by the North Koreans on December 1, 1950, operated under the most extraordinary con-

ditions of any journalist on assignment in Korea. A year after his capture, after secret consultations at the Panmunjom truce talks with communist correspondents, the AP sent Noel a camera for Christmas. The idea was that Noel would take exclusive photographs of the North Korean prison camps for release by the AP. The project was dubbed "Operation Father Christmas"—for "Pappy" Noel. Three weeks later, Tokyo wired New York, "Christmas package in hand. . . ."

The communists censored all but seven of the photographs, which were radiophotoed to the United States. Publications across the country gave the images full play; headlines read: "Exclusive—'Pappy' Noel Comes Through," "First Photos from Korean POW Camp," "Captured AP Lensman Scores Exclusive from Behind Iron Curtain." The American military was less than pleased. General Matthew Ridgway, the Far East commander, initially censured AP for "trafficking with the enemy," then allowed twenty-three new images to pass. Ridgway approved the pictures, he said, because he "realized the great interest of families in the photos, though they were obviously passed by the Reds for propaganda purposes."[50]

Korean war correspondents, like their predecessors, often obtained their stories through feats of bravery. They played with their lives. As was said of Higgins, "More than once, Maggie Higgins has jeeped or hiked to hot spots while other correspondents hung back, thus forced them to go along, too. Said one correspondent ruefully: 'She's either brave as hell or stupid. Her energy and recklessness make it tough on all the others.' "[51] Risk was an integral element in the journalists' work in Korea, but it was often taken to gain a competitive edge. Spanish-American War reporters and photographers flaunted themselves promiscuously on the front lines more to prove their personal courage than to come back with a story; World War I correspondents were escorted around the front and forbidden much of the danger; World War II pooled journalists exposed themselves as the only way to bring back the story. And during the Korean War, the press, once again, took chances to get the news, but because the war coverage was rarely pooled—either by reporters or photographers—any scoops became personal victories.[52] Everyone in Korea wanted to be an Ernie Pyle or a Robert Capa.

But scoops could also lead to personal tragedies. In four years of World War II, only thirty-seven civilian correspondents died. Yet in the first seven weeks of the Korean conflict, ten journalists were killed or missing. By late January 1951, twelve were dead, two missing, two prisoners, and twenty-three wounded.[53] By the end of the war, eighteen journal-

ists had been killed, nine in frontline fighting and nine in air crashes. Eleven of the eighteen were Americans. Among them were Charles Rosencrans, Jr., and Ken Inouye, photographers from INP, and Albert Hinton, a reporter with the *Norfolk Journal and Guide*—the first black correspondent to die while covering a U.S. war.[54] The new competitive war journalism promised to be an increasingly dangerous profession.

Image and Reality

Margaret Bourke-White, who was in as good a position as anyone to know, believed that "probably no war in history had been so thoroughly documented." There were more reporters and photographers to the square inch of the Korean front than there had been on the lines during World War II or before. The picture magazines especially were represented in force. "My own magazine," wrote Bourke-White, speaking of *Life*,

> had given it brilliant coverage, with David Douglas Duncan and Carl Mydans on the hot front at the 38th parallel almost from the beginning. Howard Sochurek parachuted in with the 187th Airborne. Michael Rougier and another half-dozen of my *Life* colleagues had put their personal stamp on hundreds of dramatic and sensitive photographs. With all the major news services and broadcasting chains, each with its quota of photographers, reporters and broadcasters on the spot, Korea was the most consistently raked-over news center in the world.[55]

But as always, covering the war and bringing home accurate images of the fighting were different propositions. There were three major obstacles to duplicating the experience of battle. First, war photography is a hazardous business. David Duncan apologized for the quality of some of his photographs of the marines at Changjin Reservoir. "Some of the pix," he said, "aren't quite sharp. The trouble was that I had to raise my head to focus, and I didn't want to get it shot off." Even a telephoto lens didn't place a photographer beyond the range of most arms and the artillery. And for those photographers who tried to capture the experience of the infantry at the front, there was no substitute for being up there with them. "I want to give the reader something of the feeling of the guy under fire, his behavior in the presence of threatening death," Duncan explained. "The only trouble is that you've got to be *right there* to do it."[56]

In addition, there were hazards that were not a direct result of enemy fire. The knifing cold of winter in Korea froze the photographers' fingers so stiff that they could not load film in their cameras or manipulate the focusing rings. The film itself cracked and broke in the frigid weather. Shutters would stick in the low temperatures; photographers would try and compensate by estimating that when the lens was set at a 500th of a second it would actually operate at a 100th. To make the cameras work at all, photographers often had to warm them with their own bodies after taking each individual picture. Summers were better, but the yellow dust of the roads seeped into the mechanisms of the cameras also preventing the apparatus from functioning.

A second obstacle was that war photography physically couldn't capture some of the incidents of war. In the opening months of combat, much of what happened was photogenic. Often as not, fighting occurred during the daytime; extraordinary visions of bombed bridges and streams of civilians were scenes to be recorded. But with the entry of the Chinese into the war, the conflict changed. Much of the war happened at night. As one combat photographer observed, "Opportunities for spectacular battle coverage were very few. The day of the burning village, the photogenic refugee and the daylight action was over. Activity was confined to night patrols and it was difficult to get any worthwhile pictorial material other than routine front line activities."[57] Furthermore, the camera could not capture the smells and sounds of battle. Photographs fell short of accurately recording the spectrum of the combat soldier's experience.

As always, any single photographic image selected, cropped, and isolated subjects that did not necessarily have the same importance outside the photographic frame. Ironically, the mere act of photography could change certain realities of war. When troops under a photographer's scrutiny, for example, realized that they were being immortalized on film, they responded as they had been taught to do. They sat up straighter and smiled. "I wonder," asked one Signal Corps photographer, "how many commanders and Signal officers realize the effect that the presence of a photographic team during an operation has on the committed troops? I saw tired, scared, bewildered and battle weary men come to new life—just so they would look good to the folks at home. Holes are dug deeper, weapons are fired with enthusiasm and positions are held. There is no humor in battle, yet troops smile for the camera."[58]

A third obstacle for photographers bringing back the reality of war was that at times the photographers laid their cameras aside. War photography could be a lower priority than saving one's own neck or help-

ing others to save theirs. It was a dilemma. "A photographer," wrote
Carl Mydans,

> has a choice at certain times of taking a picture or participating, of
> choosing between his historic function and his human one. There
> is a conflict. Each must make his choice. Suppose a tank has been
> hit, catches fire, and men are struggling to get out. Do you make
> pictures of it? Or do you help the people out? An experienced man
> weighs it quickly—and makes his decision. If on an assault landing
> men called for aid and assistance—it's up to the photographer to
> decide whether to make pictures or help them. I have never known
> a good war photographer who was not a deeply compassionate man
> and who did not make his decision in such a circumstance on the
> side of compassion.[59]

Interestingly, most civilian photographers decided that taking photo-
graphs was more important—and ultimately more compassionate.
They could help only a few, and so many needed assistance. Duncan,
photographing refugees, agonized over his decision. "When I came
upon an ancient couple serenely holding hands in their cart," he wrote,
"while their eldest son strained every fiber of his being to pull them to
safety I felt nothing but shame at being bigger than all three and yet
helplessly tied to the tiny camera in my hands. And I wondered
whether my pictures would really make any difference."[60]
For the military combat photographers, the choice was more clear-
cut. They were soldiers first and photographers second. First Lieutenant
Robert Lee Strickland, a combat cameraman with the 1st Marine Divi-
sion, described his coverage of the fighting to free Seoul. "There was
only one medic," he recalled, "a corps man in the Marines, so I put my
camera aside and gave him a hand. I missed a lot of good pictures but
there is no need to say that the pictures were not that important. I have
seen a lot of men get hit both in this war and in the last one, but I think
I have never seen so many get hit so fast in such a small area."[61]
Photographers passionately desired to bring the truth of war home.
Men were dying. People should know. War was not a movie. People
should know. Duncan put together a book of photographs with an open-
ing text. Entitled *This Is War!* it was, he said, "an effort to completely
divorce the word 'war' as flung dramatically down off the highest
benches of every land, from the look in the man's eyes who is taking
his last puff on perhaps his last cigarette, perhaps forever, before he

grabs his rifle, his guts and his dreams—and attacks an enemy position above him." Duncan's aim was to confront the people back in the United States with the reality of war—and to do so through photographs. He wanted no intermediaries between the images and the viewers. "Believing that the look in that man's eye's tells more clearly what he felt," Duncan wrote,

> I am presenting this book to you without a single caption, for any caption that I might write would just mirror [what] I was feeling, or thought I felt. . . . To learn their stories, each page of photographs must be read as carefully as you might read a page of written text in a novel. Asking you to read the story in their faces and hands and bodies, as they were feeling it themselves at the moment of impact, is only fair to them—and is asking more of you than ever before has been asked of the picture-viewing audience.[62]

The United States was not yet linked by television. Most families still received their picture coverage of war from magazines and newspapers, although the news was also available from newsreels in movie theaters and just recently on television. The Korean War photographers spread the war out for the country to view. "John Q. Public," as the magazine *U.S. Camera* styled the civilian at home, "sees closeups of war in the comfort of his home. He views pictures made under fire, pictures of the face of battle. . . . John Q. Public expects news photographers to risk lives for photos that will keep him abreast of events." *U.S. Camera* reproached the American public for taking this hard-won reportage for granted. "Mr. Public," said *U.S. Camera*, "likes to sit back in his chair and have things done for him without having to expend more than a minimum of energy and that, minus danger. . . . J.Q.P. expects much, risks nothing. It isn't too much to ask that he think about and appreciate what news photographers do for him."[63]

As the wars of the twentieth century rolled on, correspondents became increasingly embittered by their experiences. "In these days," wrote correspondent Reginald Thompson on the Korean conflict, "I lost my last illusions about war. I had called myself for some years a 'war reporter'. It would be more accurate to call myself a reporter of death." It was becoming harder for the war photographers to do what they did. Wars were becoming more frequent, more diabolical, more encompassing. Napalm and "strategic bombing" of targets behind the lines took a horrific toll on soldiers and civilians alike. "Death," observed Thompson, "comes now in ever more hideous guises, death to the unseen, the

unknown multitudes, the remote communities, unaware as they go about their business, of living and loving, growing things and making things, that someone may have surrounded them on a map, and may 'press a button'. . . . The great toll of civilian death in Korea has been estimated as high as two million. No one can know."[64] Photographer Bourke-White was ahead of her time in her interest in reporting on the devastation of the war for the Korean civilians. "I felt," she said, "that there was an important area which no one had covered: the Korean people themselves."[65]

Photographers and writers increasingly came to believe that their job was to report the facts—*all* the facts—of war. The "see-no-evil" war policy of the past was no longer sufficient. Even those journalists who agreed with the U.S. intervention believed that all the repercussions of the war had to be shown. Duncan wrote that his book was "simply an effort to show something of what a man endures when his country decides to go to war, with or without his personal agreement on the righteousness of the cause."[66] The truth, the correspondents believed, had to be told because the world could not go on like this. Pictures of hungry and dispossessed Koreans and cold and defeated Americans were sent back to educate the public.

To many people, Duncan, the preeminent photographer of the privates, sergeants, and company commanders of the U.S. Marines, became the truth-telling Ernie Pyle of Korea. In September 1950, Duncan cabled to *Life*, "EYEM GOING BACK THIS TIME TRYING GIVE YOU STORY WHICH IS TIMELESS NAMELESS DATELESS WORDLESS STORY WHICH SAYS VERY SIMPLY QUIETLY 'THIS IS WAR'."[67] Americans became witness to the glazed, frustrated faces of the American soldiers. Duncan, Mydans, and all the rest tried harder than ever to distill the essence of battle into the visual images exhibited in the pages of American publications. The photographers focused in closer on the men. They argued, in effect, that the reality of the war in Korea was not the weaponry of battle, the air support, or even the devasted landscape. It was the faces of people. These faces, they said in their pictures, are what the fighting is all about. This is the look of war. This is Korea.

And Why

Most of the men and women who took pictures on the lines in Korea were veterans of World War II. They had seen, as one correspondent recalled, "arms, legs, heads, busts, buttocks, hands, in macabre confusion in the death pits." They remembered "men roasting alive, or starved to grotesque caricatures, disintegrating in obscene heaps." For those witnesses, Korea was an outrageous continuation of war. "The glamour is false. The illusion is gone."[68]

Of course, a shiver of adrenalin could still thrill the photojournalists and reporters. Danger could provoke a response not altogether unwelcome to men and women who pursued excitement as a career. For Margaret Bourke-White, who thought nothing of taking pictures perched out on a Chrysler Building gargoyle 800 feet above the sidewalk, or for David Douglas Duncan, who tramped around the world from the Cayman Islands to Chile combining his enthusiasms for deep-sea fishing and underwater photography, the war was another challenge not to be missed. Korea attracted those journalists who were the best and brightest of their generation—and who were not yet too sickened or too embittered by their experiences.

Those journalists who did rendezvous in Korea found what little was fine and precious in the war in the intense camaraderie shared by those who faced death together. "The only clear, deep, good," said Marguerite Higgins,

> is the special kind of bond welded between people who, having mutually shared a crisis, whether it be a shelling or a machine-gun attack, emerge knowing that those involved behaved well. . . . It is a feeling that makes old soldiers, old sailors, old airmen, and even old war correspondents, humanly close in a way shut off to people who have not shared the same thing. I think that correspondents, because they are rarely in a spot where their personal strength or cowardice can affect the life of another, probably feel only an approximation of this bond. So far as I am concerned, even this approximation is one of the few emotions about which I would say, "It's as close to being absolutely good as anything I know."[69]

But for most, Korea had little to commend it. Few journalists stayed for the entire war. Unlike World War II, when the entire population

was asked to give their all for as long as it would take, during the Korean War, both the troops and the correspondents rotated through the conflict. Korea was not such a clear and present danger; it was a nasty fight that for some was one straw too many on top of four years of worldwide battle. "It was remarkable," observed the British reporter and sometime photographer Reginald Thompson, "that many first-class men had had enough after two or three months, and it was considered that no man should cover for more than three weeks without a rest. One or two had rushed off scarcely waiting to welcome their 'reliefs', as though the devil were at their heels. Yet, five years of the Second World War under heavy bombardment, and often under the most terrible conditions, had failed to daunt anyone."[70]

Thompson attempted to explain why Korea was so disturbing to journalists who had, after all, seen much worse. The reason, he believed, was the ambivalence that was growing about the role of the United States and the UN in the world and in the war. At what price and for what ends was the war being fought? He told of walking through the suburbs after the fall of Seoul.

> It was strangely quiet. The people eyed us with a curious impassivity—almost a "knowing look," or it may have been a kind of austere cynicism—as we walked as nonchalantly as possible through the maze of hovels and hillocks, uncertain how to meet all these eyes, whether with smiles, which seemed out of place, or with grave greeting. It was difficult to ignore these people we had come to save; but it was equally difficult to do otherwise. For the saving had taken on a bitter and terrible flavour.[71]

There had been no such ambivalence during World War II—at least in the minds of the Americans and the Allies.

Americans began the war with the firm public and private belief that it was the right thing to do. Less than a month into the war, editorials in Life declared the man-on-the-street and newspapers of all political persuasions unanimous in their opinion that "At last! It was the only thing to do." The Boston Herald said, "Stand fast." The Atlanta Journal said, "The next move is up to the Politburo." The Los Angeles Times, repeating the words from Lexington in 1775, said, "If they mean to have war, let it begin here." The New York Times said, "A momentous and courageous act." And even the Chicago Daily Tribune, controlled by Colonel Robert McCormick, admitted (after initially proclaiming

that Truman's statement on Korea was "an illegal declaration of war") that Truman had done "the politically popular thing."[72]

"There are two possible outcomes of the fight in Korea," *Life*'s editors wrote. "One is that the military bets will be continually raised by both the U.S. and Russia, with world conflagration ensuing before the snow comes. The other possibility is that Russia will back down under some face-saving scheme, with Korea restored to the community of free nations."[73] *Life* did not even countenance a third possibility—what became the reality—a truce following a no-win situation.

Three years after those initial editorials, on armistice morning July 27, 1953, *Life* photographer Michael Rougier recorded the emotions at Boulder City, a marine position and the target of the last heavy communist attacks. "By noon that day," Rougier cabled, "the intense heat and smell of corpses made Boulder City one of the most horrible places imaginable. 'It read in the directive,' muttered one officer, 'that there would be no firing of weapons to celebrate the cease-fire. What the hell,' he said, looking around and shrugging, 'is there to celebrate?' "[74]

It would take a new generation of correspondents, young and unbloodied by the holocausts of World War II, to find battle bearable and, at times, even attractive again. It would take a new breed of photographer/warrior to revel in the new wars that were to come. In Korea, men still acted as if war was to be conducted by existing and mutually agreed-on rules. By Vietnam, men began to believe that rules—even if they did exist—no longer mattered. (And by Lebanon, men were surviving—if one could call it that—in a Hobbesian state of nature.[75]) Korea was the last war in which American correspondents implicitly believed that the United States was in the right. Even then, journalists did not always believe that the American military was properly conducting the war, but they believed in the war itself.

The journalists who came to report on the war in Korea came for uncomplicated reasons. Few hoped, as had many during World War II, that their words or photographs could prevent future wars. Korea, coming so soon after the Second World War, seemed to put the lie to that dream. Instead, the photographers and reporters came simply, plainly, to record the facts and to add to the story of war. They believed it was their duty to bring the scenes of battle back so those at home could see it and so history would remember it. "A photographer's job, like that of a writer," believed Carl Mydans, "is to record history. He must never forget this. It is so important, so all pervasive, that it has carried me through the terror of combat. . . . When I've said—as others have said—

in a very tough spot: 'What am I doing here?' I've always found comfort and the will to go on in my own answer. My job is to record the history of our times."[76]

Cameramen Charles and Eugene Jones wrote in the preface to their book on Korea, "Correspondents are only transients on a battlefield, the journalistic hobos of war, drifting from one point of impact to another, searching, seeking, trying to explain, trying to tell a world only vaguely understanding. Sometimes a camera helps."[77]

And Bourke-White said,

> The impersonality of modern war had become stupendous, grotesque. The remoteness between killer and killed in this kind of warfare doubtless has to be there if those of us who deal with war are going to carry on. But what are one's responsibilities? . . . I can only think in terms of my own field, how a photographer tries to help—how all the best photographers I know have tried to help by building up the pictorial files of history for the world to see. Just one inch in the long mile. I like to think that our profession can help a little.[78]

To help bridge that remoteness, to make personal the impersonal, photographers and reporters in Korea made more universal their World War II tendency of emphasizing the experience of the single soldier. Photographers such as Duncan and the Pulitzer Prize–winning Max Desfors of AP shocked the public at home with the aggressive intimacy of soldiers' faces in close-up. Edward Steichen, the director of photography at the Museum of Modern Art in New York and a former combat photographer in both world wars, mounted a show of 125 images of the Korean War. In his selection of prints for the exhibit, he purposely chose those photographs "which bring out most strongly the terrible impact of war on the individual, whether he be 'high brass,' front line GI, or hapless civilian." A review of the exhibition commended this choice: "Despite the complex mechanization of modern warfare, the individual emerges, clearly defined and in proper perspective, from the welter of tanks and guns, carriers and jets. It is a tribute to this group of photographers, all combat-experienced from the last war, that they have recognized this fact and sought to capture the human equation behind the trigger rather than the shell-burst."[79]

This focus on the common man was equally apparent among reporters, the military's public relations officers, and the troops themselves. Writers continued the Ernie Pyle tradition of quoting and mentioning

individual soldiers in their stories home. "One interesting feature of reporting from Korea," noted a *Washington Post* correspondent, "has been the general tendency to squeeze as many names as possible into dispatches from the front."[80] And PIOs reminded the military that

> the importance of the individual in a news release from the fighting front should never be overlooked. Almost without exception, the people of the United States are interested in what the individual fighting man is going through in any action. In the individual, the people at home see themselves reflected. A soldier, sailor, airman or Marine does not have to be known personally for his words to carry weight. The mere fact that he comes from a particular town or state is sufficient to arouse local pride or interest.[81]

All men, photographer Carl Mydans believed, live in history and die in drama. To some, that history is writ more clearly than to others. And possibly to tell the story of those individuals—whether they be famous or anonymous—is to shed light on all lives. Mydans told a story about one late afternoon in 1951, when "the sun jumped behind the snow-covered ridges of the Korean mountains." Mydans watched a procession of figures through his camera's viewfinder, the figures silhouetted against the failing light. They "half-carried, half-dragged a poncho in which quivered an incredible bundle." Mydans followed them to the medic's tent, where a Turkish doctor looked at what was brought to him.

> Wrapped from head to foot in rough bandages and bits of stuffing from a Korean coverlet was a mound that moved. Two holes at the top showed black, glazed eyes. . . . As the bundle was slipped onto a litter . . . the doctor rose and faced the mountains. Pointing toward the darkening horizon, he turned to me and shouted: "History!" In exasperation he searched for other English words, but they would not come. "History," he shouted again and then stood jerking his fist into the air, looking wordlessly toward the purple twilight.[82]

In earlier wars the cry would have been "Glory!" or "Sacrifice!" or "Freedom!" But by Korea, too many wars had happened too frequently for men to be taken in by gasps of emotion and calls of idealism. By Korea, men had recognized that death was not glorious, that sacrifice could be to little purpose, that freedom was rarely purchased with corpses. By Korea, the epitaph for the dead was simply "History!" By Vietnam, there would not be even that much.

12

The Photographs:

A Question of Balance

The Publications

ONLY FIVE YEARS AFTER V-J Day, the press and the military had to learn how to deal with each other all over again. The system of censorship in the Korean War had to be rediscovered as if the problems inherent in the media's coverage of war were novel questions. During the opening months of the war, the military, and General Douglas MacArthur especially, attempted to ignore the adversarial relationship between the press and the armed forces. But the interest of the correspondents in getting as much news as they could and that of the officials in hiding information which they did not want publicized caused a sharper conflict in Korea than it had in World War II.

The previous competition between the two institutions of the press and the military had perhaps been most intense during the blanket censorship of the First World War and least strong during the Second World War when the sympathies of the press had overwhelmingly meshed with those of the officials. At no time had there been any way to win the contest; the most satisfactory situation to all involved was always a mutually acceptable balance between censorship and disclosure. In the first six months of the Korean War, MacArthur believed that such a balance had been found. He cabled the Department of the Army in late September 1950:

CORRESPONDENTS ASSIGNED TO WAR REPORTING ARE ESSENTIALLY RESPONSIBLE INDIVIDUALS AS ARE THEIR EDI-

TORS AND PUBLISHERS AND THEIR ABILITY TO ASSUME THE RESPONSIBILITY OF SELF-CENSORSHIP HAS BEEN AMPLY AND CONCLUSIVELY DEMONSTRATED.... IN THE MANY MILITARY CAMPAIGNS IN WHICH I HAVE ENGAGED CMA [comma] MOST OF WHICH WERE COVERED BY THE MOST RIGID FORM OF NEWS CENSORSHIP CMA I HAVE NEVER SEEN THE PROPER BALANCE BETWEEN PUBLIC INFORMATION AND MILITARY SECURITY AS WELL ACHIEVED AND PRE-SERVED AS DURING THE PRESENT CAMPAIGN PD [period][1]

Editors and correspondents disagreed with MacArthur that a satisfactory balance had been reached. The press was willing, although not eager, to police itself on the issue of military security; information that might give tactical knowledge to the enemy was reasonably clear-cut (casualty numbers, embarkation dates, weaponry figures), but mistakes in judgment and timing could be and were made. As had been the case during World War II, editors and correspondents wanted to support the American war effort. Members of the press were unwilling, however, to restrict the publication of information that reflected on the issue of military prestige; they had no interest in trying to define narrowly the amorphous policy restricting information that might give "aid and comfort to the enemy." As Time magazine reported, "Every honest newsman wanted to tell the story straight, even if the telling reflected on the prestige of U.S. arms."[2]

The press did not want to be its own adversary. It was news when the GIs who were fighting the war in its opening weeks wailed to reporters: "It was a slaughterhouse." In the lead article in Newsweek the week of July 24, 1950, one "bloodshot-eyed" officer was quoted as saying: "You don't fight two tank-equipped divisions with .30-caliber carbines. I never saw such a useless damned war in all my life." A lieutenant grumbled: "I don't claim to understand the grand strategy of this thing but I will never again lead men into a situation like that one. Our orders were to hold at all cost. We did, but the cost was awful high as far as I am concerned."[3] Few journalists would voluntarily blue-pencil such comments on the off chance that such quotations might raise the morale of the enemy.

Although MacArthur had not been pleased with the press's interviews of critical and despondent soldiers in those opening weeks, he did not believe that censorship could prevent the publication of such stories:

EXCESSES AND ERRORS OF INDIVIDUAL CORRESPONDENTS
LAYING TOO GREAT EMPHASIS UPON THE OUTCROPPING OF
EMOTIONAL STRAIN SUCH AS APPEARED AT THE START OF
THE CAMPAIGN ARE NOT SUCH AS COULD PROPERLY BE
CONTROLLED THROUGH CENSORSHIP BUT IN DUE COURSE
FIND THEIR CORRECTION CMA AS IN KOREA CMA IN THE
MATURITY GAINED THROUGH EXPERIENCE AS THE CAM-
PAIGN PROGRESSES PD[4]

And, indeed, until the press leaked the accidental death of General
Walton Walker in late December 1950, MacArthur was unwilling to
impose any official censorship even to protect military security. He con-
tinued to assert that the voluntary cooperation of the press was suffi-
cient to ensure the secrecy of all critical information even after receiv-
ing a message, dated December 16, 1950, from the Joint Chiefs of Staff
directing him to "impose a news blackout and impound pertinent com-
munications media" to forestall ongoing security threats. "Recent dis-
closures in the public media," the message stated, "relative to the
movement and operations of military forces and material to and within
the Korean Combat Zone are becoming and [sic] increasingly serious
threat to the security and safety of our troops and operations."[5] As late
as January 20, 1951, in a letter written to *Editor & Publisher*, MacArthur
reiterated his earlier assertion that the policy of "voluntary censorship
by editors and publishers . . . has resulted in the most complete and
prompt public disseminations of information on the course of opera-
tions of any military compaign in history, without as far as is known a
single security breach of a nature to assist the enemy."[6]

MacArthur, although playing ostrich in his failure to acknowledge
publicly the need for official censorship, was at least correct in his as-
sessment that censorship could not prevent the publication of negative
reports and commentary. Even after the imposition of censorship, peri-
odicals continued to publish statements and write editorials critical of
the conduct of the war. In its June 30, 1951, issue, *Collier's* published a
special two-page editorial, in addition to its usual column, entitled
"Year of Decision." The editors excoriated President Truman and his
administration: "the government's present policy may aptly be called
vacillating." One "paramount aspect" of this policy was especially of
"deep concern to many Americans, including the editors of this maga-
zine. That is the seemingly endless continuation of the slaughter-and-
be-slaughtered policy which Mr. Truman and his advisers have decided
is the only possible policy in Korea if the third world war is to be

avoided."[7] And half a year later, in an issue of *Look* dated February 12, 1952, the column "*Look* Reports" baldly declared: "Korea is a tragedy, for us and for the Koreans."[8]

Publishers, editors, reporters, photographers, and broadcasters, although still on the American "team" as they had been in World War II, were yet considerably more critical of the U.S. war effort than they had been during the previous conflict. The American media as a whole supported the rationale for going to war in Korea, but they frequently disapproved of the management of it. Democratic President Harry Truman bore the brunt of the criticisms of an increasingly conservative press. The Cold War rhetoric in the public discourse, evident in the speeches of Senator Joseph McCarthy and the 1952 Republican campaign slogan of "Korea, Crime, Communism, Corruption," permeated American magazines and newspapers. (Some publications, of course, remained "fair and objective." Notable among them were the *New York Times*, the *New York Herald Tribune*, and the *Christian Science Monitor*.) Colonel Robert McCormick's *Chicago Tribune*, the Hearst journals, the Scripps-Howard papers, and Henry Luce's *Time* and *Life* were the most prominent periodicals that fed the "Red Scare." As the editorial in the July 17, 1950, issue of *Life* said, "The popular response to the Korean crisis definitely proves that there is a will in the U.S. to support *any* action that may be necessary to check the spread of the Soviet cancer."[9]

Although the *editorial position* of most periodicals was conservative, many of the staff reporters and photographers remained more liberal than their publications reflected. According to the Roper and Harris survey of the press over the recall of MacArthur, "half of the reporters who generally supported Truman on the recall are accredited to newspapers which editorially have been outspoken MacArthur backers."[10] This political dichotomy between the editors/publishers and the reporters/photographers was reflected in a mild distinction between the sentiments expressed on the editorial page and those exhibited in the photographs and copy in the rest of a publication. In the October 9, 1950, issue of *Life* magazine, for example, the editorial stated: "We also salute the 3,000 or more who have died in the hope that their deaths would prove to be affirmative contributions in the defense of the democratic world." Seven pages earlier, a photograph by David Douglas Duncan of a soldier looking at a copy of *Life* was captioned: "Corporal Leonard Hayworth sees his picture in Sept. 18 LIFE story. Next morning he was killed in action." The earlier picture of Corporal Hayworth showed him in tears. It was the opening photograph to a story by Duncan entitled " 'This Is War.' " The text read: "Duncan's story starts below with a

corporal, who is out of ammunition and has lost all but two of his squad, crying in anger and frustration."[11] The impression one received from the photographs and captions certainly did not reinforce the editorial's statement that these soldiers' deaths could possibly have been "affirmative contributions" to anything.

In the five years since the end of World War II, the media—together with the rest of the country—had grown more conservative, but this shift in editorial outlook did not affect the visual appearance of the popular periodicals. The photomagazine *Life* remained in a class by itself, using glossy stock and letterpress printing to cover hard news, compared with *Look*'s less serious features that were run on a rotogravure press. *Collier's* and the *Saturday Evening Post* continued to emphasize illustrations over photographs, and features, short stories, and serials over hard news. Newsmagazine *Time* maintained its circulation lead over its rival *Newsweek*. Together with *Life*, these two newsmagazines continued to be the major magazine outlets for breaking-news stories and photographs. The sole difference between the magazines' layouts on Korea and their earlier layouts on World War II was their more frequent use of color for inside photographs and covers.

Proportionately, many more photographers covered events in Korea than had covered World War II. In Korea, photographers were not generally restricted to pooling regulations as they had been ten years previously. But the primary reason for the lavish coverage of the war was that World War II had set a precedent for up-front combat photography that photographers and their editors and publishers needed to best if they were to continue to attract an audience. Magazines, newspapers, picture agencies, and news services competed to have their reporters and photographers on top of the action—wherever the action was. *Life*, which gave the war its most comprehensive picture coverage, shuttled eleven photographers (although not all of them were staff photographers) through Korea during the three years of the war. "In the 157 weeks of its duration," *Life* reported, "the Korean war has been reported by some 454 pages of pictures." In its issue on the final cease-fire, August 3, 1953, *Life* looked back on the war. "On June 25, 1950," it said,

LIFE's David Douglas Duncan was on a beach near Tokyo when a fisherman told him of the North Korean attack. Two days later Duncan was shooting the first news pictures of the fighting. . . . The course of war can be read in our photographers' assignment sheet: the retreat to the Pusan perimeter, Duncan and Carl Mydans; the Inchon invasion, Mydans and Hank Walker; the drop with the

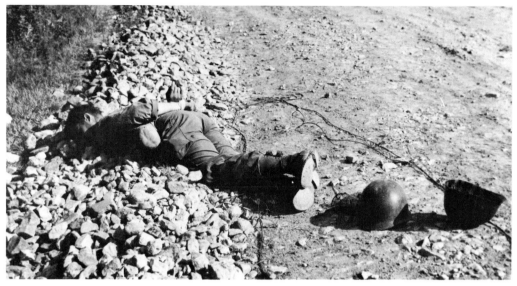

39
U.S. Army
"Face down on a Korean roadside lies the body of an American soldier
who was captured by Communists, trussed up and then murdered."
Life, July 24, 1950

40
Carl Mydans
"The blanketed corpse of an infantry lieutenant
lies across the straw-camouflaged
jeep in which his men brought him back from the front."
Life, July 17, 1950

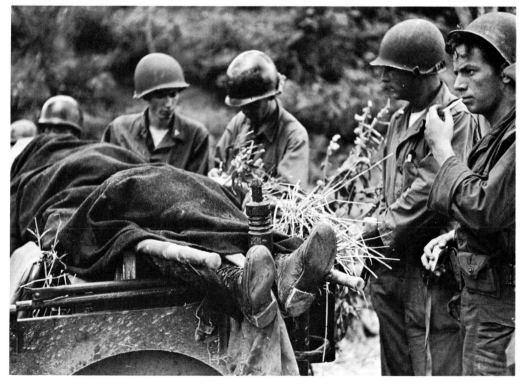

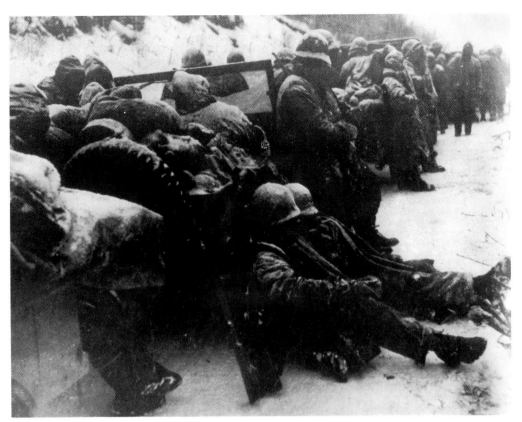

41
Department of Defense
"Night must fall: This fine twilight picture shows Marines resting during the breakout in Northeast Korea."

Newsweek,
December 25, 1950

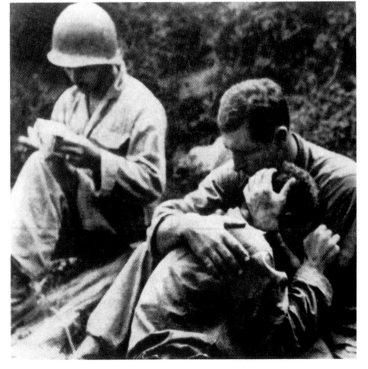

42
Department of Defense
"The Price of Victory:
A soldier grieves for
his lost buddy. . . ."

Newsweek, October 9, 1950

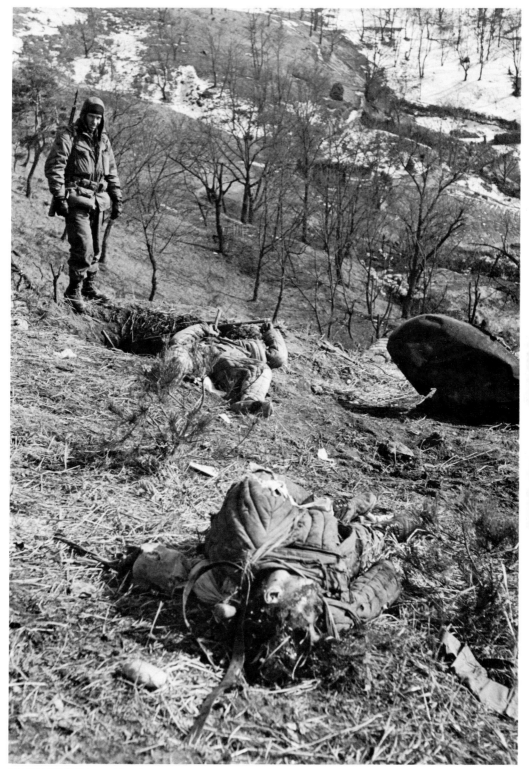

43

Carl Mydans
"Dead Chinese lie all over the Chipyong battlefield.
These reached only the edge of a GI's foxhole."

Life, March 5, 1951

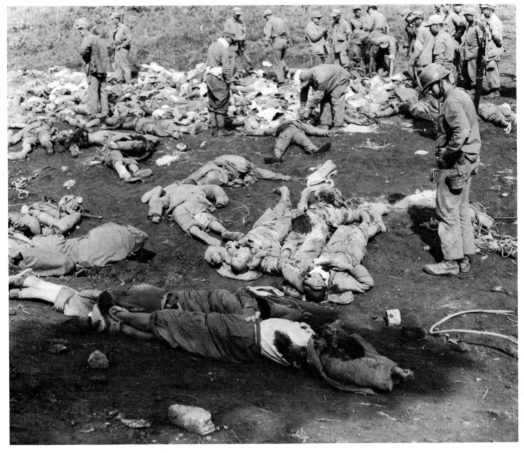

44

Associated Press

"This radiophoto shows GI's searching the corpses of Chinese Communists killed in round 2 battles and evidently stacking them in the background."

Newsweek, May 28, 1951

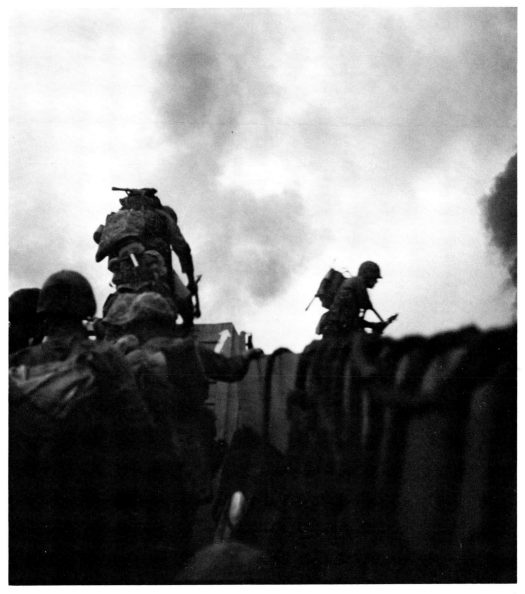

45
Hank Walker
"Inchon invasion: Scrambling from their landing craft to the sea wall on
the beaches of Inchon, assault waves of Marine infantrymen lead the U.N.
forces in a bold sea invasion to the enemy's rear in 1950."

Life, August 3, 1953

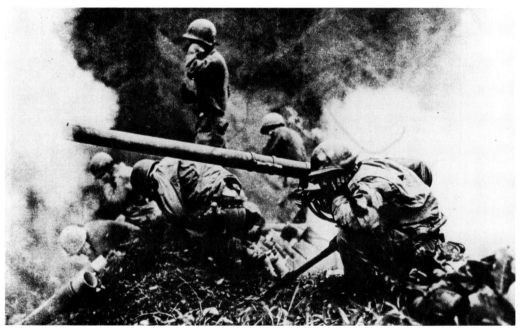

46
Department of Defense
"In a hell of smoke, shell cases, dirt and noise, infantrymen fire 75-mm.
recoilless rifle in support of platoons battling the enemy
directly across the valley."

Look, January 29, 1952

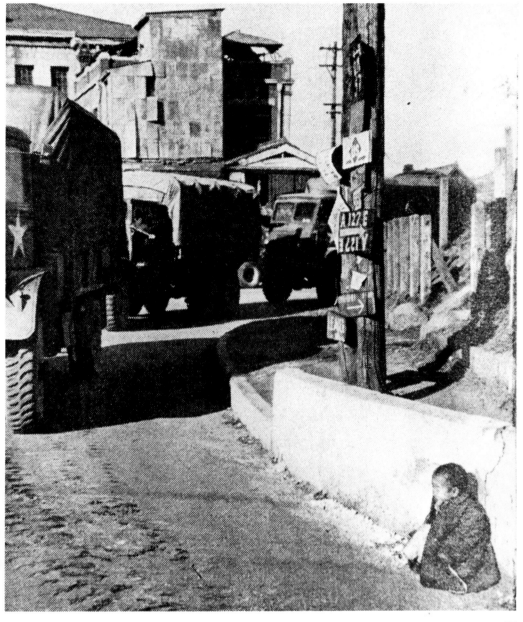

47
Acme
"UN military convoy ignores
a tiny waif."
Newsweek, December 25, 1950

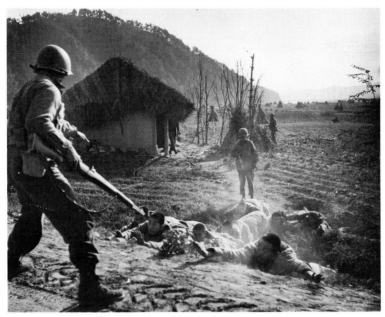

48
Hank Walker
"Red Surrender: Terrified Red soldiers, flushed from their hiding place in
a roadside ditch, surrendered to American GIs as U.N. forces
headed for the Yalu in 1950."
Life, August 3, 1953

49
Margaret Bourke-White
"War Within a War: A dead guerilla . . . was the prize of
South Korean police who fought throughout the war
against Red terrorists working far behind the battle lines."
Life, August 3, 1953

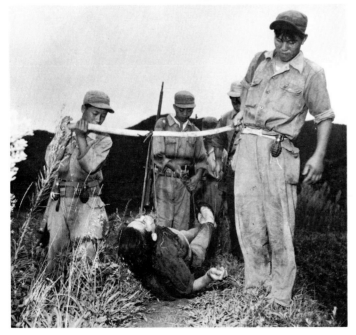

187th Airborne, Howard Sochurek; the dash to the Yalu, Walker; the retreat from Changjin, Duncan; the push back into North Korea, John Dominis and Joe Scherschel; the spring offensive of 1951, Mike Rougier. After the nerve-tearing stalemate began, Margaret Bourke-White photographed the behind-the-lines war on guerrillas. Werner Bischof described life in the Koje prison camps. Rougier and Horace Bristol reported Eisenhower's visit. With Jun Miki, Rougier covered the negotiations at Panmunjom, and the truce riots in Seoul.[12]

According to the results of a survey printed in *Newsweek* in early 1951, photographs were "the biggest drawing card" in the press. And of those pictures, images portraying "National Defense" and "Foreign War" were looked at by more readers—both male and female—than photographs (in descending order of male readership interest) of "Accidents and Disasters," "Crime," "Sports," "Beauty Queens, Glamour Girls," and "Children and Babies."[13] With such an incentive, it made good business sense to use photographs of the Korean War copiously. After all, by the 1950s, picture magazines had to compete not only with each other for the living-room attention of the public but with the new interloper, television. By 1952, television had gained a significant place in the U.S. market: more than 34 percent of American homes—15 million—had television sets. By the end of the decade, television was gaining: 86 percent of households had a television set.

Korea was the last war that most Americans viewed primarily through photographs in print. The forties and the fifties were the heyday of the glossy picture magazines; by the 1960s, the public could watch news events live—they did not have to wait a day, a week, or a month to see what something looked like. Television is easy; one does not have to turn any pages or read any copy. It captures movement and sound. It has all the appeal of Hollywood brought to the doorstep. But still photographs would continue to have a place in the media; single photographers can go places that cameramen attached to their mikes, battery packs, and sound systems cannot. Still photographs can concentrate events into one or several pictures; in many ways, this visual distillation is more memorable than fleeting television images.

But during the Korean War, magazines were still, incontestably, king. Publishers such as Henry Luce fed the American audience with compelling photographs of combat and persuasive editorials of opinion. After the brilliant success of Inchon and the flight of the North Koreans across the 38th parallel, *Life* counseled that Korea should be unified.

"The danger of Chinese or Soviet intervention," it wrote in its editorial, "if the North Korean Communists are pressed close to the Manchurian border is, in our curbstone opinion, negligible."[14] Of course, *Life* was wrong. Two months later, *Life* admitted, "the news is of disaster. World War III moves ever closer." However, rather than blaming MacArthur (who shared *Life*'s opinions) for the misguided campaign to the Yalu, *Life* blamed "our leaders at home" who were "frightened, befuddled and caught in a great and inexcusable failure to marshal the strength of America as they ought to have done in recent months." But, *Life* said,

> at last we know—we really know—our enemy. We know that our enemy is the Soviet Union. We know that the Chinese Communist armies assaulting our forces in Korea are as truly the armies of the Soviet Union as they would be if they wore the Soviet uniform. . . . There are no proxies in the armies of Communism. . . . We must never forget that what we can do in Asia and elsewhere depends first of all on what we do at home to prepare for the ultimate war that our real enemy seems determined to force upon us.[15]

For the prominent magazines of the time, coverage of the Korean War was coverage of a hot spot in the Cold War. Editors and publishers floundered in their rhetoric while they, ironically, printed photographs showing soldiers trapped in the Cold War politics. *Life*'s Christmas 1950 editorial reflected: "There is in the temper and the conflict of our times some element of restraint which dissuades us from identifying our cause with God's and from maintaining, in the manner of World War I, that our armies are God's armies. . . . Where, then, is God? . . . God, as always, is in the hearts of all who will have Him there. . . . We do not need to put God at the head of our battalions. He is in them."[16] Yet the eight-page photo-essay in the same issue, written and photographed by Duncan, told of no God, but of Hell. "Eyes of men who have looked at undiluted hell are not pleasant to meet soon after," Duncan wrote. His pictures spoke not of the "rightness of our cause" or of "MacArthur's greatness" but of those men "who survived unhurt," those men "who were wounded and pulled through," and those men for whom "Christmas is now forever."[17] During the Korean War, not only were photographers beginning to stand apart from the official government- and military-sponsored war effort, they were beginning to stand apart from their own publications. The Cold War in evidence in the photographs

of this conflict was not the ideological battle between the Soviet Union and the United States but the corporeal fight against the snow and freezing wind sweeping across the Korean landscape.

The Aesthetics

In the first few days of the fighting in Korea, photographers took and sent home graphic pictures of American soldiers killed by atrocities. *Newsweek*, in its July 24, 1950, issue, published an image from International Photos of a soldier, legs bound, hands wired behind his back, executed by the side of a road. The caption read: "Murdered: This American prisoner, with hands bound, was shot by Reds." The accompanying story opened with a quotation from an American photographer: "This is not killed in action. I call it murder." The article went on to describe four specific atrocity incidents, three perpetrated by the North Koreans, one by the South Koreans.[18]

That same week, *Life* ran a similar image, large, on its first page of text. *Life*'s photograph, credited to U.S. Army Photo, pictured the same soldier as the *Newsweek* image, only taken from a different angle (figure 39). The caption was similar: "Face down on a Korean roadside lies the body of an American soldier who was captured by Communists, trussed up and then murdered." The article the photograph headed, "Why Are We Taking a Beating?" began: "On the Korean front retreating American soldiers, bitter at their own blameless failure and the brutal execution of their comrades, were asking some savage questions. 'Why don't you tell them how useless it is?' said Lieut. Edward James of Columbus, Ga."[19]

The public's reaction to the atrocity pictures, at least as represented in the "Letters to the Editors" column in *Life* three weeks later, was in favor of the publication of such images. (The single reported negative reaction was less a response to the publication of a photograph of a dead American than a response to *Life*'s "*method of exploiting* a picture of a dead GI to further a political end [emphasis added]."[20]) The military in Washington, however, believed that the country was not ready for vivid photographs of the horrors of Korea. Even before the *Newsweek* and *Life* pictures appeared, the official word went out from the army to the Far East Command: "Due to decidedly unfavorable public reaction to re-

cent atrocity pictures and pictures of wounded men in battle areas, strongly recommend no release this type picture to media in theater."[21]

Three years later, Tom Maloney, the editor of *U.S. Camera* (the preeminent photographic magazine of the period), critiqued those photographs that had been allowed past the censor. "Pictures that come through service censorship," he said,

> rarely tell the most important of all war stories—death. There are pictures of firing, of destruction, of dirt, of utter fatigue and desolation. But death, the end result, seems an unsalable article to the men who reluctantly admit that rigor mortis is their business. Yet, the last war and every war proves the public realizes what it is facing, quickest, only when it is brutally apprised of what is happening to its youth. So, in this instance—not the photographers, not the photographs, but the censorship of frankness is to be condemned.[22]

A surprising number of photographers, however, such as David Douglas Duncan of *Life*, avoided taking "brutally" explicit pictures of the American dead or wounded. To take such graphic photographs, they believed, was unconscionably intrusive, bordering on the obscene.[23] Many photographers in Korea believed they could show the reality of combat without invading the soldiers' privacy; they believed that it was important to show the public at home that Americans were dying in combat—in the same manner as the public had been shown during World War II—but they felt they could do so without escalating the horror of the visuals by focusing on blood-soaked faces or mutilated corpses. In effect, the photographers tacitly acquiesced in that aspect of the censorship that restricted the release of graphic photographs of dead Americans.

Even with the military censorship of photographs and the self-restraint exercised by many photographers, however, the war, as it was brought home in pictures, was not whitewashed with patriotism. Just as had been the case during the latter half of World War II, photographs of dead, shrouded American soldiers killed in battle appeared in the pages of home-front periodicals. (Some pictures from Korea were almost identical to their Second World War counterparts; Carl Mydans's photograph of an interment of bagged corpses in a line of open graves is a twin to an image from Normandy six years earlier.[24]) Yet, unlike those from the world wars, pictures from Korea omitted all pomp and pageantry. The photographs both reflected and affected American attitudes about

the war: the chauvinism that had unified the country during the 1940s began to divide it during the 1950s. Pictures of military funerals in Korea included no Stars and Stripes, only mounds of earth and rows of crosses. Americans were tired of war, of calls for sacrifice. Americans' "Jungian" need to be the guarantor of the world order had become a burdensome responsibility.

As always, however, some articles on the American dead featured studio photographs of the casualties, rather than combat pictures of the bodies. *Look*, for example, illustrated a story on West Point's Class of 1950 with twenty-eight portraits banded in black. The headline read, not the World War I sentiment, "Dulce et Decorum . . ." nor the World War II fact, "Killed in Action," but the comment, "From their hour of joy . . . these went to duty . . . and death."[25] Other articles pictured scrapbook shots of soldiers from infancy to enlistment; one, entitled "The Life Story of a Dead Marine," ran in *Life*. The patriotism of World War II was turning bitter; the subhead to the *Life* article noted: "Lieut. John Guild, now buried in Korea, leaves behind a memory-filled scrapbook and a father angry at himself and the U.S." Guild's father sent a letter to the *Denver Post*. "I am writing," he said, "as the father of one of the 5,000 boys killed by the Reds in Korea. . . . Our sons were not given a fair fighting chance for their lives. . . ."[26]

Because of this bitterness, officials and the press backed off from the new candor. In the first month of the war, photographs of soldiers dead not only as a result of battle but of torture appeared in print. The Far East Command then stopped the dissemination of such photographs, but, for the next six months, allowed the release of more restrained pictures of the American dead, similar to those published in the second half of World War II. During the last two and a half years of the Korean War, the World War II–type pictures of the American dead continued to be allowed. However, they appeared infrequently in print, partly because as the war settled into stalemate, fewer articles on Korea were published.

The first picture of an American killed in Korea to be printed in *Life* was taken by Carl Mydans during the second "grim" week of the war. It was one of the strongest images to come out of the conflict (figure 40). A letter to the editors described the photograph. "Your picture," wrote the reader, "of a dead lieutenant and his men—especially the face of the last boy on the right—seems to portray combat as the young soldier sees it better than any photograph I have seen. In his eyes and the expression of his face are skepticism, horror and a sudden grownup look from the realization of death."[27] No longer did readers speak of heroic

sacrifice; the romance of war had dissipated. In its place was a restive acceptance of a necessary battle. The Mydans photograph spread across two pages of Life's July 17 issue. In the picture, a half dozen or so soldiers stood to the right of a jeep; the body of the lieutenant lay covered on a stretcher. The dead officer's boots stuck out over the rear fender; they were in focus in the center of the image. The photograph was reminiscent of the Spanish-American War image of Hamilton Fish (see figure 1). In both pictures, the feet of the victim arrest the viewer as a synecdoche for death.

Five months later, the second full-scale retreat of the war was under way. For Life's Christmas issue, David Duncan photographed the marines' march back to Hungnam and the sea. Duncan described the retreat in his book This Is War! printed the next year. "As they moved down the road," he recalled,

the wounded and frozen got to ride. The dead also rode—tied upon trucks and trailers. Behind them—the shuffle of their feet following the rising and falling beat of a tragic rhythm—walked the living.

They passed the last Chinese ambush where lay crumpled the men soon to be given places on other trucks and trailers farther back in the column—the men never to freeze, or worry, or go hungry . . . or march again.[28]

The entire last page of Duncan's December 25 article pictured the scene. The troops, guns in hands, swaddled to their helmets, tramp down a dirt road. A jeep is in the background. In focus, in middle distance, a marine looks over his shoulder, staring at the heap of dead sprawled in the scrub at the side of the road. The marines, said Duncan, always bring their dead out with them. The caption read, "These dead were picked up later."[29] (Unfortunately, David Douglas Duncan has refused permission for the reproduction of his photographs in this book. But there is no way I can write him out of the story of the photography of the Korean War. His contribution to the coverage of war is indisputable. I apologize to my readers for the inconvenience and I recommend to them that they go back to the original articles in Life to see his still-powerful photographs.[30])

Three weeks later, Life printed two columns of letters to the editors in response to Duncan's article. Representative of them all was one from a woman in Georgia, who wrote, "You have had many great stories in your magazine, but 'There Was a Christmas' is your masterpiece for all time." One man from Wyoming commented: "The scenes of the Marine

retreat in your Christmas issue moved me strongly as I am a veteran of World War I, and have one son who served four years with the Marines in World War II." And Edward Steichen, at seventy-one the grand old man of photography, a former military photographer during both world wars, and director of the Department of Photography at the Museum of Modern Art in New York at the time of the Korean War, also sent a letter. "David Douglas Duncan's wonderful photographs of Marines in Korea," he said, "have set a new high for war photography. I want to join in the richly-merited cheers coming from many photographers for these deeply moving photographs."[31]

Other publications also joined Life in offering their readers a dark Christmas portrait of the war. Newsweek's essay was particularly strong. Entitled "No Peace on the Beachheads," its story mourned the "sound of guns and bombs [that] echoed around the world—a sort of shattering Christmas carol of ill will toward men everywhere." Newsweek ran eight photographs in its four-page series of articles, the first image of which captured the same sense of exhaustion that was found in the Duncan essay. Captioned evocatively "Night must fall," and credited to the Department of Defense, the photograph pictured another column of marines (figure 41). This one, too, showed them huddled around halted jeeps, slumped in their shadows, dusted by snow. The dead were all that was missing.[32]

The photographs of American casualties in Korea that appeared in print gave the public a curiously different message about the war than did the articles and editorials in the same magazines (unless those articles were written by the photographers who took the pictures). Stories that were positive about the war, as for example an article in Newsweek on October 9, 1950, contrasted with their accompanying images. The Newsweek story began, "The United States has taken the risks and paid the price of victory in South Korea. Now it is also reaping the rewards of victory—and not only in Korea. From all over the world comes the story of Russian plans disrupted . . . and, above all, of an upsurge of confidence, not only in the willingness of the American soldier to fight and die, but in his ability to win by boldness and superior organization." The two photographs illustrating the spread demonstrated no such confidence. The caption to them read: "The Price of Victory: A soldier grieves for his lost buddy . . . while in a military cemetery services are held for Marine dead."[33] The first image captured the distress of a soldier who is being comforted in the arms of another (figure 42), and the second image depicted a cemetery with scores of fresh graves.

The photographs from Korea admitted what the magazine articles

and editorials were unwilling to: that there is no triumph in death—and precious little triumph in war. Finally, by Korea, American visions of the glory of war were being superceded by images of the sadness of it. A reader in Uniontown, Pennsylvania, wrote to Newsweek two weeks after the publication of the "Price of Victory" photographs. "I think," he said, "the Korean war picture, 'A soldier grieves for his lost buddy' . . . should take its place in the annals of history alongside that other immortal classic 'The Marines plant the American flag on Suribachi,' which came out of World War II."[34] Newsweek reprinted both pictures as illustrations for his letter.

The writer's recommendation suggested a great deal about the difference between the public's perception of World War II and its perception of the Korean War. The World War II photograph of the six marines raising the flag on Iwo Jima was a picture of victory and rejoicing (see figure 23). It was a brave image of men succeeding together. The Korean War photograph celebrated no victory; it was an image of personal sorrow and compassion. In it there was no cowardice, but neither was there any sense of pride or positive achievement.

This new-found ambivalence about war reflected in the photographs of American soldiers also found voice in the images of the enemy. The pictures of the enemy dead—the North Koreans and the Chinese—captured the candid quality of the photographs from World War II but lacked the vindictiveness inherent in those images. The contrast is especially notable when one compares the photographs from the Pacific theater during World War II with those from the Korean War. Although the enemy in both cases were Asians, the photographs from Korea focused less on identifiable faces or extreme forms of death than had the photographs of World War II—a function, as well, of the fact that the U.S. soldiers were defending South Koreans who were indistinguishable from their North Korean enemy. The photographs of the North Korean and Chinese dead were hardly more explicit than those of the German dead or even the American dead during World War II.

Indeed, a photograph by Mydans of dead Chinese soldiers that appeared in the March 5, 1951, issue of Life (figure 43) was strongly reminiscent of the image of retreating marines and dead Americans taken several months earlier by Duncan. Life ran both photographs full page. Both were shot from similar angles: the corpses lay on the ground perpendicular to the lens of the camera; an observer on the left stood looking at the bodies. Although the dead Chinese lay on a hillside and the Americans lay on the side of a road, both pictures were framed by surrounding mountains. The most significant difference between the two

images was that the Mydans photograph included only three figures, one standing American and two prostrate Chinese, while the Duncan photograph pictured a score of marching marines and an undetermined number of dead. The Mydans photograph did, however, insinuate that there were other corpses; the caption to it read: "Dead Chinese lie all over the Chipyong battlefield. These reached only the edge of a GI's foxhole."[35]

The Mydans image was similar to but not as graphic as many of the images of the enemy taken during World War II. During Korea, there were no slow-motion images of burning Koreans or photographs of enemy skulls speared on top of tanks. There were no pictures of Koreans or Chinese exhibited as American trophies, as had been the case in earlier wars. Grim photographs did appear from Korea—for example, a row of naked "Reds" burned and killed by flame throwers—but the pictures did not emphasize faces or treat the enemy corpses as prizes that had been won. Photographers did not move in for close-ups of gore. The image of the "Burned Reds," for instance, was no worse than the picture of the charred Spaniard taken fifty years earlier during the Spanish-American War.[36]

There were several reasons for this relative restraint. First, photographers and publishers desired to depict the American troops as the vanguard of the free world. The negative reaction to the horrific pictures of the Japanese printed during World War II had made publishers, as well as the military and press in Korea, loathe to publicize any analogous incidents. As the graphic photographs from World War II demonstrated, it was more difficult to substantiate the Americans' credibility as humane soldiers of democracy when the photographs portrayed, in meticulous detail, the horrors that the troops had wreaked on other men. A more important reason for not showing extreme photographs, however, was that the Korean War—at least for the Americans—was not a total war. A total war gave Americans license. Everything was legitimate in a battle for survival—especially if the other side did it first. The absolute commitment of the home front to World War II and the swaddling of the troops in the American flag justified or at least condoned even such practices as torching someone to death or mounting his head as a hood ornament for a tank. There was no such commitment or swaddling during the Korean "police action."

A third reason for the shift from photographs that zoomed in on the mutilated individual enemy was that with the end of World War II had come a new understanding of war. With the liberation of the concentration camps had come the shocked recognition that the war had extermi-

nated millions of people. The mortal insult to a single victim paled next to the carts and pits heaped high with butchered corpses. The grimmest photographs of the enemy (or of the enemy's actions) in the Korean War, then, were the pictures of piled bodies. In October 1950, *Newsweek* printed a photograph from Acme of "slaughtered South Koreans . . . left unburied where they fell."[37] Seven months later, *Newsweek* ran a radio-photo from AP showing "GI's searching the corpses of Chinese Communists killed in Round 2 battles and evidently stacking them in the background" (figure 44). Scores if not hundreds of bodies littered each image. The pictures could have been taken at Buchenwald.

"We slaughtered so many," declared an American colonel, "their blood covers our boots." Photographs of piles of Chinese bodies seemed appropriate in a war in which the Chinese were always referred to in units of "hordes." One or two dead Chinese would hardly have sufficed to staunch the flow. The headline and subhead to the latter article in *Newsweek* reinforced this impression: "Mangling the Massed Red Might," trumpeted the headline. "Red Waves of Death," noted the subhead.[38] The photograph of the Chinese corpses appeared as the American response not only to the threat of the communist hordes but to the reports of communist atrocity killings of thousands of American and UN troops: do unto others as they have done unto you.

The Americans were especially appalled at the rumors and confirmations of U.S. soldiers killed at the hands of their captors. It was one thing to read about the massacre of other populations but something else to read about the death of American boys. President Truman, expressing the dismaying ethnocentricity of the nation, branded the atrocity killings "as the most uncivilized thing that had happened in the last century"[39]—a comment indicative of the Americans' anguish but frightening for its cavalier dismissal of the millions of Jews, Russians, and Eastern Europeans who were killed by the Nazis less than ten years before (not to mention the systematic slaughter of the Armenians by the Turks, the methodical murders under the Japanese Co-Prosperity Sphere, those under Stalin, and so on).

The unthinkable scale of twentieth-century war—first World War I, then a truly global Second World War, then a Cold War dividing the Earth in two with Korea being the line between—was too much for the public at home to comprehend. As the numbers mounted and the technology of war increased, correspondents concentrated even harder on the individual American soldier. The more inhuman the wars became, the higher the piles of bodies, the more the journalists fixated on the single man. In World War II, Ernie Pyle championed the GI. In Ko-

rea, a war more distant and less understood, *everyone* focused on the faces and stories of the common soldier. World War II was the first engagement in which American troops had been photographed in close-ups; in Korea, the close-up became the signature of the war.

The photographs of the individual soldiers in Korea were more sophisticated than their counterparts from World War II. The straightforward, black-bordered pictures taken by George Silk for *Life* of four privates on the western front did, however, have their parallels in Korea: Hank Walker took photographs for a similar page consisting of four images of four sergeants stationed in Korea.[40] And the feature magazines, especially, relied on set-up pictures of individual men and their squads.[41] But most frequently, the close-up shots from Korea were not posed "documentary" images but grim candids of the men taken in the minutes before going into action, in the moments of combat, or in the hours succeeding the fighting. Articles, even in the newsmagazines *Time* and *Newsweek*, occasionally emphasized such candids. *Newsweek*, in a March 5, 1951, story, ran a large AP photograph of the battered and bruised face of a soldier.[42] And the feature magazines, such as *Life*, often focused on unrelenting images of the troops. Mydans's picture of a sweat-soaked, arm-akimboed black corporal who had just arrived at the front ran full page in the August 21, 1950, issue of *Life*. Duncan's photograph of a gesticulating corporal, frustrated to tears, began the September 18, 1950, issue. And the December 25, 1950, *Life* carried Duncan's image of a young marine holding a can of frozen rations full bleed opposite its opening text.[43]

These and other compelling close-ups superseded, but did not replace, more conventional pictures of action. Such pictures attracted attention because they were a new perspective on war. Never before had Americans at home been privy to the unguarded emotions of their soldiers in the field. It was riveting for families at home to look into the eyes of the soldiers who were suffering on the lines. Readers found the close-ups more insightful and more informative about the war than the classic, World War II–type pictures of combat.

Life's photographs during Korea were distributed to member newspapers of the AP (of which *Life* was also a member) for publication after the relevant issue of *Life* was on the stands. The most widely reprinted of all the images from its December 25, 1950, article on Korea was the photograph of the solemn marine with the frozen rations. More traditional images of combat were passed over in its favor. That Christmas, newspapers across the country chose not to offer their readers positive photographs of action but chose instead to confront their subscribers

with this face of despair. The Houston *Post* found the picture "more appropriate today . . . than a picture of a Christmas tree or a little child." The San Francisco *Chronicle* captioned the photograph: "What d'You Mean, 'Merry'?"[44]

Articles, such as " 'This Is War' " and "There Was a Christmas" in *Life,* which included both photographs of action and of soldiers' faces, seduced readers into believing that they knew the boys who were fighting. Readers believed that because of these articles they could better understand and even share the troops' experiences. Such photo-essays spoke on a "gut" level; little information was given other than what could be gleaned from the pictures. In the two preeminent examples from *Life,* there were no more than a couple of paragraphs of copy in addition to the photo captions. Readers did not miss the accompanying text; they believed the photographs distilled the essence of the war. "David D. Duncan," said one in response to the " 'This Is War' " article, "should be elected 'Photographer of the Year.' Many photographers have tried, but none have ever shown war with such terrible realism." And an editorial in the Detroit *Free Press* noted, after the *Press* had run eight columns of Duncan's pictures: "In the whole history of the photographic art, a camera lens has never produced masterpieces to surpass those portraying the freezing, fighting retreat to Hungnam. . . . As sheer compositions of mass and line they are eligible for space in any museum where great pictures are hung. . . . Automatically, all prizes offered for the outstanding photography triumphs for this year should go to the man who took them, David Douglas Duncan of the LIFE magazine staff."[45]

Although Duncan's photo-essays focused on the individual soldier, they also included shots of combat. Duncan's eye was as true in capturing the decisive moment of action as it was in arresting the telling expression on a soldier's face. His pictures of troops in combat, however, did not investigate a new angle of the war as did his candid close-ups. Battle was neither dissected nor analyzed. Photographers in Korea were willing to question the effect of war on the individual soldier but were not as yet willing to go too public with questions about the need for the war itself. Photojournalists in Korea did not apply the irreverent subjective approach to combat subjects that photographers back in the United States—such as Robert Frank—applied to their documentary subjects. This new fifties' attitude of "subjective realism" was first to inform the coverage of war during the Indochina conflict. During the American engagement in Vietnam, for example, images of combat offered a provoking alternative commentary to the military's and gov-

ernment's version of the war's conduct. In Korea, combat/action pictures seemed to accept the officially mandated account.

The action photographs from Korea, as taken by Duncan and others, continued the World War II tradition of romanticizing war. Men were still men. The combat photographs pictured rugged, John Wayne–type warriors, in contrast to the sensitive, Gregory Peck–type youths exhibited in the close-ups of the soldiers. The combination of the two types of images in a single story blurred the message each type of picture proffered. The portraits of questioning, critical, despondent soldiers suggested that the men believed the war was not worth the cost; the photographs of those same troops shooting, advancing, and attacking argued that they were willing and able to fight the foe. The ambivalence of the collected photographs mirrored the ambivalence of the public at large.

The combat photographs from the Korean War fell into the same aesthetic categories as those from the earlier conflicts. There were sequential pictures of fighting comparable to the freeze-frame–type photographs from Cantigny during World War I. In his story " 'This Is War,' " Duncan included several groups of images that portrayed incremental changes in action. And other photographers and other magazines used the technique of grouping time-lapse images—a technique at least as old as the movies—to suggest a sense of movement in their still pictures.

In addition to their rejection of the new "subjective realism" treatment of documentary subjects, combat pictures from the Korean War also resisted the aesthetic of the art photography of the period. The prevalent neutered, hermetic style of the "New Objectivity" was overlooked. Instead, the Korean war images imitated the gray, gritty visions of indistinct action most notably captured in the World War II D-Day pictures of Robert Capa. Photographer Hank Walker, for example, especially in his coverage of the Inchon invasion and the race to Seoul, was forced to resort to shooting pictures under less-than-optimum conditions. In the low light of dawn, the smoky haze of exploding shells, and the blur of haste and fear, Walker and other photographers took their pictures. Two of Walker's muddy images from his (and Mydans's) October 2, 1950, story of the invasion were considered two of the best photographs "taken during the three years of bitter fighting." The *Life* photo-essay (August 3, 1953), which included eight pictures "by LIFE's photographers on the Korean battle lines," clearly signaled that to many—before, during, and after Korea—grimy pictures of men in action would always be the quintessential images of battle.[46]

The first of Walker's photographs in the original invasion article in

which they appeared depicted that old chestnut of combat: men going over the top (figure 45). Similar to the shadowy photographs from the western front in both world wars, the Korean picture borrowed as well from the busy island photographs of World War II. The subject, composition, and caption were almost identical to the Marine Corps image from Tarawa of men on the beach going "over the top of a coconut-log retaining wall" (see figure 32). The Korean photograph's caption reported: "Scaling sea wall, an assault wave of the 5th Marine Regiment climbs out of its landing craft at Red Beach. Carrying only light combat packs, Marines ran or rolled into the nearest ditches as Red machine guns opened up on them. But as wave after wave swept over the sea wall, the Marines beat down the defenders and pushed into the burning and exploding city. By nightfall the beachhead was secure."[47]

Other pictures from Korea shared the aesthetics of the Pacific theater photographs of World War II—and some had more of the clarity that was remarkable in the images from the island campaigns. Look illustrated a feature article written by Major William Clark, the son of General Mark Clark, with Department of Defense photographs from Bloody Ridge and Heartbreak Hill. The story entitled " 'I Saw Them Die in Korea' " emphasized the high drama of the Army infantry fighting. The photographs corroborated the text. The final image of the article pictured a half dozen men bent down, hands over their ears, protecting themselves from the blast of their artillery (figure 46). The caption explained: "In a hell of smoke, shell cases, dirt and noise, infantrymen fire 75-mm. recoilless rifle in support of platoons battling the enemy directly across the valley."[48] Triangles of smoke spurted from both ends of the recoilless rifle. The men and landscape formed an hourglass image between the white clouds of fire; the barrel of the gun bisected its neck. Only one man stood up above the horizontal in the top bowl of the glass; all the others crouched low. The metaphor was clear; the sand, the men, the time in Korea were running out.

Few combat photographs underscored that point. Any consistent, cultivated critique of the war surfaced primarily in the close-up portraits of men in extremity and in the few pictures of the wounded that captured naked moments of agony. The full-page, final image of Duncan's brilliant photo-essay " 'This Is War' " was one photograph to do so. It caught the piercing distress of a young soldier with a bare, bandaged arm. The understated caption read: "A wounded Marine is about to be taken away in a jeep."[49] The Duncan image had few antecedents. Formerly, pictures of the wounded showed them at worst in placid shock or in the ordeal of treatment and, more generally, in the positive

stages of recovery. Duncan's photograph foreshadowed the images of the Vietnam War that dwelt on the immediate physical pain of the victims of war, as well as on the emotional anguish of the survivors.[50] His image blurred the movement yet caught the concentration that pain insists on.

Other photographs, such as one credited to International in *Newsweek*'s Christmas 1950 issue, also depicted soldiers who "wince . . . with pain."[51] But most pictures of the wounded in Korea, like one by Mydans of a wounded medic that appeared in the September 11, 1950, issue of *Life* or one by Signal Corps photographer Private First Class Nebbia, of a frontline aid station that was in the August 14, 1950, issue, copied the earlier world wars' pattern of showing the wounded already receiving care.[52] In both images, the wounded lay on stretchers on the ground and were aided by kneeling corpsmen. The images were similar in content to the photograph from World War II of the wounded "crucified" marine (see figure 35) and the World War I picture of the "laying out" of a doughboy in a trench (see figure 13). In these photographs from all three wars, the emphasis remained on the positive aspect of help being given to the wounded, rather than on the negative facet of the pain of that wounding.

Few magazines during the Korean War gave their readers a full diet of critical or depressing images of war. Photo-essays that emphasized the failures of the war were often offset by articles or additional photo-essays that cheered the successes. Perhaps the most unrelievedly despairing story of the war to run in a major magazine was Duncan's Christmas essay on the retreat of the marines from Changjin Reservoir. Immediately following Duncan's story in *Life* was a photo-essay by Walker tracing the stages of recovery of one wounded man from that march.[53] Walker's essay was considerably more upbeat—and more banal—than Duncan's lead-in. Stories tracking the progress of wounded soldiers had been a convention since World War I, especially since the essay by Ralph Morse in World War II that followed a single casualty, George Lott, from his evacuation from battle in France to his return to the United States for further treatment. By Korea, stories covering the wounded from combat to hospital had become common. *Look*, for example, ran a seven-page photo-essay entitled "The Wounded Fly Home," subcaptioning the article with the comment "It's the greatest morale booster of the war."[54]

These upbeat articles served a propagandistic purpose. The negative images and photo-essays exposed the sordid, "realistic" side of war that would increasingly be emphasized in the years and conflicts to come.

The positive photographs and articles, however, were both a bow to the past wars' coverage of events that focused on victories, success stories, and boys coming home, and a bid by the military and the establishment press to obtain and retain support for official, conservative policies. It was an accurate indication of the changing attitudes of the public toward the U.S. engagement in the war that so many critical pictures were published during the Korean conflict.

Several images of civilians joined both those of American wounded and the close-up portraits of soldiers in critiquing the situation in Korea. To show its disapprobation, Newsweek, for example, recalled the visual force of the famous photograph dating from the Japanese invasion of China. The wail of the burned Chinese baby left alone on the railway platform in Shanghai 1935 found a parallel with equally distraught orphans of the Korean conflict. In its October 9, 1950, issue detailing the fall of Seoul, Newsweek ran an image from Acme describing "the wail of the war waif," and in its Christmas issue of that year, it published another, blunter photograph from Acme. "UN military convoy ignores a tiny waif," this second picture read.[55] A small child cried, huddled alone against the curb of a city street, as monstrous, impersonal U.S. army trucks lumbered by (figure 47). The Acme photographer ably captured the isolation of the Korean toddler, but the editors of Newsweek went out of their way in their caption to indict the United Nations (and through them the United States) for the little boy's plight. The war we are fighting, the editors stated, is one that creates "human tides" of refugees, and then "ignores" them as part of the inevitable detritus of combat.

Considerably more stories published during the Korean War covered the fate of the civilians than had been the case during World War II. Yet, in a traditionally inspired attempt to underscore the humanity of the GIs, most stories in the feature magazines pictured Americans sympathetically helping Korean civilians. Children always received especial attention; they are natural heroes in photography. An article in Look, for example, entitled "G.I.'s Have Big Hearts," reported on the 1st Cavalry Division's adoption of a seven-year-old war orphan.[56] And the newsmagazines broadened the focus on children to include the problems faced by adult refugees of the war.[57] In these articles, photographs depicting hopeless mothers and sobbing orphans shared space with images of entire families fleeing Seoul or pictures of husbands and wives still trying to eke out their lives at the side of a road.

A picture by Duncan, captioned "A Korean mother nurses her child while ROK medics bandage a shell wound," was one of the most effec-

tive documents against the horrors of war. In the full-bleed photograph on a right-hand page, a young woman sat on the ground. Trickles of blood dripped down her throat. Two South Korean medics wrapped her head in a white wimple of a bandage. Her face was turned away. Her shirt was open and her child suckled at her breast. Duncan's accompanying article only escalated the pathetic quality of the situation. "I came upon two medics bandaging a taut-faced peasant woman who had ignored the Army's warning and stayed on her land," he recalled. "A Communist shell had driven fragments into her head. As the medics probed for pieces of steel, her infant son nursed for his breakfast. . . . Then a neighbor approached and mumbled a few words. Her head flew back and her eyes filled with anguish. She had been told that her other son had just died of wounds suffered in the same shellburst."[58] For Americans, the pictures of wounded and bereft civilians, such as the Acme photographs of crying children and Duncan's image of the nursing mother, added a different perspective on war. The emphasis on combat close-ups of men's faces, the publicizing of portraits of the wounded in agony, and the stress placed on the condition of civilians exposed facets of war to which the public at home had previously been less privy.

Life culled eight photographs from its photographers' three years in Korea to run in its last issue before the truce was signed in August 1953. The only full-page photograph of the eight ran on the last page: Duncan's view of the marines' retreat past their dead comrades.[59] Opposite this picture were the grey and gritty images of combat near Inchon by Walker (see figure 45). The first page carried three photographs: a little Korean boy by Michael Rougier; a sky full of parachutists by Howard Sochurek; and three GIs napping at the side of a road by Mydans. Two other photographs, on the second page, one from Walker of "terrified Red soldiers" cowering in a ditch and the other by Bourke-White of a dead guerrilla slung from a pole held by South Korean police, completed the layout (figures 48 and 49).

The photographs not only were a fair sampling of the best images from the war, they were good examples of the changing aesthetics of war photography. Several could have been identified as representing earlier conflicts: Mydans's photograph, Sochurek's picture, and the two Walker images on the third page could all have been taken during World War II. Rougier's war orphan and Duncan's dead marines seemed more particular to the Korean conflict. Previously there had been less interest in the lost waifs of war—at least there had not been sufficient interest in civilians to merit placing a picture of them on any "best of"

lists. Furthermore, although pictures of dead Americans were published during the last half of World War II, few publishers were bold enough to print a photograph showing so many of them in a situation that was not, ultimately, a victorious or positive one. Finally, Bourke-White's and Walker's pictures of the enemy on the second page of the article foreshadowed the photography that would be taken during the Vietnam War.

Walker's second-page photograph was captioned "Terrified Red soldiers, flushed from their hiding place in a roadside ditch, surrendered to American GIs as U.N. forces headed for the Yalu in 1950."[60] Pictures taken during the Korean War rarely placed their subjects in an identifiable landscape; backgrounds were blurred, cropped, or simply nondescript. The landscape of Walker's photograph, however, was an important element in the image; the thatched house and furrowed field placed the Americans and "Reds" in the particularized context of Northeast Asia—a context similar to that emphasized during the Vietnam War. The composition of the Walker image also anticipated the more jarring framing typical of the Vietnam era. Images characteristic of the Korean conflict and the earlier wars borrowed their rules of composition from classic artistic conventions: subjects balanced one another on the diagonal, were symmetrical, or were otherwise in equilibrium. Photographs representative of the Vietnam War, by contrast, appropriated their sense of composition from the language of television wherein in no single frame did elements balance one another, the implication being that life is not neat, that photographs should not be taken with an eye for art but with an eye for serendipitous reality.

Bourke-White's image presaged the photography of the Vietnam War for different reasons. Her picture, clearly a beneficiary of her education in documentary photography with the Farm Security Administration, had no compositionally jarring features. Instead, her photograph was shocking for its subject: the incredible inhuman brutality of civil war. Her picture, captioned "A dead guerrilla . . . was the prize of South Korean police who fought throughout the war against Red terrorists working far behind the battle lines," took the principle of "dead enemy as trophy"—evident since the Spanish-American War picture of the dead Spaniards on the Cuban beach (see figure 5)—to new heights.[61] Four South Koreans "carried" a corpse stiffened by rigor mortis by slinging a rope around its neck and attaching that rope to a pole and by slinging a second rope under its feet and holding both ends of that. The dead guerrilla was trussed and displayed as if he were a game animal. Vietnam was the first war in which Americans frequently witnessed the

depredations of an Asian civil war in the pages of the press; this photograph and its original accompanying article were one of the few attempts to identify such a war in Korea.

The photograph had first appeared as the opening image to a story entitled "The Savage, Secret War in Korea" in the December 1, 1952, issue of *Life*. With the change of a few names, the introduction to the essay could have been written fifteen years later. "About 150 miles to the rear of the Korean battle line," it stated,

> in the misted hills and twisted valleys of the peninsula's rice bowl, there is a war within a war. Waged in territory officially held by U.N. forces [it is] fought without truce lines or quarter. . . .
>
> The enemy is a fluid and scattered force . . . whose mission is to puncture U.N. communications lines, sabotage harvests, keep the countryside in turmoil and tie down Republic of Korea manpower. . . .
>
> Miss Bourke-White accompanied the police on forays against Red bands. She watched them bring back their foes, living and dead, for trial or burial. Sometimes the bodies are dragged in on poles. . . . When it is too difficult to bring the corpses back only the grisly heads are retrieved, not as trophies but to be identified and the names checked against lists of known guerrillas. And in the poor villages of the provinces, she saw both noisy celebrations of victory and deep mourning for sons and husbands who fought and died in this obscure and poignant war.[62]

In *Life*'s final issue before the truce, two paragraphs introduced those eight "memorable" photographs from the war. "It was plain," *Life* noted, "that the end of fighting in Korea, at this moment in history, did not promise either surcease from anxiety or lasting peace. . . . Since there was no real victory, there was no occasion for celebration—no whistles, no cheering, no dancing in the streets. . . . the war itself will be long remembered for its cruelty, horror, pity, frustration and desperate bravery."[63] The mood of the times had greatly changed in the eight years since V-J Day. Whereas during World War II there had been a sense of common purpose and common cause, during the Korean War there was an atmosphere of ambivalence. Anti-"Red" rhetoric ran high, but so did criticisms of ways to confront the communists. More than the preceeding wars and more than the succeeding one, Americans during the Korean War looked backward and forward to a war-torn world. The Korean War was so close in time to the major conflicts on either end of

it: World War II was only five years back; three years later, the first military advisers would leave for Vietnam. In contrast, the Spanish-American War, World War I, and World War II were each twenty years apart. Without the demands of total war, without the panacea of victory, without the hope of a peaceful world, Americans began to question their responsibilities in the Cold War era—questions that would only grow more pressing in the years to come.

As is evident in the photographs of the Korean War, Americans still found romance in combat, but they also learned to see the waste and unwarranted suffering. The photographs from Korea did not reflexively operate in the government's or military's interest; some images of the war even offered an alternative statement to the official one. Pictures of soldiers in close-up and images of the horrors inflicted on civilian bystanders supplemented the more restrained or idealized images of combat; Americans at home saw the human costs of their policies and rhetoric. Prompted by the photographs in the press, Americans reacted to the war with increased intelligence. They cheered the soldiers' role but were bitter and doubtful about the official direction of the conflict. Their beliefs did not substantially change the conduct of the war, but they did affect how the following war in Vietnam would be conducted. The photographs from Korea, said David Douglas Duncan, had an impact on the public. They may not have affected Truman's or Eisenhower's government policy. But they had the power to touch one person. And ultimately, he said, raising a single finger, "It's just about one."[64]

PART FIVE

The Vietnam War
February 8, 1962–
April 29, 1975

13

The Context:

"A Kind of Schizophrenia"

WAY BACK IN 1843, President John Tyler appointed Abel P. Upshur as his secretary of state. For several months, Upshur attended to the usual run of functions associated with his cabinet position. Then, in early 1844, as part of his governmental duties, he participated in a naval ceremony involving a huge new iron cannon capable of firing a 225-pound projectile. The cannon, all too significantly, had been named the "Peacemaker." It was to be fired as a main feature of the event. It was; it burst; and Secretary Abel P. Upshur was killed.

The tale carried a certain ironic, metaphorical moral not lost on later inhabitants of that office. In 1969, former Secretary of State Dean Acheson suggested to the then Secretary of State William Rogers that he "would do well to keep Abel P. Upshur in mind."[1] Indeed, it would have been well if many other officials involved in the Vietnam War had also stopped to ponder Mr. Upshur's fate.

The dates for the Vietnam War given here (February 8, 1962–April 29, 1975), are rather arbitrary. For example, good arguments can be made for dating the beginning of the war from when the Americans first sent ground troops or from when the Americans first sent aid (although then another decision has to be made about whether to consider the first aid as that given to bolster the French colonial effort after World War II or that given to support the Ngo Dinh Diem government after the Geneva accords). I have chosen February 8, 1962, because that was when the American Military Assistance and Advisory Group was replaced by the Military Assistance Command, Vietnam (MACV), in "Project Beefup." And, for the purposes of this book, another reason to choose early 1962 is because in February 1962 of that year the Associated Press transmitted its first news photograph by radio from Saigon. It was during the Kennedy administration that the American press first began to focus significantly on the conflict in Vietnam.

Critics of the Vietnam War are continually discovering new ironies inherent in the conflict. Some statesmen, such as Acheson, felt the irony to be that even the best-intentioned peace efforts have a tendency to blow up in the United States's face. Some commentators believed the irony to be that "The System Worked."[2] Some historians found that "the paradox is that the Vietnam War, so often condemned by its opponents as hideously immoral, may well have been the most moral or at least the most selfless war in all of American history. For the impulse guiding it was not to defeat an enemy or even to serve a national interest; it was simply not to abandon friends."[3]

The perspectives on the conflict have themselves been conflicting. Unlike the assessments of the previous two wars, the assessments of Vietnam have demonstrated little unanimity over its politics, its strategy, or its morality. Comparatively, World War II and the Korean War have suffered far fewer major historical revisions or disputes. World War II was a "good" fight that ended with an indisputable Allied-American triumph and the unconditional surrender of the Axis adversaries; the Korean War was an unsatisfying, even disquieting conflict, whose ultimate settlement was ambivalent but at least comprehensible in conventional terms. Although *occasional* debates have arisen about who was responsible for certain policy decisions during the Korean War, historians have consistently challenged and argued about *every* aspect of the Vietnam War. Conservative historians have discussed different theories about how the United States lost the war and, by extension, different theses of how the United States could have won. But other analysts have wondered whether the issue of winning or losing is even the right question to ask. "Only in a war fought for credibility," wrote journalist Jonathan Schell, "could the question of victory or defeat ever seem so immaterial."[4]

These disagreements and questions are not only of historical interest; the problem of how to define the war was contemporary to the war itself. The Vietnam War was the longest war in which the United States has fought. In previous wars, sentiments that were held at the start of the American engagement represented—or at least approximated—those held at the close of the conflict. Not so in Vietnam. In the early years of the war, Americans hummed the song "The Battle of the Green Berets," but by the American withdrawal, many had switched over to singing "The Draft-Dodgers Rag." Initially, the country—the civilians, the military, the officials, and the press—had trusted in the rightness of the war. Then, during the mid-sixties, although most Americans still believed in the validity of the cause, many came to doubt the political

and military strategies of the fight. Finally, following the Tet offensive in 1968, a sizable percentage of the country came to feel that the war itself was wrong.

The Vietnam era provoked controversy. Americans entered the conflict unified by the Cold War consensus, but the consensus fell apart, wracked by the strains of "guns and butter," "Black Power," the "generation gap," "We had to destroy the village to save it," "America—Love It or Leave It," "the light at the end of the tunnel," and all the multitude of slogans, phrases, and "buzz" words that attempted to simplify the conflict and make the disintegration of the post–World War II world understandable. Even the expressions that were invented for the occasion failed to sum up the war. Journalists wrestled with this fact. Malcolm Browne, reporter and photographer for the Associated Press in Saigon beginning in 1961, wrote as early as 1964: "Viet Nam does not lend itself well to numerical reporting, or even to the kind of simple, narrative statement required of the average newspaper lead. There are too many uncertainties, too many shades of gray, too many dangers of applying English-language clichés to a situation that cannot be described by clichés."[5] Five and a half years later, Michael Herr, Vietnam reporter for *Esquire*, agreed. "Conventional journalism," he said, "could no more reveal this war than conventional firepower could win it, all it could do was view the most profound event of the American decade and turn it into a communications pudding."[6]

As a result, the New Journalism of the 1960s, the Hunter Thompsonesque, drug-inspired, high-wired, stream-of-perhaps-you-could-call-it-consciousness writing, seemed uniquely suited to the war. How could one sanely report on locations such as Khe Sanh, Cam Ne, and My Lai; about people named Ngo Dinh Diem, Nguyen Ngoc Loan, and Trich Quang Duc; about weapons called "Bouncing Betty" and "Willy Peter"; about helicopters and airplanes termed "slicks," "dustoffs," and "Puff the Magic Dragon"; about soldiers referred to as FNGs, REMFs, and Ruff-Puffs; and about military euphemisms such as "discreet burst," "friendly fire," "meeting engagement," and casualties "described as light"?[7] Peter Newman, editor of the *Toronto Star*, mused in 1970: "It seems strange to me that the most memorable insights on Vietnam came out of a novel—David Halberstam's *One Very Hot Day*. But perhaps it's that kind of a war."[8] And correspondent Morley Safer, in a 1967 *CBS Special Report*, told his audience: "Something happens to you when you stay in this place long enough. A kind of schizophrenia takes over and you become both a believer and a cynic. You get the Vietnamese disease. . . . Vietnam is like a lunatic asylum."[9]

Although Vietnam was a limited conflict, it permeated the country in a way that the Korean War never did. Considered the "living room war," Vietnam affected American culture, society, arts, letters, foreign policy, domestic affairs, dinner-table conversations, and shop talk as only the "total" world wars had done. But in contrast to those global battles, the Vietnam War generated conflict, not consensus; the war exacerbated issues of race, poverty, and gender. The negative emotions directed against the foreign enemy, which in previous wars had united the country, seemed during Vietnam to be turning inwards. Anticommunism continued to be a rallying point for war but, by the middle of the sixties, there were vocal homegrown radicals in the United States, too. Racism toward Orientals was another traditional incentive for hostility, yet American streets were teeming with angry blacks. To the bewildered public, the war appeared to be the poisoned touchstone for the upheavals of the time—a touchstone all the more dangerous because half of all Americans during the war, according to the Gallup poll, had no idea of what the war was about.[10]

Yet, as poll analyzer John Mueller has pointed out, people's lack of knowledge about a subject does not prevent them from holding and offering opinions on it.[11] Former South Vietnamese Ambassador Bui Diem noted the general tendency well: "for many developments in history," he said, "perceptions count more than facts."[12] And what Americans perceived, when they took their first steps into Vietnam, was, as veteran diplomat George Kennan observed, that "the Russians, as part of their design for world domination, were bent on the military-political conquest of Asia, and that the effort of the Vietnamese communists to establish their power in Southeast Asia was a part of this supposed 'design.' "[13] Needless to say, Americans, who were still unified by the Cold War consensus at the outset of the war, had the impression "that we were confronted . . . with a great, terrible, remorseless enemy, dedicated to our undoing, and holding in his hands the wherewithal to do us immense damage, even right here at home."[14] Five years, even ten years after the McCarthy Era, communism remained a red flag to the bull of public opinion and government policy. As Mueller remarked about the polls taken during the Vietnam War: "Throwing the word 'communist' into a question about Vietnam almost always altered the response, often by 20 percentage points or more." "These observations . . ." he said in an endnote, "suggest the notion of stopping communism was an important element in support for the [war], as was the idea of carrying out a commitment; saving or defending . . . the South Vietnamese, however, was not."[15]

Intertwined with this fear of communism was the fear of a crippling loss of American credibility. Vietnam was the place where, as John Kennedy told James Reston, the United States was going "to make our power credible" to the Russians.[16] Paul Kattenburg, a State Department official and the chair of the Interdepartment Working Group on Vietnam, commented on the Vietnam policy of Kennedy's National Security Council: "We could not consider thoughts of withdrawal because of our will to 'see it through,' a euphemism once more hiding the fear of our top leadership that it might look weak—to Congress and the U.S. public even more than to the Soviets."[17] Every postwar administration faced the domestic blackmail of losing a country to communism. The threat had dogged the makers of foreign policy at least since the fall of China: "countries were ours, we could lose them."[18] No one dared lose Vietnam on his watch.

So the United States "invested its men and money so heavily because it believes South Viet Nam is the strategic key to Southeast Asia. A Communist triumph could mean Red domination of the entire area," reported the *New York Herald Tribune* in 1963. The domino principle: if one goes, they all go. But the *Herald Tribune* noted an additional problem. As the article phrased it, "the Vietnamese government's present autocratic policies are unacceptable in Washington."[19] Washington faced the challenge of saving South Vietnam for the South Vietnamese, yet rejecting the South Vietnamese government that was currently holding office. The choices made by the successive American administrations were not the preferred ones but, rather, the options least precluded by Cold War rhetoric, power politics, and domestic opinion. Commitment and then escalation appeared justified—or the dominoes would be "forfeit."[20]

Out in the field in Vietnam, the administrations' dilemma was phrased in the terms of the American military commitment. "It's like everything else we do over here," expostulated Major-General Lewis Walt of the marines, "we're damned if we do and damned if we don't." But the catch-22 of the military strategy in Vietnam—"We cannot defeat this armed enemy unless we win the people; yet unless we defeat the armed enemy, we cannot win the people"—just like the catch-22 of the political strategy, did not prevent anyone from trying to solve the unsolvable. "It might surprise many Americans to learn," *Life* noted, "how many of our fighting men in Vietnam understand this dilemma perfectly and how many of them are dedicated to resolving it, by humanity as well as by force of arms."[21] Only belatedly did anyone think to ask not how to solve the dilemmas but whether the dilemmas could

be solved. And only later did it become all too clear that the United States sought a military solution to what was essentially a political problem. As even General William Westmoreland remarked, in the preface to his official report on the status of the war: "Frequent reference is made throughout [this account] to changes in the government in Saigon and to political problems and disruptions which arose from time to time. The fact of the matter is that these events were as important and in some cases more important than the unfolding of the tactical situation on the ground. . . . Upon my arrival in Vietnam, this strong and direct connection between military and political problems was quickly impressed upon me."[22] Henry Kissinger also noted the general rule: "In a guerrilla war," he said, "purely military considerations are not decisive; psychological and political factors loom at least as large."[23]

Paul Kattenburg had believed in 1963 that "we would never be able to succeed there";[24] the strategy in Vietnam was never to "win"—it was only to survive. The successive American administrations did what President Lyndon Johnson in 1965 said would be done: "We will do everything necessary to reach that objective [of self-determination for South Vietnam]. And we will do only what is absolutely necessary."[25] In other words, at any given time, the United States only did what it considered was the *minimum* necessary to prevent a victory by Hanoi—but the "minimum" sending of aid and advisers under Presidents Eisenhower and Kennedy escalated into Johnson's "minimum" commitment of ground troops and substantial air and naval forces. The stages were incremental, and the increments became increasingly greater without any greater likelihood of an American triumph. United States policy had become, in Daniel Ellsberg's words, a "stalemate machine."[26]

To the men fighting in Vietnam, politics and ideology never loomed as consequential as they did in the United States. Michael Herr observed that the men who were fighting knew that "the country could never be won, only destroyed." There was a joke in-country, he said, that explained how the United States could be victorious. "What you do," he related, "is, you load all the Friendlies onto ships and take them out to the South China Sea. Then you bomb the country flat. Then you sink the ships."[27] The primary interest of the soldiers in combat remained what it always had been: to stay alive through their tour. "It is almost axiomatic that a soldier fights because he wants to preserve the good opinion of his buddies," wrote AP correspondent Browne. "He very often fights because his buddies have been killed, and he has come to hate the enemy."[28] To those men in combat, the problem greater than

the puzzling "political implications of this strange war" was the military reality: there was "no 'front,' no 'rear' and it is absolutely impossible to tell friend from enemy without a program—even with one."[29]

That military "reality" frustrated the troops in the field on two levels. First, the enemy was everywhere and nowhere. American soldiers could enter a target village, kill suspected or imagined guerrillas, and declare the area safe. Then when they left, the enemy would filter back again. And second, the Americans could win battles and skirmishes, could "take" villages and hills, could count the bodies killed and the weapons captured, and none of it mattered; the enemy refused to abandon the struggle, they could not be bled dry. The frustrations led to a change in acceptable military tactics.[30] The Americans, as General Fred Weyand stated, began to use " 'things'—artillery, bombs, massive firepower—in order to conserve our soldiers' lives."[31] Although that basic American strategy had been implemented for much of the century, the tactic became doctrine during the Vietnam conflict. Faced with the known difficulty of separating the "friendlies" from the enemy, of identifying the hidden mines and booby traps in a village, Americans, from early in the war, bombed and shelled those villages that were suspected of harboring hostile forces—even before the American troops made contact. And frequently, when the ground troops did encounter small arms fire, they called in an artillery or even a B-52 strike.

What differentiated this Vietnam strategy from the tactics employed in other wars was the issue of the "proportionality" of the retaliation. In Vietnam, minimizing civilian casualties was not a high priority—an important consideration in a civil war conducted in the middle of a civilian population. "If you go in there worrying about women and children," said one Naval Reserve flier, "you can't do your job."[32] The men had been taught since induction that "dinks are little shits;" as one soldier put it: "To understand what happens among the mine fields of My Lai, you must know something about what happens in America. You must understand Fort Lewis, Washington. You must understand a thing called basic training."[33] The men's job, as they had been given it, was to get a high enemy body count while keeping their own casualties "light." In this aggressively quantitative conflict, a Vietnamese who was taken prisoner could turn out to be a civilian, but a Vietnamese who was killed in action was a Viet Cong (VC). "You know the system," Life reported one marine as saying to another. "If they're dead, they're confirmed VC, and if they're still breathing they're suspects."[34] Faced with the imperatives of a guerrilla war, the frustrations of measuring success, the ambivalence of the cause, and the strain of watching their

buddies die, the men when sent on "search and destroy" missions did just that. The fear, the lack of inhibitions, even the "blood-lust," could turn war—never pretty, never innocent—into an atrocity. "Back in the world . . . we were taught," wrote one young lieutenant,

> that to take another man's life was wrong. Somehow the perspective got twisted in a war. If the government told us it was alright and, in fact, a must to kill the members of another government's people, then we had the law on our side. It turned out that most of us liked to kill other men. Some of the guys would shoot at a dink much as they would at a target. Some of the men didn't like to kill a dink up close. The closer the killing, the more personal it became.
>
> Others in the platoon liked to kill close in. A few even liked to torture the dinks if they had a prisoner or cut the dead bodies with knives in a frenzy of aggression.
>
> A few didn't like to kill at all and wouldn't fire their weapons except to protect their buddies.
>
> Mostly, we all saw it as a job and rationalized it in our own way. Over it all ran the streak of anger or fear that for brief moments ruled us all. . . . Every day we spent in the jungle eroded a little more of our humanity away.[35]

By 1969, Americans' rejection of the implementation of policy had shifted to an abhorrence of that policy itself. Moral indignation over the war in Vietnam flamed out to censure not only the personal acts of violence reported by the media but the entire American military, political, and industrial complex and operations as well: My Lai, free-fire zones, the secret bombings, and the chemical companies' manufacture of napalm and Agent Orange. In 1970, the Senate Committee on Foreign Relations conducted hearings on the "Moral and Military Aspects of the War in Southeast Asia." One witness, the president of Union Theological Seminary, raised the question "as to the difference between killing helpless people, including children, on the ground at short range when they are seen and the killing of them from the air, at longer range, when they may not be seen. . . ." "I realize," he said, "that the psychological difference is very great, but how great is the moral difference when it is well known that there will often be many of the same helpless victims? There is another difference; the air strikes are clearly a matter of policy and the highest policymakers are responsible and all of us who consent to them are guilty."[36]

In Vietnam, it came out into the open: "at the heart of every political

question there lies a moral question."[37] The conflict inherent in waging war for the purpose of bringing democracy to another nation finally surfaced—as it never had during the world wars and as it only threatened to do during the Korean War. The tactics employed to mobilize the American people and the industrial complex to battle were never democratic; the war-making machinery ran roughshod over the individual desires of the citizenry. Even early in the Vietnam conflict, to secure a consensus and, more important, approval at home, the American military and government resorted to secrecy, misrepresentations, and lies. By the end of the war, the lengths to which the officials would go—not even to "win the war but to gain a 'decent interval' " before South Vietnam collapsed—extended to include wiretaps and enemies lists. In trying to keep Southeast Asia out of the communist camp, the United States came perilously close to losing its own democratic ideals.

At the end of five days of Tet celebrations, in the predawn hours of February 7, 1965, a "bunch" of correspondents, including Pulitzer Prize–winning journalist Malcolm Browne and cartoonist Bill Mauldin of World War II "Willie and Joe" fame, awoke at the U.S. base in Pleiku, South Vietnam.[38] Shortly after 2:00 A.M., North Vietnamese guerrillas had attacked the airfield, killing 9 Americans and wounding 128. Sixteen helicopters and 6 fixed-wing aircraft were damaged or destroyed.

The first news of the assault reached the Pentagon at 2:38 P.M., February 6, Washington time. That evening, the National Security Council met in the Cabinet Room of the White House, and in a seventy-five-minute meeting, President Lyndon Johnson reached the decision to give an "appropriate and fitting" response. The "Flaming Dart" reprisal came in less than fourteen hours: navy jets from the Seventh Fleet bombed North Vietnam forty miles north of the 17th parallel. Five days later, Johnson approved "Rolling Thunder," the sustained bombing of the north. And one month after the first "Flaming Dart" mission, on March 8, 1965, two marine battalions, the first U.S. ground combat units "committed to action" in South Vietnam, "splashed ashore" at Danang.[39]

"There is a continuum in Indochina that one can certainly trace back even to Roosevelt," said Browne in a recent interview.

But at the same time there were quantum steps all along the way in each of the administrations that had a role in Vietnam. . . . In the case of Johnson, the big jump was on February 7, 1965 when an attack on Pleiku airfield was used as a pretext for the beginning of

the bombing of the North and the landing of the Marines. And it clearly was a pretext. I've never been clear in my mind whether Johnson fully understood that it was merely a pretext, or whether he sincerely believed that main-force North Vietnamese units had attacked Pleiku. In fact it was done by five guerrillas with all their equipment strapped on their backs. They got in and got out, blew up the whole airfield without losing a single man. . . .[40] In the first hours it was almost impossible to believe that this vast wreckage and shambles had been accomplished by such a small group, but it soon became apparent that that's what had happened. . . . The commander of the American advisory group there . . . one of the few truth-sayers . . . was able to reconstruct what had happened that morning from survivors who had actually seen these guys cutting their way in and setting up mortars. . . . It hadn't taken long. . . .

Later that day a bunch of the brass came up from Saigon. General Khanh, the Prime Minister, came up and Ambassador Maxwell Taylor and a contingent from Washington which included McGeorge Bundy. They had this wonderful C-123 . . . outfitted with all sorts of luxuries, which included communications equipment capable of reaching Washington. So on the spot, Taylor and Khanh and Bundy and the other players decided that what had happened in Pleiku was just the spark that was needed to get things going. They were literally on the phone in the C-123 (called the "White Elephant") parked on this wrecked ramp at Pleiku to the White House, saying "This is it. Go." That night the White House put out the word that main-force North Vietnamese units had attacked *in force* at Pleiku and had caused this terrible wreckage. We were therefore going to do something to put a stop to it.

"Well," Browne summed up, "there were lots of things. The Gulf of Tonkin incident in which there was or was not a ship, but nobody ever proved it was anything more than a blip on the radar. And so on. Each of these was one of the little steps. . . . One could have stopped it at any point along the way. But it never was stopped."[41]

The war was like that. Events turned out to be nonevents, or to be overstated or understated, or simply to be misunderstood: the Gulf of Tonkin "attack," the Tet offensive, the siege at Khe Sanh. The commitments and logic inexorably led to more and more and more. McGeorge Bundy, in the memorandum drafted to the president while in flight back to Washington after Pleiku, wrote, "The stakes in Vietnam are

extremely high. . . . The international prestige of the United States, and a substantial part of our influence, are directly at risk in Vietnam." Yet, he continued, "there is no way of unloading the burden on the Vietnamese themselves, and there is no way of negotiating ourselves out of Vietnam which offers any serious promise at present. . . . The energy and persistence of the Viet Cong are astonishing. . . . They have accepted extraordinary losses and they come back for more. . . . At its very best the struggle in Vietnam will be long." In response to these givens, Bundy recommended a *"sustained reprisal"* of air and naval action against the north as the "best available way of increasing our chance of success." After enumerating probable risks—"significant U.S. air losses," "higher" casualties—he still believed that "measured against the costs of defeat in Vietnam, this program seems cheap. And even if it fails to turn the tide—as it may—the value of the effort seems to us to exceed its cost."[42]

Bundy's statement summed up the official perspective on the war for much of its duration. Despite the costs, which became greater and greater, the successive administrations and military personnel involved in Vietnam believed that the "value of the effort" was worth the price. But in their need to ensure that the costs did not outstrip the value, the officials often underestimated, denied, and hid both the necessity for the burgeoning "expenses" of manpower and the concomitant casualties. Whereas in 1964 there were 20,000 American advisers in-country and a handful of deaths, by the end of 1965 there were 200,000 troops and 1,600 dead; by 1967, half a million men and 16,000 dead; and by 1975 and the fall of Saigon, over 56,000 dead.

As press historian Edwin Emery has written, it was not "that the military consistently and deliberately falsified information. Rather, it more often withheld information detrimental to continued belief in the eventual success of U.S. policies, and it established elaborate statistical counts to justify the policies of the White House and the Pentagon."[43] The issue of numbers was peculiarly pressing throughout the war; the official report of the Military Assistance Command, Vietnam (MACV) admitted that the war was the "most computerized, and most statistically analyzed in history."[44] But even as early as the summer of 1966, sundry spokesmen for the government were admitting that "you can just take your choice and get any kind of figures you like."[45] The numbers were manipulated ceaselessly; the military and the administration were concerned that if the real numbers, especially of the enemy's troop strength and casualties, were published, Americans might believe there had been no progress in the war. So, for example, in April 1966,

the president said that 50,000 enemy soldiers had been killed since the first of the year, yet four months later, the official figure had declined to 31,571.[46] At another point, in the fall of 1967, one-quarter of the enemy troop strength was "wiped off the books." Paul Walsh of the CIA wrote in an internal memo that this juggling was "one of the greatest snow jobs since Potemkin constructed his village."[47] The situation became so endemic that the journalists began referring to American estimates as WEGs, or "wild-eyed guesses."

The renewed emphasis on math and science after Sputnik had led Americans in the early sixties to believe in the importance and validity of numbers. Unlike World War II, in which gains in enemy territory could mark progress toward victory, in this war, there was no similar yardstick. So, by default, numbers, such as the weekly "body counts," became a way for the Americans to gauge success. "Every quantitative measurement we have," said Secretary of Defense Robert McNamara, on his first trip to Vietnam, "shows we're winning this war."[48] But the other side realized that statistics did not tell the whole story. Correspondent Harrison Salisbury reported that according to North Vietnamese Premier Pham Van Dong, the "problem was one of relative morale and spirit between the United States forces and those opposing them in Vietnam." "I have told you," said the premier, "the crucial problem does not lie in numbers."[49] By the American withdrawal, the United States was forced to agree; all its numbers had not added up to victory, no matter what the bottom line read. A joke made the rounds at the end of the war that in the early months of the Nixon administration Pentagon analysts fed all the data on the war—comparative populations, gross national products, troop strengths, armaments, casualties, and so on—into a computer. After days of punching in the numbers, the computer was asked: "When will we win?" Seconds later the answer came back: "You won in 1964."[50]

The manipulation of numbers, especially during the Johnson administration, intimately related to the White House's political fortunes. Johnson's concern for party politics and his Great Society programs kept publically stated optimism so high that one commentator jeered, "We've 'turned the corner' so often now we're about to lap ourselves."[51] Domestic constraints also influenced the calls for manpower; Johnson was loathe not only to appropriate funds away from his social programs but also to institute the reserve mobilization—or even a strict universal draft—that he believed would signal the country was on a "war footing."[52] The Johnson administration finessed this dual problem by enlisting the army to help fight the War on Poverty. "Very possibly our best

hope is seriously to use the armed forces as a socializing experience for the poor," reported Daniel Moynihan, then chair of the Task Force on Manpower Conservation. "Given the strains of disorganized and matrifocal family life in which so many Negro youth come of age, the armed forces are a dramatic and desperately needed change." As a result of this attitude, the greatest percentage of Americans to serve in Southeast Asia, in addition to professional military men and volunteers, were draftees from minority and lower-income families—men who were, "coincidentally," less likely to protest their service. Military historian and retired general S. L. A. Marshall commented that "in the average rifle company, the strength was 50% composed of Negroes, Southwestern Mexicans, Puerto Ricans, Guamanians, Nisei, and so on. But a real cross-section of American youth? Almost never." For most of the sixties, the military manpower policymakers "did not care who was drafted as long as enough people were drafted"; only belatedly, during President Richard Nixon's term of office, was a change instituted, resulting in the lottery draft.[53]

As had been the case with the Korean War, the men, once drafted and trained, rotated into combat units already in place in Vietnam. But without the proper training that mobilization could have provided, with the piecemeal and hasty deployment of troops to Vietnam, and with the constant turnover of soldiers caused by the short tours of twelve months (thirteen months for marines), American combat performance suffered.[54] Although the lack of mobilization and hasty deployment circumvented protest at home and the short tours aided morale overseas, the policy meant that men entered the war as undependable FNGs ("fucking new guys") and left after suffering through "short-timer fever."

The military was further troubled by an internal generational divide that seriously reduced its effectiveness in the field. Young blacks and whites, alike, chafed under the authority of the official hierarchy; Vietnam aggravated the crisis proportion of drug abuse and racial conflict present in the society as a whole. First marijuana use then heroin addiction reached epidemic levels; more and more men "checked out" of the war only to come home to find that a $6 habit in Vietnam became a $200-a-day burden in the United States. Racial tension, especially among support troops and in rear areas, also became exacerbated over time; discrimination against black soldiers from a white and substantially Southern command structure increasingly divided the armed forces along racial lines. Black consciousness and alienation among the men, a result of hostility in the United States and in the service, raised

charges that Vietnam was a "white-man's war." The resulting mutual distrust led white officers to fear fraggings (potentially fatal assaults, usually with grenades, from their own men) and ultimately hindered the combat effort.

However, compared to the effectiveness of the South Vietnamese forces in the field, the performance of the American troops was high. Although Johnson had said "we are not going to send American boys nine or ten thousand miles away from home to do what Asian boys ought to be doing for themselves,"[55] the South Vietnamese—at least to their American observers—could *not* do for themselves. The early and massive infusion of American advisers was an attempt to address the critical lack of "leadership and morale" and "combat skill and teamwork within the Vietnamese units." And once the U.S. ground-combat troops arrived in 1965, General Westmoreland tried everything from "setting standards and providing practice" to developing a " 'Buddy System' which involved the pairing off of American and Vietnamese units."[56] But to the U.S. troops in the field, the Army of the Republic of Vietnam (ARVN) never learned. *"Maybe the people in Nam are worth saving,"* said one American soldier, *"but their army isn't worth shit."*[57] Journalists never tired of quoting the troops saying about the Viet Cong: "If we only had them fighting on our side, instead of the goddamned Arvin, we'd *win* this war."[58]

Americans faced many of the same problems in Vietnam as had their counterparts in World War II and Korea. The North Vietnamese use of camouflage, mortar and rockets, interlocking fields of fire, and bunkers that were almost impervious to artillery paralleled the situation of combat during the Pacific island campaigns in World War II. And the circumstance of fighting in a civil war against forces of communism and nationalism recalled the Korean conflict. Yet the Vietnam War had more significant differences from than similarities with the two previous engagements. Whereas in the Second World War, U.S. soldiers "stormed an island or a hill, took their objective and moved on to the next, American troops in Vietnam often seemed to be in the situation of storming Tarawa over and over again."[59] And whereas the Korean War was a rather conventional fight begun when a uniformed enemy with massed troops crossed a border, the Vietnam War was a political battle with no specific starting date and a critical guerrilla strategy. As a result, the objective in Vietnam was not the seizure and occupation of land, as in World War II, for example, but the interdiction of the enemy's armed forces and the destruction of the enemy's national will.

In Vietnam men were sacrificed not for territory but for limited political ends.

Unfortunately, the differences between the Vietnam War and the preceeding wars did not stop there. As was true of the Republic of Korea in 1950, the Republic of Vietnam would have collapsed in the 1960s if it had not been for massive American intervention. But although the American strategy during the Korean War had been limited to a military response—the challenge of countering subversion and building a viable government was left substantially to the Koreans—that was not the case during the Vietnam conflict. In Vietnam, the United States was actually fighting "three separate or only loosely related struggles. There was the large-scale, conventional war . . . there was the confused 'pacification' effort, based on political-sociological presumptions of astronomical proportions . . . and there was the curiously remote air war against North Vietnam."[60]

What seemed to attract most of the controversy over the conduct of the war was that "confused 'pacification' effort." The military tactics of the war could be stated simply: "we" were to draw the North Vietnamese "into a fight," as one lieutenant said, "so we could use our superior firepower to destroy them."[61] What this amounted to, said another American, was "going out and looking for someone to shoot at you."[62] But the implications were not as straightforward: "The trouble with Nam," continued the lieutenant, "was that we didn't control anything that we were not standing on at the time. Anything that moved outside our perimeters at night was fair game because the night belonged to the enemy and both sides knew it."[63] Surrounded by uncertainty, the Americans reacted accordingly; they shot at everything that could be potentially hostile, with the repercussion that the psychological warfare goal of winning "hearts and minds" was undermined by the military imperative of firing on what could turn out to be a civilian. As one historian noted, "The tautology that 'the destruction of the enemy would bring security to the countryside' obscured the more basic question of who and where the enemy really was."[64] One sardonic explanation for the confusion was that the intelligence branch was getting its information from smuggled Chinese fortune cookies.

In an attempt to cope with the problems, the Americans initiated a tactic of "Find, Fix, Fight, Finish" that they recommended to the ARVN troops.[65] The operating principle was to hunt out the Viet Cong before they became intermingled with the civilian population. After the U.S. entry into ground combat, the strategy became known as "search and

destroy," which, in turn, became transmogrified into the presumably less costly (to the Americans) and less directed "clear-and-hold" tactic—the ultimate expression of the classic comment made by the American major in the village of Ben Tre in the Mekong Delta: "It became necessary to destroy the town to save it."[66] Truly, the SNAFU (Situation Normal, All Fucked Up) common to all wars had become the FUBAR (Fucked Up Beyond All Recognition) unique to Vietnam.

The air war, which served as a means of disguising the human cost and impact of the conflict, was also not without controversy. As reporter Browne noticed, "The Pentagon always had an inflated view of what could be achieved by technology and force of arms alone. . . . That was another myth that was perpetrated from World War II—that air power will fix everything."[67] The air force and navy furnished unparalleled air support to the ground troops, but their efforts were concentrated on the bombing of North Vietnam; for example, air sorties over the north increased from 55,000 in 1965 to 148,000 in 1966. Although the trade-off of high technology for infantry lives held its appeal for the course of the war (U.S. air power closed the door on the American involvement in Southeast Asia),[68] the "surgical" strikes and "saturation" bombings, it early became apparent, achieved their objectives much less frequently than was claimed. "I could begin to see quite clearly," wrote *New York Times* journalist Salisbury from North Vietnam, "that there was a vast gap between the reality of the air war, as seen from the ground in Hanoi, and the bland, vague American communiqués with their reiterated assumptions that our bombs were falling precisely upon 'military objectives' and accomplishing our military purposes with some kind of surgical precision which for the first time in the history of war was crippling the enemy without hurting civilians or damaging civilian life."[69]

Later observers were to disagree with Salisbury, arguing that "the application of American air power was probably the most restrained in modern warfare. At all times, targets, munitions and strike tactics were selected to minimize the risk of collateral damage to the civilian population." But even these commentators admitted that the bombing of the North "diverted attention from the real hub of the Vietnam problem— the southern battlefield—where the war was going to be won or lost." Frustrated over the "lagging fortunes" of the ground combat troops in the South, the Johnson administration turned to an air war that appeared to offer easy advantages. And it was from that decision on that "the air war developed its own momentum."[70]

The expenditure of bombs and artillery was profligate. "My god,"

breathed an awed American after watching such a show, "there's been so much lead thrown in here that if somebody flew over with a big magnet the whole goddamn province would just rise up in the air."[71] In 1966 alone, bombing cost the United States $9.60 for every dollar of damage inflicted, and the cost of killing the enemy was estimated at "$400,000 per soldier, including 75 bombs and 150 artillery shells for each corpse."[72] All told, American air forces dropped more than 7 million tons of bombs on Indochina—nearly 3 times the total tonnage dropped in both World War II and Korea. The United States relied on its superior technology to act as a "multiplier" of its personnel and concomitantly to bear the brunt of the sacrifice that had to be made. The financial costs took longer to influence U.S. policy on the war than the human costs in American casualties did. But the high financial price eventually was paid; so many guns eventually did displace the column of domestic butter in the American ledger.

The unprecedented reliance of the military on bombs and artillery was one symptom of the fact that the ground-level fighting was not understandable in traditional terms. The combat consisted of thousands of small savage contests without a single major battle in the conventional modern sense (although the fighting in Quang Tri province in summer 1972, for instance, did begin as a World War II–style battle of massed divisions). Both Viet Cong guerrillas and North Vietnamese army forces regularly engaged the American and ARVN troops, yet the fighting up through the Tet offensive, except for the occasional sieges and garrison actions, consisted of clashes, usually at platoon level and never at more than battalion strength, even in the occasional large-scale operation. "This ain't a war," observed one character in a novel set in Vietnam circa 1968, "it's a series of overlapping riots."[73]

But actual combat rarely mimicked fictionalized accounts or Hollywood visions of battle. For long periods of the war, it would not have been unusual for even an infantryman to spend his entire year in-country without seeing a single live, identifiable enemy. "Combat!" snorted a former soldier, "I hadn't seen no combat. All I seen was guys getting killed!"[74] A Marine Corps PFC described a search-and-destroy operation. "We went fifteen days out in the field there trying to find the Vietcong," he recalled. "I remember getting shot at that first day. . . . So for fifteen days we burned villages down, blew up tunnels and walked through rice paddies up to your ass in mud and shit and leeches. You were hot and sweaty, drinking scummy water, eating these cold C rations and basically up most of the night."[75]

Combat in the field—as opposed to fighting in the cities during Tet or

siege situations, for example—rarely was characterized by the classic battle formations set up because of the existence of clearly demarcated front and rear zones. In Vietnam, units were always forced to guard their entire perimeter; the defensive posture taken, whether out in the jungle, in a battalion firebase, or in a main base camp like the one at Pleiku, was circular, with the command, communications, and medical aid as the center hub of the wheel and with listening posts set up outside the circle to act as an early-warning system. When the units left these defensive positions on foot, the infantry patrols generally followed the typical order of march: the point squad, the flank squad (which in thick jungle merely fell in behind the point), and the "tailend-charlie" squad.

Getting into the field was not always achieved by simply walking away from the base camp. The military enjoyed unprecedented mobility in this war, due in part to the amphibious ducks, M-113 armored personnel carriers, and river craft, but primarily due to the revolution in the manufacture and use of helicopters. Choppers transformed the tactics of the U.S. and ARVN soldiers, so much so that the conflict could accurately be called the "chopper war." The new machines in operation during the Vietnam War differed dramatically from the slower, less powerful ones used in Korea. Nicknamed the "Huey," the "Cobra," and the "Superhook," the offensive fleet of new Vietnam-era choppers could do everything from ferrying seven or eight soldiers into combat, to laying down heavy fire, to transporting thirteen tons of equipment.

Although most of the weapons in use in the early days of Vietnam were basic World War II types, by midway through the war considerable innovation had changed the character of many of the armaments. "A Korean War soldier," wrote John Hay, Jr., the commander of the 1st Infantry division, "would recognize the steel helmet, the pistol, the mortars, the towed howitzers, and the jerry can. The rest of today's hardware is new. The lightweight M16 rifle has replaced the old M1, and the M79 grenade launcher, the light antitank weapon, and the claymore mine have increased the infantryman's firepower."

Americans in the military harbored few doubts that their advanced weaponry could triumph over the enemy's "bamboo technology." After all, to track the enemy, Americans had seismic sensors, chemical "people sniffers," and electronic communications intercepts. To "take the night away from Charlie," they employed ground radar, infrared sensors, and low-light television cameras. To increase the lethality of their firepower, they developed "smart" bombs, cluster bombs, and air-based artillery so intense that it was said that a ten-second burst from "Puff the Magic Dragon" would cover every square foot of a football field.

342

And, finally, to make use of all these modernized weapons, the Americans depended on the most sophisticated communications system ever used on a battlefield.[76]

American use of napalm and defoliants further capitalized on the U.S. domination of technology. Although it was not until March 1965 that the use of napalm was authorized against North Vietnamese targets, napalm had long been part of the American–South Vietnamese arsenal. In mid-1962, *Life* photographer Larry Burrows witnessed a napalm run in Danang with the 93rd Helicopter Company. "So often when napomb [sic] is dropped in the forrest [sic]," he observed, "it just drips from the 100 ft tree's [sic] and the VC can side step most of it—but the rockets they don't like because they wing their way through the trees—We know they are in the target area—but it would be good to see them running once in a while then the pilots could count their successes."[77] So, partly to exploit the "potential" of napalm and other weaponry and to deny the North Vietnamese the cover of the jungle canopy, Americans turned to defoliants. The effect of Agent Orange—and the other herbicides, Agents Blue and White—was dramatic: "trees were stripped of leaves," recalled Admiral Elmo Zumwalt, Jr., commander of the American in-country naval forces, responsible for the spraying of Agent Orange around navy-patrolled waterways, "thick jungle growth was reduced to twigs, the ground was barren of grass."[78]

In all, the American government defoliated 5.2 million acres of land in Southeast Asia. The United States sprayed an estimated 11 million gallons of Agent Orange, which contained about 400 pounds of the chemical by-product dioxin—although the toxicity of the dioxin present in Agent Orange long remained unknown. (In tests, dioxin has killed monkeys at a strength of one part per 20 billion, but because its effects are delayed and mutagenic, a direct cause-and-effect relationship between dioxin and a multitude of medical problems has been disputed in the courts.)[79] From the outset of its use, the Viet Cong charged the Americans with initiating a chemical warfare campaign, while the American and South Vietnamese governments insisted it was safe. To counteract the North Vietnamese "propaganda," reported Malcolm Browne, "government psychological teams roamed the countryside eating bread soaked in defoliant spray, washing their faces in it, and so on."[80] Many peasants remained—rightly as it turned out—skeptical. The defoliants destroyed about 60 percent of their targeted vegetation; as a result, American casualties, Admiral Zumwalt believed, "dropped significantly as more and more of the chemical was used."[81] Yet even before the long-term harmful effects were known, its overall effective-

ness was challenged. "There is no question," wrote reporter Browne in 1964, "that defoliation gives the communists a perfect propaganda hook on which to hang a campaign that has hurt the Free World cause badly. On balance, I think the communists got the better of the deal."[82]

The American military adapted the grand strategy of the war effort to accommodate the new weaponry, but the average GI was also a "beneficiary" of American wizardry. The infantryman was "looped, draped or hung with the latest gismos of Western innovation." The men could be weighed down with seventy-pound packs; appended from them somehow could be a claymore mine, a machete, a pair of canteens, a dozen or so magazines for an M16 rifle, hundreds of rounds of machine-gun ammunition, and a rucksack with C-rations and other supplies. Other men carried mortars, grenade launchers, and radio equipment. But the high-tech equipment could come out the loser against the ravages of Vietnam. As photographer Tim Page noted, "Gear dropped apart in a million mysterious mildewed ways, the body seemed to grow things that existed only in horror movies."[83] One marine told of his first issue of equipment on his arrival in-country:

> It was raining out like a son of a bitch, and I still had my stateside fatigues on. So they brought us down to supply and issued us what they call 782 gear, which was your web gear, pack, helmet. . . . There was a soggy pile of wet, moldy, grungy 782 gear sitting there—web gear, steel pot and flak jacket on top of it. And I found out it came from this one kid that got blown away out there. He was a machine gunner and he got killed that day. And they gave me this guy's shit. His gear, you know? I don't want it, you know? I want some clean, brand new, dry stuff. I don't want something that some dead guy just wore. [But] in the Marine Corps, you get, you take. So I took it."[84]

All this "superior" weaponry and equipment was both supposed to protect the men by compensating for additional troops and intended to make those men better soldiers. One rationale given for the military's insistence on a fully automated rifle, for example, was that the number of men who actually would fire their arms in combat would rise as a result. And, indeed, the fire ratio that hovered during World War II at less than a quarter of the men in action, rose during Korea to about 50 percent and in Vietnam to 80 percent. One army psychiatrist remarked that while "in previous wars large numbers of American GIs could not

bring themselves to fire their weapons the first time in combat . . . the opposite was true in this war."[85]

Fear led to widely divergent patterns of behavior. It might cause men to fire their guns when they were dropped off at a "hot LZ," but it might also cause them to radio back fake reports of contact with the enemy when they were out on patrol. Fear caused some to refuse to go into a dangerous situation; and others to "frag" their officers. Fear caused some to find relief in drugs and to withdraw from the war; it caused others to go on rampages and commit atrocities. The abuse of alcohol and drugs became endemic, especially late in the war; in 1971, 50 percent of the army personnel in Vietnam had smoked marijuana, and 30 percent had taken heroin, opium, or other psychedelic drugs.[86] A former army corporal stationed in Vietnam in 1970 described the situation: "At the time I was twenty and I don't think I was afraid of anything—but the level of our situation in Vietnam had me in the shithouse. You know, I said, Gee, this place is lousy. It just permeates you all with fear. . . . Kids who'd never had a beer before would have shot heroin after two weeks."[87]

Fear, coupled with the condoning of aberrant behavior and the ambivalent attitude toward the war, also led to the commission of atrocities. "When you see a kid that's been fired at for weeks and weeks and weeks," argued Rick Ducey, a former army buck sergeant and, more recently, executive director of the Vietnam Veterans Leadership Program, "and he takes an enemy soldier and stands him up against a tree and batters him to death with the butt of his rifle because he's lost all his friends and he's just flipped out, that's a situation of temporary psychosis as a direct result of battle fatigue." Ducey continued, comparing Vietnam to previous wars:

The type of war that was being fought did create, perhaps, more atrocities. And did, perhaps, necessitate that to some degree. But you can't convince me that those kind of atrocities haven't gone on in every war this country has been involved in. The difference is that the American people supported the valor and bravery of our American fighting forces [in World War II] because the enemy was dehumanized and we were built up. In Vietnam that wasn't the case. The enemy was the poor working-class peasant fighting to overcome U.S. imperialism and we were the Big Green Machine that was winning their hearts and minds by grabbing them by the balls.[88]

And Michael Herr noted, "Every time there was combat you had a license to go maniac, everyone snapped over the line at least once there and nobody noticed, they hardly noticed if you forgot to snap back again."[89]

Actually, according to official records during the war, relatively few cases of traditional combat fatigue surfaced: in 1965–66, psychiatric casualties totaled only 5 percent of evacuations from Vietnam, and in 1967–68 the figure dropped to less than 3 percent.[90] (Post-Traumatic Stress Disorder is, of course, a post–tour-of-duty phenomenon.) Several factors contributed to the low number of in-country victims: the military's promise of a maximum thirteen-month tour of duty, broken up by one and possibly two paid vacations to "any spot in the Orient friendly to the U.S.";[91] and the continuation of the World War II policy of treating psychiatric casualties immediately, in the combat zone, and then returning them to duty. Line officers and medics in Vietnam were counseled to be alert to the symptoms of stress and breakdowns and were backed up by divisional psychiatrists, two neuropsychiatric treatment-center teams, and a psychiatric consultant for the theater forces as a whole.[92]

Men who were wounded in combat in Vietnam also found themselves backed up by a formidable array of personnel and services in-country, ranging from infantry-platoon aidmen to field, surgical, and evacuation hospitals. The rapid battlefield-to-hospital system called MEDEVAC saved countless lives; the death rate of the wounded in Vietnam was half that of Korea and a quarter that of World War II. Responsible for that significant decrease in fatalities were the MEDEVAC helicopters—called "dustoffs"—which could literally pick up as many as four wounded on litters within minutes of their being hit and transport them directly to medical-evacuation stations and field hospitals. Not only did the dustoffs' response time average less than thirty minutes from the time of the radio call to the arrival at a medical facility, but the airborne ambulances also offered a crew of medics equipped and trained to perform emergency in-air medical treatment.[93]

The total number of Americans who died "in connection with the conflict in Vietnam" was recorded in an immediate postwar Department of Defense (DOD) document as 58,721. The wounded totaled 303,713, over 150,000 of whom required hospital care. In addition, 2,477 men were classified as missing. In a breakdown of casualties incurred as of mid-April 1974, DOD noted that 55,555 men had died, 46,229 of them from hostile causes. Of those killed by hostile forces, 18,447 died from gunshot wounds; 8,464, from multiple fragmentation wounds; and

7,428, from grenades and mines. Another 381 men committed suicide. Of the total, 7,198 were black. Sixty-four percent of all the men were younger than age 21: 12 were age 17 and 3,092 were age 18; 6,892 officers died, including 8 colonels and 4 generals, but only one of the senior officers was killed because of hostile fire.[94]

At the end of the U.S. involvement, official American estimates placed North Vietnamese losses at close to a million and the South Vietnamese ARVN dead at nearly 200,000—with perhaps a million civilians killed in both the north and the south (caused mostly by the massive American and South Vietnamese artillery and air strikes) and 9 million Indochinese refugees left homeless.[95] At the height of the fighting (1968–69), the U.S. military estimated that there were 130,000 civilians made casualties a month, 585,000 refugees created a year, and 200,000 "communists" killed in action.[96] Some of these figures, however, like most of the numbers associated with the statistical portrait of the war, may bear little relationship to reality. The body count, especially of the enemy, was subject to gross exaggeration. "American analysts," one historian has remarked,

> increased ARVN's claim of enemy deaths by 35 percent, an arbitrary estimate of the number of Communists soldiers who died of wounds or were permanently disabled. In 1972 this method produced an astonishing estimate of 180,000 enemy troops permanently put out of action, or more than half the entire Communist combat force. If only one man were wounded for each man killed, that would mean the entire Communist army had become casualties.[97]

Although the figures are disputed, the casualties were undoubtedly immense. Other costs, as well, were great: from 1955 to 1975, American aid to South Vietnam totaled $24 billion, and direct American expenditures for the war totaled $165 billion.

It is not surprising that at the finish, numbers were what the commentators fell back on in their final wrap-up stories. On CBS television, Ike Pappas, speaking on the morning of the fall of Saigon, closed his report by saying: "So, the end came, and here, in this capital, there were mostly numbers to tell of it. For the United States—56,000 dead, 303,000 wounded. $141-billion in military aid down the drain. For South Vietnam—260,000 dead. For North Vietnam—over a million dead. For civilians on both sides—millions more dead, after years of human suffering."[98]

The end of the American involvement in Vietnam ostensibly came on January 23, 1973, when Henry Kissinger, assistant to President Richard Nixon for national security affairs, and Special Adviser Le Duc Tho, representing the Democratic Republic of Vietnam [North Vietnam], initialed the Paris peace agreement. Nixon addressed the country that evening. "The important thing," he asserted, "was . . . to get peace and to get the right kind of peace. This we have done."[99] But, of course, they had not. The war did not really end, even for the Americans, until two years later, when, on April 30, 1975, the North Vietnamese forces captured the South Vietnamese capital of Saigon.

On television, the first film of the final evacuation of the American embassy appeared that evening on CBS Evening News. Dan Rather substituted for Walter Cronkite. "Good evening," Rather greeted the American public. "South Vietnam now is under Communist control." Later in the half hour, he talked via satellite with correspondent Ed Bradley in Manila.

Bradley had been one of the last newsmen out on the choppers that left from the roof of the American embassy in Saigon. He had driven around the city for hours, trying to get to the Tan Son Nhut Airbase. On being turned away from the field by ARVN paratroopers, he drove to the United States compound and—surrounded by thousands of South Vietnamese clamoring to get in—climbed over the back wall. "Describe for us," requested Rather, "what you saw and what you felt in that embassy in those last hours."

"That was perhaps the strangest part of the day, Dan," recalled Bradley.

We went out in the hallway to the water fountain—and this hall runs the entire length of the embassy building, the main embassy building, quite a long hallway. And the hallway was very dark. It was very subdued lighting. And at the other end, there was a large conference room, and the doors were open to that conference room and it was lit by fluorescent lights and there was an embassy official still sitting there, giving orders to other U.S. officials concerned with the evacuation. And that was really the bright light—I just thought of the expression that we've heard and used so many times—"the light at the end of the tunnel". . . . and that's the way America was leaving Vietnam.[100]

14

The Photographers:

The Committed Critics

Who, What, Where, When

"IN VIEW OF THE IMPACT of public opinion on the prosecution of the war," General William Westmoreland asserted in the summer of 1968, "the accuracy and balance of the news coverage has attained an importance almost equal to the actual combat operations."[1] The Vietnam War appeared to be a different sort of conflict than those in which Americans had fought previously. Vietnam was a place where battlefield success seemed at least insufficient and at most incalculable, where uncritical official optimism gave birth to a virulent strain of propaganda and statistics, and where the management of the news at all levels, by all parties, pitted traditional "straight" reporting against the "adversary" or "new" journalism. In earlier wars, military victories had indicated a direction to a conflict, government support of a war effort had been perceived as benevolent control, and the press's coverage of both fighting and politics had been, at worst, a friendly and "constructive" critique of events. Not so in Vietnam.

Yet widely held myths about the press's coverage of Vietnam—that the relationship between journalists and government and military officials was consistently adversarial and that this clash of opinions shaped the outcome of the war—are also not necessarily so. The argument that the print and electronic media were responsible for the "loss" of Vietnam by their facile and immature undermining of American policy is a case in point. Richard Nixon snidely and bitterly observed that

"this was the first war in our history during which our media were more friendly to our enemies than to our allies. . . . The dishonest, double-standard coverage of the Vietnam War was not one of the American media's finer hours. It powerfully distorted public perceptions, and these were reflected in Congress."[2] Major-General Winant Sidle, chief of information for Westmoreland in Saigon until 1968, the U.S. Army's chief of information until 1973, and deputy assistant secretary of defense for public affairs until 1975, was not facetious when he pointed out that the "Baseball Writers Association had more stringent rules for the assignment of reporters" than did the American press for assignment to Southeast Asia. "Had our media used similar rules for the assignment of reporters to Vietnam," he argued, "I believe reporting of the war would have been much more objective. And this might well have changed the entire outcome."[3]

To a great degree, these conservative critics have reacted to what they identify as the liberal bias of those correspondents who covered the war in Southeast Asia. And these critics are accurate in their assessment of the majority of the press as leftist; for example, in a survey of journalists affiliated with major media outlets, 54 percent described themselves as "liberal" or "left of center," while only 19 percent called themselves "conservative." In addition, during the four presidential elections from 1964 to 1976, an average of 86 percent of those surveyed voted Democratic.[4] In keeping with those findings, many journalists on assignment in Vietnam would have agreed with Sidle's assessment of their lack of objectivity with one major caveat: most of the press did not believe, at the time of the Vietnam War, that objectivity was a journalistic possibility. Some reporters even went so far as to preface their published remarks with explicit statements declaring their bias, although no similar disclaimers were ever forthcoming by quoted American officials. Controversial television broadcaster Morley Safer opened one 1967 CBS Special Report with the comment that his story would "be full of prejudice and opinion of my impressions of Vietnam, of the war and mostly of people, people thrust into the extraordinary condition of war, and the even more extraordinary condition of the war in Vietnam."[5]

The fundamental charge underlying the conservatives' critique that the reportage on Vietnam was liberal and biased is that the coverage of the war was pessimistic—in opposition and in response to the official "positivism" that held sway at least until the Tet offensive.[6] Yet those very press outlets that have been so vehemently criticized, such as the New York Times, voluminously quoted and recorded the speech and actions of government and military spokespeople who, because of their

official positions, could command print space and air time far in excess of their detractors and could do so without the immediate filter of journalistic editorializing. These stories espoused the official "euphoria" on the war. But it is true that in addition to "news analysis" and "opinion" pieces other articles, such as "human misery" or "bang-bang" stories, were framed not only by events but by how the soldiers, officials, and journalists *felt* about these events. These other stories were also related through the words and opinions of those involved and interviewed, and by midway through the war, many "grunts" (GIs) and civilians, younger officers in the field, and officials in the embassy were pessimistic about the current American policy and conduct of the war. By their accounts, the war did not appear to be working, and the reports quoting these spokespeople did not hesitate to say so.

In assessing the conduct of the media during the Vietnam War, one question remains crucial: Why did the "team" spirit disappear? Why, after so many years and wars of partnership in thought if not always in deed, did the press during the Vietnam War become—was almost forced into becoming—adversaries of the explicitly stated government position? True, by the time most members of the press had started rigorously to question American policy in Southeast Asia, so, too, had other established American institutions, most notably Congress and the universities. But the answer to why journalists—many of whom, by their own admission, were supportive of the war well into the 1960s—came to stand against it is more complicated.

The journalists' political stance changed over time. From John F. Kennedy's 1961 decision to send thousands more advisers to Southeast Asia, to the 1964 Gulf of Tonkin episode, to Lyndon Johnson's sustained bombing of North Vietnam beginning in 1965, the press in Saigon substantially backed the American involvement in Vietnam. "We were accused of criticizing policy," remembered Neil Sheehan, a young reporter for United Press International (UPI) in Saigon during those years. "In fact we were not. We were criticizing the implementation of policy."[7] Few correspondents took alternative or adversarial positions during this period; there was a lack of diverse or dissenting official sources that could counter the prevailing governmental lies and dissembling about the war.

In addition, the journalists in Vietnam, as *New York Times* reporter Charles Mohr recalled, "were all children of the Cold War."[8] They were part of the Cold War consensus; they believed, said Sheehan, that the war

was a good thing. . . . We thought all communists were alike and that Ho Chi Minh was a pawn of the Chinese, trying to take over all of Southeast Asia and if the Vietnamese communists won, the Chinese communists would win and if South East Asia fell, Indonesia would fall and ultimately Japan would fall. We believed in the domino theory. . . . And we desperately wanted to see the United States win this war. . . . Americans at that time were very ideological. . . . We believed we were morally superior beings. Our cause was always right. We had a right to kill Vietnamese in an American cause.[9]

Although the press believed in the American cause, the younger journalists, even during the first half of the 1960s, felt they could be critical of the direction and focus of American operations in Vietnam; they thought they could criticize the American military and government without being unpatriotic. In so doing they took the first step toward an adversarial critique—but an adversarial critique that always operated from within the American tradition. By Tet 1968, certain journalists came to criticize the American government not for applying American ideology to the conflict in Southeast Asia but for *not* doing so. The press came to believe that by establishing American control of Vietnam, by killing civilians and by lying to its own public, the United States government had abandoned its own democratic principles and, not so coincidentally, was losing the war.

But it took until the Tet offensive of 1968 for the print press to become thoroughly skeptical in its coverage of the war. (The electronic media remained "strongly supportive" of American actions until after Tet.) Furious about having been misled during the beginning phase of the conflict, correspondents for the newspapers, magazines, and wire services believed that the previous wars' uneasy "partnership" between officials and journalists had been unforgivably betrayed. If at first the American press out of ignorance and a sense of chauvinism helped whitewash the U.S. involvement in Vietnam—as they had in previous wars—all too soon, for Washington's liking, the reporters became cynical and independent by the simple expedient of keeping their eyes and ears open. John Mecklin, press affairs officer in Saigon, could admit that "major American policy was wrecked" not by the press's "deliberate" falsification of the conflict—as had been the "role of the New York newspapers in precipitating the Spanish-American War more than a half century earlier"—but by "*unadorned* reporting of what was going on [emphasis added]."[10]

The process had begun with the buildup of troops after the marines' landing at Danang in 1965. At that time, the journalists' early problem of finding government and military sources that offered dissenting opinions ended. As more Americans entered the country, the journalists had more insiders to talk to—at least some of whom took exception to the prevailing American strategy. Just at the time when the U.S. government began to harbor its own doubts about the viability of its policies and therefore needed to practice what became known during the Nixon administration as "damage control," the press refused to fall in with the government's public relations campaign. "The administration," said Mohr in the summer of 1966, "seems to want to make this war a sanitary war. Well, it's not. . . . They don't want to talk about napalm. . . . They don't want to talk about certain antipersonnel bombs that are very effective. Well weapons are meant to kill people. And good weapons kill a lot of people. . . . As I say, I support the war, but I don't support attempts to pretend we're not killing people."[11]

Photographers were rarely as politically articulate as their more verbal colleagues, yet many did become politicized during the course of the war. AP photographer Eddie Adams, best known for his picture of South Vietnamese Brigadier General Loan shooting a Viet Cong prisoner in the streets of Saigon during the 1968 Tet offensive, described his own change in attitude toward the war. "When I first went in in 1965," he reminisced, "I was gung-ho. I was just like the Marines. . . . But [over the next year] I watched the buildup of the war on both sides, and saw we had started it. And I thought this was wrong." Adams compared his politicization to that of his print-journalist colleagues: "There were some writers," he said,

Peter Arnett, Halberstam, Malcolm Browne—all these guys saw this happening at the very beginning. They were labeled communists by the government in the early days for writing what they did, but they were right. At the beginning, I was against what they were doing—I didn't see what they saw until a little later. Why I changed, what really happened is, I saw people get blown away, yet we weren't making any progress. I couldn't understand. I went over there to take pictures; I wasn't interested in politics. . . . But then I saw America dictating to other countries the American way of life which is not necessarily good in other countries. Look, if a guy's a dictator in one country and it works, let it work, leave him alone, for Christ's sake. I don't like anybody shoving anything down anybody's throat.[12]

353

Certain photographers, such as *Life*'s Larry Burrows, "came late," his son Russell recalled, "to an understanding that the Vietnamese wanted to be left alone." Burrows's story, "Vietnam: 'A Degree of Disillusion,' " published in *Life* in the fall of 1969, had been a turning point for him. In it he stated, "I have been rather a hawk." But Burrows, who was killed during the invasion of Laos in 1971, never did question the "rightness" of the war, as many print and television reporters had come to do by the late 1960s. "His change," his son believed, "had nothing to do with the fact that the war was wrong; he was opposed to its stupidity. . . . to how the war was being waged."[13] "Many people, journalists and others," Russell Burrows stated, "radically changed their minds around 1968. Where my father was different was in his beliefs that the South Vietnamese people wanted and supported the American effort, and that they would be willing and able to shoulder that burden as the United States withdrew. It was in photographing an essay on those people that his beliefs were confronted, and the result was 'A Degree of Disillusion.' "[14]

Other photojournalists, such as Magnum photographer Philip Jones Griffiths, who had come to Vietnam believing the war to be wrong, found that their opinions only became more firmly entrenched over time. Griffiths described his attitude: there was a "progressive reinforcement of my beliefs. . . . The breakthrough came for me in 1967, when I had some definitive proof that the Vietnamese were smarter than the naive American assessment of them. From then [the war] started making sense. The evidence had always been the same, it was just that now I was seeing it clearly."[15]

These shifts in the photographers' attitudes toward the war did not necessarily result in an aesthetic change in the images they took. Photographers operating on tight deadlines, as AP journalist Malcolm Browne observed, do not have the same luxury of time as do photographers who take pictures for feature stories or books. "No newsman," said Browne, "can afford to think about history. He has to have something to put on the wire machine." AP photographer Adams concurred: "My change in attitude made me *think* more about what I was doing, but I don't think my pictures changed—maybe they did, I wanted them to, but I got caught up in the war, in just combat." Yet Adams believed that *feature* photographer Burrows had been affected by a pivotal experience he had while shooting a story on the death of a member of a helicopter crew. Burrows, operating under lenient deadlines from *Life*, had the leisure to craft his ideas into visual images. " 'Yankee Papa 13' [the name of the story and the call number of the helicopter in the arti-

cle] was the turning point in Larry Burrows' life," Adams thought. "Up to that time, I had always thought Larry Burrows was a so-so photographer. . . . But from that time on . . . his pictures just became greater and greater. . . . I don't know what it did to him—he always had a good drive. But afterwards, whenever he'd do anything, it was like this guy can't miss."[16]

But, curiously, the expressed political opinions of photographers did not always signal a comparable attitude expressed in their work; some of the most telling documents used to protest the conflict were taken by journalists who professed to be apolitical in their reportage. Browne observed matter of factly: "Journalistic photographs certainly have no point of view in them because there is no time or energy for point of view in this kind of photography. Any point of view ascribed to them later is just that. That would apply to my pictures of the burning monk. I had no point of view. I was concerned that they be properly exposed, but since the subject was self-illuminated that wasn't much of a problem."[17]

But, as Browne would be the first to admit, the photographer's intent in taking a photograph could bear little relation to the later impact of that image. "Had a Western newsman with a camera not been present at Quang Duc's suicide," Browne wrote, "history might have taken a different turn. . . . I have been told that when Henry Cabot Lodge was called in to see President Kennedy about taking over the ambassadorship to Viet Nam, the President had on his desk a copy of my photograph of Quang Duc."[18] The politics of the war could transcend the politics of the camera operator. It was not merely the case that photographs, like Shakespeare's Scripture, could be cited for any purpose, but, rather, that tough pictures, true to their situation, reflected not only the angle of vision of the photographer but the perspective of the subject. And the subjects were at times savvy enough to recognize that. Journalist Michael Herr told of "grunts . . . hip enough to the media to take photographers more seriously than reporters, and . . . officers who refused to believe that I was really a correspondent because I never carried cameras."[19] The soldiers not only wanted to see themselves in pictures, they wanted the journalists to "tell it like it is." Philip Jones Griffiths told of photographing a Vietnamese father carrying his severely wounded child. "I walked 50 yards backwards taking that picture," Griffiths recalled. "And all the time he fell in step with me—as I walked backwards he walked at the same speed. We walked together as if we were on a moving platform. And I remember that in all the frames he never looked at the camera . . . and also he held her in a way that was unnatu-

ral—he wanted to show me what had happened."[20] It would have been difficult to have taken any other kind of photograph of that subject than what the father offered; the resulting photographic images were less a result of Griffiths' politics than of the emotions of the Vietnamese parent.

The opinions and attitudes, the approaches and interests of the press in Vietnam were not monolithic. There was a split between photographers and reporters, for example. Griffiths believes that his book *Vietnam, Inc.* "is hated by every writer. Every writer says the same thing: 'Nice pictures, but stick to the camera, old boy.' It's partly jealousy—because they can't take pictures, I'm not supposed to write. But also they think it's their province somehow."[21] Eddie Adams noted the same tendency: "For years," he said, "photographers were labeled as idiots."[22] But photographers could also be jealous of reporters; Russell Burrows suggested that perhaps one reason why his father liked to work alone was that he was afraid that if a *Life* reporter accompanied him on assignment, "there'd be too many words that might take up space that might be occupied by pictures."[23] The rivalry that occasionally surfaced between photographers and writers reflected the greater competition between younger journalists and older correspondents, between those in the press who went out into the field and those who wrote their stories from the safety of Saigon, between such organizations as AP and UPI, and the *New York Times* and the *Washington Post*. As Peter Braestrup pointed out, "the major media do not constitute an organized, unified information conglomerate."[24]

Conflict between young, resident journalists and their older colleagues could become especially heated, partly because the younger members of the press had undergone a conversion process while in Vietnam. According to the chief correspondent for *Time*, Frank McCulloch, Americans went through five distinct phases after they came into the country:

> The first stage: very upbeat, Americans can save these people and they really want to be saved and they will be grateful for it. Second stage (usually about three months later): we can do it but it's harder than I thought and right now it's being screwed up. Third stage (perhaps six to nine months later): you Vietnamese (always the Vietnamese, never the Americans) are really screwing it up. Fourth stage (twelve to fifteen months later): we are losing and it's much worse than I thought. Fifth stage: it isn't working at all, we shouldn't be here and we're doing more harm than good.[25]

Because they put in extensive time in Vietnam, younger photographers were more likely to have their work reflect the latter stages expressed by Frank McCulloch. Older photographers, because they were influenced by the previous, more "benevolent" wars and because few of them stayed long enough in Vietnam to undergo the entire "conversion process," were more likely to have their images mirror the former stages.

The government and many media offices back in the United States (*Time* magazine and the Hearst publications chief among them) seized on the existence of this generational divide between journalists to legitimate the government's and media institutions' own interest in the more conservative, traditional perspective of the older, nonresident correspondents. Reporters and photographers of the World War II and Korean War era often checked into Vietnam in the early days of the war and vociferously disapproved of the attitudes of the resident "Young Turks." Marguerite Higgins, a *New York Herald Tribune* writer during the Korean War who later married an air force general, toured Vietnam in 1963. *Time* quoted her as saying: "Reporters here would like to see us lose the war to prove they are right."[26] Richard Tregaskis, of *Guadalcanal Diary* fame, told *New York Times* reporter David Halberstam: "If I were doing what you are doing, I would be ashamed of myself."[27] And Joseph Alsop, who was treated like a visiting head of state by the American embassy, blamed the "young crusaders" for pushing the Diem government "around the bend."[28]

The resident journalists in Saigon took umbrage at these criticisms. Not all of them were young or inexperienced. Eddie Adams had served as a marine in Korea; Malcolm Browne had been a photographer for *Stars and Stripes* during Korea; David Halberstam had previously been assigned to the war in the Congo; François Sully, the *Newsweek* correspondent, had lived in Vietnam for seventeen years; and Homer Bigart, another *New York Times* reporter, had twice won the Pulitzer Prize. The dichotomy between the two schools of journalists lay not solely in a difference in experience or chronological age. As Browne explained, the conflict stemmed from the fact that Higgins, Tregaskis, and Alsop were mired in the past; they "persisted in seeing Vietnam in the context of World War II and the China experience and somehow it never seemed to dawn on them that it was neither World War II nor could it be fought like World War II, nor was it really a replay of the China situation."[29] Alsop and company were, in the jargon of the UPI, "parachutists": they parachuted in with their minds made up. Photographer David Douglas Duncan was another such; he came to Vietnam on occa-

sional assignments for *Life* and saw just what he had seen in Korea and World War II. He photographed and wrote about the agony and ecstasy of Vietnam, just as he had during the previous two engagements; for him, that war was the same war. "The men view Con Thien," he wrote in a *Life* photo caption in 1967, "in the same light as Tarawa and Iwo Jima and are proud and happy to have held this hillock in a remote land."[30] And later in his book *War Without Heroes*, published in 1971, he observed: "Very little seemed changed in combat photography—for me—between the battlefields of Viet-Nam, today, Korea, in 1950, and the Solomon Islands, during World War II."[31]

The number of these visiting correspondents, short-term press people, and resident journalists accredited to MACV added up over the course of the war: in 1961–63 there were no more than 10 accredited members of the foreign (non-Vietnamese) press; in 1964, there were 40; in 1965, there were 400; and by the height of the Tet offensive in 1968, there were 637. After Tet, the numbers began to decrease: 1969, 467; 1970, 392; 1971, 355; and 1972, 295. By mid-1974, only 35 journalists were left, although the number rose, once again, in 1975, during the last days of South Vietnam.

But the numbers were deceiving. Browne, who spent fourteen years in Vietnam and whose news affiliation changed over time from AP reporter and photographer, to ABC newsperson, to freelancer, to *New York Times* correspondent, assessed the figures. "In the beginning," he said,

> there were a half dozen newspeople accredited and along towards the end it was not uncommon to see an accreditation list about 700 long. However, the basic structure of coverage never changed. There was always a very hard core of perhaps no more than fifteen or twenty reporters who furnished 99 percent of the important news and photography. The rest were groupies and intelligence types and religious fanatics and god knows what. There were people who had come over on subsidized tours on behalf of their papers but really paid for by the Pentagon—huge numbers of people like that who had really nothing to do with journalism. And also I guess I'd say that in television there are the correspondents who were involved and certainly cameramen, but there was also this gigantic infrastructure [of technicians, producers, and analysts] who were formally accredited as newspeople but who were in fact just there for working some of the nuts and bolts.[32]

Most of those journalists who Browne identified as part of the "hard core" had impressive credentials for their work. But not all the active journalists did. Catherine Leroy, for instance, who was, according to AP's Saigon photography chief Horst Faas, "one of the best four or five freelancers here," had come to Vietnam with no prior professional camera experience.[33] Photographers Dana Stone and Sean Flynn (son of Errol), both still listed as missing in action in Cambodia, were another, more flamboyant, example. UPI reporter Perry Deane Young remembered that "neither had used a camera professionally before the war. . . . When UPI gave Stone a new Nikon camera just after his arrival, he had to ask another photographer to show him how to change the film."[34] And several other women freelance photographers originally came to Southeast Asia only because they had tagged along with their boyfriend-journalists. Vietnam was the first war in which such fluidity and such liberality was possible. For the first time, women in substantial numbers covered the war, several of whom were, or were to become, prominent: Leroy won an Overseas Press Club award for her photographs; Elizabeth Pond of the *Christian Science Monitor*, Kate Webb of UPI, and Michele Ray, a French freelancer, were each captured by the enemy and later released to write stories of their experiences; and Dickey Chapelle, who had published the first picture of an "American ready for combat" in *National Geographic*, was killed in Vietnam in 1965.

The charitable policy of accreditation in effect during the war facilitated the coverage of the conflict by professional journalists and rank amateurs alike. After obtaining a Government of Vietnam press card— an easy feat—"commercial" press members needed only to submit one letter from their home office to receive a MACV accreditation card, which entitled the owner to "air, water, and ground transportation" within South Vietnam, and a Department of Defense (DOD) noncombatant's "Certificate of Identity," which established that the owner had the assimilated rank of major in case of capture by the enemy. "Freelancers" had only to submit two letters from hometown "agencies" or from bureaus in Saigon. And once accreditation was forthcoming, the AP and UPI, for example, would lend these nascent journalists cameras, film, light meters, and instructions to get them started.

The wire services would give virtually anyone a letter of accreditation, and all that prospective freelancers had to do was to get another from their local newspaper back in the United States.[35] And even that easy a policy was circumvented. AP photographer Adams recalled:

"Anybody could get accreditated. I don't care who you were. You could just type your own little letter saying so-and-so is a so-and-so—it didn't have to be on a letterhead. It was a joke. You typed it up and then you were accreditated."[36] However, the authorities could eventually catch up with freeloaders. Philip Jones Griffiths, who had come to Vietnam accredited to the Magnum agency but who had no assignments from it and rather photographed for his prospective photodocumentary book of the war, ran afoul of the system:

> Well, the clipping service that they had was pretty impressive, so that as the months went by if your name didn't appear—that story was published here, there, or somewhere—they'd say, "What about that story you covered? Didn't it ever get published?" They'd start to get a bit suspicious. So I pleaded with Magnum to get me some assignments, just so I could establish who I was, because there was a little footnote in the application for your pass that said JUSPAO [Joint United States Public Affairs Office] is not in a position to accredit authors or playwrights. In other words, you had to be a bonafide journalist.[37]

The transportation and facilities that MACV provided the journalists greatly expedited the gathering of the news. MACV furnished "food and lodging" when the correspondents were out in the field—which often worked out to C-rations and the corner of a tent—and "flight benefits": "priority seating on a number of regular C-130 flights" to the country north of Saigon; "a helicopter ... on standby" for the region south of the capital; and "the privilege of 'hitching' rides on almost all other U.S. aircraft."[38] In one year, October 1965 to August 1966, for example, MACV personnel "arranged more than 4,700 in-country trips by newsmen, to include ground and air transportation."[39] (And, when military transportation was not available, there was always the local train system or Air Vietnam, the commercial airline, with its daily flight schedule.) Photographer Griffiths described how the military's arrangement operated:

> The mechanism by which you actually worked in Vietnam was you went to the public affairs office called JUSPAO ... and you said I want to go to so-and-so. You couldn't go anywhere without them because the roads were all closed. The communists controlled all the roads. So you had to take a helicopter and in order to get on the helicopter you had to tell JUSPAO what you were doing. Looking back on it now there were probably a few places you could have

gone by yourself actually—and later in the war you could go quite far by yourself, but [the American authorities] didn't want you to go [anywhere by car]. They wanted you to go by helicopter because it meant they knew where you were and what you were doing. Not because they were keeping tabs on you so much, but because they wanted to make sure you got to a good place where they'd just had a big battle or uncovered this or that. They wanted to have you so they could use you.[40]

The press's dependence on the military for transportation allowed the officials to control the press's access and timing; officials could delay the coverage or filing of a story until a military advantage rested with the South Vietnamese or American position. And even with the military's assistance, a short 800-word article or comparable photoessay could take a journalist four or five days to pull together. Getting from Saigon to the demilitarized zone (DMZ) or to Bien Hoa in the Delta usually took twenty-four hours; two days were normal for gathering information and taking pictures, even for an "old hand"; and getting the stories and images home added additional time.[41]

Control of the press took many different forms. In the early days of the war, before U.S. ground-combat troops went in and before the American press operated under the aegis of the U.S. forces, the correspondents were hampered by the Diem regime's censorship of news and pictures. Journalists relied on "pigeons" to get their copy and film out. Even American officials, such as Ambassador to India Chester Bowles and Public Affairs Officer John Mecklin, were pressed into service as couriers. Neil Sheehan described how a more ordinary pass-off worked.

There would be a plane on the runway . . . [and] at the last minute some guy would run into the airport, some American, a correspondent . . . and vault the turnstyle, the customs barrier, literally vault the thing and run right out to the airplane and right up the steps as they were about to withdraw the ladder and close the door and [he would] hand [the copy or film] to a passenger or to a stewardess and say please call the UPI office . . . [in] Hong Kong on arrival. . . . The customs men knew this was going on. . . . They'd laugh and say did you get it out? . . . They hated the regime.[42]

Another way of circumventing the Diem censorship was to play fast and loose with the wire transmitter at the Saigon Post, Telephone, and

Telegraph office. One of the tricks Malcolm Browne repeatedly used was to "get an innocuous-looking picture ok'd by the censor showing somebody giving a speech or children giving out flowers and then [waiting] until just the instant before the drum started to turn. You'd have in your hand something to stick on top of it—it would be a short message saying what had actually happened that day: the prime minister had quit in protest against the government, a riot had happened someplace or other, or a small picture. You could slap it on, stand with your back to the thing while it turned, and quickly rip it off the instant that it stopped."[43] The nerve-wracking ploy worked well; the *New York Herald Tribune* was so enamoured of the cloak-and-dagger operation that on August 24, 1963, it ran on its front page, above the fold, a print of such a collaged photograph just as it had come off the wire.

For the duration of the war, photographic prints left Saigon on the transmitter heading east to relay stations in Tokyo or San Francisco (written copy traveled along the new cable linking Saigon, Guam, Honolulu, and the West Coast). Because, for all intents and purposes, only black-and-white prints could be sent on the wire, the wire service journalists only shot in black and white. AP and UPI developed their film in-country and the Saigon bureau chiefs made the decisions about what to transmit. (Because the scale of the AP and UPI operations in Vietnam was rarely sufficient to cover the entire country adequately with writer-photographer teams, reporters as well as photographers were charged to take pictures.) Conversely, most color film, such as that used by *Life*, was shipped to New York for processing and editing, although for an important *Life* feature story—either in color or black and white—the film would occasionally be developed in New York and then sent back to the photographer-reporter team in Hong Kong for their personal editing suggestions.[44] At every stage in the process, decisions were made about how to present the war.

In the last years of the Diem government, in 1963 especially, journalists suffered through periods of official South Vietnamese censorship; delays or halts of their cable and wire traffic; formal reprimands; severances of official cooperation; withdrawals of visas and expulsions of reporters (even those from such institutions as the *New York Times*, *Newsweek*, and *NBC*); and police brutality. Correspondents were tailed and telephones were tapped. Many were "branded . . . as Communist stooges or worse."[45] A rumor, initiated by Madame's Nhu's younger brother, circulated saying that a list of foreign journalists slated for assassination had been prepared by the Diem regime. South Vietnamese

contacts were questioned and jailed. And American correspondents were severely beaten and arrested.

Photographers and camerapeople were particularly at risk. Following the international repercussions of Browne's photograph of a Buddhist monk's self-immolation, the Diem regime recognized the immense propaganda value of pictures and acted accordingly. Three newsmen, Larry Burrows and Milton Orshefsky of *Life*, and Burton Glinn of the *Saturday Evening Post*, were arrested and detained for taking photographs of an anti-Diem riot. The police released them only after they had exposed their film. However, unbeknownst to the authorities, the men had managed to switch their film, and after they were let go, they were able to ship their pictures of the protest back to the United States.[46] David Halberstam was beaten for trying to rescue some television film of another immolation. A cameraman had taken the film and when stopped had fobbed the police off with a false roll and given the real one to Halberstam. But in this instance the authorities caught on to the switch and chased Halberstam down. "The police said, 'No pictures, no film,'" Sheehan remembered. "They would come over with a billy club and say, 'Look, stop taking that film or we're going to beat you.' And if you kept taking film, they'd smash the camera."[47]

The U.S. government also attempted to persuade the journalists to toe the line—only the Americans used less Draconian methods. It is often repeated that the Vietnam War was an aberration for its lack of American military censorship. And so it was. But, in the same breath, it is acknowledged that the government and the media organizations alike practiced a substantial amount of "news management" and heavy-handed "editing"—censorship by another name. Even establishment speakers during the congressional hearings on "News Policies in Vietnam" in 1966 drew the parallel. "There are different kinds of censorship," the director of the U.S. Information Agency quoted. "There is formal censorship that involves actually cutting pieces or words out of copy. And there is the kind of censorship that has been described in recent years as news management." And Walter Cronkite declared: "The political lie has become a way of bureaucratic life. It has been called by the more genteel name of 'news management.' I say here now, let's call it what it is—lying."[48]

Brigadier General Peter Dawkins, director of strategy, plans, and policy for the army from 1980 to 1982, accurately expressed the military's and government's attitude toward the media's access to the war. "War is an ugly, dirty, obscene business," he said, "and if you take snippets

of it and constantly expose the American public to its reality, that that [sic] is going to profoundly influence their attitude toward the enterprise. *And I'm not sure that that reality, in itself, ought to be the controlling influence of what determines the public's attitude toward the policy* [emphasis added]."[49] To ensure that "that reality" was moderated and euphemized for the public at home, officials prodded correspondents to "get on the 'Team,' " asking them in so many words to be "handmaidens of government."[50] And up until the mid-to-late sixties, many reporters and photographers needed no prompting; they already were on the Team. The extent of the cooperation was such that NBC's Chet Huntley narrated the U.S. Navy's official film on the Gulf of Tonkin crisis. (Tonkin remained the classic case of Cold War news management. Through its manipulation of the "facts," the Johnson administration was able to present the "retaliatory" air strikes as the only possible response to "unwarranted aggression." The media took up the cause joyfully; *Time* and *Life* "viewed the event as if the *Maine* itself had been sunk."[51])

Too soon for the government's liking, however, smart-aleck journalists punned: "The brass wants us to get on the team, but my job is to find out what the score is."[52] As a result, the government initiated an intense public relations campaign. Officials raised the tattered flag of patriotism and national interest, calling for the press to rally around "our side"; they capitalized on the journalists' natural sympathy for the soldiers in the field; and they encouraged the correspondents' gratitude for such governmental favors as transportation and visa assistance.

Official American policy on the news changed over time. An early directive dating from 1960 and 1961 declared that "correspondents were to be denied coverage facilities if thir [sic] resulting stories might reflect unfavorably on the course of the Vietnamese government's war against the Viet Cong and/or on the U.S. role in that war."[53] A new directive, Cable 1006, sent to Saigon in February 1962, responded to unforeseen problems raised by the earlier policy: "Recent press and magazine reports are convincing evidence that speculation stories by hostile reporters often [are] more damaging than facts they might report."[54] By 1965, and the U.S. ground-troop involvement, official interest, by necessity, shifted to an overriding regard for how the press reported American casualties. On Bastille Day, 1965, the DOD released guidelines for presenting combat information, requesting the press's adherence to traditional military strictures on troop movements and technological secrets, as well as ruling that "there will be no casualty reports and unit identification on a daily basis or related to specific actions except in general terms such as 'light, moderate or heavy.' " In mid-

January of the next year, the assistant secretary of defense for public affairs sent a memorandum to all the U.S. news outlets demanding restraint in their use of images of wounded and dead GIs. And in April of that year, the DOD released guidelines on combat photography that were liberal enough to be generally followed. "The most personally sensitive information in any war," the directive began, "is that pertaining to casualties." After mentioning concern for the next of kin, the notice concluded:

> In the war in Vietnam complete reliance has been placed on news media representatives. There has been no effort to impose restrictions on movement of audio-visual correspondents in the field or to require in-country processing, review and editing of audio-visual material produced by accredited correspondents. We hope to preserve these freedoms and ask that correspondents cooperate by—
>
> a. Not taking close-up pictures of casualties that show faces or anything else that will identify the individual.
>
> b. Not interviewing or recording the voices of casualties until a medical officer determines that the man is physically and mentally able, and the individual gives permission.[55]

The decision not to impose a formal apparatus for the suppression or control of the news derived largely from the assessment that this type of censorship would not be feasible (although successful news blackouts preceded the invasions of Cambodia and Laos in 1970 and 1971). Access to the troops in the field and to other countries' filing facilities would have to be blocked, American legal jurisdiction to censor the reportage of foreign nationals in Vietnam seemed sticky, without a declaration of war there could be no censorship back home, and the advent of television and satellite technology made "the very mechanics of censoring," according to Westmoreland, "forbidding to contemplate."[56] With that understanding of the difficulties inherent in a formal censorship, the government relied on the "integrity" of the newspeople to follow the "voluntary restrictions." However, JUSPAO did reserve the right to suspend an offending journalist's MACV accreditation card for "intentional noncompliance." In fact, the records show that officials suspended accreditation privileges for a variety of causes, few of them for military security. A correspondent with NBC was not accredited because of a "history of mental problems"; a freelancer with AP and the Hearst chain was denied reaccreditation because she was "promisouius [sic]"; one reporter for the *Baltimore Afro-American* was under suspi-

cion for not paying his hotel bill; another freelancer was denied reac-
creditation for borrowing money from the troops and from the Ameri-
can Embassy; a photographer with World Vues was disbarred for selling
photographs of the soldiers to their parents; another man had his ac-
creditation withdrawn because his letter of support was from a nonexis-
tent firm and he "has a rather long police record and is a con man and
pervert"; and, finally, journalists such as Catherine Leroy were only to
be accredited "w/caution" because "she is apprently [sic] very anti-
US."[57] Manipulation of accreditation privileges was a way for the Amer-
ican authorities to control the journalists without recourse to a formal
censorship.

The lack of an *official* censorship put the burden on the correspon-
dents and editors: the press had to judge for itself what information
could be deleterious to military security. As in the two previous
conflicts, numerous public information officers (PIOs) were on duty
twenty-four hours a day to "advise and guide" the journalists "just in
case." PIOs from JUSPAO held the infamous "Five O'Clock Follies"
(which for years actually began at four-fifteen). These daily briefings
were the wire services' and broadcast networks' prime source for the
official version of the political and military status of the conflict, as well
as for the daily war wrap-up—the body counts and all the other statisti-
cal detritus of battle. PIOs also released official photographs and televi-
sion newsfilm during the meetings; in the year roughly following the
marine landing at Danang, for instance, they distributed 641 still pic-
tures and 157 television newsfilms.[58] The JUSPAO briefings attracted
over a hundred members of the press a day at the height of the fighting;
most of the journalists attending were either political correspondents
covering events in the capital or reporters who never dared stray from
Saigon. Those writers and photographers with alternate sources of in-
formation rarely visited the JUSPAO follies; most considered the gov-
ernment "floorshow" to have, as photographer Dickey Chapelle com-
plained, "all the authenticity of patent-medicine ads."[59] JUSPAO, as
Michael Herr so neatly phrased it, "had been created to handle press
relations and psychological warfare, and I never met anyone there who
seemed to realize that there was a difference."[60]

Officialdom had another regularized point of intersection with the
civilian press: the armed forces photography units, which took photo-
graphs for internal use within the military establishment and for public
distribution to the media back home. A total of 1,500 soldiers, sailors,
airmen, marines, and Coast Guardsmen served as combat photogra-
phers in Vietnam. Among them were Sergeant Ronald Haeberle, who

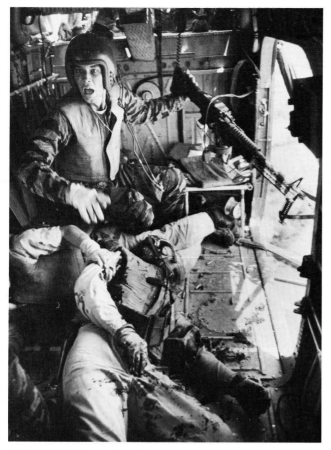

50
Larry Burrows
"In a U.S. copter in thick of fight—
a shouting crew chief,
a dying pilot."
Life, April 16, 1965

LIFE MAGAZINE © *1979 Time Inc.*
LIFE MAGAZINE © *1966 Time Inc.*

51
Larry Burrows
"Under fire. Four Marines
recover the body of
a fifth as their
company comes under
fire near Hill 484."
Life, October 28, 1966

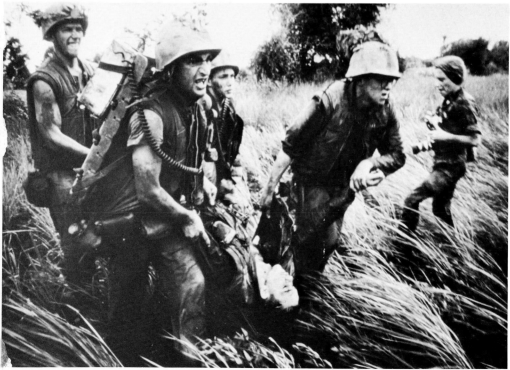

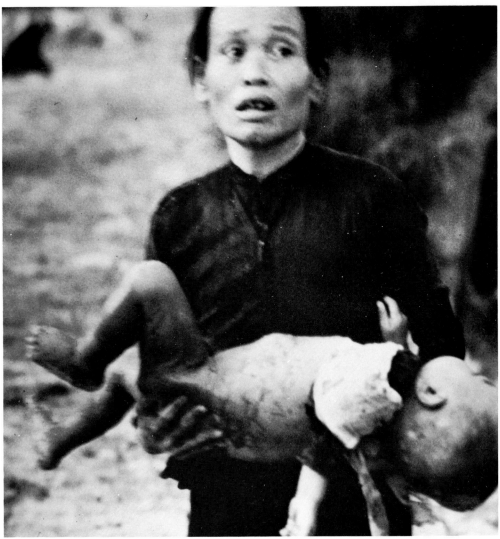

52
Paul Schutzer
"Screaming with terror amid the furious noises
of war, a Vietnamese woman clutches her
blood-drenched child who was wounded when
jets strafed before the landing."
Life, November 26, 1965

53
Malcolm Browne
"An elderly Buddhist monk,
the Rev. Quang Duc,
is engulfed in flames as he burns
himself to death in Saigon, Vietnam,
in protest against persecution."
Philadelphia Inquirer, June 12, 1963

54
Eddie Adams
"GUERILLA DIES: Brig. Gen. Nguyen Ngoc Loan,
national police chief, executes man
identified as a Vietcong terrorist
in Saigon. Man wore civilian dress
and had a pistol."
New York Times, February 2, 1968

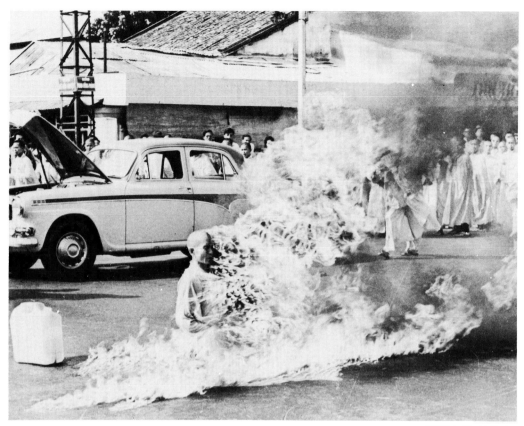

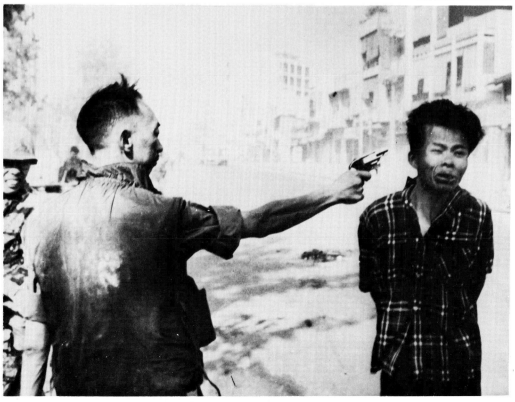

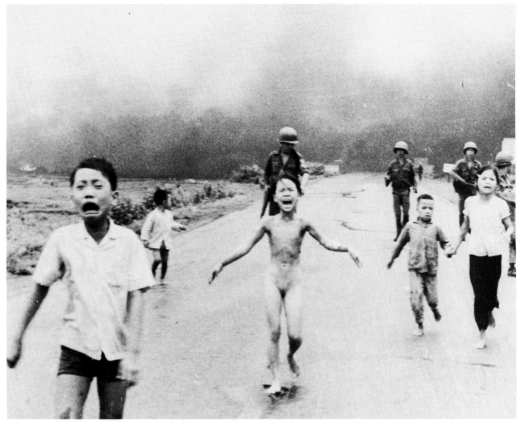

55
Huynh Cong ("Nick") Ut
"ACCIDENTAL NAPALM ATTACK:
South Vietnamese children
and soldiers fleeing Trangbang
on Route 1 after a
South Vietnamese Skyraider
dropped bomb. The girl at center
has torn off burning clothes."
New York Times, June 9, 1972

56
Ronald Haeberle
"Guys were about to shoot these people. . . .
I yelled, 'Hold it' and I shot my pictures.
As I walked away, I heard M16's
open up and from the corner of my eye
I saw bodies falling but I did not
turn to look."
Life, December 5, 1969

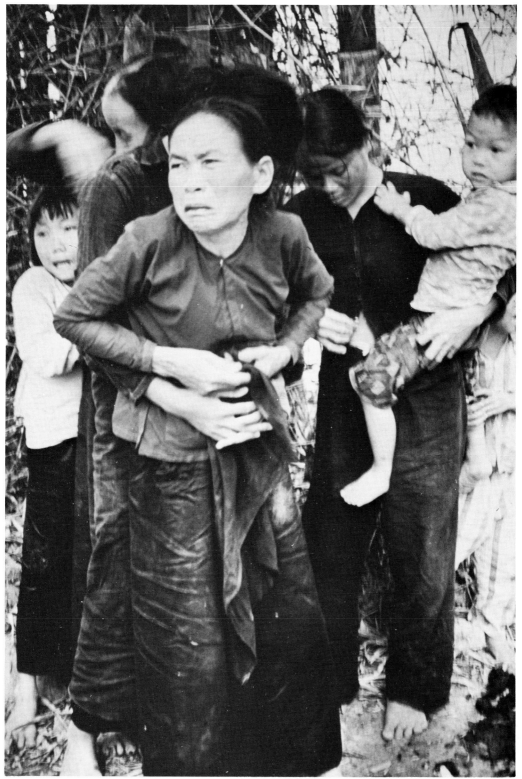

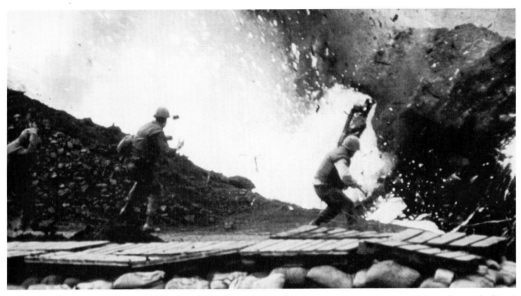

57
Robert Ellison
"Direct hit: As an enemy shell roars into an
ammunition dump, marines dodge exploding rounds."
Newsweek, March 18, 1968

58
Larry Burrows
"At a first-aid center, during Operation Prairie,
a wounded GI reaches out towards a stricken comrade."
Life, February 26, 1971

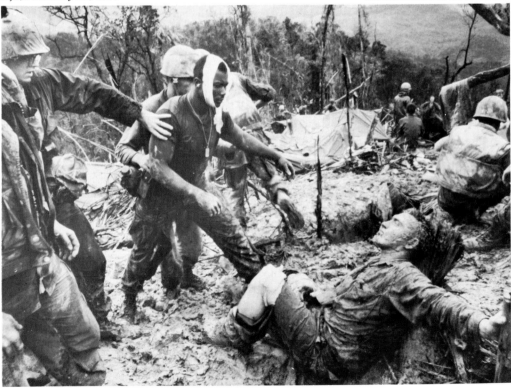

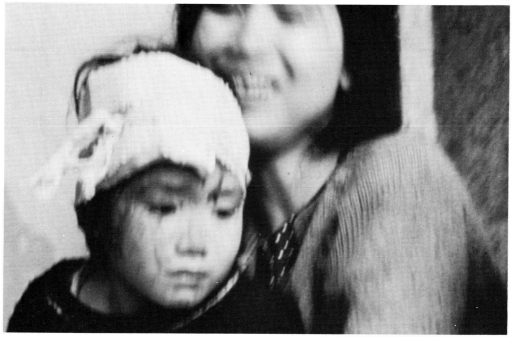

59
Catherine Leroy
"The town was destroyed. I saw thousands of new refugees
with no food, no home, hate in their hearts."
Look, May 14, 1968

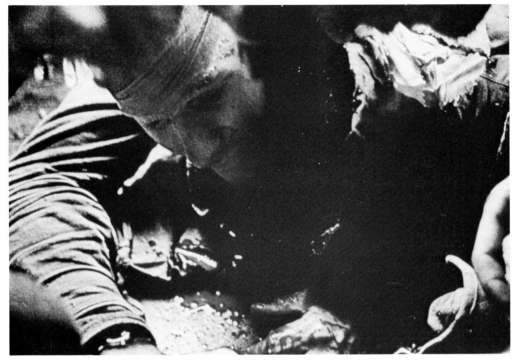

60
Catherine Leroy
" 'I lose men,'
the commander said.
'I lose so many men.' "
Look, May 14, 1968

photographed, on assignment, the massacre at the My Lai 4 hamlet, and Army Specialist 4 John Olson, who won the Overseas Press Club's Robert Capa Award in 1968 for his pictures of the fighting in Hué during the Tet offensive.

"The face of war is ugly," the Department of the Army observed, "but it is a face that must be recorded."[61] Beginning in 1962 with the formation of the Department of the Army Special Photo Service (DASPO), men rotated into Vietnam from Hawaii for three-month tours. At that time, the only operational U.S. pictorial unit in-country was an element of the Signal Corps' 39th Signal Battalion. With the entry of combat troops in 1965, however, the other branches of the service sent their own members to cover the fighting, and as the war increased in intensity, so did the military's photographic coverage of it. By the end of 1967, the army had created the Southeast Asia Pictorial Center (SEAPC), which became the first army facility capable of developing and printing color film in a combat zone. SEAPC, which acted as an in-country DASPO, maintained a central office in Long Binh and operated complete, comprehensive support units in Phu Bai, An Khe, Cam Ranh Bay, Can Tho, and Saigon.[62]

By the mid-sixties, the navy, marine corps, and air force also had photographic operations befitting their responsibilities. The navy, which initially had relied on photographer's mates for the coverage of naval activities, rotated twenty photographers—three or four of whom were still-picture takers—through Vietnam on six-month tours. The marine corps had a similar operation of rotating men through Vietnam on 120-day tours. And the air force, operating both out of Travis Air Force Base in California and the major air fields in Vietnam, organized its combat photographers into such units as the 600th Photo Squadron and the 460th Recon Tech Wing.[63]

The staff of the Marine Corps' *Leatherneck* magazine and the correspondents from the army's *Stars and Stripes* newspaper took some of the best military combat photography to come out of Vietnam. Although these men functioned like their civilian counterparts, while in the field their film belonged to the military and was censored accordingly. Army photographers, who together took as many as 1,000 still photographs a month, sent their film back to the Pentagon for review where some of the images were captioned and released, some classified, and the rest destroyed. The military heavily censored the pictures from these photographers, as well as that film taken by regular servicemen that was developed on U.S. Army bases. Because the official images were a part of the public record, photographs that could be construed

as portraying the military in a "bad light"—even those as seemingly harmless as that of a GI with a cigarette butt hanging from his lip—were either destroyed or portions were obscured. Those pictures taken by the GIs received a similar review; images showing wounds or mutilations, for example, were blacked out.

As had been the case in the previous wars, much of the military's photographic mission was for intelligence gathering or other internal functions. New technology, such as 3-D images taken from jet fighter–reconnaissance planes flying at 400 miles an hour, and infra-red equipment capable of differentiating between normal foliage and camouflage foliage, allowed the air force especially to wage an increasingly sophisticated fight. Ground-level photographers struggled with less sophisticated equipment. As had been true during the earlier conflicts, the military photographers preferred to work with commercial camera equipment, rather than the armed forces' standardized, often clunky equipment, but unlike the Korean War and World War II, the military photographers in Vietnam were actually authorized to use civilian cameras. Robert Moeser, a navy cameraman, enumerated what he carried on assignment.

> After trial and error on the first few trips, I left behind tripods, flashguns, and all of the large and small extras that tend to fill a photographer's camera bags. I pared my equipment down to what I felt was the most dependable and versatile. This included 4 camera bodies: 2 Leica M-2s and 2 Nikon Fs. I always carried at least 4 lenses; 21mm., 35mm., 105mm., and 200mm. With the exception of the color "Navy in Vietnam" exhibit that I worked on, I usually shot only black and white films, having settled on Tri-X after experimenting with most of the popular types.[64]

Moeser's catalog was substantially similar to the equipment carried by the civilian photographers. Adams, Griffiths, Burrows, and Duncan, to name a few, all carried both Leica range finders and Nikon Fs. Most carried four or five lenses, generally choosing among 21, 28, 35, 50, 85, 105, and 200mm lenses. Browne told of using a 2¼-inch format camera on his arrival in Vietnam in 1961, but "discovered that when one is trying to take pictures out of the door of a CH-21 helicopter or the like that you really have to have an eye-level camera."[65] Within two months, he switched to the 35mm format.

The equipment received hard service. Browne recalled that "the AP began furnishing [to their correspondents] bag-loads of cheap Minolta

cameras. . . . Typically each of us would use a Minolta camera—and use it up in about one month and throw it away because it would be full of mud and mold and so forth. The focal plane shutters wouldn't last forever."[66] And Griffiths admitted that he spent most of his time in Vietnam "repairing other people's equipment" that had been gummed up by the dust blown around during helicopter landings.[67]

In addition to the camera bodies and lenses, photographers carried filters (Duncan used a medium yellow for his black-and-white work), spare batteries, cleaning cloths, and occasionally a motor drive, which weighed a significant amount at that time. Some photographers brought along some kind of camera bracket or tripod (Duncan had an aluminum, custom-built unipod camera-clamp). Photographers looked for the fine balance between carrying too much and carrying enough; the outside of the camera-equipment envelope was constantly being stretched. Midway through the war, photographers Tim Page and Sean Flynn even played around with the idea of building a bracket to mount a motor-driven Nikon on the front of an M-16 so when a soldier pulled the trigger of his gun, it would press the shutter of the camera—a "sure-fire" way, they believed, to get photographs of the "moment of death."

The wire-service photographers worked only with black-and-white film; Tri-X was the most common choice. Magazine photographers did some of their shooting in black and white; several, such as Duncan, shot in black and white exclusively. But more and more feature news photographers, especially after the landing of the ground troops in 1965 and the concomitant decision of the American publications to publish expensive war stories using color images, shot Ektachrome and Koda-chrome. Burrows, who was *Life*'s chief photographer of the war, took most of his pictures using Ektachrome. His son explained:

> The reason for the Ektachrome was that he found that by slightly underexposing it, it produced the greens and the browns which were the hallmark colors of Vietnam. You'll notice in a lot of his pictures that tonally the color was quite deliberate. He did use Ko-dachrome—and I wished he had used more Kodachrome because it lasts so much longer, some of the early Vietnam stuff has faded quite badly—but the bulk of it is Ektachrome. And then otherwise it was Tri-X.[68]

The photographers carried massive quantities of film into the field: Duncan might carry over sixty rolls of Tri-X with him on assignment, and Burrows carried so much that he had rolls stuffed into his socks

where "it's handy to get at it there."[69] The argument went that "film is the cheapest part" of getting a story. Occasionally, journalists would run through a lot of film because "if you're under a lot of stress, if you're being shot at, you tend to shoot the camera almost as if it were a gun." Taking pictures "burns time and nervous energy." The wire service and newspaper correspondents took a lot of pictures because "everyone was aware that there was this torrent of photographs coming out of Vietnam, all of them competing against each other and therefore the best thing to do was just to take as many pictures as possible and leave it to the desks in New York to sort them out."[70] And the feature photographers shot a lot of film "to get the composition and pictures [they] had in mind." Burrows, for instance, would take a "number of similar frames" on a roll of film "whether he was in the heat of battle or was taking a picture of the single soldier eating food out of a ration tin."[71]

As they had in the previous wars, correspondents individually outfitted themselves, usually on location in Saigon. Many photographers had safari-type coats made—called "CBS jackets"—with extra-deep, expanding pockets for their camera equipment. Others sported, or wore in addition, bullet-proof vests. Military gear was appropriated in a haphazard fashion; Duncan wore a flier's jacket and others wore Royal Air Force sunglasses, steel helmets, and army steel-soled shoes to protect against punji-stakes (sharp bamboo smeared with feces, hidden along a trail bed). In addition, the journalists secreted around their person binoculars or a telescope, a "subminiature" radio, candles, a flashlight, note pads, extra underwear, a toilet kit, canteens, salt tablets, bug repellent, a knife, rations, and, in Duncan's case, a "deep-sea diver's luminous-dial wrist compass" because "one day I may have wanted to know directions in a hurry—without stopping to inquire the way of those local characters familiar with every nearby jungle path."[72] In this new "jungle" war, many journalists also felt it necessary to carry a gun. Chapelle wrote: "The war in Viet Nam marked the first time in more than twenty years as a war correspondent that I had carried a weapon in the course of my work,"[73] but other photographers, Duncan among them, vehemently refused to carry one.

The working journalists in Vietnam operated under different time constraints. The wire service and newspaper correspondents, such as Adams, had to turn around a story in a couple of days, while magazine photographers, such as Burrows, had the leisure to work on an article for a month to six weeks. "We'd go out to a battle," Adams recalled,

say you'd go to Danang with the Marines, and maybe the operation would be about a couple days or three days or it might be even

longer—but you'd spend a couple days to do the story, you'd then get on a helicopter back to Danang, then back on a plane to Saigon with the film. And once back we'd get drunk and live it up for a couple days—really get smashed. Then you'd hear that there's a good battle going on in the Delta, so you'd get on a plane and go down to the Delta and do that for a couple days, then get back and get drunk all over again, smoke dope. You'd do it because everybody knew that you could get blown away the next day.[74]

Usually, the journalists operated on their own recognizance. "You can't give a foreign correspondent an assignment," Browne noted. "By the time it reaches him it's history." But the wire services and daily papers had, in addition to tight filing deadlines and intense competition with their rivals, a normal routine of stories that had to be covered: "Understand Joe Blow from Kiacock was in a fire fight the other day. Unipress has fullest, how ours please." But for most of the years of the war, "there were no actual policy directives" from the journalists' home offices[75]—which is not to say that the editors and publishers at home had no biases, but, rather, that they generally gave their people in the field a free hand and worried about policy once the reports and pictures came to New York.

Photographers such as Griffiths, who was working on his own, and reporters such as Herr, who had lenient deadlines for Esquire, had even greater control over their actions. "From '65 onwards," Russell Burrows remembered about his father's habits, "it seemed as if the editors in New York and others in general felt that 'he knows more about this than we do. He's now spent three and a bit or four years there.' And so when my father proposed doing stories on different things, most of the time it was 'you do it.' That was the real luxury of working for Life then; they were prepared to let somebody go and work for however long it took." Long memos circulated back and forth, from Hong Kong to New York, detailing and discussing the story concepts of the editors in the States and the ideas of the reporters and photographers in Southeast Asia—which were not always in agreement. Questions ranging from the focus of a piece to whether a story should be covered in black and white or color were freely debated.

To report on the stories of combat took a certain kind of courage and an appreciable level of audacity and simple imprudence. Herr told of one five-day period during the May "Second Wave" in 1968 when eight correspondents died and more than a dozen others were wounded. And still the journalists went out.[76] Not surprisingly, over the course of the

war, photographers and cameramen suffered more casualties than their writer-colleagues. Reporters could write from interviews behind the lines and from official briefings in Saigon. But the visual, picture media had to travel to where the images could be obtained. Official estimates, as of 1971, listed thirty-five foreign (non-Vietnamese) journalists killed, over a hundred wounded, and thirty-five captured (only eleven of whom had been released). Of that number, at least twenty-five of the thirty-five who died were photographers or cameramen, as were eleven of the twenty-four who were missing and presumed dead.[77]

"I tell everyone who can write the same thing," Griffiths said. "I say, 'Look, everybody's worried about Vietnam vets who were soldiers, but actually it's the death rate and the casualties among journalists, especially photographers, who went to Vietnam that's interesting. Not only during the war, but what's happened to them since. . . . There's a whole list of people who never quite got it all together again. That war's affected everybody who went near it.' "[78]

Image and Reality

The Vietnam War photographers labored under fewer technological and logistical constraints than did their earlier colleagues. The 35mm camera was in universal use, lenses ranged from wide angle to extreme telephoto and had fast shutter speeds, both color and black-and-white film could capture a wide latitude of lighting situations, and facilities for covering stories and sending the film or prints back home were unparalleled. Traditional concerns of war photographers did not stop being of importance, rather the improved camera equipment and transportation and communication facilities allowed other issues to become paramount. John Saar, *Life*'s Far East bureau chief, cabled a message to New York after hearing about photographer Larry Burrows's presumed death in a helicopter crash during the Laos invasion in 1971. "As a photographer," Saar believed, Burrows "began where most others stopped—exposure, speed, focus were always reflexively correct, but he worried constantly about composition and most of all, meaning."[79] And in 1968, reviewer Irving Desfor wrote that talent, endurance, and courage alone were insufficient to ensure important images of war. The photographer, he said, must have the "spiritual strength" to meet

"countless tragedies" and to distill out of these occasions compassionate and humane lessons.[80]

But critics of the "interventionist" journalistic approach, such as military historian S.L.A. Marshall, excoriated the press for preferring "a piece that will make people squirm and agonize." "The war," he and others thought, "is being covered primarily for all bleeding hearts."[81] Fundamentally, Marshall objected to the Vietnam War photographers' lack of patriotism and failure to document accurately "how good the chances" were for a "military victory." In the *Life* article that served as Larry Burrows's epitaph, the final words observed: "Larry Burrows looked at war; what he saw was people."[82] What bothered Marshall was that the people pictured in the Vietnam photographs were increasingly shown in a nonheroic fashion; more Americans were photographed dead or wounded or disheartened or simply in an "unmilitary" pose, and more Vietnamese civilians were pictured as injured by American-induced or American-inflicted ravages of war. As Peter Braestrup, in *Big Story*, noted in his tally of those photographs published in the *New York Times*, the *Washington Post*, *Time*, *Newsweek*, and *Life* during the 1968 Tet offensive:

> In terms of content, the photographs, with the exception of *Time's*, exaggerated the same tendency toward the "negative" which was apparent in headlines and stories, even after the beginning of the military upturn in March. . . . Photographs showing U.S. troops "weary or ducking fire" or "wounded or dead" were more numerous than those showing aggressive "U.S. troops—combat," with the New York *Times* and *Newsweek* prominent in this regard. Over a two-month period, the net result, pictorially, was a mosaic of Vietnam in flames and despair, showing the Vietnamese as victims but seldom as fighters, and American troops under pressure (even after that pressure had eased) from a largely unseen enemy striking heavy blows.[83]

More liberal critics of the media's coverage of Vietnam than Marshall or Braestrup have argued the opposite: that the press's reporting of the war was not "negative" enough.[84] "It may be one of the many ironies of Tet coverage," noted analyst Dan Hallin, "that it gave the public a more accurate view of the overall course of the war through the *inaccurate* view it gave of the outcome of the particular battle."[85] These analysts have criticized the media most severely for stubbornly defining the complex international situation in strictly American terms—what

television critic Michael Arlen called "the parochial factor." Even arti-
cles and photographs that centered on the Vietnamese military, politics,
economy, or population, such critics have observed, usually placed
these issues in the context of the difficulties they raised for American
policy.[86] And, moreover, these critics have suggested that the press's
failures in covering the war were not because the press was too gloomy
in its portrayal of the American military situation, but because by not
concentrating enough on the Vietnamese military, political, economic,
and social situation, the press failed to comprehend early enough the
hopelessness of the U.S. strategy.[87]

It is undeniable that the press as a whole, not only the photographers,
focused more thoroughly on military operations than on political is-
sues, on the U.S. forces than on the ARVN troops, and on the individual
GI than on the "Big Picture." The media covered extensively the "set-
piece" stories: the U.S. buildup, the Tet offensive, the seiges at Khe
Sanh and Con Thien, and the war of technology. "But in Viet Nam," as
Browne perceived as early as 1964, "the actual clashes are probably less
important than the subtle thinking of people and the social upheaval of
the nation."[88] With its proclivities for picturesque spectacle and ethno-
centric reporting, the press neglected such important stories as the con-
sequences for North and South Vietnam of defoliation and the bombing
campaign beginning in 1969. Even stories on refugees or urban poverty
tended to emphasize the drama of people living in graveyards or drain-
pipes over a broader analysis of the situation. It is ironic, considering
the media's relative neglect of the social consequences of the conflict
and the historical changes during the war, that more attention has been
given to those prominent critics, such as Marshall and Braestrup, who
have lambasted the press primarily for its distortion of the "military
outcome" of the fighting. For, although the press's immediate coverage
and later analysis of an event such as Tet did leave something to be
desired, statistical military victory in Vietnam was never the crucial
issue. The military effort was meaningless without considering the po-
litical, social, and economic conditions in Vietnam—the understanding
of which was so roundly overlooked by Westmoreland and the Wash-
ington strategists even more than by the press.

If the writers and photographers did not cover all that could be cov-
ered, if they focused on Americans, on combat, on tragedy, and on vic-
tims, at least the photographers tried to do well what they did best:
communicate to their readers and viewers the (no doubt narrow) range
of emotions of the people in those situations on which the press did
concentrate. Ralph Graves, the managing editor of *Life*, wrote of Bur-

rows that "he was more concerned with people than with issues. . . .
'He ran terrible risks because he was a perfectionist and he had to take
the risks to get perfect pictures—the only kind he found satisfac-
tory.' "[89] "It's not easy to take a shot of a man crying, as though you
have no thoughts, no feelings as to his sufferings," admitted Burrows.[90]
"When I see people suffer I feel I'm intruding on their innermost
feelings. . . . But I'm trying to show other people what is happening here
in Vietnam, to make them aware that they are lucky to be where they
are. People here do suffer and if I can convey that in photographs, then
I've made a point."[91] If the press failed to report adequately on the politi-
cal situation in Vietnam, it did not ignore the politics of the war; photog-
raphers treated the Vietnam War as much more of a political and social
issue than the photographers of previous wars ever treated their con-
flicts. Photographers did trade a single-minded concern with reproduc-
ing the "reality" of combat for also including insights into the personal
emotions and attitudes of the individual GI or Vietnamese peasant.

These insights were prompted by the fact that there was no way for
the journalists to escape responsibility for what they saw—and in Viet-
nam, "what one saw" was less likely than in earlier wars to be some-
thing that a journalist could unequivocally support. As Herr said of one
photographer: "I'll never forget what he looked like, that front-line face,
he never got anything on film that he didn't get on himself, after three
years he'd turned into the thing he came to photograph."[92] It may be
true that, as people in some Third World countries believe, a subject
can lose his soul when a photographer takes his picture. What seems to
be more certain is that war photographers can lose theirs.

Photographers and correspondents differed as to the extent of their
acceptance of the responsibility—and guilt—for taking images, for their
intrusion into another person's life—and death. Don McCullin argued:
"People think that because a person has been killed he's no longer use-
ful He's useful to say look what's happened to this young man to this
child Should we stand for this? Can we tolerate this? Is anyone
taking any notice?"[93] Yet other journalists wondered what kind of mo-
rality allowed a photographer to circle a body looking for the best angle.
"There's no way around it," agonized Herr. "If you photographed a
dead Marine with a poncho over his face and got something for it, you
were some kind of parasite. But what were you if you pulled the poncho
back first to make a better shot, and did that in front of his friends?
Some other kind of parasite, I suppose. Then what were you if you stood
there watching it, making a note to remember it later in case you might
want to use it?"[94] In a war without an official censorship, the photojour-

nalists had a greater responsibility for and a greater latitude in shooting images. They set their own limits.

As a result, the soldiers' attitudes toward the photographers were mixed: sometimes the troops wanted to help the journalists tell the "true" story, sometimes the soldiers believed the photographers were parasites and war profiteers, and sometimes even the men got tangled up in the media-movie–madness and wanted to "see themselves in pictures." "If you're with a group of soldiers," said Griffiths, "and somebody gets killed or hurt, while then it's okay [to take photographs] because you've been with them all the time. But imagine the situation where there's been a firefight and there's guys lying there wounded and you fly in with the medevac and you jump out like a bolt and start shooting. Of course they're going to resent you. . . . The sixty-four thousand dollar question," he continued,

> is what would you do as a photographer if it had to be a choice . . . take a picture or carry the stretcher? . . . There are obviously people who say take the picture. My attitude is if you're the kind of photographer who would answer that way, then the picture you take probably won't be any good anyway. My answer is you carry the stretcher. (Of course, you could learn how to carry a stretcher and take pictures with the other hand!) . . . Your humanity has to take precedence over anything else—because why are you taking pictures? . . . There has to be a moral basis to one's actions. There are photographers who really believe wars and strife happen in order to provide them with photo-opportunities to further their careers and win awards. Those kind of people would never dream of helping anyone until the picture was safely in the can.[95]

The photographers' attitude about news reporting led directly to their approach to their own roles as witnesses and recorders. But at issue in that $64,000 question was rarely the good that a single actor could do in a given situation. "The extent to which a photographer can do much about an unfolding situation is generally pretty limited," noted Browne. "There are certainly instances where lots of correspondents and photographers have gone out and tried to drag people to safety," he conceded, in discussing his thoughts about his picture of the burning monk, taken June 11, 1963 (figure 53).

> And that's particularly true in the case of combat casualties. But suicide is another matter. I must say that during the monk episode,

I had no impulse to try to go in and save him. I knew for one thing that he had intended it this way. The Ngo family argued afterwards, Mme. Nhu did in particular, that I had even paid them to set the fire. The main point she was trying to make was that this was a conspiracy on the part of all the monks and that this poor old guy was drugged and didn't know what he was doing—that they led him out and did the whole thing to him. I was standing 20 or 25 feet away from him and knew that that was not the case. It was entirely voluntary. Including lighting the fire. He did it himself. I wouldn't have thought of intervening in a case like that. In fact, in practical terms, I probably couldn't have anyway, because the monks wouldn't have allowed me to do it.[96]

Military cameraman Ron Haeberle did not intervene in the events surrounding his pictures either. But, in contrast to the veteran civilian reporter Browne, he did not do so more because he felt helpless and uncertain about the nature of combat in Vietnam than because of any conscious professionalism. The operation at My Lai 4 on March 16, 1968, was Haeberle's first big combat action, and he had been told there would be no one in the hamlet but Viet Cong. To rationalize the actions of C Company, he said, "You hear a lot of stories about little kids carrying grenades, kids who are booby trapped, stuff like that."[97] In his description of that day, which appeared almost two years later in the December 5, 1969, issue of Life, Haeberle described the situation behind one of his most famous photographs, the image of a group of terrified women protectively huddling over their children (figure 56). "Guys were about to shoot these people," he recalled. "I yelled, 'Hold it' and I shot my pictures. As I walked away, I heard M16's open up and from the corner of my eye I saw bodies falling but I did not turn to look."[98]

For Eddie Adams, the event of the South Vietnamese general shooting a prisoner passed so quickly that he literally had no time to think (figure 54). One day during the Tet offensive, in early February 1968, he remembered,

NBC heard about a battle taking place in Cholon, the Chinese section of Saigon. Vietcong were inside a Buddhist temple, using that as a cover to shoot out into the street and into the South Vietnamese soldiers and police. A small minor battle was going on. So the NBC crew came over [to the next-door AP offices] . . . and said "Anyone want to come?" And I said, "Why not?" So we drove up into the area, parked our car a few blocks away from where we heard

the shooting, walked over there, took pictures or did whatever we did of the battle.... As we walked back towards the car, we saw that the South Vietnamese had just grabbed this guy.... We saw them walking him down the street. And so like any newsman, we followed up on the story; we continued photographing [the prisoner] in case somebody were to take a swing at him or he fell or whatever. So we just followed them down to the corner where they stopped for a minute, and ... some guy walked over—we didn't know who he was—and ... pulled a pistol out. As soon as he went for his pistol I raised the camera thinking he was going to threaten him. I took a picture. That was the instant he shot him. I had no idea it was going to happen. He put the pistol back in his pocket and walked over to [us] and said, "He killed many of my men and many of your people." And walked away.[99]

Fortunately, for most journalists, the question of participation is rarely so absolute; if intervention is possible and desirable, there is often a moment available for shooting a quick picture if not for taking an entire roll of images. At issue, more frequently, in this classic conundrum of choices is the intent of the photographer and the role of his or her pictures. The original formulation of the question begins with the premise that direct, "hands-on" action to aid one victim is preferable to the more remote, yet wider effect of a published photograph. The question opposes presumably "callous" detachment with "compassionate" intervention. But stated another way, the dilemma has greater applicability, even validity: Should photographs and captions and text and television film merely report the facts, or should they offer a commentary, proffer an analysis, and suggest a moral perspective? Should photographers and their photographs be "involved"? During the Vietnam War, feature writers and photographers and the daily newspeople—those working on quick deadlines for the wire services or daily papers—split over the latter question. Griffiths, for example, and a few of his colleagues—perhaps Don McCullin, Marc Riboud, and Catherine Leroy—took "advocacy" photographs. "Being cynical and questioning is absolutely essential to being civilized," said Griffiths. "I've always felt that taking pictures without content is analogous to learning scales on the piano. If you actually want to play music you have to go beyond that."[100] Yet Peter Arnett, a correspondent for AP, believed his role to be more properly someone who just dealt in facts. Arnett told of going out on assignment with UPI reporter Sheehan: "We took pictures of those burning buildings, we told of the civilian dead and how they died,

but we didn't make judgements because we were witnesses, and, like witnesses to robbery, accident, or murder, surely it was not for us to be judge and jury."[101]

But the question remains as to whether the photographers' intent made an appreciable difference to the reception of their images. The individual photographs, as well as the photographic essays published during the Vietnam conflict, were not representative of the war; the images overemphasized some aspects of the war and minimized others. And most of these photographs, taken both by breaking-news and feature correspondents, were nondescript images of no particular persuasion. They were not remembered; they had little effect. But what was and has been remembered are certain "atrocity" pictures: photographs of the dead, wounded, and bereaved. These became and have become reference points for thinking about Vietnam. These images, such as Browne's burning monk, Adams's Tet execution, and Haeberle's My Lai villagers, overwhelmed the photographer's intent and willy-nilly defined as well as described the conflict. In the media and in the memory, photography, intentionally or not, selectively paraphrased the war.

And Why

A new generation of correspondents came of age during the Vietnam War. Older journalists wandered through the conflict, often on special assignments for prestigious magazines. And some of the younger men had experience in other wars: in Korea as soldiers or in the Congo or Angola as reporters and photographers. But ten years had elapsed between Vietnam and the previous American engagement, time enough for old ways and aesthetics to pass out of date and for new styles and approaches to be on the ascendancy. In the early days, a pragmatic idealism, inspired by some of the correspondents' coverage of the civil rights movement, and a youthful conviction that "the times they are a-changin' " led the Vietnam-era journalists to reject the reportage— and the reporters—of the previous wars. "Joseph Alsop and others like him," wrote one correspondent, "were regarded as absurd old men still trying to recount the valiant victories of World War II. 'Who the fuck's he think he is?' the Marines asked."[102] And Malcolm Browne noted,

> Many of us, in retrospect, came to have a certain measure of contempt for our predecessors in World War II and Korea for the fact

that they were all show. Essentially, it wasn't to cover news that so many of them were eager to be on the "first wave," it was in order to live up to the Richard Harding Davis image of the proper foreign correspondent—pistol on his belt, bush hat and all the rest of it. We believed in workmanship rather than show. None of us in those days dreamed of things like Pulitzer prizes—and I think Pulitzer prizes poisoned the atmosphere later. I think when big prizes are at stake it produces the kind of nonsense that produces bad news.[103]

Prizes created the very kind of "stars" against whom the younger journalists, committed to "workmanship," were reacting—those stars who had an investment in portraying the conflict in accordance not with the undistorted facts but with their past reputations.

Of course, a sizable number of correspondents turned up in Saigon less because they were inspired by a commitment to excellence than because they were seduced by the war, by the drugs, and by the thrilling potential of becoming "rich and famous." "Some of the press corps," believed Eddie Adams, "were real assholes. . . . You had a lot of adventure seekers, little rich kids who had never taken a picture in their lives, and writers the same way."[104] UPI even advertised for them. In one American photography magazine, an article quoted the UPI photography bureau chief as saying: "If you're young and hungry and want to get rich and famous then Vietnam is the place to be." And UPI wrote back to all inquirers to "stop by the bureau 'when you get to Saigon.' " (In reality, only one of the four UPI photographers killed in the war made more than $200 a week, and he—a Pulitzer winner—made only $225.)[105]

UPI correspondent Perry Deane Young acknowledged that in a war "almost devoid of glamour (dear God, have we come to the point where a face like Martha Raye's is the best that can be found to inspire our troops to battle?)" these swashbuckler do-or-die journalists supplied "a sort of mock romance in the only war we had."[106] Griffiths told of being in combat once with another photographer who during the fighting had become "hardly recognizable." He had "*come alive.* He was Rudolph Nureyev: he didn't walk anymore, he danced. He leapt like some gazelle in and out of the tanks and the bullets flying around. His eyes were glazed; he was alive. I," confessed Griffiths, "was shit-scared."[107] Herr referred to the antics of the crazed Tim Page, and Young wrote of the intrepid Dana Stone and the movie-starish Sean Flynn. Although some journalists found the actions of these photographers (for some reason,

it seemed that more of the outrageous correspondents were photographers) to be "obscene," other correspondents could admit that "even those of us who never shared the all-American fascination with weapons of death got a certain charge from being with those who did. We were heirs to the tradition of war, and war still meant finding the personal courage to edge right up to death while staying calm."[108]

Fewer writers, but most photographers, had to leave the safety of the Saigon cafés to go out into that danger to get stories. To record a napalm drop, an officer recalled, Burrows "conned the T-28 pilot into flying so low that we actually went through part of that fireball after he made his picture." "Larry," mused *Life* correspondent David Snell, "is either the bravest man I ever knew—or the most nearsighted."[109] Burrows, as well as the more devil-may-care Page, Stone, and Flynn, were too close to the realities of the war to be unaware of the hazards. Sadly, Burrows, Stone, and Flynn all died in the war, and Page was seriously injured on several occasions. But they had not been oblivious to the dangers. Burrows responded to the question of why he continued to take chances: "Someone once suggested that maybe I had a death wish. But I certainly don't want to die and I cannot afford the luxury of thinking about what could happen to me."[110] And Stone wrote to his parents in 1967, three years before he was declared missing in action: "I'm not sure whether or not I'm finished in Vietnam—it looks as though the war will last a while, a long while, but I'm not sure that I would, and the risks were getting way out of proportion to the gains. I seemed to be getting the same pictures that I had made many times before and as I became more accustomed to the war what had initially been interesting and exciting became dull and frightening."[111]

Many of the "hard-core" journalists who were most concerned with "workmanship" and who furnished "99 percent of the important news and photography"[112] had come to the war and stayed "glued to the place" for similar reasons: they "wanted to go and *see*."[113] "I went to cover the war," Herr wrote, "and the war covered me. . . . I went there behind the crude but serious belief that you had to be able to look at anything, serious because I acted on it and went, crude because I didn't know, it took the war to teach it, that you were as responsible for everything you saw as you were for everything you did."[114] Larry Burrows wrote before his death: "When my lips go dry and my stomach turns over I feel, should I be doing this? But then I feel, if I don't, what am I missing? There is always this urge to go have a look and see what is happening, to my left, to my right, further forward. I can't resist it." And Burrows granted the importance of sharing the danger of the men he

was photographing: "The best thing that happens—and this is important to me—is when someone turns round and says, 'Well, you've taken your chances with the rest of us.' "[115] Or, as Herr put it, "All right, yes, it had been a groove being a war correspondent, hanging out with the Grunts and getting close to the war. . . . Every where I'd gone, there had always been Marines or soldiers who would tell me . . . *you got balls.*"[116]

Few journalists remained in Vietnam long. Those who stayed in Saigon found the war confusing and the post remote, while those who went out in the field tired of the pace and the danger. AP, for instance, ran through 300 Saigon reporters over the course of the conflict. Many of the correspondents who did "time" in Vietnam merely visited the war for several weeks on their way to Singapore, Hong Kong, or Tokyo, and most of the others stayed in-country only a couple of months or at most a year. Even at that, newsmagazine journalists received a week's paid vacation for every 10 weeks in the war, and television correspondents for every 6 weeks. Journalists such as Arnett, who arrived in Vietnam in 1962 and left 13 years later; Browne, who lived in and out of Vietnam from 1961 to 1975; and Burrows, who covered Vietnam from 1962 until his death in 1971, were the exceptions.

The ones who stayed were often those, like Browne, who were "emotionally involved up to our necks."[117] (Browne is married to a Vietnamese woman.) "At any given moment," agreed Tim Page, "you were never a bystander, you had to be involved, be it a 21mm [camera lens] a foot off a tortured man's face, or 300mm dissecting a city block disintegrating."[118] To an increasing extent as the war progressed, being involved meant coming to an understanding of what the war was doing to the Vietnamese people. "All over Vietnam you see the faces," wrote Burrows in an article that appeared in September 1969, "more inscrutable and more tired now than I have ever known them to be. . . . They are in the middle. The pressure on them is terrible and has existed for some 30 years."[119]

During World War II, the press celebrated the American democratic cause by reaching down to embrace the common GI. Columnist Ernie Pyle and photographer Robert Capa both emphasized the exploits of the individual soldier. In Vietnam, however, the fight for democracy was enlarged by the media to include the Vietnamese civilians. During the Vietnam War, there came a broadening of the narrow focus of World War II and the Korean War. Photographers still took close-up portraits of the troops at their most vulnerable, but since it had been technologically proven that the camera could document the features of a single soldier even in the midst of combat, photographers' lenses turned to-

ward investigating—in depth—the context in which that soldier stood. The emphasis of the media's reportage was still on the American GI, but a quantitative step had been taken, simply by trying to look at the American effort through a serious portrayal of its impact on another country and its people. By so investigating the war, the media helped to reveal the failures of the U.S. ideology and strategy. The press, even though it failed to analyze the Vietnamese people and country outside their intersection with American policy, still aided in exposing American (and the media's own) ethnocentrism. Photographs of war no longer reflexively affirmed what was possible at the best of times; instead, they confirmed what had happened at the worst of times. Photography of the Vietnam War exhausted belief in American exceptionalism.

At this late date in the twentieth century, few of the photographers had many illusions about their images putting an end to war. Some had simple goals. David Douglas Duncan, flown in to cover the siege at Con Thien for *Life*, looked "on [his] story as a letter to the families and friends of the men of the Third Battalion, 9th Regiment, 3rd Marine Division. . . . Perhaps my pictures will add meaning to the letters the men themselves write home."[120] Other journalists had larger ambitions, validated by the new, observable power of the media—whether they considered the power to be for good or for ill.[121] Perhaps better than anyone else, Eddie Adams, by virtue of his photograph of South Vietnamese General Loan executing a Viet Cong prisoner, had come to an understanding of the potential effect of even a single photograph. Over a decade after the war, he spoke not only about the pain and frustration but also about the joy and satisfaction of photographing "anything really rough." "War and refugee camps and people dying and suffering," he said, "you can only handle so much of it. . . . It gets to the point where you go out on these stories and you cry so much. A lot of people don't know, but it takes a lot to do this. You can't really help; at best you can take pictures of them."

"I got to the point," Adams continued, "where I was just tired of crying. . . . I just couldn't take it any more. And that's why I started doing this." He swept his arm to indicate the wall of his studio where five exquisitely composed, color-glossy portraits hang. The faces of Ronald Reagan, Fidel Castro, Jerry Lewis, Clint Eastwood, and Lee Marvin stared back at him. "But now just recently I was thinking that I have to go back and do some of the other stuff again. These people," he gestured, "take nothing out of here," and he pointed to his heart. "But it's fun because these people made it, who really gives a shit, I'm making money. The other people I don't make any money with. But they're the

ones who are important. I mean to me. These people," he gestured again to the wall, "aren't important to me. . . . My pictures aren't going to help these people. They don't need pictures. . . . But the other people. . . ."

"I know the power of a still picture. I *know* what it can do. And if a picture can help somebody some way or another . . . that's pretty good. And to me it's important. Look, I'm not out to save any world. I never was. But I do know what a picture can do."[122]

15

The Photographs:

A Subversion through

Exposure

The Publications

FOR MANY IN THE UNITED STATES, the war in Vietnam started when the combat in Southeast Asia reached into American "living rooms," when, as Assistant Secretary of Defense for Public Affairs Arthur Sylvester noted, the media "spilled the blood on the rug, so to speak."[1] On February 27, 1962, the Associated Press transmitted its first Saigon news photograph by radio. Taken by Yuichi ("Jackson") Ishizaki, the picture portrayed an attack on Diem's presidential palace during an abortive coup.[2] Eleven months later, on January 25, 1963, *Life* ran an early cover story on Vietnam; the headline inside announced: "We Wade Deeper into Jungle War." Covered by Larry Burrows, the story was the first incidence of a war being "thoroughly and satisfactorily photographed in color."[3] Then, in September of 1963, first CBS and then NBC doubled the length of their nightly news programs from fifteen minutes to half an hour; television began to investigate war within the regularized format of the evening news two months before the fall of Diem.

During the previous four conflicts, the press's attention to matters of war, while not always welcomed, had not been a matter of fear and

loathing by the government and the military; the press had worked (or been forced to work) reasonably well in concert with them to further the American war effort as the officials had defined it. But Vietnam was to become a war in which the dominant opinion makers considered the media to be an outright adversary; the persistent conflict extended from the days of the Kennedy administration to those of the Nixon White House.

The highlights of the battle have entered media lore. In October of 1963, President John Kennedy, in a meeting with the new publisher of the *New York Times*, Arthur Ochs Sulzberger, suggested that David Halberstam, the *Times* correspondent in Saigon, be transferred. Sulzberger not only refused but even cancelled Halberstam's upcoming vacation to avoid any appearance that the *Times* might have been swayed by the president's dislike of Halberstam's "lugubrious" reports.[4] Two years later, in August 1965, CBS's Morley Safer enraged the military and the Johnson administration by showing footage of U.S. marines burning the thatched roofs of the village of Cam Ne with Zippo cigarette lighters. Although similar reports had been routinely documented in the print media, the visual effect of the television coverage so irritated LBJ that he is said to have woken up Frank Stanton, president of CBS News, with the demand "Are you trying to fuck me?"[5] Then, in 1968, Walter Cronkite, after returning from an inspection of Vietnam during the Tet offensive, declared live on television that the war was a "bloody stalemate," and Hedley Donovan, the editor-in-chief of Time-Life, approved a Tet article that ended: "the fate of Hué demonstrated the sickening irony into which the war has fallen—the destruction of the very things that the U.S. is there to save."[6] (Although no one has ever satisfactorily explained exactly what the United States wanted to "save" in Vietnam—Americans were always more interested in creating a new Vietnam than in saving the old one.) Johnson credited the turning of both Cronkite and Donovan with costing him the war. And finally, in 1971, the *New York Times* published the classified Pentagon Papers, which prompted the Supreme Court's support of the press against the Nixon White House, and with that, a complete reexamination of American policy in Southeast Asia.

While these legendary battles that have gained so much attention present the media as a monolithic entity, in reality there existed a serious split between the correspondents and the institutions for which they worked. Most press people were severely handicapped by their employers. Few of the publications and press outlets in the United States "turned" as early as did most of the resident correspondents; it

was well known that the editors, publishers, and producers back home were significantly more conservative and cautious than their journalists in the field. Arthur Sylvester, in a notorious, informal meeting with the press in 1965, acknowledged as much when he taunted the Vietnam correspondents with the comment: "Look, I don't even have to talk to you people. I know how to deal with you through your editors and publishers back in the States."[7] The journalists themselves knew it. In a roundtable discussion on National Educational Television in 1966, Malcolm Browne argued that the "pre-conceived notions that editorial staffs have of what things are here are distorting the picture."[8] And Michael Herr told of another reporter who "loved to call his New York superiors 'those leg motherf——ers,' taking it from the Airborne term for anyone who was not jump-qualified."[9]

To obtain its news of the war, the American audience had few distinct alternatives. Only two wire services, three networks, two national newsmagazines, two national news-photograph magazines, and a handful of newspapers maintained any reporting staff in Saigon. (The New York Times and the Washington Post were the only newspapers to make a substantial commitment of resources, although the Times staff during Tet, for instance, was four times larger than that of the Post.) And of these outlets, several were operated or controlled by the same owner or family: Henry Luce, of Time and Life, and the Meyer family, of the Washington Post and Newsweek.[10] All these institutions were members of the establishment media, most of which, especially in the early days of the war, allowed themselves to be guided more by White House spokespeople than by their own correspondents in Vietnam.

The upper echelons of these media institutions cramped the correspondents' photographic reportage and restricted the journalists' writing (including captions) and interpretation of events. Optimistic—or politically conservative—senior editors back in the United States altered and killed stories that criticized the establishment opinion. Time and Life were especially zealous in their flag-waving, but editorial comment in other national periodicals also overwhelmingly supported the administration's policy on Vietnam until well into the 1960s, even after internal dissension had broken out within the government. As late as 1970 and beyond, news outlets censored their reporters in-country; Peter Arnett revealed that the AP had killed his story and pictures of the American troops' looting and arson during the Cambodian invasion out of fear that the publication of such information might further inflame the campuses in the wake of the deaths at Kent State and Jackson State universities.[11]

It took a long time for the editors in the home offices to come around to the opinions of their correspondents in the field, but the political dichotomy between the two groups did not matter quite as much at the picture magazines of *Life* and *Look* as it did at the wire services or at *Newsweek* or *Time*. *Life* and *Look*, after all, relied on their photographs, which the editors had to take or leave; editors could not easily make a photo-essay say the very opposite of what the negatives had pictured, as occasionally happened with the prose stories filed by reporters. Words had a much greater chance of being manipulated at every step in the process. Reporters Charles Mohr and Mert Perry of *Time*, for instance, resigned in protest over the egregious news management of editor Otto Fuerbringer. In two separate articles in the September 20, 1963, issue of *Time*, Fuerbringer changed the Saigon writers' filed stories to read the opposite of what they had said.[12] Although especially "subversive" or "graphic" images never saw the light of day, or were published well after the fact when editorial attitudes had changed (for example, in 1962, Dickey Chapelle photographed an execution similar to the one later immortalized by Eddie Adams in 1968 but the image appeared only in one obscure periodical[13]), *Life* and *Look* had a tendency to go with their strongest photographs and then to attempt to modify the photo-essay's "statement" by contrasting it with more upbeat articles, editorials, and news analyses.[14] This is not to say, however, that the photographs as published in these magazines were the reflection solely of their photographers. Indeed, the importance of editorial decisions in the makeup and layout of a photo-essay cannot be overstated.

Yet, in comparison to the wire-service photographers who complained about the internal censorship of their photographs, the photojournalists at *Life*, including Larry Burrows, Carl Mydans, and David Douglas Duncan, rarely thought their images were seriously misused.[15] Perhaps because of their own centrist politics, the big-name staff photographers still felt themselves to be, even in the sixties, part of a family. And their complaints, when they had any, related primarily to the amount of space given their photo-essays, rather than to the political slant that the editors imposed on them. Russell Burrows recalled his father's reactions to the publication of his pieces. "There were many occasions where he would rant and rave and pace back and forth, because he was quite unhappy with the layouts. . . . He would sit down and write a letter of complaints to the editor or art director. And my mother would say 'Why don't you leave it until tomorrow?' The next day it might get written again but in a toned-down version, and by the third day it was 'I wish we had a couple more pages.' "

THE PHOTOGRAPHS: A SUBVERSION THROUGH EXPOSURE

Even for the "essentially mild-mannered" Burrows, however, more substantive disagreements did arise. "It was great thing to have a cover of *Life*," his son reminisced,

> but there were a couple of pictures that he had on the cover that were embarrassing to him. There was one of a patrol boat in the Delta which is essentially a picture of a flag draped across the stern with the wake of the boat behind it. It's more like a recruitment picture. It was a picture that he obviously took knowingly . . . but the story as it appeared was too patriotic, jingoistic for his liking.
>
> But in general, his complaints, I should say, when it came to layout, were photographic complaints as opposed to political ones.
>
> The only story on which there was ever any major crisis of that type was the one which was called "A Degree of Disillusionment" which ran in September of '69. . . . The text went back and forth . . . and it ended with *Life* watering it down verbally. . . . But whether it was watered down photographically, I'm not sure. Because of the type of story it was—noncombat—there aren't pictures that you could say, "Oh hey, there's a great picture that they made a mistake by leaving out." The pictures that were left out were more pictures of the same.[16]

At both *Time* and *Life*, the editorial policy on Vietnam revolved around the issue of Communist China. Henry Luce never really recognized its existence; Chiang Kai-shek never fell from grace in the pages of *Time* and *Life*. When Donovan inherited Time, Inc., as editor-in-chief in 1964, he inherited Luce's China policy as well. While Donovan was no hero-worshipper of Chiang as Luce was, for Donovan's first few years of tenure there was still no question of changing editorial policy. Donovan, too, was an early supporter of the war who believed that China was the aggressor in Vietnam and that the situation was analogous to Munich. To Donovan, like to Luce earlier, the idea of helping Vietnam to help itself, by using American combat troops, was pragmatic. And as long as he viewed China as actively hostile to American commitments and interests in Vietnam and Southeast Asia, Donovan had no interest in revising Time-Life's Asian policy. It was only in 1967, when the costs of the Vietnam War were beginning to loom too large and the promises of victory were starting to appear so slim, that Donovan slowly began to shift his editorial policy on Asia. The center itself was beginning to move—for pragmatic and moral reasons. The price of the war was becoming too great to pay for the dubious benefits of its uncertain goals.

By early 1968, Donovan and *Time* and *Life* began to call for a reappraisal of American policy. And by 1969, Time, Inc., had drifted away from the official government line. As President Johnson observed, it was one critical indication of middle America's shift in attitude toward the war.

Partly because their politics were to the right of much of the artistic community and partly because they had already been around for decades, the mass-market conservative publications, such as *Time*, *Newsweek*, and, to a lesser extent, *Life* and *Look*, were no longer on the aesthetic cutting edge of war photography, as they had been in previous conflicts. Rather than setting trends during this war, combat imagery in the periodical press borrowed heavily from other sources. Television and the art photography "snapshot" movement, especially, inspired the new style; the seemingly random, alienated images captured by television and the snapshot movement mirrored what appeared to be the alienating, haphazard nature of the war. Recognizing the power and appropriateness of this aesthetic, *Life* and *Look* seized on the new imagery and incorporated it into their own reportage of the war.

However, the newsmagazines did make a major aesthetic contribution to the telling of the Vietnam conflict: their early and ubiquitous use of color photography. (Both television cameramen and the proponents of snapshot imagery shot primarily in black and white.) In 1963, *Life* exulted in the editors' note to its first color combat story: "back came this week's pictures showing, as only color can, the blood and mud and savagery of this war."[17] *Life* tallied up the letters that came into the magazine as a result of that article (including three published responses): 43 percent of the writers were "Concerned and Ashamed" by the war; 28 percent of the readers took "Shots at LIFE"; 6 percent of the letters gave "Kudos" to *Life*; and the final 23 percent offered "Challenges" about certain facts in the story. Several of the letters in the first three categories mentioned the use of color; for some, the color photographs made "adults ever aware of the pathetic hells of war"; for others, however, the use of color was just one more sensationalist ploy by the editors of *Life*: "Leave it to LIFE to have one of her sporting photographers on hand to record this vicious war in Vietnam, and according to the LIFE tradition of always trying to offer the best in journalism, from an artistic angle and in color of course. This issue, like so many before, should certainly be kept from children and adults with a less sadistic constitution than your editors." "Dunno, what this means," scrawled editor Hugh Moffett across the memorandum.[18]

"Clearly," believed Russell Burrows, "one of the reasons the magazines ran pictures in color was because it was now possible—both in

terms of the magazines' closings and because of the new color film."[19] The thrill of color outweighed the expense and lead time, although when Ralph Graves took over as the last editor of the weekly *Life*, one of the costs to be cut was color coverage of the war. By that time, however, photographers had actively debated the pluses and minuses of color versus black and white; more and more of them had come to agree with Edward Weston's pronouncement in 1953: "Those who say that color will eventually replace black-and-white are talking nonsense. The two do not compete with each other. They are different means to different ends."[20] Burrows had strong feelings about whether he should do a story in black and white or color; he believed color gave "far more realism to the beauty and harshness" of the war. And Milt Orshefsky, the *Life* writer-counterpart to Burrows in the Far East, stated that color was good "for the spectacle part—the chopper patterns, the rockets firing etc. and blackwhite for the 'human' part, the emotions, the fatigue, the tension etc."[21]

Throughout the war, the wire services continued to shoot in black and white and to buy negatives from freelancers for $15 a frame (although a photographer would have to sacrifice the two negatives on either side of the desired image because a single 35mm negative was too difficult to handle). Many of the agency photographers felt an even firmer philosophical commitment than did the feature journalists to covering the war in black and white. Eddie Adams, for example, could say: "I think all war should be done in black and white. It's more primitive; color tends to make things look too nice. Makes the jungle in Vietnam look lush—which it was, but it wasn't 'nice.' "[22] And certain other photographers went back and forth in their use of color. Philip Jones Griffiths, for instance, at first shot only black and white for his prospective book, but then, on Magnum's recommendation, shot in color as well. When the book finally appeared, however, it was all in black and white; Griffiths had to convert about 15 percent of the color photographs to black and white, admittedly an uncommon practice.[23]

The newsmagazines, however, flaunted their use of color in an attempt to compete with television.[24] During the war, the data from polls showed that 60 percent of Americans received their war news from television: television had an audience of fifteen to twenty million for some programs; *Life* had half to a third of that. But rather than try to adapt to the presence of television by narrowing their market and making their product more sophisticated and more responsive to reality than was the information on the "tube," *Life* and *Look*, the "picture" magazines, tried to compete in an unwinnable numbers game: numbers

of subscribers versus size of audience. The two magazines plus *Collier's* and the *Saturday Evening Post* tried to show advertisers that the magazine medium was competitive. But to make their periodicals attractive to anywhere near the size of the television market, the magazines had to sell subscriptions so cheaply that their fees ran below cost. In the end, it was the very advertisers that the magazines were attempting to woo who had to eat the losses by paying an inflated price for space. First *Collier's* and the *Saturday Evening Post* folded, and then *Look* and *Life*.

But it is important not to conclude from these failures that the era—and value—of the still picture is over. As the *New York Times* television critic John Corry wrote regarding the Vietnam War,

> Television, despite its huge effort, furnished little that was lasting. The two most enduring anti-war images of Vietnam were conventional still photographs. One showed a group of screaming children fleeing a misplaced napalm strike by South Vietnamese planes. The 9-year-old girl in the middle of the group has torn off her clothes. The other, by Eddie Adams, an Associated Press photographer, showed the chief of the South Vietnamese national police shooting a Vietcong lieutenant in the head with a pistol. Television couldn't match anything like that; its technology worked against it. Images on television move too fast to be digested.[25]

What Corry did not mention was that in both incidents television *did* have the opportunity to match "that"; television cameras caught both these events. And the footage was dramatic. But even when film was able to compete head to head with a still photograph, the still picture remained more insidiously influential. As another commentator argued, writing shortly after the Nick Ut photograph of the napalmed children appeared, "It was the still picture that fixed the image, that called forth the editorials, that will stick in memories. In such moments it is the film that builds the emotional impression, but the still that remains forever. They complement and should not quarrel."[26] Even considering the best of television's coverage, Vietnam did not sound the death knell for the still photograph. Instead, the war proved the enduring power of the silent, frozen image.

The Aesthetics

The first Vietnam War pictures of the American dead came wrapped in the flag and accompanied by a drum roll of patriotism. In the pages of the national press, upright, uniformed men saluted, while other sol-

diers labored under the weight of tidy aluminum coffins shrouded in the Stars and Stripes. The new use of color in the photographs gave a red, white, and blue "zip" to the monochromatic "suntan" khakis and dust of the backgrounds.

That was in 1962. In April, the first American "advisers" had officially fallen in "battle against the Communist Viet Cong."[27] For the next several years, an increasing number of pictures of the American dead began to come back, if only because the number of men who were killed in combat had risen from only a handful in 1962 to 1,600 ten short months after the marines splashed ashore in early March 1965.

In January 1964, a year before the engagement of American ground troops, Larry Burrows, the sole *Life* photographer from New Zealand to India, and Milton Orshefsky, a *Life* reporter also based, like Burrows, in Hong Kong, began planning "another war story in Vietnam." The two men wanted to concentrate on "one chopper company," which would, they felt, allow "a dramatic, candid close-in look at the most photogenic phase of the U.S. commitment in South Vietnam." The proposed "essay-type story," Burrows argued, would differ from what had already been done by the magazine because it would show "the readers how big a part the Americans are playing in this war and how hopeless it would be for the Vietnamese if the U.S. withdrew their help." "All our previous stories," Orshefsky noted, "were so general and Americans brought in so incidentally that I don't really feel they had the impact for an American public that this kind of detailed intimate treatment of a single American outfit could have."[28]

The essay got the go-ahead. Over a year later, in March and April 1965, Burrows, working alone, photographed the story. The crew of helicopter Yankee Papa 13 had been chosen, partly for the "symbolic reasons" of the number thirteen, to be the focus group. "It was meant to be," remembered Burrows's son Russell, "what it was like for those people going through their entire day—'a-day-in-the-life-of'—but photographed over the period of a month or so. Well there are about 120 rolls of film on Yankee Papa. But 17 of the 25 pictures that were published—which is a very large number actually—were taken from 8 rolls of film. The other rolls were never touched. Because what happened on one mission on one day was a story that became in a sense a news story. Although there were a few scene-setting pictures taken from what the whole story was going to be, the rest of them were just taken from that single mission."[29]

That single mission turned out to be a bloody one. The helicopter made three runs to drop off South Vietnamese troops into a suspected

enemy staging area. After dropping off its third quota of ARVN under heavy fire, Yankee Papa 13 went to the aid of Yankee Papa 3. Crew Chief Jim Farley, aged twenty-one, tried to rescue the pilot of Yankee Papa 3, but he was unable to lever him out of his seat. Believing him to be dead from a bullet hole in his neck, and still under severe fire, Farley gave up to get back to his own chopper and airlift out Yankee Papa 3's gunner and co-pilot who were also wounded. (The first pilot was later rescued by another helicopter's crew.) On the way back, in Yankee Papa 13, gunner Wayne Hoilien and Farley tried to attend to the two men's wounds. The wounded gunner of Yankee Papa 3 had a smashed left shoulder, but the pilot had been fatally hit below his armpit and above his flak jacket. "If there was any sound coming from the pilot's mouth," Burrows recalled into a tape recorder a couple of days later,

> it was drowned by the noise of the helicopter. He looked pale and I wondered how long he could hold on. Then blood started to come from the mouth and nose; the boys worked harder. A glazed look came into the eyes and he was dead. . . . I tried to find a way in which to hide the pilot's face when the boys were working on him, feeling that should a photograph be used, it would be hard on the family. Yet it would bring home to many people that this was a war and people were getting killed. It was important to show such a scene and for all to realize that despite the pretty pattern that helicopers [sic] made when flying at 1500 feet, life can be hell.[30]

The centerpiece photograph of the essay—the cover of the magazine—pictured Jim Farley, lit by the open door of the chopper, turning, "aghast," from the body of the dead pilot (figure 50). After the crew landed back in Danang, Farley "cursed that he couldn't have done more" and then moved to a wooden box behind a door and "sprawled and sobbed."[31] The story ended with that final portrait.[32]

Much of the power of the Yankee Papa 13 article came from the inexorable progress of the illustrations. The previous wars' photographs of combat death had pictured men who had died well before the camera had snapped their image; in other pictures, in other essays, the deaths were *faits accomplis*. With the sole possible exception of Robert Capa's last photographs from Leipzig in World War II showing a man in the moments immediately before and after his death (see figure 24), no published pictures from the world wars or Korea brought their readers into the life of the troops and made their viewers watch the day-long, step-by-step events leading to a man's death.

THE PHOTOGRAPHS: A SUBVERSION THROUGH EXPOSURE

But unlike that Capa essay, the Yankee Papa story and the central images of Farley and the dead pilot focused less on co-pilot First Lieutenant James Magel's death than on Farley's rescue; the emphasis was on the emotional distress of the survivor. The "contrasty" light inside Yankee Papa 13 helped harshen Farley's features and emphasized the technological environment of the helicopter and, by extension, the war. The black-and-white photographs are sharp, tense, and evocative pictures of chopper combat. But one side effect of that sharpness and lighting was that the dead pilot became another object within the environment. The sole face that is seen in the cover photograph is Farley's, his expression is the focal point. Only on second look does the reader find the immediate cause of Farley's anguish—and perhaps some of the power of the image comes from the viewer's realization that one could "overlook" a man's death. By directing the readers' eyes to glide over the victim of that battle and focus on the witness, the photographs allow the viewers to identify with Farley, the observer, not with the dead pilot. The audience becomes witness to death through the eyes and emotions of a man who has seen it—but at a cost, however, of the audience's greater identification with the dead man himself.[33]

A year and a half later, in October 1966, *Life* ran a color story entitled "Invasion DMZ Runs into the Marines," and in it was another image (figure 51) of an American combat casualty.[34] Upon seeing the already-cropped layout, Burrows cabled his caption back to New York. "OBVIOUSLY," he noted of the image picturing four marines each grabbing an arm or a leg of a fifth as they ran "under fire," "THE MAN IS DEAD OR ELSE THEY WOULD NOT BE CARRYING HIM THIS WAY.... HAVING MOVED OUT INTO AN OPEN AREA AND APPROACHING A FORTY FOOT HILL WE CAME UNDER NVA FIRE THE POINTMAN RAN TO THE TOP OF THE HILL AND WAS SHOT DEAD (HE IS THE ONE BEING CARRIED IN PIC.) SHORTLY AFTER THIS HAVING RECEIVED THE SOS FROM THE TANKS WE EVACUATED THE ONE DEAD AND THREE WOUNDED."[35] The picture appeared across a page and a third of the October issue. It ran large, yet *Life* cropped out of the right-hand side of the frame (and in subsequent *Life* reprints) the figure of photographer Catherine Leroy with several cameras in hand. *Life* was naturally unwilling to detract from its gritty representation of combat by including mention of another correspondent in a caption or photograph. *Life* (but no more so than the other photomagazines or newspapers) had an investment in making it look as if the photographs of war that the press published every day, every week, or however often were taken by an omniscient observer—and perhaps, by extension, an omni-

scient United States—who did not interfere with the action. Any hint of such interference was excised; for instance, in Burrows's internal report on Yankee Papa, which was used as the basis for his article, his comment that his "presence" on the chopper bumped one of the troops to be ferried was deleted by an editor.[36]

Burrows took both of these photographs of the American dead, one in the Yankee Papa 13 article and the other in the Invasion DMZ story, in the context of combat. Neither glorified war, yet each, by so ably communicating the danger of the situation, made the survivors heroic and the deaths tragic but comprehensible. The men performed their duties, and more, under extreme conditions. The photographs straddled the awkward position of confronting the cause of the deaths, while certifying the cause of the survivors.

Over the next two years, as U.S. ground troops entered the war in increasing numbers, the barely audible voice of protest evident in these two photographs continued—only to be overwhelmed by the louder voice and number of those images that gave a reflexively patriotic portrayal of the American soldiers in combat. *Life* cover stories by photojournalists Henri Huet, Burrows, Co Rentmeester, and David Douglas Duncan; *Look* articles photographed by Thomas Koeniges and James Hansen; and even shorts in *Time* and *Newsweek*, all published up-close, sympathetic images of wounded or stricken soldiers.[37] Duncan's photographs, especially, were exquisitely framed portraits. The mantle of Korea and World War II aesthetics had not yet been lifted; the photographs still featured a tough-edged, war-is-hell-but-it's-dramatic approach. The implication was that the Americans were caught in a dirty war but they were fighting like men. In the cover article that appeared in October 1966, for example, mention was made of the flouting of the DMZ territory by the North Vietnamese. If only the United States had more troops and supplies, *Life* insinuated, we could make the National Liberation Front (NLF) and the North Vietnamese Army (NVA) play fair.[38]

But with the reaction to the Tet offensive in early 1968 and the massive American military commitment to take back Hué and the other territory seized by the NLF and the NVA, this illusion was shattered. Perhaps, just perhaps, it was believed, we can win the war on our own terms. But the terms were becoming well-nigh unacceptable. The underlying doubts about the worth and value of the war, hidden in the Yankee Papa and Invasion DMZ images, surfaced in *Life*'s issue of June 27, 1969, entitled "The Faces of the American Dead in Vietnam: One Week's Toll."

THE PHOTOGRAPHS: A SUBVERSION THROUGH EXPOSURE

By 1969, the American death toll was over 36,000 combat casualties. It was clear by then that Vietnam was a war played by the numbers: the military establishment's way of gauging the vicissitudes of the conflict was in term of statistics. The "new" statistic, the daily body count, was just one figure in a lengthy list of numbers—of engagements, defections, hamlets lost, villages "pacified," weapons captured, and people relocated. The military, and that most quantitative of American officials, Robert McNamara, secretary of defense, atomized human issues into discrete statistics until only computers were capable of digesting it all. It was a war of "lies, damn lies and statistics," and the immediacy of life and death got lost in the shuffle. Even combat pictures of individual men killed in action seemed to be an inadequate comment on how the war was being waged.

To *Life*—to Ralph Graves, the new editor of the magazine—American boys dying in Vietnam were, after all, the story. The discovery of how to penetrate the inpenetrable numbers, of how to visualize the insidious, creeping quality of the daily body count, resulted in the single most powerful piece of journalism on the war, *Life*'s "high-water mark." In its issue of June 27, 1969, the magazine ran the photos of all the young men killed "in connection with the conflict in Vietnam" during the week of May 28 through June 3, 1969. That single average week, 242 American soldiers died. *Life* carried the photographs of all but 25 of them. *Life* rediscovered the tradition of the printing of studio portraits of the dead practiced in every conflict since the Spanish-American War and turned the artless journalistic technique into a sophisticated commentary.[39]

It was fitting that in the piece of journalism that signaled *Life*'s unequivocal confrontation with governmental policy, the photographs of those killed in action should not be pictures of men in battle with heads turned or obscured, but simple portraits of the dead come face to face with their audience. Formerly, compendiums of studio photographs had been, at best, a study in compulsive patriotism, but *Life* used the convention to call into question the validity of the war itself by challenging the war with its most basic commodity: the men. In the introduction to its article, *Life* wrote: "More than we must know *how many*, we must know *who*."[40] With the exception of the opening two paragraphs that primarily explained the format and the closing page that gave snippets of the personal histories of the men, the pictures stood alone. There was no overt verbal editorializing. There was no need. The photographs spoke for themselves.

What was so arresting, so frightening, was the simplicity of the layout. There were no blood-red or full-color photographs with screeching titles. The cover was in black and white—an enlarged, amateurish snapshot of one of the dead men, focused in so tight that it encompassed only the man's features, not even his entire head. In relatively small print, next to the *Life* logo, were the words "The Faces of the American Dead in Vietnam: One Week's Toll." "In retrospect," *Life* editor Loudon Wainwright recalled,

> the cover was probably the only bad mistake we made with the story. Blown up as it was, the cover was grainy and hard to read and not at all as dramatic as we hoped it would be. Newsstand buyers, it turned out, were apparently quite puzzled or unmoved by it; the newsstand sales were rather poor, surprisingly so when one takes into account the fact that the story immediately generated a lot of good comment and people all over the country were quickly talking about it.
>
> In hindsight, the cover would have been much better if we'd used an album page from our story inside. At the very least, that would have given our readers a clear idea of what we were up to with the whole story. Instead, we'd been reluctant to give away the punch we had inside and opted for a picture that was both indistinct and dull.[41]

One later letter to the editor pointed out that the inside format was like a high school yearbook. Under each picture was the man's name and age, his branch of the service, his rank, and his hometown. Most of the men were in uniform; some were smiling and some were solemn. Any one of them could have been the boy next door. The effect was devastating. As that letter noted: "June has been a month of commencement."[42] Never, during the course of the war, had the issue of Americans dying in faraway combat been phrased so starkly. Never before had the Vietnam War been so baldly exposed.

Over 1,300 letters poured in. Some were "passionate in their fury" at what one called *Life*'s "ghoulish exploitation of the agony of America."[43] But many more were deeply moved by the story. A man from Florida wrote, "Every once in a while there comes a particular photograph that emphasizes an era of man's history. One, a picture of a severely burned Chinese baby during the Japanese raids on Shanghai in

1935; another, Negro demonstrators being sprayed by water hoses in Birmingham in 1963. The June 27 issue of LIFE has printed 217 such pictures." "Ever since the beginning of the 'conflict in Vietnam,' " disclosed a man from California, "I have been an adamant hawk. However, your article is causing an agonizing 180° change of attitude." And a woman from Michigan confided: "My husband is presently serving his year there and each face in that article is his face."[44]

With these pictures, the American dead were not only separated from the context of combat, they were divorced from their heroic roles as GIs. The men were accorded respect but not glory. Since World War II and the Korean War when it had become technologically and politically feasible to photograph men killed in action *during* action, the media had always assumed that if people at home could see exactly how men looked when they died in battle, they would withdraw their support of—at least future—wars. Unfortunately, although the public found such photographs distressful, it was not sufficiently outraged to agitate for peace. A picture of men running under fire while toting a dead comrade, which could trace its roots back to a Spanish-American War image of men carrying the wounded, still seemed fundamentally romantic to the readers at home. Photographs still do not convey the sounds and smells of combat; while looking at the printed page, readers do not foul their pants out of fear because they hear mortars walking in on them, nor do they have to live in that uniform all day and night if they survive. The "One Week's Toll" article, therefore, acknowledging the inadequacies both of ten-point type and the photographic medium, tried to reduce the conflict to a common denominator with which the public at home could identify.

Other subjects did not elicit such photographic or editorial care from the mass-market press. Pictures of the Vietnamese, for example, did not call up the same level of inspired concern; the American press consistently emphasized coverage of the American GIs over the Vietnamese allies, civilians, and enemy. The media did, however, report more thoroughly on the ARVN troops than they had on the Republic of Korea allies during the Korean War. But what was partly responsible for the coverage of the ARVN troops was the initial fiction in the early 1960s that the Americans were present in Vietnam only as advisers. Perforce, the articles that appeared on Vietnam during that period had to investigate the activities of the South Vietnamese. In an internal memo listing his captions for his January 1963 article, Larry Burrows wrote: "*Important*: The pilot in this picture, the man who actually fired these rockets, is an American pilot. But since, publically at least, Americans are only

there as advisors, it would probably do considerable harm if we publish that fact, although it has been hinted at before. It is probably better to refer to the man here as a Vietnamese pilot, since there's nothing in the picture that would give him away as an American, we hope."[45] Burrows's nonchalant suggestion also helps illuminate the press's early self-censorship and, as a consequence, the ease with which the government could escalate the war.

These early ARVN stories created an expectation that the war would focus on—or at least look at—non-Americans. And, as the war progressed and Americans entered the conflict in strength, this perspective turned to an investigation of the actions of the South Vietnamese soldiers (how they fought, how they treated the enemy); of the enemy (which generally meant a portrayal of the dead enemy or of captured POWs); and of the Vietnamese civilians, who were, as everyone pointed out, indistinguishable from the combatants. These three types of images, more than any images of Americans alone, helped to establish a moral tone for the war even before such a moral tone was evident in the verbal reportage.

These images did not speak with a single voice, however. The photographs of civilians most emphatically criticized the effects of the war; the early explicit images of children wounded and dead gave force to the moral argument that the war, in its totality, was "wrong." Initially, the pictures of civilian casualties were similar in subject to, if more graphic than, those of previous wars: civilians were shown as injured by the enemy and as receiving care from the Americans. In Look's January 28, 1964, issue, for instance, the first double-page spread in an article on the war carried a page-and-a-half black-and-white photograph of an American medic cradling "the limp body of a child slain by Vietcong raiders." "Once again," the headline proclaimed, "we carry the tragic burden of war." Several pages later, an American doctor tended to another victim. The little girl in the full-page photograph, also taken by James Karales, lay in the middle of an iron-frame cot. The doctor bent over her, his hand held her arm. Where her elbow should have been was a mass of gouged and mutilated flesh. Her eyes stared in fear at her arm.[46] In response to the images, an American mother wrote, saying that she had shown the pictures to her nine-year-old son so he would learn "that war is no exciting adventure, but the hideous and agonizing thing it really is." Another woman asked for pictures of those children who were hurt not by the enemy but by American bullets, "so that I can rage and weep and suffer at the vicious brutality and hypocrisy of the human heart and our American press."[47]

Almost two years later, *Life* ran a similar series of pictures, taken by Paul Schutzer, except that these new photographs were in color and this new infant casualty *was* killed by Americans. The first image in the three-page, three-photograph spread on the incident pictured an anguished mother clutching her "blood-drenched child who was wounded when jets strafed before the landing"(figure 52).The second, larger, right-hand–page photograph portrayed an American corpsman "double-timing" with the child in arms "so he can treat the baby in safety." The third and final image pictured the woman "numbed by shock . . . clinging to her dying child." Although the more graphic photographs of the group were laid out on the less-important left-hand pages, the effect of those pictures remained shocking. The two photographs of the mother and child were somewhat blurry images, but the black of the woman's clothes and dull color of the background created an effective frame for the naked child who was so badly injured that his buttocks were shot away.[48] *Look*'s letter writer had been answered in *Life*. "When I saw the picture of that poor Vietnamese woman and her dying baby," wrote a woman from Georgia, "I could not hold back the tears."[49] The image of a mother carrying her dead or dying child became a classic of the war—often repeated, always appalling. *Time*'s feature story of "The Last Retreat," on March 31, 1975, ran on the cover three images of what had come to be the Vietnam pietà: one labeled 1967; a second labeled 1972; and the third, in color, labeled 1975.[50]

Images of North and South Vietnamese soldiers were more ambivalent than those of civilians. In the years before the involvement of American ground troops, photographers suggested a racist view of the conflict: neither side was shown to be humane, compassionate men fighting for the ideals of freedom and nationalism—as the Americans were depicted. Indeed, in 1963, an early *Life* cover of the war pictured South Vietnamese soldiers overseeing the loading of trussed-up Vietcong into a boat: the North Vietnamese were literally savage and stupid beasts to be haltered, and the South Vietnamese were so many slavers.[51] As the war continued, the images moderated slightly. The South Vietnamese were metamorphosed from malleable wards who, with enough guidance from Americans, could learn how to retake their country, to the fall guys who explained and covered for the United States' own inadequacies, to men who never had a chance because Americans did not give them one. In effect, the American opinion that the South Vietnamese were U.S. dependents or charges never varied; what altered was the Americans' conception of their own responsibilities. American attitudes went from condescension to contempt to pity, but never to

401

empathy. The South Vietnamese army, commented *Look*'s senior editor in 1970, "has been expensively graven in our image, but we call him 'dink,' 'gook,' 'slant,' and 'slopehead'. . . . Now, on his young shoulders, we have dumped the dead weight of our Asian policy, through a statistical shell game we call Vietnamization. Put simply, it means that we hope he will keep killing while we pick up our illusions and go home."[52]

Attitudes toward the North Vietnamese changed similarly; the Americans had concluded from the outset that the North Vietnamese regulars and guerrillas were inimically opposed to American policy and principles. That view did not change. What did change, however, was the Americans' faith in their war effort. By Tet, many argued that to continue to fight the war would be to destroy "something precious in the word 'America.' " "So let us learn," said *Look*'s editors, "to be useful to the world without trying to be its policeman, or to make its rules. Let us strive, in John F. Kennedy's phrase, to keep the world safe for diversity."[53] Yet accompanying these words, *Look* ran the image of a dead North Vietnamese soldier lying "in dirt and debris." The world was safe for diversity as long as the enemy could be treated as so much literal trash. The photograph of the enemy that the editors chose took a harsher, less forgiving line than the copy dared. In a war the Americans were losing, the rhetorical way out was to say that "diversity" was best after all, but the photograph betrayed the true emotions: we want to win.

The moral suasion of images of the Vietnamese becomes most evident when one considers the three photographic icons of the war: Malcolm Browne's 1963 photograph of the burning monk (figure 53), Eddie Adams's 1968 photograph of the Tet execution (figure 54), and Huynh Cong ("Nick") Ut's 1972 photograph of the napalmed children (figure 55)— and, one could add, Ronald Haeberle's 1968 (published in 1969) series of the My Lai 4 massacre (figure 56). None of the famous, notorious, now synonomous with antiwar photographs included Americans in the image. The Americans stand offstage. The pictures are about the Vietnamese.

The three iconic images were all taken by correspondents for AP. Each captured a critically different era of the war: the waning days of the Diem regime, before the American ground troop engagement; the height of the Tet offensive, in the period of greatest U.S. military intervention; the protracted stage of the bombing offensives, during the de-escalation of American involvement. And each captured as well an action of war that was anathema to traditional American ethics. The events depicted in the images could not be romanticized or glorified.

THE PHOTOGRAPHS: A SUBVERSION THROUGH EXPOSURE

They could not be explained in the context of combat. By American values, there could be no excuse for napalming children or for allowing political unrest to get to the point where ritual suicide was an appropriate or contemplated action. Even Adams's picture, which caught a moment of retribution for actions taken during battle, was unacceptable; to Americans, even in war, prisoners have rights. Through these pictures, the American people became witness to what some categorized as "war crimes"; they saw horrific forms of death overtaking these Vietnamese and they understood that Americans either supported or actually were the aggressors in these incidents. As columnist Shana Alexander wrote in *Life* after the Adams picture blanketed the country:

> The questions continue. Some are too obvious, too cheap to linger over long. For example: Is this the sort of "freedom and justice" that over half a million Americans are in Vietnam to fight for? Is this what some 18,000 already have died to defend? Of course it is not. In any war, outrages occur. Through poor questions, as well as worthy ones, a sort of negative answer does emerge; one learns at least what the point of the picture is not. It is not that in the Orient life is cheap; not that turtle-head is trigger-happy; not that accidents happen; not that war is hell.[54]

More than any other compilation of images from Vietnam, the three AP photographs and the pictures taken by Sargeant Ron Haeberle of the 11th Infantry Brigade challenged the conduct of the war. Yet at the time the pictures were taken, none of the journalists themselves considered the issue of morality. The photographers had taken the pictures because the events needed to be covered; the events were not only photographic opportunities but newsworthy incidents for the print press. "If one comes across a mother clutching a burned baby or the wreckage of a village or something," said Browne, "this is an enormously forceful image that speaks against the horrors of war. But it really has very little to do with news reporting. . . . I don't believe in looking for the perspective which seems to wrap up all the symbolism of the situation, because it's probably wrong. It's an artifact of the photographer's imagination to look for the weeping, bomb-blasted peasant on the steps of the luxurious palace . . . as a symbol of government repression. This in a way is cheating."[55] The four "journalists" were newsmen or army photographers, not antiwar activists or even feature correspondents who had the time to put together a piece that had a point of view. Ironically, by

403

"merely" reporting the events in the most dispassionate manner possible, they created the strongest statements against the war.

The Adams photograph appeared inside magazines and on the front pages of newspapers around the world. In contrast, recalled Browne, "*The New York Times* would not publish the burning monk picture, nor would many of the newspapers in this country on the grounds that this was not fit fare for the breakfast table."[56] (Although "Casey" Jones, the editor of the Syracuse, New York, newspapers charged that "an editor who didn't run that picture wouldn't have run a story on the Crucifixion."[57]) But even without the kind of blanket coverage of the media that the later iconic images were to achieve, the photograph of the burning monk was quickly adopted by groups protesting the Diem government. Henry Cabot Lodge believed that "no news pictures in recent history had generated as much emotion around the world as that one had." Mme. Nhu was so irritated by the publicity and response that she offered to provide "gasoline and a match if David Halberstam and some of the other reporters would follow the example" of the monk.[58] And the voices that the early Browne image raised only became louder with the publication of the Adams, Haeberle, and Ut photographs. "Is the real importance of the picture," asked commentator Alexander about the Loan execution image, "the fact that this act was committed by 'our' side? Or is it that the picture was printed at all? Every publication which ran it received outraged letters deploring the display of horror for its own sake. But if we had been able to print early pictures of the Nazi destruction of the Jews, millions might have been saved."[59]

Other photographers, feature journalists such as Larry Burrows, felt less of a responsibility than did the AP correspondents to tell just the "news"; they primarily wanted to tell stories. They carefully crafted essays that could place their audience in the American zone of Vietnam—in the air war, in the operating room, in the Khe Sanh trenches. Journalistic intent was at issue. These feature photojournalists calculated how best to make their impact, how best to attract their audiences so they would look in rather than look away. "My father's pictures," said Russell Burrows, "were seductive. People look at the pictures and say 'How beautiful,' and because they are beautiful they look at them longer. And it is only after a while that they understand the horror"[60] (a sentiment made manifest in Burrows's Yankee Papa 13 pictures).

The wire-service photographers could tell of the unrelievedly horrible pictures they had taken that were never published; Horst Faas of AP had photographs pinned up on his office walls that the wire service would not touch: pictures of severed heads, a face with gouged eyes, a

disembodied hand. "We used to take pictures with the full knowledge that they wouldn't be used," remembered Browne.[61] But the wire-service photographers continued to take such images anyway, not because they were voyeurs, although some were, but because the images recorded the facts. That is why the three "icons" of the war—the three famous pictures of atrocities—were all taken by the breaking-news photojournalists. Because the photographers for the wire services and the daily papers had to cover events when they happened, they had a better chance of capturing a moment of consequence if it happened within the context of an already "newsworthy" incident. But the feature photographers, especially those who took pictures for *Life* and *Look*, did not have to attend the set-piece events; they either happened on events or created them. As Gene Thornton wrote in the *New York Times*, "the photographer is almost never present when the really significant action occurs."[62] (And rarely did the feature photographers work within a time frame that could help gear their publications to cover breaking-news stories other than the most major ones. *Look*, for example, did not even publish a story on Tet; its biweekly format was ill-equipped to gear up for even a long-lasting news event.)

The feature journalists were not restricted to the wire-service facts but neither were they the beneficiaries of that factual reporting. The feature correspondents edited and pummeled and pulled at a story until it said what they and their editors wanted it to say. They lost the disadvantages but also the advantages of the wire-service photographers' adherence to single-image coverage of breaking-news stories. The newsmagazines' articles on Con Thien and Khe Sanh were a case in point. Con Thien and Khe Sanh were unusual engagements for the war: they were enemy offensives against major American bases that each lasted for two months and ended with hundreds of Americans and thousands of North Vietnamese wounded and dead. But because they were set-piece battles, it was possible, as it had not been during the small-unit conflicts that better characterized the war, for photographers to take traditional pictures of "combat" over a period of time and to group the images to address the charges that each seige was the Americans' Dienbienphu.

There had been established by the time of Con Thien in the fall of 1967 and Khe Sanh in the early spring of 1968 a recognizable, new genre of combat images appropriate to the military tactics in place in Southeast Asia. This genre consisted of three broad subject areas: men slogging through paddies, men calling in artillery, and men leaping out of choppers. Pictures of men in relationship to machines proliferated; im-

ages accentuating the communication umbilical lines of the artillery and the lumbering ballet of helicopters predominated. Other photographs of "combat" also surfaced, but the warfare conducted from the computerized cockpits of airplanes and the sterile flattops of carriers did not seem as photogenic.

The images from Con Thien and Khe Sanh drew on this new, greater confrontation with battlefield technology. Yet more than other pictures from the war, they harkened back to scenes that were more familiar in the Korean and world wars. Photographs of men crouching in trenches vied with close-ups of "glassy milky eyes not of the trenches, but of the ambush. It is the thousand-meter stare cranked down to fifty, to five. . . . A surrender to cool perfect murder."[63] David Douglas Duncan was the past master of this type of photography; he photographed for *Life* both at Con Thien and Khe Sanh. Shooting in black and white, Duncan pulled together photo-essays of "the broad gamut of activity at Khe Sanh, as well as the topography and scale of the area, supplying information as well as drama."[64] But in either location, his "information" never lacked drama. Nor did his pictures and stories lack references to previous conflicts. "The last time I covered the Marines," wrote Duncan in his first paragraph on Con Thien, "was at Chosin Reservoir in Korea."[65] Duncan always covered the marines; he had been a marine combat cameraman in the Pacific in World War II.

Duncan recorded the marines in shades of light and shadow; he saw the reality and emotional feel of battle in chiaroscuro. His grainy images featured louring skies and malevolent clouds of artillery bursts. The men were lit with a straking light, almost invariably shot from a low perspective to lend them both drama and power. The opening double-page photograph of the Con Thien article in *Life* encapsulated all these aspects: a smudgy pillar of fire blended in with dark anvil-shaped thunderheads, an authoritative figure with legs braced and rifle steady loomed above the helmeted heads and shoulders of a half dozen or more men, and wooden ammunition crates the shape of coffins pockmarked the grainy landscape. Succeeding images spun out the tale of men waiting for an artillery barrage to be walked in on them, of dustoffs coming for the wounded, of bunkers for "cooking, cleaning weapons, writing home, or talking: of Communism; of there being no retreat for a Marine; of God—an intensely personal God; of their hatred but respect for enemy Charlie."[66] Although Duncan argued that he was not prowar, he was vehemently promarine. In his book on Vietnam, entitled *War Without Heroes*, there are "221 photographs of American Marines in the current war without showing a single Vietnamese face—of either side.

Small wonder," said John Morris, former picture editor for *Life* and the *New York Times*, "that Dave's critics, looking at the pictures, fail to understand his anti-war position."[67]

Duncan was not the only photographer to look back to the previous wars for ways of framing the Vietnam conflict. In its photo-essay on "The Dusty Agony of Khe Sanh," *Newsweek* out-Duncaned Duncan.[68] Although the *Newsweek* article was shorter, in color, and focused only on shots related to the action, the essay was strikingly similar to Duncan's. Both Duncan and Robert Ellison, the freelance photographer who took the pictures that appeared in *Newsweek*, emphasized the men over their environment. By focusing on the moments of battle (figure 57), Ellison, who was killed in Khe Sanh when his plane was hit by enemy fire, presented a more pessimistic view of the seige of Khe Sanh than did Duncan, but the two men's concerns were the same. Both, for example, took close-ups of the soldiers to celebrate the democratic intent of a war that was being fought by Ernie Pyle's common man (à la World War II), and both took portraits of the troops to champion the fortitude of the individual soldiers in their sad triumph over the hardships of warfare (à la the Korean War).

While the national magazines liberally published photographic close-ups of the troops, their publication of these close-ups never became a signature of the Vietnam War as it had been of the Korean War. Instead, photographs that put the individual soldier sharply back into the context of the conflict took precedence; the political and moral concerns raised by Vietnam caused such images to become a more fitting mode. The new style of the Vietnam War photography broke with the aesthetic of the past two wars. Instead of careful compositions isolating decisive moments of combat, the images that seemed to dominate and characterize the bulk of the photographs from Vietnam appeared simply to arrest randomly selected scenes—random, yet all the more significant for their seeming representativeness precisely because they were "random." The new photographs looked like freeze-frames from a film. Entire image areas appeared to be in momentary suspended animation; a viewer could envision the action continuing if the "film" were to keep rolling. Framing also seemed less premeditated; again, as with film, a viewer could expect to see the surrounding landscape when succeeding footage panned the locale. The photography from Vietnam had picked up the new fifties' and sixties' casual snapshot aesthetic of street photography, practiced by photographers such as Gary Winograd and Lee Freidlander, and turned it into a political statement. By Viet-

nam, the younger war photographers had also assimilated the ironic "subjective realism" of the photographer Robert Frank.

Several of the pictures best representative of this new look were photographs of American casualties. One series of images of the wounded, taken by Burrows in October 1966, pictured a marines' first-aid center during "Operation Prairie." Three photographs of the group ran in the October 28, 1966, issue of *Life*: one on the cover and the other two on the last double-page spread.[69] *Life* published a fourth photograph in its February 26, 1971, issue, in an article that memorialized Burrows's death earlier that month.[70] Back in 1966, when Burrows went to cover the marines by the DMZ, he had not realized his photographs were to accompany a lead story; in a cable to the New York office, another *Life* correspondent, in sending back Burrows's six rolls of color, noted: "BURROWS WANTED MENTIONED THAT HE WOULD HAVE SHOT MORE ROLLS IF HE HAD KNOWN ABOUT THE LEDE. HE WAS LOOKING FOR EXPRESSION OF MEN IN COMBAT, BUT HOPES THE TAKE IS SUITABLE FOR LEDE USE."[71] When Burrows came "OUT OF THE BOONIES" to file his own captions, he apologized for the roughness of his notes: "SORRY IF MY CAPTIONING IS NOT UP TO STANDARD BUT WITH ALL THAT SNIPER FIRE AROUND I DIDNT DARE WAVE A WHITE NOTEBOOK (EXCLAM)"[72]

The pictures depicted a hilltop awash in yellow mud. Wounded men, medics, and other marines grouped haphazardly on the ridge; the muck coated their hands, faces, and dull-green uniforms. In his cable, Burrows described the tight cover shot: "IN FOREGROUND IS NEGRO WOUNDED IN LEGS, HEAD AND SHATTERED LEFT HAND HE IS SUFFERING HELL, MAN ON LEFT IS CRADLING HIS HEAD WHISPERING 'YOU'RE OKAY, YOU'RE OKAY, WE'LL HAVE YOU OUT OF HERE SOON.' " The inside pictures (in both the 1966 and 1971 issues) also featured another injured black marine. Burrows described these photographs:

BIG NEGRO IS SARGENT [sic] OR GUNNER PURDY, WHO HAD BEEN DIRECTING THE OVER HEATED ANDSMOKING [sic] TWO FIFTY CAL. AND M60 MACHINE GUN FIRE AT HILL 484 WHILE THE MARINES WERE MAKING THEIR SUCCESSFUL ASSAULT ON THAT HILL. THEY HAD FAILED TO TAKE IT THE PREVIOUS DAY. PURDY LURCHED PAST ME, SLIPPING AND SLIDING THROUGH THE MUD TO GET AWAY FROM THE CREST OF THE HILL AND FIND A DUG OUT, BLOOD WAS STREAMING DOWN HIS FACE AND HE WAS SHOUTING MORTAR ATTACK. HE HAD

BEEN HIT BY SHELL FRAGMENTS FROM THE FIRST OF THREE SHELLS. SHORTLY AFTER HE WANTED TO RETURN TO HIS POST BUT WAS RESTRAINED FOR MEDICAL TREATMENT AND REFUSED TO BE CARRIED BUT WALKD [sic] TO THE TOP OF THE HILL FOR HELICOPTER EVACUATION.[73]

A double-page image of the scene in the 1971 essay was the most striking of the published shots of the action (figure 58). In that photograph, the injured black soldier staggered forward in the center of the image, a white bandage, the bottom soaked in blood, wrapped around his head as if he had a toothache. The red of the dangling bandage was the only violent note of color in the image. On the right of the picture, sprawled in the mire, lay another wounded marine, a white man with curling blond hair that matched the color of the mud plastering his face. His left trousers were ripped down to the bottom, exposing his bandaged leg. His arms were flung out in a crucifix position. The black man, as the caption read, "reaches out towards [his] stricken comrade."

The letters in response to the 1966 photographs spoke more of the implied concern between the black and white GIs than they did of the action itself. Mentioning the words "brotherhood" and "compassion," the letters found the scene worthy of celebration: "Larry Burrows' cover and his picture of the Negro and the white Marines stretching out their hands to each other . . . illustrate that in the midst of man's most brutal experience, mutual respect transcends the sophists, demagogues and bigots—whether one is purple, polka-dotted or streaked. Beyond being Marines, who take care of their own, they are men who are performing their human obligations under the greatest pressures known."[74] The photographs "signified" so much to their audience because they appeared transcendent. The picture of the man "reaching out" transcended the "great racial problems" of the American home front because it appeared to transcend the moment in which it was taken. (It also transcended the reality of racial relations in the service.) The photograph implied that the compassion that is evident in the emotions of an instant was indicative of the attitudes for the duration. The photograph was able to communicate such a belief not only because it froze the compassionate moment in time but also because the image, itself, by nature of its composition, appeared to be not a "decisive moment"—that instant which is like no other—but a random moment—that instant which could be any time and, therefore, can be every time. Although, in fact, Burrows's photograph of the two wounded marines had been carefully thought through, it lacked artifice. It was unposed,

even appearing erratically framed. The composition recalled not the deliberately composed masterworks of art that Burrows had spent his career in the 1950s copying, but stills from television film in which the balance is to be found less in any individual frame than in the synergy of the whole.

Two and a half years later, in the May 14, 1968, issue of *Look*, this new style of war photography reached its apogee. The article ran for ten pages but carried only five images: two of them were full-size single-page photographs and three were full-bleed double-page pictures. The single-page photographs had no captions; the double-page images had only a line or so. Two small blocks of copy ran on the first and last pages. All the photographs were taken by Catherine Leroy. " 'We all belong to the same war. We all have the same God. We're all in the same adventure,' " proclaimed the boldfaced quotation above the headline. "This is that war."[75]

Look, the biweekly magazine that, unlike its rival *Life*, covered no breaking-news stories, ran many fewer articles on Vietnam than did the other photographic periodicals. Yet, perhaps because of that fact, *Look's* images and graphics on the war, when they did appear, were more innovative and daring than anything attempted by *Life*, *Time*, or *Newsweek*. The Leroy article, *Look's* first story on Vietnam after the Tet offensive, was the most visually striking of all the photo-essays of all the publications for all the war. The confrontational size of the color photographs made the essay distinctive—the editors decided to run all the vertical pictures full page and all the horizontal frames double page.

Leroy's five images slashed out against the sentimental posturing of earlier wars and other photographers. Her saturated color images are nothing like the mass of photographs from Vietnam; they presage the pictures that were to come ten and fifteen years later from Lebanon, Guatemala, Chile, Rhodesia, El Salvador, Iran, Nicaragua, Ireland, Pakistan, Honduras, Thailand, and Cambodia. The first and last of the Leroy images, the single-page ones, pictured American GIs in the aftermath of combat. In the first photograph, a soldier leans back exhausted against a wall; in the last image, a black soldier is supported by a white friend. The middle three pictures covered other, different aspects of the backwash of war. One pictured an American casualty dripping a pool of blood (figure 60), the second pictured a dead North Vietnamese soldier lying among the leaves, and the third pictured an anguished Vietnamese mother holding her wounded child (figure 59).

With the exception of the final photograph of the black and white soldiers, the article grouped images that reflected a passionate and at

times pejorative perspective. Leroy's picture of the camaraderie be-tween the races was the one falsely positive note of the essay. Just as Burrows's depiction of the wounded black and white soldiers had sug-gested a brotherhood on the field of combat that was rarely borne out in reality, so did Leroy's photograph two years later—when the racial conflict had become even more exacerbated—glossing over a situation of conflict that was so strikingly evoked in her other images. In a war in which 20 percent of the combat troops were black (some infantry units were as much as half black), and 14 percent of the battle casualties were black, precious few of the photographers took pictures of minority troops. And those images that did depict blacks or Hispanics or other nonwhite groups most often showed them in harmonious juxtaposition to white soldiers. Despite the fact that some of the Vietnam correspon-dents covered the civil rights movement in the American South, the trenchant, courageous photographs of racial unrest from Selma, Bir-mingham, Watts, and Newark had no equivalents in the jungles and rice paddies of Southeast Asia. Comparable situations existed—of vio-lence and frustration—but the moral outcry against the American en-gagement in Vietnam evident in the photographs of the war was silent when it came to speaking out against the black-white racial conflict inherent in that war.

The *subjects* of the other four photographs in Leroy's essay were not especially unusual either, but the way in which Leroy *approached* them was extraordinary. First, Leroy's use of color enhanced the graphic quality of her images. Few Vietnam War photographers had discovered how to exploit color to new effect—a skill generally mas-tered by war photographers only in the conflicts since Vietnam. During the Vietnam War, most photographers were still thinking in black and white even when they were shooting in color. As a result, the colors of most Vietnam photographs distracted their audience from the subjects of their images; viewers' eyes were attracted to the bright greens of the men's uniforms or the blues of the sky, rather than to the actions of those men.

Second, Leroy's angle of vision brought *Look*'s readers into the quo-tidian subjects. Her photograph of the mother and child (figure 59), for example, was blurred; in the low-light setting, the emotional agitation of the mother, and perhaps even of the photographer, acted to smear the image into a confusion of warm reds, yellows, greens, and oranges. The woman's face is hazily recognizable; her features are distorted into a wrenching anxiety. Her child is thrust out before her; all that can be seen of either figure is the infant's head and the mother's face and

411

shoulder. The mother's face is life size; the child in front of her is twice life size. The infant's head is crudely wrapped and tied with a white bandage; the face is averted. The little features are serene; blood drips down the child's cheeks. The viewer looking at the image sees what the photographer saw: blurred movement, an injured child held out nose close by a distraught mother. The photograph is entitled "The Ravaged." "The town was destroyed," Leroy's caption reads. "I saw thousands of new refugees with no food, no home, hate in their hearts."[76]

The image of the American casualty is equally compelling, equally disturbing (figure 60). Although the picture of the mother and child is indistinct because of the camera's blur, the photograph of the wounded soldier is indistinct because of the darkness of the image. Again, the figures are at least life size: the injured man lies on his stomach, his head slightly raised, his arm curled in front of him. Another soldier at the right of the frame leans over the wounded man; only his hand and profile are visible. The somber browns, greens, and blacks of the photograph are relieved only by one blotch of color: the spatter of brilliant red blood dribbling from the man's head onto the floor. Once again, the reader is there, only inches away. At that distance, confrontation and perturbation are unavoidable.

These photographs are close-ups unlike any other close-ups. The obscuring of the subjects' features disallowed any presumptive interest in any individual represented. Instead, the images demanded an imperative reckoning with the situation in which the people pictured found themselves. In its article "The Faces of the American Dead," *Life* had tried to persuade its readers to reassess the value of the war by forcing them to remember the individuals—the American men and boys who actually had been killed; using Leroy's pictures in "This Is that War," *Look* tried to convince its readers to reassess American policy in Vietnam by transporting them to the war and rubbing their faces in its ubiquitous, anonymous horrors. Both essays were moving documents that, through different applications of photographic close-ups, caused Americans to reexamine their beliefs.

But the press during the Vietnam War was not solely responsible for the public's turn against the war effort. The press did help. They helped legitimate internal dissent within the government and the military. They helped protest specific policies and specific events. They helped frame the antiwar issues. Photographers, especially, helped the country to visualize the conflict better than had ever been done in the past. And with vision came emotion, and with emotion came discontent. During the Vietnam War, as never before so unequivocally, photographs (if not

always the photographers) became the fifth column of a rebellious fourth estate. But that fifth column never succeeded in sufficiently educating the public in the United States about the political and social situation of the Vietnamese, although those who took the photographs made a greater effort to do so than did any other group. Photographs of the war helped to subvert the American military effort by the simple stratagem of exposing certain realities. But the public discontent that the press fulmigated did not extend to a meaningful discontent about anything other than issues that directly affected Americans in combat. As one reader of *Life* wrote in to say after looking at "The Faces of the American Dead" essay: "I doubt that your 'tribute and record' will do one bit of good. We tend to be like those in Robert Frost's poem: 'And they, since they were not the one dead, turned to their affairs.' "[77]

In January 1919, at the close of the First World War, William Butler Yeats, gazing ahead to other nascent conflicts, asked: "what rough beast, its hour come round at last, Slouches toward Bethlehem to be born?" The greater knowledge of combat gained through the photography of war over the past century has not killed what appears to be a Hydra-headed monster. Perhaps at this late date we have to reconcile ourselves to its existence and be content in the hope that the photography of war, while perhaps not the hoped-for burning brand and severing sword of Hercules, may yet at least prevent false warriors from mistakenly doing battle.

Epilogue

George Bernard Shaw said, "I would willingly exchange every single painting of Christ for one snapshot." *That's* what photography has got going for it.

—Philip Jones Griffiths

AMERICAN MILITARY ENGAGEMENTS since Vietnam have avoided, above all, the great failing of that earlier conflict: the apparent inability of the policymakers to extricate themselves from the quagmire. The United States has remained leery of being held public hostage to the demands of its military excursions—however defensible they may appear. And, in fact, the one lengthy involvement of U.S. personnel overseas in a military situation—the taking of the U.S. embassy officials in Iran—only reinforced the country's unwillingness to forgive those it held responsible for that debacle: President Jimmy Carter and his Democratic administration. As a result, the recent history of U.S. military involvement, especially in the 1980s, has been characterized by quick interventions calculated to risk little: get-ins and get-outs, with the snatching of victory or the lashing of defeat never much more than a pat on the back or a slap on the wrist.

The perceived adversarial nature of the media in the post-Vietnam, post-Watergate period has been greatly responsible for this change in the nature of military operations; the Reagan administration has assigned the blame for the U.S. loss of world stature and credibility during the Vietnam era to the "self-serving" and "sensationalist" reportage of the press. As a result of this mentality, the Reagan officials excluded the media from rapid participation in what came to be the 1980s version of the "splendid little war": Grenada. Curiously, the Spanish-American War and the invasion of Grenada had much in common: both focused

Epilogue

on operations in the Caribbean, both were U.S. victories in spite of poor American military planning, and both were portrayed at home as far smoother exercises than they actually were. However, whereas the press in 1898, because of its own chauvinism, depicted the Spanish-American War as a glorious, successful affair despite its knowledge to the contrary, the media during the initial days of the Grenada invasion pictured the conflict as well run because they were denied any access that would have contradicted that notion. Former actor President Ronald Reagan viewed the war, frighteningly, as something of a movie, believing that the United States (or at least his administration) could script it, change the ending if it needed, and have the Americans in the white hats come home victorious in the closing reel.[1] But to do that, the media, for the first time since the beginning of the Vietnam War, had to be restrained from relating the unadulterated story.

In October 1983, two days after the terrorist bombing of the U.S. Marine headquarters in Beirut, Lebanon, American armed forces invaded the tiny spice island of Grenada. Their excuse was that the charismatic prime minister, Maurice Bishop, had just been arrested and murdered by a member of his own party, Bernard Coard, who wanted to run the country along stricter Leninist lines. Bishop, himself a Marxist who had overthrown the repressive regime of Prime Minister Eric Gairy in 1979, had called both for nonalignment in foreign affairs and for economic policies based on popular ownership and control—an openness that irritated the more ideological Coard, and for opposing reasons the United States.

But the U.S. intervention ultimately had little to do with the political upheavals of the island itself, although the ostensible, officially proclaimed cause for the invasion was the protection of 224 American medical students in residence there. The Reagan White House was unenthusiastic about communism in the Caribbean and did fear a repetition of the Iranian hostage crisis, but more compelling motivations for the attack were the administration's need to deflect the sharp criticisms for the Beirut bombings, its wish to provoke the Marxist Sandinistas in Nicaragua, and its desire to demonstrate resolve to the El Salvadoran government fighting its own indigenous guerrillas.

Critical to the successful manipulation of these interests was the Pentagon's management of the news of the invasion. Correspondents were not allowed on the island for days; forced to rely on the early, unverified reports from the military, wildly distorted accounts of the action initially appeared even in such respected publications as *Newsweek*. Most publications, for example, accepted the administration's contention

that there was a "hardened professional corps of about 600 Cuban troops" in Grenada, whereas it turned out later that of the 784 Cubans on the island, most were construction workers—only 43 were professional soldiers. Photographer Eddie Adams, who landed on the island three days into the fighting, said he "understood" why the Pentagon did not allow journalists to accompany the troops. "The reason they didn't want anybody to go to Grenada," he contended, "was there wasn't any enemy there. I was there. I know. I got called in late, but it was a joke."[2]

Code-named "Urgent Fury," the operation, despite its name, was not a lightning strike or a *coup de main*. The invasion, under the overall command of the navy, consisted of U.S. forces establishing bridgeheads and then hacking their way to the capital—much as the troops had in the Normandy landings of World War II. Because of the planned, and adhered-to, sequence of the operation, the Grenadian leaders and the Cubans were able to organize their resistance—a situation that might not have evolved if the U.S. army, trained in land warfare, had commanded the operation. And the press, not yet on the island, was unable to report firsthand on much of the fighting, a fact that successfully blunted any lessons to be learned from the bureaucratic pitfalls fouling the U.S. action.[3]

Still, the postmortems were many. On the issue of media coverage alone, two official groups met to consider the future involvement of the press in military operations. Secretary of Defense Caspar Weinberger and Major-General Winant Sidle, USA, Retired, headed up the Defense Department's and the Joint Chiefs of Staff's respective panels. While most of the findings of both groups were restricted to such inoffensive comments as "the U.S. media should cover U.S. military operations to the maximum degree possible consistent with mission security and the safety of U.S. forces," one recommendation did result in the establishment of a media pool, on alert at all times for emergency posting, similar to that in use during World War II. First employed during the Persian Gulf crisis, the pool (currently in use) consists of a handful of correspondents—camerapeople, reporters, and still photographers from the major networks, periodicals, and wire services—who rotate each month through the pool operation. While the media, as represented on the DOD and Sidle panels, "were unanimous in requesting that pools be terminated as soon as possible and 'full coverage' allowed," the issue of when that would happen was left to be decided on a "case-by-case" basis. Other questions, such as Should the press go in on the "first wave"? Should non-U.S. citizens be allowed to participate in the pool?

Epilogue

and Should the personal politics of the individual correspondents pro-
hibit them from consideration? were also left to be decided on a "case-
by-case" basis. The media, however, did assure their voluntary compli-
ance with censorship guidelines similar to those in place during the
Vietnam War.[4]

The Sidle Panel closed its report with this final comment:

> An adversarial—perhaps politely critical would be a better term—
> relationship between the media and the government, including the
> military, is healthy and helps guarantee that both institutions do a
> good job. However, this relationship must not become antagonis-
> tic—an "us versus them" relationship. The appropriate media role
> in relation to the government has been summarized aptly as being
> neither that of a lap dog nor an attack dog but, rather, a watch dog.[5]

Despite this suggestion, this hope, the photographs of battle since Viet-
nam (if not always the verbal coverage of war) have become even more
critical, more adversarial, and more antagonistic than ever. Perhaps
one could now say that the watch dog is on the attack. In the late 1970s
and in the 1980s, photographers have spared few feelings in their depic-
tion of the graphic horrors of war. Journalists have not flinched from
taking pictures that condemn certain policies of the American govern-
ment. Yet there has been one crucial difference between these new
photographs of war and the previously discussed images: these recent
pictures do not depict U.S. troops in combat or on the offensive. The
images that came home from Grenada were an important exception;
few of the wars that monopolize either the pages of Time and Newsweek
or the airwaves of the evening news involve the actual presence of
American fighting forces. U.S. "advisers" may be involved, American
government agencies may be—in the words of investigative journal-
ists—"unindicted co-conspirators," but the wars commonly pictured
have not been, fundamentally, fought by American soldiers.

The lack of engagement of American ground troops in battle has freed
the picture media to criticize U.S. policy. As a result, assumptions about
the adversarial nature of the press have been reinforced. Traditionally,
and currently, once Americans step into battle, the country and the
press immediately move to support the action. The engagement might
be questionable but the soldiers remain "our boys." (Later, however, if
the engagement does not go well, the media may respond negatively.)
But in the conflicts raging around the world, for instance in Central
America, there has generally not been the factor of the engagement of

417

American infantry to moderate photographers' assessment of the situation. The liberal press has, therefore, felt licensed to criticize government policy with which it does not agree.

Other factors, as well, have acted to permit, to embolden, and to validate censorious photographic reportage. The growing numbers of freelance photojournalists, the proliferation of picture syndication agencies—such as Gamma, Sygma, and Sipa—and the growth of the European and South American picture magazines as outlets for images have meant that more photographers with fewer personal and professional constraints are out taking pictures. The loss of such former mass-circulation, general-interest picture magazines as *Look* and the weekly *Life* has partly been compensated for by the increasing numbers of foreign periodicals and by the greater range of American special-interest publications that are now using photojournalism. Periodicals from *Vogue* to *Mother Jones* are running—although perhaps not in every issue—photo-articles on the poor in India or on the contra war in Nicaragua. "When *Life* died in 1972," remembered photographer Adams, "everybody thought that was the end. But what's happened since then? There are more magazines on the market today than there ever has been in the history of America—and a lot of them are using pictures. I'm not talking about *Time* and *Newsweek*. I'm talking about the other magazines. Have you ever seen *New York Woman*? See what they're doing? See *Vanity Fair*? What they're doing? *Inc.*? And *Life* is back. They . . . are a real magazine again."[6]

During the 1970s especially, the investigative photo-essay—and the magazines that catered to it—suffered a beating in competition with television coverage, but the limitations of the electronic media soon surfaced. Few three-minute reports on the network news or even special documentaries on late-night television can make the kind of sustained, complex statement that it is possible to make using a combination of still images and printed text—and without VCR technology, none can make the kind of report that a viewer can go back to and linger over. With this knowledge gained after two decades of network news broadcasts, therefore, the still photograph and the photo-essay have come back. They are being recast in special series in the daily paper, in the pages of the Sunday newspaper magazines, in the former all-fluff periodicals, as well as in the old but revamped publications such as *Life*. The ubiquitous presence of color in the pages of the press has added to the resurgence in interest in still images; color sells, and surveys back that up. Technological advances in processing color have shortened the time it takes to get color photographs into the pages of the periodicals;

Epilogue

with the use of laser scanners to make four-color separations and with the satellite beaming of page negatives, a color picture can go on press anywhere in the country less than two hours after it is shot. Now a decision as to whether a story should run in color or black and white can be made on the basis of aesthetics rather than on the basis of time— although the difference in cost remains an issue.

The reports of the still photograph's demise have been greatly exaggerated. Indeed, if there is anything to be mourned, it is that the pictures of war can place so many demands on their audience's instinctive desire to respond and help in times of crisis that their impact can be numbing as well as enlightening. Yet, we need to learn of the prevalence of violence and tragedy in our midst. "The real horror of war," believed journalist Malcolm Browne, "is not seeing a dismembered body. You get used to them. They smell and they're awful, but you do get used to them up to a point. What you never get used to is the ghastly injustice and horror for the living: the dismemberment of families and the human tragedy. That's the part that becomes overwhelming. And to the extent that a photograph can convey symbolically the grief that a family is feeling, then that can be a good and powerful photograph."[7]

The camera has always been proficient at depicting certain aspects of violence: the carnage of death and the rubble of destruction especially. But over time the compelling, even attractive black-and-white images have given way to repelling, disturbingly colorful images of war. Black-and-white photographs and earlier notions of honor shielded viewers from the spilled guts and putrefying bodies of combat. Distance and graininess and atmosphere created heroes in heroic situations—not victims in scenes of indecipherable tragedy. The aesthetics have changed, but the wars of the twentieth century have changed as well. The essence of a soldier's experience is no longer in being a hero—it is in survival. The rules of the Geneva Convention no longer apply, and even correspondents can no longer walk with immunity through the ranks of combat. "You'd have to be out of your mind to even think of covering a place like Beirut," argued Browne. "And, in fact, Americans don't. We rely upon the services of cannon fodder from Europe to do that—which in a way is very unfair because an Englishman is no less likely to be kidnapped or assassinated than an American."[8] Now, at least as much as ever before, we need to see the imperfections in our world. The new realities of these new wars do not negate the need for the coverage of them.

We today are the most vehemently visual generation ever. Our world has been explored by television, mapped by instant Polaroids, invaded

by home video. "Photography," as Eddie Adams noted, "is important. It has been important for a long time, but now it's really important."[9] Every generation since 1839 has viewed more of the universe around them because of the medium of photography. From daguerreotypes to plastic roll film, view cameras to SLRs, albumen plates to computer printouts, photography has kept pace with the times by mirroring the times. And in its reflection of the world, photography has changed the world. As much as in any moment in our past, we need that mirror. By seeing who we are today, we can decide who we want to be tomorrow.

Notes

Preface

1. Although, as with all Washington functions, some names undoubtedly were left off the list.

2. Actually, amateurs liberally took photographs in all the wars except during the early years of World War I, when censorship was so strict that it was a capital offense to have a camera in the trenches. Few soldiers, naturally, took the risk, although photographs do exist that were taken with spy cameras—like one inside a pocket watch that could take photographs no larger than a fingernail. After the American entry into the war, however, the censorship was not so harsh. Many soldiers who fought during 1917–18 put together photo albums of their experiences—but even in this last year very few pictures were taken of frontline action.

Introduction. Interpreting War

1. Edgar Allan Poe, "The Pit and the Pendulum," in W. H. Auden, ed., *Edgar Allan Poe: Selected Prose, Poetry, and Eureka* (New York, 1950), p. 67.

2. Personal interview with Carl Mydans, August 25, 1986.

3. Jimmy Hare, quoted in Lewis Gould and Richard Greffe, *Photojournalist: The Career of Jimmy Hare* (Austin, Tex., 1977), p. 18.

4. Robert Capa, quoted in David Sherman, ed., *Life Goes to War: A Picture History of World War II* (Boston, 1977), p. 4.

5. "Hellbox," *Newsweek*, April 23, 1951, p. 57.

6. Personal interview with Carl Mydans, August 25, 1986.

7. Philip Caputo, *DelCorso's Gallery* (New York, 1983), p. 223. In his well-researched and highly regarded novel, Caputo acknowledged the war photographers Eddie Adams, Philip Jones Griffiths, Don Kincaid, Lawson Little, and Don McCullin for "explaining the ABCs of photography to a novice and for their insight into the complexities of the war photographer's mind."

8. Joel Meyerowitz, interviewed by D. C. Denison in "Mr. Summer," *Boston Globe Magazine*, August 25, 1985, p. 56.

9. Robert Capa to Martha Gellhorn (then mistress and later wife of Ernest Hemingway), quoted in Richard Whelan, *Robert Capa* (New York, 1985), p. 275.

10. Personal interview with George Silk, July 14, 1986.

11. Joseph Conrad, *Heart of Darkness and The Secret Sharer* (New York, 1910, renewed 1950), p. 138.

12. W. Eugene Smith, quoted in George Santayana, "The Photograph and the Mental Image," in Vicki Goldberg, ed., *Photography in Print: Writings from 1816 to the Present* (New York, 1981), pp. 261–62.

13. Whelan, *Robert Capa*, p. 143.

14. Michael Herr, *Dispatches* (New York, 1977), pp. 221 and 222.

15. Jorge Lewinski, *The Camera at War: A History of War Photography from 1848 to the Present Day* (New York, 1978), p. 17.

16. A recent example was Tim Page, who hitchhiked to Vietnam from Europe and, at the age of twenty, was a stringer for *Life*. In Vietnam, he was wounded four times—each time more seriously. (In 1965 in Chu Lai, Page was hit with shrapnel in the legs and stomach. His second year, in Danang, he received more shrapnel, in his head, back, and arms. On the third occasion his boat was blown up in the South China Sea and all but three of the crew were killed. He took 200 wounds and floated for hours in the water before he was rescued. The last time he was hit by a two-inch bit of shrapnel from a mine that went through his forehead deep into the base of his brain. He was not expected to survive. But he clung to life even after the surgeons removed some bone from his skull which caused the right side of his face to cave in. Herr, *Dispatches*, pp. 252–53, 262.) While he was undergoing physical therapy after the fourth injury, a British publisher approached him about doing a book whose working title was *Through with War*. Its intention was to take "the glamour out of war" once and for all. Page could not believe it. "Take the glamour out of war! I mean, how the bloody hell can you do *that*? Go and take the glamour out of a Huey, go take the glamour out of a Sheridan. . . . Ohhhh, war is *good* for you, you can't take the glamour out of that. It's like trying to take the glamour out of sex. . . . I mean, you *know* that, it just *can't be done*! The very *idea*! Ohhh, what a laugh! Take the bloody *glamour* out of bloody *war*!" As quoted in Herr, *Dispatches*, pp. 265–66.

17. "Discounting actual or imaginary cases of shell-shock," commented one observer after World War I, "the state of usefulness of a soldier, unwounded, exposed to the . . . ordinary routine of life in the trenches and rest billets, might range from six to eight months. He might be able to stand the turmoil, the constant imminence of danger, the continued and prolonged spells of sleeplessness and exhaustion a few weeks longer without permanently damaging himself, if his nervous system in the first place were of the best. After that neurosis of some kind or other developed until he had recuperated; in other words, he ceased to think and function as a normal human being. The time limit, of course, varied with the quality of hardship he was exposed to—some sectors were quieter than others—but the result of any prolonged 'exposure' to front line conditions even in the cases of hardy and healthy men were often disasterous [sic]." See Eugene Löhrke, ed., *Armageddon: The World War in Literature* (New York, 1930), p. 7. Similar statements could be made of the other twentieth-century wars.

The pioneering research that was done on combat stress was collected by the American Research Branch, Information and Education Division, War Department, during World War II. The research and the four-volume study that resulted was a model for all succeeding research into combat. The World War II study—especially the volume *The American Soldier: Combat and Its Aftermath* by Samuel Stouffer et al. (Princeton, 1949)—discussed similar findings to the World War I observation: "Actually, there is quite high agreement . . . as to what factors were most frequently observed as having a 'very bad' or 'rather bad' effect on combat performance. . . . The most frequently cited . . . was 'Fatigue of troops from being in combat too long.' " (p. 73).

18. William F. Stapp, " 'Subjects of Strange . . . and of Fearful Interest. . . .': Photojournalism from Its Beginnings in 1839," in Marianne Fulton, ed., *Eyes of Time: Photojournalism in America* (in press).

19. Photographer Henri Cartier-Bresson is considered to be the father of photojournalism for his belief that there exists a "decisive moment" in any action and that it is a photographer's responsibility to capture it on film.

20. David Hockney, quoted in "David Hockney's Drawing Power," *Washington Post*, January 20, 1985, p. F5.

21. Robert Doisneau, interviewed in Paul Hill and Thomas Cooper, eds., *Dialogue with Photography* (New York, 1979), pp. 92–93.

22. Ibid., p. 92.

23. Susan Sontag, *On Photography* (New York, 1977), p. 3.

24. Although the little girl running down the road after having been napalmed survived her experience.

25. Sigmund Freud, *Civilisation, War and Death* (London, 1953), pp. 15 and 17.

26. That image of the pietà can also be turned into a critical one. During Vietnam, for example, pictures of Vietnamese mothers holding their dead children became a cynical commentary on the military strategy of bombing guerrilla/civilian strongholds. Those images contained no intimation of a resurrection to follow. To continue the metaphor, Christ had abandoned the world.

27. As quoted in Robert Dallek, *Franklin D. Roosevelt and American Foreign Policy, 1932–1945* (New York, 1979), p. 284.

28. Robert B. Reich, "Political Parables for Today," *New York Times Magazine*, November 7, 1985, pp. 126, 128–29. Reich mentions four parables: (1) "The Rot at the Top," about "the malevolence of powerful elites . . . the story of corruption in high places, of conspiracy against the public"; (2) "The Triumphant Individual," the story of "the little person who works hard, submits to self-discipline, takes risks, has faith in himself, and is eventually rewarded with wealth, fame and honor"; (3) "The Benign Community," about "neighbors and friends rolling up their sleeves and pitching in to help one another, of self-sacrifice, community pride and patriotism"; and (4) "The Mob at the Gates," the tale of "mob rule, violence, crime and indulgence—of society coming apart from an excess of democratic permissiveness."

29. Paul Fussell, *The Boy Scout Handbook and Other Observations* (New York, 1982), p. 233.

30. George M. Frederickson, "Redemption Through Violence," *New York Review of Books*, November 21, 1985, pp. 38, 39.

31. That thesis has been formulated most comprehensively by Richard Slotkin in his two works *Regeneration Through Violence: The Mythology of the American Frontier, 1600–1860* (Middletown, Conn., 1973) and *The Fatal Environment: The Myth of the Frontier in the Age of Industrialization, 1800–1890* (New York, 1985). See also Richard Drinnon, *Facing West: The Metaphysics of Indian-Hating and Empire-Building* (New York, 1980).

32. This division has not always been so clear cut—as the American firebombing of Tokyo or the atomic bombing of Hiroshima and Nagasaki demonstrate.

33. The most notable expression of that sentiment was enunciated by a U.S. major during the Vietnam War's Tet offensive: "We had to destroy the village to save it."

With the official closing of the frontier in 1890, America—according to the related myth of Manifest Destiny—had to look for new territory to subdue, new lands to conquer. Very little had to change to apply the principle of Manifest Destiny to America's next conflict, the Spanish-American War. The means of warfare did not even have to be adapted. With the help of the regular army, formerly posted on the frontier, and the Rough Riders, partly consisting of cowboys, the range could be ridden again. The only, small, difference was that this time the Indians were fighting alongside the army, as members of the Rough Riders. The late inhabitants of the frontier were fighting with the whites for America's new frontiers overseas.

34. George C. Marshall, H. H. Arnold, and Ernest J. King, *The War Reports of General of the Army George C. Marshall, General of the Army H. H. Arnold, Fleet Admiral Ernest J. King* (Philadelphia, 1947), p. 255.

35. Personal interview with Ralph Morse, July 13, 1986.

36. Ed Siegel, "Apartheid, uncensored," *Boston Globe*, December 14, 1987, p. 29.

37. Stapp, " 'Subjects of Strange . . . and of Fearful Interest . . .' "

38. Ibid.

39. All quoted in ibid.

40. Ibid.

Chapter 1. "A Grand Popular Movement"

1. H. Irving Hancock, *What One Man Saw* (New York, 1900), p. 94.

2. Theodore Roosevelt, as quoted in Gerald Linderman, *The Mirror of War* (Ann Arbor, 1974), p. 200.

3. William McKinley, as quoted in Richard Hofstadter, *The Paranoid Style in American Politics and Other Essays* (New York, 1965), p. 177.

4. Ibid., p. 161.

5. James Creelman, *On the Great Highway* (Boston, 1901), pp. 169–70.

6. Richard Harding Davis, *Cuba in War Time* (New York, 1897), p. 105. The Spanish countered and defended themselves by arguing that their campaign in Cuba was only modelled on Sherman's and Sheridan's campaigns in the South during the U.S. Civil War. See Thomas C. Leonard, *Above the Battle* (New York, 1978), p. 19.

7. Stephen Crane, "In the First Land Fight Four of Our Men Are Killed" and "Only Mutilated by Bullets," in Fredson Bowers, ed., *The Works of Stephen Crane: Reports of War*, vol. 9 (Charlottesville, Va., 1971), pp. 129 and 131.

8. Theodore Roosevelt, *The Rough Riders and Men of Action*, vol. 11 (New York, 1926), p. 68.

9. Stephen Crane, "Stephen Crane at the Front for *The World*" and "How Americans Make War," in Bowers, ed., *The Works of Stephen Crane*, pp. 144, 230–31.

10. Stephen Crane, "Hunger Has Made Cubans Fatalists," in Bowers, ed., *The Works of Stephen Crane*, p. 148.

11. Leonard, *Above the Battle*, pp. 122–23.

12. Stephen Crane, "Stephen Crane's Vivid Story of the Battle of San Juan," in Bowers, ed., *The Works of Stephen Crane*, p. 163.

13. Charles Belmont Davis, ed., *Adventures and Letters of Richard Harding Davis* (New York, 1917), p. 249.

14. Nelson A. Miles, *Annual Report of the Major-General Commanding the Army to the Secretary of War* (Washington, D.C., 1898), p. 597.

15. Stephen Bonsal, *The Fight for Santiago* (New York, 1899), p. 443.

16. William McKinley, *Message of the President of the United States on the Relations of the United States to Spain, and Report of the Committee on Foreign Relations, United States Senate, Relative to Affairs in Cuba* (Washington, D.C., 1898), p. 13.

17. Linderman, *The Mirror of War*, p. 64. Typical of the poorly planned and poorly advised policies of the war in general was the decision to recreate the Civil War volunteer army. This resurrection of a distinct volunteer branch in the armed forces meant that all the regular army men remained in their regiments while all the volunteers were herded into new ones. Because of this grouping, it was not possible to temper the volunteer troops with the regular soldiers.

18. General Grenville M. Dodge et al., *Report of the Commission Appointed by the President to Investigate the Conduct of the War Department in the War with Spain* (Washington, D.C., 1899), p. 9.

19. Roosevelt, *The Rough Riders*, p. 67. It is interesting to note that the press and public went out of their way to compliment the American black troops. Writing of the taking of El Caney, correspondent Hancock wrote, "The Twenty-fifth Infantry, negro troops with West Point officers, has just started up that hill in the face of the rain of death. What a splendid sight it is! . . . These figures are dropping, too—dropping faster than we can witness with composure, for these men are trying to carry the Stars and Stripes up to the fort. It is so glorious that we feel like dancing. We have read about such deeds, but this is the first time that we have seen men of flesh and blood performing them before our eyes. They are proving that Americans have not deteriorated as fighters, and these men are black, neither better nor worse fighters than their white comrades. In the army the color line is little heard of. There are white infantrymen and cavalrymen standing nearby, in support of the battery. They are eager spectators, and they tingle with pride at sight of the splendid work the Twenty-fifth is doing on that slope slippery with red blood. These eager spectators can stand it no longer and keep quiet. A wild cheer rises." Hancock, *What One Man Saw*, pp. 102–3.

20. Stephen Crane, "Regulars Get No Glory," in Bowers, ed., *The Works of Stephen Crane*, pp. 171 and 173.

21. Roosevelt, *The Rough Riders*, p. 40.

22. Ibid., p. 37.

23. J. Glenn Gray, *The Warriors: Reflections on Men in Battle* (New York, 1959), p. 106.

24. Edward Marshall, "A Wounded Correspondent's Recollections of Guasimas," *Scribner's Magazine*, September 1898, p. 275.

25. Captain Arthur Lee, "The Regulars at El Caney," *Scribner's Magazine*, October 1898, p. 403.

26. Richard Harding Davis, "The Battle of San Juan," *Scribner's Magazine*, October 1898, p. 401.

27. Ibid., p. 402.

28. Ibid.

29. Theodore Roosevelt, as quoted in Linderman, *The Mirror of War*, p. 113.

30. Crane, "Stephen Crane's Vivid Story of the Battle of San Juan," p. 158.

31. Ibid.

32. Joseph Edgar Chamberlin, "How the Spaniards Fought at Caney," *Scribner's Magazine*, September 1898, p. 281.

33. Major Matthew F. Steele, as quoted in R. Ernest Dupuy and Trevor N. Dupuy, *Military Heritage of America* (Fairfax, Va., 1984), p. 321.

34. Davis, "The Battle of San Juan," p. 397.

35. Davis, ed., *Adventures and Letters of Richard Harding Davis*, pp. 242–44.

36. John C. Hemment, *Cannon and Camera* (New York, 1898), pp. 114–16.

37. Lee, "The Regulars at El Caney," p. 406.

38. Miles, as quoted in *Annual Report of the Major-General Commanding the Army*, p. 598.

39. Field-Marshall Viscount Montgomery of Alamein, *A History of Warfare* (London, 1970), p. 459.

40. Stephen Crane, "Captured Mausers for Volunteers," in Bowers, ed., *The Works of Stephen Crane*, p. 170.

41. Lee, "The Regulars at El Caney," p. 406.

42. Chamberlin, "How the Spaniards Fought at Caney," pp. 279–80.

43. John G. Winter, Jr., "How It Feels to Be Under Fire," in James William Buel, ed., *Behind the Guns with American Heroes* (Philadelphia, 1899), p. 315.

44. John H. Parker, *Tactical Organizations and Uses of Machine Guns in the Field* (Kansas City, 1899), p. 44.

45. John Black Atkins, *The War in Cuba* (London, 1899), p. 180.

46. Roosevelt, *The Rough Riders*, p. 87.

47. Stephen Crane, "The Red Badge of Courage Was His Wig-Wag Flag," in Bowers, ed., *The Works of Stephen Crane*, p. 137.

48. Caspar Whitney, "The Santiago Campaign," *Harper's New Monthly Magazine*, October 1898, p. 810.

49. Marshall, "A Wounded Correspondent's Recollections of Guasimas," p. 273.

50. Hancock, *What One Man Saw*, p. 106.

51. Richard Harding Davis, "In the Rifle Pits," *Scribner's Magazine*, December 1898, p. 647.

52. Marshall, "A Wounded Correspondent's Recollections of Guasimas," p. 274.

53. Quoted in Miles, *Annual Report of the Major-General Commanding the Army*, p. 383.

54. Winter, "How It Feels to Be Under Fire," pp. 315–16.

55. Hemment, *Cannon and Camera*, p. 153.

56. Dodge et al., *Report of the Commission*, pp. 84–85.

57. Hancock, *What One Man Saw*, p. 106.

58. Ibid., pp. 127 and 128.

59. Crane, "Stephen Crane's Vivid Story of the Battle of San Juan," p. 159.

60. Hancock, *What One Man Saw*, p. 117.

61. Crane, "Stephen Crane's Vivid Story of the Battle of San Juan," p. 159.

62. Davis, *Cuba in War Time*, p. 116.

63. Roosevelt, *The Rough Riders*, p. 79.

64. Atkins, *The War in Cuba*, pp. 169–70. The brass-coated bullet that was shot from the .45 caliber rifle carried by the irregular Spanish troops, however, was not so "humane." Upon firing, its brass coat was ripped off, making a thin plate of hard metal with a jagged edge that inflicted a "ghastly wound."

65. Dodge et al., *Report of the Commission*, p. 75. Undoubtedly, however, the number

of operations is considerably underestimated, since in the press of work in the advance against Santiago record keeping was often impracticable..

66. The War Department, *Annual Reports of the War Department for the Fiscal Year ended June 30, 1899, Reports of Chiefs of Bureaus* (Washington, D.C., 1899), pp. 501–3.

67. Richard Harding Davis, *Notes of a War Correspondent* (New York, 1912), p. 129.

Chapter 2. The New Profession

1. Arthur Brisbane, "The Modern Newspaper in War Time," *The Cosmopolitan*, September 1898, p. 549.

2. Richard Harding Davis, "Our War Correspondents in Cuba and Puerto Rico," *Harper's New Monthly Magazine*, May 1899, p. 940.

3. Charles Belmont Davis, ed., *Adventures and Letters of Richard Harding Davis* (New York, 1917), pp. 247 and 252.

4. Ralph Paine, *Roads of Adventure* (Boston, 1922), p. 187.

5. "War Time Snap Shots," *Munsey's Magazine*, October 1898, pp. 3 and 4.

6. Charles H. Brown, *The Correspondents' War: Journalists in the Spanish-American War* (New York, 1967), p. 225.

7. William R. Shafter, "The Capture of Santiago de Cuba," *The Century Illustrated Monthly Magazine*, February 1899, p. 615.

8. Quoted in Frank Luther Mott, *American Journalism* (New York, 1941), p. 536.

9. Brown, *The Correspondents' War*, p. 226.

10. Ibid., p. 227.

11. Davis, ed., *Adventures and Letters*, p. 232.

12. Stephen Bonsal, *The Fight for Santiago* (New York, 1899), p. 262. Actually, drawings had already been sent by wire as early as 1895, but the technology for transmitting photographs for press use did not appear until the early 1920s.

Another innovation at this time in pictorial journalism—whose perfection was to be years in the future—was the kinetoscope. A kinetoscope man arrived in Cuba, complete with his heavy, awkward equipment. He had lofty aspirations: "My idea," he said, "is that when the war is over and Congress meets, they will vote to have my pictures strung around the Capitol on revolving screens, where everybody can see them. You see it's un-American, those old Greek facades and Roman porticos, with which we have been putting up so long. The people of the United States want something with a little snap and go to it, and won't they be pleased when they see my pictures moving and quivering with life right under their eyes, as they move around the base of the Capitol." Unfortunately or not, the plan came to naught. "I don't think," the kinetoscope man was finally forced to admit, "there is much in this campaign for the kinetoscope." Quoted in ibid., pp. 161 and 162.

13. John C. Hemment, *Cannon and Camera* (New York, 1898), pp. 99–103.

14. War Department, *Annual Reports of the War Department for the Fiscal Year ended June 30, 1899, Reports of Chiefs of Bureaus* (Washington, D.C., 1899), p. 818.

15. Samuel Reber, *Manual of Photography* (Washington, D.C., 1896), p. 9.

16. Ibid., p. 10.

17. Hemment, *Cannon and Camera*, pp. 62–63, 65–66.

18. Ibid., pp. 266–67.

19. Ibid., p. 267.

20. Frederic Remington, "With the Fifth Corps," *Harper's New Monthly Magazine*, November 1898, p. 963.

21. Ibid., p. 99.

22. H. Irving Hancock, *What One Man Saw* (New York, 1900), p. 133.

23. Hemment, *Cannon and Camera*, p. 103.

24. Cecil Carnes, *Jimmy Hare News Photographer: Half a Century with a Camera* (New York, 1940), p. 93.

25. Burr McIntosh, *The Little I Saw of Cuba* (New York, 1899), p. 173.

26. New York *Journal*, July 7, 1898, p. 21.

27. Davis, "Our War Correspondents," *Harper's*, p. 943.

28. James Creelman, "My Experiences at Santiago," *American Monthly Illustrated Review of Reviews*, November 1898, p. 546.

29. James Burton, "Photographing Under Fire," *Harper's Weekly*, August 5, 1898, p. 774.

30. Hemment, *Cannon and Camera*, pp. 268–69.

31. McIntosh, *The Little I Saw of Cuba*, pp. 121–22.

32. Hemment, *Cannon and Camera*, p. 158.

33. Ibid., p. 186.

34. McIntosh, *The Little I Saw of Cuba*, pp. 126–27.

35. Hemment, *Cannon and Camera*, p. 24.

36. McIntosh, *The Little I Saw of Cuba*, p. 82.

37. Ibid.

38. Hemment, *Cannon and Camera*, p. 265.

39. Edward Marshall, "How It Feels to Be Shot," *The Cosomopolitan*, September 1898, pp. 557 and 558.

40. Davis, ed., *Adventures and Letters*, p. 246.

41. Richard Harding Davis, *Notes of a War Correspondent* (New York, 1912), p. 125.

42. Hancock, *What One Man Saw*, pp. 103–4.

43. Bonsal, *The Fight for Santiago*, p. 234.

44. Ibid., pp. 289–90.

45. Richard Harding Davis, *Cuba in War Time* (New York, 1897), p. 116.

46. Hemment, *Cannon and Camera*, pp. 269–70.

47. Ibid., p. ix.

48. James Creelman, *On the Great Highway* (Boston, 1901), p. 199.

Chapter 3. A Validation of Expectations

1. Charles Belmont Davis, ed., *Adventures and Letters of Richard Harding Davis* (New York, 1917), pp. 254–55 and 240.

2. James Creelman, *On the Great Highway* (Boston, 1901), p. 203.

3. Ibid., p. 188.

4. Ralph D. Paine, *Roads of Adventure* (Boston, 1922), pp. 265–68; and U.S. Government, *Correspondence Relating to the War with Spain . . .* , vol. I (Washington, D.C., 1902), p. 176.

5. Creelman, *On the Great Highway*, p. 176.

6. Will Irwin, *Propaganda and the News or What Makes You Think So?* (New York, 1936), p. 97.

7. Creelman, *On the Great Highway*, p. 187.

8. As quoted in Marcus Wilkerson, *Public Opinion and the Spanish-American War* (Baton Rouge, La., 1932), pp. 125–26.

9. Arthur Brisbane, "The Modern Newspaper in War Time," *The Cosmopolitan*, September 1898, p. 542.

10. Joseph E. Wisan, *The Cuban Crisis as Reflected in the New York Press (1895–1898)* (New York, 1934), p. 460.

11. Ibid., pp. 460 and 454.

12. Davis, ed., *Adventures and Letters*, p. 246.

13. "From the Front," *Collier's Weekly*, April 30, 1898, unpaginated.

14. Brisbane, "The Modern Newspaper in War Time," pp. 544–54.

15. Lincoln Steffens, "The Business of a Newspaper," *Scribner's Magazine*, October 1897, p. 461.

16. Creelman, *On the Great Highway*, p. 177.

17. Burr McIntosh, *The Little I Saw of Cuba* (New York, 1899), p. 68.

18. William James, "The Moral Equivalent of War," *McClure's Magazine*, August 1910, p. 463.

19. McIntosh, *The Little I Saw of Cuba*, p. 82.

20. Theodore Roosevelt, "The Rough Riders," *Scribner's Magazine*, March 1899, p. 263.

21. McIntosh, *The Little I Saw of Cuba*, p. 82.

22. Davis, ed., *Adventures and Letters*, p. 250.

23. McIntosh, *The Little I Saw of Cuba*, p. 82.

24. Ibid.

25. James Burton, "Photographing Under Fire," *Harper's Weekly*, August 6, 1898, p. 774.

26. Burr McIntosh, "A Rough Rider's Photographs Taken at the Front," *Leslie's Weekly*, July 28, 1898, p. 71.

27. Burr McIntosh, "On the Eve of Battle at Santiago," *Leslie's Weekly*, July 28, 1898, p. 69. The caption of this photograph is misleading, since the Rough Riders had just had an "onslaught" against the Spanish, which had hardly been irresistible. Interesting, too, is the identification of the Rough Riders as belonging to Theodore Roosevelt, although the commander of the Rough Riders was Colonel Wood, who is in the photograph as well.

28. McIntosh, *The Little I Saw of Cuba*, p. 82. Theodore Roosevelt, the main target of McIntosh's condemnation, did feel the loss of his men. Speaking of the early deaths of Hamilton Fish and his officer, Captain Capron, Roosevelt wrote: "Here, at the very outset of our active service, we suffered the loss of two as gallant men as ever wore uniform." Roosevelt, "The Rough Riders," p. 272. But the difference between Roosevelt and McIntosh was that Roosevelt did not take the deaths personally; to him, death in whatever guise was a fact of war.

McIntosh finally forgave Roosevelt. In the copy of McIntosh's book *The Little I Saw of Cuba*, now in the Roosevelt archives at Widener Library, Harvard University, McIntosh wrote: "In memory and genuine appreciation of Theodore Roosevelt, who in my Cuban days, didn't do everything just as I wished, but who I learned to deeply admire for cause, in later years, I beg to subscribe myself. Sincerely, Burr McIntosh New York. Dec. 29th, 1925."

29. The advertising firm of Ted Bates was responsible for the Navy recruitment "adventure" theme of the past eleven years. However, beginning with fiscal year October 1987, the New York agency BBD & O is handling the navy's advertising account. The new recruitment theme centers on the attraction of "high-tech" careers in the navy. Telephone interview with Lieutenant Commander Sam Falcona, Navy Recruitment Command, Advertising Department, Washington, D.C., October 29, 1987.

30. James Burton, "General Lawton's Attack with the Right Wing—The Battle of El Caney, July 1," *Harper's Weekly*, July 30, 1898, p. 736.

31. Naomi Rosenblum, *A World History of Photography* (New York, 1984), p. 299.

32. J. C. Hemment, "All That Is Left of Cervera's Once Famous and Formidable Spanish Fleet," *Leslie's Weekly*, August 4, 1898, p. 89.

33. W. Stanley Church, "On Board Cervera's Destroyed Cruisers," *Collier's Weekly*, August 6, 1898, p. 4.

34. William Dinwiddie and James Burton, "Before Santiago—Photographs Taken Under Fire," *Harper's*, August 6, 1898, p. 779.

35. Burton, "General Lawton's Attack," p. 736.

Chapter 4. "An Affair of the Mind"

1. Quoted in Malcolm Cowley, *A Second Flowering* (New York, 1974), p. 6.

2. Owen was killed in France a week before the Armistice. Wilfred Owen, "Anthem for Doomed Youth" in Richard Ellmann and Robert O'Clair, eds., *The Norton Anthology of Modern Poetry* (New York, 1973), p. 516.

3. Winston Churchill, as quoted in George Kennan, *American Diplomacy: 1900–1950* (Chicago, 1951), p. 59. Kennan quotation on same page.

4. David M. Kennedy, *Over Here: The First World War and American Society* (New York, 1980), p. 46.

5. Quoted in Kennan, *American Diplomacy*, p. 63.

6. "Hate," *Collier's Weekly*, February 16, 1918, p. 10.

7. Kennan, *American Diplomacy*, pp. 72–73.

8. Quoted in Charles V. Genthe, *American War Narratives, 1917–1918: A Study and Bibliography* (New York, 1969), p. 29.

9. Edith Wharton, *The Marne* (New York, 1918), p. 44.

10. Floyd Gibbons, *And They Thought We Wouldn't Fight* (New York, 1918), p. 394.

11. Ibid., p. 217.

12. Arthur Guy Empey, *'Over the Top'* (New York, 1917), pp. 279–80.

13. Heywood Broun, *The A.E.F.* (New York, 1918), p. 111.

14. Gibbons, *And They Thought*, pp. 272–73.

15. Robert Graves, *Good-Bye to All That: An Autobiography* (London, 1929), p. 240.

16. Quoted in Kennedy, *Over Here*, p. 45.

17. John Dos Passos, *Three Soldiers* (Boston, 1921), p. 211.

18. Dalton Trumbo, *Johnny Got His Gun* (New York, 1939), pp. 114–15.

19. Ernest Hemingway, *A Farewell to Arms* (New York, 1929), pp. 184–85.

20. "With Our Heads Up," *Collier's Weekly*, December 1, 1917, p. 10.

21. Committee on Public Information, public service advertisement, "He Will Come Back a Better Man," *Collier's Weekly*, November 30, 1918, p. 22.

22. Wythe Williams, "The Sins of the Censor," *Collier's Weekly*, January 12, 1918, p. 6.

23. Quoted in Clyde M. Hill and John M. Avery, eds., *The War Book* (Montpelier, Vt., 1918), pp. 7 and 8.

24. Leonard P. Ayres, *The War with Germany: A Statistical Summary* (Washington, D.C., 1919), p. 17.

25. General John J. Pershing, *Final Report of Gen. John J. Pershing* (Washington, D.C., 1920), p. 8.

26. Ibid., pp. 14 and 15.

27. George Clarke Musgrave, *Under Four Flags for France* (New York, 1918), p. 348.

28. Quoted in Thomas C. Leonard, *Above the Battle: War-making in America from Appomattox to Versailles* (New York, 1978), p. 135.

29. Gibbons, *And They Thought*, pp. 247–48.

30. Dante Alighieri, *The Inferno*, John Ciardi, trans. (New York, 1954), p. 110.

31. Quoted in Ellmann and O'Clair, eds., *Norton Anthology*, p. 517.

32. Remarque, *All Quiet on the Western Front* (Boston, 1929), p. 55.

33. Gibbons, *And They Thought*, p. 231.

34. Ibid., p. 189.

35. Quoted in Richard Holmes, *Acts of War: The Behavior of Men in Battle* (New York, 1985), p. 170.

36. The first aim of an attack was to destroy what lay between one's own side and the enemy's. When the artillery bombardment was deemed sufficient to have cut the barbed wire and destroyed specific targets—after minutes or hours or days or weeks—the troops for the assault were brought up to the front line. At zero hour, the artillery concentrated its fire in front of the first line of infantry to go over the top. Theoretically protected by this moving wall of steel, the infantry entered No Man's Land and then, with luck, the enemy trenches or enemy line. The hope was that the initial artillery barrage would be sufficient to cut the wires and to be so devastating that the enemy would be forced into hiding and there killed or put out of commission long enough for the attackers to reach the enemy without the enemy having had time to get back into its defensive position. But there were always problems. The timing was never split second nor the aim of the artillery perfect. The enemy frequently had ample time to hide in its bunkers and survive to come out and reman its machine guns in the seconds between the letup of the barrage and the wave of attack. Waves upon waves of attackers were mowed down in No Man's Land—hundreds and thousands and millions of them.

37. Musgrave, *Under Four Flags*, p. 348.

38. John Keegan, *The Face of Battle* (New York, 1976), p. 232.

39. Quoted in Ayres, *The War with Germany*, p. 65.

40. Keegan, *The Face of Battle*, p. 234.

41. Benedict Crowell, *America's Munitions, 1917–1918: Report of Benedict Crowell, the Assistant Secr'y of War, Director of Munitions* (Washington, D.C., 1919), pp. 67, 69, 75, and 79.

42. Gibbons, *And They Thought*, p. 367.

43. Quoted in Colonel Trevor N. Dupuy, *The Evolution of Weapons and Warfare* (New York, 1980), p. 223.

44. Ayres, *The War with Germany*, pp. 99–100; Pershing, *Final Report*, p. 76.

45. Quoted in Emmet Crozier, *American Reporters on the Western Front, 1914–1918* (New York, 1959), p. 101.

46. Gibbons, *And They Thought*, p. 191.

47. Ayres, *The War with Germany*, p. 78. Compared to those who were wounded in other ways, fewer of those who survived to be cared for in the hospitals died from the effects of the gas. "Out of 74,573 gas cases in the hospitals," it was reported, "1,194 proved fatal, while out of 145,830 wounded in other ways, 13,519 died, showing respective fatality of 1.3/4 percent and 9.1/4 percent" (although it is unclear how many of the gassed died before being treated in a hospital relative to how many of those wounded in other ways died before reaching the hospital. See Fred A. Sassé, *Rookie Days of a Soldier* (St. Paul, Minn., 1924), p. 231.

48. Graves, *Good-Bye*, p. 191.

49. Graves, *Good-Bye*, p. 237. A rough translation would be, "And finally, these animals tore the ears off their enemies and put the ears in their pockets."

50. Frederick Palmer, *With My Own Eyes: A Personal Story of Battle Years* (Indianapolis, Ind., 1933), p. 321.

51. Quoted in Gibbons, *And They Thought*, p. 302.

52. Ibid., p. 298.

53. Ibid., pp. 303–4.

54. Major Frederick Palmer, *America in France* (New York, 1918), p. 278.

55. Frederick Palmer, *Our Greatest Battle (The Meuse-Argonne)* (New York, 1919), pp. 494–95.

56. Tony Ashworth, *Trench Warfare, 1914–1918: The Live and Let Live System* (New York, 1980).

57. Gibbons, *And They Thought*, p. 167.

58. Graves, *Good-Bye*, p. 215.

59. Broun, *The A.E.F.*, p. 262.

60. Quoted in Kelly Miller, *Kelly Miller's History of the World War for Human Rights. . . .* (New York, 1919), p. 415.

61. Quoted in ibid., p. 269.

62. Palmer, *Our Greatest Battle*, p. 494.

63. Ibid., p. 174.

64. Remarque, *All Quiet*, p. 135.

65. Graves, *Good-Bye*, p. 211.

66. Boyd Cable, *Between the Lines* (New York, 1915), p. 109.

67. Empey, '*Over the Top*,' pp. 260–61.

68. Remarque, *All Quiet*, p. 291.

69. Michael Walzer, *Just and Unjust Wars: A Moral Argument with Historical Illustrations* (New York, 1977), p. 109.

70. Dos Passos, *Three Soldiers*, p. 210.

71. Owen, "Dulce et Decorum Est," in Ellmann and O'Clair, eds., *Norton Anthology*, p. 519.

72. Palmer, *With My Own Eyes*, p. 380.

73. Palmer, *American in France*, p. 117.

74. Ayres, *The War with Germany*, p. 101.

75. Pershing, *Final Report*, p. 77.

Chapter 5. The Command Performance

1. "Aero-Photography," *Abel's Photographic Weekly*, December 21, 1918, pp. 533 and 537.

2. Ian Hamilton, *Gallipoli Diary*, 2 vols. (New York, 1920), vol. 1, p. 338.

3. Quoted in Lewis L. Gould and Richard Greffe, *Photojournalist: The Career of Jimmy Hare* (Austin, Tex., 1977), p. 123.

4. Emmet Crozier, *American Reporters on the Western Front, 1914–1918* (New York, 1959), pp. 23–24.

5. Frederick Palmer, *With My Own Eyes: A Personal Story of Battle Years* (Indianapolis, Ind., 1932), p. 342.

6. William G. Shepherd, *Confessions of a War Correspondent* (New York, 1917), pp. 89–90.

7. Ibid., pp. 90, 92, and 107.

8. Ibid., pp. 89 and 93.

9. Palmer, *With My Own Eyes*, p. 322.

10. Ibid., pp. 319–20.

11. Shepherd, *Confessions*, pp. 115, 116, 117, and 118.

12. Ibid., pp. 119–20.

13. Ibid., p. 120.

14. Gould and Greffe, *Photojournalist*, pp. 123 and 139.

15. Ibid., p. 139.

16. Robert W. Desmond, *Windows on the World: The Information Process in a Changing Society, 1900–1920* (Iowa City, Iowa, 1980), pp. 377–79.

17. "For Chief of Staff," June 8, 1918, in file "Number of Correspondents to Be Accredited—Agreement & Bond," Box 6132, Entry 221, rg. no. 120, NNMR, National Archives, Washington, D.C. (All succeeding National Archives notes are from the same rg. no., same section.)

18. "Paragraph for Cable," December 26, 1917, in file "Photography—Signal Corps G-2-D," Box 6191, Entry 233, National Archives.

19. "Memorandum for: Capt Wm H. Moore, Asst G-2-D," April 2, 1919, in file "Sig. Corps Lab.—Photos—Correspondence G-2-D," Box 6190, Entry 233, National Archives.

20. "For Chief of Staff," June 19, 1918, in file "Photography—Signal Corps G-2-D," Box 6191, Entry 233, National Archives.

21. "General Orders. No. 96," June 15, 1918, in file "Sig. Corps Lab—Photo. Sec. Regulations G-2-D," Box 6191, Entry 233, National Archives.

22. "For Chief of Staff," June 19, 1918.

23. Historical Division, Department of the Army, *United States Army in the World War, 1917–1919, Reports of Commander-in-Chief, A.E.F., Staff Sections and Services, Part II*, vol. 13 (Washington, D.C., 1948), p. 131.

24. In addition to the total of 1,650 passed, 56 were held by the censor. In comparison, 3,418 Signal Corps photographs were passed and 149 were held in the same three-month period. In addition, 46 official British photographs, 360 official French photographs, 651 photographs taken by YMCA photographers, 241 photographs taken by the Red Cross, and 95 taken by the CPI were passed; and 11 YMCA photographs, 3 Red Cross photographs, and 6 CPI photographs were held. See "Memorandum" (monthly reports of the photographic censor), August 7, 1918, in file "Photographic Sub-Sec. Mo. Reports G-2-D," Box 6191, Entry 233, National Archives.

25. Lieutenant-Colonel Kendall Banning, *Military Censorship of Pictures in World War I* (Washington, D.C., undated, but between 1919 and 1930), U.S. Army Military History Institute Archives, Carlisle Barracks, Pa., p. 7.

26. Ibid., pp. 23–24. The authorities were right; to a surprising degree, the censorship—at least by the editors, if not the journalists—was voluntary. As the *Nation* wrote immediately after the Armistice, "During the past two years we have seen what is practically an official control of the press, not merely by [the government] but by the logic of events and the patriotic desire of the press to support the government." Quoted in Frank Luther Mott,

American Journalism: A History of Newspapers in the United States Through 250 Years, 1690 to 1940 (New York, 1941), p. 625.

27. Wythe Williams, "The Sins of the Censor," *Collier's Weekly*, January 12, 1918, p. 6.

28. "General Orders No. 15," January 24, 1918, in file "Photography—Signal Corps G-2-D," Box 6191, Entry 233, National Archives.

29. "News Photographers Wanted for the Service," *Abel's Photographic Weekly*, May 18, 1918, p. 446; and "A Call for Photographers," *Abel's Photographic Weekly*, March 9, 1918, p. 203.

30. War Department, *Annual Report, War Department, Fiscal Year ended June 30, 1919: Report of the Chief Signal Officer to the Secretary of War* (Washington, D.C., 1919), p. 345.

31. "Memorandum for Major Robert Johnston, Historical Branch, W.P.D.," April 22, 1918, in file "Photographic Sub-Sec. G-2-D," Box 6191, Entry 233, National Archives.

32. "Memorandum to Lt. Col. Adna G. Clark," August 19, 1918, in file "Sig. Corps Lab.—Photos—Correspondence G-2-D," Box 6190, Entry 233, National Archives.

33. War Department, *Annual Report*, 1919, p. 341.

34. Gear, "Aerial Photography," *Abel's Photographic Weekly*, March 30, 1918, p. 269.

35. Wilfred A. French, "Aërial Fighting Cameras," *Photo-Era*, November 1918, pp. 248–49.

36. Historical Division, *United States Army*, vol. 15, p. 286.

37. War Department, *Annual Report*, 1919, pp. 341–42.

38. Committee on Public Information, *Complete Report of the Chairman of the Committee on Public Information, 1917; 1918; 1919* (Washington, D.C., 1920), p. 61.

39. James R. Mock and Cedric Larson, *Words That Won the War: The Story of the Committee on Public Information, 1917–1919* (Princeton, N.J., 1939), p. 153.

40. "Distribution of Signal Corps Photographs in America," August 28, 1918, in file "Photography—Signal Corps G-2-D," Box 6191, Entry 233, National Archives.

41. "Memorandum" (monthly reports of the photographic censor), May 1, August 7, October 1918, in file "Photographic Sub-Sec. Mo. Reports G-2-D," and September 1918, in file "Photographic Sub-Sec. G-2-D," Box 6191, Entry 233, National Archives.

42. Historical Division, *United States Army*, vol. 13, p. 134.

43. "Distribution of Signal Corps Photographs in America," National Archives.

44. "Pictures of American Expeditionary Forces," July 27, 1918, in file "Sig. Corps Lab.—Photos—Correspondence War College—G-2-D," Box 6190, Entry 233, National Archives.

45. "Report for August," September 9, 1918, in file "Photographic Sub-Sec. Mo. Reports G-2-D," Box 6191, Entry 233, National Archives.

46. Letter to Captain William E. Moore, August 20, 1918, in file "Sig. Corps Lab.—Photos—Correspondence War College—G-2-D," Box 6190, Entry 233, National Archives.

47. Letter from Edward Trabold, August 25, 1955, in folder "Photo & Trabold Papers," Box: Signal Corps Photography, The Signal Corps Collection, U.S. Army Military History Institute Archives, Carlisle Barracks, Pa.

48. "Are You One of Those Reluctant Ones?" *Abel's Photographic Weekly*, January 12, 1918, p. 9.

49. "Progress of Work in Photographic Div," June 7, 1918, in file "Photography—Signal Corps—Monthly Reports G-2-D," Box 6191, National Archives.

50. Albert K. Dawson, "Photographing on the Firing-Line," *Photo-Era*, May 1917, pp. 232 and 234.

51. R. Ernest Dupuy and Trevor N. Dupuy, *Military Heritage of America* (Fairfax, Va., 1984), p. 375.

52. A year after the war, Trabold wrote an article, "Counterattacking with a Camera," for *The Photographic Journal of America*, September 1919, pp. 407–12, describing the events of May 28. Thirty-six years after the war, Trabold wrote a series of letters to the Signal Corps Photography Division to ascertain whether he was the first photographer who "went over with [American] troops and made pictures of them making and [sic] attack." After "very extensive research into the claim," the army concluded he was. The facts related in Trabold's letters agree with his earlier article, but the events as recalled in the letter sound stylistically truer, less edited than the account written for publication.

53. Letters from Edward Trabold, August 25, 1955, and March 9, 1954, U.S. Army Military History Institute Archives.

54. War Department, *Annual Report*, 1919, p. 345.

55. Williams, "The Sins of the Censor," p. 6.

56. James H. Hare, "When the Austrians Reswam the Piave," *Leslie's Weekly*, August 24, 1918, p. 243.

57. Dawson, "Photographing," p. 232.

58. David H. Mould, *American Newsfilm, 1914–1919: The Underexposed War* (New York, 1983), p. 218.

59. "Report from Lieut. Paul D. Miller," Nov. 1, 1917, in file "Correspondence of Signal Corps Laboratory G-2-D," Box 6191, Entry 233, National Archives.

60. Quoted in Mould, *American Newsfilm*, p. 220.

61. Quoted in ibid., p. 218.

62. "Memorandum to Major A. L. James, Jr.," July 23, 1918, in file "Photographic Sub-Sec. G-2-D," Box 6191, Entry 233, National Archives.

63. Banning, *Military Censorship*, pp. 12–13.

64. Shepherd, *Confessions*, pp. 64 and 50.

65. Ibid., pp. 56–57.

66. Ibid., p. 69.

67. Ibid., p. 75.

Chapter 6. A Suppression of Evidence

1. "Memorandum for Lt. Colonel Dennis E. Nolan," December 17, 1917, in file "Press Misc. Data Am-Th; Misc. Visits & Data Ac-At," Box 6122, Case 66-4, Entry 221, rg. no. 120, NNMR, National Archives, Washington, D.C., p. 1.

2. Ibid., p. 2.

3. "Committee on Public Information: What the Government Asks of the Press," January 1, 1918, in file "Censorship: Rules of the Press," Box 6127, Case 67-1, Entry 228, rg. no. 120, NNMR, National Archives.

4. "Memorandum: To Colonel Moreno," March 3, 1919, in file "Lists and Status of Visiting and Acc. Correspondents," Box 6132, Case 67-2, Entry 221, rg. no. 120, NNMR, National Archives, p. 8.

5. Will Irwin, *Propaganda and the News or What Makes You Think So?* (New York, 1936), p. 191.

6. Robert W. Desmond, *Windows on the World: The Information Process in a Changing Society, 1900–1920* (Iowa City, Iowa, 1980), pp. 316 and 279.

7. "Jimmy Hare, 82, Opines There'll Always Be War," unidentified newspaper clipping stamped Oct 2, 1938, in the Brooklyn Collection, History Division, Pamphlet File "Hare, James H. (Jimmy)," Brooklyn Public Library, Brooklyn, New York.

8. Lieutenant-Colonel Kendall Banning, *Military Censorship of Pictures in World War I* (Washington, D.C., undated, but between 1919 and 1930), U.S. Army Military History Institute Archives, Carlisle Barracks, Pa., p. 11.

9. Ibid., p. 23.

10. "Our Nation's Roll of Honor," *Mid-Week Pictorial*, April 11, 1918, unpaginated.

11. "Our Nation's Roll of Honor," *Mid-Week Pictorial*, March 7, 1918, unpaginated.

12. "Pershing's Army in France Now Engaged in Warfare in Grim Earnest, as Shown by the Daily Report of Casualties Sustained," *Mid-Week Pictorial*, May 16, 1918, unpaginated.

13. Americans on the Fighting Line in Lorraine," *Mid-Week Pictorial*, March 14, 1918, unpaginated.

14. William Slavens McNutt, "Under Fire with the Yanks," *Collier's Weekly*, July 27, 1918, p. 11; and "Our Heroes at the Front," *Leslie's Weekly*, August 10, 1918, p. 177.

15. H. Irving Hancock, "Snarl When You Use Cold Steel," *Leslie's Weekly*, February 2, 1918, p. 155.

16. "Grim Actualities Photographed on the Scene of the Americans' Heroic Achievements in the Marne Salient," *Mid-Week Pictorial*, August 29, 1918, unpaginated.

17. "Where the Great Battle Rolls On," *Leslie's Weekly*, June 15, 1918, p. 834.

18. James H. Hare, "The Red Harvest on the Piave," *Leslie's Weekly*, August 24, 1918, p. 244.

19. Lucian S. Kirtland, "War's Skulls *and* Crossbones," *Leslie's Weekly*, May 25, 1918, p. 718.

20. "A Flashlight on the War—Gas and Gas Masks," *Mid-Week Pictorial*, March 14, 1918, unpaginated.

21. F. Britten Austin, "There!" *Saturday Evening Post*, October 19, 1918, p. 8.

22. Captain D——, French Army, Lawton Mackall, trans., "While the Big Guns Clear the Way, The Gallant Americans Go Forward," *Leslie's Weekly*, July 20, 1918, pp. 74–75.

23. E. R. Trabold, "Counterattacking with a Camera," *The Photographic Journal of America*, September 1919, p. 409.

24. "The American Army in New Phases of Its Activity," *Mid-Week Pictorial*, May 30, 1918, unpaginated; and McNutt, "Under Fire with the Yanks," p. 11.

25. Cover art, *Mid-Week Pictorial*, May 2, 1918.

26. "A Word of Criticism from 'A Bunch of Doughboys,' " *Mid-Week Pictorial*, August 8, 1918, unpaginated.

27. Ibid.

28. Arthur Ponsonby, *Falsehood in War-Time* (New York, 1928), p. 135.

29. "Real War Pictures—And the Other Kind," *Collier's Weekly*, January 26, 1918, pp. 12–13.

Chapter 7. "An Urgent Obligation"

1. Quoted in Studs Terkel, *The Good War: An Oral History of World War Two* (New York, 1984), p. 185.

2. Quoted in Paul Fussell, *Thank God for the Atom Bomb and Other Essays* (New York, 1988), p. 132.

3. John Steinbeck, *Once There Was a War* (New York, 1958), p. 19.

4. John Morton Blum, *V Was for Victory: Politics and American Culture During World War II* (New York, 1976), pp. 53 and 16.

5. Bill Mauldin, *Up Front* (New York, 1945), p. 10.

6. Quoted in James MacGregor Burns, *Roosevelt: The Soldier of Freedom* (New York, 1970), pp. 34–35.

7. Major H. A. DeWeerd, ed., *Selected Speeches and Statements of General of the Army George C. Marshall* (Washington, D.C., 1945), p. 204.

8. Steinbeck, *Once There Was a War*, p. 76.

9. Quoted in Margaret Bourke-White, *They Called It 'Purple Heart Valley': A Combat Chronicle of the War in Italy* (New York, 1944), pp. 73 and 76.

10. John Hersey, *Into the Valley: A Skirmish of the Marines* (New York, 1966), p. 111.

11. For a discussion of the racist nature of the war in the Pacific, see John W. Dower, *War Without Mercy: Race and Power in the Pacific War* (New York, 1986).

12. Ernie Pyle, *Last Chapter* (New York, 1945), p. 5.

13. Although the men who had seen action were "strikingly less vindictive toward the Japanese than were . . . soldiers in training in the United States," 44 percent of an average American combat performance group in training would "really like to kill a Japanese soldier" and 32 percent would "feel that it was just part of the job." When asked about the Germans, however, only 6 percent were enthusiastic about killing the enemy and 52

percent were willing to do it as part of the job. See Samuel A. Stouffer et al., *The American Soldier: Adjustment During Army Life* (Princeton, 1949), vol. 1, pp. 157–78 and 34.

14. Mauldin, *Up Front*, p. 46.

15. "How to Tell Your Friends from the Japs," *Time*, December 22, 1941, p. 33.

16. "How to Tell Japs from the Chinese," *Life*, December 22, 1941, p. 81.

17. See John Dollard, *Fear in Battle* (New Haven, 1943)—the Yale Institute of Human Relations study of American veterans of the Abraham Lincoln Brigade in the Spanish Civil War.

18. Peter Bowman, *Beach Red* (New York, 1945), p. 105.

19. Mauldin, *Up Front*, p. 46.

20. Ernie Pyle, "Thanks, Pal," in Curt Riess, ed., *They Were There: The Story of World War II and How It Came About by America's Foremost Correspondents* (New York, 1944), pp. 558–59.

21. Stouffer et al., *The American Soldier*, vol. 1, p. 432.

22. Training Division, Bureau of Aeronautics, U.S. Navy, *Hand-To-Hand Combat* (Annapolis, Md., 1943), pp. v, 14, and vii, respectively.

23. Mauldin, *Up Front*, pp. 11–12.

24. Ibid., pp. 46–47.

25. Actually, the soldiers were likely to keep bones other than the skull as souvenirs. It was an incredibly messy and tedious task to boil a skull clean. See Edgar L. Jones, "One War Is Enough," *The Atlantic Monthly*, February 1946, p. 49.

26. George F. Kennan, *American Diplomacy: 1900–1950* (New York, 1951), pp. 77–78. See also Michael Walzer, *Just and Unjust Wars* (New York, 1977).

27. For an informed debate on this issue, see Fussell, *Thank God for the Atom Bomb and Other Essays*, pp. 13–43, in which Fussell includes a discussion between himself and Michael Walzer on the individual soldiers response to the dropping of the bomb.

28. Columbia Broadcasting System, *From Pearl Harbor into Tokyo* (New York, 1945), p. 246.

29. Of course, issues of morality and even the saving of American lives were more rationales than motivating causes for the dropping of the bomb. For an analysis of the decision to drop the bomb, see Barton Bernstein, *The Atomic Bomb: The Critical Issues* (Boston, 1976). For a discussion of the orthodox version of the decision, see Harry S Truman, *Year of Decisions* (Garden City, N.Y., 1955); Henry Stimson, "The Decision to Use the Atomic Bomb," *Harper's Magazine*, February 1947; and Henry Stimson and McGeorge Bundy, *On Active Service in Peace and War* (New York, 1948). For challenges to the orthodox version, see Gar Alperovitz, *Hiroshima and Potsdam* (New York, rev. ed., 1985); Martin Sherwin, *A World Destroyed* (New York, rev. ed., 1987); and Barton Bernstein, "A Post-War Myth: 500,000 U.S. Lives Saved," *Bulletin of the Atomic Scientists*, June–July 1986.

30. "Extra! Extra!" *Newsweek*, December 15, 1941, pp. 33–35; and CBS, *From Pearl Harbor*, pp. 5–6.

31. CBS, *From Pearl Harbor*, pp. 21–22.

32. U.S. Congress, Senate, *Declarations of a State of War with Japan, Germany, and Italy*, 77th Cong., 1st sess., Document 148 (Washington, D.C., 1941).

33. CBS, *From Pearl Harbor*, pp. 60–61.

34. George C. Marshall, H. H. Arnold, and Ernest J. King, *The War Reports of General of the Army George C. Marshall, General of the Army H. H. Arnold, Fleet Admiral Ernest J. King* (Philadelphia, 1947), pp. 64–65, 265, 350, and 494.

35. The acronyms stood for North African Theater of Operations; Mediterranean Theater of Operations; European Theater of Operations; South West Pacific Area (Theater); South Pacific Area (Theater); Pacific Ocean Areas (Theater); China, Burma, India (Theater); and India-Burma Theater, respectively.

36. Marshall, Arnold, and King, *The War Reports*, p. 104.

37. Quoted in R. Ernest Dupuy and Trevor N. Dupuy, *Military Heritage of America* (Fairfax, Va., 1984), p. 636.

38. Stouffer et al., *The American Soldier*, vol. 2, pp. 69–70.

39. Ibid., pp. 66–68.

40. Mauldin, *Up Front*, p. 41.

41. American LSTs had a speed of 11.6 knots, could transport 175 troops, and carry tanks and other vehicles ashore.

42. Robert Sherrod, "Tarawa," in Riess, ed., *They Were There*, pp. 486–87.

43. Ibid., p. 485.

44. Douglas MacArthur, *A Soldier Speaks: Public Papers and Speeches of General of the Army, Douglas MacArthur*, Major Vorin E. Whan, Jr., ed. (New York, 1965), p. 115.

45. Audie Murphy, *To Hell and Back* (New York, 1949), p. 272.

46. Steinbeck, *Once There Was a War*, p. 147.

47. Ibid., p. 138.

48. Mauldin, *Up Front*, pp. 86–87.

49. For a discussion of the historical expansion of the "killing zone," see John Keegan, *The Face of Battle: A Study of Agincourt, Waterloo and the Somme* (New York, 1976).

50. Carl von Clausewitz, *On War*, quoted in Jack Belden, *Still Time to Die* (New York, 1944), p. 237.

51. Steinbeck, *Once There Was a War*, p. 201.

52. Drew Middleton, *Our Share of Night* (New York, 1946), p. 375.

53. Mauldin, *Up Front*, p. 39.

54. Steinbeck, *Once There Was a War*, pp. 150–51.

55. S. L. A. Marshall, *Men Against Fire* (New York, 1947), p. 111.

56. Steinbeck, *Once There Was a War*, pp. 155–56.

57. Murphy, *To Hell and Back*, pp. 244 and 249.

58. Stouffer et al., *The American Soldier*, vol. 2, pp. 197–205.

59. Steinbeck, *Once There Was a War*, p. 28.

60. Richard Holmes, *Acts of War: The Behavior of Men in Battle* (New York, 1985), pp. 259–60.

61. Quoted in ibid., pp. 261–62.

62. Stouffer et al., *The American Soldier*, vol. 2, p. 198.

63. George S. Patton, Jr., *War as I Knew It* (Boston, 1947), p. 382.

64. Murphy, *To Hell and Back*, p. 109. Murphy, whose book was published in 1949, presumably pilfered this quotation from Bill Mauldin. Mauldin had captioned a Willie and Joe cartoon published during the war with the sentence "I feel like a fugitive from th' law of averages."

65. Keith Wheeler, *The Pacific Is My Beat* (New York, 1943), pp. 296–97.

66. Quoted in Holmes, *Acts of War*, pp. 181–82.

67. Charles M. Wiltse, *The Medical Department: Medical Service in the Mediterranean and Minor Theaters*, unnumbered volume in *The Technical Services*, series United States Army in World War II (Washington, D.C., 1965), pp. 1–6.

68. Bourke-White, *They Called It 'Purple Heart Valley,'* p. 118.

69. Steinbeck, *Once There Was a War*, p. 80.

70. The figures of the incidence of deaths from disease in previous wars were obtained from Marshall, Arnold, and King, *The War Reports*. However, if the official figures from the previous wars, as reported in the documents dating from those wars, are used to calculate the number of deaths from disease, the percentages are strikingly higher. It is difficult to know what figures the 1947 *War Reports* was using, but suffice it to say that the incidence of deaths by disease in World War II was significantly lower than it had been in either World War I or the Spanish-American War.

71. Marshall, Arnold, and King, *The War Reports*, pp. 130–32, 274–79.

72. Ibid., pp. 274–75 and 723.

73. Ibid., p. 310.

Chapter 8. A Model Partnership

1. F. A. Resch, "Photo Coverage of the War by the 'Still Picture Pool,'" *Journalism Quarterly*, December 1943, pp. 311–14; and Ralph Turner, "Photographers in Uniform," in Frank Luther Mott, ed., *Journalism in Wartime* (Washington, D.C., 1943), pp. 78–80, 82.

2. Erwin D. Canham, "The Newspaper's Obligation in Wartime," *Journalism Quarterly*, December 1943, p. 315.

3. Signal Corps Historical Project, F-2b, "Official Photography," January 28, 1945, File No. 4-11, Accession No. 386/2R, NNMR, National Archives.

4. "Documentation of Accredited War Correspondents," July 15, 1944, in *SHAEF Special Staff Public Relations Div.*, Executive Branch, Policy on Travel, Decimal File 210.482-2, NNMR, National Archives.

5. "Prescribed Uniform for Civilians," June 19, 1944, in *SHAEF Special Staff Public Relations Div.*, Executive Branch, 421-1, Entry 82, Box 13, NNMR, National Archives.

6. William L. Worden, "Correspondents and Their Curly Mustaches," *Saturday Evening Post*, February 3, 1945, p. 45.

7. Ibid., p. 45.

8. John Gunther, *D Day* (New York, 1944), p. 109.

9. Personal interview with Ralph Morse, July 13, 1986.

10. Worden, "Correspondents," p. 45.

11. Personal interview with Ralph Morse, July 13, 1986.

12. Personal interview with George Silk, July 14, 1986.

13. "Typewriter Commandos Get Workout in Africa; Catch Haystack Naps and Battle Copy Logjam," *Newsweek*, November 23, 1942, p. 62.

14. Columbia Broadcasting System, *From D-Day Through Victory in Europe* (New York, 1946), p. 35.

15. Personal interview with Ralph Morse, July 13, 1986.

16. "Talk of the Town," *New Yorker*, April 7, 1945, p. 18.

17. George Rodger, *Far on the Ringing Plains: 75,000 Miles with a Photo Reporter* (New York, 1943), pp. 293–94.

18. Margaret Bourke-White, *They Called It 'Purple Heart Valley': A Combat Chronicle of the War in Italy* (New York, 1944), p. 107.

19. Quoted in Loudon Wainwright, *The Great American Magazine: An Inside History of Life* (New York, 1986), p. 143.

20. Personal interview with Ralph Morse, July 13, 1986.

21. Arthur Krock, "In Wartime What News Shall the Nation Have?" *New York Times Magazine*, August 16, 1942, p. 3.

22. Fletcher Pratt, "How the Censors Rigged the News," *Harper's Magazine*, February 1946, pp. 99–100.

23. John Steinbeck, *Once There Was a War* (New York, 1958), pp. xiii, xi, and xviii.

24. Dwight D. Eisenhower, General, U.S. Army; Supreme Commander, AEF, "Accredited War Correspondents," April 1944, in *SHAEF Special Staff Executive Branch*, Box 2, Entry 82, Decimal File 000.74, NNMR, National Archives.

25. Edward Steichen, *A Life in Photography* (London, 1963), chap. 12, unpaginated.

26. F. Barrows Colton, "How We Fight with Photographs," *National Geographic*, September 1944, p. 257.

27. Signal Corps Historical Project, F-2b, *Combat Photography*, File No. 4-11, Accession No. 386/2R, NNMR, National Archives, esp. pp. 6–26, 50–57.

28. Ibid., pp. 28–38.

29. K. B. Lawton, Colonel, Signal Corps; Director, Army Pictoral Service, "Pictoral Procedure," September 19, 1942, in ibid.

30. John Cahill Oestreicher, *The World Is Their Beat* (New York, 1945), p. 238.

31. Dickey Chapelle, *What's a Woman Doing Here? A Reporter's Report on Herself* (New York, 1962), p. 287; and Dickson Hartwell and Andrew Rooney, *Off the Record: The Best Stories of Foreign Correspondents* (New York, 1952), p. 214.

32. Ibid.; and Bourke-White, *They Called It 'Purple Heart Valley,'* pp. 13–16.

33. "Assignment Invasion," *Newsweek*, May 29, 1944, p. 89.

34. Colonel Barney Oldfield, *Never a Shot in Anger* (New York, 1956), p. 65.

35. "War Photographer's Stories," *Life*, June 26, 1944, p. 13.

36. Robert Capa, *Slightly Out of Focus* (New York, 1947), p. 147.

37. Ibid., pp. 148–49.

38. Richard Whelan, *Robert Capa: A Biography* (New York, 1985), p. 214.

39. Capa, *Slightly Out of Focus*.

40. Capa was not told the truth about the mishap until later. He was initially informed

that the rest had been ruined by seawater seeping into his camera. The caption that accompanied the photographs when they appeared in *Life* was equally disingenuous. It read that the reason for the blur was that Capa's hands were shaking badly.

41. Quoted in Hartwell and Rooney, *Off the Record*, p. 216.

42. Capa, *Slightly Out of Focus*, p. 150. In describing his D-Day schedule, Brandt was reasonably detailed but was terse to the point of curiousness about his time spent "on the beach." The entire recorded recollection of those moments is as follows: "The flat bottom of our craft ground against the sands of France—the huge steel door in front fell open and we splashed ashore. After taking several dozen pictures, I decided to try and get them somewhere for shipment to London. Every photographer knows that pictures are no good as long as they are in your camera case. I boarded an empty landing craft and asked for a lift to a nearby destroyer." Quoted in Hartwell and Rooney, *Off the Record*, p. 215.

43. Personal interview with George Silk, July 14, 1986.

44. 1st Lieutenant Leonard Spinrad, SCPC, "The Combat Photographer," *Business Screen Magazine*, vol. 7, no. 1, no date, p. 84; in Box: Signal Corps Photography, The Signal Corps Collection, U.S. Army Military History Institute Archives, Carlisle Barracks, Pa.

45. Rodger, *Far on the Ringing Plains*, p. 73.

46. Steichen, *A Life in Photography*, chap. 12, unpaginated.

47. Rodger, *Far on the Ringing Plains*, pp. 225–26.

48. Capa, *Slightly Out of Focus*, p. 47.

49. Eliot Elisofon, "Tunisian Triumph," *American Photography*, September 1943, pp. 32–33.

50. Mauldin, *Up Front* (New York, 1945), p. 120.

51. Audie Murphy, *To Hell and Back* (New York, 1949), p. 231.

52. Steinbeck, *Once There Was a War*, p. 22.

53. Margaret Bourke-White, *Shooting the Russian War* (New York, 1943), p. 245.

54. Ibid., p. 265.

55. Chapelle, *What's a Woman Doing Here?* pp. 91–95.

56. Duncan Norton-Taylor, *With My Heart in My Mouth* (New York, 1944), p. 38.

57. Although, as *Newsweek* pointed out in a footnote to its story, the *Daily News* was notorious for having run a photograph of the murderess Ruth Snyder in the throes of electrocution, large enough to cover its entire front page. "Realism for Breakfast," *Newsweek*, September 20, 1943, p. 98.

58. Ibid., p. 98.

59. Steinbeck, *Once There Was a War*, p. 28.

60. "Three Americans," *Life*, September 20, 1943, p. 34.

61. Ibid.

62. Ibid.; and Letter to the Editors, *Life*, October 11, 1943, p. 4.

63. Ibid.; and *Life*, July 17, 1944, p. 6.

64. George Rodger, *Far on the Ringing Plains*, p. 293.

65. Bourke-White, *They Called It 'Purple Heart Valley,'* p. 147.

66. Ernie Pyle, *Here is Your War* (New York, 1943), p. 214.

67. Personal interview with George Silk, July 14, 1986. Silk is the same photographer who, on assignment in Italy, got so rattled that he spent "five futile minutes trying to change his film before he noticed he was jamming a roll of Life Savers into his camera." See "War Photographers' Stories," *Life*, June 26, 1944, p. 14.

68. Capa, *Slightly Out of Focus*, p. 138.

69. W. Eugene Smith, "24 Hours with Infantryman Terry Moore," *Life*, June 18, 1945, p. 20.

70. Ibid., pp. 23–24.

71. Quoted in Sean Callahan, ed., *The Photographs of Margaret Bourke-White* (New York, 1972), p. 26; and Jonathan Silverman, ed., *For the World to See: The Life of Margaret Bourke-White* (New York, 1983), p. 152.

72. Bourke-White, *Shooting the Russian War*, p. 231.

73. Steichen, *A Life in Photography*, chap. 12, unpaginated.

74. W. Eugene Smith, *His Photographs and Notes*, Minor White, ed. (New York, 1969), unpaginated.

75. Carl Mydans, *More Than Meets the Eye* (New York, 1959), p. 8.

76. Personal interview with George Silk, July 14, 1986.

77. Personal interview with Carl Mydans, August 25, 1986.

78. Capa, *Slightly Out of Focus*, p. 236.

Chapter 9. An Inspiration to Sacrifice

1. Dwight D. Eisenhower, "Accredited War Correspondents," April 1944, Box 2, Entry 82, SHAEF, Special Staff Executive Branch, rg. 331, Records of Allied Operational and Occupation Headquarters, World War II, 000.74, NNMR, National Archives, Washington D.C.

2. *Editor & Publisher*, April 8, 1944, pp. 7 and 56. For a discussion of news management, see Michael Schudson, *Discovering the News: A Social History of American Newspapers* (New York, 1978), esp. pp. 160–94.

3. The chief photographic agencies during World War II were: Acme Newspictures (allied to the United Press and the Newspaper Enterprise Association, both Scripps enterprises); Wide World Photos (a subsidiary of the *New York Times*); International News Photos (allied with the Hearst-owned International New Service and Universal Service); and AP News Photos.

4. Quoted in Theodore Peterson, *Magazines in the Twentieth Century* (Urbana, Ill., 1964), p. 327.

5. Loudon Wainwright, *The Great American Magazine: An Inside History of* Life (New York, 1986), pp. 137 and 8.

6. *Life*, April 23, 1945, cover and pp. 19 and 32.

7. Henry R. Luce, "America's War and America's Peace," *Life*, February 16, 1942, pp. 86 and 88.

8. ABC News, *LIFE: 50 Years*, November 15, 1986.

9. W. Eugene Smith, interviewed in Paul Hill and Thomas Cooper, eds., *Dialogue with Photography* (New York, 1979), p. 259.

10. Personal interview with Carl Mydans, August 25, 1986.

11. Wainwright, *The Great American Magazine*, p. 172.

12. David Halberstam, *The Powers That Be* (New York, 1979), p. 68.

13. ABC News, *LIFE: 50 Years*.

14. Roy E. Larsen, "Dear LIFE Subscriber," *Life*, January 26, 1942, p. 2.

15. Daniel D. Mich (executive editor of *Look*), "The Rise of Photo-Journalism in the United States," *Journalism Quarterly*, September 1947, p. 205.

16. Peterson, *Magazines in the Twentieth Century*, p. 345.

17. "There Are Two Ways to Learn about War," *Life*, November 30, 1942, p. 131.

18. Ibid.

19. Ibid., pp. 130–31.

20. "The Worlds's Two Wars: Teruel Falls and Tsingtao Burns," *Life*, January 24, 1938, p. 9.

21. Letters to the Editors, *Life*, September 21, 1942, p. 4.

22. "Morale Photography," *Newsweek*, May 24, 1943, p. 15.

23. Letters to the Editors, *Life*, February 21, 1944, pp. 8 and 11.

24. "Realism for Breakfast," *Newsweek*, September 20, 1943, p. 98.

25. "America's Boys, Deep in Real War, Start Telling What Real War Is," *Life*, November 9, 1942, p. 40.

26. Wide World from Pathé, "Admiral Bill: Destroyer Ace Led the Raiders Who Paid Off for Pearl Harbor," *Newsweek*, February 23, 1942, p. 21.

27. Personal interview with Joe Rosenthal, August 13, 1986.

28. "The American Purpose," *Life*, July 5, 1943, p. 39.

29. Personal interview with Carl Mydans, August 25, 1986.

30. Robert Landry, "First Pictures of Sicily Invasion," *Life*, August 2, 1943, p. 23.

31. Robert Capa, "An Episode: Americans Still Died," *Life*, May 14, 1945, pp. 40B–C.

32. "How to Tell Japs from the Chinese," *Life*, December 22, 1941, p. 81.

33. U.S. Navy, "At Last Some Japs Are Giving Up but Bloody War Still Lies Ahead," *Newsweek*, July 2, 1945, p. 30.

34. Triangle, International, "Hong Kong Blood Bath," *Newsweek*, March 23, 1942, p. 15.

35. Personal interview with Carl Mydans, August 25, 1986.

36. Ralph Morse, "Guadalcanal: Grassy Knoll Battle," *Life*, February 1, 1943, pp. 26 and 27.

37. Personal interview with Ralph Morse, July 13, 1986.

38. Letters to the Editors, *Life*, February 22, 1943, p. 8.

39. Letters to the Editors, *Life*, March 15, 1943, pp. 2 and 4.

40. U.S. Signal Corps Photos through News of the Day Newsreel from International, "A Jap Burns," *Life*, August 13, 1945, p. 34.

41. Johnny Florea, "Firing Squad," *Life*, June 11, 1945, pp. 47, 48, and 50.

42. "Lest We Forget," *Look*, May 15, 1945, pp. 51–55.

43. U.S. Signal Corps Photo, "War Comes to the People of Normandy," *Life*, July 3, 1944, p. 11; *Look* credits the photograph to International, "Hitler Is Running Out of Men," *Look*, August 22, 1944, p. 23.

44. U.S. Signal Corps photo from AP, "Objective: Manila," *Newsweek*, March 27, 1944, p. 30; and Carl Mydans, "Santo Tomás Is Delivered," *Life*, March 5, 1945, p. 31.

45. Official U.S. Navy Photo, "Pearl Harbor Damage Revealed," *Life*, December 14, 1942, pp. 36–37; and Official U.S. Navy Photo, "America at War: The First Year," *Newsweek*, December 14, 1942, p. 20.

46. W. Eugene Smith, *Life*, April 9, 1945, cover.

47. "The War Ends," *Life*, August 20, 1945, pp. 26 and 27.

48. "The Atomic Age, *Life*, August 20, 1945, p. 32.

49. Lieutenant-Colonel Kendall Banning, *Military Censorship of Pictures in World War I* (Washington, D.C., undated, but between 1919 and 1930), U.S. Army Military History Institute Archives, Carlisle Barracks, Pa., p. 13.

50. "The Fight for Tarawa," *Life*, December 13, 1943, p. 28.

51. The blurb accompanying Silk's pictures stated: "These pictures also show that ordinary black-and-white photographs have not done full descriptive justice to the war in Italy. They have omitted the soft browns and grays of the ruined Italian towns, the bright, shocking redness of freshly spilled blood, the incongruously gay colors of spring in the midst of battle." See "The Fall of Esperia," *Life*, August 14, 1944, p. 55.

52. See chap. 8 for the story behind Capa's D-Day images. See also Robert Capa, "Beach-heads of Normandy," *Life*, June 19, 1944, pp. 25–31.

53. Personal interview with George Silk, July 14, 1986.

54. Ibid.

55. U.S. Marine Corps, "Meet the Wounded," *Look*, February 20, 1945, p. 23.

56. Ibid.

57. U.S. Army Signal Corps from Harris & Ewing, "Drama in Blood," *Newsweek*, September 13, 1943, p. 23.

58. W. Eugene Smith, "War's Terror Struck at the Innocent," *Life*, August 28, 1945, p. 78.

59. Notes on W. Eugene Smith exhibition poster, Sol Lewinsky Gallery, 1981.

60. George Silk, "Winter Soldiers," *Life*, February 26, 1945, p. 31.

61. Personal interview with George Silk, July 14, 1986.

62. U.S. Coast Guard, "Pacific House Cleaning," *Newsweek*, March 20, 1944, p. 22.

63. "Talk of the Town," *New Yorker*, April 7, 1945, p. 18.

64. Personal interview with Joe Rosenthal, August 13, 1986.

Chapter 10. "The Concept of Restraint"

1. Bernard Brodie, *War and Politics* (New York, 1973), p. 77.

2. Initially, the U.S. goal was to reestablish the *status quo ante bellum*. But the subsequent support and decision of the Truman White House, the Joint Chiefs of Staff, and the

UN Security Council to back MacArthur's desire to cross the 38th parallel in fall 1950 changed that modest goal to one of reunification of the country. See William Manchester, *American Caesar: Douglas MacArthur 1890–1964* (New York, 1978), esp. chap. 9; and Max Hastings, *The Korean War* (New York, 1987), esp. chaps. 6 and 7.

3. "War by Jet and by GI," *Life*, July 17, 1950, p. 27.

4. Matthew B. Ridgway, *The Korean War* (Garden City, N.Y., 1967), p. v.

5. Harry S Truman, "Address by the President, December 15, 1950," in U.S. Department of State, *United States Policy in the Korean Conflict, July 1950–February 1951* (Washington, D.C., 1951), p. 27.

6. Ibid., p. 28.

7. For a discussion of military versus political factors in American policymaking, see National Security Council document NSC-68; and George F. Kennan, *American Diplomacy*, expanded ed. (Chicago, 1951), esp. the Grinnell Lectures.

8. Bill Mauldin, *Bill Mauldin in Korea* (New York, 1952), p. 10.

9. James Michener, *The Bridges at Toko-ri* (New York, 1953), p. 27.

10. See John E. Mueller, *War, Presidents and Public Opinion* (New York, 1973), p. 53.

11. Ibid., p. 49.

12. Michener, *The Bridges at Toko-ri*, p. 42.

13. The Chinese were always referred to in the months after their entry into the war as "hordes." The use of the word in military dispatches or in the official briefings became a standard joke. The amusement began during an early press conference in Korea after the journalists had been informed that the enemy "hordes" had swollen to nearly a million within days of their crossing the Yalu. Correspondent Michael Davidson then asked dead-pan: "Will you tell us how many Chinese battalions go to a horde, or vice versa?" The point was made.

The joke was picked up and circulated around Korea. The new version had a soldier saying, "I was attacked by two hordes and killed both of them." See Reginald Thompson, *Cry Korea* (London, 1951), p. 265; René Cutforth, *Korean Reporter* (London, 1952), p. 137; and E. J. Kahn, Jr., *The Peculiar War: Impressions of a Reporter in Korea* (New York, 1952), p. 6.

14. Department of the Army, *Korea Handbook* (rated "confidential") (Washington, D.C., September 1950), p. 95.

15. Marguerite Higgins, *War in Korea: The Report of a Woman Combat Correspondent* (New York, 1951), p. 203.

16. Thompson, *Cry Korea*, p. 44.

17. Cutforth, *Korean Reporter*, p. 22.

18. Thompson, *Cry Korea*, p. 62.

19. Ibid., p. 54.

20. Mauldin, *Bill Mauldin in Korea*, p. 10.

21. Higgins, *War in Korea*, p. 84.

22. Michener, *The Bridges at Toko-ri*, p. 27.

23. Higgins, *War in Korea*, p. 84.

24. "Needed: A Rule Book," *Time*, July 24, 1950, p. 58.

25. Interview with Captain Stephen J. Patrick, July 28, 1954, in "Welfare and Morale Activities in Korea: July 1951–July 1953," File No. 8-5.1A AA.E, Box 625, Office of the Chief of Military History, NNMR, National Archives, Washington, D.C., p. 279.

26. John G. Burke, "A Brief Sketch of Logistical Operations in Korea Carried Out in Support of United Nations Forces from 25 June 1950 through 8 July 1951," September 1951, File No. 2-3.7A AJ, Box 106, Office of the Chief of Military History, National Archives, Washington, D.C.

27. "Why We Are In Korea!" *FEC Troop Information Bulletin*, No. 6 prepared by the Troop Information and Education Section, HQ-AFFE, File No. 8-5.1A AA.E, Box 625, Office of the Chief of Military History, National Archives, Washington, D.C.

28. Interview with Lieutenant-Colonel James A. Klein, August 6, 1954, in "Welfare and Morale Activities in Korea: July 1951–July 1953," p. 320.

29. Interview with Patrick, in ibid., pp. 277–78.

30. Marguerite Higgins also related this story about Duncan's encounter with the marine, and it is she who directly quotes Duncan's question. Higgins, *War in Korea*, p. 196.

31. David Douglas Duncan, *This is War! A Photo-Narrative in Three Parts* (New York, 1951), unpaginated.

32. James had stumbled on the story one and a half hours before he put it on the wire. He had gotten up early that Sunday to wrap a mail dispatch he had wanted to send, the gist of which stated, "the best opinion did not believe there would be any invasion at least before the Fall." On his way out of town at 8:00 A.M. to go to a picnic, he dropped by the American embassy to pick up a raincoat that he had forgotten there the previous evening. James ran into an intelligence officer who assumed he was on the story. The officer, not realizing James knew nothing, asked him what he had heard from the border. James replied, "Not very much yet. What do you hear?" "Hell," the officer said, "they're supposed to have crossed everywhere except in the Eighth Division area." James had his story and after holding it for confirmation, sent an abbreviated cable at 9:50 A.M. and a longer one half an hour later.

Not only did James scoop the American officials, he scooped the rest of his colleagues in the press, who, because it was Sunday morning, had not bothered to come to their offices until after 11 A.M. See "UP's Jack James Was Going to Picnic June 25," *Editor & Publisher*, July 22, 1950, p. 10.

33. Because the fighting occurred under the aegis of the UN, the Korean War began and ended without a declaration of war by the U.S. Congress. It was the first large-scale foreign conflict in American history without one.

General J. Lawton Collins, chief of staff, U.S. Army, listed other earlier incidents involving U.S. military forces operating without declarations of war: "naval engagements against French vessels during President John Adams' administration in 1797; the Boxer Rebellion, 1900–1901; seizure of Vera Cruz in 1914 under President Wilson; and General Pershing's Punitive Expedition into Mexico in 1916. All were limited operations," Collins noted, "that did not lead to war [sic]." Collins neglected to list the so-called Indian Wars. See General J. Lawton Collins, *War in Peacetime: The History and Lessons of Korea* (Boston, 1969), p. 24.

34. Ibid., p. 4.

35. Ibid., p. 67.

36. Ridgway, *The Korean War*, pp. 34 and 88.

37. U.S. Department of State, *United States Policy in the Korean Conflict*, pp. 45–46.

38. Mark W. Clark, *From the Danube to the Yalu* (New York, 1954), p. 31.

39. Quoted in Collins, *War in Peacetime*, pp. 77–78.

40. Robert Leckie, *Conflict: The History of the Korean War, 1950–53* (New York, 1962), p. 74.

41. Once the American ambassador's cable was received in Washington, the administration immediately brought the news to the attention of the UN. At 3:00 A.M. on June 25, the Americans requested an urgent meeting of the Security Council. Eleven hours later, the council convened at Lake Success, New York, and adopted, by a vote of nine to zero with one abstention and one absence, the resolution that called for cessation of the hostilities and withdrawal of the North Korean troops to the 38th parallel. (The ability of the United States to obtain the UN Security Council's support was entirely adventitious. It was made possible by the fact that the Soviet representative had, since January 10, 1950, been boycotting the council meeting to protest the seating of Nationalist China, rather than Communist China.) Two days later, the Security Council recommended that the "members of the United Nations furnish such assistance to the Republic of Korea as may be necessary to repel the armed attack and to restore international peace and security in the area." See U.S. Department of State, *United States Policy in the Korean Crisis* (Washington, D.C., 1950), esp. pp. 1–4.

42. "War by Jet and by CI," p. 27.

43. Higgins, *War in Korea*, pp. 159–60.

44. Roger W. Little, "Buddy Relations and Combat Performance," in Morris Janowitz, ed., *The New Military: Changing Patterns of Organization* (New York, 1964), pp. 196–98.

45. Thompson, *Cry Korea*, p. 84.

46. Elmer Roper and Louis Harris, "The Press and the Great Debate: A Survey of Corre-

spondents in the Truman-MacArthur Controversy," *Saturday Review of Literature*, July 14, 1951, esp. pp. 6, 9, and 29.

47. Ibid.

48. The Korean battle line shifted back and forth across the 38th parallel so frequently that it became a popular jest that eligibility for rotation was determined by "the number of times a man has crossed the Parallel—three points per crossing being the usual sardonic recommendation." See Kahn, *The Peculiar War*, p. 41.

49. Quoted in Thompson, *Cry Korea*, p. 247.

50. Higgins, *War in Korea*, p. 70.

51. Clark, *From the Danube*, p. 69.

52. The South Korean allies were flabbergasted by the array of food offered to the GIs. One group who was offered their first "C" ration, which consisted of a can of meat, a can of biscuits, sugar, cookies, powdered coffee, jam, and a plastic spoon, did not even know how to open the cans. Once the cans were opened, the Koreans were even more nonplussed. As an observer wrote: "They opened cans that had foods such as they had never seen. Finally they solved their problem: crackers were put on the ground in pairs. Powdered coffee was poured equally on each of the two crackers. Then sugar was poured on the dry coffee and dry powdered milk was put on top of all. The remaining two crackers from the four in the can were used to cap the sandwich, which the Koreans ate with great grimaces of disgust." See ibid., p. 182.

53. "The Shame of Our Infantry—Young Men with Old Guns," *Look*, November 4, 1952, pp. 89–92.

54. Guenter Lewy, *America in Vietnam* (New York, 1978), p. 243.

55. Kahn, *The Peculiar War*, pp. 131–32.

56. Cutforth, *Korean Reporter*, pp. 174–75.

57. Burke, "A Brief Sketch of Logistical Operations," pp. 5–8 and 14.

58. Ibid., p. 62.

59. Mauldin, *Bill Mauldin In Korea*, p. 135.

60. "Public Information Policy: CW-BW-RW," January 2, 1952, in File No. 7-1, Temp. Box 2141, Far East Command, Adjutant General Section, NNMR, Suitland, Md., pp. 1–3.

61. Roper and Harris, "The Press and the Great Debate," p. 29.

62. For a discussion of why the Americans did not use nuclear weapons and why they applied the principle of sanctuary, see Brodie, *War and Politics*, pp. 63–70; Manchester, *American Caesar*, chap. 9; Richard Betts, *Nuclear Blackmail and Nuclear Balance* (Washington, D.C., 1987); and Barton Bernstein, "New Light on the Korean War," *International History Review*, April 1981, esp. pp. 270–77.

63. " 'Keep Your Shirt On,' " *Time*, December 18, 1950, p. 76.

64. Ridgway, *The Korean War*, p. viii.

65. However, the total marine casualties for the Inchon landing on D-Day, September 15, 1950, were phenomenally light. Twenty were killed in action, one died of wounds, and 174 were wounded and survived. See Collins, *War in Peacetime*, p. 135.

66. Ibid., p. 54.

67. Higgins, *War in Korea*, pp. 186–89.

68. Russell A. Gugeler, *Army Historical Series: Combat Actions in Korea* (Washington, D.C., 1970), p. 12.

69. Kahn, *The Peculiar War*, p. 88.

70. Morris Janowitz, *Sociology and the Military Establishment* (New York, 1959), pp. 73 and 75.

71. Frank A. Reister, surgeon general, *Battle Casualties and Medical Statistics: U.S. Army Experience in the Korean War* (Washington, D.C., 1973), pp. 8 and 116–17.

72. Eli Ginzberg et al., *Patterns of Performance* (New York, 1959), pp. 153–54.

73. To officials, R & R stood for rest and rehabilitation. To the troops, however, it meant rape and restitution. See Kahn, *The Peculiar War*, pp. 12–13.

74. Interview with Patrick, "Welfare and Morale Activities," p. 280.

75. S. L. A. Marshall, *Men Against Fire* (New York, 1947).

76. Ibid.

77. Gugeler, *Combat Actions*, pp. 9 and 11.

78. Reister, *Battle Casualties*, pp. 16–17 and 35–39.

79. Burke, "A Brief Sketch of Logistical Operations," p. 63.

80. W. A. Beiderlinden, Major General, GSC, "Outgoing Message," July 22, 1950, File No. 77-1, Temporary Box 1888, rg. no. 338/349, Far East Command, Adjutant General Section, NNMR, National Archives, Suitland, Md.

81. Robert C. Miller, "News Censorship in Korea," *Nieman Reports*, July 1952, p. 6.

82. Thompson, *Cry Korea*, pp. 210–11.

83. The other UN forces suffered 3,124 killed in action, and the South Korean Army lost 50,000 men. Estimates of communist battle casualties varied widely, from 1.5 to 2 million, with an additional 400,000 nonbattle casualties. In addition to the deaths in the two opposing camps, close to half a million South Korean civilians were killed, died, or disappeared as a result of the war. See R. Ernest Dupuy and Trevor N. Dupuy, *Military Heritage of America* (Fairfax, Va., 1984), p. 688.

84. "Altogether, 57,559 atrocity victims have been reported in war crimes case files. Of these, it is the opinion of legal officers who examined the records, that 29,815 is the 'probable' accurate figure. Bodies of 10,032 known victims have been recovered, and 533 survivors have returned to provide living proof of the acts." U.S. Army, Korean Communications Zone, "Extract of Interim Historical Report: Korea War Crimes Division," (manuscript, 1953), pp. 35–36 and 39.

85. "Outgoing Message," November 28, 1951, in File No. 7-1, Temporary Box 2141, Far East Command, Adjutant General Section, NNMR, National Archives, Suitland, Md.

86. Clark, *From the Danube*, p. 203.

87. "News of Death Hits U.S. Homes," *Life*, July 17, 1950, p. 47.

88. Higgins, *War in Korea*, p. 64.

89. Ibid., p. 63.

Chapter 11. A Maturing Responsibility

1. Bruce Downes, "Assignment: Korea," *Popular Photography*, March 1951, p. 42.

2. Even the five photographers were only allowed to cover the negotiations after much argument by the Western press who, up to that point, had been forced to get its information of the talks from the communist press covering the meetings. Finally, the army agreed to take five photographers to Kaesong, but ordered them to rip off their press shoulder patches so they could pass as "photographers accredited to the U.S. Army." While a technically accurate description, correspondents thought this a clumsy subterfuge. Later, twenty UN journalists covered the peace talks.

It turned out afterwards that six UN photographers had attended that first Kaesong conference open to the Western press. A Far East Command photographic officer "equipped with one of those Polaroid Land cameras that can almost instantaneously produce prints" was there the same day. "He, however, brought only five pictures back to Munsan with him; he took a good many more than that, but it seemed that the Communist subjects of his pictures were fascinated with the rapid developing and printing of which his camera is capable, and he blithely presented them with all but the five shots." E. J. Kahn, *The Peculiar War* (New York, 1953), pp. 209–11.

3. Reginald Thompson, *Cry Korea* (London, 1951), pp. 66–67.

4. The fact that both Chinese correspondents and correspondents of Tass, the Soviet news agency, were accredited to the Far East Command was partly responsible for the difficulty all journalists had in obtaining any military information on the UN forces.

5. M. P. Echols, "Information in the Combat Zone," *Army Information Digest*, April 1951, p. 61; "Correspondents in the Far East Command (FECOM), up to and including 28 August 1950," August 28, 1950, File No. CCS-000.73 (6-26-43) Sect. 3 Censorship, rg. no. 218, Records of the United States Joint Chiefs of Staff, NNMR, National Archives, Washington, D.C.

6. Marguerite Higgins, *War in Korea* (New York, 1951), p. 98.

7. Melvin B. Voorhees, *Korean Tales* (New York, 1952), p. 81.

8. Barney Oldfield, "USAF Press Relations in the Far East," *Army Information Digest*, November 1950, p. 43.

9. Thompson, *Cry Korea*, pp. 210–11.

10. Robert C. Miller, "News Censorship in Korea," *Nieman Reports*, July 1952, p. 8.

11. Ibid., p. 3.

12. Oldfield, "USAF Press Relations," *Army Information Digest*, pp. 44–45.

13. Higgins, *War in Korea*, p. 97.

14. Ibid., p. 98.

15. Echols, "Information in the Combat Zone," p. 62; and Oldfield, "USAF Press Relations," p. 44.

16. Higgins, *War in Korea*, p. 52.

17. Ray Erwin, "Voluntary Censorship Asked in Korean War," *Editor & Publisher*, July 8, 1950, p. 7.

18. Downes, "Assignment: Korea," p. 98.

19. Accredited correspondents included "press reporters, photographers, columnists, editors and publishers, radio and television reporters, commentators and cameramen, and newsreel and other documentary picture production personnel." Departments of the Army, the Navy, and the Air Force, "Public Information: Correspondents Accompanying Armed Forces of the United States," December 7, 1951 in *AR 360-60, OPNAY INSTRUCTION 5720.6, AFR 190-9* (Washington, D.C.), p. 2.

20. Ibid., pp. 5–6; "CINCFE cable" July 7, 1950, and "Incoming Message," July 8, 1950, in File No. 77-1, Temporary Box 1888, rg. no. 338/349, Far East Command, Adjutant General Section, NNMR, National Archives, Suitland, Md.

21. Erwin, "Voluntary Censorship," p. 7.

22. Marshall Andrews, "What Can You Believe?" *The United States Army Combat Forces Journal*, October 1950, p. 21.

23. "Memorandum for Secretary of Defense," September 29, 1950, in File No. CCS-000.73 (6-26-43) Sect. 3 Censorship, NNMR, National Archives, Washington, D.C.

24. René Cutforth, *Korean Reporter* (London, 1952), p. 27.

25. "MacArthur Says Press 'Demanded' Censorship," *Editor & Publisher*, January 20, 1951, p. 7.

26. Departments of the Army, the Navy, and the Air Force, "Public Information," p. 8.

27. "JCS 2184/6 Enclosure 'A': Censorship of Photographic Material," in File No. CCS-000.73 (6-26-43) Sect. 3 Censorship, NNMR, National Archives, Washington, D.C.

28. The quotation is from courses at the Signal Corps Photo Division Signal School in New Jersey. Cited in Bob Schwalberg, "School for Combat Photographers," *Popular Photography*, June 1952, p. 43.

29. "Intelligence and Counterintelligence Problems During the Korean Conflict," in File No. 8-5.1A AA.g, Box 625, Office of the Chief of Military History, NNMR, National Archives, Washington, D.C., pp. 13–14; and "Combat Intelligence Photography," December 12, 1951, File No. 062-1, Temporary Box 1563, rg. no. 338/349, Far East Command, Adjutant General Section, NNMR, National Archives, Suitland, Md., p. 1.

30. "Commendation for Combat Photography," September 6, 1950, in File No. Photo Material Misc., Box: Signal Corps Photography, The Signal Corps Collection, U.S. Army Military History Institute Archives, Carlisle Barracks, Pa.

31. Tom Maloney, "Korea—and the Unsung Combat Cameramen," *U.S. Camera*, August 1953, p. 101.

32. Schwalberg, "School for Combat Photographers," p. 46.

33. Ibid., p. 94.

34. "Economy in Still Photographic Operations and Use of Photographic Supplies," October 2, 1952, in File No. 062-1, Temporary Box 1707, rg. no. 338/349, Far East Command, Adjutant General Section, NNMR, National Archives, Suitland, Md.

35. Schwalberg, "School for Combat Photographers," p. 98.

36. Margaret Bourke-White, *Portrait of Myself* (New York, 1963), pp. 328–29.

37. According to Frank Scherschel, *Life's* assistant picture editor, Duncan's photographs turned out to be the sharpest 35mm negatives the laboratory ever processed. See Downes, "Assignment: Korea," p. 47.

38. Schwalberg, "School for Combat Photographers," p. 101.

39. Quoted in ibid.

40. Ibid., p. 94.

41. As quoted in ibid., p. 44.

42. Downes, "Assignment: Korea," p. 100.

43. Personal letter from David Douglas Duncan, July 15, 1986.

44. Downes, "Assignment: Korea," pp. 47 and 98.

45. Bourke-White, *Portrait of Myself*, pp. 337–38.

46. Quoted in Higgins, *War in Korea*, p. 131.

47. Ibid., p. 130.

48. Ibid., pp. 130–31.

49. Homer Bigart and Marguerite Higgins, quoted in "Covering Korea," *Time*, August 21, 1950, p. 51.

50. Norman B. Moyes, "Major Photographers and the Development of Still Photography in Major American Wars," unpublished Ph.D. dissertation, Syracuse University, 1966, pp. 286–89; and "Ridgway Passes More Noel Pix," *Editor & Publisher*, February 16, 1953, p. 66.

51. "Pride of the Regiment," *Time*, September 25, 1950, p. 64.

52. Notable exceptions to the "no-pooling" arrangements were during President-elect Dwight D. Eisenhower's trip to Korea and during the truce negotiations.

53. "Last Assignment," *Time*, August 21, 1950, p. 52; Echols, "Information in the Combat Zone," p. 62.

54. Edwin Emery and Michael Emery, *The Press and America: An Interpretive History of the Mass Media*, 5th ed. (Englewood Cliffs, N.J., 1984), pp. 491 and 497.

55. Bourke-White, *Portrait of Myself*, p. 329.

56. Frederic Sondern, Jr., "Dave Duncan and His Fighting Camera," *Reader's Digest*, May 1951, p. 46.

57. Charles F. Vale, "Photo Unit Commander Describes Experiences During 'Old Baldy' Action," July 1952, in File No. Photo Material Misc., Box: Signal Corps Photography, The Signal Corps Collection, U.S. Army Military History Institute Archives, Carlisle Barracks, Pa., unpaginated.

58. Ibid.

59. Quoted in Robert E. Hood, *12 at War: Great Photographers Under Fire* (New York, 1967), p. 93.

60. David Douglas Duncan, *This is War! A Photo-Narrative in Three Parts* (New York, 1951), unpaginated.

61. Robert Lee Strickland, "Combat Cameraman," October 21, 1950, in File No. Photo Material Misc., Box: Signal Corps Photography, The Signal Corps Collection, U.S. Army Military History Institute Archives, Carlisle Barracks, Pa., unpaginated.

62. Duncan, *This Is War!*

63. "Face of Battle," *U.S. Camera*, March 1951, p. 33.

64. Thompson, *Cry Korea*, p. 291.

65. Bourke-White, *Portrait of Myself*, p. 329.

66. Duncan, *This Is War!*

67. David Douglas Duncan, " 'This Is War,' " *Life*, September 18, 1950, p. 41.

68. Thompson, *Cry Korea*, p. 291.

69. Higgins, *War in Korea*, p. 101.

70. Thompson, *Cry Korea*, p. 84.

71. Ibid., pp. 70–71.

72. "Popular Response to Korea Means the U.S. Has Mobility to Act," *Life*, July 17, 1950, p. 40.

73. Ibid.

74. Michael Rougier and Jun Miki, "How the Truce Came to Korea," *Life*, August 10, 1953, p. 18.

75. Thomas Hobbes wrote in *Leviathan*, part 1, chap. 13: "No arts; no letters; no society; and which is worst of all, continual fear and danger of violent death; and the life of man, solitary, poor, nasty, brutish, and short."

76. Quoted in Hood, *12 at War*, p. 92.

77. Charles and Eugene Jones, *The Face of War* (New York, 1951), p. 6.

78. Quoted in Jonathan Silverman, *For the World to See: The Life of Margaret Bourke-White* (New York, 1983), p. 195.

79. "Impact of War," *U.S. Camera*, April 1951, p. 52.

80. Andrews, "What Can You Believe?" p. 21.

81. Oldfield, "USAF Press Relations," p. 43.

82. Carl Mydans, *More Than Meets the Eye* (New York, 1959), pp. 3–4.

Chapter 12. A Question of Balance

1. General Douglas MacArthur, "Routine—Unclassified," September 28, 1950, in File No. 000.73-1, Temporary Box 1451, Far East Command, Adjutant General Section, Unclassified General Correspondence, 1950, NNMR, National Archives, Suitland, Md.

2. "Needed: A Rule Book," *Time*, July 24, 1950, p. 58.

3. "Angry U.S. Girds for Rough War," *Newsweek*, July 24, 1950, p. 11.

4. MacArthur, "Routine—Unclassified."

5. "Outgoing Classified Message," December 16, 1950, in File No. CCS-000.73 (6-26-43) Sect. 3 Censorship, NNMR, National Archives, Washington, D.C.

6. "MacArthur Says Press 'Demanded' Censorship," *Editor & Publisher*, January 20, 1951, p. 7.

7. "Year of Decision," *Collier's*, June 30, 1951, pp. 23 and 22.

8. "*Look* Reports," *Look*, February 12, 1952, pp. 94–95.

9. "A Restored Position," *Life*, July 17, 1950, p. 40.

10. Elmo Roper and Louis Harris, "The Press and the Great Debate," *Saturday Review of Literature*, July 14, 1951, p. 31.

11. "Salute to Our Warriors" and "Seoul and Victory," *Life*, October 9, 1950, pp. 38 and 31, respectively; and David Douglas Duncan, " 'This Is War,' " *Life*, September 18, 1950, p. 41.

12. "A Look Back Makes Us Proud," *Life*, August 3, 1953, p. 13.

13. The survey was conducted by the Bureau of Advertising of the American Newspaper Publishers Association and the Advertising Research Foundation over a period of eleven years. "What You Read: Death and Weather," *Newsweek*, January 29, 1951, p. 58.

14. "Salute to Our Warriors," p. 38.

15. "The Prospect Is War," *Life*, December 11, 1950, p. 46.

16. "The Blessing of God," *Life*, December 25, 1950, p. 20.

17. David Douglas Duncan, "There Was a Christmas," *Life*, December 25, 1950, p. 13.

18. "Murdered Yanks," *Newsweek*, July 24, 1950, pp. 12 and 13.

19. "Why Are We Taking a Beating?" *Life*, July 24, 1950, p. 21.

20. Letters to the Editors, *Life*, August 14, 1950, p. 6.

21. "Incoming Message," July 13, 1950, in File No. 000-77-1, Temporary Box 1888, rg. no. 338/349, Far East Command, Adjutant General Section, NNMR, National Archives, Washington, D.C.

22. Tom Maloney, "Korea—and the Unsung Combat Cameramen," *U.S. Camera*, August 1953, p. 45.

23. Personal conversation with David Douglas Duncan, November 13, 1986.

24. Compare Carl Mydans, "They Fight, Retreat and Bury Their Dead," *Life*, August 14, 1950, p. 29, with Wilmott Ragsdale, *Life*, June 26, 1944, p. 33.

25. J. Robert Moskin, "From Their Hour of Joy . . . These Went to Duty . . . and Death," *Look*, June 3, 1952, pp. 32–33.

26. "The Life Story of a Dead Marine," *Life*, December 18, 1950, pp. 30–31.

27. Letters to the Editors, *Life*, August 7, 1950, p. 7.

28. David Douglas Duncan, *This Is War! A Photo-Narrative in Three Parts* (New York: 1951), unpaginated.

29. Personal conversation with David Douglas Duncan, November 13, 1986; and Duncan, "There Was a Christmas," pp. 14 and 15.

30. As a writer himself, and as a man of strong opinions, Duncan does not allow others

to reproduce his pictures; he believes he can best describe his own images and experiences. (I, for one, hope that he does see fit to tell the story of his war photography.) In his letter informing me of his decision to refuse permission, Duncan criticized my "opinions and conclusions" in this chapter, which I had sent him to read. "Your problem," he wrote, "is that you are trying to write a book years after the wars are down the drain—from an impossible distance, which you try to bridge with a scholary [sic] philosophical point of view." Duncan's letter, although addressed from Verona, Italy, was postmarked from the United States. Duncan had used two American stamps to mail his message to me. The three-cent stamp pictured the profile of "Frances Parkman American Historian." The twenty-two-cent stamp was even more significant. The words read: "Veterans Korea." Engraved in khaki on a cream background was Duncan's photograph of the marines' retreat to Changjin. The same men as in the photograph tramp through a chill landscape. The same men stare at the side of the road, and the same marine glances over his shoulder. But what is not the same is the heap of dead. They do not exist on the stamp. The men marching down that road to Hungnam look at nothing. If there is any unfortunate revisionism on the Korean War to be found, it is in this white-washed version. I hope David Douglas Duncan did not give his imprimatur to that.

31. Letters to the Editors, *Life*, January 15, 1951, p. 10.

32. "No Peace on the Beachheads," *Newsweek*, December 25, 1950, p. 24.

33. The photographs are credited to the Department of Defense but, in a letter to the editor, December 25, 1950, the photograph of the grieving soldier is identified as a picture taken by Sergeant First Class Albert Chang, U.S. Army Signal Corps, who, at the time, was attached to the Fifth Regimental Combat Team in Korea. See "Key to Conflict . . . And Its Significance," *Newsweek*, October 9, 1950, pp. 24–25; and "Letters," *Newsweek*, December 25, 1950, p. 2.

34. "Letters," *Newsweek*, October 23, 1950, pp. 2–3.

35. Carl Mydans, "Light of Day Shows the Red Death Toll," *Life*, March 5, 1951, pp. 30–31.

36. Carl Mydans, "Army and Marines Force Crossing of Han River," *Life*, October 9, 1950, p. 31.

37. "This is Communism: How the Reds Behaved While Winning," *Newsweek*, October 19, 1950, p. 21.

38. "Mangling the Massed Red Might," *Newsweek*, May 28, 1951, p. 25.

39. "Hope for a Speedy Armistice; Anguish from Atrocity Report," *Newsweek*, November 26, 1951, p. 31.

40. Hank Walker, "48-Hour Rest Means Showers and a Meal," *Life*, September 11, 1950, p. 47.

41. See, for example, "Fourth Squad, Third Platoon," *Collier's*, January 13, 1951, pp. 9–11.

42. "Mud, Dead Reds, A New U.S. Policy," *Newsweek*, March 5, 1951, p. 32.

43. Carl Mydans, "The General Gambles," *Life*, August 21, 1950, p. 19; Duncan, " 'This Is War,' " *Life*, p. 41; and Duncan, "There Was a Christmas," p. 8.

44. Letters to the Editors, *Life*, January 15, 1951, p. 10.

45. Ibid.

46. "No Whistles, No Cheers, No Dancing," *Life*, August 3, 1953, p. 15.

47. Hank Walker, "The Invasion," *Life*, October 2, 1950, pp. 26–27.

48. Major William Clark, " 'I Saw Them Die in Korea,' " *Look*, January 29, 1952, p. 25.

49. Duncan, " 'This Is War,' " p. 47.

50. Compare the Duncan image with the photograph from Vietnam by Larry Burrows of the expression on a man's face after a helicopter crew member dies in his arms, in "Yankee Papa 13," *Life*, April 16, 1965, cover.

51. "No Peace on the Beachheads," p. 26.

52. Carl Mydans, "The Peripatetic 27th," *Life*, September 11, 1950, p. 45; and Private First Class Nebbia, "War on Two Fronts," *Life*, August 14, 1950, p. 22.

53. Hank Walker, "Wounded," *Life*, December 25, 1950, pp. 16–19.

54. "The Wounded Fly Home," *Look*, March 11, 1952, p. 69.

55. "New United Nations Line—MacArthur's," *Newsweek*, October 9, 1950, p. 21; and "No Peace on the Beachheads," p. 28.

56. "G.I.'s Have Big Hearts," *Look*, May 22, 1951, p. 13.

57. See, for example, Carl Mydans, "Refugees Get in Way," *Life*, August 21, 1950, pp. 22–23; "War's Tragedy in Korea," *Collier's*, August 26, 1950, pp. 24–25; and "Battered and Burned," *Newsweek*, October 9, 1950, p. 21.

58. David Douglas Duncan, "The Durable ROKs," *Life*, September 11, 1950, p. 54.

59. "No Whistles, No Cheers, No Dancing," pp. 15–19.

60. Ibid., p. 17.

61. Ibid.

62. "The Savage, Secret War in Korea," *Life*, December 1, 1952, p. 25.

63. "No Whistles, No Cheers, No Dancing," p. 15.

64. Personal conversation with David Douglas Duncan, November 13, 1986.

Chapter 13. "A Kind of Schizophrenia"

1. William Rogers, Department of State, *Viet-Nam in Perspective*, an address (Washington, D.C., 1969), p. 1.

2. See Leslie Gelb and Richard Betts, *The Irony of Vietnam: The System Worked* (Washington, D.C., 1979).

3. Ernest May, "Commentary: The Paradox of Vietnam," in Peter Braestrup, ed., *Vietnam as History* (Washington, D.C., 1984), p. 128.

4. Jonathan Schell, *The Time of Illusion* (New York, 1975), p. 365.

5. Malcolm Browne, "Viet Nam Reporting: Three Years of Crisis," *Columbia Journalism Review*, Fall 1964, p. 8.

6. Michael Herr, "The War Correspondent: A Reappraisal," *Esquire*, April 1970, p. 160.

7. Definitions: "Bouncing Betty," a mine that jumps up out of the ground and explodes at waist height; "Willy Peter," a shell or grenade containing white phosphorus; "slicks," a helicopter with no external weapons, used to carry troops; "dustoffs," helicopters used to carry away the dead and wounded; "Puff the Magic Dragon," an AC-47 with rapid-fire miniguns set up at the cargo doors, each gun capable of firing up to 4,000 rounds per minute; "FNG," fucking new guy (a new soldier in-country); "REMF," rear-echelon motherfucker (a soldier who does not go into combat); "Ruff-Puff," Regional Forces/Popular Forces; "discreet burst," short, directed firing of an automatic weapon (often resulting in casualties); "friendly fire," the attack of possibly fatal fire by one's own side; "meeting engagement," ambush; and casualties "described as light," either fewer (American) casualties than might have been expected or fewer (American) casualties than claimed for the enemy "body count."

8. Peter Newman, "The Media and Vietnam: Comment and Appraisal," *Columbia Journalism Review*, Winter 1970–71, p. 27.

9. "Morley Safer's Vietnam," Morley Safer, narr., *CBS Special Report*, April 4, 1967, Museum of Broadcasting, New York.

10. Phillip Knightly, "The Role of Journalists in Vietnam: A Feature Writer's Perspective," in Harrison Salisbury, ed., *Vietnam Reconsidered: Lessons from a War* (New York, 1984), p. 107; and "The New York Times Survey: Vietnam Remembered," February 23–27, 1985, manuscript, unpublished and unpaginated.

11. John Mueller, "Summary of Public Opinion and the Vietnam War," in Braestrup, ed., *Vietnam as History*, unpaginated appendix.

12. Deborah Kalb, "The Uncontrollable Element: American Reporters in South Vietnam, 1961–1963," interview transcript, p. 2. Interview with Ambassador Bui Diem, December 21, 1984, for a Harvard University undergraduate senior honors thesis in the Department of History.

13. George Kennan, *American Diplomacy* (Chicago, 1984), p. 163.

14. Ibid., p. 169.

15. Mueller, "Summary of Public Opinion," unpaginated appendix.

16. David Halberstam, *The Best and the Brightest* (New York, 1972), p. 97.

17. Paul Kattenburg, *The Vietnam Trauma in American Foreign Policy, 1945–75* (New Brunswick, N.J., 1980), p. 120.

18. Halberstam, *The Best and the Brightest*, p. 144.

19. "Who Rules Viet Nam?" *New York Herald Tribune*, Late City Ed., August 24, 1963, p. 22.

20. Godfrey Hodgson, *America in Our Time: From World War II to Nixon, What Happened and Why* (New York, 1976), p. 127. Perhaps the bluntest acknowledgment that the United States was fighting the war for the sake of appearance was the suggestion by Senator George Aiken of Vermont in 1966 that the Americans should just declare the war won and then get the hell out.

21. Michael Mok, "In They Go," *Life*, November 26, 1965, pp. 51 and 62.

22. Admiral U.S. Grant Sharp and General William Westmoreland, *Report on the War in Vietnam (As of 30 June 1968)* (Washington, D.C., 1969), p. 71.

23. Henry A. Kissinger, *American Foreign Policy*, expanded ed. (New York, 1974), p. 106.

24. Kattenburg, *The Vietnam Trauma*, p. 120.

25. Lyndon B. Johnson, *Public Papers of the Presidents: Lyndon B. Johnson 1965*, vol. 1 (Washington, D.C., 1966), p. 395.

26. Daniel Ellsberg, *Papers on the War* (New York, 1972), pp. 42–135. For an interesting discussion of the appropriateness of the metaphor "quagmire" as compared to "stalemate machine," see that chapter entitled "The Quagmire Myth and the Stalemate Machine."

27. Michael Herr, *Dispatches* (New York, 1977), p. 62. Ideology has often been cited as a prime reason for why the North Vietnamese won the war. "From our point of view," Premier Pham Van Dong told *New York Times* reporter Harrison Salisbury in 1967, "it is a sacred war . . . for Independence, Freedom, Life. It stands for everything, this war, for this generation and for future generations. That's why we are determined to fight this war and win this war." Quoted in Harrison Salisbury, *Behind the Lines—Hanoi* (New York, 1967), p. 137. Although the Americans (and the South Vietnamese) could also (and did) make such claims, the Americans' claims did not translate into military tactics. Ho Chi Minh had warned the French in the 1940s: "You can kill ten of my men for every one I kill of yours, but even at those odds, you will lose and I will win." And during the conflict against the United States, General Vo Nguyen Giap often spoke of fighting ten, fifteen, twenty, fifty years, regardless of cost, until victory. The United States was unwilling to back up its ideological rhetoric with comparable military and financial resolve. See Stanley Karnow, *Vietnam: A History* (New York, 1983), pp. 17–18.

28. Malcolm Browne, *The New Face of War* (New York, 1965), p. 58.

29. Mok, "In They Go," p. 51.

30. See, for example, Michael Walzer, *Just and Unjust Wars* (New York, 1977), esp. pp. 188–96.

31. Colonel Harry G. Summers, Jr., "Lessons: A Soldier's View," in Braestrup, ed., *Vietnam as History*, p. 113.

32. "Pictures to Remember," *The Nation*, February 19, 1968, p. 229.

33. Tim O'Brien, *If I Die in a Combat Zone, Box Me Up and Ship Me Home* (New York, 1973), pp. 51 and 40.

34. Mok, "In They Go," pp. 59–60.

35. Frederick Downs, *The Killing Zone: A True Story* (New York, 1978), pp. 161–62.

36. U.S. Senate, Committee on Foreign Relations, *Moral and Military Aspects of the War in Southeast Asia*, 91st Cong., 2nd sess. (Washington, D.C., 1970), p. 3.

37. Peter Marin, "Rerunning the War," *Mother Jones*, November 1983, p. 16. See also Walzer, *Just and Unjust Wars*, esp. pp. 188–96; and Guenter Lewy, *America in Vietnam* (New York, 1978), esp. pp. 223–417.

38. Mauldin was there visiting his son who was a helicopter pilot.

39. *The Pentagon Papers: The Defense Department History of U.S. Decision-Making on Vietnam*, Senator Gravel ed. (Boston, 1971), vol. 3, pp. 276–78, 286, 302, and 417.

40. Correspondent and historian Stanley Karnow (who was not one of the journalists at Pleiku that day) wrote, in his lengthy history on the war, that one of the "Vietcong assailants" was found inside the base enclosure with a detailed map on his body—"testimony," Karnow said, "to a meticulous job of espionage." Stanley Karnow, *Vietnam*, p. 412.

41. Personal interview with Malcolm Browne, November 20, 1987.

42. *The Pentagon Papers*, vol. 3, pp. 309, 311, and 687. Memoranda went out as early as March 1965 delineating suggested techniques for "minimiz[ing] the after-damage" of failure including these: "Publicize uniqueness and congenital impossibility of SVN case (e.g., Viet Minh held much of SVN in 1954, long-sieve–like borders, unfavorable terrain, no national tradition. . . .)" and "Create diversionary 'offensives' elsewhere in the world (e.g., to shore up Thailand, Philippines, Malaysia, India, Australia; to launch an 'anti-poverty' program for underdeveloped areas)." See vol. 3, pp. 324 and 700.

43. Edwin Emery, "The Press in the Vietnam Quagmire," *Journalism Quarterly*, Winter 1971, p. 621.

44. Sharp and Westmoreland, *Report on the War*, p. 1.

45. U.S. Senate, Committee on Foreign Relations, *News Policy in Vietnam*, 89th Cong., 2nd sess. (Washington, D.C., 1966), p. 95.

46. Arthur M. Schlesinger, Jr., *The Bitter Heritage: Vietnam and American Democracy, 1941–1966* (Greenwich, Conn., 1967), p. 73.

47. Quoted in Morley Safer, "How to Lose a War: A Response from a Broadcaster," in Salisbury, ed., *Vietnam Reconsidered*, p. 160.

48. Schlesinger, *The Bitter Heritage*, p. 41.

49. Salisbury, *Behind the Lines*, p. 195.

50. Summers, Jr., "Lessons," p. 109.

51. Anonymous, "Behind the Viet Nam Story," *Columbia Journalism Review*, Winter 1965, p. 17.

52. "Domestic resource constraints with all of their political and social repercussions, not strategic or tactical military considerations in Vietnam, were to dictate American war policy from that time on." *The Pentagon Papers*, vol. 4, p. 528.

53. Lawrence Baskir and William Strauss, *Chance and Circumstance: The Draft, the War and the Vietnam Generation* (New York, 1978), pp. 125, 8, and 14.

54. Shelby Stanton, *The Rise and Fall of an American Army: U.S. Ground Forces in Vietnam, 1965–1973* (Novato, Calif., 1985).

55. Schlesinger, *The Bitter Heritage*, p. 45.

56. Sharp and Westmoreland, *Report on the War*, p. 214.

57. Downs, *The Killing Zone*, p. 225.

58. Mary McCarthy, *Vietnam* (New York, 1967), p. 9.

59. Ronald Spector, "Strangers in a Strange Land: Fighting the War in Vietnam," *The Washington Post Book World*, September 8, 1985, p. 4.

60. Townsend Hoopes, *The Limits of Intervention* (New York, 1969), pp. 61–62.

61. Downs, *The Killing Zone*, p. 113.

62. Carl and Shelley Mydans, *The Violent Peace: A Report on the Wars in the Postwar World* (New York, 1968), p. 414.

63. Downs, *The Killing Zone*, p. 117.

64. Lewy, *America in Vietnam*, p. 86.

65. Sharp and Westmoreland, *Report on the War*, p. 249.

66. Confirmed quotation "by an *unidentified* U.S. major (Army or Airforce?) as reported by AP reporter Peter Arnett, who heard it on a MACV-arranged tour of Ben Tre in the Mekong Delta on 7 Feb 1968," manuscript, MHRC, U.S. Army Military History Institute Archives, Carlisle Barracks, Pa.

67. Deborah Kalb, "The Uncontrollable Element," interview transcript, pp. 15–16. Interview with Malcolm Browne, December 28, 1984.

68. Although it is officially recorded that the Americans stopped bombing in Indochina on August 14, 1973, acting in compliance with a June congressional decision, one air force tech sergeant I interviewed claimed that the bombing continued. "The mission that I was sent over to do," he said, "was the ground-directed bombing . . . in 1974–75. I don't care what anyone tells you about the bombing stopping in 1973, the bombing went on all the way to '75. . . . We did missions up into the DMZ and past the DMZ up till the time I closed the door on the radar in '75. I firmly believe," he continued, "that a lot of the things in history basically are written out of the official orders, they're not written out of what actually happened. The world in Southeast Asia did not go down according to official orders. It went down according to each contingency. Each operation."

69. Salisbury, *Behind the Lines*, p. 69.

70. Lewy, *America in Vietnam*, p. 416.

71. Arnold Isaacs, *Without Honor: Defeat in Vietnam and Cambodia* (Baltimore, 1983), p. 25.

72. Mydans and Mydans, *The Violent Peace*, p. 421.

73. Gustav Hasford, *The Short-Timers* (New York, 1979), p. 87.

74. C. D. B. Bryan, *Friendly Fire* (New York, 1976), p. 436.

75. Personal interview with Tom Dargan, April 16, 1984.

76. Edgar C. Doleman, Jr., *Tools of War*, in *The Vietnam Experience* (Boston, 1984), pp. 38 and 17.

77. Larry Burrows, notebook, undated but probably July 1962, unpaginated.

78. Elmo Zumwalt, Jr., and Elmo Zumwalt 3d, "Agent Orange and the Anguish of an American Family," *New York Times Magazine*, August 24, 1986, p. 36.

79. Commonwealth of Massachusetts, *Final Report of the Special Commission Established . . . for the Purpose of Making an Investigation and Study of the Concerns of Vietnam War Veterans*, Senate No. 2307 (Boston, December 30, 1983), pp. 34–37.

80. Browne, *The New Face of War*, p. 37.

81. Zumwalt and Zumwalt, "Agent Orange," p. 34.

82. Browne, *The New Face of War*, p. 38.

83. Tim Page, *Tim Page's Nam* (New York, 1983), p. 34.

84. Personal interview with Tom Dargan, April 16, 1984. Ironically, not only could the supplied equipment be from someone who *was* killed, it could also get someone *else* killed. Radio-telephone operators, for example, always had one of the highest mortality rates in a platoon because the radio antenna sticking up above their heads identified them as a prime target.

85. Perry Deane Young, "Two of the Missing," *Harper's Magazine*, December 1972, p. 86. See also Charles Moskos, *The American Enlisted Man* (New York, 1979).

86. Richard Holmes, *Acts of War: The Behavior of Men in Battle* (New York, 1985), p. 251.

87. Personal interview with George Cushman, April 13, 1984.

88. Personal interview with Rick Ducey, March 22, 1984.

89. Herr, *Dispatches*, p. 61.

90. Holmes, *Acts of War*, p. 260. These figures do not include the men who suffered psychiatric difficulties after their tour of duty.

91. Young, "Two of the Missing," p. 86.

92. Holmes, *Acts of War*, p. 258.

93. Sharp and Westmoreland, *Report on the War*, p. 242.

94. Gloria Emerson, *Winners and Losers: Battles, Retreats, Gains, Losses and Ruins from the Vietnam War* (New York, 1976), pp. 58–59; Holmes, *Acts of War*, p. 350; and OASD (comptroller), *SEA Statistical Summary*, Table 860B, February 18, 1976.

95. See Lewy, *America in Vietnam*, appendix 1, "Civilian Casualties," for an interesting comparison of the ratio of civilian to military casualties in Vietnam to other wars.

96. See Charles Mohr, "History and Hindsight: Lessons from Vietnam," *New York Times*, April 30, 1985, pp. A1 and A6; Tom Morganthau et al., "We're Still Prisoners of War," *Newsweek*, April 15, 1985, pp. 35 and 36; and Thomas Boettcher, *Vietnam: The Valor and the Sorrow* (New York, 1985), p. 341.

97. Isaacs, *Without Honor*, pp. 127–28.

98. CBS News, New York, "The End in Vietnam," *CBS Morning News with Hughes Rudd* (Special Report), April 30, 1975, transcript, pp. 5–6.

99. "Documentation on the Viet-Nam Agreement," reprint from *The Department of State Bulletin* (Washington, D.C., 1973), p. 2.

100. *CBS Evening News with Walter Cronkite*, Dan Rather substituting, April 30, 1975 (CBS News Archives, New York), pp. 2, 7, and 8.

Chapter 14. The Committed Critics

1. Quoted in Peter Braestrup, "Covering the Vietnam War," *Nieman Reports*, December 1969, p. 8.

2. Richard Nixon, *The Real War* (New York, 1980), pp. 115–16.

3. Winant Sidle, "The Role of Journalists in Vietnam: An Army General's Perspective,"

in Harrison Salisbury, ed., *Vietnam Reconsidered: Lessons from a War* (New York, 1984), pp. 111–12.

4. The correspondents' support of Democratic candidates did not prevent them from criticizing the war as conducted by those same Democratic administrations. See S. Robert Lichter and Stanley Rothman, "Media and Business Elites," *Public Opinion*, October/November 1981, p. 42.

5. "Morley Safer's Vietnam," Morley Safer, narr. *CBS Special Report*, April 4, 1967, Museum of Broadcasting, New York.

6. See Peter Braestrup, *Big Story: How the American Press and Television Reported and Interpreted the Crisis of Tet 1968 in Vietnam and Washington*, 2 vols. (Boulder, Colo., 1977).

7. The Saigon press corps, while supportive of the American involvement, did not lose its sense of humor over the follies to which that involvement led. Homer Bigart, *New York Times* correspondent in Saigon and twice a winner of the Pulitzer Prize, coined a phrase for the Kennedy administration's Vietnam policy: "Sink or swim with Ngo Dinh Diem, and let's have no poo about Madame Nhu." Quoted in Deborah Kalb "The Uncontrollable Element: American Reporters in South Vietnam, 1961–1963," interview transcript p. 12. Interview with Neil Sheehan, December 30, 1984, for a Harvard University undergraduate senior honors thesis in the Department of History.

8. Ibid., p. 7. Interview with Charles Mohr, February 8, 1985.

9. Ibid., p. 8. Interview with Neil Sheehan.

10. John Mecklin, *Mission in Torment: An Intimate Account of the U.S. Role in Vietnam* (Garden City, N.Y., 1965), p. xii.

11. "Shop Talk at Thirty: Telling the Viet Nam Story," *Editor & Publisher*, August 6, 1966, p. 52.

12. Personal interview with Eddie Adams, November 22, 1987.

13. Personal interview with Russell Burrows, November 20, 1987.

14. Letter to the author from Russell Burrows, June 24, 1988.

15. Personal interview with Philip Jones Griffiths, November 21, 1987.

16. Personal interview with Eddie Adams, November 22, 1987.

17. Personal interview with Malcolm Browne, November 20, 1987.

18. Malcolm Browne, "Viet Nam Reporting," *Columbia Journalism Review*, Fall 1964, p. 7.

19. Michael Herr, "The War Correspondent: A Reappraisal," *Esquire*, April 1970, p. 98.

20. Personal interview with Philip Jones Griffiths, November 21, 1987.

21. Ibid.

22. Personal interview with Eddie Adams, November 22, 1987.

23. Personal interview with Russell Burrows, November 20, 1987.

24. Peter Braestrup, *Big Story*, vol. 1, p. 727.

25. David Halberstam, *The Powers That Be* (New York, 1979), p. 472.

26. "Foreign Correspondents: The Saigon Story," *Time*, October 11, 1963, p. 55. Higgins later denied making that statement. See Marguerite Higgins, *Our Vietnam Nightmare* (New York, 1965), p. 128.

27. David Halberstam, "The Role of Journalists in Vietnam: A Reporter's Perspective," in Salisbury, ed., *Vietnam Reconsidered*, p. 115.

28. Quoted in James Aronson, *The Press and the Cold War* (Indianapolis, Ind., 1970), p. 204.

29. Interview with Malcolm Browne, in Kalb, "The Uncontrollable Element," p. 9.

30. David Douglas Duncan, "Inside the Cone of Fire: Con Thien," *Life*, October 27, 1967, p. 42b.

31. David Douglas Duncan, *War Without Heroes* (New York, 1971), unpaginated.

32. Personal interview with Malcolm Browne, November 20, 1987.

33. "Photographers: Gnat of Hill 881," *Time*, May 12, 1967, p. 42.

34. Perry Deane Young, "Two of the Missing," *Harper's*, December 1972, pp. 85–86.

35. *MACV Accreditation Eligibility Criteria*, File No. 412-15 Correspondent Accreditation Files (72), Box 1, rg. no. 334; Accession No. 74–0510, MAC.01 Adv. Div., Historical Records Branch, Historical Services Division, U.S. Army Center of Military History, National Archives, Suitland, Md.

36. Personal interview with Eddie Adams, November 22, 1987.

37. Personal interview with Philip Jones Griffiths, November 21, 1987.

38. Admiral U.S. Grant Sharp and General William Westmoreland, *Report on the War in Vietnam (As of 30 June 1968)* (Washington, D.C., 1969), p. 273.

39. U.S. Senate, Committee on Foreign Relations, *News Policy in Vietnam*, 89th Cong., 2nd sess. (Washington, D.C., 1966), p. 67.

40. Personal interview with Philip Jones Griffiths, November 21, 1987.

41. Braestrup, "Covering the Vietnam War," p. 12.

42. Interview with Neil Sheehan, in Kalb "The Uncontrollable Element," pp. 15–16.

43. Personal interview with Malcolm Browne, November 20, 1987.

44. Personal interview with Russell Burrows, November 20, 1987.

45. Bernard Fall, *The Two Viet-Nams: A Political and Military Analysis* (New York, 1963), pp. 282–85.

46. Mecklin, *Mission in Torment,* pp. 191–92.

47. Interview with Neil Sheehan, in Kalb, "The Uncontrollable Element," p. 2.

48. U.S. Senate, Committee on Foreign Relations, *News Policy in Vietnam,* pp. 20 and 64.

49. Columbia University Graduate School of Journalism, *The Military and the News Media: The Correspondent Under Fire,* Media and Society Seminars in association with WQED, Pittsburgh; WNET, New York; and the Bonneville Broadcast Group (New York, 1985), program transcript, p. 14.

50. U.S. Senate, Committee on Foreign Relations, *News Policy in Vietnam,* p. 66.

51. Don Stillman, "Tonkin: What Should Have Been Asked," *Columbia Journalism Review,* Winter 1970–71, p. 22.

52. Fred Friendly, "TV at the Turning Point," *Columbia Journalism Review,* Winter 1970–71, p. 14.

53. Anonymous, "Behind the Viet Nam Story," *Columbia Journalism Review,* Winter 1965, p. 17.

54. *Cable 1006,* Department of State to Saigon, February 21, 1962. National Security File, Box 195, John F. Kennedy Library, Boston, Mass.

55. U.S. Senate, Committee on Foreign Relations, *News Policy in Vietnam,* pp. 74–75.

56. William Westmoreland, *A Soldier Reports* (New York, 1976), p. 359.

57. *MACV Accreditation Eligibility Criteria,* File "Bad Guy List" and File No. 412-15 Correspondent Accreditation Files (71) (Disaccreditation) COFF 31 Dec. '71, WNRC Jan 73, Permanent, Box 14, rg. no. 334, Accession No. 74593, Historical Records Branch, Historical Services Division, U.S. Army Center of Military History, National Archives, Suitland, Md.

58. U.S. Senate, Committee on Foreign Relations, *News Policy in Vietnam,* p. 68.

59. W. E. Garrett, "What Was a Woman Doing There?" *National Geographic,* February 1966, p. 270.

60. Herr, "The War Correspondent," p. 101.

61. Major-General Thomas Rienzi, Department of the Army, *Vietnam Studies: Communications-Electronics, 1962–70* (Washington, D.C., 1972), p. 125.

62. Ibid.

63. Nick Mills and the editors of Boston Publishing Co., *The Vietnam Experience: Combat Photographer* (Boston, 1983), pp. 9 and 11; and Bureau of Naval Personnel, *Photographer's Mate 2* (Washington, D.C., 1958).

64. Robert Moeser, *US Navy: Vietnam* (Annapolis, Md., 1968), p. 248.

65. Personal interview with Malcolm Browne, November 20, 1987.

66. Ibid.

67. Personal interview with Philip Jones Griffiths, November 21, 1987.

68. Personal interview with Russell Burrows, November 20, 1987.

69. George Hunt, "Editor's Note: He Went Off to War with Film in His Socks," *Life,* January 25, 1963, p. 5.

70. Personal interview with Malcolm Browne, November 20, 1987.

71. Personal interview with Russell Burrows, November 20, 1987.

72. Duncan, *War Without Heroes,* unpaginated.

73. Dickey Chapelle, "Water War in Viet Nam," *National Geographic,* February 1966, p. 278.

74. Personal interview with Eddie Adams, November 22, 1987.

75. Personal interview with Malcolm Browne, November 20, 1987.

76. Herr, "The War Correspondent," p. 175.

77. It is difficult to determine in some instances whether a casualty is a writer, an on-camera reporter, or a technician, or whether the victim is a photographer or a camera operator. Most of the information on the journalist-casualties identifies their press affiliation but not necessarily their occupation within an organization. See *News Media Killed in Southeast Asia, Captured Correspondents,* and *News Media Casualties in Vietnam,* all in File "Correspondents Killed and Wounded," WNRC, Box 14, rg. no. 334, Accession No. 74593, Historical Records Branch, Historical Services Division, U.S. Army Center of Military History, National Archives, Suitland, Md. Other nonofficial totals list alternatively 45 or 51 correspondents killed by the early 1970s; however, these figures are not broken down by name or affiliation, so it is difficult to work with these higher numbers.

78. Personal interview with Philip Jones Griffiths, November 21, 1987.

79. Ralph Graves, "Editor's Note: Larry Burrows, Photographer," *Life,* February 19, 1971, p. 3.

80. Irving Desfor, "Cameras on the Front Lines," *Christian Science Monitor,* February 13, 1968, p. 17.

81. Douglas Gallez, "Pictorial Journalism at War," *Journalism Quarterly,* Autumn 1970, fn. 6, p. 494.

82. "Vietnam: A Compassionate Vision," *Life,* February 26, 1971, p. 34.

83. Braestrup, *Big Story,* vol. 2, p. 323.

84. For a discussion countering many of Peter Braestrup's charges, see Peter Arnett, "Tet Coverage: A Debate Renewed," *Columbia Journalism Review,* January/February 1978, pp. 43–50.

85. Daniel Hallin, *The "Uncensored War": The Media and Vietnam* (New York, 1986), p. 173.

86. Hallin, *The "Uncensored War,"* esp. p. 201, made a similar point about television coverage during the war.

87. Braestrup, in his examination of the Tet images, also spoke of this tendency: U.S. journalism's ethnocentricity was even more marked in still photographs than in television or text. . . . At Tet, as in most complicated crises, the published photographic coverage—although it consumed up to 20 percent of the total Vietnam space allocation—dealt with only a narrow range of subjects. Pacification, enemy strategy and tactics, the *scale* of urban destruction, the response of the South Vietnamese Administration to the crisis, the countrywide "situation"—none of these matters lent themselves to traditional U.S. journalistic photography. (See Braestrup, *Big Story,* vol. 2, p. 323.) But Braestrup's "categorical breakdown" of the still images in the press published during February and March 1968, although not unique to Tet, did not hold for the photographic coverage of the war before and after that period. It is obviously a great distortion of *Life*'s coverage of the war, for example, to extrapolate *Life*'s emphasis on the ARVN troops from this two-month time in which no pictures of "South Vietnamese troops in action" were published. Between January 1962 and December 1972, *Life* published stories on combat in Vietnam (as distinct from the war at home or other related topics) in 114 issues. And of the 36 cover stories, roughly a third of them dealt with subjects not restricted to the American fighting: the ARVN troops, the South Vietnamese political situation, the North Vietnamese military effort, and the plight of the civilians. (It is not surprising that the articles published before 1965 and after 1969 were most likely to detail the situation of the ARVN soldiers.) Braestrup's concern in his tabulation was that the American press coverage of the war should be shown to have been inaccurately pessimistic about the allied, but especially the U.S. military successes. If one takes a longer perspective of the press coverage, specifically of the photographic reportage, than Braestrup did, one can see that although the press's general commentary on any ongoing military effort was negative—and became increasingly so—its analysis was still, if anything, too hopeful about a "favorable" outcome to the war, primarily because of its continued reflection of governmental and military positivism.

88. Malcolm Browne, "Viet Nam Reporting: Three Years of Crisis," *Columbia Journalism Review,* Fall 1964, p. 8.

89. Graves, "Editor's Note," *Life,* February 19, 1971, p. 3.

90. *Life* editors, *Larry Burrows: Compassionate Photographer* (New York, 1972), unpaginated.

91. "Vietnam: A Compassionate Vision," p. 44.

92. Michael Herr, *Dispatches* (New York, 1977), p. 271.

93. Donald McCullin, *Is Anyone Taking Any Notice?* (Cambridge, Mass., 1973) unpunctuated, unpaginated.

94. Herr, "The War Correspondent," p. 172.

95. Personal interview with Philip Jones Griffiths, November 21, 1987, and letter to the author, June 15, 1988.

96. Ibid.

97. Nick Mills and the editors of Boston Publishing Co., *Combat Photographer*, p. 136.

98. "The Massacre at Mylai," *Life*, December 5, 1969, p. 36.

99. Personal interview with Eddie Adams, November 22, 1987.

100. Personal interview with Philip Jones Griffiths, November 21, 1987.

101. Phillip Knightly, *The First Casualty: From the Crimea to Vietnam—The War Correspondent as Hero, Propagandist, and Myth Maker* (New York, 1975), p. 397.

102. Young, "Two of the Missing," p. 85.

103. Personal interview with Malcolm Browne, November 20, 1987.

104. Personal interview with Eddie Adams, November 22, 1987.

105. Young, "Two of the Missing," p. 89.

106. Ibid., p. 84.

107. Personal interview with Philip Jones Griffiths, November 21, 1987.

108. Young, "Two of the Missing," p. 85.

109. Hunt, "Editor's Note," p. 5.

110. *Life* editors, *Larry Burrows*, unpaginated.

111. Young, "Two of the Missing," p. 92.

112. Personal interview with Malcolm Browne, November 20, 1987.

113. Personal interview with Philip Jones Griffiths, November 21, 1987.

114. Herr, *Dispatches*, p. 20.

115. *Life* editors, *Larry Burrows*, unpaginated.

116. Herr, "The War Correspondent," p. 99.

117. Phillip Knightly, "How to Lose a War: A Response from a Print Historian," in Salisbury, ed., *Vietnam Reconsidered*, p. 154.

118. Tim Page, *Tim Page's Nam* (New York, 1983), p. 83.

119. Larry Burrows, "Vietnam: 'A Degree of Disillusion,'" *Life*, September 19, 1969, p. 67.

120. David Douglas Duncan, "Inside the Cone of Fire," p. 42b.

121. In the 1970s, Harvard political scientist Samuel Huntington, one of the chief proponents of the "strategic hamlet" program, verbalized what many of the 1960s press had already realized for other reasons: that since the Korean War, the media is "the most important new source of national power." See Michael J. Crozier, Samuel P. Huntington, and Joji Watanuki, *The Crisis of Democracy* (New York, 1975), p. 98.

122. Personal interview with Eddie Adams, November 22, 1987.

Chapter 15. A Subversion through Exposure

1. U.S. Senate, Committee on Foreign Relations, *News Policy in Vietnam*, 89th Cong., 2nd sess. (Washington, D.C., 1966), p. 89.

2. John G. Morris, "This We Remember," *Harper's Magazine*, September 1972, p. 75.

3. George P. Hunt, "Editors' Note: He Went Off to War with Film in His Socks," *Life*, January 25, 1963, p. 5.

4. Halberstam mentioned that "the *Times* was very nervous about the entire situation [Halberstam's 'aggressive' reporting]. It hated the idea of one of its reporters being contro-

versial and it hated the idea that it might be blamed for being soft on Communism. In addition, some editors disliked what they felt was my lack of balance and wished my reporting were more conventional, with more articles directly quoting high-level offices about how well things were going." See David Halberstam, The Powers That Be (New York, 1979), p. 446. At least twice the Times vigorously questioned Halberstam, once when his story was vehemently denied by Dean Rusk. Press Secretary Pierre Salinger, among other officials, also took exception to the journalists in those early years; Salinger even attacked members of the press in Saigon in front of their Washington colleagues. See James Aronson, The Press and the Cold War (Boston, 1970), p. 202.

5. Halberstam, The Powers That Be, p. 490.

6. "The Battle that Regained and Ruined Hué," Life, March 8, 1968, p. 26.

7. U.S. Senate, Committee on Foreign Relations, News Policy in Vietnam, p. 66.

8. "Shop Talk at Thirty: Telling the Viet Nam Story," Editor & Publisher, August 6, 1966, p. 44. Browne cited his previous boss, Wes Gallagher of AP, as a prominent exception to the rule that the news executives were, at first, unsupportive of their reporters in Vietnam. In 1963, Gallagher went to Saigon, as did several of the other news chiefs and network vice presidents over the course of the war, and got the official guided tour, complete with high-level briefings and helicopter rides. However, unlike his colleagues, he stayed and toured the country with his own men, whereupon "he realized that everything he had been told during the previous day by the riffraff in Saigon had been crap.... This was one of the reasons to this day, I think that Wes Gallagher is one of the heroes of the Viet Nam and the press war." Quoted in Deborah Kalb, "The Uncontrollable Element: American Reporters in South Vietnam, 1961–1963," interview transcript, p. 11. Interview with Malcolm Browne, December 28, 1984, for a Harvard University undergraduate senior honors thesis in the Department of History.

9. Michael Herr, "The War Correspondent: A Reappraisal," Esquire, April 1970, p. 168.

10. Godfrey Hodgson, America in Our Time (New York, 1976), p. 141.

11. Peter Arnett, "The Last Years and the Aftermath," in Harrison Salisbury, ed., Vietnam Reconsidered: Lessons from a War (New York, 1984), p. 134.

12. The story is related in a number of sources. See, for example, Halberstam, The Powers That Be, pp. 461–67; Aronson, The Cold War, pp. 200–2; and Stanley Karnow, Vietnam: A History (New York, 1983), p. 297.

13. Fred Ritchin, "The Photography of Conflict," Aperture, Winter 1984, p. 24.

14. Personal interviews with Russell Burrows, November 20, 1987, and with Carl Mydans, August 25, 1986.

15. Personal interviews with Russell Burrows, November 20, 1987, and with Carl Mydans, August 25, 1986; personal conversation with David Douglas Duncan, November 13, 1986.

16. Personal interview with Russell Burrows, November 20, 1987.

17. Hunt, "Editors' Note," p. 5.

18. "Summary of Mail Received About LIFE January 25, as of February 8, 1963," internal memorandum from Mabel Foust to Hugh Moffett, unpaginated. Time, Inc., Archives.

19. Personal interview with Russell Burrows, November 20, 1987.

20. Quoted in Andy Grundberg, "Photo Classes: Color vs. Black and White," New York Times, November 30, 1986, p. 59.

21. "Hong Kong Mailer No. 648," memorandum from Orshefsky, Hongkong, to Lang for Rowan, January 11, 1964, p. 2. Time, Inc., Archives.

22. Personal interview with Eddie Adams, November 22, 1987.

23. Personal interview with Philip Jones Griffiths, November 21, 1987.

24. It was only in the early 1960s that the new medium had become portable enough to go out on military operations to "shoot bloody," as they called it. But even with the technological improvements, there were still situations that precluded television coverage, such as "operations that have an awful lot of secondary growth, this tangled underbrush." As Malcolm Browne, who went to work for ABC after quitting AP, remembered: "We were at the mercy of the terrible Auricon camera—the great big Mickey-Mouse 16mm. You had to go out three tied together: the correspondent, the cameraman, and the soundman all connected by cables, even while leaping out of helicopters" (quoted from personal interview with Malcolm Browne, November 20, 1987). The three networks made a major investment in the war. By 1967, CBS, NBC, and ABC had Saigon staffs of two

dozen each, together spending around $5 million—a monetary commitment that ensured space on the evening news whenever possible. See Hodgson, *America in Our Time*, p. 149.

With biases similar to those of many of their colleagues in the print press, television producers emphasized footage of Americans rather than the Vietnamese. In addition, because of the expense of satellite feeds, the networks also emphasized "timeless" action footage that could run days or even weeks after filming. The result was that the viewing audience was left with the impression that there was a constant momentum to the war—but a momentum that never resulted in victory. The average report ran 90 seconds, or about 300 words. Of necessity, these "stand-upper" scripts were produced around the footage "and in the end," as Browne observed, "what was getting through was the wonderful images of war. . . . You get fire and smoke. You get the locker room story with the dying Marine. All this great stuff that the viewers eat up, I guess. But to try to convey ideas more sophisticated than the one-liners that are appropriate to stand-uppers is very, very difficult" (quoted from personal interview with Malcolm Browne, November 20, 1987).

One result of the inadvertent stress placed on the photogenic images of war was that the top military leaders believed the television reports to be even more hostile to the American war effort than those of the printed press. See Douglas Kinnard, *The War Managers* (Hanover, N.H., 1977), p. 175. But numerous analyses have shown that the television coverage was generally supportive of the war effort, even up to 1970. See, for example, Daniel Hallin, *The "Uncensored War": The Media and Vietnam* (New York, 1986); and Lawrence W. Lichty, "Comments on the Influence of Television on Public Opinion," in Peter Braestrup, ed., *Vietnam as History* (Washington, D.C., 1984), p. 158. And, indeed, a survey conducted for *Newsweek* in 1967 suggested that television had actually encouraged support for the conflict: when the viewers were asked whether watching television had made them feel more like "backing up the boys in Vietnam" or more like opposing the war, 64 percent responded that they were moved to support the war and only 26 percent replied they were prompted to oppose it. See "The Press: Room for Improvement," *Newsweek*, July 10, 1967, p. 78. Most television historians have concluded that television coverage trailed American public opinion in its criticism of the war.

25. John Corry, "TV's Legacy From the Vietnam War," *New York Times*, April 21, 1985, sec. 2, p. 29.

26. Morris, "This We Remember," p. 77.

27. "South Viet Nam: We Are Being Overrun," *Time*, April 20, 1962, p. 40.

28. "Hong Kong Mailer No. 648," pp. 1 and 3.

29. Personal interview with Russell Burrows, November 20, 1987.

30. Transcript of Larry Burrows tape of Yankee Papa 13, "Da Nang, April 4th, 1965," p. 10. Time, Inc., Archives.

31. Ibid., p. 11.

32. Larry Burrows, "One Ride with Yankee Papa 13," *Life*, April 16, 1965, pp. 24–37.

33. Predictably, the letters to the editors comment—both positively and negatively—on the power of the photographic series. See Letters to the Editors, *Life*, May 7, 1965, p. 27.

34. "Marines Blunt the Invasion from the North," *Life*, October 28, 1966, pp. 36–37.

35. Larry Burrows Cable, "To Lang for Orshefsky, Rogin, Newyork, Fm Larry Burrows, Hongkong," October 17, 1966, unpaginated. Time, Inc., Archives.

36. Transcript of Larry Burrows tape of Yankee Papa 13, "Da Nang, April 4th, 1965," p. 3.

37. Cover stories, listed by photographer, from *Life*: Henri Huet, "The War Goes On," February 11, 1966; Larry Burrows and Co Rentmeester, "Invasion DMZ Runs into the Marines," October 28, 1966; and David Douglas Duncan, "Inside the Cone of Fire at Con Thien," October 27, 1967. Stories, listed by photographer, from *Look* (*Look* ran no "cover" stories on the war): Thomas Koeniges, "19-Year-Old Marine in Vietnam," August 24, 1965; and James Hansen, "A Marine's Longest Night," May 2, 1967.

38. Burrows and Rentmeester, "Invasion DMZ Runs into the Marines," p. 35.

39. "As we went ahead with our plans [for the publication of the story]," *Life* editor Loudon Wainwright remembered, "none of us recalled—if, in fact, we'd ever known of it—the *Life* story that ran in 1943 with the names of almost 13,000 Americans who'd

been killed up to that point in World War II." Loudon Wainwright, *The Great American Magazine: An Inside History of* Life (New York, 1986), p. 409.

40. "The Faces of the American Dead in Vietnam: One Week's Toll," *Life*, June 27, 1969, p. 20.

41. Wainwright, *The Great American Magazine*, p. 414.

42. Letters to the Editors, *Life*, July 8, 1969, p. 16A.

43. Wainwright, *The Great American Magazine*, p. 414.

44. Letters to the Editors, *Life*, July 8, 1969, p. 16A.

45. Larry Burrows caption notes, "War in Vietnam; To: Anthony for Public Affairs, From: Orshefsky, Hongkong; Oct. 6, 1962." Time, Inc., Archives.

46. Sam Casten, "What Johnson Faces in South Vietnam," *Look*, January 28, 1964, pp. 20–21 and 28–29.

47. Letters to the Editor, *Look*, March 10, 1964, pp. 4 and 6.

48. Michael Mok, "In They Go—To the Reality of This War," *Life*, November 26, 1965, pp. 54–56.

49. Letters to the Editors, *Life*, December 17, 1965, p. 21.

50. "The Last Retreat," *Time*, March 31, 1975, cover.

51. "In Color: The Vicious Fighting in Vietnam," *Life*, January 25, 1963, cover.

52. Christopher Wren, "The Vietnamese GI: Can He Win His Own War?" *Look*, August 11, 1970, p. 13.

53. The editors, "An Editorial," *Look*, May 14, 1968, p. 33.

54. Shana Alexander, "The Feminine Eye: What Is the Truth of the Picture?" *Life*, March 1, 1968, p. 9.

55. Personal interview with Malcolm Browne, November 20, 1987.

56. Ibid.

57. Morris, "This We Remember," p. 75.

58. Kalb, "The Uncontrollable Element," pp. 69 and 80.

59. Alexander, "What Is the Truth," p. 9.

60. Personal interview with Russell Burrows, November 20, 1987.

61. Personal interview with Malcolm Browne, November 20, 1987.

62. Gene Thornton, "Photography View: War Pictures That Go Beyond Historical Fact," *New York Times*, March 17, 1985, sec. 2, p. 31.

63. Larry Heinemann, *Close Quarters* (New York, 1977), p. 294.

64. Peter Braestrup, *Big Story: How the American Press and Television Reported and Interpreted the Crisis of Tet 1968 in Vietnam and Washington* (Boulder, Colo., 1977), vol. 2, p. 323.

65. Duncan, "Inside the Cone of Fire," p. 28d.

66. Ibid., p. 39.

67. "Letters," *Harper's Magazine*, November 1972, p. 5.

68. Merton Perry, "The Dusty Agony of Khe Sanh," *Newsweek*, March 18, 1968, pp. 28–36.

69. "Marines Blunt the Invasion from the North," *Life*, October 28, 1966, cover and pp. 30–39.

70. "Vietnam: A Compassionate Vision," *Life*, February 26, 1971, pp. 34–45.

71. Cable, "To: Lang for Rowan, Newsfronts; Fm: Parker, Saigon," Oct. 10, 1966, unpaginated. Time, Inc., Archives.

72. Cable, "To Lang for Orshefsky, Rogin, Newyork; Fm Larry Burrows, Hongkong," October 17, 1966, unpaginated. Time, Inc., Archives.

73. Ibid.

74. Letters to the Editors, *Life*, November 18, 1966, p. 31.

75. "This Is that War," *Look*, May 14, 1968, p. 24.

76. Ibid., p. 30.

77. Letters to the Editors, *Life*, July 8, 1969, p. 16A.

Epilogue

1. See, for example, Department of State and Department of Defense, *Grenada: A Preliminary Report* (Washington, D.C., December 16, 1983). In this forty-three–page report there is no description of the three days of fighting. The description proceeds directly from the morning of October 25, 1983, when "a combined U.S.-Caribbean security force landed" to October 28, when "all significant military objectives had been served" (p. 1).

2. Personal interview with Eddie Adams, November 22, 1987.

3. For a well researched, yet devastating, account of the Grenada invasion, see either Hugh O'Shaughnessy, *Grenada: An Eyewitness Account of the US Invasion and the Caribbean History That Provoked It* (New York, 1985); or Edward Luttwak, *The Pentagon and the Art of War: The Question of Military Reform* (New York, 1985).

4. Office of Assistant Secretary of Defense (Public Affairs), *News Release* (Washington, D.C., n.d.); Joint Chiefs of Staff, *Report by CJCS Media-Military Relations Panel (Sidle Panel)* (Washington, D.C.); and personal interview with Eddie Adams, November 22, 1987.

5. Joint Chiefs of Staff, Report (Sidle Panel), p. 16.

6. Personal interview with Eddie Adams, November 22, 1987.

7. Personal interview with Malcolm Browne, November 20, 1987.

8. Ibid.

9. Personal interview with Eddie Adams, November 22, 1987.

Index

Index

Index

Index

465

Index

Index

Index

471

Index